Langford's Advanced Photography

Seventh Edition

Langford's Advanced Photography

Seventh Edition

Michael Langford FBIPP, HonFRPS
Royal College of Art, London

Efthimia Bilissi MSc PhD AIS ARPS
Senior Lecturer
University of Westminster, London

Contributors
Elizabeth Allen BSc MSc
Course Leader BSc (Hons) Photography and Digital Imaging
University of Westminster, London

Andy Golding
Head of Department of Photography and Film
University of Westminster, London

Hani Muammar BSc MSc PhD MIET
Senior Scientist
Kodak European Research

Sophie Triantaphillidou BSc PhD ASIS FRPS
Leader Imaging Technology Research Group
University of Westminster, London

AMSTERDAM • BOSTON • HEIDELBERG • LONDON • NEW YORK • OXFORD
PARIS • SAN DIEGO • SAN FRANCISCO • SINGAPORE • SYDNEY • TOKYO

ELSEVIER

Focal Press is an imprint of Elsevier

Focal
Press

Focal Press is an imprint of Elsevier
Linacre House, Jordan Hill, Oxford OX2 8DP, UK
30 Corporate drive, Suite 400, Burlington, MA 01803, USA

First published 1969
Second edition 1972
Third edition 1974
Fourth edition 1980
Fifth edition 1989
Reprinted 1992, 1993, 1994, 1995
Sixth edition 1998
Reprinted 1999, 2001, 2003, 2004, 2005, 2006
Seventh edition 2008

British Library Cataloguing in Publication Data
Langford, Michael John, 1933–
 Langford's advanced photography. – 7th ed.
 1. Photography
 I. Title II. Bilissi, Efthimia III. Langford, Michael John,
 1933–. A dvanced photography
 771

Library of Congress Number: 2007938571

ISBN: 978-0-240-52038-4

For information on all Focal Press publications
visit our website at www.focalpress.com

Typeset by Charon Tec Ltd (A Macmillan Company), Chennai, India
www.charontec.com

Printed and bound in Slovenia
08 09 10 11 11 10 9 8 7 6 5 4 3 2 1

Contents

Picture credits

Cover photograph: Bernardo Medina [foureyes] 4eyes@4eyesphoto.com
Picture research: Efthimia Bilissi and Leah Bartczak

Figure 1.2 Bert Hardy/Hulton Getty Picture Library. 1.3 Dr Jeremy Burgess/Science Photo Library. 1.4, 1.7, 1.8, 2.27, 5.3, 5.7, 5.30, 7.4, 8.10, 8.13, 8.14, 8.16, 8.18, 12.30, 13.19, 14.5, 14.7, 14.8 Michael Langford. 1.5 John Downing/*Daily Express*. 1.6 Annie Morris, London. 2.1 (a) Photo courtesy of iStockphoto, KjellBrynildsen, image# 3070189, (b) Photo courtesy of iStockphoto, LongHa2006, image, image# 2157020, (c) Photo courtesy of iStockphoto, ZoneCreative, image# 3568468, (d) Photo courtesy of iStockphoto, hartcreations, image# 1873049, (e) Photo courtesy of iStockphoto, fabphoto, image# 2958829. 2.4 Canon (UK) Ltd. 2.15, 11.2, 11.5, 11.12, 11.14, 11.16, 11.25 Elizabeth Allen 2.17 (a) Phase One Inc. (b) Better Light Inc. 3.14 Carl Zeiss, West Germany. 3.18 Rodenstock. 3.21 The terms and definitions taken from ISO 12233:2000 Photography – Electronic still-picture cameras – Resolution measurements, Figure 1, are reproduced with permission of the International Organisation for Standardization, ISO. This standard can be obtained from any ISO member and from the Web site of ISO Central Secretariat at the following address: www.iso.org. Copyright remains with ISO. 3.26 From: http://www.flickr.com/photos/robsinclair/515407474/ Image by Rob Sinclair, made available under the terms of the Creative Commons, Attribution 2.0 license. 3.27 Ilkay Mehmet/*Daily Telegraph*. 3.28 From: http://www.flickr.com/photos/geishaboy500/469965020/ Image by Thor, made available under the terms of the Creative Commons, Attribution 2.0 license. 4.2 (image of spectrum) The Colour Group (GB) 4.12 Gossen Foto-und Lichtmesstechnik GmbH. 4.17 (a) and (b) The Colour Group (Great Britain). 5.2 Kodak Ltd. 5.8 Dick Swayne, Godalming. 5.10 Sophie Triantaphillidou. 5.11 (top left and right) Reprinted with permission from Eastman Kodak Company, (bottom left and right) Reprinted with permission from Fujifilm UK Ltd. 5.14 (a) and (b) Reprinted with permission from Ilford Photo/Harman technology Limited, (c) and (d) Reprinted with permission from Eastman Kodak Company. 5.15 Reprinted with permission from Fujifilm UK Ltd. 5.20, 5.26, 6.7 Reprinted with permission from Eastman Kodak Company. 6.10, 6.15, 6.16, 6.17 Hani Muammar. 7.1, 7.2, 7.3, 7.5, 7.7, 7.19, 7.21 Andy Golding. 7.8 Photo courtesy of iStockphoto, jimbycat, image# 3628315. 8.11, 12.24 (photograph), 12.26 Andrew Schonfelder. 9.1 Patrick Eagar, London. 9.2 Monique Cabral, London.9.3 Sue Packer, Tintern, Gwent. 9.4 Photo courtesy of iStockphoto, LyleGregg, image# 3322295. 9.5 Photo courtesy of iStockphoto, Xaviarnau, image# 3938699. 9.6 Photo courtesy of iStockphoto, antb, image# 2438549. 9.7 Photo courtesy of iStockphoto, alaincouillaud, image# 3240665. 9.8 Photo courtesy of iStockphoto, compassandcamera, image# 2336293. 9.10 Philip Fraser-Betts, Centremark Design and Photography, Chelmsford. 9.11 Photo courtesy of iStockphoto, PaulTessier, image# 3438963. 9.12 Photo courtesy of iStockphoto, rpbirdman, image# 3725313. 9.15 Photo courtesy of iStockphoto, texasmary, image# 4310461. 9.17 Photo courtesy of iStockphoto, freezingtime, image# 2043824. 9.18 Photo courtesy of iStockphoto, kickstand, image# 93704. 10.5 Photo courtesy of iStockphoto, Hofpils, image# 1889049.

10.8 Efthimia Bilissi. 10.9 Photo in the diagram courtesy of iStockphoto, eyedias, image# 290020. 10.13 ColorVision by Datacolor AG. 10.15 Photo courtesy of iStockphoto, gmnicholas, image# 2206249. 10.17 Photo courtesy of iStockphoto, BirdofPrey, image# 1412955. 11.7 (a) Photo courtesy of iStockphoto, Casarsa, image# 1057009, (b) Photo courtesy of iStockphoto, duncan1890, image# 1881060, (c) Photo courtesy of iStockphoto, naphtalina, image# 2145930, (d) Photo courtesy of iStockphoto, Ladida, image# 2748092, (e) Photo courtesy of iStockphoto, philipdyer, image# 3254640, (f) Photo courtesy of iStockphoto, BirdofPrey, image# 981783. Photo courtesy of iStockphoto, cworthy, image# 3201816, 11.9 Photo courtesy of iStockphoto, photomorphic, image# 2694933. 11.10 Photo courtesy of iStockphoto, shoobydoooo, image# 2467700. 11.17 Photo courtesy of iStockphoto, photomorphic, image# 2663993. 11.23 Photo courtesy of iStockphoto, ferrantraite, image# 2601236. 12.25 Tim Stephens/Faber and Faber. 12.27 Photo courtesy of iStockphoto, wolv, image# 133276. 13.1 Photo courtesy of iStockphoto, Saturated, image# 379721. Fig 13.5 Photo courtesy of iStockphoto, Skyak, image# 3532524. 13.6 (a) Schneider Kreuznach (b) Image from "Sam's Laser FAQ", © Samuel M. Goldwasser, www.repairfaq.org. 13.7 Bjørn Rørslett / NN / Samfoto. 13.9 Photo courtesy of iStockphoto, rsallen, image# 1301295 13.10 Chris Smith/*Sunday Times*. 13.11 Photo courtesy of iStockphoto, Tammy616, image# 4371980. 13.14 Ken MacLennan-Brown. 13.15 Muna Muammar 13.16 Photo courtesy of iStockphoto, kickstand, image# 139527. 13.18 Roundshot/Seitz Phototechnik AG. 13.20 Photo courtesy of iStockphoto, kickstand, image# 93626. 13.22 Photo courtesy of iStockphoto, timstarkey, image# 3790960. 13.24 Ledametrix.com. 13.26 Aran Kessler. 13.30, 13.31 Alastair Laidlaw and Christine Marsden. 14.11 Ulrike Leyens 15.1, 15.7 James Boardman Press Photography (*www.boardmanpix.com*). 15.2, 15.3 © Association of Photographers. Forms reproduced courtesy of the AOP (UK), from *Beyond the Lens, 3rd edition*, www.the-aop.org). 15.4, 15.6 Ulrike Leyens (www.leyens.com) 15.5 Ulrike Leyens (www.leyens.com) and Andre Pinkowski (www.onimage.co.uk). Chapter 5 title image: Photo courtesy of iStockphoto, April 30, image# 709674. Chapter 7 title image: Photo courtesy of iStockphoto, rion819, image# 185287. Chapter 15 title image: Photo courtesy of iStockphoto, kwanisik, image# 4271172.

Introduction

Ever since Michael Langford's book, *Advanced Photography*, was first published in 1969, the book has inspired and educated many thousands of photographers. In the seventh edition the original text has been fully revised and updated while ensuring that the breadth of technical detail that was present in previous editions has been maintained.

Langford's Advanced Photography, seventh edition, approaches the science and technology behind photography and relates it to practical issues. The book covers a wide range of topics from photographic equipment and processes to image manipulation, archiving and storage of both silver halide and digital images. In most cases the chapters have been designed to be read independently and not necessarily in the sequence they were written. Each chapter concludes with a short summary and you can exercise your knowledge of the subject by implementing some of the projects given.

The digital photographic industry has seen unprecedented growth over the last ten years. This has been primarily due to the availability of high quality electronic imaging devices and fast and affordable computing power and digital storage. As a result, digital photography has displaced traditional silver halide film capture in many areas of the photographic profession. In this edition of the book the content has been extensively revised and restructured to reflect the current state of the photographic industry. Much of the content of the 6th edition has been updated to include information on both silver halide and digital photographic equipment and techniques. For example, the chapters on cameras, lenses, tone control and specialized photographic techniques including infrared and ultraviolet photography have all been updated. New chapters on digital imaging have been introduced. You will read a detailed introduction to imaging sensors and will learn about some of the image artefacts associated with them. The characteristics of input and output devices in digital imaging, such as scanners, printers and displays, have an effect on the quality of your photographs. A chapter on digital imaging systems provides an overview of device characteristics such as dynamic range, resolution, tone and colour reproduction. Practical advice on using these devices is also given. You will also read about the imaging workflow, file formats, compression and basic image adjustments.

Traditional, silver halide photography is still in use today. Printing on silver halide paper provides a low cost, convenient and high quality medium for producing hardcopy prints of digitally captured images. Although printing on silver halide has continued to decline over the past ten years, the availability of online and retail printing services has meant that consumers have started to turn back to traditional photographic paper as a more convenient and affordable alternative to home ink-jet printing. This book provides updated information on the current developments in film. It also includes a chapter on film processing and colour printing techniques. In that chapter a detailed explanation of film processing management is given, and the different methods and equipment used are described. An in-depth overview of printing from negative and positive films starting from first principles is given. The overview assumes prior

knowledge of black and white printing theory and techniques which are covered in detail in Langford's Basic Photography.

A good understanding of the specifications of photographic materials and equipment is important for the photographer who wants to have full control of his or her final results. An in-depth explanation of the technical data provided by manufacturers of imaging equipment and materials is given. You will also find advice on choosing films, cameras, lenses and other photographic equipment.

Control of lighting is essential for high quality photographs, whether they have been captured digitally or on film. The type of light source and its direction will have a dramatic effect on your photographs. By tailoring your light source and adapting it to your needs you can control the final look and mood of your work. Different types of light sources, studio lighting equipment and several lighting techniques for portrait photography are described in the chapter on lighting control. Also included are techniques for location interior lighting, still-life and on using a flashgun effectively. The photographic technique you will use is highly dependent on your subject. The 'Subjects' chapter covers portraiture, sport, landscape, architectural, nature, wedding and aerial photography. It explains how to organise your work, the equipment you need to use and provides suggestions on suitable techniques. Further specialized techniques including infrared and ultraviolet photography, underwater, panoramic and stereoscopic photography are also presented in this book.

The photographic business, today, is a rapidly changing, increasingly technical and highly competitive profession. In order to succeed the professional photographer, whether working as an employee or as a self-employed freelance photographer, needs to understand the fundamental business practices associated with his or her profession. An introduction to professional photographic business practice is provided and several issues in the photographic business such as running a business, insurance and copyright are analysed.

The revised and restructured seventh edition maintains the spirit and character of Langford's original text and will continue to provide technical guidance to students and professional photographers.

E.B.

Special thanks to Professor Geoffrey Attridge and Terry Abrams for their valuable feedback and comments on the technical content of the manuscript. Special thanks are also due to the Focal Press team, especially David Albon and Lisa Jones. James Boardman and Ulrike Leyens are thanked for their input in the content of the chapter 'Business Practice'. Last, but not least, thanks are due to iStockphoto for providing many of the images in this book.

1 Amateur and professional photography

This chapter reviews photography as an occupation – whether you are an amateur or professional, and perhaps take pictures which are anything from strictly functional illustrations to expressive works of art. It looks broadly at the qualities you need for success in widely differing fields, and it discusses markets for all kinds of professional photography, comparing work as an employee with being a self-employed freelance or managing a business with a staff of your own. Most of the types of photography outlined here are discussed further in greater organizational and technical details in Chapter 9.

Differences in approach

Amateur

People often describe themselves as 'only' amateurs, as if apologizing for this status. After all, the word *amateurish* suggests the second rate. However, amateur simply means that you earn your living doing something else. Do not assume that amateur photography must always be inferior to professional photography. Each requires an attitude of mind which differs in several ways – but is not necessarily 'better' or 'worse'.

As an amateur, you may envy the professional, wishing you could combine business with pleasure into a kind of full-time hobby, using professional equipment and facilities. However, the professional knows that much of the hidden advantage of being amateur is the freedom you have to shoot what and when you like. You can develop your own ideas – experiment in approach, subject and technique – without much concern over how long any of this might take.

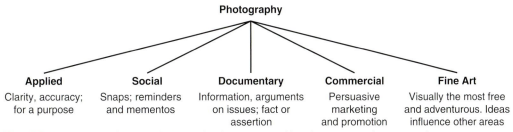

Figure 1.1 The main areas of photography. Many other divisions are possible and sometimes work spans more than one area.

You can be self-indulgent. (Throughout the history of photography many amateurs have been the visual innovators, such as Julia Margaret Cameron, Paul Strand, Ralph Eugene Meatyard and Jacques-Henri Lartigue.)

As an amateur, you can work for an exhibition or a competition of your choice – or just for yourself or family. You can also enjoy the equipment and techniques as a refreshing change from your daily work. On the other hand, you lack the pressure of deadlines, the challenge of commissions

and commercial competition to keep you on your toes. It is easy to become complacent or set targets too low to be much of a challenge. After all, the world is not bounded by the judge's view of photography at the local camera club. If you want to take your hobby seriously, you should find the time to keep yourself aware of trends by looking at published photographs and visiting galleries. In this way you can widen your knowledge of how different people use photography to express ideas and communicate information.

Professional

A professional photographer must be reliable. He or she also needs financial and organizational skills, just as much as visual and technical expertise, in order to stay in business. People rely on you as a professional to produce some sort of result, always. Failure does not simply mean you receive no fee – most work is commissioned, so you have let someone down. A client's money invested in models, props, special locations, etc. is thrown away, a publication deadline may be missed or an unrepeatable event remains undocumented.

You therefore have to ensure – as far as humanly possible – that everything in the chain between arriving to shoot and presenting the finished work functions without fail. You need to be an effective organizer of people, locations, transport, etc., able to make the right choice of time and day, and, of course, arrive punctually yourself. You must be able to anticipate hold-ups and avoid them. As a last resort, you should know how to act if a job has to be abandoned or re-shot. Pressures of this kind are both a worry and a stimulus – but, of course, they make a successful result all the more worthwhile (see page 26).

Working professionally also means that you have to produce results at an economical speed and cost. You must think of overheads such as rent and taxes, and equipment depreciation, as well as direct costs such as photographic materials and fuel. It is seldom possible to linger longingly over a job as if it was a leisure occupation. You also need to know how to charge – how to cost out a commission accurately and balance a reasonable profit margin against client goodwill (will they come again?), bearing in mind the competition and the current going rate for the job.

Equipment is no more or less than a set of tools from which you select the right 'spanner' for the picture you have in mind. Every item must give the highest quality results but also be rugged and reliable – vital gear may need duplicate backup. The cost of fouling up an assignment because of equipment failure can be greater than the photographic equipment itself, so it is a false economy to work with second-rate tools. You must know too when to invest in new technology, such as digital gear, and what is best to buy.

One of the challenges of professional work is to make interesting, imaginative photographs within the limitations of a dull commercial brief. For example, how do you make a strong picture out of a set of ordinary plastic bowls – to fill an awkward-shaped space on a catalogue page? Eventually, you should be able to refuse the more dead-end work, but at first you will need every commission you can find. In the same way, you must learn how to promote yourself and build up a range of clients who provide you with the right subject opportunities and freedom to demonstrate your ways of seeing, as well as income. Another relatively open way of working is to freelance as a supplier of pictures for stock libraries.

Photography is still one of the few occupations in which you can create and make things as a one-person business or department. It suits the individualist – one reason why the great

majority of professional photographers are self-employed. There is great personal satisfaction in a job which demands daily use of visual and technical skills.

'Independent'

Photography does not just divide neatly into amateur and professional categories. After all, it is a *medium* – of communication, expression, information, even propaganda – and as such can be practised in hundreds of different ways. You can shoot pictures purely to please yourself and develop your style; for example, working for one-person exhibitions, books and sponsored projects, awards and scholarships. It is possible to build up a national or international reputation in this way if your photography is good enough. You can sell pictures through galleries or agents as works of art.

To begin with at least most of these so-called 'independent' photographers make their living from another occupation such as teaching, writing or some other kind of photographically related full- or part-time job. Independent photography relies on the growing number of galleries, publications and industrial and government sponsors of the arts interested in our medium. In this, photography follows long established patterns in painting, poetry, music, etc. If you are sufficiently motivated, then working for yourself free of commercial pressures can lead to exciting *avant-garde* results. Some independent photographers work for political or other ideological beliefs. Outlets here include pressure groups, trade unions, charities, arts centres, local community associations, specialist publishing houses and archives. It is one of the great strengths of photography that so many of these options are open to be explored.

How photographs are read

I f you are really going to progress as any kind of photographer, in addition to technical expertise you need a strong visual sense (something you develop as an individual). This should go beyond composition and picture structuring to include some understanding of why people see and react to photographs in different ways. The latter can be a lifetime's study, because so many changing influences are at work. Some aspects of reading meaning from photographs are blindingly obvious, others much more subtle. However, realizing how people tend to react to pictures helps you to predict the influences of your own work – and then to plan and shoot with this in mind.

The actual physical act of *seeing* first involves the lens of your eye forming a crude image on the retina. Second, it concerns your brain's perception and interpretation of this image. You might view exactly the same scene as the next person but differ greatly in what you make of what you see. In the same way, two people may look at the same photographic print but read its contents quite differently.

Look at Figure 1.2, for example. Some people might see this picture primarily as a political document, evidence of life under a particular regime. For others, it is a statement documenting the subjugation of women. Some would find it insulting on ethnic grounds, or alternatively see it as a

Figure 1.2 This picture was taken by Bert Hardy in 1949, for the weekly magazine *Picture Post* (see text).

warm picture of relationships. Still others may simply consider the shot for its composition – the visual structures it contains. Again, the same picture could be read as containing historical information on dress or decor of a particular period, or it might even be seen as demonstrating the effect of a particular camera, film or lighting technique.

None of us is wholly objective in interpreting photographs – everyone is influenced by their own background. Experience so far of life (and pictures) may make you approach every photograph as a work of art … or some form of political statement … or a factual record for measurement and research, etc. This kind of tunnel vision, or just general lack of experience, confuses visual communication between photographer and viewer. In a similar way, it is difficult to imagine a colour you have not actually seen or to speak words you have never heard.

A shot like Figure 1.3, for example, which happens to be a leaf section greatly magnified, would probably be viewed as an abstract pattern by someone unused to seeing electron photomicrographs. A scientist might recognize and look 'through' the picture as if seeing into the microscope eyepiece itself, picking on the subject's factual detail. A sculptor, architect or industrial designer might file it as a reference for particular three-dimensional forms it shows. The point is that none of us works entirely in a vacuum. Unless you are uncompromisingly working to please yourself you must think to whom your photography is directed and how is it likely to be received.

Figure 1.3 Electron micrograph of a fractured turnip leaf, showing the cell structure. Magnification (in this reproduction) ×170. (Dr Jeremy Burgess/ Science Photo Library).

This will help to clarify your aims in approaching subject and presentation.

Sometimes your visual communication must be simple, direct and clear – as in most product advertising. This may be aimed at known groups of receivers identified because they are readers of a particular journal, drivers past billboards or people buying at art store counters. Other photographs may be more successful and mind-provoking when they *suggest* rather than *state* things – see Figure 5.8, for example. The more obscure your image, the more likely it is to be interpreted in different ways – but may be this is your intention?

Much also depends on the way your pictures are physically presented – how they relate to any adjacent pictures, whether they appear on pages you turn or are isolated in frames hung on the wall. Some photographers add slogans, quotations or factual or literary captions when presenting their work to clarify it, to give an extra 'edge' by posing questions, or even purposely to confuse the pictures. They often rate word and image as equally important. It is an approach which has worked well in the past (see examples by Duane Michals, Jim Goldberg and Barbra Kruger). In less able hands literary additions can become a gimmick or a sign of weakness, patching up an inability to express yourself through pictures. They can easily seem pretentious (flowery titles) or patronizing (rhetoric emphasizing something viewers are well able to appreciate for themselves). It is significant that in the advertising world copywriting is a very

skilled profession, heavily market-researched. Pictures and words are planned together, adding a great deal to total message impact.

Markets for professional photography

At one time, second-rate 'professional' photographers could make a good living simply out of the mystique of working the equipment. They knew what exposure to give and how to use camera movements, and they employed much better lenses than were available to amateur photographers. Improvements in equipment and simplification of processes today allow talented amateurs to equal or surpass this level, while top professionals – with flair, imagination and business sense – reach greater heights than ever before. You can still find mediocre professional photography, of course. Some is produced by transients, people who drift into photography and just as quickly disappear again. Some professionals do stay in business but only by clinging to rockbottom prices, which stunts growth.

Professional photography, a loose collection of individuals or small units, is structured mostly by the markets for pictures. The main markets are commercial and industrial; portraits and weddings; press and documentary; advertising and editorial illustration; and technical and scientific applied photography. These are only approximate categories – they often merge and overlap. A photographer in 'general practice', for example, might tackle several of them to meet the requirements of his or her local community. Again, you may be a photographer servicing the very wide-ranging needs of a stock-shot library issuing thousands of images in CD-ROM form to publishing houses or graphic design studios. Then there are specialists working in quite narrow fields – architecture or natural history, for example – who operate internationally and compete for worldwide markets.

Commercial and industrial photography

This covers the general photographic needs of commerce and industry, often businesses in your immediate area but sometimes spread quite widely, as when serving companies within a widely dispersed group. Clients range from solicitors, real estate agents, local light industry and town councils up to very large manufacturing or construction organizations working on an international scale.

Your photography might be used to spread a good public relations image of the company. It will be needed to record processes, products and new building developments. Some pictures issued with 'press releases' will be reproduced on editorial pages of magazines (often specialist publications). Others are used in catalogues, brochures and internal company reports. Photographs may be an essential element in a staff-training scheme, or needed as legal evidence or for archival records. Work will extend beyond supplying prints and transparencies, and is likely to include video work and sequences for presentation in some form of multimedia. When your client is a company, it is important to ask for information on the company's image and publicity policy.

Owing to the wide range of subjects that you may have to cover in commercial and industrial photography (promotion of varied services and products, public relations, staff portraits, etc.), you may have to work on location or in the studio and you must have very good skills in several types of photography such as still-life, editorial photography or portraiture.

On the other hand, you may want to specialize only in one type of commercial photography. Large commercial/industrial studios dealing with a lot of public relations commissions may offer a total communications 'package'. This teams up photographers, graphic designers, advertising and marketing people and writers. The result is that a complete campaign, perhaps from the launching conference (announcing a new product to the client's sales force), through press information, general and specialist advertising to brochures and instruction manuals for the client's customers, can all be handled in a coordinated way 'in-house'. Development of electronic imaging encourages ever-larger amounts of brochure and catalogue photography to take place within graphic design studios. Here, it is conveniently fed direct through desktop publishing channels into layouts for the printed page (see Chapter 14).

A few industrial organizations run their own small photographic departments employing one or more staff photographers. As a staff photographer you may be involved in different types of photography, depending on your employer. For example, you may work on public relations, scientific photography, portraiture or still-life photography. Since they work for a specific company, staff photographers have knowledge of the media for which the images will be used and the company's publicity policy. They are also familiar with the company's personnel and its geographical layout. Such departments may be general purpose or form part of a larger public relations unit.

Fashion photography

As a fashion photographer you must have an interest in fashion and an understanding of the creative work of fashion designers. You are commissioned for publications (magazines, newspapers and companies) and you are briefed by the editor on the required style of the images and the output media. The briefing may be very specific or, in other cases more open, allowing you to use your creative skills and produce innovative images. You work with a team which may include models, stylists, make-up artists, hairdressers, set-builders, painters and assistants with different specialties. In fashion photography it is important to understand not only the properties of the fabric, but also the concept of the fashion designer, the style of the clothes and the client's image. You must therefore be creative and keep up-to-date with current trends in fashion and styles in photography. Experimenting with different styles and techniques contributes to developing innovative images. Technical skills are also important to produce high-quality images in fashion photography. Correct lighting is essential to show design aspects of the clothes and the properties of different types of fabrics. If you create photographs for clothes catalogues, you will have to produce a large number of images quickly, in a stylish way. You work either on location or in the studio.

Portrait and wedding photography

Professional businesses of this kind deal with the public directly. Some operate out of High Street studios, but because so much of the work is now shot on location (for example, portraits 'at home') special premises are not essential. Some businesses operate from inside departmental stores, or linkup with dress/car rental and catering concerns to cover weddings. In all instances it is important to have some form of display area where your best work can be admired by people of the income group you are aiming to attract.

Figure 1.4 Portrait taken in the child's home using a pair of flash units. A camera with waist-level finder makes it easier to shoot at floor level.

To succeed in photography of this type you need an absorbing interest in people and the ability to flatter their appearance rather than reveal harsh truths about them. After all, it is the clients or their closer associates who pay your bill – unlike documentary or advertising pictures commissioned by magazines or agencies. The people you arrange in front of the camera require sympathetic but firm direction. It helps to have an extrovert, buoyant personality and the ability to put people at ease (especially in the unfamiliar environment of a studio) to avoid self-conscious or 'dead'-looking portraits.

The work typically covers formal portraits of executives for business purposes; family groups; weddings; animal portraits; and sometimes social events and front-of-house pictures for theatrical productions (see Chapter 9).

Press photography and documentary

Press photography differs from documentary photography in the same way as single newspaper pictures differ from picture magazine features. Both are produced for publication and therefore have to meet firm deadlines. However, as a press photographer you usually have to sum up an event or situation in one final picture. You need to know how to get quickly into a newsworthy situation, seek out its essence without being put off by others (especially competitors) and always bring back technically acceptable results, even under near-impossible conditions.

Most press photographers work for local newspapers. Where there is relatively little 'hard' news, you work through an annual calendar of hand-shaking or rosette-waving local events, plus general-interest feature material which you generate yourself. Other press photographers work as staff on national or international papers where there is keen competition to cover public events (see Figure 1.5, for example). However, most 'hot' news events are now covered by television, with its unassailable speed of transmission into people's homes. With digital cameras you have the ability to get pictures back to base by mobile phone which is helpful, but newspapers still lose out due to the time needed to print and distribute them to their readers.

More photographers are employed by or work freelance for press agencies. These organizations often specialize – in sport, travel, personalities, etc. – or handle general-interest feature material. The agency's job is to slant the picture and written material to suit the interests of a very wide range of different publications and sell material to them at home and abroad. For pictures which are less topical, this activity merges with stock-shot library work, able to generate income over a period of years.

Documentary photography refers to work allowing you more of an in-depth picture essay, shot over a longer period than press photography and aiming to fill several pages in a publication. In the past this has been called photo-journalism, through its use in news magazines, but has now fallen into decline. Other outlets continue, however, including corporate house journals and prestige publications from leading names in oil, finance, shipping, etc.

As a documentary photographer you should be able to provide a well-rounded coverage of your story or theme. For example, bold start-and-finish pictures, sequence shots, comparative

Figure 1.5 Shooting pictures at a press conference often means tough competition from fellow photographers and television. It is difficult to get something striking and different. Showing the whole situation like this is one approach. (By John Downing/*Daily Express*)

pairs and strong single images all help a good art editor to lay out pages which have variety and impact. (On the other hand, a bad art editor can ruin your set of pictures by insensitive hacking to fit them into available space.) One way into this area of photography is to find and complete a really strong project on your own initiative and take it to editors of appropriate publications for their opinions and advice.

Editorial and advertising photography

Editorial illustration means *photography* (often single pictures) to illustrate magazine feature articles on subjects as diverse as food, gardening, make-up, fashion, etc. It therefore includes still-life work handled in the studio. For each assignment the editor or the picture editor of the magazine, book, newspaper, website, etc., will brief you on the story for which you have to produce images, and the type of images they need according to the specific target group of readers. You have less scope to express your own point of view than is offered by documentary photography, but this allows more freedom of style than most advertising work. You have to be organized and work under tight deadlines, producing high-quality images. Editorial photography in prestigious magazines and books is a good 'shop window' for you and can provide a steady income, although it is not usually well paid.

 Advertising photography is much more restrictive than outsiders might expect. At the top end of the market, however, it offers very high fees (and is therefore very competitive). As an

advertising photographer you must produce images that communicate a marketing concept. The work tends to be a team effort, handled for the client by an advertising agency. You must expect to shoot some form of sketched layout, specifying the height-to-width proportions of the final picture and the placing of any superimposed type. Ideally, you will be drawn into one of the initial planning stages with the creative director, graphic designer and client, to contribute ideas. Sometimes the layout will be loose and open – a mood picture, perhaps – or it might be a tight 'pack shot' of a product, detailed down to the placing of individual highlights. At the unglamorous lower end of the market, advertising merges into commercial photography with an income to match.

Whether or not you are chosen as a photographer for a particular campaign depends on several factors. For example, is your approach in tune with the essential spirit required – romantic, camp, straight and direct, humorous? Depending on the subject, do you have a flair for fashion, an obsession for intricate still-life shots, skill in organizing people or in grabbing pictures from real-life situations? Have you done pictures (published or folio specimens) with this kind of 'feel' or 'look' before, even though for some totally different application? Do you have any special technical skills which are called for, and are you careful and reliable enough – without lacking visual imagination? Can you work constructively with the team, without clashes of personality? Finally, are your prices right?

Figure 1.6 An editorial still-life shot like this looks deceptively simple. It takes skill and patience to suggest the differences in decoration, shape and size, and also achieve a strong grouping. (By Annie Morris)

Most of these questions, of course, apply to the choice of a professional photographer for any assignment. However, in top advertising work the financial investment in models, locations, stylists and designers (as well as the cost of the final-bought advertising space) is so high that choosing the wrong photographer could be a disaster.

Art photography

Art photography shares concerns with other photographic occupations; the artist must have a product, a market and an audience. Many artist photographers are graduates of national art colleges and university courses and have a thorough background in historical and contemporary conceptual art practice as well as a critical awareness of art history and theory. The product, the art works, will be driven variously by a commitment to a particular theme or visual strategy and may be linked to a particular social observation or critique. The successful artist must find curators and galleries interested in showing his or her work and an audience wishing to buy it. Some artists are supported by educational establishments, which provide a framework for dissemination of ideas through teaching, offer time and assistance both to make research grant applications for funding, and support to produce work. Some make a reputation in

the art market through an appropriation of their existing commercial practice – documentary and fashion photography is frequently repackaged as an art commodity by national and private galleries. Equally, artists are often commissioned by commerce, advertising and the fashion industry to keep their products 'at the cutting edge' and to associate them with the art world.

The ability to present ideas verbally and in written form, informed by contemporary debates, is often an essential skill. This is both to persuade curators of the value of the work, and to make complex and articulate funding bids, as well as to lecture and write in support of the exhibited work. It is also essential to have an eye on the current art market to see which forms of presentation are favoured and to note which shows are in preparation so that work can be targeted at key galleries and publications. 'Social capital' – the business of getting to know people in the art world and markets and networking with them – is invaluable in keeping the artist and their art in the minds of commissioners, exhibitors and buyers.

The most powerful and influential art works are created from a sense of passion about the subject matter and a commitment to reach an audience to raise concerns and interrogate the world of images and issues.

Technical and scientific photography

This is a very different area, where meticulous technical skills and accuracy are all-important. Any expressionism or original personal style of your own will tend to get in the way of clearly communicating information. Photographs are needed as factual, analytical documents, perhaps for forensic or medical evidence, military or industrial research and development. You will probably be a staff photographer employed by the government, a university or an industrial research institute. Photographic skills required include photomacrography, photomicrography, infrared and ultraviolet photography, photogrammetry, remote sensing, high-speed recording and other forms of photo-instrumentation, including video. There is also a great deal of routine straight photography on location and in the laboratory.

You will be expected to have more than just photographic know-how. As a medical photographer you will most often work in a hospital's medical illustration department. You need a working knowledge of anatomy, physiology and an understanding of medical terms as well as concern for patients and an interest in medicine, generally. You must have technical skills in a range of photography areas such as microphotography, photomacrography, ultraviolet photography and thermal imaging. You may also take photographs of the hospital staff and facilities or public relations photographs. As a scientific photographer you should have a sufficiently scientific background to understand advanced equipment and appreciate clearly

Figure 1.7 Technical record of a fractured metal die, to illustrate an equipment failure report.

what points scientist colleagues want to show in their reports and specialist papers. As a police photographer you should be thorough and pay attention to detail, use suitable lighting techniques and give correct exposure. The images must be sharp and with maximum depth of field. You must be able to work with accuracy and keep a detailed record of the scene photographed, the lighting conditions and the equipment used. You should also know what is or is not admissible in law and how to present evidence effectively to a court. On top of this, you must assess the potential of all new photographic materials and processes which might be applicable to your field. You will also be expected to improvise techniques for tackling unusual requirements.

Figure 1.8 An informational picture showing preparation of the sand core for an engine casting. This was shot for education and training purposes.

To be a good 'applied' photographer you should therefore enjoy a methodical, painstaking approach to solving technical challenges. You will probably be paid according to a fixed, national salary scale which is not particularly high. However, there is better job security than that offered by many other branches of professional photography.

Roles within a photographic business

Perhaps you are a one-person freelance or one of the team in an independent studio or in-house photographic department. Every professional photography business must combine a number of skills, and for each skill you might require an individual employee, either on the payroll or 'bought in' (by using an outside custom laboratory, for example). For the lone freelance several or all of the following roles have to be filled by one person.

Manager/organizer

Managing means making sure photography goes on efficiently and economically. You must hire any necessary staff and/or outside services, check that quality control and reliability are maintained and watch finances. Like any other administrator, you will be concerned with safety; premises; insurances (including Model Release, page 362); and best-value purchase of equipment and materials. You must know when to buy and when to rent items. Every assignment must be costed and charged accurately, remembering the competition and producing the work as economically as possible without dropping standards. As a manager, you must understand essential book-keeping and copyright, and be able to liaise with the accountant, bank manager, tax inspector and lawyer. If you employ staff you must be concerned with their health and safety as well as have the ability to direct and motivate them, creating a team spirit and pride in the photography produced.

Photographer

Ideally, a photographer should be free to take photographs. In practice, apart from being technically reliable and visually imaginative you must be a good organizer and also be able to liaise directly with the client. Dealing with whoever is paying for your services is harmonious enough if you both see eye to eye, but, unfortunately, clients have odd quirks of their own. When it is obvious that this will lead to disaster (for which the photographer will eventually be blamed) considerable tact and persuasiveness are needed.

At a pre-briefing you should identify what the client has in mind, or at least the purpose of the picture and how and where it will be used. If the brief is very open-ended, float some ideas of your own and see how cooperatively these are received. If still in doubt, do the job, photographing the way you would like to see it done, but cover yourself by shooting additional (for example, more conventional?) versions the client might expect. Often in this way you can 'educate' clients, bring them around to using more distinctive photography. But never experiment at the client's expense, so that they end up with results they cannot use. As a photographer, you should carry through each of your jobs whenever possible – if not printing yourself then at least supervising this stage. Finally, discuss the results directly with whoever briefed you in the first place.

Technicians

Technicians provide the photographer's a back-up – processing, printing, special effects, finishing – to turn camera work into final photographs. Technical staff are employed full-time or hired as and when required for jobs, some as freelances or, most often, through their employment in professional custom labs. As a technician, you have specialized knowledge and skills highly developed by long practice in their particular area. Equally, they can offer new skills such as digital manipulation, producing what the photographer needs much faster than he or she can do alone. For a technician with specialized digital imaging skills the photographer can refer to a *Digital Imaging Specialist*. Technicians often give photographers valuable advice before shooting … and sometimes bail them out afterwards if some technical blunder has been made.

Working as a technician is sometimes creative but more often routine. You must produce work fast, and to the highest professional standards. In return, there is more security and often better pay in being a first-class technician than an ordinary photographer. Too many people want to be photographers, overlooking equally satisfying jobs of this kind.

Digital imaging specialists

The digital imaging specialists work in professional laboratories and are responsible for the whole workflow, from file downloading and scanning of images to colour management and image output. You are specialized in digital image manipulation using software packages such as Adobe Photoshop, and have an in-depth understanding of photography. You may also be involved in layout design and so need to have knowledge of relevant software packages such as Quark or Adobe Illustrator. The digital imaging specialists should also have knowledge of digital image archiving and image restoration. It is essential to update your knowledge of current developments in colour management, imaging devices and calibration tools and methods.

Accurate calibration of all equipment such as scanners, displays and printers is essential for accurate reproduction of the images throughout the imaging chain (see Chapter 10). Digital imaging specialists may also work in picture libraries where they need to have additional skills in archiving and image databases.

Ancillary roles

Supporting roles include photographer's agent – someone who gets commissions for you by taking and showing your work to potential clients. Agents seek out jobs, promote you and handle money negotiations. In return, they are paid a percentage of your fees. Stylists can be hired to find suitable locations for shots, furnish a studio set or lay on exotic props. Model agencies supply male and female models – attractive, ugly, 'characterful', young and old. Specialist photographic/ theatrical sources hire trained animals, uniforms or antique cars for you – everything from a stuffed hyena to a military tank.

Turning professional

There is no strictly formal way into professional photography. You do not have to be registered or certified, or, for most work, belong to a union. Most young photographers go through an art college or technical college photography course. Some come into photography from design, fine art or some form of science course. Others go straight into a professional business as a junior member of staff and work their way up, perhaps with part-time study.

In the UK, Further Education (FE) colleges and university photographic programmes include Higher National Certificate (HNC), Higher National Diploma (HND) and Foundation Degrees (FdA). Other programmes include Bachelors (BA) and Masters (MA) degrees. Certificate courses tend to train you for the technical procedures and processes which make you immediately useful today as an employee. Diploma courses are also craft-based but are more broadly professional. Foundation Degrees in photography include a considerable work-based learning component as well as involving modules in the practice and historical and critical aspects of photography. Foundation Degrees are two-year courses, but students may elect to progress to the final year of a BA course. Most degree courses aim to help develop you as an individual – they are academic, like humanities courses, encouraging original ideas and approaches which pave the way to tomorrow's photography and to wider roles in the creative industries, roles in image management, galleries, museums and academia, as well as into traditional jobs. The best courses develop photographic skills and critical thought as well as develop you as an individual. Ideally, you should seek work experience and work placements during the course to make contacts in the world of photography in which you wish to work. Alongside this, your best proof of ability is a portfolio of outstanding work. Organizations, such as the Royal Photographic Society in the UK and various professional photographers' associations, offer fellowships to individuals submitting pictures considered to reach a suitable standard of excellence. Make sure that your commercial portfolio contains not only photographs but also cuttings showing how your photography has been used in print. Pages from magazines, brochures, etc. ('tearsheets'), all help to promote confidence in you in the eyes of potential clients.

■ Amateur photography allows you greater freedom than professional work, but being a professional makes commercial factors – reliability, fast economic working methods and good organization – as important as your photographic skills. Often, you have to create interesting pictures within a quite restrictive brief.

■ In the same tradition as other creative arts, some fine *avant-garde* photographers operate as 'independents'. They build up international reputations through exhibitions, books, direct sale of prints, etc., yet earn their living at least in part from another job.

■ To progress beyond a certain level in photography you need to learn how people read meaning from photographs – single pictures or sequences. Understanding how your work is likely to be received will help you to decide the best approach to your subject.

■ Professional photography is mostly market structured – commercial and industrial, portraits and weddings, press and documentary, advertising and editorial and technical and scientific.

■ Commercial/industrial work covers promotional and record photography for firms and institutions. Your photography may be part of a complete communications 'package', including brochure design. As a fashion photographer you should produce innovative images and you need to understand the ideas of the fashion designer and the properties of the fabrics. Portrait/wedding photography is aimed directly at the public. You need to be good at flattering people through your photography and general manner.

■ Press photography, very time-based and competitive, means summing up a newsworthy event. Some publications still accept visual essays, offering space for in-depth documentary coverage of a topic. You can therefore think in terms of sequence – supply the art editor with a full coverage containing strong potential start-and-finish shots.

■ Editorial/advertising photography means working close with designers. Catalogue work, particularly, justifies the use of digital studio photography direct to desktop publishing (DTP). Advertising work is heavily planned – you usually work on a layout within a team including a creative director, a graphic designer and a copywriter. You must be organized to meet tight deadlines.

■ In art photography the product is driven variously by a commitment to a particular theme or visual strategy. The theme may be linked to a particular social observation or critique. It is also important in most cases to have the ability to present ideas, informed by contemporary debates, in both verbal and written forms.

■ Technical/scientific applications of photography call for factual, analytical records. You are likely to be an employed staff photographer, either working on industrial/university research projects or at a forensic or medical centre.

■ There are several key roles in any photographic business or department. A manager administrates quality control, accounts, safety, equipment and materials. One or more photographers organize shoots, liase with clients and carry out jobs efficiently, imaginatively and economically. Technicians follow through the photographers' work and service reprint orders. Digital imaging specialists work on file transfer, image manipulation, colour management and archiving of images. Ancillary roles include agent; stylist and agencies for models, props, etc.

■ Most people get into professional photography by taking an appropriate full-time college course, or they start in a studio and study part-time. However, 'getting on' depends more on evidence of your practical achievements than on paper qualifications.

SUMMARY

2 Camera equipment

Despite the proliferation of digital imaging systems, learning about and understanding the characteristics of the different formats in film-based systems provides an important starting point in the understanding of photography and can make the process of deciphering the complexities of digital imaging easier. Indeed, it is often the use of film cameras and the joy of watching a print appear under the safelight that initially piques the interest of a would-be photographer, even today. Without first considering film-based systems, there is no benchmark for evaluating the merits of digital camera systems. Additionally, at the time of writing, although smaller formats are now dominated by digital equipment, the limited choice and high cost of digital large format can be prohibitive; therefore a number of professionals still work with film. This chapter begins by introducing camera systems using film, providing a comparison of the main formats used by professionals, before moving on to digital cameras. It attempts to provide an overview, necessary when considering the purchase of camera equipment. It also aims to highlight the way in which camera design influences the method and type of photographic work. Included is a section on specialized accessories. This mainly covers cameras using film, although a number of accessories can be adapted for digital (but some of them, such as Polaroid (Instant-picture) adaptors, are not necessary when working digitally). Following this is a section on avoiding camera failures. The remainder of the chapter covers digital cameras, characteristics, basic features and types of camera systems. It is hoped that the level of detail will highlight the differences between working with film and working digitally. A summary comparison is provided at the end.

Camera design

Fundamentally, all cameras consist of the same basic components: a light-tight box, a method of focusing the image onto the image plane, an image sensor to capture and record the image, and some means of controlling exposure. However, the history of camera design has seen many developments, leading to ever more sophisticated and portable devices, culminating in the twentieth century with the addition of electronic components and of course, the introduction of digital cameras. Today, many manufacturers are winding down their production of film-based cameras in favour of the development of digital systems.

Cameras may be classified according to their design and this is often dependent on the way in which the image is viewed (Figure 2.1). The four main categories of camera design are: direct vision/rangefinders (both compact and advanced models), twin-lens reflexes, single-lens reflexes and view cameras, all of which are described in more detail in *Langford's Basic Photography*. When considering purchasing or using a camera for serious photography, however, what is more important is the camera *system*. The system encompasses not only the design of the camera, but the level of sophistication in design, the degree of control by the user, the way in which it is used and the type of accessories available with it. Traditionally, camera systems using film have been classified by image format; that is the size and dimensions of the captured image.

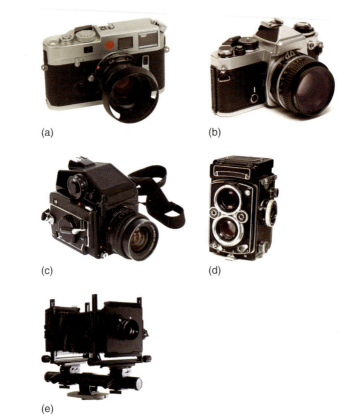

(a) (b)

(c) (d)

(e)

Figure 2.1 The main types of camera design: (a) a compact rangefinder camera; (b) a single-lens reflex camera, 35 mm format camera; (c) a single-lens reflex camera, medium format; (d) a twin-lens reflex, medium format camera; (e) a view camera.

Image format

Many formats have been introduced during the history of photography, but in the professional market, three main camera formats have dominated: 35 mm, medium format and large format (also known as view cameras). Using a particular format has implications in many areas for the photographer: in the quality of the final image, the portability of the equipment, versatility of use, the maximum aperture of the lenses and importantly in the cost of both equipment and film. These factors influence the way in which the photographer works at every level. Ultimately the system and format they select will probably determine – or be determined by – the type of photography in which they specialize.

The size of the image ultimately determines the size of the camera and accessories. Each format has a 'standard' lens (see Chapter 3). This lens is the one that gives a *field angle of view* of somewhere between 45° and 57°. The amount of lens refraction producing this angle, although less than the angle of view of the human eye, produces an image close to that perceived by the human visual system. This means that relative size of and perspective between objects within the images will be least distorted and closest to the way in which the original scene was perceived. The focal

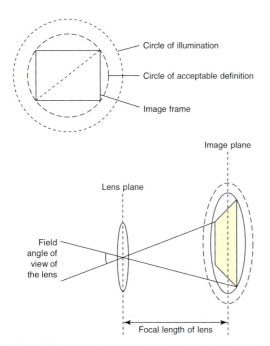

Figure 2.2 Lens covering power – the inner circle of acceptable definition defines the covering power of the lens. Its diameter must be equal to the diagonal of the image format.

length of the standard lens will be determined by this. Fisheye, extra wide angle and wide-angle lenses are then shorter in focal length and telephoto lenses longer than the standard lens.

One of the limiting factors of a lens is its *covering power*. When light is imaged through a lens there will be an acceptable *circle of illumination* formed, outside of which there is rapid fall-off illumination and *natural vignetting* occurs. Within the circle is another circle, called the *circle of acceptable definition*. This defines the physical extent of an image through the lens that will be sharp and conform to some measure of acceptable objective image quality. The diameter of the circle of acceptable definition must cover the diagonal of the image format (see Figure 2.2). This, together with the required field angle of view defines the focal length of the lens for a particular format. As shown in Figure 2.3, the larger the image format, the longer the focal length of the lens. This has a bearing on a number of

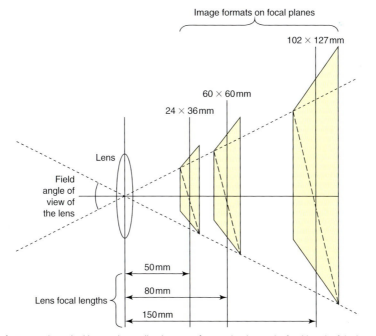

Figure 2.3 Image formats and standard lenses: the smaller the image format, the shorter the focal length of the lens required to give the standard field angle of view.

characteristics of the overall system. It also has important implications in terms of the focal lengths used in digital systems, discussed later.

35 mm format

35 mm format cameras use rollfilm with an image dimension of 24 × 36 mm, which is the smallest currently used in the professional market. The small format means that the camera body is smaller and less bulky than medium format or view cameras, and so it is the most portable. Using equipment of this size means that you can carry around a comprehensive outfit in a small case. There is an unrivalled range of lenses and accessories available, and the whole system will incorporate the very latest developments in technology.

The 35 mm market includes both professionals and amateurs. The majority of cameras are single lens reflex (SLR) cameras, although the format also encompasses compact cameras and rangefinders. 35 mm cameras probably represent the best value for money because prices are highly competitive. They sell to a huge market of amateurs and the 35 mm format is the one that has moved furthest away from traditional mechanical operation towards more and more electronic control, on-board processing and in some cases complete automation. In more recent years a type of hybrid camera, the 'Semi-professional', more recently known as the 'Prosumer' ('Professional Consumer') camera has appeared. These SLRs tend to have more of the features of the professional ranges, but are cheaper and aimed at the serious amateur (Figure 2.4). Often the lower price results in a compromise in-build quality and lens performance and Prosumer cameras tend to be the ones with the most programmable and automatic features. These models are updated quite rapidly and bristle with every conceivable feature. This 'bells and whistles' aspect is sometimes more to upstage rival brands than to improve your photography.

Figure 2.4 35 mm Prosumer SLR cameras often have camera bodies very similar to their professional equivalents.

One of the useful features 35 mm cameras tend to include as standard is through-the-lens (TTL) exposure metering. This of course means that the whole imaging process is faster than it would be if separate exposure metering were required. Metering can be performed while looking through the viewfinder and in many cases, the camera controls are designed to be easily altered in this position. Modern SLRs often include a number of TTL metering modes, such as centre-weighting and spot metering, and with knowledge and experience the most difficult subjects can be correctly exposed. This is a factor that really defines how the cameras are used; they are portable, all-in-one units, allowing the user to capture fleeting shots without spending a long time setting things up. Although they may indeed be used in a studio setting, where there is time and space to get everything right, they are also designed for all other types of photography and they far surpass the other formats in their versatility. Many 35 mm ranges also include dedicated flash units and at the more expensive end, these may include TTL flash metering.

Indeed, later models of independent flash units may also be adapted to use the TTL metering systems of 35 mm cameras. This is a huge bonus when using on-camera flash and is particularly useful in photojournalism.

Because of the small image format, lenses for 35 mm camera systems are the shortest, with a standard lens of focal length 50 mm, telephoto lenses longer than this, wide-angle lenses beginning at around 24 mm and extra wide-angle lenses at 20 mm and below. Depth of field is affected by a number of factors, such as focusing distance, selected aperture and importantly, lens focal length. Shorter lens focal lengths produce a larger depth of field, especially useful when subjects are close. Another important characteristic of shorter focal length lenses is wider achievable maximum apertures (f/1.0–f/1.4 at the more expensive end of the 35 mm market), therefore the lenses are also faster. The result of this is that they are the most versatile in low light level conditions. The smaller camera size means that they are already the most portable, but with faster lenses, they are also the easiest to hand-hold in existing light, meaning that fewer accessories such as tripods and additional lighting may be necessary. Large apertures also allow the selection of faster shutter speeds to freeze motion, particularly important in areas such as sports photography.

As previously highlighted, modern 35 mm cameras tend to rely heavily on electronics to control everything from exposure metering, film winding, ISO setting, exposure compensation and bracketing to sophisticated program modes. A downside of this is the possibility of camera failure either as a result of failure of the power supply, or because of a fault in on-board circuitry, which can be expensive to repair. Excessive control buttons or, alternatively, total automation can also be counterproductive for serious work. The many mode options and viewfinder signals get in the way, even lead you into errors – perhaps through mis-selection or distraction by data displays at the key moment of some fleeting shot. Any camera for advanced amateur or professional work *must* also offer complete manual control. You need to have the assurance that you can take over and make use of your personal experience to get exactly the result required, including chosen effects.

A fully automated camera is well worth considering however, for fast, candid photography (including situations where you must shoot over your head in a crowd). Autofocusing can be useful, particularly if panning and focusing on a moving subject but it is important to remember how power-hungry continuous focusing is. There can also be a tendency for the focus to slip between different subjects and it can sometimes be easier to change focus manually. The more sophisticated models have a range of autofocus zones within the frame, which are useful if the subject is off-centre. Some of the highest quality (and of course most expensive) lenses have ultrasonic image stabilizers to combat camera shake which can result in a huge improvement in image quality, but as this is also a form of continuous autofocusing, they will eat up your camera batteries.

It is important to remember that these cameras are only superficially intelligent. For example, they program greatest depth of field in bright light, and they can easily be focusing on, or exposing for, the wrong part of the subject. Worse still, you may start composing your pictures in ways which ensure that the auto mechanisms work perfectly (key element centre frame, for example). So make sure that there are convenient read-then lock facilities for autofocus and for TTL exposure measurement. If the camera autosets film speed by DX cassette

code sensing (page 101) it must also have a + or − exposure compensation control. Thus you can effectively set a different speed to suit up or down rating and changes to processing. Other features you may well rate as essential for any SLR camera include a stop-down button to preview your actual depth of field with all preset aperture lenses.

Because film structure is the same regardless of frame size or format, image quality is another important consideration. Film grain is the result of either specks of silver (black and white) or clouds of dye (colour) being formed in the emulsion layers during processing. When enlarged for printing, beyond a certain level film grain becomes apparent. The random structure of the film grain can be used for creative effect, but it can also degrade the image appearance in terms of sharpness and noise. The size of developed grains is also a limiting factor in the *resolution* of the film, or its ability to record fine detail. Relative to a 35 mm frame size, film grain will be much larger than it is in the larger formats. 35 mm film therefore has the lowest effective resolution of the three, which means that if enlarged to the same size as a frame of medium- or large-format film, the images will be less sharp, grain will be more evident and generally they appear to be of lower quality. Scratches and blemishes will also be much larger when the film is printed and perhaps more difficult to remove. The lower image quality may be problematic if the images are enlarged much beyond 8 × 10 in. (203 × 220 mm), however other factors can compensate for this, such as variations in the processing chemicals, and also in the distance at which the prints are to be viewed.

Medium format

Medium-format cameras tend to dominate in many other areas of professional photography, where image quality is paramount or more important than the speed of capture. They represent a good compromise between the size and quality of the image produced by their large-format counterparts and the versatility of use of 35 mm.

The medium-format market is quite different to that of 35 mm format cameras. They require more skill in use and are not as portable, therefore they do not appeal to any but the most serious amateurs, who are usually prepared to invest more in a camera system. As a result of this, the market is less competitive, with fewer manufacturers making fewer different models. Additionally, the larger format image requires lenses of higher quality, so generally these systems are larger and significantly more expensive. Features tend to be more conservative, and because of the small numbers manufactured you can expect to pay over twice the price of an equivalent 35 mm kit. Where the competition among small-format camera manufacturers has lead to the development of many gimmicks and automatic features, medium-format cameras tend to be simpler in design and rely more on mechanics than electronics. The increase in cost is often in the quality of components and the camera build.

Medium-format cameras are small enough to use hand-held and cope with action subjects. You can use most types at waist or eye level – there are a range of direct viewfinder wide-angle models as well as reflexes (Figure 2.5). At the same time, shift cameras (Figure 2.6) and monorail view cameras are now made for medium formats. Since rollfilm picture size is between three and five times the area of 35 mm, you can crop after shooting if you wish and print (or reproduce) from just part of the image without too much lost quality. An SLR this size also has a screen large enough to usefully attach a drawn overlay for critical jobs where your composition must fit a tightly designed layout.

Figure 2.5 There are a range of different camera designs available in medium-format cameras for general work.

Figure 2.6 Medium-format cameras providing camera movements. Top: scaled-down monorail design accepts rollfilm magazines, instant picture or digital backs. Bottom: bellowless wide-angle shift camera for architectural work offers rising and drop front, accepts rollfilm backs.

There are a range of image formats available for medium-format cameras. The films are mainly 120 mm wide and the most common image formats are 60 × 45 mm, 60 × 60 mm and 60 × 70 mm. They are available as sheet film but are mainly used as rollfilm. Here the camera designs allow more versatility than 35 mm. When using a roll of 35 mm it is usually necessary to shoot the entire roll before the film can be changed. The alternative is to rewind the shot part of the film, change films and then, when ready to use the film again, it is necessary to wind it on to the point at which it had been wound to before. As well as being inconvenient, this is fraught with difficulties, resulting often in gaps of unused film which is wasted, or in double exposure of frames due to incorrect guesswork. Many medium-format cameras solve this problem with detachable, interchangeable film backs, meaning that different types of film

can be loaded during a shoot, without any of the hassle of rewinding, so you can be shooting using one film back while an assistant is quickly emptying and reloading another, allowing fast, continuous photography. You can also shoot one scene on several different kinds of film stock by juggling backs. It is a facility which permits you to swap to an instant picture (peel-apart) back at any time during a shoot to visually check on lighting or exposure (see Figure 2.7). Many professional type rollfilm cameras will accept digital backs too (page 37).

Figure 2.7 An instant-picture back, accepting packs of peel-apart material, attached to a rollfilm SLR camera in place of the film magazine.

The standard lens for medium format is generally an 80 mm focal length. If you are used to working with 35 mm the shallower depth of field given by the longer focal length lenses normal for medium formats can be an unwelcome surprise – especially when shooting close-up. Lenses also have maximum apertures one or two stops smaller than their 35 mm camera equivalents (typically, f/2.8 or f/4 for a standard focal length lens) meaning that although they can be hand-held, they

require relatively bright conditions. The longer lens also means more camera shake, so a tripod is usually a necessary accessory. The range of film stocks made in 120 rollfilm is also more limited, with the emphasis on professional rather than amateur emulsions.

The method of exposure determination in these systems is often built-in, but as already mentioned, these cameras tend not to have as many features to aid the photographer as their smaller counterparts. Using them takes you back to the fundamentals of photography, with the majority of exposures made in manual mode, with manual focusing. They require more consideration in their approach. The process of loading or changing film backs, or winding on film, is more technical than the point-and-shoot and wind-on approach that might be used with 35 mm and the skills required to use them properly take time to acquire. However once you are used to this way of working, they can be just as versatile and the increase in quality means that they tend to be preferred for high-quality print output such as that produced for magazines and books.

Large-format view camera systems

In many ways cameras using 4 × 5 in. (102 × 127 mm) image format and upwards are a world apart (Figure 2.8). Photography with this type of equipment is more craft-orientated; it demands more elaborate preparation and encourages a more considered approach to your subject. There are fewer camera designs to choose from, and both cameras and lenses are expensive – especially the 8 × 10 in. (203 × 254 mm) size.

Figure 2.8 Typical 4 × 5 in. unit constructed monorail camera.

These cameras are closest to very early camera designs, incorporating a bellows extension between moveable lens and film planes. Most commonly, they are attached along an axis, a monorail, allowing the distance between them to be altered; the two planes also have a range of positions and tilts that can be applied in a variety of camera movements, to manipulate the size and shape of the subject, covered imaging area, magnification and depth of field (see Figure 2.9 – more details on camera movements are covered in *Langford's Basic Photography*). Making the most of these cameras requires skill, practice and a genuine understanding of the optical principles governing them. Most certainly not for the amateur, the image capture process is involved and time-consuming. The cameras are bulky and cumbersome, requiring a tripod and they often lack electronic aids completely, unless you add costly accessories. Therefore, you must expect to use a separate hand-held exposure meter and calculate the exposure increase needed for bellows extension, etc. which is taken care of in other cameras by TTL light measurement. The image is inverted and viewed directly through a large ground glass screen in the position of the film plane at the back of the camera.

Because these cameras require tripods and time to set up, they tend to be used more for still-life subjects. The camera movements available and large image format allow great representation of detail and fine tuning of image shape; this type of precision work lends itself to high-quality studio still-life photography. The other main application, for the same reasons, is architectural photography, where tilting camera movements may be used to correct converging

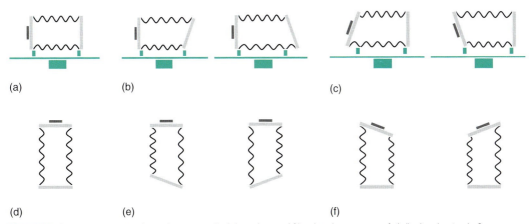

(a) (b) (c)

(d) (e) (f)

Figure 2.9 Camera movements using a view camera. Both lens plane and film plane have a range of tilt (b, c) and swing (e, f) movements for achieving different manipulations of the image plane.

verticals and translational movements may be used to capture the top or edges of a building that other formats would not cover.

The standard lens for a 4 × 5 in. large-format camera is most commonly 150 mm, or 180 mm. The long focal length results in shallower depth of field than either 35 mm or medium format, however, if the subject allows it, tilting or swinging either front or back planes may bring required zones of subject into focus, improving effective depth of field. You must expect to stop down more and consequently require more light or longer exposures. Even maximum lens apertures average around f/4.5–f/5.6, some three to four stops slower than most 35 mm format lenses.

On the other hand, you can expect view camera lenses to have a much wider image circle than lenses intended always to be dead-centred on the film. For example, a good normal-angle 180 mm lens designed for 4 × 5 in. will give a circle of acceptable quality about 300 mm in diameter when focused for infinity and stopped down to f/22. This means that you can shift or pivot the lens until its axis is more than 70 mm off-centre if necessary for rising, cross or swing front effects before you see loss of image quality at any corner. It is a false economy to buy, say, a monorail view camera offering extensive movements and use it with an economy lens barely covering the format.

After setting up a shot, the image is usually captured on individual sheets of film, which are loaded into a sheet film holder and are then processed separately. This means that there is the same versatility as medium format in terms of being able to repeat the same shot on different film stock. Single sheets are more expensive, but the time taken in setting up means that fewer mistakes are made and less film is wasted. The range of film available is much lower than that available for other formats, but the large image size ensures that grain is finest, images are sharpest and the tonal range and level of detail is the greatest possible. Images from 4 × 5 in. film are 13 times larger than a frame of 35 mm and can easily be enlarged to 10 × 16 in. and beyond.

To work with the relatively large focusing screen of a view camera is like having upside-down colour television. The equipment brings you much closer to the optical craft aspects of photography than any smaller camera, but you must understand what you are doing. Remember, too, that a 4 × 5 in. camera with a couple of good lenses can cost you over three times the price of a professional quality 35 mm three lens outfit.

Specialized accessories

You can choose from a very large range of camera accessories. Many are unnecessary and gimmicky, but some of the more specialized add-ons allow you to interface cameras with completely different kinds of technology.

Optical adaptors

Most 35 mm SLR camera systems include different adaptor rings which allow the camera body to fit over the eyepiece end of a microscope, telescope, medical endoscope, etc. Owing to reflex design you can still accurately frame-up, focus and measure exposure whatever optical device is fitted. In fact the camera becomes a film-containing back for the other device.

Camera triggers

You can buy electronic sensor units which trigger your camera in response to light, sound, radio or infrared radiation. Normally, you wire one of these devices to a small- or medium-format camera having electric release sockets plus motor-drive so that any number of pictures can be taken remotely. The camera might be set up in some inaccessible position, such as under a jump on a racecourse, and then fired when you transmit an infrared or radio pulse from the safety of the track-side. For natural history photography you can mount the camera in some hidden location, its shutter triggered automatically when your subject breaks the path of an infrared beam projected out of the trigger box itself (see Figure 2.10). This works equally well day or night.

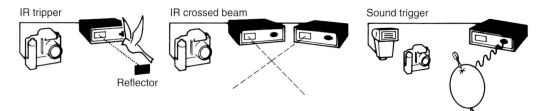

Figure 2.10 Remote triggers. Left: breaking an invisible infrared beam projected and reflected across the path of some event. Centre: two IR beams angled to correspond to one point in space. Only an object breaking the beams here triggers the camera. Right: ultra-high-speed flash triggered by sound detection.

With high-speed analytical work, a sudden happening – a spark or one object striking another, for instance – can trigger events via a light or sound sensor or by breaking a strategically placed beam. Here you can set up the camera in a darkened studio with the shutter locked open and using the trigger to fire an ultra-short duration flash. Most trigger units allow you to tune their level of sensitivity to suit ambient conditions, sound or light. You can also dial in a chosen delay (milliseconds or microseconds) between sensing and firing to capture the event a little after trigger activation.

Instant-picture (Polaroid) adaptors

Instant-picture adaptors for 'self-developing' film are made to fit most professional type small-, medium- and large-format cameras, provided they have detachable backs. Peel-apart

instant-picture material (page 102) is necessary, otherwise your result is laterally reversed. Small- and medium-format cameras only use film in pack form – two 35 mm pictures can be exposed side by side on one sheet if the back adaptor incorporates a slide-over device. Large-format cameras can use either packs or individual pull-apart sheets in envelopes which push into a back inserted into the camera like a sheet film holder. Backs for instant-picture sheets also accept some regular sheet films in envelopes. This is useful if you do not want to keep changing from an instant-picture adaptor to film holders. Instant pictures are not only invaluable for previewing results and checking equipment, but your instant colour print will probably be good enough to scan direct into a digital system via a flat-bed scanner (see also Chapter 10).

Programming and data backs

Most advanced 35 mm (and some medium-format) camera systems allow you to replace the regular camera back with a dedicated program or data back. The substitute back is considerably thicker and carries electronic keys and a battery compartment. It extends the camera's electronic facilities in various ways. For instance, some backs for motor-driven cameras allow you to program autobracketing – a quick series of frames each shot at a different level of exposure such as half, one or two stops' progression. The same back may also act as an 'intervalometer', so that you can trigger pictures at intervals of seconds, minutes or hours, and preset the total number of frames to be shot. Usually the inside face of the back carries a printing panel of low intensity LEDs to expose characters and figures through the base of your film, alongside or just within each frame. (The diode brightens or dims by varying its pulse rate to suit the slow or fast ISO speed set for the film.) This feature allows you to program in date, time, frame number, etc., or the camera can automatically imprint the aperture and shutter settings it made for each picture. A good programming/data back is expensive but invaluable for various kinds of record photography, especially time-lapse and surveillance work. It frees you from tedious logging of notes.

Special view camera backs

One or two specialist back accessories are made for view cameras principally 4 × 5 inches. They are mostly designed to make the camera quicker and more convenient to use. For example, a sliding back reduces the delay between composing and exposing. Simple rails allow you to rapidly exchange focusing screen for film holder (Figure 2.11) or digital back. Meanwhile, the shutter is closed and set en route by an electrical or mechanical link between the front and back of the camera. Working in reverse, the shutter locks open when you return the focusing screen.

Other replacement view camera backs accept a spot meter probe. This

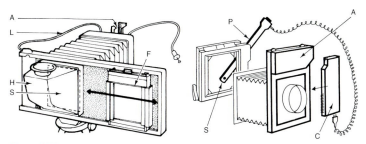

Figure 2.11 Special view camera accessories. Left: time-saving sliding back arrangement. A, aperture-setting indicator. L, link holds bladed shutter open when focusing screen (S) and reflex hood (H) are aligned with lens. F, film holder, with darkslide facing camera already removed (see text). Right: TTL exposure-metering equipment. Probe (P) has a spot-reading tip (S) you can move to measure any chosen area on the lens side of the focusing screen. C, control unit for setting film speed, etc. A, electronic bladed shutter which operates with all lenses.

measures image light reaching the focusing screen from the lens and can program an electronic bladed shutter to give you aperture-priority exposure control. Other forms of exposure program are unsuitable for view camera photography because the subject itself and movements mostly determine what aperture you should set. Elaborate 'add-on' items for view cameras are manufactured in quite small numbers, which makes them expensive. Some more than double the cost of an outfit. So although extras make your camera quicker and more convenient to use they may not be justified unless you use large-format equipment most of the time.

Which one is best?

Clearly, no one camera will serve you well for every kind of assignment. Some give you a choice of at least two formats – a 120 rollfilm camera with a 35 mm back, for example; a 4 × 5 in. plus rollfilm back or an 8 × 10 in. camera adapted down to 4 × 5 in. However, the result is often an unsatisfactory compromise, with the lens too long focus and the camera unnecessarily bulky for the smaller format. Most photographers therefore opt for two camera outfits – for example, small and medium format or medium and large. Having two complementary kits means that you can exploit their advantages and minimize their individual shortcomings for the widest range of subjects. When you have made this decision go on to choose whether reflex, direct viewfinder or monorail designs (as available) will suit you best, and pick appropriate lenses.

On price, you will find that within any one category of camera the difference between cheapest and most expensive models can easily be a factor of 2 or 3 (six to eight times with 35 mm gear). Sometimes this extra cost is because the body has features utilizing the latest technology, or it is built with greater precision and finish, using much tougher components. Like hand-built cars, this lasting precision and reliability cannot really be seen unless you open up the inside.

Avoiding camera failures

Even the finest cameras are basically just machines and their users only human, so mistakes do occur from time to time. Every photographer must have occasionally lost pictures at the camera stage. The important thing is to minimize risks by setting up safety routines you follow as second nature, especially checks before and during shooting. It should be impossible for you to completely ruin any assignment through some failure of camera handling. Here are some typical hazards and suggested precautions.

Misuse of unfamiliar equipment: This is most easily done with rental cameras and lenses. Check anything complex and strange by exposing and processing a test film before using it on an important shoot.

The pre-set aperture fails to stop down within the lens of your SLR camera when you take the picture, usually due to sticky blades or a broken spring. The result is various degrees of overexposure (unless you set widest aperture). Do a quick pre-check before loading film. Set a small aperture and slow shutter speed, then notice if the diaphragm stops down by looking through the back of the open camera and pressing the release.

Your shutter fails to open, or close, or fully close. The result is no picture, or fogging and vast overexposure. Often the camera mechanism sounds abnormal, but check by looking through the back of the empty camera or make a trial exposure on instant-picture film.

Using flash, you get no image (perhaps just faint results from existing light) or, with a focal plane shutter camera, your correctly exposed flash picture only extends over about one-half or one-quarter of the frame. These failures are due to mis-synchronization (for example, part frames result from using fast-peaking electronic flash with a focal plane shutter at too short a shutter speed). Be wary of any camera which has an old X/M (or X/FP) switch for change of synchronization. Electronic flash fired on these M or FP flashbulb settings goes off before the shutter opens – no matter what speed is selected or whether it is a lens or focal plane shutter type. This error happens easily on a camera with a hot shoe and a sync selection switch tucked away somewhere else on the body. Pre-check by pointing the flash and empty wide-aperture camera towards a white surface in a dimly lit area. Through the open back of the camera you should briefly see the full picture area as a white shape when the shutter fires.

A run-down battery, making the camera meter erratic or non-active: this may also cause failure of the camera's electronically timed shutter and other circuitry. Always check with the battery state button when preparing for a session. Carry a spare set of batteries too, and as further back-up include a separate hand-held exposure meter. There are clearly advantages in having a camera body which, in the event of battery failure, still allows you use of at least one (*mechanically* powered) shutter speed.

Mechanical jam-up of an SLR camera: The whole unit locks solid, often with the mirror up. Some cameras offer you a reset lever or (medium formats) have some accessible screw you can turn with a small screwdriver to release the mechanism. The best precaution is to carry a spare body.

Shooting on already exposed film: This is most likely on 35 mm, 70 mm and sheet film, as regular rollfilm winds up onto a new spool, its backing paper marked 'exposed'. Adopt a rigorous safety routine. Exposed 35 mm film can always be bent over at the end or rewound completely into its cassette. Each sheet film holder darkslide must be reinserted with the black top facing outwards after exposure. Seal 70 mm cassettes and all cans of bulk film with labelled tape.

35 mm film not properly taken up when loading: Consequently, unknown to you, the film fails to wind on by one frame between exposures. Get into the habit of noticing, after shooting two or three frames, whether some rotation of the camera's rewind knob (or equivalent tell-tales) proves that film is actually transported inside the camera. Cameras with autoload mechanisms rarely suffer from this problem.

Out of focus due to coming too close with an autofocus camera: practise, and get used to recognizing nearest focusing distance from the way, say, a head reaches a particular size in the viewfinder.

Soft focus, and sometimes upset of the camera's whole electronic system, due to condensation on the lens and internal mechanism: If this happens on the internal glass surfaces of a direct viewfinder camera its effects are hidden until you see the results. Avoid bringing very cold equipment into a warm, moist atmosphere unless it is wrapped up and allowed to reach ambient temperature slowly.

Obstruction of part of the picture: The cause is usually in front of the lens (your finger, strap, lens hood or a filter holder too narrow for the lens's angle of view, etc.), especially with a direct viewfinder camera. Alternatively, it might be between lens and film (part of a rollfilm sealing tab fallen into the camera, crumpled bellows in a view camera used with shift movements or an SLR with its mirror not fully raised). Always glance into the camera space behind the lens as you are

loading film. Fitting a hood of correct diameter will reduce the risk of something getting in front of the lens.

Remember the value of having an instant-picture back, to allow you to confirm visually that lens and body are working correctly – plus checking lighting, exposure and composition – at any time during a shoot. Some professional photographers habitually expose one instant picture at the beginning and another at the end of every assignment, as insurance. It is also a good idea to carry another complete camera (a 35 mm SLR, for example) as emergency back-up.

The digital revolution

The first patents for devices capturing images electronically were filed as far back as 1973. Kodak created a prototype digital camera in 1975 using a charge-coupled device (CCD), recording black and white images on to digital cassette tape; however it was built to test the feasibility of digital capture using solid state sensors, rather than as a camera for manufacture (due to it's bulky size and a weight of nearly 3.6 kg). It was not until 1981 that Sony developed a camera using a CCD, suitable to be hand-held and available to the consumer. The birth of digital still cameras as we know them today happened in 1988, when Fuji showcased their camera, the DS-1P, at Photokina. Early digital formats could not compete with their film equivalents in terms of cost or quality; digital cameras as a practical option for consumers were not really available until the mid-1990s. Since then the digital market and technologies have grown exponentially.

The move to digital imaging by many photographers has involved a preceding step via 'hybrid' imaging – that is, capture on film followed by digitization using a scanner. However, in the last ten years, huge advances in sensor technology, computing capabilities and the widespread adoption of broadband (ADSL) Internet connection by the consumer have meant that digital imaging has finally arrived. For example, most households in Britain now own at least one computer and the majority of new mobile phones have a built-in digital camera. The digital camera market has therefore been advanced by the consumer market and of course the widespread use of imaging on the Internet.

Immediate results and the ability to easily manipulate, store and transmit images have become a priority in many disciplines, with some sacrifice in the quality that we expect in our images. In the professional market there have also been compromises between versatility of systems and image quality, but progress towards the uptake of entirely digital systems has been somewhat slower. In some types of photography image quality is still more important than speedy processing and the lack of equipment available in larger formats has meant that film-based systems are still common. Sports photography and photojournalism, however, have embraced a predominantly digital workflow from capture to output.

The image sensor

Instead of exposing onto silver halide coated film, currently the majority of digital cameras contain one of two types of light sensitive array, either a charge-coupled device, known as a CCD, which is common in earlier digital cameras, or fast overtaking it, the complementary metal-oxide semiconductor or CMOS image sensor. The sensor is in the same position as the film in an analogue camera. Many of the key external features of digital and film cameras are similar, but digital cameras have a whole other layer of complexity in terms of user controls in the camera software.

Both types of digital image sensor are based on the same material, silicon, which when 'doped' with small amounts of other elements, can be made sensitive to light. When exposed to light, it produces a small amount of electrical charge proportional to the amount of light falling on it, which is stored, transported off the sensor, converted into a stream of binary digits (1's or 0's, hence the name 'digital imaging'), and written into a digital image file. The process is a complex one, and the structure and operation of the sensor is covered in more detail in Chapter 6. There are many fundamental differences between film-based and digital imaging, not least that where a frame of film both captures and stores the image, and is therefore not reusable, a digital sensor captures the image, but it is then transported away and stored as an image 'file' somewhere off the chip. Theoretically, if an image file is not compressed and is continually copied and migrated across different media, it is permanent and can be reproduced as many times as required, without any degradation in quality.

Sampled images

Another key difference between digital and analogue imaging is the fact that the digital image is captured across a regular grid of pixels (Picture Elements). Each pixel is an individual image-sensing element, which produces a response based on the average amount of light falling on it. Where film 'grains' are distributed randomly through a film emulsion and overlap each other to create the impression of continuous tones, pixels are non-overlapping and if a digital image is magnified, individual pixels will become very evident. Digital images are a *discrete representation*. This is further accentuated by the fact that pixels are not only discrete units across the spatial dimensions of the image, but that they can only take certain values and are solid blocks of colour. The process of allocating a continuous input range of tone and colour to a discrete output range which changes in steps, is known as *quantization* (see Figure 2.12). The whole pixel will be the same colour, regardless of the fact that the light falling on it in the original scene may have varied across the pixel area.

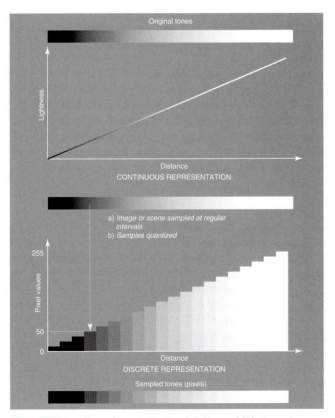

Figure 2.12 Sampling and quantization in a digital image: (a) The image is spatially sampled into a grid of discrete pixels; (b) The continuous colour range from the original scene is quantized into a limited set of discrete levels, based on the bit depth of the image.

A digital image is therefore 'sampled' both across its physical dimensions and in terms of its colour values. The stepped changes in colour values and the non-overlapping nature of the pixels are limiting factors in the quality and resolution of a digital image. The spatial sampling rate is determined by the physical dimensions of the sensor. The quantization levels depend upon the sensitivity of the sensor, analogue to digital conversion, image processing in the capture device and ultimately on the output file format.

Resolution in digital imaging

Resolution is the capability of an imaging system to distinguish between two adjacent points in an image and is a measure of the detail-recording ability of a system. It defines how sharp your images will appear and what level of fine detail will be represented. In any imaging system this is affected by every component through which light passes; in a film-based system the lens and the film will be the key factors, but anything placed over the lens or sensor, such as a filter, may also affect it. It is usually the resolution of the image sensor that is the ultimate limiting factor, which is why film grain is important, although a poor quality lens, as any photographer knows, is a primary cause of loss of sharpness. There are a number of measures of resolution, but two commonly used and covered in more detail in the chapters on lenses and film are *resolving power* and *Modulation Transfer Function (MTF)*.

Where resolution in traditional film-based imaging is well-defined, the different ways in which the term is used and its range of meanings when referring to digital systems can be confusing. It is helpful to understand these differences and to be clear about what resolution means at different stages in the imaging chain. You will see the term explained and used in different contexts throughout this book, but to summarize.

Fundamentally, digital images do not have an absolute resolution, but a number of pixels. The level of detail that is represented will depend upon how this number of pixels are captured or viewed. Therefore, image resolution is often quoted in pixel numbers, calculated by number of rows × number of columns. It may be referred to in terms of *megapixels*, a megapixel being a million pixels; this is a value often quoted by digital camera manufacturers.

At different stages in the imaging chain, resolution may also be measured as a function of distance. Scanner or monitor resolution, for example, may be quoted in terms of numbers of pixels per inch (ppi) and printers are often specified in terms of dots per inch (dpi). The combinations of these different resolutions in the output image determine the final image quality and also output image size. These relationships are examined in more detail in the chapter on digital imaging systems. When quoted by manufacturers of these devices, they will usually quote the upper limit for that device, although it will be possible to capture and output images at a range of resolutions below this.

A clever trick that manufacturers often use to enhance the apparent characteristics of their devices is to quote *interpolated resolution*. This applies to cameras and scanners. The actual (or *optical*) resolution of a device is defined by the number of individual elements and their spacing; however it is possible to rescale an image by interpolating values between the actual values, in effect creating false pixels. The visual effects of this are a slight blurring of the image, because the interpolation process averages adjacent pixels values to create the new pixels.

In cameras too, the *effective resolution* may be quoted, although manufacturers may not identify it as anything other than resolution. Again, this is a form of interpolated resolution, but refers in this case to the fact that in the majority of cameras, the sensor is filtered, so that each pixel captures only one colour, usually red, green or blue. To obtain the other colour values at each pixel in the captured RGB image, adjacent pixels of each colour are used and the missing values interpolated. As with all interpolation there is an associated blurring and loss of quality. There is an exception, however: in the last few years, a new sensor, the Foveon™ chip, has been developed, which captures colour at different depths in the sensor and therefore captures all three RGB values at every pixel. This sensor, however, is only available in a few cameras currently on the market, so for the majority, effective resolution still applies.

How many pixels?

When buying a digital camera, resolution is a primary consideration, and a key factor in image quality, however the previous discussion indicates the confusion around the subject. The highest number of megapixels does not necessarily represent the highest quality or automatically mean that the largest level of detail will be reproduced. Other factors are involved as well.

The pixel *pitch*, which is the centre-to-centre distance between pixels and relates to the overall pixel size, is important in determining the maximum level of detail that the system is able to reproduce. Tied up with this however, is the imaging area of each pixel, which in some cameras may be as low as 20%, due to the inclusion of other components and wiring at each pixel and channels in between imaging areas. Also, the pixel shape; whether there are *microlenses* above each pixel to focus and maximize the light captured; even the interpolation algorithms used in calculating missing colour values, which vary between manufacturers, these will have an effect on final image resolution. These factors combine to influence the shape of the sensor's MTF and it is this that is a far better indicator of how well a camera will perform. The quality of the lens must additionally be taken into account. Finally, and really important, is the pixel size relative to the overall size of the imaging area on the sensor.

What the above discussion highlights is the complicated nature of resolution as a measure of image quality in digital cameras. Do not make a choice based solely on the number of megapixels. Make informed decisions instead, based on results from technical reviews and from your own observations through testing out different camera models. You need to decide beforehand how you want to use the camera, for what type of subjects, what type of photography and what type of output.

Bearing all this in mind, it is still useful to have an idea of the physical size of output images that different sensor resolutions will produce. Print resolution requirements are much greater than those for screen images. Although it is now widely accepted that images of adequate quality can be printed at 240 dpi, or perhaps even lower, a resolution of 300 dpi is commonly given as required output for high-quality prints. Some picture libraries and agencies may, instead of specifying required image size in terms of output resolution and dimensions, state a required file size instead. It is important to note that this is *uncompressed* file size. It is also necessary to identify the bit depth being specified as this will have an influence on file size. Figure 2.13 provides some examples for printed output.

INPUT: CMOS or CCD image sensor					OUTPUT: 8 bits per channel RGB images printed at 300 dpi		
Megapixels	**Sensor resolution**		**Sensor size**		**File size**	**Output print size**	
	Pixels		**mm**		**MB**	**inches**	
	w	**h**	**w**	**h**		**w**	**h**
16.6	4992	3328	36	24	47.5	16.6	11.1
12.7	4368	2912	35.8	23.9	36.4	14.6	9.7
10.1	3888	2592	22.2	14.8	28.8	13.0	8.6
8.2	3504	2336	22.5	15	23.4	11.7	7.8
7.1	3072	2304	5.7	4.3	20.3	10.2	7.7

Figure 2.13 Sensor resolution, dimensions, file size and printed output.

Features of digital cameras

Digital image capture is a complex process. The signal from the sensor undergoes a number of processes before it is finally written to an image file. The processes are carried out either on the sensor itself, in the camera's built-in firmware or via camera software, in response to user settings. They are designed to optimize the final image according to the imaging conditions, camera and sensor characteristics and output required by the user. The actual processes and the way they are implemented will vary widely from camera to camera. Some are common to most digital cameras however. They will be covered in more detail in other chapters, but are summarized below. They include:

- *Signal amplification*: This may be applied to the signal before or after analogue-to-digital conversion; this is a result of auto exposure setting within the camera and ensures that the sensor uses its full dynamic range. In effect the contrast of the sensor is corrected for the particular lighting conditions.
- *Analogue-to-digital conversion*: The process of sampling and converting analogue voltages into digital values.
- *Noise suppression*: There are multiple sources of noise in digital cameras. The level of noise depends upon the sensor type and the imaging conditions. Adaptive image processing techniques are used to remove different types of noise. Noise is enhanced if the camera gets hot (the sensor is sometimes cooled to reduce the noise levels), also if long exposures or high ISO settings are used.
- *Unsharp mask filtering*: Used to sharpen edges and counteract blurring caused by interpolation.
- *Colour interpolation (demosaicing)*: This is the process of calculating missing colour values from adjacent colour-filtered pixels.

These are sensor specific, in-built and not user controlled. Additionally, settings by the user will implement processes controlling:

- *White balance*: The image colours (the gamut) are shifted to correct for the white of the illuminant and ensure that neutrals remain neutral. White point setting may be via a list of preset colour temperatures, calculated by capturing a frame containing a white object, or measured by the camera from the scene. In film cameras, this requires a combination of selecting film for a particular colour temperature and using colour-balancing or colour-correction filters.
- *ISO speed*: The sensitivity of the sensor is set by amplifying the signal to produce a required range of output values under particular exposure conditions. Again in film cameras, this would be achieved by changing to a film

of a different ISO. ISO settings usually range from 100 up to 800. Some cameras will allow ISO values up to 1600 or even 3200. The native ISO of the sensor however is usually 100–200. Anything above this is a result of amplification. Amplifying the signal also amplifies the noise levels and this may show up as coloured patterns in flat areas within the image.

- *Exposure and the image histogram*: This is a process of shifting the output values by amplification of the input signal, to ensure that the maximum range of output values is produced, ideally without clipping the values at the top or bottom of the range. The actual exposure measurements are taken through the lens as for a film camera and image processing takes care of the rest. To optimize this process the *image histogram* is provided in SLRs and larger formats to allow exposure compensation and user adjustment. This is a graphical representation, a bar chart of the distribution of output levels and is an accurate method of ensuring correct exposure and contrast, as viewing the image in the low resolution and poor viewing conditions of the LCD preview window may produce inaccurate results. In particular, it can be difficult to tell in the preview when highlight values are clipped, a situation to be avoided. The histogram will easily alert you to this and allow you to make necessary adjustments for a perfect exposure. For more information on exposure and the histogram, see Chapter 11.
- *Image resolution*: Many cameras, will allow a number of resolution settings, lower than the native resolution of the camera to save on file size. These lower resolutions will be achieved by down-sampling, either dropping pixel values completely if the image is being downsampled by a factor of 2, or by interpolating values from the existing sensor values.
- *Capture into a standard colour space*: With the necessary adoption of colour-managed workflow, a number of standard colour spaces have emerged. Capturing into a standard colour space means that the image gamut has the best chance of being reproduced accurately throughout the imaging chain (see Chapter 11 for further details). The two most commonly used standard colour spaces in digital cameras are sRGB and Adobe RGB (1998). sRGB is optimized for images to be viewed on screen. The slightly larger gamut of Adobe RGB encompassed the range of colours reproduced by most printers and is therefore seen as more suitable for images that are to be printed.
- *File quality (if image is to be compressed) and file format*: Most cameras will offer a range of different output file formats. The most common ones in digital cameras are JPEG, TIFF and RAW formats. The merits of these different formats are discussed in detail in Chapter 11. Of the three, JPEG is the only one that compresses the image, resulting in a loss of information. A quality setting defines the severity of the loss, file size and resulting artifacts. TIFF and RAW are uncompressed and therefore file sizes are significantly larger. TIFF is a standard format that may be used for archiving images without loss. RAW is more than a file format, as it results in almost unprocessed data being taken from the camera. With RAW images, the majority of the image processing detailed above is performed by the user in separate software after the image has been downloaded from the camera.

This short summary highlights some of the differences between using film and working digitally. The immediacy of results from digital cameras is somewhat counterbalanced by the number of settings required by the user before image capture. However it also highlights the high degree of control that you have. Many of the adjustments that would have to be performed optically with a film-based system, or by changing film stock, may be achieved by the flick of a switch or the press of a button.

Digital sensor sizes

One of the initial problems in producing digital cameras with comparable image quality to film was the difficulty and expense in manufacturing CCDs of equivalent areas. Many digital cameras have sensors which are significantly smaller than 35 mm format. The sizes are often expressed as factors, and they are based on the diagonal of a 1 in. optical image projected onto a sensor by a lens, which is close to 16 mm. Examples of the actual dimensions of some image sensors are shown in Figure 2.14, compared to typical film formats.

Sensor/format	Horizontal (mm)	Vertical (mm)	Diagonal (mm)	Aspect Ratio	Sensor Type	Camera types
Film						
35 mm	36.0	24.0	43.3	3:2	Film	Compact/SLR
120 mm	60.0	60.0	84.9	1:1	Film	Medium format/ various
Large format	120.0	101.6	162.6	5:4	Film	View cameras (5″ × 4″)
Digital sensors – consumer market						
1/5	2.6	1.9	3.2	4:3	CMOS	Mobile Phone
1/2.7	5.4	4.0	6.7	4:3	CCD/CMOS	Compact
1/2	6.4	4.8	8.0	4:3	CCD/CMOS	Compact
1/1.8	7.2	5.3	8.9	4:3	CCD/CMOS	Compact
2/3	8.8	6.6	11.0	4:3	CCD/CMOS	Compact
1	12.8	9.6	16.0	4:3	CCD/CMOS	Compact
1.8*	22.2	14.8	26.7	3:2	CMOS	SLR
1.8*	23.7	15.7	28.4	3:2	CCD	SLR
Digital sensors – professional market						
Full frame 35 mm	36.0	24.0	43.3	3:2	CMOS	SLR
Medium/large format back	36.9	36.9	52.2	1:1	Full frame CCD	Digital Back
Medium/large format back	48.0	36.0	60.0	4:3	Full frame CCD	Digital Back
Medium/large format back	49.0	36.9	61.0	4:3	Trilinear array CCD	Scanning back
Large format back	96.0	72.0	120.0	4:3	Trilinear array CCD	Scanning back
Large format back	100.0	84.0	130.6	4:3	Trilinear array CCD	Scanning back

* There are a variety of different sensors labelled 1.8 and sizes vary slightly between manufacturers

Figure 2.14 Dimensions of typical film formats and digital image sensors.

The small sensor sizes mean that in most digital cameras the focal lengths of lenses are significantly shorter than in film-based systems. This has a number of implications. First of all, it means that in the compact market, it has been possible to make much smaller camera bodies, and this is the reason that miniature cameras have proliferated (it has also made the tiny cameras used in mobile phones a possibility, see below). As for film camera formats, a shorter focal length means greater depth of field. The result of this is that using a shallow depth of field for selective focus on a subject is much more difficult in digital photography, because more often than not everything in frame appears sharp. This is one of the reasons that professionals often prefer a full-frame sensor of the same size as the equivalent film format, because in this case the lens focal lengths and depth of field will be the same as for film.

A further implication of the smaller sensors is that lens of focal lengths designed for film formats will produce a smaller angle of view when placed on a digital camera with a smaller sensor. This means that standard focal length lenses effectively become telephoto lenses (see Figure 2.15). The problem affects small-format SLRs, where lenses from the equivalent film format might be used, and also the larger formats when using digital backs with a smaller imaging area than the associated film back. It can also cause confusion when comparing the zoom lenses of two cameras with different-sized sensors. Effective focal length is sometimes quoted instead. This expresses the focal length as the same as a focal length of a lens on a film camera, usually 35 mm, based on an equivalent angle of view.

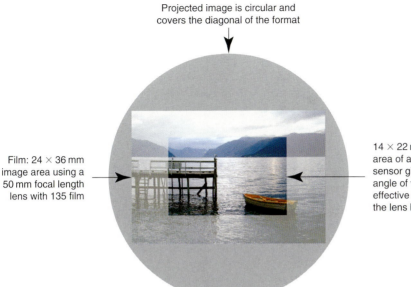

Projected image is circular and
covers the diagonal of the format

Film: 24 × 36 mm
image area using a
50 mm focal length
lens with 135 film

14 × 22 mm image
area of a 1.8 digital
sensor gives a smaller
angle of view. The
effective focal length of
the lens becomes 80 mm

Figure 2.15 Change in angle of view as a result of smaller sensor size and focal length. Manufacturers often quote 'effective focal length' for digital lenses, which relates the field of view of the lens to that provided by the focal length of the lens in the related film format.

Digital camera equipment

Digital camera equipment is less easily classified by image format than film simply because of the huge variation in sensor size. Cameras can, however, be put into broad categories based upon the market for which they are aimed and like film cameras, this dictates the level of sophistication and cost of the equipment.

The equipment falls into a number of main types (see Figure 2.16):

(a)

1 Specially designed compact type cameras for point-and-shoot snapshots. Mobile phone cameras – with fewer features – can also be included in this category.
2 Hybrid cameras. There are a range of different designs, but they often bridge the gap between compacts and SLRs, containing many of the features of both.
3 Small-format SLR cameras. Up to 35 mm, these fall into two classes: Prosumer (or semi-professional) which are cheaper and aimed at the serious amateur, and professional SLRs based on existing film cameras, retaining their same 'front-end' features, but permanently housing a digital sensor in place of film.
4 Medium- and large-format digital backs. These are high resolution, capturing either an entire frame at once or in the larger formats scanning down the frame using a linear sensor. The majority are digital backs, which you simply attach and detach from your present medium- or large-format camera in the same way as a conventional rollfilm magazine or sheet film holder. There are a few available, however, that are built on to camera bodies.

(b)

(c)

Figure 2.16 Types of digital camera: (a) high-end compact, (b) hybrid and (c) professional SLR.

Point and shoot: Mobile phone cameras and compacts

At the lowest end of the market are mobile phone cameras. Pixel counts of up to 5 megapixels on sensors in mobile phones are now beginning to rival and surpass those in the compact point-and-shoot cameras of a few years ago. CMOS image sensors were first used in mobile phones; at the time the noise levels and low resolution associated with CMOS were unacceptable for other cameras, but the advances in the sensors in terms of both smaller pixel sizes and improved noise suppression have meant that image quality has steadily improved. These improvements have lead to the development of full-frame 35 mm CMOS sensors now used in professional SLRs. The optics on mobile phone cameras tend to be low quality, often plastic, however this is of much less importance bearing in mind the way in which these cameras are used. Interestingly, mobile phone cameras are currently the fastest growing part of the digital camera market. In recent years it has become common to see mobile phone images sent in by the public used in newspapers and television reports, where it would not have been possible to obtain such images unless a journalist had been on the scene.

There are a huge variety of compact cameras available, with many of the features typical on film compact cameras, such as built-in flash, a large variety of exposure and shooting modes, including movie modes and red-eye reduction. There has been a trend towards miniaturization by some manufacturers, aided by the ease of producing small CMOS sensors and the fact that many have scrapped viewfinders in favour of viewing the image on the LCD screen at the back. The other types of compact commonly available look more like an SLR, but tend to have smaller sensors. Nevertheless, recent models have sensors of up to 10 megapixels. Both types tend to be more automated, often without manual options. They may also only have digital zoom rather than optical zoom and output still image file formats may be limited to JPEG only. Prices are widely variable and continually coming down. The shelf-life of a particular camera model continues to decrease; often the next version in a successful range will be out six months after the last.

At the top end of the compact market are a couple of cameras aimed more at the professional (see Figure 2.16(a)) – the point-and-shoot for the professional photographer, if you will. They are significantly more expensive than the majority of compacts, up to three times more than those at the cheaper end but have fewer automated features, some without zoom lenses. They allow manual setting of most features; capture to RAW file format and sensor resolutions rival those of some SLRs. The cost is in the quality of sensor and the optics.

Semi-professional SLRs (Prosumer cameras)

These cameras are hybrids, with many of the automatic features of compact cameras, but with more of the manual controls available with SLRs. Where professional SLRs may be sold as camera body only, these tend to be marketed as all-in packages. Currently they do not include full-size sensors, i.e. of equivalent size to the film format. Actual sensor sizes are variable (see Figure 2.14). The upper limit of effective resolution of the sensors in these cameras is around 10.1 megapixels, which can theoretically produce an output print size of nearly 330 mm × 220 mm and a file size of around 30 MB. They may have a range of interchangeable lenses and a variety of accessories available and are sometimes compatible with the lenses from the equivalent film cameras. However, the smaller sensors mean that there will be a conversion factor between the lenses. The lenses are also of lower quality than the professional ranges. This is not to knock them however; some of the hybrid cameras produced by manufacturers such as Canon and

Nikon in recent years contain sensors that surpass the performance of those in professional ranges of a few years ago.

They are aimed at the serious amateur and their price reflects their hybrid status, being significantly more affordable, sometimes half the price (including lenses) of the professional equivalent (body only).

Full-frame SLRs

These cameras are the closest to conventional film formats and are aimed at the professional. The camera bodies are almost identical in design, apart from the image sensor and related optics, processing and the LCD screen on the back. Some manufacturers have even maintained the position of the main controls to make the transition from film to digital even easier. Sensors are full-frame; the same image size as 35 mm format and this means that there is no lens conversion factor required. The variation in price is therefore down to number of pixels and hence resolution, with an upper limit at the time of writing of around 16 megapixels, giving an output file size of nearly 50 Mb. Often sold as a camera body only (although some may come with cheaper lenses), they are designed to replace the film camera body in a professional kit, without requiring additional lenses or accessories. They tend not to have the array of automatic features of their semi-professional counterparts, with fewer modes and more manual control. These cameras have been widely adopted by photojournalists, in particular sports photographers, who often carry laptops as part of their kit and are able to download, crop and adjust their images before sending them wirelessly to their picture editors within a matter of minutes. In these types of photography, speed is of the essence and can mean the difference between your images, or someone else's, being used and syndicated.

There are also a number of medium-format full-frame digital SLRs available. Significantly more expensive, the sensors are larger than those used in 35 mm, but smaller than the physical dimensions of their film equivalent (36 mm × 48 mm is quite typical). More commonly available are digital backs for this format (see below).

Digital backs

For highest quality digital images intended for big prints, larger file sizes are required. This is made possible by fitting a digital back to a rollfilm SLR or view camera (see Figure 2.17). At this level, CCDs dominate. There are two main types: either frame arrays, which capture the entire frame at once, and are mainly medium format (although some can be attached to large-format camera bodies), or digital scanning backs, which use a trilinear CCD array (three rows of sensors, each capturing red, green or blue), and are designed for both medium and large-format cameras. The single shot arrays are not equivalent in size to their film counterparts, the largest currently available at around 49 × 37 mm, but with pixel counts of up to 7216 × 5412 (39 million), a sensor of this size produces image files of over 100 MB and resolution easily matches that of medium-format film.

(a) (b)

Figure 2.17 Digital backs: (a) A digital back for a medium-format camera (image courtesy of Phase One, Inc.), (b) a scanning back containing a trilinear CCD array for a large-format view camera (image courtesy of Better Light, Inc.).

Because digital scanning backs physically track across the camera image plane throughout an exposure, subject matter is limited to still-life as both camera and subject must remain still for a couple of minutes. Therefore they cannot be used with flash, and using tungsten illumination you must avoid any lighting intensity variations (such as minor flickering) because this will show up as a band across the picture. A full colour image of many millions of pixels is built up line by line to give image files at the top end of the scale of over 400 MB.

Clearly, dealing with files of this size is a completely different matter compared to the convenience of using digital SLR. There are huge storage requirements involved and processing must be done predominantly on a peripheral computer, therefore digital large format is much more likely to be used in a studio setting than its analogue counterpart.

Comparing digital and silver halide camera equipment

Advantages of digital:

- You get an immediate visual check on results (for example, displayed on a large studio monitor screen).
- No film or lab costs, or liquid processing in darkrooms.
- Sensitivity can be altered via ISO speed setting to match a range of lighting conditions.
- Exposure can be checked using the histogram to ensure correct scene intensity/contrast and to prevent highlights being 'blown out'.
- You can erase images, and reuse file storage, on the spot.
- Colour sensitivity is adjustable to suit the colour temperature of your lighting.
- Camera images can be transmitted elsewhere rapidly and wirelessly.
- Digital image files can feed direct into a designer's layout computer – ideal for high-volume work for catalogues, etc.
- Extensive ability to alter/improve images post-shooting.
- Digital image files are theoretically permanent, if correctly archived.
- Silent operation.

Disadvantages of digital:

- Much higher cost of equipment; this includes powerful computing back-up with extensive file capacity (RAM) necessary for high-resolution work. The technology is continuing to develop, meaning that equipment may require frequent updating, another source of expense.
- There are a huge range of knowledge and skills required to keep up with changes in the imaging systems, to ensure that your methods match standard workflows within the industry and to maximize the potential of the equipment. This needs extra investment from you in terms of both time and money.
- Digital workflow is not simply restricted to capture, but requires an imaging chain consisting of other devices such as a monitor and printer.
- Correct colour reproduction of a digital image from input to output requires the understanding and implementation of colour management which is a complex and still developing process.
- Silver halide film still offers excellent image resolution at low cost – roughly equivalent to 3 billion pixels for every square centimetre of emulsion. Also colour prints, particularly in runs, work out much cheaper by traditional neg/pos chemical methods.
- The limits to final acceptable image size are highly influenced by the number of pixels per inch the camera sensor codes within a file. So when planning a large final print you must start with a camera delivering sufficient pixels.
- High-resolution systems based on scanning are limited to still-life subjects.
- Cameras with digital sensors, like computers, are adversely affected by heat (i.e. from tungsten lamps).

■ The 35 mm film format is the smallest used by professionals. These systems are the most portable, versatile and the cheapest, with the largest range of accessories. Using 35 mm camera equipment you gain the benefit of latest technology at competitive prices. However, equipment may be either too automated or offer excessive options which get in the way. Consider manual override to be essential.

■ Medium-format cameras offer a sensible compromise between equipment mobility and final image quality. As well as SLR and direct viewfinder types, shift cameras and monorail designs are made for rollfilm format. Often they allow use of interchangeable film magazines, instant picture and digital backs. However, equipment is expensive, and has a smaller range of lenses than 35 mm. Using this format also means less depth of field and narrower choice of film stock.

■ Large-format view cameras demand a slower, more craft-knowledgeable approach. They tend to be expensive, yet basic. The range of lenses is limited, with relatively small maximum apertures, but most often give excellent coverage to allow you to utilize comprehensive movements for architectural, still-life and technical subject matter. You can shoot and process pictures individually, and their size means that large prints show unique detail and tonal qualities.

■ It is vital to have reliable camera technique – get into the habit of routine precautionary checks before and during shooting. Look through the back of the empty camera to see that the shutter, aperture and flash work and that there are no obstructions. Take an instant-picture shot before and after a session. Carry a spare body or some back-up camera; an exposure meter; spare batteries – plus a screwdriver.

■ Digital imaging is now the dominant means of image production for the consumer photography market, but remains a developing area. The high cost and limitations of larger digital formats mean that certain sectors of the professional photography market still work with film.

■ Professional digital camera systems aim to match image format and resolution for the three main formats used in film systems.

■ Currently, digital cameras use one of two types of image sensors, the charge-coupled device (CCD) or the complementary metal-oxide semiconductor (CMOS), both of which use a silicon-based 'array' of picture sensing elements (pixels) to convert light falling on the sensor into electronic charge.

■ Once the image has been recorded on the image sensor, it is processed, transferred off the chip, and stored as an image file, consisting of binary digits ('Bits') representing the image data. If archived properly, a digital image file may be stored permanently and reproduced as many times as required without any loss of quality.

■ Digital images are *sampled*: spatially, they consist of discrete non-overlapping elements usually arranged in a rectangular grid. They are also sampled in terms of their colour values (*quantized*), as pixels may only take a fixed range of values, determined by the *bit depth* of the image file. These two factors determine the image file size, ability to represent fine detail and ultimately the quality of the final image.

■ Resolution has a number of different meanings in digital imaging and it is useful to understand these different definitions. Fundamentally it describes the detail-recording ability of an imaging system. Resolution of a digital image is normally expressed in terms of number of pixels. Resolution in a digital camera also refers to number of pixels, but may refer to interpolated resolution rather than the real resolution of the chip and can therefore be misleading as a figure of merit. For other devices, resolution is usually quoted in terms of numbers of pixels (or dots) per inch – this defines the level of detail captured at input and the dimensions of the image at output.

■ Although the front-end design of digital cameras, particularly for professional formats, is the same as that of film cameras, digital cameras have a number of features and settings not required with film. These are changed via a software user interface, either on an LCD screen on the back of the camera or remotely using a peripheral computer. This offers you a huge range of options at your fingertips, but it adds an extra layer of complexity to the capture process, however this is counterbalanced by the ability to view immediate results and adjust as necessary.

■ Digital camera settings to change the white balance of the sensor and ISO speed rating to match illumination means that a wider range of imaging conditions are catered for by the same sensor. Correct exposure in digital cameras is further aided by the image histogram, allowing fine tuning of brightness and contrast. In film systems sensitivity and colour balance is achieved using different film stocks and filters and is therefore a more complicated and time-consuming process.

■ The physical dimensions of digital image sensors vary widely and are often smaller than film formats. This has implications for the optics of the cameras, as the smaller format means that shorter focal length lenses will produce the same field of view as those used on film cameras. Shorter lenses mean smaller cameras and larger depth of field. More recently professional cameras containing full-frame sensors that are the same size as their equivalent film format have been developed. For these cameras, there is no change in terms of field of view or depth of field when lenses for equivalent film formats are used with them.

■ Digital camera systems may be loosely classified according to the market that they are aimed at. The largest section of the market comprises compact cameras and mobile phone cameras. These vary hugely in design and features. More expensive than these are semi-professional (Prosumer) cameras, which are aimed at the serious amateur, are usually SLR in design and tend to have many of the features of professional 35 mm cameras.

■ For the professional market, a number of manufactures now make 35 mm full-frame SLRs, which are designed to match their film-based equivalents in terms of quality and features. These are currently significantly more expensive than either the film versions or the semi-professional SLRs.

■ There are a range of medium-format digital camera systems available. A few manufacturers make SLR cameras, but many professionals opt for digital backs designed to be used with existing equipment. Currently, the sensor dimensions are smaller than the 120 mm film; however image quality is generally regarded as equivalent.

■ Large-format digital systems are usually digital backs containing either an area CCD array of smaller dimensions than large format films, or a tri-linear array of CCD elements scanned across the image. Full-frame sensors are more difficult to successfully manufacture to this size. The scanning backs, which do match the imaging area of the equivalent films, require still-life subjects and non varying light sources to prevent image artefacts such as banding.

■ The decision to move to a digital workflow requires careful consideration. The technology continues to evolve and equipment will need to be updated on a more regular basis than film-based systems.

■ Digital camera systems are more expensive and require understanding of a range of different issues on top of those required for film photography. However, the versatility of the systems and the ability to view and alter images immediately post capture offer profound advantages compared to the time required to produce an image using film.

■ Top-end digital cameras can deliver results fully the equal of equipment using silver halide materials; capital cost is far higher, although reducing every year.

1 This project involves the use of the histogram as an exposure tool:

(a) Set up a still-life scene using a variety of objects, including a test chart, if you have one, such as the Macbeth colour checker chart. If not, ensure that there are a range of colours in the scene and that there is one white, one black and one mid-grey object included. Set the lighting so that there is a range of approximately seven stops between shadows and highlights (you can check this by zooming in and taking exposure readings from these areas).

(b) Ensure that a memory card is in the camera, turn the camera on and perform a complete format. Set the speed to 200 ISO. Set the colour space, if possible, to Adobe RGB.

(c) Take 5 bracketed exposures, in increments of 1 stop, from 2 stops below correct exposure to 2 stops above.

(d) Ensure that the histogram is displayed when the images are played back. Examine how the shape of the histogram changes as the exposure changes. Identify the point at which shadows or highlights within the image are clipped – this will show on the histogram as a peak at either side. Your camera LCD screen may also display clipped areas within the image.

2 This project involves investigating the ease of use and results obtained using the different methods of setting white balance in your camera:

(a) Select a number of scenes under different lighting conditions, e.g. daylight, tungsten, and fluorescent. In each, include a white object, such as a sheet of paper, and a mid-grey object, such as a Kodak grey card.

(b) Set the speed to 200 ISO throughout. Find correct exposure, set colour space to Adobe RGB and file format to JPEG (high quality).

(c) Take shots of each scene using the different white balance methods available: (i) Auto-white balance, (ii) Pre-set to the light source or colour temperature and (iii) Using custom white balance (you will need to check the instructions for the camera to do this – it usually requires a reference frame of a white object).

(d) Download the images to your computer and view them side by side on screen in an imaging application such as Adobe Photoshop. Identify the method that works best for each light source.

3 This project involves the capture of a scene using the different ISO speed settings to investigate the effect on image quality and noise levels:

(a) Use the camera on a tripod for one scene in daylight conditions and another scene with low light conditions (not night conditions, but indoor using natural light, for example).

(b) For each scene shoot a range of images using all the possible ISO speed settings on your camera.

(c) Download and examine your images in Photoshop. Zoom into areas of shadow and mid-tone.

(d) Identify at which ISO speed noise begins to be visible and in which areas it is most problematic. You may find you get different results depending on the lighting conditions.

(e) You might want to further extend this project by trying out some noise removal techniques (see the Image Manipulations chapter).

PROJECTS

3 Choosing lenses

ine image quality depends a great deal on having a good lens, but you will find that even good lenses are only intended for a limited range of working conditions. Optics which excel under one set of circumstances can give quite poor results under another. This chapter explains some of the problems faced by lens designers and manufacturers, and shows how every product is a compromise between what today's technology will allow and what we as photographers will actually buy. It also helps you to understand the lens quality data in manufacturers' technical literature, and what to look for when buying a lens, new or secondhand. Special types of lenses are discussed too, in terms of practical handling and suitability for different kinds of photography. With the recent increase in popularity of digital still cameras (DSCs), consideration to the requirements of lenses for DSCs is given. The advantages and disadvantages of using existing lenses designed for 35 mm film cameras in digital single lens reflex cameras (SLRs) are examined.

The lens designer's problems

e all tend to take a modern lens for granted. It is just accepted as an image-forming collection of glass elements, somewhat overpriced and easily damaged. In fact, every good lens is really a skilfully solved set of problems concerning the control of light. Designing a lens means juggling image quality, the picture area covered, consistency over a wide range of subject distances, an acceptably wide aperture – and finally coming up with something which is not too large, heavy or expensive to manufacture.

Glass

The designer's raw material is optical glass, which starts as a molten mixture of chemicals, including barium, lanthanum and tantalum oxides. According to its chemical content, each type of glass has a particular (1) refractive index (RI) and (2) dispersive power (Abbe number).

RI relates to the light-bending power of a glass. Since the RI of an optical material varies with frequency and hence wavelength, it is normal to measure RI at a specific wavelength. This is done for several well-known emissions, for example, the wavelength of light near the middle of the spectrum (typically, 590 nm yellow, see Figure 3.1). The higher the RI, the more steeply oblique light entering the glass is changed in direction.

Substance	Mean RI*
Vacuum	1.000
Water	1.333
Magnesium fluoride	1.378
Fused silica	1.458
Hard crown optical glass	1.519
Common window glass	1.528
Lead crystal drinking glass	1.538
Dense flint optical glass	1.927
Diamond	2.419
*Measurement at wavelength 590 mm	

Figure 3.1 Some refractive index values.

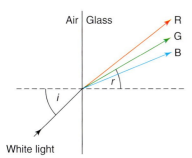

Air | Glass

White light

Figure 3.2 Refraction and dispersion. Mean refractive index with this glass is sin *i* divided by sin *r*. Dispersion (exaggerated here) is shown by the different RI for red and blue lights. Glass dispersive power is given an Abbe number: the greater the dispersion, the lower the number.

The 'dispersive power' of the glass is related to the change in the RI of the optical material with respect to the wavelength of the light. The greater the difference between the RIs for red and blue lights, the greater is the dispersion in the glass (see Figure 3.2). Therefore, the higher the dispersion, the more white light is split into a wide spectrum of colours, just as a prism or droplets of rain disperse sunlight into a rainbow. Typically, the RI for all types of glass is greater for blue light than it is for red light. The average dispersion is calculated from a range of wavelengths that include red (656 nm) and blue (486 nm) lights. Dispersion is an important factor in glass for photographic lenses because your subject matter is often multicoloured, and is lit by a white-light mixed-wavelength source.

Mean RI and dispersive power are fairly independent. You can have two glasses which have the same RI but different dispersive power, and glasses which differ in RI but which have identical

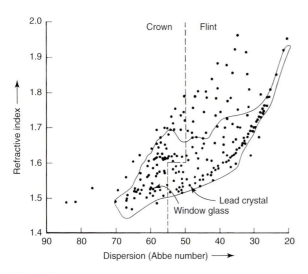

dispersive power. Figure 3.3 shows how this makes over 150 different kinds of optical glass available for the designer to choose. The Abbe number shown in the figure is defined as the reciprocal of dispersion. Glass used for lenses must also have the right physical properties to be machined and polished to the designer's chosen shapes without breaking. It must be completely colourless, unlike ordinary window glass, which shows a green tinge when you look through it end-on. Other requirements include general stability; freedom from defects such as bubbles, plus resistance to atmospheric conditions and reasonable handling during day-to-day use.

Figure 3.3 The 150 or so optical glass types produced for lenses by Schott, Germany. Glass for windows and lead crystal tableware are included for comparison. Enclosed zone defines the limits to manufacture 70 years ago.

Recently, types of glass that show special dispersion properties or that have a very high RI have been applied in the design of DSCs. These types of glass are more effective at reducing artefacts such as chromatic aberration and can result in smaller, more compact, lenses that improve performance. One type of material with special dispersive properties is fluorite. When used in the manufacture of zoom lenses it can be very effective at correcting chromatic aberration owing to its unusual dispersive properties. However, it requires special care when it is handled since it has a very delicate surface.

Design and manufacture

A photographic lens is built up from a series of lens elements. The designer works by calculating the necessary front and back surface contours of each element, its appropriate glass and the spacing of one element relative to another in the lens barrel (allowing for the aperture diaphragm and perhaps the shutter). The aim in all this is to correct the mixture of optical errors – 'aberrations' – which always occur in images of a scene formed by simple lens elements alone. Broadly speaking, there are two reasons why aberrations in an optical system occur. Firstly, these errors occur due simply to imperfections in the individual optical components and are very difficult to avoid, even when the best components are used. Secondly, errors in fabrication and in the alignment of the individual optical components can result in further aberrations. Closely check the image of a scene formed by a single-element magnifying glass and you will see the slightly fuzzy, distorted, low-contrast picture which is the collective effect of aberrations.

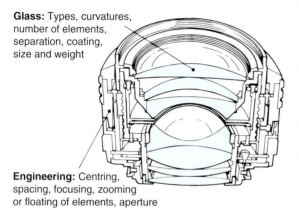

Glass: Types, curvatures, number of elements, separation, coating, size and weight

Engineering: Centring, spacing, focusing, zooming or floating of elements, aperture

Figure 3.4 Internal structure of a regular *f*/1.4 50 mm lens for a 35 mm SLR camera. Lens design is a complex, mathematical combination of different lens elements, precisely located in the barrel along with aperture and focusing mechanism.

There exist seven main geometrical aberrations that can occur in an optical system and these are shown in Figures 3.5–3.11. Chromatic aberrations occur when light of more than one wavelength is being imaged. The remaining aberrations are monochromatic and occur when light of only one wavelength is imaged. It is not too difficult to reduce or eliminate each one *individually* by some means. For example, Figure 3.12 shows how the designer can correct longitudinal chromatic aberration by combining a converging shape lens made in high RI, medium-dispersion glass (the element is usually made from flint glass) with a diverging shape lens of glass having less RI (usually crown

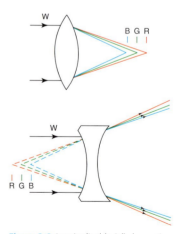

Figure 3.6 Longitudinal (axial) chromatic aberration. Dispersion of white light in simple converging (top) and diverging (bottom) lens elements causes different points of focus for each colour: red (R), green (G) and blue (B).

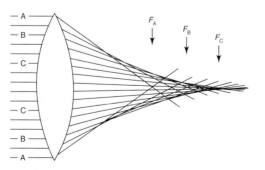

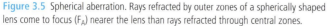

Figure 3.5 Spherical aberration. Rays refracted by outer zones of a spherically shaped lens come to focus (F_A) nearer the lens than rays refracted through central zones.

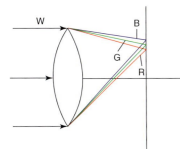

Figure 3.7 Lateral chromatic aberration. Colour fringing occurs due to change in image magnification which occurs as a function of wavelength. It tends to be more visible than longitudinal chromatic aberration and is zero at the centre of the field and increases at the edges.

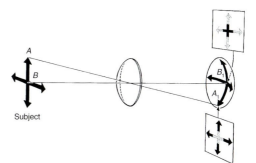

Figure 3.8 Curvature of field. A is farther from the lens centre than B. Therefore, sharp image A_1 forms closer to the lens than B_1. The focal plane is saucer shaped: centre and edges cannot both be focused on a flat surface at any one setting.

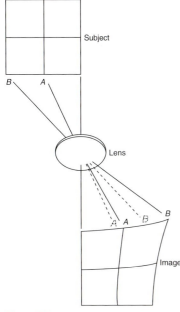

Figure 3.9 Curvilinear distortion. The rays most off-axis make too large an angle with the axis, 'stretching' the image of a square into a curved, pincushion shape. When refracted rays make too small an angle the opposite effect, barrel distortion, results (see Figure 3.24).

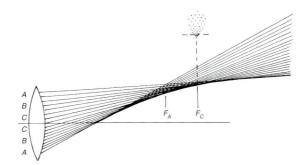

Figure 3.10 Coma. Each circular zone of the lens focuses oblique rays from an off-axis point at a different position relative to lens and lens axis. The patch of light formed (drawn as it appears at point of focus C) is pulled out like a comet. An oblique form of spherical aberration (Figure 3.5).

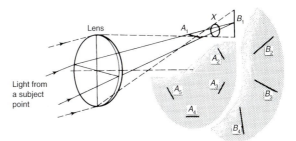

Figure 3.11 Astigmatism. Light from an off-axis subject point is imaged spread out as either a radial line (at focal plane B) or a tangential line (plane A). Best compromise image is at intermediate plane X. Other off-axis points image as lines A_2 or B_2, etc.

glass) but lower dispersion. The dispersion effects of converging and diverging elements then cancel each other out, although together they still converge light and so form an image. This type of lens is known as an achromat doublet lens. Achromatic lenses correct for chromatic aberration exactly in two separate wavelengths. Other wavelengths will have a small shift in focus position. The lens designer can choose the two wavelengths, usually, red and blue, to bring into the same

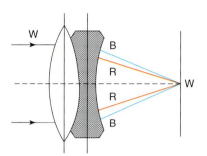

Figure 3.12 Correcting chromatic aberration by combining positive and negative elements of different glass types (see text).

focus plane. An apochromatic lens is a specially designed lens where three wavelengths are brought into focus. The advantage is that colour errors are much less than the colour errors in a similar achromat. A disadvantage with the apochromat is that the required glass is expensive and manufacture of the lens is difficult. Many apochromats have highly curved surfaces and suffer from a type of spherical aberration. Apochromats are used mainly for high-performance long focal length telephoto lenses.

Some aberrations are, at least partially, corrected by similar 'equal-but-opposite' combinations, some by stopping down, others by the mathematical ratio of surface curvatures or an equal arrangement of elements in front of and behind the aperture. The handicap every designer faces is that the best way to correct one optical fault often worsens another. Matters can be helped by adding further lens elements (each offers a choice of two further surface curvatures and different glass), or you can fit a smaller aperture, or limit lens coverage to a narrower angle of view to cut out the worst aberrations which always tend to appear away from the centre of the image field. However, as elements are added light scatter builds up at every extra glass surface, and this gradually reduces image brilliance, despite the anti-reflective coating given to all modern optics. The lens also becomes heavy and expensive because of the cost of machining so many elements. Again, photographers want wider, not smaller, aperture lenses and optics which have generous covering power, especially for camera movements.

Using sophisticated computing equipment, the designer calculates the paths of hundreds of light rays from a test target to each part of the picture format the lens is being designed to cover. Compromises have to be made. Ideally, image quality should remain excellent whether the lens is focused for close or for distant subjects, or when it is used at any of its aperture settings. And the image should show no quality differences between the centre and corners of the picture format. At the same time, it is no good the designer pursuing ideal aberration correction if the resulting lens is uneconomic to make.

Each advance in lens manufacturing also helps the designer. For example, you can have groups of 'floating' elements which mechanically alter their position in the lens barrel as the

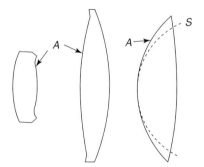

Figure 3.13 Various lens elements, each having one aspheric-shaped surface (A). S shows how one of these contours would be, if given a normal and more easily produced spherical surface.

lens is focused for different distances. Elements can be given 'aspheric' instead of spheric surface contours (see Figure 3.13) or, in the case of small elements, be made in glass which has a graduated RI between centre and edges. These developments allow lenses with a better and more consistent performance, using fewer rather than more lens elements. So the trend is towards lighter and more compact lenses, as well as more extreme focal lengths and wider maximum apertures. This is of particular importance in the design of lenses for digital still cameras, where very high RI materials have meant that more compact cameras with smaller sensors can be manufactured.

Anti-reflection coatings are applied to the surfaces of multi-element camera lenses to reduce the level of light that is reflected from the surface of the glass where it meets the air. Multi-coated glass surfaces reduce the level of reflection from about 4% (for an uncoated polished glass surface) to less than 1%. Despite the use of multi-coating in lenses bright light sources such as the sun, light bulbs or specular reflections can give rise to flare, ghosting and a reduction in contrast in the captured image. Before anti-reflection coatings were invented, lens designers would try to design lenses with as few elements as possible to minimize the number of glass to air surfaces. Today, with modern anti-reflection coatings it is common to see lenses with 10 or more elements.

Checking lens image quality

Lens quality is difficult to pin down by something simple such as a number. Sharpness is subjective – clarity judged by human vision – and has to include image contrast as well as how much fine detail is actually present. Look carefully at Figure 3.14, for example. You can do

(a) (b)

Figure 3.14 Image sharpness is subjective, depending on contrast as much as fine detail. Left-hand picture (A) was shot with a lens giving poor resolution but good image contrast. Right-hand picture (B) used a lens corrected to resolve finer detail but giving lower contrast. Viewed carefully from normal reading distance, (B) looks the sharper. But from two metres away (A) seems sharpest – your eyes no longer see the fine detail reproduced in (B) so this factor no longer matters. Courtesy Carl Zeiss.

simple practical tests yourself to get an idea of the quality of a lens. This is helpful if you are trying out a secondhand lens before buying. On the other hand, manufacturers do much more sophisticated tests and publish typical performance as figures or graphs for each of their lens range.

D-I-Y lens tests

Irrespective of whether the lens is for small-, medium- or large-format photography, try to test it mounted in some larger-format camera which has a fine-etched focusing screen. A 35 mm or

rollfilm format lens can be fitted onto a 4 × 5 in. view camera or a 4 × 5 in. camera lens on an 8 × 10 in. (203 × 254 mm) camera. Use bag bellows or a recessed lens panel if necessary to allow the lens close enough to focus. Have the lens axis dead centre and at true right angles to this enlarged focusing screen, which you trace out with the vertical and horizontal outlines of the format your lens must cover. Acceptable image quality outside this area will prove how much you could use the lens off-centre – by shift or swing movements, for example. Have a focusing magnifier to examine the appearance of the image on the screen.

Some image qualities are best checked if you use a large-area, detailed subject. Pin up several sheets of newspaper at right angles to the lens axis at, say 4 metres away (for a general-purpose lens) or any other distance you know you will often use. Have this improvised 'test chart' brightly and evenly lit. Then with the lens at widest aperture, focus for the centre of the format and examine image quality over parts of the screen further away from the axis. As you increase this distance the image may look less sharp, due to various off-axis aberrations and curved field. The latter is proved by refocusing – see if the outer zone grows sharper at the expense of the centre.

Slight curved field is a problem with some wide-aperture lenses, but is overcome when stopped down one to two stops. The position of sharp focus for the screen centre should be quite definite. If you have any uncertainty about this position, or see it change as you stop down, this suggests residual spherical aberration (Figure 3.5). You can also check for curvilinear distortion by having straight lines in the subject imaged well out in the image field and comparing these against a ruler laid flat across the screen.

Other faults are best seen using a rear-illuminated pinhole as a subject. Set this up at an appropriate distance and sharply focused centre frame, then slide it sideways, parallel to the screen until imaged well out in the field. A change in the *shape* of the spot of light and any colour fringing that appears could be the combined effects of astigmatism, coma and lateral colour. Some of this will disappear when you stop down.

Try altering the focusing when the spot is imaged well off the centre. If you see reduced aberration fringes on two parts of the spot's circumference (in line with a line drawn outwards from the lens axis) at one focusing position, and on parts at right angles to these at another focusing position, astigmatism is probably present. A damaged lens may show no dents but still have one or more elements de-centred. (It only takes a few thousandths of a millimetre misalignment between the axis of some lens elements to produce noticeable loss of image quality.) To check this, image the pinhole centre-format. When you move either lens or screen forwards or backwards through the position for sharp focus the spot of light should widen to a truly symmetrical patch, not any other shape. Tests like this are interesting to do but really require more critical analysis than is possible by just looking at a camera-focusing screen, however fine-grained it may be.

Understanding modulation transfer function

Modern lens manufacturers put their products through far more extensive tests than you can do yourself and publish what they call 'modulation transfer function' (MTF) information. Do not be intimidated by this jargon, which comes from electronics rather than photography. Once you know how to read them, MTF data give plenty of practical information

to judge lens quality against price. Unfortunately, graphs often appear in technical brochures without much explanation of terms, so it is worth looking at how they are drawn and what they mean.

MTF test procedure is somewhat like checking a hi-fi system, where you feed in signals covering a range of known sound frequencies, then compare each one against its purity of output. However, for lens testing the 'subject' is a patchwork chart of grids such as Figure 3.15, each grid having a number of equal-width black and white lines. One black and one white line is considered a pair, so you can quote the number of line pairs per millimetre (lp/mm) to describe the fineness or coarseness of the grid subject. High numbers of lp/mm mean fine detail, which scientists call high spatial frequency. Low lp/mm represent coarse detail or low spatial frequency.

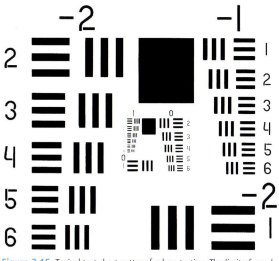

The next bit of terminology is *modulation*, which basically means the change between light and dark values. A microscope/computer system scans across the lens's image of chosen bars and the resulting signals are compared against direct readings off the chart. A perfect lens would image the grid with black lines perfectly black, and white lines white. In

Figure 3.15 Typical test chart pattern for lens testing. The limit of good image sharpness is taken to be the point at which you can no longer tell whether bars are oriented horizontally or vertically (test it with your eyes at various distances).

practice, because of remaining aberrations and diffraction, black lines become lighter and white lines darker, and original contrasty boundaries between the two appear more graduated when the light from the subject is *transferred* through the lens. Modulation is therefore always less than 100%, and could even drop to the point where bars are completely indistinguishable from spaces (zero modulation). Mathematically, modulation is defined as:

$$M = \frac{(I_{max} - I_{min})}{(I_{max} + I_{min})}$$

where I_{max} and I_{min} are the maximum and minimum intensities, respectively, in a test target or a pattern with a sinusoidal variation in intensity, I.

What MTF graphs mean

The usual kind of lens MTF graph (Figure 3.16) shows modulation 0–100% on the left-hand axis. On the baseline it maps out distance across the image patch, from the lens axis (left-hand end) out to some appropriate radius point to the right. For a lens designed to cover 35 mm format without movements this might be 22 mm. For a 60 × 60 mm format lens the equivalent would be 40 mm, and for 4 × 5 in. (102 × 127 mm) format about 80 mm. However, if your camera offers movements which shift or tilt the lens axis away from the centre of the film, it is important to have information 'further out' than a circle only just covering the format. For example, Figure 3.16, for a 4 × 5 in. view camera lens, shows performance out to a radius of 177 mm, with a marker showing the acceptable limit of off-axis use as about 155 mm.

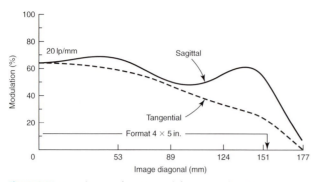

Figure 3.16 Basic elements of an MTF graph for a camera lens designed to cover a 4 × 5 in. negative, allowing ample movements. The higher and straighter the plots, the more consistent the image quality (note that image diagonal distances from the centre are in log values, which expand central area data relative to edges).

Lens performance is plotted for a particular frequency of patterns perhaps 20 lp/mm. As you move further from the lens axis towards corners of the picture, performance (percentage modulation) drops. The better the lens, the less this drop-off will be. You also find that the plot line splits into two. One is marked S for sagittal, meaning response when the grid has its lines parallel to a radial line drawn outwards from the axis. The other, T for tangential, is for when the grid pattern is turned 90°. Any remaining aberrations such as astigmatism (Figure 3.17) cause differences in the two results. Again, the less they differ, the better the lens.

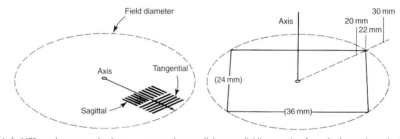

Figure 3.17 Left: MTF graphs separately plot patterns running parallel to a radial line running from the lens axis, and others at right angles to these. Right: performance over an image field at least 22 mm radius must be shown for a lens intended to cover 35 mm format.

Plots for 35 mm format lenses are usually shown for 40 lp/mm. This figure is related to the resolution assumed necessary for the final image you view. For example, a 24 × 36 mm format picture shot with a 50 mm lens, then enlarged onto 8 × 10 in. paper 25 cm wide (magnification 7×) and seen from 30 cm typical normal viewing distance, looks natural in subject scale and perspective (see *Langford's Basic Photography*). However, at this reading distance the human eye can resolve, at best, about 5–6 lp/mm. Try it yourself looking at a ruler. (It is a stark reminder that limited eye ability forms the whole basis of depth of field.) So referring back to 35 mm format, eye resolution 7× gives about 40 lp/mm necessary in the camera for the final image to look sharp.

On larger formats this is different again – an 8 × 10 in. print from a 4 × 5 in. negative is enlarged 2×. About 20 lp/mm on the film will give a result which looks sharp to the eye. So MTF graphs for large format lenses seldom show plots for spatial frequency finer than about 20 lp/mm. Clearly, these taking and viewing assumptions can be upset if you are to enlarge from only a part of the negative or make giant enlargements to be seen in close-up. The brightness of the illumination the final print receives when displayed also greatly influences eye resolution.

The performance of lenses designed for digital SLR (DSLR) cameras can be different from the performance needed for the 35 mm format and is governed by the size of the camera sensor. For example, the sensor used in the Nikon D70s digital camera is 23.7 mm × 15.6 mm. To make

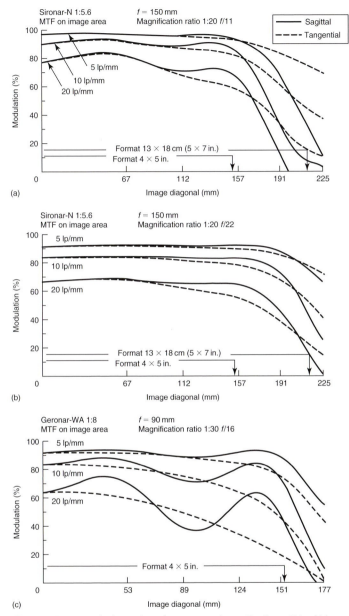

an 8 × 10 in. print from this sensor would require that the recorded image be magnified by approximately 11 times. For the final image to look sharp, the camera must be able to resolve about 56 lp/mm on the sensor. MTF graphs for lenses designed for digital cameras often show plots for spatial frequencies up to 60 lp/mm.

Most MTF graphs plot extra lines showing performance at 30 or 20 lp/mm, or even (large-format lenses) 10 and 5 lp/mm. Do not ignore them. With a good lens it is important that broad detail also maintains contrast across the image. Some of the finer detail is lost by the graininess of the light-sensitive material you expose it on (page 90) or the dot pattern of a halftone screen (page 330). In these instances it is the lower frequencies that communicate most of your image. When comparing MTF graphs for different lens brands remember too that manufacturers tend to present performance in the most favourable way.

Figure 3.18 MTF graphs for two large-format camera lenses. The Sironar-N is a high-quality six-element lens. Graphs show changes when lens is at *f*/11 (top) and *f*/22 (middle graph). Image quality across the film becomes more consistent as stopping down reduces aberrations. However, the general level deteriorates slightly due to diffraction from the smaller aperture. The Geronar lens (bottom graph) is a budget-priced four-element wide angle (courtesy Rodenstock).

Compare carefully the scaling of graphs, such as spacings between figures on the modulation axis relative to those on the image field axis. Some manufacturers label the latter as 'image height'.

Checking the small print

Alongside the graph should be the *f*-number used during testing. Often this is *f*/5.6 or *f*/22 for 35 mm and large-format lenses, respectively. If an MTF curve is shown for the widest aperture it will show poorer performance because of more pronounced aberrations; at smallest aperture it will again deteriorate mostly due to diffraction. In the case of a large-format camera lens, comparing graphs at different apertures tells you how the limits of coverage change. For example, stopped down appropriately, a normal lens for 4 × 5 in. format might well cover 5 × 7 in. or even 8 × 10 in. (both as a wide-angle lens), provided you do not use movements. Alternatively, the same graphs show how far movements on a 4 × 5 in. camera can bring the lens off-centre on the film before image quality suffers on one side of your picture. Establishing the *f*-number used during testing for digital camera lenses is especially important particularly if the magnification factor required for enlarging the image recorded on the sensor is high. Image degradations resulting from aberrations or diffraction will be more noticeable in the final enlargement if the magnification factor is very high.

Graphs should also state the distance of the subject test chart, usually as a ratio (typically, 20:1 for a 4 × 5 in. format lens, but for a macro lens 1:1 and for a 35 mm format enlarging lens 1:10). You should expect to see a macro lens giving best performance at around 1:1, whereas a general-purpose lens image would deteriorate when used so close. Enlarging lenses need characteristics similar to macro lenses (see page 61). However, do not expect any lens to give 100% modulation, even with a coarse frequency subject like 10 lp/mm, imaged on-axis and at optimum *f*-number. This is because the aperture always creates some diffraction, varying with different lens designs. Often plots for 40 lp/mm start on-axis at less than 50% modulation and then get worse.

50 mm f/1.8 lens for 35 mm SLR at 1:50

f-no.	Axis	Corner
1.8	45 lp/mm	40 lp/mm
2.8	50	45
4	56	50
5.6	63	56
8	70	63
11	63	56
16	56	50
22	50	45

Average resolution figures* at widest aperture		
Lens type	Axis	Corner
45 in. (all)	28 lp/mm	22 lp/mm
66 cm (80 mm)	32	25
35 mm (50mm)	40	30

* Just-distinguishable lines before modulation drops to unacceptable level

Figure 3.19 Lines per mm resolution performance of typical camera lenses. The top table shows how image quality peaks at *f*-numbers about the middle of the range.

Other MTF graphs

Another type of MTF graph (Figure 3.20) allows you to compare two lenses in a different way, plotting percentage modulation against a wide range of lp/mm. It does not tell you anything about image quality *across the image field,* but makes it easy to see how response worsens as detail becomes finer. As with previous MTF graphs, the greater the area shown *under* the plot line, the better the lens. One lens plotted in Figure 3.20 has its aberration corrections biased in such a way that the most contrasty, best-quality image occurs with *broad* detail, then it rapidly deteriorates with finer detail. A lens designed with these priorities is ideal for a video camera, where the limitations of the television medium (traditionally, 625 or 525 lines) are so crude that anything

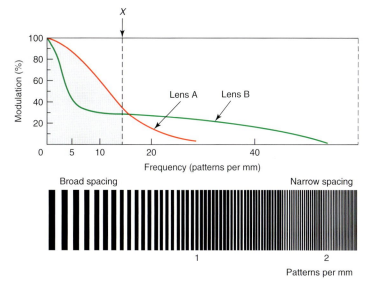

Figure 3.20 Modulation transfer function plotted (axial image) from two lenses, for different fineness of detail. Lens A is most suitable for a video camera – X denotes the cut-off frequency of 625-line television systems (see text). Lens B is more suitable for silver halide film photography, where acceptable modulation is needed down to about 40–50 lp/mm. Bottom: type of test chart used. For photographs of a subject taken with these lenses see Figure 3.14.

finer would be lost in the system. The other lens is designed for regular photography. Priority here has been given to corrections which give generally lower but more consistent percentage modulation down to much finer patterns, because silver halide systems are more able to record such detail. Still higher performance needs to be met in lenses intended for use with high-end charge-coupled device (CCD) digital camera backs. The graph proves again how lenses can be closely designed for a set function.

MTF graphs scaled in the same way are also published for different kinds of photographic films. As explained in Chapter 5, the resolving power limits of films range between about 200 and 25 lp/mm according to speed, grain, level of exposure and type of development. So you can combine the performance of your camera lens and your film to get one graph plot representing the complete imaging system from subject to processed result. This is about the closest anyone can get to representing photographic image quality through diagrams or figures (see page 94).

Resolution and frequency response

The resolution of a camera is related to its ability to distinguish fine details in a scene. The higher the resolution of the camera, the finer the level of detail that can be recorded. Several factors contribute to determining the resolution. These include lens quality, aperture setting on the lens, the type of film or, in the case of a digital still camera, the number and size of pixels in the sensor and any associated electronics in the camera. A test chart is prepared that contains a pattern comprising an alternating series of black and white lines (or bars) that decrease in width (increase in frequency) to some predetermined limit. The chart is photographed and the result can be either viewed on photographic film, a print can be made or it can be viewed on an electronic display, such as a monitor. The point on the pattern where the black and white lines can no longer be distinguished is that defined as visual resolution. The resolution in this case corresponds to the highest frequency pattern that the system can capture. Resolution is usually measured in both the vertical and horizontal directions. One metric used to report resolution is line pairs/mm. This corresponds to the number of black and white pairs per millimetre that can be visually resolved. The International Organization for Standardization (ISO) define a test chart as part of standard ISO 12233 that is designed for the purpose of testing digital still cameras (see Figure 3.21).

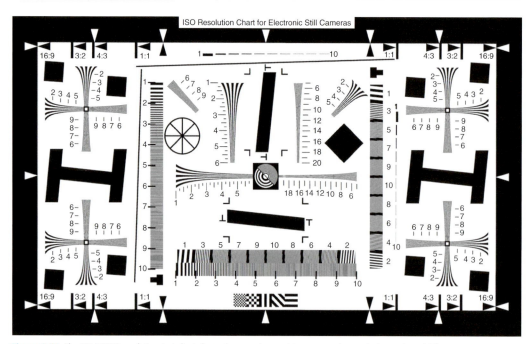

Figure 3.21 The ISO 12233 resolution test chart shown here can be used to measure the resolution and spatial frequency response (SFR) of a digital camera. '*The terms and definitions taken from ISO 12233:2000 Photography – Electronic still-picture cameras – Resolution measurements, Figure 1, are reproduced with permission of the International Organization for Standardization, ISO. This standard can be obtained from any ISO member and from the Website of ISO Central Secretariat at the following address: www.iso.org. Copyright remains with ISO.*'

The chart includes hyperbolic test wedges that are optimized for the measurement of visual resolution. The units reported on the chart are in line widths per picture height (LW/PH). The hyperbolic wedges shown in Figure 3.21 are alternating black and white curved-line patterns that converge gradually (increase in frequency) thereby giving the appearance of a wedge. They can show moiré patterns and are especially suited for measuring visual resolution.

There is a close relationship between resolution and frequency response of an imaging system. Unlike resolution, frequency describes the way that an imaging system responds to a wide range of input frequencies. Note that frequency response and MTF are almost the same. The ISO 12233 test chart contains targets that can be used to measure the spatial frequency response (SFR) which is essentially the frequency response of the system. Consider two camera systems that have the same visual resolution but different frequency responses. One system exhibits a higher frequency response for mid-range frequencies than the other. Although the two systems have the same visual resolution, the images captured by the first system will appear sharper than those captured by the second. The higher level of contrast in the former results in images that are perceptibly sharper than the latter. An example of an image shot with a lens of poor resolution but good image contrast (which corresponds to a good MTF) compared to an image shot with a lens corrected to resolve a finer level of detail but lower contrast is shown in Figure 3.14.

Buying lenses

Each manufacturer sets its own minimum quality image acceptance standards, but every lens – even though one of the hundreds of the same design – is also an individual product. Glasses, shaping, spacing and centering can differ in minute ways as lenses come off the production line. So, although quality control should ensure that no lens giving less than a minimum standard gets through, some lenses may in fact be considerably better. You will also find two manufacturers offering lenses of similar specification at quite different prices. One significant reason may be that the cheaper manufacturer sets slightly lower standards and operates less-strict quality control. The result is more of a 'lucky dip' from which you may (or may not) draw a good lens.

Understanding some of the lens designer's problems shows you the importance of using a lens only within its intended performance range. A telephoto lens fitted with an extension tube *may* focus close enough for 1:1 copying, but your results will probably be of poor quality. (This is not the same as a lens, such as a zoom, designed to offer 'macro mode' which shifts internal floating elements to correct for working at one close distance.) Again, some true macro lenses give indifferent results when focused for distant landscapes.

Most lenses give their best image quality stopped down to about the middle of their *f*-number range. The wider you open up, the less certain aberrations are corrected; but too much stopping down begins to lose quality because of diffraction (Figure 3.19). So the upper and lower ends of the *f*-number scale are limited by lens design and what the manufacturers regard as the limits of acceptable image quality. Sometimes two lenses of the same brand and with identical focal lengths are radically different in structure and price, because one opens up an additional stop or covers a larger area (allowing camera movements) without worsening quality.

Lenses for specialized purposes have their aberration corrections biased in a particular direction. For example, a lens for an aerial survey camera must give optimum quality for distant subjects and avoid any distortion of shape because results are used for measurement purposes. A lens for enlarging or copying has its corrections balanced to give best quality when subjects are close. A shift lens, or any lens for a camera offering shift movements, needs generous covering power (and to achieve this will probably not have a very wide maximum aperture). A lens for 35 mm press photography or surveillance work may only just cover its format, because all the design emphasis is directed towards widest possible aperture.

New lenses designed for digital backs outputting large files (page 37) give higher resolution than is needed for silver halide film. (Circles of confusion should not exceed in diameter the 'pitch' or distance between each of the millions of elements in a CCD matrix). And a lens designed for the curtailed resolution requirements of video cannot be expected to perform well while taking silver halide photographs.

When choosing a lens decide too the handiest size and weight for your expected shooting conditions. This is especially important with long focal length lenses to be used on difficult locations. Do not go for maximum apertures wider than you will ever need – it only increases bulk and cost. Lens condition is especially important if you are buying secondhand. Elements with scratches (perhaps from excessive cleaning?) will more seriously affect image quality than a speck of black or even a bubble in the glass. A lens which has been dropped may show no obvious external sign of damage yet have internal elements miscentred, giving general deterioration of image quality. So if you are buying an expensive secondhand lens always try it

out first under your own typical working conditions or invest in a professional test (available from most major camera repairers).

Special lens types

Zoom lenses

New optical glasses with novel combinations of RI and dispersive properties, plus better lens design, mean that the best modern zoom lenses give really good image quality. To understand how a zoom lens works, remember that the focal length of a complete lens depends on the focal lengths of its component elements and the distances by which they are separated (affecting their 'throw'). In a zoom lens, groups of elements move within the lens barrel when you alter the focal length control. This zooming action therefore 'restructures' the lens – for example, from inverted telephoto through to telephoto (shown schematically in Figure 3.23).

Zooming should alter focal length and therefore image magnification, without disturbing focus. At the same time, the designer has to ensure that aberration corrections also adjust to keep pace with your focal length changes as well as your focusing. It is particularly difficult to hold corrections for curvilinear distortion (Figure 3.9). The tendency in a poor-quality zoom is for square-shaped subjects to be imaged pincushion-shaped at one end of the zoom range and barrel-shaped at the other (see Figure 3.24).

Ideally, a zoom should also maintain the f-number you set throughout its zooming range. In practice, to reduce cost and size, many zooms slightly alter how much light they pass at widest aperture (see Figure 3.32). The widest setting when used at longest focal length becomes up to one stop wider when you change to shortest focal length setting. Automatic through-the-lens (TTL) camera exposure metering takes care of any changes as you zoom. However, if you use

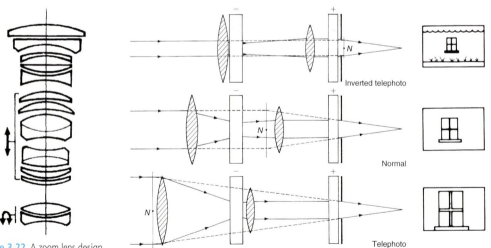

Figure 3.22 A zoom lens design showing groups of 'floating elements' which are repositioned during zooming to alter focal length and maintain best correction of aberrations.

Figure 3.23 One basic form of zoom lens construction in which two sets of components are movable. Top: movement backwards to give inverted telephoto setting. Bottom: movement forwards for the telephoto setting. Rear nodal point (N) becomes progressively further from the focal plane, giving longer focal length and larger image detail. Converging components (+) and diverging (−) components remain static (see also Figure 3.33).

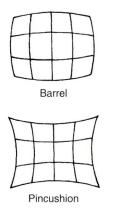

Barrel

Pincushion

Figure 3.24 Barrel and pincushion image distortion, shown here in exaggerated form.

manual through-the-lens metering, a non-dedicated flashgun or a separate exposure meter, be prepared to re-adjust for the new widest aperture at different zoom settings.

Because of their complexity, and a very competitive market, zoom lenses vary more in image quality than any other lens type. Some zooms fully match the standards of fixed focal length lenses. Others are much worse. It is true to say that the greater the zoom range (ratio of shortest to longest focal length), the less likely image quality generally will match that of a fixed focal length lens. A zoom with a 5× or 6× range, for example, is unlikely to be as good as one of 3× or 4×. Similar reservations apply to the quality of zooms when set to macro mode. Unlike a good fixed macro lens, sharpness often deteriorates towards the corners of the picture. The answer is to tread warily, read the technical specifications and, when possible, make practical tests to check whether a particular zoom gives you good enough results.

Zoom lenses designed for compact 35 mm film cameras generally cannot be transferred directly for use in digital still cameras. The imaging sensor in a DSC is fitted with an array of microlenses, one for each pixel, in order to ensure that the light reaching a pixel is sufficiently bright. When the focal length of a zoom lens changes, the angle with which light exits from the imaging side of the lens is altered. If light enters the microlens at an oblique angle, then problems such as vignetting can occur resulting in dark edges or poor colour reproduction in the final image. Film, on the other hand, can tolerate light falling on it over a wide range of angles without any significant loss in brightness. Zoom lenses for DSCs need to be designed so that there is little difference in the angle of light exiting the lens between its wide-angle setting and telephoto setting. The angle of light is almost always very nearly parallel to the optical axis of the lens in this case. This type of lens is known as a telecentric lens. With digital SLRs the distance between the imaging sensor and lens is generally greater to accommodate the hinged mirror and the hence the light rays are by design almost telecentric. Generally, you can use a zoom lens designed for a 35 mm film system with digital SLR without significant problems, but bear in mind that you may experience some loss in brightness colour distortion or fringing, especially at wide angle settings.

Mirror lens designs

A photographic lens can be combination of glass elements and curved mirrors. Figure 3.25 shows a typical mirror lens layout; it has a characteristic squat drum shape and an opaque circular patch in the centre of the front lens (the back of the inward-facing second mirror). The advantage of mirrors is that a long focal length lens becomes physically much shorter – its optics are 'folded up'. Mirrors do not suffer from chromatic aberration because they *reflect* instead of refract light. So the designer needs fewer correcting elements and this, plus the lightweight mirrors, makes the complete lens far less heavy than the same focal length in conventional optics.

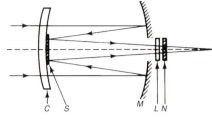

Figure 3.25 Typical 500 mm mirror lens and internal structure. C: corrector plate. M: primary converging mirror. S: secondary mirror. L: weak secondary correctors for aberration control. N: neutral density filter (changeable) for exposure control.

However, a mirror lens has three disadvantages:

1. It cannot be stopped down – having a diaphragm would vignette corners of the picture. So you cannot alter depth of field, and exposure has to be controlled by fitting grey neutral density filters or by relying on the shutter alone. Mirror lenses do not therefore suit auto-exposure cameras using shutter priority or programme modes – only aperture priority or manual modes will work.

2. Any bright out-of-focus highlights spread into doughnut-ring shapes instead of the usual discs of light we accept as similar to eyesight. The dark central shape is due to the front mirror.

3. Aberrations increase to unacceptable levels away from the lens axis, so mirror designs are limited to narrow angle, long focal lengths. Typically, they come as 500 mm, or 1000 mm lenses for 35 mm format, with a fixed aperture of about *f*/8 or *f*/11.

Relatively few mirror lenses are available (they are described as 'catadioptric' or 'reflex' types in some brochures). Nevertheless, their lightweight and handy shape make them convenient to use, especially for natural history or sports photography on location.

Fisheye lens designs

Fisheyes are special wide-angle lenses in which correction of curvilinear (barrel) distortion is sacrificed in order to give extreme angle of view. Angles of 180° or 220° are quite common, but to achieve this, image magnification varies greatly across the picture, producing strange fishbowl results (see Figure 3.26). In all other respects a good fisheye gives excellent image quality.

The lens has wide-diameter, bulbous front elements, which diverge light – similar in principle to a normal type lens looking through a concave window. You cannot add a lens hood or external filters because they cut into the angle of view, so light-shading tabs and 'dial-in' filters are built into the barrel itself.

Depth of field is phenomenal, typically stretching from 30 cm to infinity at *f*/8. Maximum

Figure 3.26 Extreme fisheye lenses produce circular pictures but, together with the distortion of shapes they give, this can suit some subjects.

Figure 3.27 Wide-angles, unlike fisheyes, are formally corrected for distortion. But extreme wide angles still 'pull' shapes farthest from the picture centre. This is especially obvious with shots of human figures, least with plain areas such as floor or sky (by Ilkay Mehmet).

aperture is often about f/5.6. A few wider aperture (f/2.8) fisheye lenses have also been marketed, using front elements 20 cm or more in diameter, which makes them extremely heavy and expensive. Another unusual variation is the fisheye zoom, such as the Pentax 17–28 mm. Most fisheyes are designed for 35 mm format cameras, and one or two for rollfilm types. You can also fit a 'fisheye converter' over the front of a regular lens. The best of these give excellent quality results, provided your camera lens is stopped down.

Development of modern extreme wide-angle lenses such as the 47 mm Super Angulon (covering formats up to 4 × 5 in.) put fisheyes into second place for record photography of confined interiors, etc. Fisheyes should always be used sparingly, perhaps to make spectacular industrial, advertising or editorial shots. They give novel geometry but you soon find that this dominates each and every subject you shoot, giving repetitive results. Some fisheyes are intended for special purposes such as surveillance work, photographs inside architectural models or all-sky photography for meteorology.

Figure 3.28 A 10.5 mm f/2.8 fisheye lens.

Soft-focus lens designs

When you focus a soft-focus lens, it images any point of light from the subject as a sharp core overlaid with a 'halo' of spread illumination. The resulting softness of outline works well for atmospheric landscapes, portraits (weddings, children, etc.), especially in colour. The effect is most noticeable with contrasty subject lighting. Large tonal areas appear less softened than fine detail. In portraits, for example, skin blemish detail is suppressed and yet facial features in general remain much clearer than an image that is out of focus (see also Figure 3.29).

Soft-focus lenses differ in detail, but all tend to be highly corrected for optical errors with the exception of spherical aberration. As Figure 3.5 showed, retaining this error gives the mixture of sharp and unsharp characteristics of a soft-focus image.

You must be able to control the degree of 'softness', to suit your subject. With some lenses this is crudely achieved by stopping down – the aperture ring shows symbols for softest focus at widest setting, down to sharpest focus fully stopped down. Better designs have floating elements

Figure 3.29 Left to right: normal lens in focus; soft focus lens; normal lens out of focus. Soft focus gives a combination of sharp and unsharp detail, and lowered contrast (see also Figure 5.7).

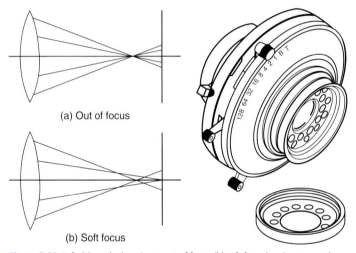

(a) Out of focus

(b) Soft focus

Figure 3.30 Left: (a) regular lens, image out of focus; (b) soft-focus lens image – each point on the subject records as a nebulous halo with a hard core. Right: soft-focus lens for a large-format camera, using interchangeable perforated discs to give different amounts of dispersion and light patches.

which shift to increase or decrease spherical aberration when you turn an extra control ring. You can then control softness independently of depth of field.

A few soft-focus lenses, undercorrected for spherical aberration, accept interchangeable multi-perforated aperture discs (Figure 3.30). Each disc increases dispersion and also makes image points consisting of a hard core (central aperture) surrounded by overlapping smaller patches of light which form a halo effect. For different effects you change discs. One disadvantage of this system is that, like a mirror lens, every bright unsharp subject highlight takes on the frontal appearance of the lens – a central patch surrounded by smaller patches. Each disc is marked with an 'equivalent *f*-number' for exposure purposes.

It is advisable to focus a soft-focus lens at the actual aperture to be used for shooting. If possible, use a plain matt focusing screen so you can then judge precise effects. Split-screen SLR manual focus aids and autofocus may not function. Where possible, measure exposure through the lens using the camera in manual or aperture priority mode.

You can produce superficially similar soft-focus results using a diffusing attachment over a regular lens. (A finely etched 'anti-Newton's rings' transparency cover glass is the cheapest.) However, close comparison of results from an attachment against a good soft-focus lens will soon convince you of the subtleties of the latter. As an alternative technique, you can shoot on reversal film with a normal lens and enlarge this onto reversal printing material (such as Ilfochrome) using a soft-focus lens or attachment on the enlarger. Do not try this when printing from negatives, because the lens will then spread shadows rather than highlights, giving a very different atmospheric effect. It is also possible to imitate the effect of a soft-focus filter or lens in a digital image using an image-editing software package such as Adobe Photoshop or Corel

Paintshop Pro. This can be done either by using a combination of digital blurring filters and masks or by using a dedicated soft-focus filter or 'plug-in' application. These can be run from within the image editing application.

Macro lenses

The aberration corrections in a macro lens are balanced to give optimum image quality when the subject is relatively close. Focal length is usually normal or slightly long for the format it covers, for example, 50 mm or 100 mm for 35 mm cameras. The lens is designed to have a relatively modest maximum aperture such as $f/3.5$ or $f/4$, but often stops down as far as $f/32$. A working range of $f/5.6$–$f/64$ is common with macros for larger formats. Macro lenses are corrected for these smaller apertures, which are helpful to improve the shallow depth of field when working close and/or using a large-format outfit.

Macro numbers

Focusing distance (m)

Figure 3.31 Macro lens, showing extra macro numbers on focusing scale relating to magnification. To find your subject magnification on film, divide the macro number into 1 (e.g. 10 means magnification of 0.1×).

Most macros for 35 mm and rollfilm cameras have extended focusing barrels so that you can continuously focus out from infinity setting to image close subjects 0.5× (half-size). As Figure 3.31 shows, the focusing ring has an extra scale of 'macro' numbers, typically from 10 down to 2. These are handy for precise record photography – by noting the number you are using for a particular shot the subject size and magnification can be accurately calculated later for captioning your picture. You can also use the scale to set a predetermined ratio, then move the camera nearer or farther until the image is sharp.

Of course, any macro lens will focus still closer subjects if you add on extension tubes or bellows between lens and camera body. However, at magnifications greater than about 2.0× you may find image quality gradually deteriorating, because you are outside the design limits of aberration corrections. For finest quality you can then change to a more expensive 'true' macro (or 'macro bellows') lens, each one corrected for optimum results at a particular magnification (for example, 5×, 10×, etc.). Such lenses come without a focusing mount, because they are intended for use with adjustable bellows. Scientific photographers often work with sets of these true macros, changing them in the same way as microscope objectives.

Always remember that TTL metering is the most accurate way of measuring exposure when shooting in close-up, using extended lens-to-film distances. Image brightness dims considerably, and is not automatically taken into account if you are using a separate meter or a non-dedicated flashgun. It is easy to overlook this when working with studio flash and a separate flash meter (see page 163).

Close-up lenses

Close-up attachment lenses are an inexpensive alternative to macro lenses for macro photography. They are worth considering if you are trying out macro photography for the first time. A close-up lens is a single element lens that you add to the front of your camera lens as a

filter attachment. The attachment enables a camera with limited focusing capability to focus on objects that are closer in distance that would be possible without the attachment lens. Close-up lenses are specified according to their power in dioptres instead of focal length. Lenses in the range 0.5–3.0 dioptres are normally used with standard focal length or telephoto lenses. Should a higher level of magnification be required, close-up lens attachments can be stacked one on top of the other. There is normally a compromise in the quality of a macro image obtained when a close-up attachment is used compared with when a true macro lens is used.

Converter lens attachments

You can buy attachments containing multi-lens elements to add to your main lens and convert its focal length. The most common types are teleconverters, containing predominantly diverging lens elements and designed to fit behind one or more specified, moderately long focal length lenses – usually by the same manufacturer. Typically, a 2× teleconverter doubles the prime lens's focal length, recorrecting aberrations so that the same image performance is maintained. Such a convertor reduces the effective aperture by two stops, and if used with a zoom lens in macro

Focal length and max. aperture		Construction: groups– elements	Angle of view	Min. f-stop	Closest marked distance (m)	Size: diameter × length (mm)
Wide-angle						
13 mm	f/5.6	12–16	118°	22	0.3	115 × 99
18 mm	f/3.5	10–11	100°	22	0.25	75 × 72
20 mm	f/2.8	9–12	94°	22	0.25	65 × 54
24 mm	f/2.8	9–9	84°	22	0.3	63 × 57
Normal						
50 mm	f/1.2	6–7	46°	16	0.5	68 × 59
50 mm	f/1.8	5–6	46°	22	0.6	63 × 36
Telephoto						
105 mm	f/1.8	5–5	23°	22	1	78 × 88
200 mm	f/2	8–10	12°	22	2.5	138 × 222
300 mm	f/2.8	7–10	8°	32	2	123 × 247
600 mm	f/4	7–9	4°	32	5	176 × 256
1000 mm	f/11	8–9	2°	32	14	134 × 577
Reflex						
500 mm	f/11	6–6	5°	–	1.5	89 × 116
1000 mm	f/11	5–5	2°	–	8	119 × 241
Zoom						
17–35 mm	f/3.5	12–15	103–62°	22	0.3	82 × 90
28–85 mm	f/3.5/4.5	11–15	74–28°	22	0.8	67 × 97
35–135 mm	f/3.5/4.5	14–15	62–18°	22	0.4	68 × 112
80–400 mm	f/4.5/5.6	10–16	30–6°	32	2.5	76 × 200
Fisheye						
6 mm	f/2.8	9–12	220°	22	0.25	236 × 171
16 mm	f/2.8	5–8	180°	22	0.3	63 × 66
Macro						
105 mm	f/2.8	9–10	23°	32	0.11	66 × 91

Figure 3.32 Specifications for a range of 35 mm format lenses. Notice the greater complexity of construction in wide-angle and zoom lens types. Also maximum apertures quoted for zooms often alter according to whether shortest or longest focal length setting is used. Long focal lengths are less able to focus close subjects (macro lenses excepted). The table also shows how telephoto lens size increases greatly with focal length, and many are heavy and costly.

mode it doubles previous magnification. Similarly, a 1.4× converter multiplies focal length, macro magnification and *f*-number by 1.4 (in other words, aperture is reduced one stop). Teleconverters are most often made for particular 35 mm format camera lenses of between 100 and 300 mm or zoom equivalents, and effectively give you two lenses from one. However, do not mix brands or try to use them on a main lens of the wrong focal length. Beware of converters claimed to be 'universal'.

A few converters are designed to fit over the *front* of a normal focal length lens. They form shorter focal length inverted telephoto lenses, giving a wide angle of view yet keeping the lens-to-film distance unchanged. A typical wide-angle converter changes a 50 mm lens to 30 mm, or a 35 mm lens to 21 mm. Often image quality deteriorates and in no way matches a fully corrected wide-angle lens of this focal length. An exception is some front-fitting converters designed to transform normal angle lenses into fisheyes (page 58).

A completely different type of converter, which fits between lens and camera body, adapts a manually focused lens to autofocus (AF), provided that the body contains autofocus drive. You leave the regular lens set for infinity. The camera's autofocus mechanism engages with the converter and then moves focusing elements within it until a sharp image is sensed. The result is a fully autofocused system, although not as fast acting as one designed for AF.

Influences on image sharpness

Good lens quality is of vital importance, but for the best possible sharpness in your final print you have to take care at every key stage on the way. The following checklist contains all the main influences on image detail:

1. *Lens quality*. Use the highest-quality modern lens you can afford. Its covering power must match or exceed your camera's picture format. The correction of aberrations must suit your typical subject distance. The lens should be multicoated to minimize scattered light.

2. *Lens condition*. Do not use a lens with scratches, grease, dust, condensation or misalignment of elements (e.g., due to physical mishandling). Avoid inferior filters, converters or close-up lenses.

3. *Camera*. Focusing must be completely accurate on the film – beware of non-registration of focusing screen, and also autofocus errors. Do not overuse movements (especially view camera shift movements which can position the picture format excessively off-axis). Sometimes the focus or zoom control slips when the camera is pointed vertically. Mechanical faults include SLR mirror movement vibration, shutter bounce or film starting to wind-on before the shutter has fully reclosed, etc.

4. *Shooting conditions*. The atmosphere may contain dust, ripples of warm air,

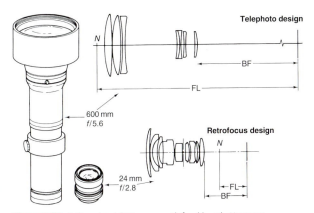

Figure 3.33 Bulk and weight increase with focal length. However, differences are made less by telephoto and retrofocus (inverted telephoto) designs. Rear diverging elements give a telephoto a greater focal length than its back focus. Front diverging elements give retrofocus designs shorter focal length than back focus. Without this the larger lens here would be 25 times longer than the wide-angle.

pollution and moisture particles. Avoid shooting through glass windows, however clear looking, especially with a long focal length lens. Prevent vibration or movement of camera or subject during exposure.

5. *The light-recording material*. Its ability to resolve fine detail. With silver halide material this means film speed, grain and emulsion thickness; degree of exposure and development; also the type of developer. With digital capture it means the number and pitch of elements in the CCD; also whether it is a static one- or three-shot matrix or scanning array (see page 37).

6. *Enlarging*. With film image magnification, type of light source, quality and condition of enlarging lens; the flatness of the film in the carrier and accuracy of focusing; movement during exposure; and the contrast and surface texture of your printing paper.

7. Finally, there are the conditions under which you view your result, especially the brightness of the lighting and your viewing distance.

No one can control all these factors all the time, of course, but at least try to use equipment and routines which minimize the pitfalls if optimum sharpness is important in your work.

Using lenses created for 35 mm systems on DSLRs

One of the advantages of digital SLR cameras is their ability to accept interchangeable lenses from existing 35 mm film SLR systems. If you currently own a 35 mm SLR film camera and are considering upgrading to a digital SLR system (or have already done so) you may be wondering if your existing collection of lenses can be effectively used on your digital SLR system. Manufacturers of DSLR systems, will fit lens mounts to their cameras that accept older lenses for film based 35 mm cameras in an effort to persuade existing users to stay with the brand. In most cases lenses designed for 35 mm cameras can be interchanged with DSLR camera systems, however, the following issues need to be considered.

Advantages

Most DSLRs use a sensor with smaller dimensions than the size of a 35 mm frame. The ratio of the sensor format relative to a 35 mm frame is known as the 'crop factor'. The smaller the sensor, the higher the crop factor. For example, the Nikon D70s has a crop factor of 1.5× and the Four Thirds System used in Olympus DSLRs has a crop factor of 2×. When a lens designed for a 35 mm film camera is used on a DSLR, its apparent focal length is increased by a multiplier equal to the 'crop factor'. This happens because the angle of view is reduced due to the smaller sensor. For example, a 50 mm lens on the Nikon D70s provides the same field of view as a 75 mm lens on a 35 mm system. Smaller and lighter lenses can be used. For example, a 400 mm *f*/5.6 lens of a 35 mm system becomes a 600 mm *f*/5.6 lens on a Nikon D70s, yet the lens is smaller lighter and cheaper.

The effective depth of field (DOF) on a DSLR is greater than on a 35 mm camera when a lens of equivalent focal length is used at the same aperture. For example, if the 50 mm lens on the Nikon was set at *f*/5.6 then the DOF on the Nikon would be greater than the DOF on the 35 mm camera when a 75 mm lens at *f*/5.6 was used even though the field of view was equivalent. Shorter exposures for the same DOF are therefore possible resulting in less chance of image blur due to camera-shake.

The image captured by a sensor in a DSLR comes from the centre of the lens. Most lenses suffer from some degree of distortion and this is generally higher at the outer edges of the lens.

Cropping from the central portion means that most of the distortion present will have been cropped out of the final image.

Disadvantages

Very wide-angle lenses are more difficult to obtain. For example an OM Zuiko 21 mm f/3.5 lens on an Olympus DSLR using the Four Thirds System is equivalent to a 42 mm f/3.5 lens on an OM system.

The greater DOF that is obtained in a digital system may not be so good if, for example, very shallow DOF is required for artistic purposes.

As mentioned earlier with very wide-angle lenses designed for a 35 mm camera, the light exiting the lens can strike the surface of the sensor at an oblique angle. This can affect the sharpness and contrast of the resulting image.

The resolution of a lens designed for a 35 mm may not be adequate. Recall, that due to the smaller sensors used in DSLRs the lens will have to resolve more lines per millimetre on the sensor than on 35 mm film if the same size print is made from both systems. Some loss in sharpness may result in this case.

Sensors used in digital cameras are highly reflective as compared with film and this can result in higher levels of stray light bouncing around inside the camera when the shutter is open. This can degrade image quality if a lens with a poor anti-reflection coating is used. The coatings used on older lenses will have been designed to reduce flare to an acceptable level for a film-based camera system. They may not be so effective at reducing light levels when used on a DSLR. Some loss in contrast may be observed. Newer lenses designed for digital systems have improved multi-coatings that are optimized for use with the highly reflective sensors used in digital cameras.

SUMMARY

■ Lenses begin with optical glasses, manufactured with precise RI and dispersive qualities (Abbe number). Glass should be colourless, offer the right machining qualities, yet be tough and stable.

■ The designer works to satisfy a given lens specification (focal length, coverage, maximum aperture, focusing range, etc.). The challenge is to avoid optical aberrations by combining elements of different glasses, deciding their shapes and spacing. Developments such as new glasses with extreme combinations of RI and dispersion, aspheric shaping and 'floating elements' extend design possibilities, but a balance always has to be found between optimum performance and economic price.

■ Lens image quality is difficult to express, depending on contrast as well as detail. Do your own test of performance using fine print or a pinhole light source as subjects, comparing their appearance on-axis and in outer-zone parts of the image. Manufacturers publish modulation transfer graphs, plotting percentage modulation against position in lens field (millimetres from axis) for a particular spatial frequency (fineness of detail) in lp/mm.

■ MTF curves show you how far acceptable coverage extends – therefore size of format covered. They show the changes in performance to expect when you stop down; come closer; use movements or a larger film; or accept lower standards. Plots are often made

for 60 lp/mm (for digital SLR formats), 40 lp/mm (relevant for 35 mm format), 20 lp/mm (for large format) and 10 lp/mm. In practice, much also depends on the film or sensor format used and your final viewing distance.

■ A different form of MTF graph plots percentage modulation against a wide range of frequencies for one given point in the format (e.g., on-axis). This is helpful when comparing lenses against each other and the known frequency range limits of your recording medium.

■ The visual resolution shows how well detail in the scene can be resolved. It is measured by visually observing the point where individual black and white lines on a test chart can no longer be distinguished. It is normally reported in lp/mm or LW/PH. Remember that two lenses with the same resolution may differ in sharpness depending on their MTF.

■ When buying a lens read the manufacturer's technical information and comparative reviews in the photographic press. Focal length and maximum aperture are important, but ensure that corrections are designed for your kind of work, the lens gives sufficient coverage, and weight and size are acceptable. Carefully check the physical condition and optical performance of used lenses before purchase.

■ Zoom lenses use floating elements to change focal length and adjust aberration corrections without disturbing focus. Zooms with variable maximum apertures can give inaccurate exposure when you alter focal length, if you use a separate meter or flashgun. Image standards vary – the best lenses (often having more limited zoom range) are excellent.

■ Mirror (catadioptric) type long focal-length lenses are compact and lightweight, and very easy to handle. However, fixed aperture limits your auto-exposure modes, and off-focus highlights have assertive shapes.

■ Fisheyes – extreme wide-angle lenses with curvilinear distortion – give results very unlike human vision. Use them with restraint for dramatic effects, recording wide expanses of surroundings, and for their extreme depth of field. Filters and lens hood are built in.

■ 'Soft focus' gives a more subtle suppression of fine detail than out of focus or general diffusion. Soft-focus lenses allow fine control of the effect by internal movement of floating elements, changing perforated discs or just stopping down. Focus, and view, at your working aperture. Soft focus spreads highlights of positive images, spreads shadows when used in enlarging negatives.

■ Macro lenses are corrected to perform best at close subject distances. Most have an extended focusing movement and scale of (reciprocal) magnification numbers. For still closer technical work, use bellows and 'true' macros, each designed for a narrow band of distances. Remember to recalculate exposure, unless you measure light through the lens.

■ A good teleconverter – designed to fit specific, same-brand, moderately long focal length lenses – gives you a still longer focal length option without loss of quality. Aperture, however, is reduced. Other kinds of lens converter change normal lenses to wide-angle or fisheye, or adapt manual lenses to autofocus.

■ Main factors affecting image sharpness are lens quality and condition; the camera's mechanical accuracy; movement, subject and lighting; characteristics of your light-sensitive material and its exposure and processing; enlarging and final viewing conditions.

■ In most cases lenses designed for use in 35 mm film cameras can be successfully used in newer DSLRs often resulting in advantages such as longer effective focal lengths and greater depth of field. But differences in the design of digital and film camera systems may mean that the image quality obtained may be compromised. Newer lenses designed for digital systems provide optimal performance and image quality. These lenses provide higher resolution, and improved sharpness, contrast and colour reproduction in a DSLR compared to lenses designed for film camera systems.

1 Arrange to photograph a target containing fine detail using a lens with normal field of view, such as 50 mm lens on a 35 mm camera. Make sure the focus is accurately set. Then take several exposures of the scene starting with the aperture set wide open, all the time ensuring that the exposure is maintained normally by adjusting the shutter speed as necessary. Verify that the depth of field is higher for small apertures than it is for larger apertures. Experiment with selective focusing using depth of field as a technique to isolate a subject from the background.

2 Using a digital camera fitted with a sensor of known 'crop' factor capture a scene using a medium or wide angle lens setting. Determine the focal length used and then using a film camera capture the same scene with a lens whose focal length is as close as possible to the equivalent focal length for a 35 mm system. A digital SLR with a 35 mm sensor size can be used instead of a film camera. In this example the focal length would be the focal length used in the digital camera multiplied by the 'crop' factor. Verify that the field of view in the 35 mm camera system and the digital camera is equivalent.

3 Fit a wide-angle lens designed for a 35 mm film SLR system to a digital SLR camera. Capture a high contrast scene at aperture values ranging from the maximum to the minimum settings. Then replace the lens with a lens of the same focal length that is designed specifically for use in a digital SLR. Capture the same scene with the digital lens. Observe the overall sharpness of the images obtained from each experiment. Compare the levels of chromatic aberration in images captured with the film lens with those captured with the digital lens. Chromatic aberration is usually noticeable in high contrast areas (e.g., tree branches against a brightly lit sky or cloud) and is normally worse at the periphery of the image.

PROJECTS

Colour in photography

This chapter describes the properties of light with regard to colour. It presents the principles that have been applied to colour photography, both analogue and digital. In the beginning of the chapter you will see how colour is produced from visible light and how we can get information about the colour of a light source. Colour originates from different types of sources and you will see how it is affected by their properties. One of the major issues in colour photography is the difference in colour between different types of light sources. This is important when you want to achieve colour-balanced scenes in your photographs. This chapter presents ways of measuring the colour of the light sources and controlling colour.

Colour exists because of the way our visual system interprets the sensation of light. An introduction to the human visual system is therefore included in this chapter, and is focused on our colour vision. This includes the Young–Helmholtz trichromatic theory where colour photography and imaging is based.

Working with colour has made the development of colour classification systems essential. With these systems any colour can be described by a unique set of numbers. Several systems have been devised and three of them are presented in this chapter. Colour, however, is a perceptual phenomenon. The characteristics of human vision have therefore been taken into account in the design of some colour classification systems.

Finally, the chapter discusses the effect of subjective judgement when looking at colour photographs. You will see how colour adaptation of the human visual system affects the colours you see. The effect of eye fatigue and psychological influences on the perception of colour are also presented and discussed.

Light and colour

Colour is produced by light rays reflected or transmitted from an object. A light ray can be considered as an electromagnetic wave, part of the wider series of electromagnetic waves that travel in space, and is described by its *wavelength* and *frequency*. The wavelength is the distance between two adjacent corresponding points on the wave train, as shown in Figure 4.1, while the frequency refers to the number of waves passing from a given point over 1 sec. The product of wavelength and frequency gives the speed of the wave.

The electromagnetic spectrum extends from wavelengths of

Wavelength

Figure 4.1 Wavelength is the distance between two adjacent corresponding points on the wave train.

0.0000001 nm to 1000 km. What we call light is the visible part of the spectrum, from approximately 400 nm to approximately 700 nm. If you take into account that 1 nm is equal to 1/1 000 000 000 m, you see that the visible spectrum is a very small part of the electromagnetic spectrum.

The ultraviolet (UV) band of radiation lies below 390 nm and the infrared (IR) band above 760 nm. The UV and IR rays are, therefore, not visible. Photographic film however, is sensitive to a wavelength range between 350 nm and 700 nm and so it is sensitive to UV rays. For this reason, a UV filter is placed in front of the lens, to stop UV rays reaching the film. In digital cameras, charge-coupled device (CCD) and complementary metal-oxide semiconductor (CMOS) electronic sensors are sensitive to IR rays. To eliminate the effect of the IR rays, a special filter is placed in front of the imaging sensor. In some digital cameras this filter can be removed and you can record in the IR region. With film cameras you can record the IR light with the use of an IR film. See Chapter 13 for UV and IR photography.

X-rays and gamma rays have wavelengths below the UV rays. Although they do not form part of the visible spectrum there are imaging applications, such as in medical imaging, where these rays are recorded. Rays above IR include radar and radio waves.

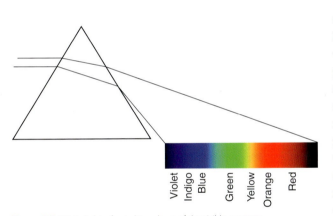

Figure 4.2 White light refracted to colours of the visible spectrum.

White light is a mixture of colour rays. In the late 1600s, Sir Isaac Newton showed that when white light falls on a clear glass prism, it is not only deviated but also refracted to many colour rays, as shown in Figure 4.2, in the following order: red, orange, yellow, green, blue, indigo and violet. The magnitude of refraction depends on the wavelength of the ray so the white light was shown to consist of rays with different wavelengths. These correspond to the colours we see in the spectrum.

The human visual system

Colour exists due to our visual perception and specifically our colour visual system, which interprets the different wavelengths of light as colour (Figure 4.3).

Many ingenious inventions are based on 'observations of nature'. The way colour films and imaging sensors work owes much to scientists' basic study of just what colour is, and how human eyes and brains respond to coloured surroundings. In 1802 Thomas Young suggested that the retina of the human eye does not contain receptors for each discernible hue. Instead it has a mixture of three different kinds of receptor – sensitive to red, green and blue. Young called these colours the primary colours of light (not the same as pigment primary colours, familiar to the artist as blue, yellow and red). This 'three-colour vision' gives your brain the sensation of colour which it derives from the combination of signals it receives. The theory

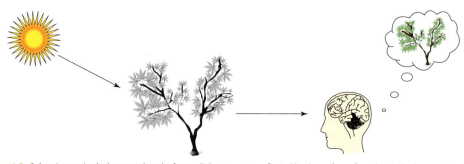

Figure 4.3 Colour is perceived when wavelengths from a light source are reflected by the surface of an object. The human visual system interprets the wavelengths as the colour of the object.

was quantified by Helmholtz in 1866 and is known as the Young–Helmholtz theory of colour vision.

James Clerk Maxwell proved this in the 1850s by demonstrating with light from blue-, green- and red-filtered lanterns overlapped on one screen. Dimming or brightening individual lanterns re-created all the colours of the spectrum, while an equal mixture of the three primary colours formed a patch of white. Combination of two primary colours results in a secondary colour. This is shown in Figure 4.4(a). This type of colour mixing is called *additive*. Note that during the 1870s and 1880s the technique of *pointillism* was used by French Impressionist painters such as Monet, Pissaro and Seurat. Pointillism is the technique of juxtapositioning tiny brush strokes in paints of strong luminous colours and subtle tones. It is a significant fact that the very first colour photography materials to go on sale were manufactured in France (Lumière's 'Autochrome', 1907) and worked on what is known as the additive principle. With the additive method, you can create any colour by mixing red, green and blue points in an image. When viewing an image from a distance, the eye sees a uniform colour and not individual colour points. One of the applications of this method is in the design of television and computer displays (see page 217). The colours are formed by very small red, green and blue dots, which you can discriminate only with very close inspection of the screen. The additive method is also used for instant picture materials and in most cases for the design of digital imaging sensors.

Another method, the *subtractive* method, has its origins in work by the French scientist Luis Ducos du Hauron in the late 1800s. He published a book *Les Couleurs en Photographie*, in 1868, forecasting several of the colour reproduction systems we now use.

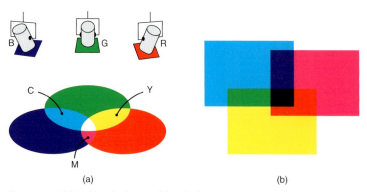

Figure 4.4 Additive (a) and subtractive (b) methods to create colour. In the additive method, mixing of two primary colours, red, green or blue, creates a complementary colour, cyan, magenta or yellow. Mixing of all three colours results in white. In the subtractive method, two complementary colours create a primary colour.

However, it was not until the 1880s that Dr Hermann Vogel's research in Germany into sensitizing additives made possible orthochromatic and panchromatic emulsions to add to the blue-sensitive materials used exclusively up until this time. Panchromatic response to all colours, and ability to control colour sensitivity unlocked the door to practical colour photography.

The subtractive method is based on light absorption using the complementary colours cyan, magenta and yellow. We can take, as an example, a set of cyan, magenta and yellow filters. The cyan filter will subtract red, the magenta will subtract green and the yellow will subtract blue. If the cyan and magenta filters overlap, they will transmit blue. This is because they will have both subtracted red and green. The same applies with the other two combinations, cyan with yellow which transmit green, and magenta with yellow which transmit red. When the cyan, magenta and yellow are combined, red, green and blue are subtracted, and the result is black. This is illustrated in Figure 4.4(b). The subtractive method is used for photographic films, colour printing and other applications which use dyes.

In colour reversal films the top layer of the emulsion is blue-only sensitive. Below it there is a green-sensitive layer and then a red-sensitive layer. Some sensitivity to blue by the red- and green-sensitive emulsion layers is nullified by a yellow filter located directly below the blue-sensitive emulsion. This filter lets green and red pass freely. The filter becomes colourless later during processing. With the exception of a few materials (one such being Kodachrome), all reversal films use silver halide emulsions with 'colour couplers' included – in the blue-sensitive emulsion these chemicals will later form yellow dye when triggered during processing. Similarly, there are other couplers to form magenta dye in the green-sensitive layers and cyan-forming couplers in the red-sensitive ones. Colour negative films use the same principle of having red-, green- and blue-sensitive layers with cyan-, magenta- and yellow-forming couplers, respectively. See Chapter 12 for a description of film processing methods.

Today it is well established that our retinas contain many millions of rod- and cone-shaped cells. The rods are more sensitive to light but have no colour discrimination. They are distributed in the peripheral area of the retina, where the image is formed. There are about 75 000 000–150 000 000 rods in that area. The less-sensitive cones react to colour with their three types of reception determined by chemical content. They are concentrated in the centre of the retina and they are fewer in number than the rods, about 6 000 000–7 000 000.

Some aspects of colour vision are not fully explained by the trichromatic theory, but the discoveries of these nineteenth-century scientists remain highly relevant for understanding colour photography. At the same time, remember that your eyes are virtually an extension of your brain, connected to it by over 750 000 fibres in each optic nerve. In dealing with colour vision the brain's ability to interpret is as relevant as the actual stimuli received from eye response.

Light sources and their characteristics

The amount of light that is emitted by a light source at each wavelength is called *relative power*. If we plot the relative power against the wavelength we have a graph that gives the spectral power distribution curve of the source. If energy is used instead of power (energy = power × time), we have the spectral energy distribution of a light source. Information and graphs on the spectral power distribution are often given as technical data for light sources.

From the spectral distribution graphs you can determine what is the colour of a light source. You are also given information on whether the specific light source has a continuous spectrum and emits light at all wavelengths or if it has a discontinuous spectrum and emits only at specific wavelengths. Light sources with continuous spectra include all incandescent sources (materials that glow with heat after a certain temperature) and the sun. Light sources such as sodium-vapour and mercury-vapour lamps have discontinuous spectrum. There is also a third type of light source that emits broad bands of continuous spectrum with magnitudes that vary. An example of this light source is the discharge tube.

Colour temperature

As described previously, incandescent light sources have a continuous spectrum. The relative proportion of short and long wavelengths produced by these sources varies widely. This variation depends on the temperature of the source. As an example we can take two 100 W household lamps, one run at correct voltage and the other underrun at a fraction of correct voltage. The underrun lamp is not only less bright but gives more orangey illumination. Similarly, if you compare correctly run 500 W and 100 W lamps, the weaker source gives out a higher proportion of red wavelengths and a lower proportion of blue ones. It looks more orangey-red.

The spectral power distribution curve gives information on the colour of the source, as we saw earlier. In photography, however, the colour of a light source is also expressed by a unit of measurement, the colour temperature. This is based on the fact that continuous spectra, emitted by incandescent light sources of equal colour temperature, are the same, so they give the same results on film. Colour temperature is defined based on the black body radiator or Planckian radiator, as follows: The colour temperature of a white light source is the temperature in Kelvins (K) of a perfectly radiating black body when emitting light matching the source under test.

The black body radiator is a solid metal dark body that does not reflect incident light. When heated it becomes incandescent and radiates continuously and evenly throughout the spectrum. It first transmits red colour and as the temperature increases, its colour changes towards blue or 'white hot'. Colour temperature is measured using the Absolute scale in Kelvins (0°C = 273 K), named after the scientist Lord Kelvin. Figure 4.5 illustrates the spectral power distribution curves of some white sources and their corresponding colour temperature in Kelvins.

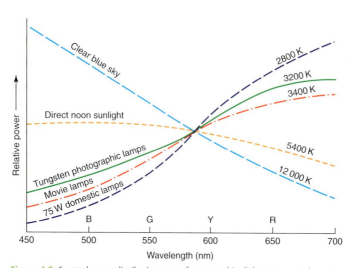

Figure 4.5 Spectral power distribution curves for some white light sources. Each contains a 'cocktail' of all the visible wavelengths — some rich in blue and depleted in red, others the reverse. They can also be described by their colour temperatures in Kelvins.

Daylight conditions	Colour temperature (K)	
	Lowest	Highest
In shade (light only from blue sky)	12 000	27 000
In shade (light only from hazy sky)	7 500	8 400
Sunlight + light from clear sky, midday	6 000	6 500
Sunlight + light from clear sky, morning or evening	5 700	6 200
Sunlight + light from hazy sky	5 700	5 900
Direct sun alone, midday	(Average = 5 400)	
Direct sun alone, morning or evening	4 900	5 600
Sunlight at sunset	1 900	2 400

Figure 4.6 Natural daylight is by no means consistent in colour temperature, as these figures show.

When the colour temperature is low, the light source emits more red and yellow wavelengths and less blue. An example is a typical candle flame, which has a colour temperature of 1900 K. The filament of a 500 W tungsten photographic lamp produces more blue and less red wavelengths and has higher colour temperature, about 3200 K. Daylight varies considerably in colour temperature, according to time of day and atmospheric conditions as shown in Figure 4.6. The 'direct noon sunlight' colour temperature (an average, measured at ground level throughout the year in Washington, DC, USA) is 5400 K. In the shade with light only from blue sky the colour temperature is 12 000 K while at sunset it is 1900 K.

An example of spectral power distribution curves and the corresponding colour temperatures of two daylight illuminants is illustrated in Figure 4.7. Note that it is important to avoid any confusion with the terms 'warm' or 'cold' colours (often used when referring to image composition), and colour temperature. With colour temperature the opposite applies: Low-colour temperature results in red colours and high-colour temperature results in blue colours.

There are also non-incandescent light sources that emit light without generating heat. These include fluorescent tubes, sodium lamps and electronic flash. They have a discontinuous spectrum and the energy is given out in lines or bands with large gaps in the spectrum where no wavelengths are produced at all, as shown in Figure 4.8.

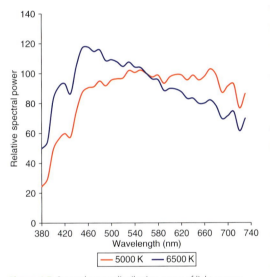

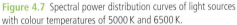

Figure 4.7 Spectral power distribution curves of light sources with colour temperatures of 5000 K and 6500 K.

Figure 4.8 Spectral power distribution graph of a mercury-vapour lamp. Only bands of wavelengths are produced. This lamp gives out no red wavelengths at all.

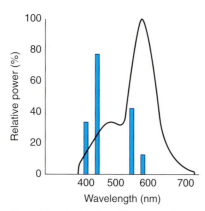

Figure 4.9 A daylight 'white' fluorescent tube produces a mixture of band and continuous spectra. This is suitable for colour photography, but will probably need a magenta filter to reduce green.

Accurate reproduction of colour in photography can be achieved if the light source emits light with all wavelengths of the spectrum and the film is balanced for that light source. Fortunately, most fluorescent tubes now used in retail shops, light boxes, etc. have both continuous and discontinuous spectrum. The tube gives a continuous spectrum overlaid with a fluorescent band spectrum from the tube coating. This is shown in Figure 4.9. The suitability of a fluorescent tube for photography depends on the proportion of continuous spectrum in the total light emitted. The larger the proportion of continuous spectrum, the more suitable the light source is for photography. Photographic flash tubes have line spectra due to their gas filling. But because of pressure and the high-density electrical discharge, the lines broaden into bands which overlap to become continuous.

The concept of colour temperature is based on the colour of a material heated to incandescence. Non-incandescent sources, such as fluorescent tubes, which create light by other means, cannot strictly be given a colour-temperature figure. For this case the term *correlated colour temperature* is used. Correlated colour temperature is the temperature of the black body when it has the same or nearly the same colour as the non-incandescent light source. Typical and correlated colour temperatures are shown in Figure 4.10.

12 000 K	Light from clear blue sky only
−27 000 K	
6 500	Fluorescent lamps (CRI 90)
6 000	Daylight (sun & clear sky)
5 800	Elec. flash (small guns)
5 600	Elec. flash (studio units)
5 400	Mean noon sunlight, and blue dyed flashbulbs
5 200	HMI lamps
4 200	Clear flashbulbs (zirconium)
4 000	Fluorescent lamps (CRI 83)
3 800	Clear flashbulbs (aluminium foil)
3 400	Movie/TV tungsten-halogen lamps
3 200	Photographic studio lamps, and slide projectors
2 800	Typical 75 W domestic lamps
2 600	Typical 40 W domestic lamps
2 200	Sunlight at sunset, and bottled kerosene lamps
1 900	Wax candle

Bluer ← → Redder

Figure 4.10 Colour temperatures for some typical light sources. CRI stands for Colour Rendering Index, quoted by fluorescent tube manufacturers. HMI lamps use a metal halide arc and provide flicker-free illumination.

Standard illuminants

The Commission Internationale de l'Eclairage (CIE) has defined the spectral power distributions of light sources known as illuminants. Illuminant A represents incandescent light with equivalent colour temperature of 2856 K. The D50 and the D65 illuminants have

been defined for daylight. For the D50 illuminant the correlated colour temperature is 5000 K and for D65 it is 6500 K. Their spectral power distribution is shown in Figure 4.7.

Most photographic films have been designed for lighting conditions with colour temperature of 5500 K. When using light sources with colour temperature of 3200 K (Tungsten) you can use Tungsten or type B film balanced (such as the Kodak Ektachrome 160T or Fujichrome T64) for that colour temperature, or daylight film with the suitable filter in front of the lens (see Figure 4.13). Digital cameras provide settings for colour temperature where colour correction is applied on the image. You can read more on digital cameras and colour temperature in Chapters 2 and 7.

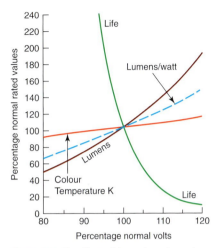

Measuring colour temperature

There are cases however where although you have set the correct white balance (colour temperature) on your digital camera or you have used the correct type of film for the light source, the image colour is not right. This may happen due to one or more of the following reasons:

Figure 4.11 The effects of decreasing or increasing the voltage applied to a tungsten lamp. Reducing the supply extends life but reduces colour temperature. Also fewer lumens of light are produced per watt consumed, and illumination dims.

1. A lamp is used at a voltage lower or higher than the correct rating (see Figure 4.11). (This does not apply in the same way with flash tubes, which are fed from storage capacitors. So variations in the supply alter the time these capacitors take to recharge.)
2. The light is bounced off a reflector or passed through a diffuser (or lamp optics) which is not quite colourless. Similarly, nearby coloured surroundings just outside the picture area tint the subject.
3. Atmospheric conditions filter sunlight. Colour temperature also changes during the day or time of year.
4. Other types of powerful light source with different colour temperatures are present.

In cases where the lighting is uncertain it is very helpful to measure the colour temperature using a colour-temperature meter (see Figure 4.12). Colour-temperature meters have three silicon photocells filtered to detect red, green and blue under an integrating diffuser. The meter circuits obtain a profile of the spectral content of your lighting by comparing the relative responses of the three colours to obtain a profile of the spectral content of your lighting. For example, the red cell has stronger response than the blue one when measuring tungsten lamps, whereas daylight produces an opposite effect. The range of light sources that can be measured varies between models and some include measurement of brief light sources such as the electronic flash.

Colour-temperature meters give a direct reading in Kelvins. There are models that take as an input the colour balance of the film and give as output the colour temperature of the light source in Kelvins together with the value of any colour-correction filter needed. The information on

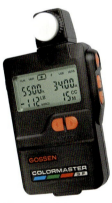

Figure 4.12 Colour-temperature meters measure light using the diffusing disk near the top. The meter is programmed for the type of film (daylight or tungsten for example) and reads out reference for the colour compensation filter needed over camera lens or light source. Image courtesy of Gossen Foto-und Lichtmesstechnik GmbH.

the correction filter is given in light balancing (LB) filter values and colour compensating (CC) filter values. The LB value refers to the red or blue LB filter and is the difference between the selected film's colour temperature and that of the measured light source. The values for these filters are given in mireds (MIcro REciprocal Degrees). The CC value is the nominal value of the required colour-compensating filter, usually green or magenta. Another point is that within the meter's operating limits, the intensity of your lighting is not important. The instrument's cells can still make their comparisons whether the illumination is a 60 W lamp or brilliant sunlight.

Using a colour-temperature meter with a good range of filters provides you with good control of lighting colour when working on location. You can also check your studio lighting for any faults or changes. See page 139 on how to use filters in practice.

How to measure colour temperature

When measuring the colour of a light source with a colour-temperature meter, you position it at your subject, with the white light diffuser pointing to the light source. Colour-temperature meters take incident light readings so if they are pointed directly at the subject they will measure the subject's colour instead of the colour of light reaching it. For measuring the colour temperature of a flash, point the meter with its diffuser facing towards the camera, preferably from the subject position or at least where it receives the same lighting.

Mireds

As mentioned previously, colour-temperature meters may give the correction LB filter you need in terms of mireds or, more accurately, in mired shift value instead of a manufacturer's reference number. In fact, all filters for colour-temperature correction work, whatever the brand, tend to have a mired rating as well as a number (see Figure 4.13). The reason that the mired instead of the Kelvin scale is used is based on the fact that the actual colour content of light sources does not change *pro rata* with colour temperature. This happens because the colour-temperature scale is based on physical temperature rather than proportional colour content. So a filter which raises colour temperature by 100 K at 2800 K has a 130 K effect at 3200 K and a 300 K effect at 5000 K, as shown in Figure 4.14.

'Warm-up' filters (positive mired values)		'Cool-down' filters (negative mired values)	
85B	+127	80A	−125
85	+112	80B	−110
85C	+86	80C	−81
81EF	+53	80D	−55
81C	+35	82C	−45
81B	+27	82B	−32
81A	+18	82A	−18
81	+10	82	−10
CC20M	+8	CC30G	−10
CC10M	+4	CC10G	−4

Figure 4.13 The mired shift values of some Kodak filters.

To solve the filter calibration problem you convert Kelvins into mireds by dividing 1 000 000 by the Kelvin value of the source.

Mired value = 1 000 000 divided by colour temperature in K.

Equal changes in the mired scale correspond to approximately equal visible variations in colour.

Notice that the higher the mired value, the lower the colour temperature and vice versa. So 'warm-up' yellowish orange filters have positive mired values and 'cool-down' bluish filters have negative ones. For example, the mired value of 2800 K household lamps is 357 M, whereas type B

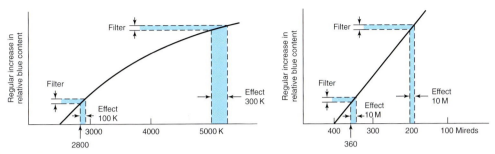

Figure 4.14 Why mireds are used. *Left*: the relative blue content of an (incandescent) light source does not increase proportionally with colour temperature. Therefore a bluish filter, which has a fixed upward influence on blue content, causes more change of Kelvins when illumination is 5000 K than when 2800 K. It cannot be given a 'Kelvin shift value'. *Right*: by converting Kelvins into mireds you have a regular scale directly relating to blue content. A filter has the same 'mired shift value' at high and low positions on the scale.

colour film is designed for 3200 K (312 M). A filter to balance the film to the lamp needs a mired shift value of −45, or as near this as possible. Used with photo-lamp lighting of 3400 K (294 M) the same filter would change the colour content to 249 M, which is 4000 K. Notice how the same filter resulted in a change of 400 K in the first case while it resulted a change of 600 K in the second case, in terms of the colour-temperature scale. A filter can therefore be given a mired shift value (+ or −), which holds well, irrespective of the colour temperature of the light source. Sometimes filters and colour-temperature meters quote 'decamireds' instead of mireds. One decamired equals 10 mireds so a filter of 100 mireds would be 10 decamireds.

Filters can be added together and this may prove useful when you do not have the filter with the exact mired value for correcting the colour temperature. If your colour-temperature meter, or simple calculation, shows that a +127 M filter is needed to colour balance the light source to your film you can either use a Kodak 85B (+127 M) or combine an 85 (+112) with an 81A (+18). If mireds are not already shown on your filter containers, calculate and mark them up. If you have a colour-temperature meter you can finally check any proposed filter by holding it over the sensing head and remeasuring your light source. The meter should show correct colour. A Kelvin/mired conversion table is given in Figure 4.15.

Colour temperature (K)	Mired value
6500	154
6300	159
6000	167
5800	172
5600	179
5400	185
4200	238
4000	250
3800	263
3400	294
3200	312
3000	333
2800	357
2600	385
2400	417
2200	454
1900	526

Figure 4.15 Kelvin/mired conversion table.

Classification of colour

In everyday life we describe colours as green, reddish, pink, light blue, etc. These names refer to attributes of colours which have been defined as hue, saturation and lightness. The term 'hue' is related to the dominant wavelength expressed as a colour title such as green, yellow, etc. and is close to the general term 'colour'. Saturation means the purity of a colour, how

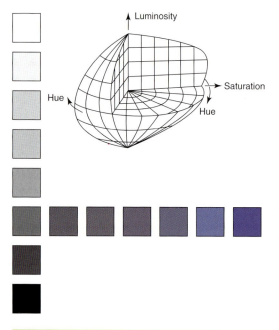

	Hue	Value (luminance)	Chroma (saturation)
Titanium white	White	9.6	0.1
Cadmium red	6.6R	4.3	13
Emerald green	4.6G	4.0	8.8
Ivory black	Black	1.5	0.9

Figure 4.16 Munsell system of colour classification. The Munsell 'solid' represents the three dimensions of the system. The central axis (neutral) runs from white at the top to black at the bottom. Saturation increases away from this central axis. In practice this sphere takes the form of dozens of charts, hinged along the vertical axis and each one dealing with a different hue. (The lopsided shape here is because printing inks have to be used rather than theoretical colours. Inks still have severe colour limitations.) Shown below are just two strips out of one chart for a blue hue, saturation increasing to the right and lightness increasing vertically. Any colour patch can be referenced by quoting hue, value and chroma coordinates. The table gives four examples.

vivid or dull it is. Pastel colours have low saturation and strong vivid colours are highly saturated. Lightness refers to how bright or dark is a colour and it is not related to saturation. A dark colour, for example, may appear saturated.

There are different systems, which can pinpoint a colour and label it with a numerical code. The Munsell Book of Colour was devised by the American artist A. M. Munsell. This system is three-dimensional and classifies colours through a collection of over 40 charts of patches with three coordinates: Value, which describes lightness, hue and chroma which describes saturation (see Figure 4.16).

The Munsell system gives every colour a reference number, which identifies its chart (hue), and then its vertical (value) and horizontal (chroma) location, like a street atlas. The vertical axis runs from white at the top to black at the bottom and chroma increases from zero at the central axis. Munsell numbers are used as matching standards for artists' paints, printing inks and any pigmented colour products. It is limited by the actual pigments available for printing the charts and for this reason the three-dimensional representation of the 'Munsell Book of Colour' has a lopsided shape rather than spherical.

Two chromaticity diagrams, the CIE xy and the CIE u′v′ have been introduced by the CIE in 1931 and 1976, respectively. The chromaticity diagrams identify all the colours of the visible spectrum by matching them to mixed quantities of blue, green and red light. Each colour is described by xy or u′v′ coordinates in the diagram which maps the relative strengths of the three sources in the spectral locus (see Figures 4.17 and 4.18). All colours whether in the form of pigment or light have a matching position somewhere within the CIE diagram, so you can describe any one by quoting graph coordinates.

The CIE has also introduced three-dimensional systems known as *colour spaces*, where each colour is described by three coordinates. The CIELAB colour space was introduced in 1976 and has been used widely in photography. You may have encountered this colour space in software packages such as Adobe Photoshop, where it is one of the image modes. It is

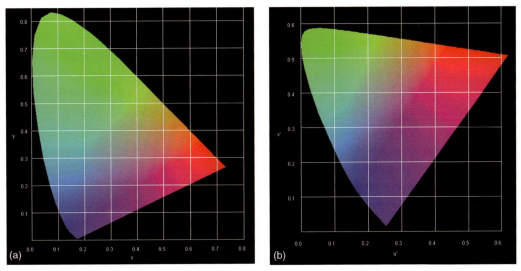

Figure 4.17 (a) The CIE xy and (b) the CIE u′v′ chromaticity diagrams, introduced by the CIE in 1931 and 1976, respectively. Reprinted with permission from The Colour Group (Great Britain).

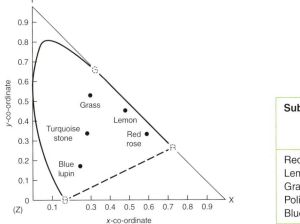

Subject	Chromacity co-ordinates		Reflection factor
	x	y	
Red Rose	0.586	0.330	12.2%
Lemon	0.473	0.467	51.3%
Grass	0.290	0.518	29.7%
Polished Turquoise	0.253	0.325	22.4%
Blue Lupin	0.228	0.182	8.3%

Figure 4.18 CIE colour classification. In basic terms imagine this as a white screen with lights – red, green and blue – shining inwards from three positions (see broken lettering). The middle of the triangle formed by the lights is neutral white. Light from any one corner is at zero at any point along the opposite side. Spectrum colours from blue through to red are located along the dome-shaped locus (bold line). Quoting x and y coordinates pinpoints any colour for matching purposes. The table gives examples for some subjects shown on the chart.

also one of the available colour space options when you use the colour picker, as shown in Figure 4.19.

The features of this colour space are illustrated in Figure 4.20. The vertical axis, L* represents lightness, as the Munsell diagram. There are also two axes that describe the colour. The a*-axis represents the red/green value and the b* represents the yellow/blue value. This three-dimensional system is based on visual perception and is perceptually approximately uniform. Equal distances between two colours in the CIELAB colour space represent visually equal differences between these colours. You can read more on colour spaces in Chapter 11, page 257.

Figure 4.19 The Color Picker tool in Adobe Photoshop includes the CIELAB coordinates of a colour.

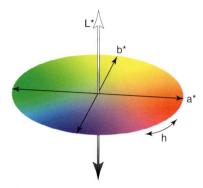

Figure 4.20 Graphical illustration of the three-dimensional CIELAB colour space. The L* axis represents lightness. The a* axis represents the red/green value and the b* axis represents the yellow/blue value. *h* represents hue.

Colours, of course, originate from all kinds of sources. This is what makes them difficult to reproduce exactly with any dyes or pigments, let alone mixtures of the three dyes in colour film, or three phosphors within a computer or video CRT screen. Any or all the following forms of colour may be in front of your camera:

(a) Pigments and dyes which selectively reflect, transmit or absorb incident light. Colours here are greatly influenced by the colour of the light and the subject surface. (At certain angles a smooth surface will reflect a high proportion of incident light unchanged off its top surface, mixing with and desaturating the colour selectively reflected from underneath.)

(b) Colours derived from white light by diffusion and scatter. For example, the blueness of clear sky caused by scatter of the shorter wavelengths in sunlight by water and dust molecules in the atmosphere.

(c) Colours formed by interference – as seen on soap bubbles or reflected from oil on a wet road. These changing hues are caused by two reflections from inner and outer surfaces of a thin transparent film. Displacement by half a wavelength interferes and cancels out this wavelength colour, forming other colours from remaining white light.

(d) Colours produced by diffraction – for example, reflected from a compact disc or the sheen of a rayon-type fabric. Such effects are caused by the change in direction of some wavelengths in white light when reflected from a surface covered in a fine pattern of lines.

(e) Fluorescent colours. Special inks or coatings, as on 'dayglow' poster papers, etc. which generate visible coloured light under sunlight or any other source containing ultra-violet radiation.

(f) Phosphorescent colours. The 'glow' from substances are able to store energy from light and release it in a coloured form later (for example, the luminous coating on the hands of a clock).

How we see colour

Normal human eyesight is quite good at comparing two coloured objects and judging if they match, provided they are seen together under identical illumination. However, colour seen in isolation is another matter. Judgement here varies from person to person and from one set of circumstances to another. Colours become personalized and you cannot even trust your own eyes. Look at the way people adjust the television to get 'realistic' colour – some have it bright and garish, others muted and restrained.

There are all kinds of eyesight inconsistencies and differences that exist between individuals.

Adaptation

Our visual system adapts itself to changes in the intensity of light (light adaptation) and the spectral quality of the light (chromatic adaptation). The dimmer the light, the wider the iris of your eye becomes (its range is about five stops). After this the retina itself slowly adapts to increase sensitivity, relying less on the cones and more on highly responsive but colour-insensitive rods. Eye peak sensitivity shifts (the Purkinje shift) further towards the blue–green, then even this colour response fades to zero. After about 20 min adaptation in extremely dim light you may just make out things in monochrome, with very poor resolution and a degree of visual 'noise' which destroys almost all detail. In a garden in dim moonlight you can only see the dark-grey shapes of flowers – but flash a lamp and their sudden colour brilliance emphasizes what our eyes have lost. To a lesser extent, the same thing occurs in a scene with contrasty lighting – your eyes see fewer colours in shaded areas than in midtones and highlights. (A point to remember in colour printing – colour inaccuracies are least noticeable if restricted to dark areas of the print.)

One aspect of adaptation is when the perceived colour of the objects remains constant even when the colour of the light changes. This is known as colour constancy. Walk from one area lit by daylight-type fluorescent tubes into another lit with incandescent tungsten lamps and you are at first conscious of the 'yellowness' of the lighting, but within a minute or so you accept this as neutral white. When you return to the tube-lit area it first strikes you as 'blue'. An example is when we look at a white piece of paper in these conditions. It will appear as 'white' in both rooms despite the change in the colour of the lighting.

Eye adaptation is continuous and is not noticed in everyday life. It is useful because it serves several purposes. There is less processing of information when the steady conditions are excluded so the response to changes is faster. It also ensures that there is colour stability for all the objects around us despite the time of the day or the artificial lighting conditions.

Adaptation may cause, however, problems in colour photography. Colour films cannot respond in the same way. Long exposure in dim light (despite reciprocity effects) will record a range of subject colours which just could not be seen by eye. Film is also balanced for specific colour temperature, for example films for daylight or tungsten illumination. Under lighting of a different colour temperature, which your eyes soon ignore, film will not reproduce colours or neutral tones accurately. You may have observed this when you take photographs indoors, in a room lit with incandescent tungsten lamps, using a daylight balanced film. Although the scene appeared as lit with neutral white light after a few minutes of adaptation, the images have a strong yellow cast. It is essential, therefore, to use a film that is balanced for the ambient lighting conditions of the scene. If this is not possible you will have to use correction filters. With digital cameras you can change the 'white balance' setting to match the colour temperature of the lighting source. You can correct further colour deviations digitally using an imaging software package or by using filters.

Colour fatigue

Your eyes' assessment of a coloured object is greatly influenced by the colour surrounding it as well as what you looked at previously. Figure 4.21 is a simple test that you can use to see the effect of colour fatigue. If this works for you it will be because blue receptors in your retina become 'fatigued'. But green and red receptors in the same area remain unchanged and so temporarily respond more actively and produce the yellow afterimage.

Similarly, a pastel colour seems to change hue when taken away from one brightly coloured backdrop and set in front of another totally different in colour. Changes in eye sensitivity also

Figure 4.21 Place a white piece of paper to the right of the coloured shape to cover the text. Stare steadily at this coloured shape from a close reading distance for about 15 sec. Then switch your gaze directly to the adjacent blank white space. Briefly the shape is re-seen on the sheet in pale yellow.

sometimes make it difficult to judge colour prints – the longer you compare any two test prints with different colour casts, the more you think correct colour is midway in between. This also applies when judging colour correction on photographic prints using red, green, blue, cyan, magenta and yellow filters. If we look at the test print for several seconds through the filter, the effect of the filter on the colour of the print is less noticeable.

Metamerism

In some cases two objects that have different spectral power distributions appear to have the same colour. These objects are said to be *metameric*. Metamerism depends not only on the spectral power distribution of the light source (illuminant metamerism), but also on the object and the observer. You may have observed the effect of illuminant metamerism when, for example, two garments appear to have the same colour when viewed indoors under incandescent lighting but they mismatch when viewed in daylight.

Individual colour vision

Everyone differs slightly in their response to colour. Can you be sure you see what someone else sees? Around 10% of the male population and 0.5% of women have some form of defective colour vision. Their trichromate response may simply be uneven or, more severely, they cannot distinguish between red and green. In some cases, which are more rare, there is defective colour vision for yellow and blue hues. Add to this the fact that the optics of your eyes grow yellower with age and it seems that we must all see colour differently. In jobs involving critical assessments – such as colour printing – good colour vision is essential. You can test yourself using charts in S. Ishihara's book, 'Tests for Colour Blindness' (H. K. Lewis, London).

Psychological influences

We are also all influenced in our judgement of 'correct' colours by experience and memory. I may not see quite the same green as you but to me the grass in that photograph is the same colour it appeared on the lawn. Studies have shown that we remember colours more saturated than the colours in the original scene. We also remember light colours as lighter, and dark colours as darker. Similarly, you know that certain favourite flowers are yellow, city buses are another familiar colour and so on. Familiarity can even make you accept and overlook a colour which is somewhat distorted – you unconsciously 'read into' it what the colour should be. On the other hand, certain subject colours such as flesh tones and common foods are read quite critically. Your eyes tend to detect small deviations. All the above mentioned parameters have an effect in colour printing, when you decide on exposure and colour adjustments based on how you remember the colours in the original scene or on how you expect the colour of familiar objects to be. Colour photographs of totally unfamiliar things are almost impossible to judge unless some reference (such as a grey scale) has been included alongside.

It is an interesting point that colour can really only be remembered by comparison. Can you imagine a colour you have never actually seen? Colours have broad emotional connotations too, also based on experience. Red suggests warmth; blue cold. These are old clichés but they are still used effectively in advertising. Therefore you have an orange bias in a sales picture of hot soup and an emphasis on green–blue for 'tingling fresh' toothpaste.

As you will soon see in more detail, manufacturers have to work within the limitations of having only three dyes present in colour films. From different mixtures of these dyes all image colours from all kinds of subjects have to be reformed. Some, such as fluorescent and phosphorescent colours, are therefore impossible to reproduce accurately. Even subjects with regular colours will only reproduce acceptably if illuminated by light for which the tri-colour-sensitive halide emulsions have been balanced. 'Adaptation' by using filters is only possible to a limited extent. In choosing their three image-forming dyes film manufacturers have to compromise between high accuracy in only a few colours and the acceptable reproduction of many. Different brands solve the problem in different ways, so final colour images vary slightly in appearance according to the film you choose, even though each film was used correctly.

Similar problems exist in digital photography, where the image displayed on your computer screen, formed by R, G and B phosphors if it is a CRT display or colour filters if it is an LCD, has to reproduce all subject colours. Even if you get this to look acceptable it differs again from what is later output onto paper in C, M, Y, K inks.

With all these variables and provisos it is incredible that colour photography is so realistic. 'Correct' rendering of colours seems so unlikely it is barely worth striving for. On the contrary, you must tightly control all the technical aspects of colour reproduction so that results are consistent and reliable, leaving human vision as the only variable. Fortunately you rarely examine final results right alongside the original subject – so here, at least, the way that your brain interprets what your eyes see is a plus factor.

SUMMARY

■ Colour exists due to our colour visual system, which interprets the different wavelengths of light as colour. A spectral power distribution graph enables you to determine the colour of a light source and whether the specific light source has a continuous or discontinuous spectrum.

■ Colours can be identified in terms of their hue, saturation and lightness. Hue is the basic colour title; saturation (or chroma) its purity; and luminance (value) describes its lightness. The Munsell system uses numbered patches on charts against which you can match pigments. The CIE xy system uses primary coloured lights and quotes any colour of pigment or light through coordinates plotted on a chromaticity diagram. The CIELAB colour space describes the colour in three dimensions and it is perceptually approximately uniform.

■ Subject colours are the result of selective reflection or transmission by pigments, dyes, etc.; also scatter, interference, diffraction, even fluorescence or phosphorescence.

■ The higher the colour temperature (degrees Absolute, in Kelvins), the greater the blue wavelengths, the less red wavelengths. However, non-incandescent sources may not give out a continuous spectrum and, at best, have only a colour temperature *equivalent*. Films are mostly balanced for 3200 K or 5500 K. Digital sensor systems can have colour sensitivity adjusted via a 'white balance' setting. Lighting

colour changes occur with wrong lamp supply voltage; non-neutral reflectors/diffusers, or coloured surroundings; atmospheric conditions/time of day; and when different colour temperature sources are mixed.

■ A colour-temperature meter measures your light source for the proportions of red, green or blue wavelengths present, reads out in Kelvins or mireds (micro reciprocal degrees). M = 1 million divided by K. Filter mired shift values (+ or −) remain constant whatever colour temperature source they are used with. The effect of combining filters is shown by adding their mired values.

■ Have conversion filters and colour-correction filters, and preferably a colour-temperature meter. When slide results show a cast, reshoot using a filter half the strength needed to correct slide midtones visually. Errors of 10 mireds can give noticeable casts.

■ Aim to match lighting to film colour balance, even with neg/pos colour. If mixed lighting cannot be avoided filter one source to match the other, or split your exposure and use a lens filter for one part as necessary. Have neutral surroundings and matched light sources in the studio; on location, white reflectors help to 'clean up' coloured environments, but do not be obsessive and destroy atmosphere.

■ Perception of colour is affected by your eyes' 'adaptation' to the intensity and colour of the viewing illumination. Other parameters include colour fatigue (previous and adjacent colours), metamerism, eyesight colour defects, and judgement influenced by memory and association. Colour film, however, has a fixed, specified response to subject colours and illumination. Its final image colours are mixtures of just three dyes.

1 Use a digital camera to test the colour correction it applies when you set it at different colour temperatures. Select an outdoors scene under bright daylight and set your camera's colour temperature (usually described as 'white balance') to 'daylight' (the settings depend on the specific camera model). Take a picture with this setting and then make some more exposures with other settings available, for example tungsten, fluorescent, etc. See the changes your images' colour balance for each of these settings.

2 When there is mixed lighting in the scene, you may correct the colour temperature for one lighting source but change the colour of another. You can do several tests using your digital camera's colour temperature settings ('white balance') or your film camera, using daylight film and filters. An example is the following:

Choose an indoors scene with incandescent ambient lighting, which includes a window. The outdoors lighting is daylight. Shoot your first picture with your digital camera's colour temperature setting to 'daylight' (or using a daylight film with a film camera). Shoot again with the white balance set to 'tungsten' (or using a suitable filter in front of the lens). Observe the colour differences between the two images.

3 Test the effect of viewing conditions on the perceived colour and contrast of your images:

(a) Select a medium contrast black and white digital photograph and display it on your screen with white background. Change the background to black and notice how the contrast of the image appears different. Try the same but with a colour digital photograph and backgrounds with different colours.

(b) Display a medium contrast black and white image on your computer monitor and view it under bright ambient lighting. Check the contrast of your image. View the image again with the room lights turned off and see how the contrast of the image changes.

PROJECTS

5 Films – types and technical data

I f you are interested in film photography it is a good idea to work with a limited range of well-chosen films as you get to know their performance intimately, their response to different subject situations and, when necessary, just how far you can abuse a film before results become unacceptable. However, you must still pick your materials in the first place. It would also be a pity not to explore some of the lesser-known films worth experimenting with for their special qualities and effects.

This chapter discusses the practical points you should consider when choosing film. A section on reading manufacturers' data explains how products are described and compared by the graphs and tables which appear in technical information sheets. Finally, there is a review of some special-purpose films, selected for their unusual results or usefulness for solving special tasks.

Film design

E arly photographers were more chemists than artists. In the 1850s they had to take darkroom tents everywhere, primitively coating sheet glass with light-sensitive silver compounds just before exposure and development. However, these 'wet plates' were followed by gelatin + silver halide emulsions which could be prepared in advance, and so opened up photographic material manufacturing from about 1876. One by one, other barriers were overcome through emulsion research by chemists and manufacturers – glass was replaced by roll-up film; speed was increased over a thousand fold; response to only blue wavelengths was extended to the full spectrum. The last opened the way to practical films for colour photography (slides 1935 and negative/positive around 1942).

Throughout this evolution there were always essential skills in emulsion making, passed down from one generation to the next. In more recent times the very large investment in research and development applied to light-sensitive systems plus advances in technology generally brought much greater mastery of production. A kind of creative chemistry was evolved, typified by Dr Edwin Land's introduction of instant-picture colour materials in 1963. Emulsion chemists became able to 'fine-tune' film performance, due to a better fundamental understanding of how an emulsion behaves when an image is focused on it in the camera. Manufacturers gained unprecedented control over crystal structuring and complex multilayer coating of film.

Although in the new millennium digital image recording seems to be gaining ground over chemical photography film, film is still used by consumers, professionals and artists. Several requirements are necessary in high-quality films, such as light sensitivity, sharpness, colour reproduction, convenience and stability. Some of these are conflicting. For example, it is difficult to increase International Organization for Standardization (ISO) speed without, at the

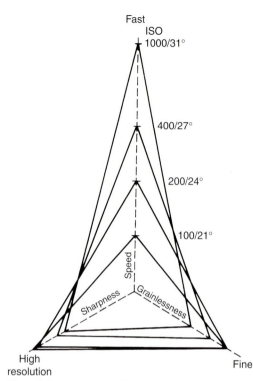

Fast
ISO
1000/31°

400/27°

200/24°

100/21°

Speed

Sharpness

Grainlessness

High
resolution

Fine

Figure 5.1 Requirements for film to offer good image resolution, light sensitivity and freedom from grain all pull in different directions. Triangles here represent four films of differing speeds. Gains in one direction inevitably result in losses in another.

same time, reducing ability to resolve detail and record subtleties of tone and colour. Sheer film speed has always been an attraction, and gives definitive figures which everyone understands. However, the larger grains and thicker emulsion coating, traditionally needed for extra light sensitivity, deprive you of fine detail (Figure 5.1).

In the recent decades manufacturers gave importance to improving image quality within their existing speed range of films. One way to do this is by advanced engineering. For example, by preventing silver halide crystals from growing into their normal smooth symmetrical shapes and instead form flat 'tabular' crystals with a ruffled surface texture greatly increases the total surface area exposed to light (ruffling alone more than double the area of a smooth crystal). Since these crystal shapes lie flatter in the coated film, emulsions can be thinner, giving less image diffusion, improving sharpness and using less silver without loss of film speed.

In other words, emulsion efficiency is improved all round (Figure 5.2).

Colour films nowadays have better colour rendering, visual sharpness and less-grainy images are achieved by incorporating chemical 'inhibitors' which are released during colour development and increase the contrast and the saturation of dominant colours without making neutral grey tones unacceptably harsh. The result is rich colour but without the sacrifice of shadow and/or highlight details you would expect if just contrast was boosted.

Figure 5.2 Thin, tabular-shaped film emulsion silver halide grains, magnified by about 10 000×. Unlike traditional flat-sided crystals these are thinner and have ruffled surfaces to increase area. The result is a better trade off between speed and resolution. Courtesy of Kodak Ltd.

Choosing films

There is still considerable competition between the main film manufacturers that continue to capture larger shares of the world's photographic film market. Whether you are choosing from existing films or assessing a newcomer, bear in mind each of the following aspects: image quality, speed, exposure and colour latitude, suitability for slides and transparencies or prints, image dye stability, and grain and resolution.

Image quality

Slides (for projection) and transparencies (larger-format reversal film) on slow material remain unbeatable for resolution of detail, colour density and saturation. A projected slide in a properly blacked-out room (with no extraneous light to grey-up shadow detail) can give highlights four hundred times brighter than shadows. This is about four times the range of a print, which is severely limited by the percentage reflectance of its paper base and maximum absorption of light by its darkest dyes. The result is that often colour prints from colour negatives tend to lack the sparkle of a colour slide. For example, specular highlights merge with diffused ones – a water droplet on a white flower petal becomes more difficult to pick out.

In slide or transparency films the image has only been through a lens once and therefore image sharpness is greater. However, you must also be much more accurate with lighting, composition and exposure at the camera stage when you use them. On the other hand, black and white negatives give you plenty of scope for control through cropping, choice of paper grades, shading and printing-in.

No good modern colour film can really be said to be of better quality than another. The different dyes used are patented by manufacturers and used in slightly varied mixtures to reproduce image colours according to the colour response of each emulsion layer. Beyond a certain point image quality is subjective. Some Asian manufacturers and users put a premium on brilliance of greens, while in North America consumers accept a 'cooler' bias, with greater richness of blues preferred. These differences are not easy to see in isolation, but show up clearly if you are unwise enough to shoot an assignment using a mixture of film brands. In order to avoid professional photographers opting for a rival brand just to obtain subtle colour variations, some manufacturers offer two different versions of a film, such as the Kodak Elite Chrome and Elite Chrome Extra Colour. They both match in speed but one gives slightly warmer, more flattering skin tones, the other more neutral hues well suited to fashion garments, outdoor scenes and so on.

Speed

In general, grain pattern and loss of colour saturation are increased with increase in ISO speed. The deterioration shows up more in fast colour slide materials than when colour negatives on film of an equivalent speed are printed. Overexposure of negatives and push-processing of films both tend to increase granularity. (Note that, this is not the case with chromogenic negative materials – both black and white and colour – where increased exposure improves both granularity and sharpness.) However, fast slide and fast black and white negative films can be push-processed most successfully for extra speed because they have lower inherent contrast. Slower films tend to produce high contrast images, and (with certain exceptions) colour negative

films should not be pushed at all. Remember that manufacturers' speed figures are not absolute. Use them as recommendations – they assume average subjects and lighting, standard processing and results which show maximum accuracy of tone and colour. Your own conditions and needs will sometimes be different. You must then decide from your own experience whether particular materials will perform better for you up- or down-rated.

Exposure latitude and colour temperature tolerance

Exposure latitude depends greatly on subject brightness range, being less with high contrast scenes and greatest with soft, flat lighting. Having said this, slides and transparencies are least tolerant of wrong exposure, and black and white negatives offer greatest exposure latitude. Reversal colour films for slides and transparencies tolerate up to about half a stop overexposure or one stop underexposure. Colour negative films expand this latitude to one stop underexposure and two stops overexposure. However, most experienced photographers often deliberately overexpose colour negatives by half or one stop, maintaining that they get optimum results. Latitude is considered two stops in each direction (Figure 5.3).

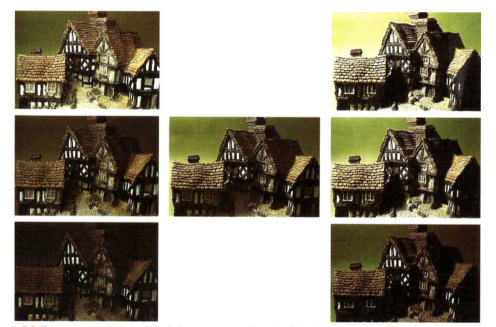

Figure 5.3 The more contrast in your subject the less your exposure latitude. Of the three softly lit pictures, left column, the top one was overexposed two stops and the bottom one underexposed two stops. When harshly lit (right column) just one stop overexposure (top) and one stop underexposure (bottom) starts to lose highlight and shadow detail, respectively. Centre picture has normal contrast lighting, correct exposure.

Colour negatives are also much more tolerant of wrong or mixed colour temperature subject lighting than reversal materials, but do not overdo it – underexposure or overexposure of one colour recording layer inevitably narrows the subject brightness range that your film can accurately reproduce (Figure 5.4). Nevertheless, colour negative films are a better choice if you are shooting under varying or mixed lighting, and they give you an extra safety margin taking available-light pictures in situations where the illumination is unknown.

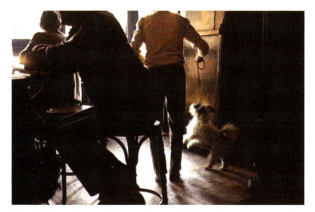

Figure 5.8 Grain can visually contribute positively to the atmosphere of a picture. This old promotional advertising shot for a brewery works through what it suggests in terms of a Sunday morning at the 'local'. By Dick Swayne.

small-format camera and high-resolution lens on fast film. Keep the image small (for extra enlargement later) and use flat subject lighting so that you can step up development to increase graininess without creating excessive image contrast. For black and white work push-process fast film in a speed-enhancing developer, or use E-6 first developer giving about 5 min at 25°C. Silver image negatives can be slightly overexposed, then overdeveloped and reduced in Farmer's Reducer (page 174). You next enlarge with a condenser type enlarger, preferably a point source, onto high-contrast glossy paper. As a less-subtle but easier-to-handle alternative, print through a grained screen sandwiched with your film in the enlarger. Screens can be bought or made by yourself, by underexposing coarse-grain film to an image of an evenly lit plain surface (Figure 5.8).

Edge sharpness

Boundaries between areas of the image – light and dark – tend to be exaggerated when silver halides are developed. Figure 5.9 shows how the higher density of a boundary becomes greater and the lower one less along the edge of light and dark. This so-called adjacency or 'edge effect' is due to chemical changes during development. Active developer diffuses from the low-density area where it is underused, boosting development along the adjacent high density one. Meanwhile, the oxidation by-products – bromide and iodide – released in largest quantities from the high-density side slow development on the low-density edge of the boundary. All this is

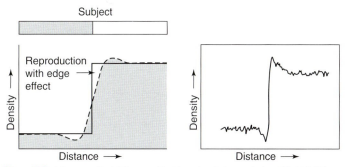

Figure 5.9 Adjacency effect. When a subject boundary between dark and light (left) is imaged onto film the density change in the processed negative does not show the expected profile (solid line). Instead, chemical changes across the boundary give an exaggerated edge effect. This improves visual sharpness. Right: the effect as recorded by a micro-densitometer showing a trace across an actual film image.

of practical importance, since exaggerated edges give a stronger impression of image sharpness. This principle is being used in digital sharpening filters available in all image manipulation applications. High-acutance black and white developers are formulated to exaggerate edge effects. They may however increase graininess by sharpening up edge contrast (Figure 5.10).

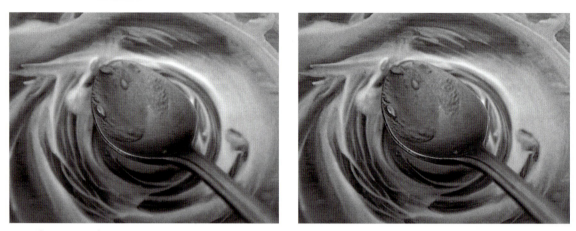

Figure 5.10 Left: unprocessed image. Right: image sharpness is increased digitally. The edge contrast is boosted but the result looks grainier too. By Sophie Triantaphillidou.

Film MTF

n Chapter 3, we saw how the quality of lens performance can be shown by a graph which plots image response (modulation) with respect to coarse and to fine detail (low-to-high spatial frequency, measured in cycles/mm or lp/mm). Modulation transfer function (MTF) is also published for films (see Figure 5.11). Notice how the graph shows 100% modulation

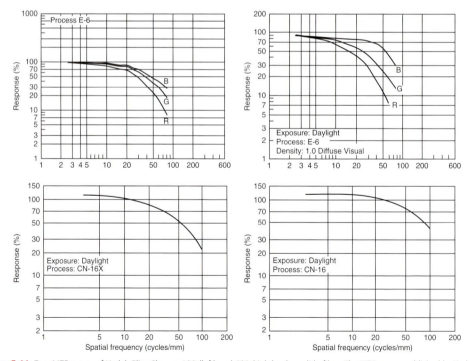

Figure 5.11 Top: MTF curves of Kodak Elite Chrome 100 (left) and 400 (right) colour slide films. The MTF curves published by Kodak are for the three different colour records. In this case, the green MTF is the most important because the eye is more sensitive to the yellow-green part of the spectrum. Reprinted with permission from Eastman Kodak Company. Bottom: MTF curves for Fujicolor 100 (left) and 1600 (right) colour negative films. The slower ISO 100 film shows better response in middle and high frequencies and a higher cut-off than the very fast ISO 1600 film. Reprinted with permission from Fujifilm UK Ltd.

(or more, depending on the film and manufacturer) with coarse to medium detail, because edge effects have greatest influence here and boost contrast. At the finest detail, shown at highest frequencies at the end of the scale, grain size and light-scatter within the emulsion take their toll, so that response dips. The point on the frequency axis where the graph line drops to 10% response is sometimes quoted as the maximum resolving power of the film. Typical limits are about 200 cycles/mm for very fine grain, slow black and white film, 120 cycles/mm for a medium speed colour negative film and 80 cycles/mm for a medium-speed colour slide material.

Most manufacturers' technical data sheets on films include an MTF graph for comparative purposes. These prove that a fine-grain thinly coated, slow film have generally a higher curve than a fast one. You can also take into account the MTF curve for the lens you are using, 'cascading' the two together by multiplying their fractional values (i.e. modulation values from 0 to 1) at each spatial frequency. The result shows the combined performance of your lens + film, as shown in Figure 5.12. Clearly, a low-resolution film can demolish the effective practical performance of an expensive lens, just as a poor lens nullifies a high-resolution film. MTF can be taken even further by considering the performance of enlarging lens and printing paper.

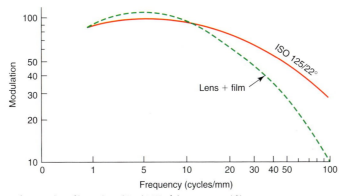

Figure 5.12 MTF curves of camera lens, film and combined MTF of the camera and film system.

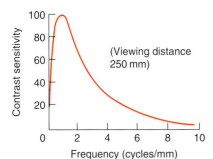

Figure 5.13 Typical contrast sensitivity function of the human visual system (considered as the MTF of the eye), for a typical reading distance. Multiply figures on the frequency scale by seven to relate them to a 35 mm film frame which will be enlarged to 8 × 10 in. print.

As discussed in Chapter 3, you can also apply a cut-off frequency beyond which performance is unimportant (say 40 cylces/mm). The exact figure will depend on camera format, degree of enlargement and the distance expected for viewing final pictures (Figure 5.13).

Characteristic curves

Curves like Figure 5.14 are the oldest type performance graphs for light-sensitive emulsions, pioneered by scientists Hurter and Driffield working in Britain in 1890. Traditionally known as 'characteristic curves', they are also called H & D curves, density curves or *D* log *H* curves. The curve plots the resulting image densities, measured after processing and plotted on the upright y-axis against a wide range of light

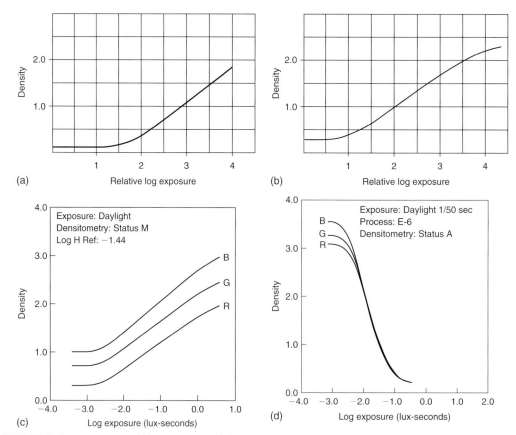

Figure 5.14 Characteristic curves of (a) an ISO 100/21° black and white film, (b) an ISO 400/27° black and white film, (c) an ISO 400/27° colour negative film and an ISO 400/27° colour slide film. Diagrams (a) and (b) reprinted with permission from Ilford Photo/Harman Technology Limited. Diagrams (c) and (d) reprinted with permission from Eastman Kodak Company.

exposures given to the film (log relative exposure), scaled on the x-axis of the graph. Both density and log exposure are logarithmic quantities (density is the log of the film opacity).

As shown in *Langford's Basic Photography*, a quick comparison of characteristic curves for different films shows you many of their vital differences. Relative contrast can be seen from the general slope of the curve; speeds can be compared broadly from how far to the left the curve rises from horizontal. Exposure latitude can also be gauged. This is done by seeing how far the range of exposure units representing your subject from the shadows to highlights (1:100 brightness range = 2.0 log E) can be moved in either direction along the log E axis before they fall on the unacceptably tone-flattening toe or shoulder of the curve. Characteristic curves published in sets like Figure 5.15 also show the effect of different degrees of development on density and contrast.

Reversal materials have characteristic curves which slope *downwards* as light exposure increases (see Figure 5.14 (d)). After reversal processing, parts of the image that contained most light reproduce as having least density – a directly positive result. The slide or transparency must have higher contrast to be viewed projected in total darkness as your final picture, unlike a negative, which is an intermediate and contrast can be boosted in the print. It also needs good

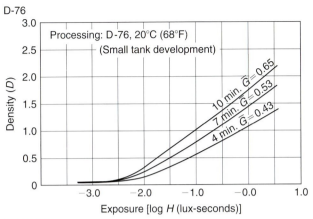

Figure 5.15 Characteristic curves showing the effect of development time on the response of a black and white negative. The film is developed for 4, 7 and 10 min. Longer times result in higher densities and increased contrast (G is the contrast index). Reprinted with permission from Fujifilm UK Ltd.

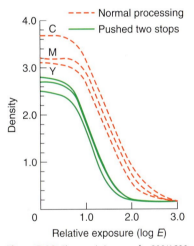

Figure 5.16 Characteristic curves for 800/1600 colour transparency film, given normal and (two stops) pushed processing. Unlike negatives, extra development lessens the final density of shadows.

clear highlights. These features are shown by a steeply angled curve and low density at the bottom of the curve 0.2 (it is mainly the density of the gelatine film base itself) (Figure 5.16).

Characteristic curves of colour film images are most often prepared by exposing the material to a transparent scale of grey tones, the light, of course, matching the colour temperature for which the film is balanced. The great majority of colour materials recreate all the colours of the picture through superimposed images in yellow, magenta and cyan dyes. So after film processing every tone on the grey-scale image is checked out three times with a densitometer, reading through a blue filter to measure yellow dye density, then a green filter for magenta and a red one for the cyan layer density. All three plots must coincide in shape along most of their length, as in Figure 5.14 (c) and (d) graphs.

It is vital that the same filters and densitometer colour response be adopted worldwide when making comparative measurements of this kind. Certified conditions known as *Status A* are used for positive colour film images. Three slightly different filter values are needed for evaluating colour negatives because the dye images here are geared to best suit the colour sensitivity of colour printing paper, not your eyes. Conditions are then called *Status M*.

Looking at Figure 5.14 (c), you can see that characteristic curves for a typical colour negative film, read through correct blue, green and red filters, are similar in contrast to regular monochrome negatives. They are also offset vertically. This displacement is due to masking built into the dye layers, designed to compensate deficiencies in negative and print dyes. Provided there is no displacement horizontally, and all curves match in shape, colour printing will cancel out this apparent discrepancy. Programs for quality control of colour processing make similar readings of test strips which are put through the system at regular intervals to check any variations in solution chemical content, temperature, etc. (see page 280).

Spectral sensitivity

A film's response to different colours of the spectrum is shown by a graph in which sensitivity (usually 'log relative sensitivity', being the log sensitometric speed of the photographic material determined at appropriate wavelengths) is shown against wavelength. The main points to look for in spectral sensitivity curves for black and white films are:

1. The highest wavelength cut-off point (Figure 5.17), showing whether a film is panchromatic, orthochromatic or only blue sensitive. Ortho films finally reproduce red lips, red lettering, etc. as black or very dark, but films can be handled under deep-red safe lighting. Blue-sensitive materials extend dark reproduction to greens but they are safe under bright amber bromide paper lights.

2. The uniformity of response of panchromatic film. Most films are panchromatic, but some fast materials have extended red light response which helps to boost speed and records more detail in deep-red subjects but also tends to bleach lips and other pale reds. Colour film sensitivity curves are in sets of three for the blue-, green- and red-sensitive layers. Each curve should just overlap so that every colour in the spectrum is recorded by some response in one or more layers.

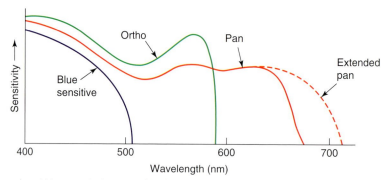

Figure 5.17 Spectral sensitivity curves for four types of black and white material. Extending panchromatic sensitivity to 720 nm boosts speed, especially in tungsten lighting. But for general work the final, positive, reproduction of red from negative material of this kind may be too bleached to be acceptable.

Colour balance

Colour films balanced for tungsten-lit subjects have blue-sensitive layers slightly faster in speed than red ones (Figure 5.18). This compensates for the fact that tungsten-lamp illumination is deficient in blue wavelengths relative to daylight. It has a lower 'colour temperature' (page 72). Therefore, by adjusting emulsion sensitivities the manufacturers can make different films balanced for practically any light source which gives out a continuous spectrum, i.e. contains a mixture of all visible wavelengths. In practice, only a few colour balances are on offer because, apart from daylight type, the market is quite small.

You may often have to pick the nearest film type and then make good any mismatch with a suitable colour-compensating filter over the lens (see Appendix F). Even with colour negative film it is still best to match up lighting and colour balance as closely as possible at the camera stage rather than rely too much on filtering back during colour printing (Figure 5.19).

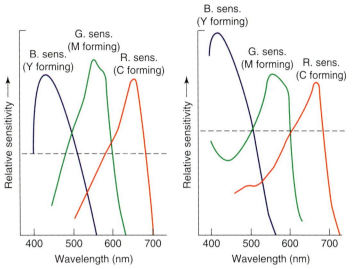

Figure 5.18 Colour-sensitivity curves for (left) daylight balanced, and (right) tungsten light balanced slide film. Only response above the broken line is significant. Notice the extra blue sensitivity of tungsten light film. If exposed in daylight it needs an orange filter to avoid excessive blue.

Film type	Colour temperature	Light source
'Tungsten' or type B	3200 K	Studio tungsten lamps
Tungsten movie stock or type A	3400 K	Photolamps
'Daylight'	5500 K	Sunlight + skylight and most studio flash

Figure 5.19 The three main colour film types and their (unfiltered) compatibility with various white light sources.

Reciprocity failure

The reduction in film speed which occurs when you give a very long exposure to a very dim image is usually presented as some form of table (Figure 5.21). Short-duration reciprocity failure is less important. Modern films are designed to respond normally for very brief (1/10 000 sec) bright images because this is needed for some forms of flash. However, long-duration reciprocity failure means that you may have to extend exposures of 1 sec or beyond. Remember this when using an AE camera in aperture-preferred mode which rarely takes reciprocity failure into account. Make corrections with the camera's exposure compensation dial.

With colour materials some form of pale correction filter may also be specified. Filter colour varies with different brands and types of film. Reciprocity correction is most critical on professional colour films, where sometimes separate types are made for different exposure times (see Figure 5.22). Try to work strictly to manufacturers' recommendations for critical record work, studio portraits, etc. Fortunately, in a great deal of existing light photography – taken at dusk or night, for example – slight colour variations are accepted as natural. Provided that you remember to bracket your exposures towards longer times, complicated filtration and multiplication calculations (leading to still more reciprocity failure) can usually be avoided.

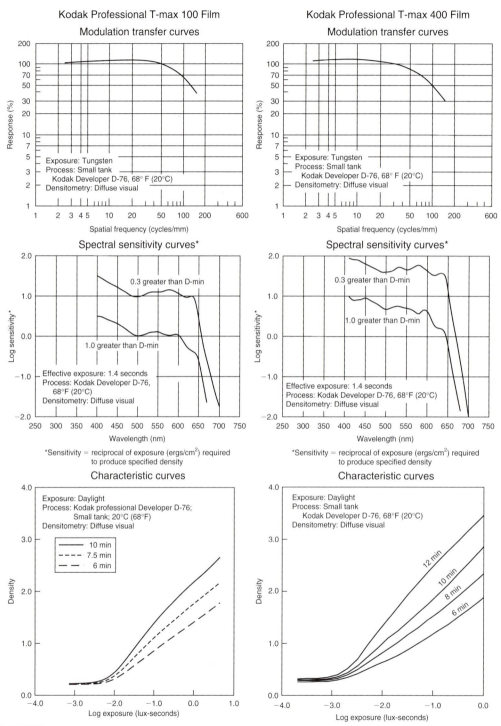

Figure 5.20 Part of manufacturer's data sheets for two black and white films, quantifying practical performance. Reprinted with permission from Eastman Kodak Company.

Indicated exposure time (sec) ▶	1	10	100
Most B&W neg films	$+^{1}/_{3}$ stop	$+^{1}/_{2}$ stop	$+1$ stops
Fujicolor 400	None	$+^{2}/_{3}$ stop	Not recommended
Fujichrome 400	$+^{2}/_{3}$ stop 5G	Not recommended	Not recommended
Ektachrome 64	$+^{1}/_{3}$ stop CC05R	Not recommended	Not recommended
Ektachrome 400	$+^{1}/_{3}$ stop	$+^{1}/_{2}$ stop	Not recommended
	CC05R	CC10R	Not recommended

Figure 5.21 Reciprocity failure varies with brand and film type. Filtration may be needed for color compensation.

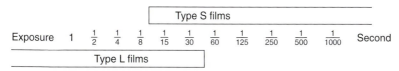

Figure 5.22 Type L professional colour films are formulated to be exposed at 1/30 sec or longer. Use Type S films for exposures of 1/15 sec or shorter. Type L films are also balanced for tungsten light 3200 K colour temperature, and Type S for daylight.

Product coding

Manufacturers mark up their products in various ways to identify type and batch. Most sheet films have coded notches (Figure 5.23) to show type, and may have a batch number impressed into the rebate of each sheet as well as printed on the outside of the box. Notches have the advantage that in the dark you can 'feel' the type of film you are loading. Rollfilm type information appears on the start and end of the backing paper and is printed by light along the film rebate for you to read after processing. Most 35 mm cassette-loaded film is DX coded to program the camera automatically for the film's characteristics.

DX information is communicated through a panel of 12 squares on the outside of the cassette, making up a chequerboard mixture of bright metal and insulated (painted) patches. As shown in Figure 5.24, shiny patches 1 and 7 are always unpainted electrical contacts. Probes in the camera film chamber use this common area as an earth. Battery power applied through probes in other positions 'read' information according to whether they touch bare metal and complete the circuit or are insulated by paint. Five patches communicate the film's ISO speed. Three more tell the camera film length – to program its liquid-crystal display (LCD) 'frames left' counter and film rewind, for example. A further two patches encode whether the film has narrow exposure latitude (colour slide material) or wider latitude (colour negative), information used to modify camera auto-exposure programs. These data are also useful if the camera's light-reading system works by comparing several highlight and shadow 'spot' measurements (see page 163).

Modern 35 mm cameras have 10 probes in two rows to fully utilize all the DX-coded information. Cameras with less than six probes default ISO 3200 film to 1600, while the simplest two-probe

Figure 5.23 Some notch codings from top right corner of sheet films.

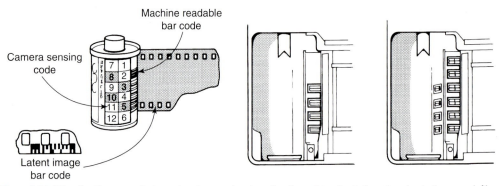

Figure 5.24 DX coding. The cassette's chequerboard pattern (numbered here) completes circuits through probes in the camera's film compartment. Centre: basic cameras use only three or four contacts. Right: advanced types have six more contacts, four covering squares 7–10 (film length, latitude, etc.).

models default all films ISO 800 and faster to ISO 400. What happens when you load the camera with an uncoded cassette depends upon the camera design. Most cameras set ISO 100/21° in default; some memorize and reset for the last film you loaded, then flash a warning in the viewfinder and top display panel. Take care if you refill old cassettes from bulk film of a different kind. Self-adhesive printed foil 'recoder' labels are available for specific ISO ratings.

Thirty-five millimetre cassettes also carry an external bar code which equipment at the processing laboratory reads immediately on arrival to sort films into batches for different processes. Finally, a code pattern, light-printed along the entire film rebate, can be read after processing by an automatic printing machine, which then adjusts its filtration and exposure to suit the parameters of your particular type of film. The machine's database will already be programmed to recall the colour balance and typical image density range of your film (along with the characteristics of dozens of other film types). Lab recognition is taken further with Advanced Photographic System (APS) 24 mm wide film in cartridges, designed for the amateur market. See *Langford's Basic Photography*.

Special materials

Instant pictures

A good range of instant-picture materials are made to be used with instant cameras and many professional cameras, provided the necessary accessories are in hand. They are made for different kind of applied photography as well as for the general professional or amateur photographer. Most peel-apart and integral-type materials are in packs which either fit instant-picture cameras or special backs which attach to regular large-, medium- or small-format cameras. Some 4 × 5 in. sheets come in packs as well as in individual envelopes. Peel-apart 8 × 10 in. colour material, in special envelopes, fits large-format view cameras. This material is 'processed' by feeding through a separate pod-crushing unit with 8 in. wide motorized rollers.

Both integral and peel-apart instant pictures are important aids for the photographer or scientist needing to confirm results immediately. However, it is difficult to run off duplicates or make enlargements without loss of quality. The complex chemistry in instant pictures is also temperature-sensitive. It is difficult to get results at all when photographing outdoors in near-freezing conditions unless you can warm the material while it processes. Instant pictures are

more expensive than regular films, even including savings on processing costs. The colour materials are balanced for daylight and flash illumination. You can fit camera lens correction filters for other light sources, but these filters may differ slightly in density and hue from types needed for conventional colour films (Figure 5.25).

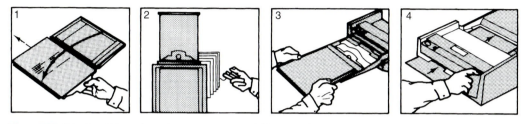

Figure 5.25 Using 8 × 10 in. peel apart instant-picture material. (1) A special holder hinges open to receive one sheet of material in a flat envelope. You reclose it, then remove envelope alone through bottom of holder. (2) Film holder is used as normal for camera exposure. (3) Holder, plus receiving paper and chemical pod, is faced up to processor unit. (4) Motor draws exposed material out of holder, passes it with the paper through pod-breaking rollers. Later you pull the two sheets apart.

Colour duplicating film

There are a few kinds of duplicating colour film made in bulk 35 mm and sheet film sizes. They are mostly colour reversal types, although some colour negatives that are designed for normal photography can also be potentially used as duplicating material. All of them are slightly low-contrast and have characteristic curves (Figure 5.26) which are predominantly long and straight with very little 'toe'. The reason for this is that when you are copying a colour photograph, duplicating a slide or turning either into a colour negative for subsequent colour printing you have to avoid two hazards. One is building up excessive contrast. The other is having correct midtone values but compressed tone and colour values in shadows or highlights, so that your result *looks* like a copy from its degraded darker tones or veiled highlights. You will meet both problems if you try duplicating on regular camera films. Colour materials designed specifically for duplicating purposes are normally balanced for tungsten light.

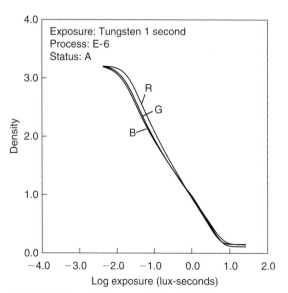

Figure 5.26 Characteristic curves of the Kodak EDUPE colour duplicating slide film. Reprinted with permission from Eastman Kodak Company.

Black and white slide film

Beautiful artistic pictures with superb image quality can be created using *black and white slide film* (true slide, in comparison to a negative processed to give a positive image). The Agfa Scala 200 35 mm slide film, is no longer made by Agfa. A replacement, the Fomapan R100, is provided by the Czech manufacturer Foma Bohemia Ltd and requires special processing using a

reversal kit specifically designed by Foma for this film. The film can be processed in variable speeds.

Lith/orthochromatic film

Lith film gets its name from the lithographic photomechanical reproduction and it is used for line drawings, some graphic arts applications and in the printing industry for line originals, lettering, etc. It is used much less nowadays, as it is largely replaced by digital processes. When processed as recommended it gives extreme contrast and very high maximum density. Lith film is very slow and most types have orthochromatic sensitivity (they are not sensitive to the red part of the spectrum), so you can handle and process them under deep-red safe-lighting. It is designed to be developed in lith developer, which allows development to start slowly and accelerate as the image forms. This so-called 'infectious' development gives lith film its extremely rich blacks combined with clear whites and no midtones. It also produces edge effects (see page 93).

Accurate exposure and processing times are very critical. The high contrast also exaggerates any uneven lighting. As with most materials of this kind processed to extreme contrast, you get some clear 'pinholes' in the image. Lith film is good for any subjects consisting pure black and white. You can make monochrome slides by exposing lith film to regular continuous tone negatives, under the enlarger or through a copy camera set-up. Three kinds of results are then possible: by processing in D-76 type developer the film gives normal contrast continuous tone monochrome slides. If you overexpose and then process by inspection in lith developer diluted to about one-quarter of the strength, results are normal in contrast but the tones are extremely warm. Alternatively, by careful exposure and standard lith development you can turn your continuous tone images into stark black and white.

Black and white and colour infrared films

Black and white infrared films, available in 35 and 120 mm rolls, have especially extended sensitivity to near infrared wavelengths (Figure 5.27). This means that they react to infrared radiation, which is invisible to humans. The effective speed will change according to the filter you use to block the visible (Figure 5.28). You can process black and white infrared films in most regular type film developers such as D-76 and print the results in regular black and white paper. Infrared properties and photographic techniques are discussed extensively in Chapter 13.

A 'false colour' infrared reversal 35 mm colour film is produced by Kodak. It differs in many ways from black

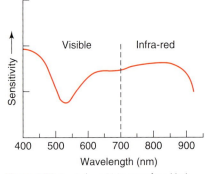

Figure 5.27 Spectral sensitivity curve for a black and white infrared film. Although sensitivity extends well beyond the (700 nm) limits of visible light the film is also sensitive to red, blue and ultraviolet. This can be controlled by using a deep-red or IR-only passing filter (see chapter 13).

Filter (Kodak no.)	ISO setting*	
	Daylight	Tungsten
25 (or 29, 70 or 89B) Deep-red, allow	50	125
Visual focusing 88A (or 87)	25	64
Visually opaque No filter	80	200
*Assumes you are not reading through filter.		

Figure 5.28 The effective speed setting for Kodak infrared black and white film varies according to the filter you use. Visually opaque filters are not very practical, and may result in excessively slow film speed.

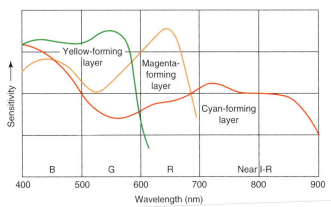

Figure 5.29 Colour sensitivity curves for emulsion layers in infrared Ektachrome film. Response is mostly to green (yellow dye forming), red (magenta forming), and infrared 700–900 nm (cyan forming). The sensitivity of the emulsion layers to blue light is subdued by exposing pictures through a yellow filter – often a Wratten 12 – is useful.

and white infrared material, as it has three emulsion layers, but instead of these being sensitive to blue, green and red they respond mostly to green, red and near infrared (Figure 5.29). The film is normally exposed through a deep-yellow filter to reduce the sensitivities of all emulsions to blue light. The three layers form yellow, magenta and cyan dyes, respectively. The practical effect of all this is that green foliage reflecting infrared (see Chapter 13) records in the green and infrared

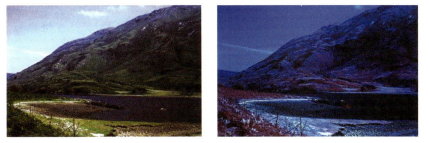

Figure 5.30 A landscape photographed (left) on regular Ektachrome film and (right) on infrared Ektachrome through a No. 12 yellow filter. Living vegetation produces magenta.

layers and so produces magenta (Figure 5.30). Red paint, flowers and lips appear yellow, but blue sky becomes dark blue or turns cyan.

Filter colour	Shifts image colour	
	from	to
As well as deep Y filter:		
Cyan	Green	More magenta
Blue	Cyan	More red
Magenta	Blue	More yellow
Cyan	Gives daylight result in	
(CC50C)	tungsten light	
Instead of deep Y filter:		
Deep red	All-over yellow	
Deep blue	All-over blue	
Deep green	Colder colours	

Figure 5.31 The effect of strong colour filters on infrared Ektachrome (deep yellow is normal). Read exposure through whatever filters are fitted, rating the film ISO at 200/24°.

Infrared colour film was designed for aerial photography, detecting camouflage from its living foliage surroundings and healthy forestry from diseased species. It is used also for medical applications. In general editorial and fashion illustration, this bizarre film is best used like a fisheye lens – with great restraint. You will produce most striking results by shooting landscapes in direct sunlight during spring (fresh growth contains most abundant chlorophyll, which reflects infrared). For different false colour effects try changing the deep-yellow filter for other strong filters, (see Figure 5.31). Focus the camera lens normally, because despite its infrared response the film still uses predominantly visible wavelengths. Infrared Ektachrome is processed in standard E-6 chemicals.

■ Early silver halide emulsions were blue-sensitive only, and crudely hand-coated onto glass. Today the industry has unprecedented control over crystal formation, thin multi-layer coatings and the use of additives. The result is new standards of light-sensitivity, colour fidelity, sharpness and freedom from graininess – but in growing competition from electronic methods of still-image recording.

■ For resolution, tone range and richness of colour, slides and transparencies are hard to beat. They are still preferred for printed reproduction. However, colour bias differs between brands.

■ Speed ratings are relative in many ways. With most materials much depends on the degree of processing you choose to give (least flexibility with colour negatives). Processing, in turn, depends on subject and lighting contrast.

■ Slides and transparencies are least tolerant of errors in exposure and lighting colour. When shooting under the most difficult conditions try to shoot colour (or black and white) negatives – then you can make improvements at the printing stage.

■ Other things being equal, the most direct route from camera to final result is usually best. Repeat exposures of the subject when runs of slides are required (colour or black and white); shoot colour negatives for colour prints and monochrome negatives for monochrome prints.

■ All dyes change with time. 'Dark' and 'light' storage stability varies with different dye types and colours. Avoid humidity, heat, fumes and prolonged bright light (including slide projection).

■ Grain ('noise') linked to fast, thick emulsions shows most in image midtones and can be measured objectively in terms of *granularity*. Subjective *graininess* combines visual effects of grain size, image detail and contrast, exposure and processing, after treatment, enlarging and final display conditions.

■ Chemical effects at tone boundaries improve the visual appearance of sharpness.

Edge effect is encouraged in emulsions and developers formulated to give such effects.

■ MTF graphs plot an emulsion's modulation against cycles per millimetre spatial frequency. Film MTF curves can be combined with the MTF of the camera lens to estimate the system MTF.

■ Characteristic curves plot image densities against log exposure to light. They help you to compare contrast, speed, palest and deepest tones, and the effect of processing. Densities of colour film materials are measured through appropriate A or M 'status' tricolour filters.

■ Spectral sensitivity curves plot emulsion response (log sensitivity) against wavelength. The relative spectral response of the three primary emulsion layers in colour film is designed to be balanced to record subject colours accurately under lighting of a particular colour temperature.

■ Reciprocity-failure loss of film speed differs in severity according to film type and brand. Published data show how to correct it through additional exposure, preferably by widening the aperture. Black and white materials can be given altered development to compensate for reciprocity-failure changes to contrast. Colour films may need a correction filter. Type S and L professional colour films are designed for shutter speeds and lighting colour balance appropriate to short or long exposure times, respectively.

■ Codings on packaging and on the film itself (notches, numbers and code light-printed on rebate) give identifying information. Thirty-five millimetre DX cassette code communicates film speed, length and exposure latitude to the camera, given sufficient sensing probes in the film compartment. Lack of DX information may set ISO 100/21° automatically.

■ Instant-picture materials come as peel-apart types (fit backs for regular cameras) and integral types for cameras having a mirror in the optical path. Thirty-five millimetre types yield instant colour or monochrome slides, given the use of the necessary Polaroid hand-processing unit. Advantages of almost

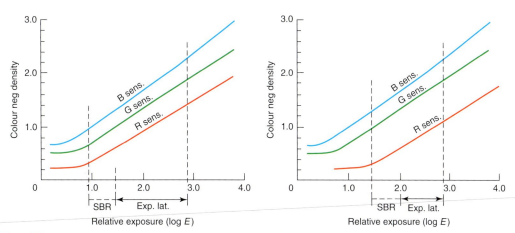

Figure 5.4 Characteristic curves for an ISO 100/21° colour negative film (left) exposed to a scene under correct colour temperature lighting, and (right) exposed in lighting deficient in red. Only the parts between the broken lines are usable if you want to avoid colour-distorted shadows. So, for the same subject brightness range (SBR) wrong colour temperature means less exposure latitude. Latitude shrinks even further with high contrast subjects.

With black and white material one-and-a-half stops underexposure and two stops overexposure are about the outside limits for fast and medium speed film. Exposure latitude is slightly less with slow films because they are higher contrast media. Even this amount of overexposure is undesirable with 35 mm or smaller images because you start losing resolution through light spread, and 'solid' highlight detail in the negative demands high-contrast printing paper which exaggerates grain.

Films for slides and display transparencies

When final results have to be slides for projection the obvious choice is 35 mm reversal film – if possible running off additional original exposures if more than one copy is needed. For extra copies later you can print off an original slide onto 35 mm low-contrast duplicating slide film (page 103). As an alternative you could shoot on colour negative stock and print onto print film. Both routes allow some adjustments of colour filtration and lightening of density through exposure, either overall or locally by shading. Best-quality monochrome slides result from 35 mm instant-picture film or black and white reversal film (see pages 102–103). Alternatively, slow general-purpose black and white negative such as Kodak T-Max can be used and given reversal processing (see *Langford's Basic Photography*). You can also print on lith film developed in dilute D-76 to get medium contrast results (page 104). Large display colour transparencies for rear-illuminated advertisements, etc. are most often enlarged on special print film from colour negatives, using the same processing chemistry as for negative/positive colour paper.

Films for prints

Prints have obvious advantages for jobs where the photograph itself is the finished product (for example, sales albums, framed display prints, etc.). Prints also accept retouching and artwork far more easily than images on film. The most obvious route to a colour print is to shoot on colour

negative and then use negative/positive paper by the same maker. The best monochrome print quality undoubtedly comes from good monochrome negatives. Bromide prints from colour negatives (preferably on panchromatic paper) give a handy method of proofing results for facial expression, etc. but do not make finished enlargements this way, because they will lack the subtle tonal values possible from black and white film. Otherwise, black and white chromogenic film, which is designed for C-41 processing and printing on color negative paper, has the advantage of rapid production in any lab that processes color negative film.

Image dye stability

All colour images change in the course of time. Dye stability varies with particular hue and from one brand to another. Materials which contain ready-formed rather than chemically generated dyes, such as dye-bleach paper give inherently long-lasting images. However, a given dye can have good stability in dark storage but fades fairly rapidly when displayed in the light, and vice versa. Trials show, for example, that the magenta dye in most regular chromogenic colour films and papers has good dark but poorer light stability. Cyan dyes often have the opposite characteristics. So when pictures are hidden away image colours gradually become warmer, but framed on the wall (or projected) they shift towards cold hues. A colour slide left showing continuously in a typical projector starts to bleach noticeably and colour changes after about 5 min. In general, slides shot on fast film stock deteriorate more rapidly than slow films and black and white silver images. Much depends on how you store your final images, of course. Always file colour photographs in cool and dry conditions (below 70°F (21°C) and less than 50% humidity) and avoid exposure to volatile chemicals. This includes contamination from unsuitable paper or plastic sleeves and envelopes. With properly processed and stored film you can anticipate a life of at least 20 years without perceptible colour change.

Understanding technical descriptions

The technical information departments of film manufacturers, and most technical photographic magazines, publish comparative data on products in the form of graphs, tables, etc. Some parts of this material are more useful than others, but provided you can read and understand it there is more information to be found here about practical film performance than in purely advertising literature. Topics covered include granularity, edge sharpness, Modulation Transfer Function (MTF) performance, characteristic curves, spectral sensitivity, reciprocity failure and DX coding.

Grain

The grain pattern seen in a processed photographic film is like 'noise' in an audio or electronic signal – an overlaid mealy pattern breaking up image tones and fine detail. You are always most conscious of grain in midtone parts of the image, especially flat, even areas such as the sky or a plain grey studio background.

Grain is coarser in fast films than in slow materials, partly because larger silver crystals are more sensitive to light and partly because fast films tend to have thicker emulsion layers. Thinner coatings of tabular shaped silver halide crystals (page 86) help to minimize this relationship, but

it is still inherent. In most colour films each colour-developed silver halide crystal produces a larger, roughly spherical patch of dye. Only these dye clouds remain after all silver is removed towards the end of processing, so although the dye coupling has effectively enlarged original grain size its *character* is softer, more globular and diffused.

Figure 5.5 Granularity measurement. A micro-densitometer tracking 0.1 mm across an apparently 'uniform' density patch gives this kind of analogue record traces indicating the density fluctuations around a mean density.

The grain qualities of a film are sometimes expressed by the terms 'granularity' and sometimes 'graininess'. They are not quite the same thing. *Granularity* is an objective figure. It is measured under laboratory conditions using a micro-densitometer which tracks across the processed image of an even mid-grey tone. The instrument's readout (Figure 5.5) can be converted into a number based on the average fluctuations of density above and below the mean density level.

Manufacturers therefore publish figures called 'diffuse RMS granularity \times 1000' for their regular film range, usually measured from an area with a density of 1.0. (RMS means 'root mean square' – an average you get by adding up the squares of the variations from mean density and taking the square root of this total.) Commonly, a 48 µm aperture is used for granularity measurements (the magnitude of the density fluctuations will vary with aperture area and therefore RMS granularity figures are comparable only if measurements are taken with similar area apertures).

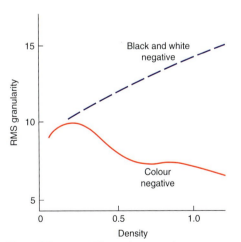

Figure 5.6 A major difference between colour negatives and black and white negatives is that as density increases image granularity pattern becomes less (colour) and greater (black and white). On this basis, colour negative film survives overexposure better than black and white film (but not chromogenic monochrome films).

A very fine-grained, ISO 25/15° thin-grained monochrome emulsion might rate 4 or 5 on this scale, whereas a black and white film of ISO 400/27° typically has a granularity figure of about 12. When you look at granularity figures for increasing densities black and white film continues to rise but colour tends to decrease slightly (Figure 5.6). One reason for this is that dye clouds visually tend to merge together more readily than silver grains. You should over- rather than underexpose colour negative film. Granularity figures are useful in comparing one film stock against another (they help to explain differences in film MTF graphs, for example, page 94). In practice many other factors influence the way grain looks in your final image.

Unlike granularity, *graininess* is a subjective measure, taking into account the overall visual impression of the enlarged result under practical

viewing conditions. It has to be based on 'average' observers reporting on just acceptable levels of grain pattern. The main factors influencing graininess are:

1. The granularity of the film you use.
2. Image content, i.e. whether your subject has a lot of fine detail that 'hide' the grain structure or uniform areas, proportion of midtones and the optical sharpness of its image. A soft-focus or movement-blurred camera image is more likely to display its grainy structure, as this emulsion pattern may be the only sharp detail you can see. However, a sharp negative printed through a diffused or unfocused enlarging lens will lose its grain pattern along with image detail (Figure 5.7).
3. Exposure and contrast. A black and white negative wholly under- or overexposed shows lower contrast and needs higher contrast printing, which emphasizes its grain pattern. Overexposure additionally scatters light, further reducing contrast so the prints made on high contrast paper end up with more graininess. Low-contrast subject and lighting conditions result in flat images which again need high-contrast paper, emphasizing graininess.
4. Degree of development – normal, held-back or pushed. Also, with monochrome silver emulsions, the choice of developer type. Overdevelopment and the use of speed-enhancing developers both increase graininess.
5. Chemical after-treatment of the film image. Most solutions which reduce or intensify image density also increase graininess.
6. Enlarging. Obviously, degree of enlargement is important, but so is type of enlarger (diffuser or condenser light source). Printing paper contrast and surface texture – glossy or textured – is a major factor, but not the paper emulsion structure because this is very slow and fine grained and not itself enlarged.
7. The viewing distance and the brightness of lighting on the final result. Also the conditions of viewing – a transparency surrounded by strong light on a viewing box shows less graininess than when masked off with dark surround.

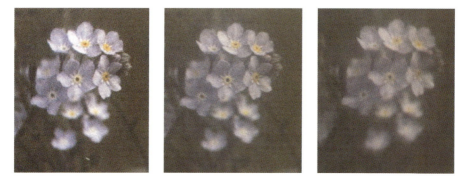

Figure 5.7 Left: normal photography on grainy reversal colour film. Centre: shot with a diffuser over the camera lens. Grain is still apparent. Right: reversal print from the left-hand transparency, with the enlarger lens diffused. Grain is blurred and thus visually lost, along with image detail.

Graininess is not always a thing to avoid. As long as it can be controlled you can use it creatively. Grain simplifies images by destroying unimportant small detail, evokes atmosphere and breaks up large monotonous areas of tone and colour. To maximize grain, shoot with a

immediate results must be balanced against cost; only camera-size pictures; and failure to work at low temperatures.

■ Lith film gives extreme black and white density and contrast in lith developer (infectious development). Exposure is critical, pinholes common; remember to maintain developer temperature. Uses include line subjects, highlight masking, etc. Processed in low-activity developer, lith film will give continuous-tone projection positives from normal-contrast negatives.

■ Black and white reversal 35 mm film is the most direct, high-quality route to monochrome slides.

■ Infrared monochrome films have sensitivity extended up to about 900 nm. Used with a deep-red or infrared-only passing filter, it records infrared reflectance that is invisible to the human eye.

■ Infrared colour reversal film (yellow filter) gives a mixture of false colours. Infrared reflecting vegetation records as magenta, lips and red paint yellow, giving bizarre results. The material is important too for aerial surveys of vegetation and some medical applications.

■ Colour reversal duplicating films offer low-contrast and long straight-line characteristic curves needed for duplicating slides.

1 Set up a display of coloured objects, such as fruits, coloured pencils, colour garments etc. Using standard lighting and your 35 mm camera try to shoot the same approximately frames on colour negative and on colour slide films. Print out the negatives on 127 × 178 mm quality glossy colour paper (see Chapter 12) or use a professional lab for the purpose. Have a good look at them under bright lighting conditions. Project the colour slides in a blackout room. Take a note on the vividness (saturation) of your colour objects and the overall image sharpness reproduced by the different media.

2 Visit the website of various film manufacturers. Download the technical specifications of one film of the same film format, speed and type (slide or negative) from each manufacturer. Compare granularity figures, characteristic curves, spectral sensitivities and MTF curves. Later, use these films in various photographic projects. Once you have collected a number of images and some knowledge on the behaviour of each film, try to associate *the objective information* provided on the manufacturers' data sheets with *the subjective impression* you get by looking at the images (e.g. MTF curves with image sharpness, granularity with graininess, characteristic curve properties with film contrast, spectral sensitivities with film colours).

3 Choose two of your pictures captured on black and white negative film. One image should contain a plenty of fine detail and the other a lot of uniform areas. Print the two images on multigrade paper:

(a) using different filtration for print contrast,

(b) at two three different sizes (contact prints, 127 × 178 mm and 203 × 254 mm). Observe graininess and with respect to image detail, image contrast and image size.

PROJECTS

The digital image sensor is considered in many ways the 'heart' of an image capture device. These silicon chips are about the size of a fingernail and contain millions of photosensitive elements called 'photosites'. They convert light imaged through the camera lens into electrical signals which are then processed to form a two-dimensional image representing the scene being captured. In this chapter the operation of a digital image sensor will be described. You will learn how photons striking a sensor are converted to electric charge. A photon is a single packet of energy that defines light. To capture an image, millions of tiny photosites are combined into a two-dimensional array, each of which transforms the light from one point of the image into electrons. A description of the different arrangements used for transferring charge from the sensor will be given. A basic image sensor is only capable of 'seeing' a monochrome image. The most commonly used methods for enabling a sensor to capture colour are presented. These include the Bayer colour filter array and the Foveon sensor array. Details about sensor fill-factor, microlenses and sensor dimensions are discussed. Image sensors are not perfect imaging devices and can introduce artefacts into the captured image. This chapter will present some of the more common artefacts associated with the application of imaging sensors. Noise, blooming and *moiré* effects, for example, are some of the most well known and studied image sensor artefacts. Another artefact, more commonly associated with modern Digital Single Lens Reflex (DSLR) systems, is caused by dust which can adhere to the sensor. Sensor specifications are an important consideration when choosing which digital camera to buy. The sensor specification will govern the type of lens required by the camera, the resolution of the captured images and the level of artefacts seen in the image.

An introduction to image sensors

The image sensor in a digital camera converts light coming from the subject being photographed into an electronic signal which is eventually processed into a digital photograph that can be displayed or printed. There are, broadly speaking, two main types of sensor in use today. The charge-coupled device (CCD), and the complementary metal-oxide semiconductor (CMOS) sensor. The technology behind CCD image sensors was developed in the late 1960s when scientists George Smith and Willard Boyle at Bell Labs were attempting to create a new type of semiconductor memory for computers. In 1970 the CCD had been built into the first ever solid-state video camera. These developments began to shape the revolution in digital imaging. Today, CCDs can be found in astronomical and many other scientific applications. One of the fundamental differences between CCD and CMOS sensors is that CMOS sensors convert charge to voltage at each photoelement, whereas in a CCD the conversion is done in a common output amplifier. This meant that during the early development of the sensors, CCD had a quality advantage over CMOS. As a result CMOS sensors were largely overlooked for

serious imaging applications until the late 1990s. Today the performance difference between the sensor types has diminished and CMOS sensors are used in devices ranging from most camera phones to some professional DSLRs. Major advantages of CMOS sensors over CCD include their low power consumption, low manufacturing cost and higher level of 'intelligence' and functionality built into the chip. In the consumer and prosumer market today, CCD is still superior due to its greater light sensitivity, dynamic range and noise performance. The Foveon sensor is based on CMOS technology and uses a three-layer design to capture red-, green- and blue-coloured light at each pixel. The Foveon X3 sensor is used in Sigma DSLR cameras designed by the company. A closer look at the Foveon sensor is given later in this chapter. More discussion on the different aspects of sensors can be found in Chapter 2.

Converting photons to charge

Image sensors are capable of responding to a wide variety of light sources, ranging from X-rays through to infrared wavelengths, but sensors used in digital cameras are tuned largely to the visible range of the spectrum; that is, to wavelengths between 380 nm and 700 nm. Sensors rely on semiconductor materials to convert captured light into an electrical charge. This is done in much the same way as a solar cell does on a solar-powered calculator. A semiconductor is formed when silicon, which is a very poor conductor, is doped with an impurity to improve its conductivity; hence the name semiconductor. Light reaching the semiconductor with wavelengths shorter than 1100 nm is absorbed and a conversion from photon to electrical charge takes place. This happens when the light provides energy which releases negatively charged electrons from silicon atoms. Note that light with wavelengths shorter than about 380 nm is essentially blocked by the silicon while light with wavelength greater than 1100 nm passes through the silicon practically uninterrupted. The response of a sensor in the infrared region is reduced in colour Digital Still Cameras (DSCs) by using an infrared-absorbing filter. Such filters are placed between the imaging lens and the sensor. The basic building block of a CCD sensor is the picture element, or pixel. Each pixel includes a photodetector, which can be either a metal-oxide semiconductor (MOS) capacitor or a photodiode. Each pixel also includes a readout structure. In a CCD, one or more light-shielded MOS capacitors are used to read out the charge from each pixel. In a CMOS sensor, several transistors are used to amplify the signal and connect the amplified signal to a readout line as the image is scanned out. The photodetectors of each pixel become electrically charged to a level that is directly proportional to the amount of light that it receives over a given period of time. The period is known as the integration time. A 'potential well' is formed at each photosite, and the positive potential of the well collects the electron charges over the period defined by the integration time. The capacity of the well is restricted and as a result a 'drain' circuit is normally included to prevent charge from migrating to neighbouring photosites, which can otherwise result in undesirable image artefacts such as blooming. You will read more about these artefacts later in this chapter. Photosite sensitivity is dependent on the maximum charge that can be accumulated as well as the efficiency with which photons that are incident on the sensor are converted into charge.

Once charge has accumulated in the potential well of the photodiode or photocapacitor, a clock circuit increases the potential of the adjacent structure, causing the charge from the photodetector to be transferred to the adjacent well. Figure 6.1 shows how charge transfer occurs between two wells. The clock signals that are applied to the gates take the form of complementary

square wave voltage signals. When the voltage at Gate 1 is high, and the voltage at Gate 2 is low, photo-electrons are collected at the Gate 1 well. When the high voltage begins to be applied at Gate 2, and the voltage at Gate 1 falls, charge flows from Well 1 into Well 2. (Note – the low potential is usually a negative voltage, not zero volts.) This process by which charge is transferred between wells is where the CCD gets its name. By arranging the MOS capacitors in a series (known as a CCD register) and by manipulating the gate voltages appropriately, charge can be transferred from one gate to the next and eventually to a common charge to voltage conversion circuit that provides the sensor output signal. This serial transfer of charge out of a CCD is sometimes described as a 'bucket brigade', where similarity is drawn to the bucket brigade of a traditional (old-fashioned) fire department.

The mechanisms by which CMOS sensors convert incident light into charge are fundamentally similar to those used by CCD sensors. The two sensors, however, diverge considerably in the way that charge is transferred off the chip.

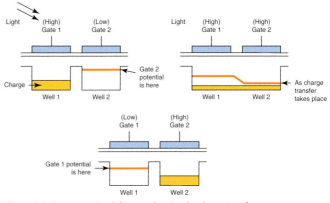
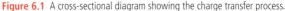

Figure 6.1 A cross-sectional diagram showing the charge transfer process.

Array architectures

In this section you will learn about the different ways that photosites are arranged in order that a two-dimensional image can be generated.

CCD sensors

An arrangement that is suited to flat-bed document and film scanners is to place the photosites along a single axis in such a way that scanning can only take place in a single direction. A stepper motor is used to position the array over the document or film (or to transport the film) and a single line of data is captured and read out of the array using the charge transfer process described above. The array is then repositioned and the data capture process is repeated. Limitations in the physical length of the array due to device fabrication constraints can be overcome by placing several linear CCDs adjacent to one another thereby increasing the overall length of the sensor. The time taken to scan an A4-sized document or a frame of 35 mm film can range from a fraction of a second to several minutes. For this reason, linear scanners are unsuitable for use in a digital still camera, except for a few specialized applications such as still life photography.

All area array sensors are based on arranging photosites on an x–y orthogonal grid. Area array sensors are the most appropriate arrangement for digital camera systems. The most popular CCD array architectures are the 'Frame Transfer' (FT) array and the 'Interline Transfer' (IT) array.

Frame transfer arrays are the simplest of all the CCD architectures and have the added benefit that they are also the easiest to fabricate and operate. A diagram of a FT array is shown in Figure 6.2. The array comprises an imaging area, a charge storage area and a serial readout register

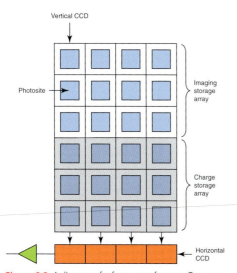

Figure 6.2 A diagram of a frame transfer array. Two arrays are used, one for imaging and the other for storage. Following exposure, photoelectrons are transferred rapidly from the imaging array to the light-shielded storage array. Data are then read out line by line to a serial register and off the chip for processing.

array. The imaging array is formed from an array of photosites, or pixels, arranged such that charge can be transferred in parallel vertically (vertical CCD). The entire pixel is dedicated to image capture in this architecture. The charge storage area is identical to the imaging array except for the fact that it is masked by a metal shield that prevents light from reaching the photosites. After exposure to light, charge is quickly transferred into the storage area. It is subsequently transferred one line at a time to the horizontal CCD and then serially to the output charge to voltage converter (shown in green). Image smear can be a problem with this type of array and this can result when the charge integration period (exposure time) overlaps with the transfer time to the storage array. The design of the frame transfer array can be simplified further by eliminating the charge storage array. To prevent light from reaching the imaging area while charge is being transferred to the

horizontal CCD, a mechanical shutter is fitted between the lens and the sensor. This has the added benefit of reducing smear which can occur during the charge transfer. This type of sensor is known as a full-frame (FF) array. Full-frame arrays are used in higher-end digital cameras such as DSLRs.

The second type of CCD architecture is the IT array. A diagram of an IT array is shown in Figure 6.3. In this type of array each pixel has both a photodiode and an associated charge storage area. The charge storage area is a vertical CCD that is shielded from light and is only used for the charge transfer process. After exposure, the charge is transferred from the photodiode into the charge storage area in the order of microseconds. Once in the storage area the charge is transferred to the horizontal CCD register and converted to an output voltage signal in much the same way as the FT array described above. One of the advantages of the interline design is that it is possible to re-expose the photodiode to light very soon after charge is transferred into the storage area thereby enabling video to be captured. IT arrays are the most commonly used array architecture in digital cameras

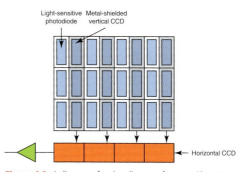

Figure 6.3 A diagram of an interline transfer array. Photosites comprise a photodiode and a light-shielded storage area. Charge is transferred from the photodiode to the storage area after exposure. It is then transferred off the chip to the horizontal CCD.

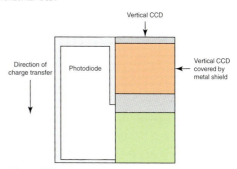

Figure 6.4 A simplified diagram showing the top view of a photosite from an interline transfer array.

today. Their ability to capture video enhances the functionality of the digital camera. Users are able to compose an image on the LCD fitted to the camera as well as being able to capture short segments (clips) of video. (Note – IT can also have smear (leakage) from the photodiode into the vertical register as the previous frame is clocked out. A shutter is normally used to eliminate this smear and to enable the sensor to use interlaced readout.) The main disadvantage of the IT architecture is that a significant portion of the sensor is now allocated to frame storage and, by definition, is no longer light sensitive. The ratio of the photosensitive area inside a pixel to the pixel area is impacted as a result. This ratio is known as the pixel 'fill-factor'. A diagram showing the top view of a pixel from an IT array is shown in Figure 6.4. The proportion of photosensitive area relative to the charge storage area is typically in the region of 30–50%. A lower fill-factor reduces the sensitivity of the pixel and can lead to higher noise and lower resolution. Later in the chapter you will read about ways in which the effective fill-factor can be improved by adding a small lens (microlens) to each photosite.

CMOS sensors

Most CMOS sensors today employ a technology in which both the photodiode and a readout amplifier are incorporated into a pixel. The technology is known as 'active pixel sensor' (APS). Unlike the CCD, the charge accumulated at each photosite in a CMOS sensor is converted into an analogue voltage in each pixel and the voltage from each pixel is connected to a common readout line using switching transistors in each pixel. The photodiode and associated amplification circuitry are arranged on an x–y grid as shown in Figure 6.5. An important advantage in the design of the CMOS array is that, unlike the CCD sensor array, charge from each pixel can be read out independently from other pixels in the array. This x–y pixel addressing scheme means that it is possible to read out portions (windows) of the array which can be used for advanced image processing applications in the camera such as light metering, auto focusing or image stabilization. The advantages and disadvantages of CCDs and CMOS sensors are summarized in the table shown in Figure 6.6.

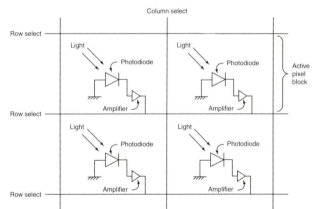

Figure 6.5 A diagram showing the arrangement of a photodiode and on-chip amplifier in a CMOS array sensor.

Canon was one of the first manufacturers to introduce CMOS sensors into digital SLRs. The first DSLR with a CMOS sensor was the prosumer Canon EOS D30 in 2000. Today CMOS sensors are finding their way into professional DSLRs. One example is the Canon 1Ds which uses an 11 megapixel CMOS sensor. The sensor size in this camera is equivalent to the size of a single frame of 35 mm film. Larger sensor sizes help improve fill-factor and reduce the higher noise levels that exist due to the additional on-chip electronics. Cameras in low power devices such as mobile phones, web cams and PDAs have, for many years now, been fitted with CMOS sensors. The sensors can be fabricated cost effectively with very small dimensions. Traditionally,

CCD advantages	CMOS advantages
Higher dynamic range (range of tonal values is greater) Very low noise levels Higher quantum efficiency High fill-factor – particularly for full frame and fram transfer CCD Mature technology	Higher level of integration of system components on the chip (system on chip – SOC). This can simplify electronics in the camera, such as analogue-to-digital conversion and image processing Lower power supply requirements and low power consumption. In addition x–y addressing scheme lowers power consumption because only selected pixels are activated Window of interest (WOI) readout capability provides flexibility and reduces power requirements Fabrication costs are lower
CCD disadvantages	**CMOS disadvantages**
Manufacturing process is complex No integration on chip	Image quality not as good as CCD mainly due to higher noise levels than CCD. This is due to the higher level of on-chip electronics Lower fill factor and quantum efficiency

Figure 6.6 The advantages and disadvantages of CCD and CMOS sensors.

the quality of images delivered by these devices has been inferior to dedicated compact digital cameras. More recently the quality of some phone cameras is comparable with low-end budget compact DSCs.

Optically black pixels

These are groups of photosites, located at the periphery of the sensor array, that are covered by a metallic light shield to prevent light from reaching the photosites during exposure. They are also commonly known as 'dummy pixels'. These pixels play an essential role in determining the black reference level for the image sensor output. Because no light reaches these pixels, the signal contained in a pixel comprises dark current only. Dark current is a consequence of the background charge that builds up at a photosite in the absence of photons (see page 123). The average dark reference signal at the optically black pixels is measured and its value is subtracted from each active pixel after exposure. This ensures than the background dark signal level is removed.

Obtaining colour from an image sensor

The sensor architectures described above are essentially monochrome-sensing devices that respond to light within a specified range of wavelengths. In order to be able to capture colour images some way of separating colours from the scene is needed before the light reaches the photodiodes in the sensor. The most obvious way to do this is to design a camera with three sensors, one sensor for red, one for green and another for blue. This technique is expensive and applied only in applications where high performance is needed; for example, high-end video capture systems. Most consumer digital cameras implement a more cost effective solution that involves bonding a colour filter array (CFA) directly onto the sensor chip above the photodiode array. In this arrangement each pixel is covered by a single colour filter, such as a red, green or blue filter. As light passes through the filter to the photodiode, only light with wavelengths

corresponding to the colour of the filter pass through. Other wavelengths will be absorbed. The resulting image, after filtering by a CFA, resembles a mosaic of red, green and blue since each pixel records the light intensity for only one colour. The remaining two colours are missing. It is worth noting that the red, green and blue filters used give wide spectral responses. The response through the red filter, for example, overlaps with the response through the green filter on its upper end and with the response through the blue filter at its lower end. Gaps which would result in some colours not being registered at all are avoided in this way. Figure 6.7 shows the response curves for an interline transfer CCD array with microlens.

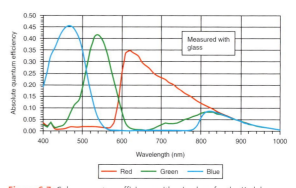

Figure 6.7 Colour quantum efficiency with microlens for the Kodak KAI-4021 interline transfer CCD image sensor. The sensor is a 4 million pixel sensor with 7.4 μm^2 pixels with microlenses. Reprinted with permission from Eastman Kodak Company.

RGB CFA filters are suited to digital camera applications due to their superior colour reproduction and high signal to noise ratio. The CFA pattern that is most widely used in DSCs today is the 'Bayer' pattern, first proposed in 1976 by B.E. Bayer from Eastman Kodak Company. The Bayer configuration, shown in Figure 6.8, has the property that twice as many green filters exist as blue or red filters. The filter pattern is particularly effective at preserving detail in the image due to the fact that the sensitivity of the human visual system peaks at around the wavelength of green light (about 550 nm). The material used for most on-chip CFAs is pigment based and offers high resistance to heat and light. Other filter patterns comprising cyan, magenta and yellow filters are used, typically in consumer video camcorders. These complementary colour filter patterns offer higher sensitivity compared to the RGB primary colour filter patterns, but there is a deterioration in the signal to noise level under normal illumination conditions as a result of the conversion of the complementary colours to RGB signals.

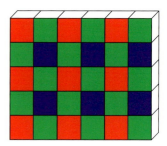

Figure 6.8 A schematic diagram of the Bayer colour filter array.

Since the CFA allows only one colour to be measured at each photosite, the two missing colours must be estimated if a full colour image is to be obtained. The process of estimating the missing colours is known as 'demosaicing' or 'colour filter interpolation' and is done off the sensor after the analogue signal has been converted to a digital form. Several methods exist for estimating the remaining colours at each pixel position. The techniques used extract as much information from neighbouring pixels as possible. The simplest methods estimate the missing colour values by averaging colour values from neighbouring pixels. These will work satisfactorily in smooth regions of the image but are likely to fail in regions where there is detail and texture. More sophisticated methods are therefore employed. For example, a reasonable assumption is that the colours across an edge detected in the image are likely to be different, while those along an edge are likely to be similar. Neighbouring pixels that span across an edge in the image are therefore avoided. Another assumption is that the colour of objects in a scene is

constant even if lighting conditions change. Abrupt changes in colour only occur at edge boundaries. Sudden and unnatural changes in colour are avoided and only gradual changes allowed. The hue-based method was common in early commercial camera systems but has since been replaced by more sophisticated methods. A poor demosaicing method usually results in colour *aliasing* (or *moiré*) artefacts in the output image. These are commonly observed around edge regions or areas with high levels of texture or detail.

The demosaicing process is, in most cases, conducted within the image processing chain in the camera and the user is likely to have little or no control over the process. Most professional and many higher-end consumer digital cameras today are able to save 'raw' image data. Raw data is the set of digitized monochrome pixel values for the red, green and blue components of the image as recorded by the sensor. Additional metadata relating to the image processing normally conducted in the camera is also saved. Proprietary software usually provided by the camera manufacturer can be used to reconstruct the full colour image externally to the camera and usually on a desktop computer. You will have more control over the quality of the result if you work with the raw image data (see Chapter 11).

Microlenses – increasing the effective fill-factor

As mentioned earlier in this chapter the interline transfer array for CCD-type sensors has a number of advantages over the FT array. This includes the ability to capture frames at a very high rate due to its fast electronic shutter. The CMOS architecture was shown to have several advantages over CCD-type arrays. Both these array types are widely used in consumer digital cameras today. One of the primary drawbacks with the IT CCD array and CMOS sensors is the relatively low fill-factor due to the metal shielding and on-chip electronics. To compensate for this, manufacturers fit small microlenses (or lenslets) to the surface of each pixel. The lenses are formed by coating resin onto the surface of the colour filter layer. The resin is patterned and shaped into a dome by wafer baking. Figure 6.9 shows a cross-sectional diagram of an interline transfer CCD with a microlens array. The tiny lenses focus the incident light that would normally reach the non-light sensitive areas of the pixel to the regions that are sensitive to light. In this way the effective fill-factor is increased from about 30–50% to approximately 70%. The sensitivity of the pixel is improved but not its charge capacity. A drawback of using a microlens is that the pixel sensitivity becomes more dependent on the lens aperture, since the lens aperture affects the maximum angle with which light is incident on the sensor. Wide angle lenses used at low *f*-numbers that are not specifically designed for use with digital cameras

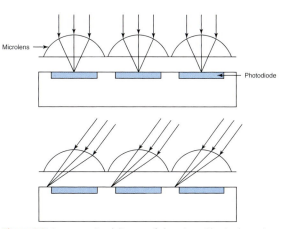

Figure 6.9 A cross-sectional diagram of photosites with microlenses in an interline transfer CCD. Light incident on the sensor at oblique angles can result in crosstalk with neighbouring pixels resulting in vignetting and a general loss of sensitivity by the sensor.

can result in light reaching the sensor at oblique angles. This results in a reduction in the effectiveness of the microlens, since some of the incident light strikes the light-shielded vertical CCDs. (Note – if light is reflected into the neighbouring photosites, it causes colour crosstalk.) This can result in vignetting (corner shading) and a general loss in sensitivity of the sensor. Another phenomenon that is caused by microlenses is 'purple fringing'. This results from a form of chromatic aberration which occurs at the microlens level and is most noticeable at the edges of high contrast objects. An example of purple fringing is shown in Figure 6.10. You can learn more about how to choose lenses for your digital camera in Chapter 3.

Figure 6.10 An example showing 'purple fringing'. This can result from 'chromatic aberration' occurring at the microlens level.

Anti-aliasing and infrared cut-off filters

When a scene is captured digitally any patterns or colours that did not exist in the original scene, but are present in the reproduced image are generally referred to as 'aliasing' (see page 120). Highly repetitive patterns and colours with sharp transitions occur regularly in the real world. For example, detail in fabric, strands of hair, text and metallic objects. If the sensor array that samples the image data projected by the lens is not fine enough then some degree of aliasing will result when the digital image is reproduced in a form that is suitable for viewing or printing. In a Bayer array sensor system, aliasing colour artefacts can be enhanced or reduced by different demosaicing processes, but processes that reduce the aliasing usually also reduce the image sharpness. To minimize aliasing artefacts manufacturers of DSCs fit anti-aliasing filters in the camera. The filter is an optical device that fits in front of the sensor and behind the camera lens. The filter band limits the image by lowering the contrast of the highest frequency patterns in the scene to match the capabilities of the sensor. Apart from minimizing aliasing and *moiré* patterns, a side effect of the anti-aliasing filter is that it introduces a slight degree of controlled blurring in the reproduced image. This is normally offset by sharpening the image. This is done in the camera signal processing, but you can apply additional sharpening when editing the image on your computer.

Silicon, as mentioned earlier, is sensitive to radiation with wavelengths in the infrared region as well as visible light. Manufacturers therefore fit infrared cut-off filters to minimize the possibility of colour contamination due to the infrared wavelengths in the final image. Some anti-aliasing filters have a built-in secondary IR coating which filters out more of the IR wavelengths reaching the sensor. Most digital cameras have anti-aliasing filters fitted, although there are exceptions. The Kodak Pro 14n digital SLR camera was fitted with a 13.7 megapixel (effective) full-frame CMOS sensor. You can read more about the meaning of megapixel ratings in the next section. Kodak decided to leave out the anti-aliasing filter and as a result the images delivered by the camera were exceptionally sharp. However, artefacts such as colour aliasing are

sometimes visible in areas of very high detail. Another camera which lacked an anti-aliasing filter was the Sigma SD-9 SLR. This camera was fitted with Foveon's X3 sensor (see page 118).

Sensor size and pixel specifications

Probably the most well known and widely reported sensor specification is the number of pixels of a digital still camera. This number, usually in the order of millions of pixels, relates to the number of photoelements, or pixels, that exists on the sensor itself. The number of pixels is usually associated with the quality and resolution of images that can be delivered by the digital camera. However, that is not always the case, and selection of a camera should not be based on pixel count alone. Several factors contribute to image quality, and some these are discussed later in the section on sensor artefacts.

It is quite common that not all the pixels in a sensor are active when an image is captured. A proportion of pixels sometimes falls outside the image circle provided by the camera lens. 'Ring' pixels lie inside the image circle and are used for processing the captured image. They do not directly form part of the image itself. Some pixels that lie outside the ring area are optically black and are used for noise cleaning. You can read more about noise cleaning later in the chapter. Figure 6.11 is a diagram showing sensor pixels. Manufacturers of DSCs will report the number of 'effective' pixels as well as the number of 'total' pixels particularly for higher-end DSLR cameras. The number of effective pixels is the total number of pixels that are used to create the image file, and includes the ring pixels described above. A guideline for noting camera specifications was published in 2001 by the Japan Camera Industries Association (JCIA). This guideline in now maintained by the Camera and Imaging Products Association (CIPA) after the JCIA was dissolved in 2002. (Note – A similar guideline, ANSI/I3A 7000, was published in the US in 2004.) The guideline states that the effective pixels should not include optically black pixels or pixels used for vibration compensation. The effective number of pixels provide a more realistic indication of the image capture performance than the total number of pixels.

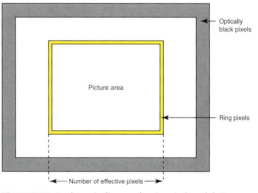

Figure 6.11 A schematic diagram showing pixels and their relationship to the image sensor.

In Chapter 2 an overview of image sensor sizes was given. CCD sensors today are given a 'type' designation that has origins that date back to the standard sizes that were assigned to imaging tubes more than fifty years ago. The optical format types (for example, 0.5 in.) are historically based on the outer diameter of the glass envelope of a vidicon tube. Examples of sensor types and their respective diagonal lengths, in millimetres, can be found in Figure 2.14. An estimate of the approximate diagonal length of the sensor can be made if you assume that 1 in. equals 16 mm for optical sensors with formats that are greater than 0.5 in.. For sensors with formats smaller than one-third of an inch assume that 1 in. equals 18 mm. Full-frame sensors have dimensions that correspond to the size of a 35 mm frame of film. They are normally used by professional digital SLR cameras. The Canon EOS-1Ds

and the Kodak DSC-14n are examples of DSLRs that use a full-frame sensor. The Four Thirds standard was developed by Kodak and Olympus for use with digital SLR camera systems. The system specifies the sensor format as well as lens specifications and is designed to meet the requirements of a fully digital camera system. One of those requirements is the telecentric lens design which you can read more about in Chapter 3. The sensor size, referred to as a Four Thirds type sensor, has dimensions that are slightly smaller than other digital SLR sensors but larger than compact digital camera sensors. One way that the Four Thirds system differs from the 35 mm film format is in its image aspect ratio. It uses a 4:3 image aspect ratio compared to the aspect ratio of 3:2 used by the 35 mm format. The 4:3 aspect ratio has traditionally been used by television and has become the most commonly used aspect ratio in computer monitor display standards. Some cameras that use the Four Thirds system include early designs such as the Olympus E-1, released in 2003, and more recently the Olympus E-510, released in 2007. Other manufacturers such as Panasonic, Fujifilm, Sanyo, Leica and Sigma have also developed cameras that use the Four Thirds system.

Alternative sensor technologies

In this section you will read about two different and alternative sensor technologies that are currently being used in commercially available digital cameras today. The Foveon sensor uses CMOS semiconductor technology but uses a three-layer photodetector that 'sees' colour in a way that mimics colour film. The Super CCD is based on CCD technology but uses an alternative pixel pattern layout that is based on a 'honeycomb' pattern.

The Foveon sensor – X3

The Foveon X3 image sensor, introduced in 2002 by Foveon Inc., is a photodetector that collects photoelectrons using three different wells embedded in the silicon. As described earlier in this chapter, image sensors are essentially monochrome-sensing devices, and by using an array of colour filters superimposed over the photodiodes a colour image from the scene can be obtained. Application of a CFA, such as the Bayer pattern, however, means that only one colour is detected per pixel and values for the other two colours need to be estimated. Unlike conventional sensors based on the CFAs, the Foveon sensor is capable of capturing red, green and blue colours at each pixel in the array. The demosaicing process described for CFA-based sensors is not needed with the Foveon sensor.

The Foveon sensor is based on the principle that light with shorter wavelengths (in the region of 450 nm) is absorbed closer to the surface of the silicon than light with longer wavelengths (600–850 nm). By specially designing each photosite to collect the charge accumulated at different layers of the silicon a record of the photon absorption at different wavelengths is obtained. Figure 6.12 shows a cross-sectional diagram that illustrates the

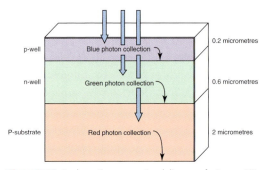

Figure 6.12 A schematic cross-sectional diagram of a Foveon X3 sensor. Light with short wavelengths is absorbed near the surface of the silicon while longer wavelength light is absorbed deeper in the silicon.

sensor layers. The Foveon sensor is formed by stacking three collection wells vertically thereby collecting photons at different depths. The silicon itself acts as a colour filter, since the blue photons are more likely to recombine near the upper well, while the red photons are more likely to penetrate much more deeply into the silicon and recombine near the deepest well. The spectral responses of the three wells are very broad, however, somewhat similar to cyan, magenta and yellow filters. Infrared and UV cut-off filters are used to band-limit the captured light. Although the demosiacing process is not needed, several processing steps and image processing functions are applied before the captured image data is suitable for being viewed on a colour monitor or printed. This includes colour correction processing to compensate for the overlapping spectral sensitivities of the three collection regions.

The Sigma SD9 digital SLR camera was the first camera to use the X3 Foveon sensor. It produced a 10.2 million value raw file that comprised 3.4 million values per colour channel. After processing the raw values a 3.4 megapixel image file was produced. It is generally recognized that images captured with the X3 sensor have higher resolution than those captured with a Bayer sensor when the detail in the scene comprises mainly red and blue primaries. The resolution provided by the X3 sensor was claimed to be comparable to a Bayer sensor with between 5 to 8 megapixels. However, the performance of the X3 sensor under low light conditions has been noted to produce noisier images.

The super CCD sensor

The arrangement of photosites described earlier for CCD and CMOS sensors involved placing rectangular photosites on an x–y grid pattern. One of the problems with IT and CMOS designs was the relatively low fill-factor due to the charge storage area in the vertical CCD. One arrangement that results in an increase of the active (light sensitive) area in the pixel relative to the normal IT CCD is the pixel interleaved array CCD (PIACCD).

(Note – This PIACCD is still an IT CCD.) The PIACCD, more commonly known as the Super CCD, was developed by Fujifilm in 1999. Octagonally shaped pixels are placed in a honeycomb pattern as shown in Figure 6.13. The arrangement increases sensitivity, since the photodetectors are slightly larger. The pixel pitch of the Super CCD is finer in the vertical and horizontal directions than is the case for a normal IT CCD with an equivalent number of pixels. This is achieved at an increase in pixel pitch along the diagonal axes (45° from the normal). The sampling characteristics of the Super CCD are reported to be better suited to the properties of the human visual system which is more sensitive to vertical and horizontal patterns.

(a) (b)

Figure 6.13 (a) Rectangular photosites on a conventional grid; (b) the Fuji Super CCD arrangement comprising octagonal sensors in a honeycomb arrangement. Note the vertical distance, d1, between cells in the conventional grid is larger than the inter-photosite distance, d2, in the Super CCD. The same applies to the horizontal distance. However, the spacing in the diagonal direction of the Super CCD, d4, is greater than the spacing in the conventional grid, d3.

To produce an image that can be manipulated, viewed on a monitor or printed the information captured by the octagonal pixels in the Super CCD has to be first converted to a

digital image with square pixels. This is done using a colour filter interpolation process that converts the offset colour sample values to an array of square pixel colour values. Since the introduction of the original Super CCD, Fujifilm has developed newer generations of the sensor known as Super CCD HR (High Resolution) and Super CCD SR (Super dynamic range). The SR sensor uses the same honeycomb pattern of the HR sensor. Each octagonal photodiode however is replaced by two smaller octagonal photodiodes that differ in size and hence sensitivity. They are known as the primary and secondary photodiodes and are placed under the same microlens and colour filter. The primary photodiode, which is larger and hence more sensitive than the secondary photodiode, measures the majority of light from the scene. The secondary photodiode has low sensitivity and records only the brightest parts of the image. Because of limitations in the charge storage capacity of a photodetector, described earlier in this chapter, photons reaching the sensor from the brightest parts of the scene can result in overflow of charge. Detail present in the brightest part of the scene is not therefore always recorded by the primary photodiodes. Fuji claim that combining the output from the primary and secondary photodiodes produces an image that contains more detail in the highlight and dark areas of the image than is possible with a conventional CCD sensor. However, this combination occurs only after the separate samples have been read out from the sensor, which doubles the number of charge packets that must be transferred, compared to a conventional IT CCD.

Image artefacts associated with sensors

You will have read earlier about some of the limitations and constraints that exist in the design of image sensors. These constraints often give rise to some well-characterized image artefacts which can affect the quality of the reproduced image. Probably the most well known and widely discussed artefact is image *noise*. This is an apparently random variation in pixel values that is similar to the grain that is sometimes visible when enlargements are made from film. If image noise is excessive, it can be undesirable. On the other hand noise may be introduced purposefully to add artistic value to an image. Other image artefacts include *blooming, clipping, aliasing* or *moiré* patterns and, in the case of digital SLRs with interchangeable lenses, dust on the sensor. In this section you will read more about what causes these artefacts, how to recognize them and how to avoid them.

Aliasing and moiré

Patterns and textures in the real world can take on an infinite range of shapes and frequencies. When a digital image is acquired the scene is sampled at discrete spatial positions by the image sensor. If the highest frequency in the scene exceeds the sampling frequency of the image acquisition system then aliasing can occur. Aliasing can give rise to jaggies or *moiré* patterns in the image. *Moiré* patterns are visible as a pattern of stripes or bands that exist where the level of texture and detail in the scene is high. Aliasing can occur not only at the acquisition stage of an image but can be introduced when an image is resized to contain fewer pixels. To avoid aliasing it is necessary to band-limit the input data using a low pass filter. The low pass filter is carefully designed to limit the maximum frequency to a value that is less than the sampling frequency. As mentioned earlier in this chapter (page 116), most digital cameras today contain an optical anti-aliasing filter between the sensor and the camera lens to limit the range of input frequencies

reaching the camera sensor. Anti-aliasing filters can, however, introduce some blurring into the reproduced image and manufacturers try and reach a compromise in the design of the filter. Coloured *moiré* patterns can also be introduced by the sampling and demosaicing processes in Bayer arrays. The effect here is observed as a pattern with false-coloured edges. Figure 6.14 is a photograph that clearly shows the effect of colour *moiré*.

Special image charts containing swept black and white square wave or sinusoidal patterns can be used to probe aliasing in digital cameras. One such target, the circular zone-plate, is a chart containing a two-dimensional swept (continuously varying spatial frequency) sinusoidal wave. This chart is essential when

Figure 6.14 A photograph illustrating aliasing and colour *moiré* in a digital camera. The numbers relate to the width of the vertical bars and are defined as the number of lines × 100 per picture height. In this example, strong aliasing and colour *moiré* are seen between 2000 and 2500 line widths per picture height. This corresponded to a spacing of approximately 0.1 mm between the black vertical bars.

it comes to designing the anti-aliasing filter in a DSC. The ISO 12233 standard test chart was developed for the purpose of testing digital still cameras and is described in more detail in Chapter 3. The chart contains swept square wave patterns which can be used to explore the amount of aliasing introduced by the camera. The ISO test chart is shown in Figure 3.24. When evaluating digital cameras look for colour *moiré* artefacts in high frequency and textured patterns. If possible look at a digital image of a test chart containing fine detail (such as the test chart described above) captured with the camera you are evaluating.

Blooming and clipping

The range of lightness values encountered in a typical scene is very wide and levels can often exceed 10 photographic stops when reflections from diffuse and specular objects and light sources such as the sun are taken into account. When a high level of light is incident on a photodiode in an

image sensor, the well capacity of the photodiode may be exceeded. Charge may then leak into neighbouring pixels and blooming can occur. This is usually seen as a bright area around the bright spot in the image where charge overflow occurred. Sources that can give rise to blooming include the sun, a specular reflection off a metal object or a lit candle captured under low light. In CCD sensors, a characteristic vertical streak that extends along the height of the sensor can occur. This happens when charge leaks into the vertical charge transfer array and contributes to the charge being transferred out of the sensor. Figure 6.15 shows an example of blooming. Note that blooming can increase the visibility of purple fringing described earlier in this chapter.

Figure 6.15 An example showing the effect of blooming in a digital camera image.

Normally when a scene is captured using a digital camera, the camera electronics will attempt to expose for the most important parts of the scene, usually the mid-tones. If the tonal range in the scene is very high, for example, a bright sunny day, or a powerful flash was used to light the subject, small changes in lightness at either end of the lightness scale may be impossible to discriminate in the resulting image. In this case the pixel values in the image are constrained (clipped) to the maximum value, at the scene highlights, or minimum value, at the scene shadows. The maximum and minimum values are set by the output device capabilities or image file format. Figure 6.16 shows an image containing highlight clipping. Note the regions in the image where detail is lost. Clipping can occur in one or more of the red, green or blue pixel values of the output image. If highlight clipping occurs in one or two colours, then a colour shift is frequently seen. For example, if the red pixels are clipped, Caucasian skin can turn orange–yellow in hue. Some quantization (banding) may also be observed. If all

Figure 6.16 A photograph showing an example of highlight clipping. Note the dramatic shift in hue that occurs in the sky region. The blue pixels are the first to clip, followed by blue and green and finally all three colours.

three colours are clipped then detail is completely lost and the area becomes white. Scene highlights are said to be burnt out. With shadow clipping, detail may be lost and shadow pixels can take a coloured appearance, although shadow clipping is generally less noticeable and objectionable than highlight clipping. The best way to avoid clipping is to underexpose the image slightly. You can adjust the lightness and contrast of the image manually later on your computer.

Image noise

One of the aspects of digital cameras that has attracted much interest over the years is image noise. Noise in digital images appears as a random variation in pixel values throughout the image. It is often described as the

Figure 6.17 A photograph showing the effect of noise in a digital camera image.

equivalent to grain in silver halide film. Although noise can take on the appearance of grain in a print or slide, it can be more objectionable when it appears as a low-frequency mottle or if it is combined with colour artefacts. Figure 6.17 shows an example that illustrates the appearance of noise in digital camera images. In general, the sources in a digital camera that contribute to image noise are difficult to identify. It is certain, however, that there are several sources of noise and they all appear as variations in image intensity. The sources of noise fall broadly into two categories; fixed pattern noise (FPN) and temporal noise.

Fixed pattern noise

Fixed pattern noise (FPN), as the name suggests, is image noise that forms a spatially fixed pattern across the image. Most of the FPN noise is introduced under dark conditions, for example if the lens cap is on or the subject is not illuminated. The source of the noise is mainly due to dark current non-uniformity (DCNU) and results when the dark current of each pixel is different over the sensor array. Dark current is the small amount of electrical current that continues to flow through the device even though no photons are reaching it. Because the generation of dark current is a random process, it is possible to reduce the noise caused by DCNU, but not to eliminate it, by subtracting the average dark current of each pixel from the captured image (see page 113). Some FPN is also introduced under illuminated conditions. DCNU is generally not visible under normal illumination conditions but can often be observed when exposure times are long, for example, in low-light photography. High temperatures increase DCNU, and sensors used in astrophotography are frequently cooled to reduce the level of DCNU. Dark current can also reduce the available dynamic range of the sensor, because the well capacity of the pixel is reduced. The dynamic range of a sensor is the ratio of the maximum output signal that can be obtained from the sensor to the dark noise output signal level.

Temporal noise

Temporal noise is a variation in image noise from one image to the next. Pixel values vary randomly over time. Unlike FPN, temporal noise can be removed by averaging the frames taken from several exposures. The effect of noise reduction by frame averaging is a characteristic of the human visual system. When you go to the movies or watch television, your eye naturally smoothes out most of the noise in the picture by averaging it from frame to frame. Some of the sources that contribute to temporal noise include shot noise, reset noise, read noise and dark current shot noise. The quantification of the effect of noise in an image on the performance of an imaging system is reported by measuring the signal to noise ratio (SNR). High values of SNR correspond to high signal quality and relatively low noise level. When the ratio of signal to noise is low, image quality can degrade and noise is likely to be more visible in the image.

Shot noise

In any photodetector system where photons arrive randomly and are converted to charge, the resulting noise is associated with shot noise. For example, shot noise is observed in thermionic values (or vacuum tubes) and semiconductor devices such as photodiodes and MOS transistors. During exposure of a photodetector to light, the actual number of photons that are collected by the detector is not known. What is known is the average number of photons collected. Therefore, the actual number is described by a statistical distribution, known as the Poisson

distribution, whose mean is centred at the average number of photons collected. In this distribution the standard deviation (a measure of the spread of values) is equal to the square root of the average number of photons. The SNR is then found by dividing the average number of photons collected by the standard deviation of the noise. The best possible SNR that can be achieved by a detector is the square root of the average number of photons collected. Shot noise is more problematic at low light levels since the signal-to-noise ratio is low. At high light intensities the SNR is higher and shot noise has a negligible effect.

Reset noise

Another source of noise is reset noise. At the sensor device level, before charge is converted into a voltage, the photodiode and video line circuitry are reset to a reference voltage by a field effect transistor (FET) amplifier. There is an uncertainty in the reference voltage that arises due to the interaction between the FET and the capacitance of the photodiode and amplifier circuitry. This noise is dependent on temperature as well as capacitance. Most manufacturers of image sensors are able to eliminate reset noise completely using special signal processing circuitry.

Read noise

Read noise (also known as readout noise or output amplifier noise) is noise that is added to the charge when it is read out of the sensor. This noise is independent of the exposure time and is produced when the charge is converted from an analogue to a digital value. Thermally dependent noise is present in the output amplifier and contributes to read noise. Other sources of read noise include flicker noise and clocking noise. Flicker noise is a noise that is inversely dependent on the frequency with which pixels on the sensor are read. Cameras that read out pixels slowly have higher flicker noise. Clocking noise arises from the various clock circuits that are used in the camera electronics to transfer the image through the sensor and to eventually process the data. Variability in the clock edge due to jitter contributes to clocking noise. Higher clock frequencies introduce high levels of clocking noise into the system.

Dark current shot noise

Dark current noise was discussed earlier in the context of FPN. Although average dark current noise that contributes to FPN can largely be eliminated, the shot noise component of dark current cannot be reliably removed. The shot noise associated with dark current is also equal to the square root of the average integrated dark charge at the photosite.

The influence of sensor size on noise

Most image sensors used in compact DSCs are very small. In Figure 2.14 you can see that the typical size of a sensor fitted in a compact DSC is in the region of 6.7–16 mm when measured diagonally. Compared with the size of the sensors fitted to many digital SLRs (around 28 mm), these sensors are very small. Today the numbers of pixels offered on compact DSCs and digital SLRs are very similar and many cameras offer pixel counts in the region of 8–10 megapixels. Thus, the dimensions of photosites in sensors fitted to compact DSCs are significantly smaller than those fitted to digital SLRs. The current state-of-the-art pixel size is of the order 2.2 μm for CCD sensors and 2.25 μm for CMOS sensors. By comparison the pixel size in a Nikon D70s SLR which is fitted with a 23.7 mm × 15.6 mm, 6.1 megapixel sensor array is 7.8 μm. Smaller pixel sizes result in a decrease in sensitivity and full-well capacity. Smaller pixels are therefore less effective at accumulating charge from incident photons and for a given exposure, the amount of

amplification needed is higher. Increasing the level of amplification also increases the noise. Thus under low light conditions, smaller sensors are more likely to produce noisier images than larger sensors. The reduction in full-well capacity also means that the dynamic range is likely to be reduced. Photosites are likely to reach saturation more quickly thereby resulting in clipping or blooming in the output image. The resolving capability of small pixels is affected also (see Chapter 2 for more information about pixel size and resolution).

It is worthwhile noting, however, that under high levels of illumination sensors with low sensitivity produce perfectly good images with very low levels of noise. Under these conditions, the cameras are likely to be used at their lowest ISO settings (for example, 80 or 100 ISO) and the signal amplification from the sensor will be at its minimum. It is under low illumination levels, when the ISO setting in the camera is likely to be set higher (for example, 400 or 800 ISO) that noise in the image can become problematic.

Reducing noise

Most digital cameras employ some form of internal processing that reduces the level of noise in the image. You can also reduce noise in your images after you have transferred them to your computer using special image editing software that offers a noise reduction capability. High levels of noise are more difficult to remove, especially if the noise is combined with colour artefacts. In this case noise reduction algorithms are sometimes unable to distinguish between the noise and fine detail in the image. Sometimes it is preferable to leave some noise in the image rather than to apply large levels of noise reduction which can result in the loss of fine detail.

Defective pixels

Hot pixels are created by pixels on the sensor that have a higher rate of dark current leakage than other neighbouring pixels. As mentioned earlier all pixels have some degree of current leakage which is visible as FPN under long exposures. Hot pixels are simply pixels with significantly higher than average dark current leakage. They normally are visible as bright one pixel wide spots that may be coloured red, orange, green, yellow or just appear as white pixels. Hot pixels are more likely to be noticeable when illumination levels are low and exposures are long. They may become more apparent after the camera heats up during a prolonged period of usage. Other pixel defects include 'stuck' pixels and 'dead' pixels. Stuck pixels are pixel values that take on the maximum value independent of the exposure level. In Bayer sensors they will appear as either red, green or blue pixels depending on the colour of the Bayer filter tile that overlies the photosite. Dead pixels are pixels that read the minimum value (zero or black) and are also unaffected by exposure. All these types of pixel defects can usually be masked by image processing that is done internally in the camera, which replaces the defective pixel value with the average of neighbouring pixels of the same colour.

Dust

A problem that can affect digital cameras is when dust or other materials, such as moisture, are unintentionally deposited on the surface of the sensor. This is more common with DSLR cameras with interchangeable lenses. Every time the lens is removed dust can enter the camera body through the lens opening. When the camera is switched on dust may adhere to the sensor surface. One possibility is that a static charge builds up on the sensor and may attract the dust. The effects of dust are most apparent when photographs are taken with very small apertures due to the large depth of focus. They are least apparent at large apertures. Usually sensor dust can

appear as dark specs in a uniform region, such as a blue sky. One of the problems with dust is that it is cumulative and can, over time, get worse. Many alternatives exist to reducing the effects of dust on the sensor. You can remove the effects by using appropriate image editing software on your computer, or you can send the camera back to the manufacturer for cleaning. Other options include cleaning the sensor yourself using compressed air or brushing the sensor using a special brush with very fine fibres. Recently manufacturers of DSLR cameras have built integrated dust removal systems into their cameras. The Canon 400D camera removes dust using ultrasound vibration, a procedure that takes about one second to complete.

SUMMARY

■ One of the basic building blocks of a CCD sensor is the MOS capacitor. When light is absorbed in a semiconductor a conversion from photon to electrical charge takes place. The amount of charge that is collected by a photodetector is proportional to the amount of light received over a given period of time. This is known as the integration time.

■ Frame transfer arrays and full-frame arrays are commonly used CCD architectures in digital SLR cameras. Frame transfer arrays contain a light sensitive array of photosites and a metal-shielded charge storage area that is used to temporarily store the charge before it is transferred off the sensor. Full-frame arrays are simpler to manufacture and reduce smear during charge transfer by eliminating the storage array.

■ Interline transfer arrays are the most common type of CCD array in consumer digital cameras today. Each pixel comprises a photodiode and an associated light-shielded charge storage area. A benefit of interline transfer arrays is their ability to capture video. Their main disadvantage is that fill-factor is reduced. This can be offset by using microlenses.

■ APS technology in CMOS sensors enables both the photodiode and readout amplifier to be incorporated into a single photosite. Charge accumulated is converted to an analogue voltage in the photosite and can be converted to a digital signal by on-chip A/D converters. Advantages of CMOS arrays over CCD arrays include higher on-chip system component integration, lower power supply requirements and the capability to read out windows of interest.

■ Optically black photosites (also known as dummy pixels) are photosites on the sensor that are covered by a metallic light shield that prevents light from reaching the light sensitive components during exposure. They play an essential role in determining the black reference level for the image sensor output.

■ CFAs enable the separation of light incident on the sensor into three colour channels. This is performed on the sensor by covering each photosite with a colour filter corresponding to a single colour. The most popular arrangement of colour filters is the Bayer pattern array in which light is separated into red, green and blue components. A demosaicing process is applied to estimate the missing colours at each pixel thereby enabling a full colour image to be generated.

■ Microlenses are used to increase the effective fill-factor of CCD interline transfer arrays and CMOS arrays. A drawback of using microlenses is that pixel sensitivity is more dependent on the lens aperture and the angle at which light is incident on the sensor.

■ Anti-aliasing filters are normally fitted to reduce the possibility of aliasing or colour *moiré* in the final digitized image. Infrared cut-off filters are normally fitted to reduce the possibility of colour contamination due to infrared wavelengths in the digitized image.

■ The 'effective' number of pixels in a digital camera is the total number of pixels that are used to create the digital image file, but should not include optically black pixels or

pixels used for vibration compensation. The special requirements of digital cameras have prompted the development of entirely digital systems that specify the sensor used to the design of lenses which are tailored to the requirements of the sensor.

■ The Foveon X3 sensor uses three vertically stacked photodiode arrays wells that collect electrons at three different depths in the silicon. Because the Foveon sensor captures all three colours at each pixel position it can provide higher resolution than Bayer sensors having the same number of pixels. The Super CCD sensor is an arrangement of octagonally shaped photosites in a honeycomb pattern. Sensitivity and vertical and horizontal resolution are increased relative to conventional CCD arrays.

■ Jaggies or *moiré*-type patterns can be introduced into an image as a result of aliasing. Coloured *moiré* patterns may be introduced by the sampling and demosaicing processes in Bayer-type sensors. Special test charts containing fine detail can be used to evaluate the degree of aliasing in a digital camera.

■ Blooming is seen as a bright area that is roughly centred about a bright spot in the image. It results when charge overflow in the sensor occurs. Clipping is when one or more of the colour bands in a digital image reach their maximum or minimum value. It can occur in the highlight or shadow regions of an image resulting in loss of detail.

■ Sources of noise in a sensor include FPN and temporal noise. DCNU is problematic under low illumination conditions and can be significantly reduced using processing. Sources of temporal noise are shot noise, reset noise, read noise and dark current shot noise. Temporal noise is more difficult to remove in a camera because it varies between exposures.

■ The small sensor sizes used in compact DSCs are less effective at accumulating charge from incident photons for a given exposure and pixel count than the larger sensors used in digital SLRs. This is due to the smaller pixel dimensions. It is difficult to remove large amounts of noise without affecting fine detail in the image.

■ Defective pixels in a sensor include hot pixels, stuck pixels and dead pixels. Hot and stuck pixels are frequently visible as bright pixel wide spots in the image. Dust on the sensor is a problem that can affect digital SLR cameras with interchangeable lenses. Dust on the sensor can appear as specs of dark pixels and are more visible in large uniform regions of the image.

1 In this project you will take an exposure in the dark using your digital camera. This will allow you to observe the effect of noise due to DCNU in the image sensor of your digital camera. This noise forms most of the FPN that is present in the sensor. You will also be able to see if your camera has any hot pixels. Preferably use a camera with manual ISO speed and exposure controls. Disable the flash and set the ISO control to ISO 100 or 200. Turn off any long exposure noise reduction and set the image quality to normal or fine. Set the capture image size in the camera to large and preferably minimize any in-camera image sharpening. Set the white balance to daylight. Then set the exposure mode to manual or shutter priority, place the lens cap on the camera lens and in a darkened room take several exposures with an exposure time of about 8 sec. Transfer your images to your computer and open them up using an image editing software package such as Adobe Photoshop. Boost the pixel values in the image using the 'Levels' command in Photoshop or an equivalent tool until the noise pixels are visible. Look for hot pixels in the image and note the similarity in noise patterns between the different frames. You may have to zoom out so that a complete frame is visible.

2 To observe the effect of temporal noise, you can capture several frames under medium or low levels of illumination. Disable the flash and set the ISO value of your camera to ISO 400 or ISO 800. Place the camera on a tripod and capture several exposures indoors at a normal exposure setting. Adjust the ISO setting, aperture and shutter speed as necessary. You can illuminate your subject using natural light from a window or using artificial illumination such as tungsten lighting. Do not move your camera between exposures. Transfer your images to your computer and compare the noise patterns in similar regions of the scene. Note the random nature of the noise and observe the low level of correlation between successive frames.

3 In this project you will observe the effect of blooming and clipping in a digital image. To demonstrate the effect of blooming, first disable the flash on your digital camera and set the ISO to ISO 200 or ISO 400. Then capture an image of a bright light source; for example, an illuminated car headlamp at night or the flame of a burning candle in a darkened room. Note the effect of blooming around the light source. Demonstrate the effect of clipping by capturing a scene outdoors under brightly lit conditions. Underexpose the scene by about 1 stop so that no clipping is present in the image. Gradually increase the exposure until clipping in the highlight regions of the exposed image can be seen. Usually bright surfaces, sky and clouds will clip first. If the scene is too overexposed large regions of the image will loose detail and colour.

PROJECTS

7 Lighting control

This chapter will enable you to control lighting for photography on location and in the studio. The lighting considered includes daylight, studio lighting and flash, as primary light sources, in combination with each other and with ambient light.

Proficiency in lighting requires an understanding of the ways different light sources illuminate subjects, reveal information about them and influence the meaning of the final image. Once these are understood you can achieve any desired effect either by manipulating available light or by setting up appropriate lighting on location or in the studio. Furthermore you will be able to analyse, refer or recreate lighting styles deployed in historical and contemporary photographs, as well as in paintings and in cinematic and theatrical productions.

To control lighting there are five key aspects to analyse and coordinate; they are: size of light sources; direction and angle of light; distribution of light; contrast and exposure and colour.

Size of light sources

The most significant qualities of light are created by the size of the principal light source in relation to the subject. Observing the play of natural light on people, places, objects and surfaces reveals the essential characteristics of light and shadow. Sunlight falling directly on a subject casts shadows which have hard edges; sunlight diffused through cloud casts soft-edged shadows and an overcast sky casts virtually no shadows.

Any small light source casts hard-edged shadows, medium-sized lights cast soft-edged shadows and a large light source casts very soft-edged shadows.

Small source
Shadows
The smaller the light source the harder edged the shadows. Small sources are referred to as hard light sources because of the shadows they cast. Though the sun is vast, relative to us it is small, occupying an area of around 1% of the sky.

The qualities of small source direct sunlight is recognizable in sunny outdoor scenes: buildings and trees cast hard-edged shadows across the land, noses cast hard shadows across faces and people cast shadows across the shape of their bodies along the ground.

The same-sized natural or artificial light produces the same quality of shadow edge. This can be observed when the relative size of source is the same, whether it is the sun, a bare light bulb, torch, headlamp, flashgun or spotlight.

All these types of illumination originate from relatively small sources radiating light waves travelling in straight lines. When the source is of a size which equates to an angle of 1–20° in

relation to a subject, then the light waves will be diverging from the subject; no light waves immediately radiating from the source can reach around the subject. The transition from light into shade is then very abrupt and that there is little shading at the shadow edge.

A small source casting light across the subject reveals the texture of its surface since raised areas are lit on one side and cast shadows from the other; indentations receive no direct light so the convolutions of the surface are either in light or shadow with no shading in between. Across a face, every wrinkle, crease and hair cast shadows. The shadows are hard-edged and highlights bright, so sharp contrasts are formed (Figure 7.1). The area between highlight and shadow, the 'lit area', is distinct and well-defined.

In the landscape when the sun is low in the sky, angling across the land, it sharply reveals folds, contours indentations and mounds: they are either in light or shadow.

Figure 7.1 Mikayo is lit by a small source giving hard-edged shadows. A studio flash head with no reflector has been used to simulate sunlight, from an angle equivalent to 11 o'clock (75°). By Andy Golding.

Highlights

Small light sources illuminating shiny objects produce small, bright, *specular* highlights, producing pinpoints of bright, reflected light in eyes, water, metallic surfaces and glass. The highlight is the same colour as the light source on neutral surfaces. A small light source on semi-matt surfaces, such as brushed aluminium, eggshell paint finishes, many plastics and leather, will form a distinct highlight region.

Lit area

The space between shadow and highlight is the *lit area*. A small light source creates a discrete space with defined edges between the highlight and the shadow; in between them the tones and colours of the object are rendered in their most saturated and intense form.

Medium source

Shadows

As a light source size increases the shadow edges soften. A cloud diffusing the sun occupying 20–50% of the sky is such a medium-sized source. As the area of the light source increases in relation to the subject, the light waves increasingly scatter and can converge around the subject; the light wraps around the subject so shadow edges soften.

In diffused light beneath a beach umbrella the sun becomes a medium light source; light gradually shades from lightest to darkest areas and faces, bodies and objects will cast soft-edged shadows.

Larger light sources are mostly formed by diffusion or a combination of reflection and diffusion – the sun diffused by cloud or reflected from the side of a building; a flashgun bounced from a ceiling, diffused through or bounced from an umbrella; the filament of a light bulb diffused through a lampshade or reflected from a wall. These diffusing surfaces scatter the light around the subject, further softening the shadow edges.

Medium-sized light sources include the sun diffused through cloud, light bounced from walls, ceilings or photographic umbrellas, light from the sky framed by a window, photographic lamps diffused through softboxes or by 'trace' (lighting quality tracing paper) (Figure 7.2). From such sources light effectively wraps around the subject and gradually gives way to shadow. The three-dimensional nature of objects is translated to the two-dimensional image through the gradual transition of light into shade. Curvature and volume of objects is fully revealed as light, tone-by-tone, gives way to shadow.

Highlights

Medium light sources give substantial highlights and the shape of the light source becomes evident in reflections. The object radiating the light can be clearly seen in close-up; shiny surfaces reflect the shape of the light source – an illuminated cloud, umbrella or window will be revealed in miniature in the eye of a subject or in the highlight on an object.

Figure 7.2 David is lit by a medium source giving soft-edged shadows. A large softbox has been used to the side of the subject at an angle equivalent to 10 o'clock. This replicates Vermeer-like north light – light from a large window without direct sunlight. By Andy Golding.

Controlled use of the shape of the medium light source can be used to define the shape and surface of the object being photographed. The rectangular shape of a softbox reflected in the eyes can be used to suggest the light of a domestic window or of an artist's studio's north light, a vertically standing strip-flash can be made to run a highlight down the side of a bottle, an overhead studio lightbank (a very large softbox) can be manoeuvred to run a highlight along the length of a car.

Lit area

As the highlight increases in size along with the size of the light it begins to extend towards the shadows. Highlights can begin to dominate shiny areas and on semi-matt and matt surfaces they will begin to de-saturate the tones and colours of the lit area.

Large source

Shadows

The larger the light source the softer edged the shadows. When a source equates to more than 90–180° around the subject the light source begins to wrap entirely around the subject until no shadows are cast. Under an overcast sky on a flat landscape shadows become virtually imperceptible (Figure 7.3).

Highlights

Large light sources fill the highlight area. Eyes fill with highlight, bodies of water mirror the clouds and car roofs reflect the sky.

Figure 7.3 Large source lighting, such as this overcast sky, casts virtually no shadows. By Andy Golding.

Lit area

As the highlight area increases it fills the 'lit area'; tone and colour are de-saturated and the subject takes on a flat and even appearance.

Source size and meaning

The size of the principal light source dictates the way the subject appears in light and shadow and the way the surface textures are revealed. Beyond this, the size of the light source occurring in nature, on location or in the studio, is most significant in determining the range of meanings and connotations of the scene; we interpret the play of light metaphorically as well as objectively.

Sunlight implies a wealth of uplifting associations – sunny, sunshine, radiant, brilliant, dazzling, light, bright and luminous. The highlights, intense colours and hard-edged shadows of the midday sun simultaneously take on the uplifting, bright, sunny, sparkling qualities we associate with sunny days.

Shadow, on the other hand, is linked to metaphors of darkness and the dark side – shadowy, shady, dark, dim, dingy, gloomy and stygian. The de-saturated qualities of a sunless day bring with them the emotional connections we make with light which is overcast, clouded, flat, leaden, murky, dreary, etc.

As the sun descends shadows deepen, the world is seen in light and unseen in shadow. We tend to fear that which we cannot see; light and dark have become associated with good and evil. Sunlight gives way to moonlight and the lower key contrasts further suggest drama, darker moods and the possibility of danger lurking in the shadows.

Medium source lighting illuminates people and objects with a full range of tones; it smoothens and emphasizes curvature and roundness. It is literally and metaphorically easy on the eye and is inextricably linked with sensuousness and pleasure. In painting, the connection is with north light – the medium light source formed by the north-facing windows of artists' studios (where direct sunshine could never cast its hard-edged shadow). It is also the light most associated with classical studio oil painting particularly that of Rembrandt and Vermeer (Figure 7.2).

Direction and angle of light

The direction from which light strikes the subject is significant in key ways: revealing textural information on the subject's surface suggesting a time of day creating variously a sense of drama and heightened emotion; sensuousness and peacefulness and featurelessness and flatness implying the nature of an out of frame light source.

The position of the light is marked by the direction of the shadows; they are cast away from the light following the same angle. In the morning or evening, sunlight is low in the sky and lights objects from a low angle; long shadows are cast horizontally away from the light. As the sun rises in the sky, the light falls on the upper sides then top of objects, shadows shorten then fall below.

A small or medium or large light source behind and above us and directly in line with our eyes, falling on to the subject in front of us will be shadowless from our viewpoint as the shadow is formed directly behind the subject; light which directly front on to the camera view will reveal little of the texture of the subject.

As the angle moves away from the centre, shadows will be cast in the opposite direction from the light source; small sources casting hard-edged shadows, medium sources soft-edged. The texture of surfaces is revealed starkly with the hard-edged shadows of small sources showing up detailed facets and the softer shadows of medium sources describing volume and roundness.

A light off centre to our eyeline and lens position, just to the left or right, the highlight in the eye of someone sitting at the same height will be revealed to the left or right of the pupil – it is useful to consider these as the 9 o'clock, or 3 o'clock positions. A studio light at the same angle can be made to suggest sunlight just after sunrise or just before sunset, or of light emanating from table lamps or windows.

Small sources angling across objects give a sense of drama as long-deep shadows are formed. Medium and large sources soften the shadows and the literal flatness of the view reinforces a calmer impression of the scene.

In the studio, small source lighting from overhead can imply light sources that we are familiar with from above, midday sunlight, midnight moonlight, streetlights and living room lights. Small source lighting from the side might suggest morning and evening sunlight. Medium light sources from the side might suggest window light or artists' north light.

Distribution of light

Light radiates from a point source so that as distance doubles from the source it has spread four times as widely. This is *the inverse square law of light*. As a light source is moved further from a subject its intensity reduces by the square of its inverse. If a light is moved twice the distance from a subject the amount of light on the subject will be the inverse of 2^2 (the doubled distance). This is $(1/2^2)$ or one quarter. If the distance is quadrupled it will be $(1/4^2)$ or a 16th of the intensity, at eight times the distance $(1/8^2)$ one-64th of the intensity. An object 1 m from a small light source will receive four times as much light as an object twice as far away. There will be two stops difference in the exposure reading from nearest to farthest. Quadruple the distance and there will be a 16th of the light which is four stops less light.

The spread of light can be compared to the spread of paint from the nozzle of a spray can. A surface held very close to the spray will receive an intense stream of paint focused in a small area. If the surface is moved back twice as far the spray will cover an area four times greater, but the density of the paint will be four times less (for the same duration of spray).

This dramatic 'fall off' is only significant when a light source is close to the subject. The sun is 93 million miles away so the difference of distribution across the earth is imperceptible. However

a lamp 2 m from an object of 2 m width will illuminate the closest edge four times as brightly as the far side. Equally, across a row of people at the same distance the nearest person will be two stops brighter than the farthest. (To make the light distribution more even the light must be either moved away from the subject so that the difference across is less significant – or the light can be bounced, so that the increased area of light will reduce the distance to the overall subject.)

Contrast and exposure

In a scene lit by sunlight the main light (or key light) is the sun. But secondary light sources are also at play which act as *fill-in* light sources and contribute various levels of light to fill the shadows. In the absence of sky or bounced light, shadows in nature would be entirely black. However on a clear day the sky acts as a secondary fill light source alongside the sun. Furthermore the sun is reflected into shadow areas from the ground, walls, and other surfaces in the environment.

A single light on a subject in a black studio will offer little or no fill-in light and the contrast between highlight and lit area to the shadow will be so extreme that an exposure based on the lit surface will reveal no detail in the shadows. A white studio will offer some fill if the light source spills on to the floor or wall and is reflected back to the subject.

If some detail is required at the shooting stage in shadow then the difference between the lit area and shadow should be less than five stops for colour transparency film, seven stops for colour negative film and nine stops for the charge-coupled device (CCD) or complementary metal-oxide semiconductor (CMOS) sensor in a digital camera. However these are extremes and such levels of contrast require work in the darkroom or using image editing software such as Adobe Photoshop if shadow detail is required in the print. If the image is needed for publication then considerably less contrast is desirable as the printing process will limit the rendering of detail in shadow and highlight.

To measure contrast in the studio or in controlled location settings where the main subject is within easy reach, an incident light meter fitted with a flat diffuser is most useful to take readings of the light falling on different facets of the subject.

First check the subject contrast. Set the (ISO) speed and aim the meter towards the main light from the surface of your subject to be 'correctly' exposed. In portraiture this would normally be the side of the face nearest to the light, in still life it would be the surface most essential to the image. Take a reading and set the camera to this reading. Then aim the flat diffuser from the same component of the subject (face, package, bottle, object) which is seen in shadow from the camera position. Take another reading. If the shadow reading is one stop different (say f/8 when the lit area was f/11), then there is half as much light on the dark side, one stop less, so the lighting ratio is 2:1. If the difference is two stops (f/5.6 to f/11), a quarter of the light, the ratio is 4:1; if it is three stops (f/4 in relation to f/11), the ratio is 8:1 and so on.

These ratios are well within range of film and sensors to reveal details throughout the metered subject. Viewing the scene through squinted eyes gives an impression of the print stage contrast. To the eye the 2:1 ratio will appear quite flat, the 8:1 ratio will look relatively contrasty. At the print stage they will appear much more contrasty.

If time permits metering should now continue throughout the scene composed for the viewfinder. Care should be taken to meter the full length and breadth of the subject or the still life, and the full depth of the set from foreground to background. Note the ratios in relation to

the area of the scene to which the exposure is to be pinned. Any shadow area in which detail is required in the final image, which is beyond the bounds of film or sensor sensitivity, will require some form of fill lighting (conversely any area in brighter light in which detail is required will need to be masked or *flagged* from the light).

In a landscape the metering is best effected with a spot meter (or single-lens reflex (SLR) or digital single-lens reflex (DSLR) camera meter set to spot or centre-weighted meter mode), taking reflective readings from an area to be reproduced as a midtone in the image, then from shadows. In a landscape the contrast can be controlled by consideration of the time of year, the time of day and by waiting for periods of clear sunshine or for the sun to be obscured by cloud (depending on the desired high or low contrast and soft or hard shadow edges). The fill-in light is either produced by the blue sky, haze or cloud.

For a full consideration of the contrast in the scene, the 'brightness range' is the product of the lighting ratio multiplied by the tonal range of the subject, often expressed as a ratio of highlight to shadow brightness. For example, direct sunlight on a subject under a clear sky in an open area gives a lighting ratio, between sun and sky lit areas, of around 10:1 (3.5 stops). If a subject has a brightness range of 13:1, this will result in a total brightness range of 130:1, or seven stops.

In the plaster-shaped images shown in Figure 7.4, the difference between the objects in the foreground and the background might be 4:1. The lighting ratio, or lighting contrast, is the difference in light readings between the lit side and the shadow side of the object. In Figure 7.4c

(a) (b) (c)

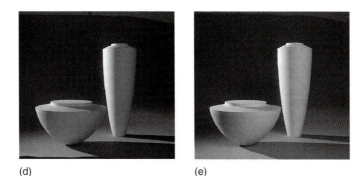

(d) (e)

Figure 7.4 Changes in lighting ratio. By increasing the amount of fill light from the camera, lighting ratios were (a) 1:64, (b) 1:20, (c) 1:8, (d) 1:4 and (e) 1:1.5. Reproduction here on the printed page has altered some tone values – they only approximate results on photographic bromide paper.

Figure 7.5 Direct sunlight on a subject under a clear sky in an open area gives a lighting ratio, between sun and sky lit areas, of around 10:1 (3.5 stops). An average subject (approximating to a midtone) gives a reflectance range of around 13:1. Altogether this gives a total brightness range of 130:1 (seven stops). By Andy Golding.

the lighting ratio might be 1:8. In combination the total contrast is 32:1, which represents the difference between the darkest area of background shadow and the brightest lit area of the object.

As a general guide (Figure 7.6) reversal films will record a maximum brightness range of 32:1 with full detail throughout. Monochrome negative will record around 128:1 (seven stops) or more if development is held back. Colour negative can record 128:1 in terms of detail but the colour begins to distort at the extremes of this range. CCD and CMOS sensors in digital cameras and backs capture a greater dynamic range than most colour films; an area array recording up to 250:1, a tri-linear array 712:1 or nine stops.

However the printing process will reveal a much more limited brightness range, around 32:1, or five stops for digital prints, 32:1 for colour negative, perhaps 128:1 for monochrome prints. Where the output range is lower than the recorded range the preferred range of tones should be printed or selected then local areas burned in or dodged out in the darkroom or in computer software.

	Maximum subject brightness range	No. of stops
Film:		
Continuous tone		
B & W neg only	1:200	7.5
Through to print	1:128	7
Reversal colour slide	1:32	5
Through to colour print	1:16	4
Colour neg only	1:128	7–8
Through to print	1:32	5
CCD (colour):		
Matrix	1:250	7–8
Tri-linear array	1:712	9–10*
Final print	1:32	5

*Reduced to eight stops for computer applications and output to printer.

Figure 7.6 The subject brightness range (subject reflectance range × lighting range) within which detail can just be recorded at one exposure setting. Often film records more than a printing paper will accommodate; you must then select your range of tones on the print through choice of exposure, and improve local areas by shading or burning-in. Similarly the dynamic range captured by CCD is electronically adjusted to meet the requirements of the printing-out device.

A great deal of time and effort can be saved in postproduction by controlling the contrast at the time of shooting; working in a subject brightness range of no more than three or four stops, 8:1 or 16:1 will ensure that colour, tone, highlight and shadow details will reproduce readily and accurately with little need for manipulation in postproduction.

When the brightness range of the scene is undesirable for the intended style, atmosphere and meaning, and it extends beyond the range of film, sensor or print then you may wish to apply some form of contrast control.

When addressing the lighting contrast:

1. Consider if the shot really needs detail from the brightest highlight to the deepest shadow. Sometimes an image benefits from black shadows to emphasize contrasts and drama. If this is acceptable or desirable then expose principally for the highlights and lit area.
2. Consider the reflectance range. High-contrast lighting is more difficult to manage for a scene including a person in a black suit standing against a white wall than it is for someone in a grey suit against a blue door.
3. Adjust the lighting ratio in relation to the film stock and sensor you are shooting with and for the final print medium.

When photographing subjects or nearby objects in the landscape consider using reflectors to bounce diffused light into the darkness of the foreground, or shoot in areas away from direct sunlight, lit only by the larger source of sky or cloud (but be aware of colour temperature changes – see page 73). Another option is to position your subject with the sun behind them and use white reflectors to catch the sun (use white card, polystyrene boards or collapsible reflectors). A reflector will create a medium light source, which becomes the main light source, the sun in turn becomes a backlight. Finally consider using flash to fill the shadows of the foreground (see the section on flashguns for details of this technique).

In the studio or indoor locations you might use white reflectors to fill in the shadows on your subject and, if possible and desirable, into the background. The reflector will always be less bright than the main light so will not add a second set of shadows.

When reflectors bounce too little light from the main light into the scene to sufficiently reduce the contrast, bounce an additional light into the reflector. Take care that the fill light does not begin to dominate the scene by becoming so powerful that it effectively becomes the main light, and take care also to ensure that the shadow shapes, depths and edges you require are not being over attenuated by the fill light source.

In the studio and on location where time permits, with every change to the lighting, take new meter readings, checking the ratios constantly against the area of the scene which is to be correctly recorded. Then take Polaroids and check the exposure, or shoot a digital frame and check the histogram to ensure that the contrast is as desired.

With experience you can judge the combined effect of subject and lighting contrast by eye with reasonable accuracy. When time allows it is best to make many meter readings throughout the scene to measure the lighting ratios so you can best assess how the final image will appear in print form – and in turn reduce to a minimum time in the darkroom or in computer manipulation.

Colour and colour temperature

The colour of light sources must be considered for photography on the one hand to ensure that colours are accurately recorded, and, on the other, as an influence on the atmosphere, style and connotations of the image.

Colour temperature

To accurately record a scene the colour of the lighting must be matched to the colour balance of the recording medium. It is most efficient and effective to control colour before the photograph is taken, rather than attempt to correct the lighting in postproduction, in the darkroom or with software.

Most colour film is daylight balanced and is manufactured to accurately reproduce colours lit by 'average sunlight' or flash lighting. Some film is balanced for photographic tungsten lamps but the range of such films is dwindling (see pages 75 and 88).

The *colour temperature* of light is assessed in relation to the colour emitted by heated metal. As metal is increasingly heated it begins to glow, first red then orange, yellow, white and finally blue (see page 72). These colours can be matched to the temperature at which they occur. So, for example the filament of a traditional 100-W-domestic light bulb heats up when switched on and glows. Measured on the Kelvin scale (K) it would have a temperature of around 2900 K. A domestic tungsten filament lamp looks yellow when compared to daylight as it radiates more yellow and red than blue light (see Figure 4.10). Hydrargyrum (mercury) medium pressure iodide arc (HMI) lights are the most favoured continuous light source for photographers and filmmakers; they are the same colour temperatures as daylight and are very bright, though very expensive.

Daylight film is balanced for 'daylight' or flash, tungsten film is designed for use with photographic lamps; under light sources of different colour temperatures the colour of objects will not be recorded accurately and colour casts will be noticeable in the final images.

Digital cameras can be balanced to a range of light sources. They can be set to auto white balance so that light falling on the sensor will be measured and processed to a neutral recording. They can also be preset for the average colour temperatures, increasing through tungsten, fluorescent, sunlight, flash, cloud and shade (blue sky only). Professional digital cameras and digital backs also allow for a 'custom white balance' to be set; the camera is aimed at a grey (or white) card illuminated by the prevailing light, and the reflected light is set as the correct colour temperature for the shot. In controlled conditions this is the most accurate method for dealing with colour temperature. In a studio shoot when the lighting has been fixed the custom white balance should be set for light reflecting from the main light. The white balance should be changed whenever the lighting setup changes.

When shooting RAW files the light prevailing at the time of the exposure can be corrected after the files are processed. Nonetheless, care with the colour temperature of the lights, ensuring that they are balanced to each other as much as possible, will greatly ease postproduction. Setting the camera's presets can be useful when shooting RAW to remind you later of the prevailing conditions.

In controlled conditions the inclusion of a grey card, and ideally a colour chart, in the first frame or two of a shoot, will provide a perfect reference for batch-processing digital files, and for printing digitally or from film. Cards and charts should be reintroduced whenever the lighting changes.

Colour temperature meters

In a neutral-coloured studio with standardized and matched lighting, results can be predictable. On location it is often only necessary to control the colour temperature of the predominant light on the principal subject. The colour temperature variances of the background can be tolerated and will often retain or enhance the atmosphere of the location. However where highly accurate colour reproduction is essential for say packaging, clothing, artworks and so on, there colour temperature of light sources can be measured with a meter (see page 75).

Note that the colour temperature meter is designed to read continuous spectrum light sources. It will give rogue readings of sources such as lasers or most sodium or mercury vapour

lamps because they all emit lines or bands of wavelengths with gaps in between (Figure 4.8). This confuses the meter's sensors.

Practical control of colour

Digital cameras can be set to the colour temperature of most prevailing light source, or set to auto white balance. Professional cameras can be custom white balanced. Colour negative is balanced for daylight and flash. Colour transparency film will also provide neutral results in flash and daylight and tungsten-balanced film will provide neutral results under appropriate photographic tungsten lights.

Radical shifts of colour temperature from tungsten to daylight and vice versa require strong blue or orange filters. A blue 80A acetate colour correction placed over tungsten photo lamps will filter the light for daylight film; it will shift the colour temperature from 3200 K to 5500 K. An orange 85B will shift a flash or daylight source to tungsten balance, 5500–3200 K. The same value glass conversion filters can be used over the camera lens to convert the colour temperature of the prevailing light to match the colour balance of film (80A if daylight film is used to shoot a tungsten-lit scene; 85B if tungsten-balanced film when shooting with flash).

In the studio when precise neutral results are needed some filtration of lights might be required. If tungsten is to be mixed with flash but both must appear neutral on daylight-balanced film, then the tungsten must be filtered with 80A acetate (or 'gel'). Exposure must be compensated for – the 80A will reduce the brightness of the tungsten lamp by two stops.

More frequently in the studio the adjustments will be needed to balance slight differences in lamps to bring them to the same colour temperature throughout the scene and to ensure no unintended casts across the subject or background.

The 81A or 81B light-balancing (yellowish) filters are often used to slightly warm up the colder than daylight average quality of light delivered by some flashtubes.

Colour-compensating (CC) filters are used to improve results when a film-based job allows for test, a test shoot and process (see page 76). When viewing a reversal film test with a cast to correct, look at the result through CC filters of the complementary colour – magenta for green, yellow for blue, cyan for red (and vice versa). Aim to make the mid-tones neutral, and ideally include a colour chart or grey card in the test to check against. Then re-shoot using a filter which is half the strength over the lens. For example, if a bluish slide looks correct when viewed on daylight-balanced lightbox with a 10Y (yellow) filter, then re-shoot with a 5B (blue) filter. This test should ideally be carried out on the same batch of film stock to be used and processed through the same line. The correction will not work on instant picture materials (Polaroid film for example) as they respond to filtration differently.

Finally check any exposure compensation needed by the addition of filter – either by re-metering the lights or by checking the literature on the lens filter (or test the difference needed by metering through the filter).

Mixed lighting

On location it is rarely possible to ensure that all light sources are of similar colour temperatures. Filtering the camera lens or setting the digital camera to one source will not balance all sources. This may not be a problem if the scene is acceptable for the intended use, and if it looks

aesthetically pleasing. However if colour balance throughout the scene is essential, then there are a number of solutions.

Filter one light source to match the other. For example if shooting a tungsten-lit interior with a window opening on to a daylight scene, the window can be draped with (full) orange 85B acetate to bring the light to tungsten balance. This has been the traditional method, often with the interior lighting boosted with supplementary tungsten lighting such as 'redheads'.

Domestic interiors are increasingly lit by 'energy-saving' lamps, these are compact fluorescent lamps which tend to give a green cast when film or sensor is daylight balanced. Fluorescent tubes come with a variety of spectral properties and subtle colours, each requiring different filtration to match them to daylight or tungsten (tubes can be identified by name and matched to filtration requirement listed in Kodak data books; an acetate sleeve of the correct value can be wrapped round each tube but this is extremely arduous and only worthwhile for big-budget shoots).

If flash is to be used in the foreground it can be covered with a filter (normally pale green) to match it to the fluorescent light, a correction filter (normally pale magenta) can then be added to the lens so that the whole scene appears neutral. Other options include relighting the interior with flash (normally through umbrellas or softboxes and bounced) or use HMI lamps and use a daylight balance.

When using film, if there will be no movement in the scene, it is possible to split the exposure; with the camera on a tripod cover the window with black velvet, and make and exposure with tungsten film. Switch off interior lights and make the second half of the exposure with an 85B orange filter over the lens. With a digital camera make two exposures – one balanced for the interior and one for the exterior and bring them together in postproduction.

It is only worth making such efforts if there is a real need aesthetically or commercially; mismatched colours can provide a sense of place and atmosphere; but ensure that the result will be as you desire. Often a controlled neutral region is all that is needed, and this can be affected with carefully directed and balanced flash leaving other light sources to be read by film or sensor, as they will.

Guidelines for lighting

To be able to create any lighting effect, no matter whether the light source is daylight, existing artificial light, a flashgun or studio flash or tungsten lighting, the following must be controlled:

- Size of light sources
- Direction of light
- Distribution of light
- Contrast and fill-in light and exposure
- Colour
- Meaning

In summary:

- Hard-edged or soft-edged shadows are controlled by the size of the light source relative to its distance from the subject.
- Direction of shadows and position of highlights are controlled by the height and direction of the light relative to the subject and viewpoint of the camera.

- Distribution, the evenness or fall off of light across the subject depends on the relative distances of the nearest and farthest parts of the subject from the light source. The more distant and large the light source the less fall off.
- Contrast or brightness range (lighting ratio) is the combined result of the highlight to shadow ratio and the subject's reflectance range. Brightness range is best controlled by the amount of fill light introduced into shadows.
- Exposure depends on the intensity of the light, due both to the power of the light output and the distance of the light source from the subject, attenuated by any reflectance or diffusion.
- Colour content is controlled by the type of light source and any colour surfaces or filters the light is reflected from or diffused through on the way to the subject.

Control of lighting is normally intended to create effects ranging from naturalistic to the theatrical. For a lighting setup to allude to nature it should be constructed on natural principles – we have one sun, which is for most of the day high in the sky, and the sky itself acts as a natural fill-in source to lighten shadows. To emulate this requires one main light source with no shade or reflector, set above eye height with some form of fill light.

When a studio setup is designed to mimic a particular location the lighting should be 'motivated' (Figure 7.7); lights should share the qualities of the lights they are intended to infer, and be sized, positioned and coloured accordingly. An overhead small source can imply a room light, or the stereotypical view of an interrogation cell; medium source side lighting can be made to suggest window light. Scenes suggesting streetslights require small sources from above coloured accordingly, knee-level-focused beams can suggest car headlamps.

Figure 7.7 Small source flash rim lighting and side lighting have been coloured within sympathy with the location lighting. The flash exposure has been balanced with the background. This is an example of 'motivated' mixed lighting. By Andy Golding.

Lighting to supplement or enhance location lighting should be 'justified' – that is designed to share the qualities of existing lighting in the home, office, shop, club, hotel, restaurant, factory and so on. Lights of similar source sizes can be positioned at similar angles to existing lighting, to raise overall intensity for exposure yet at the same time retaining the atmosphere of the place. Care should be taken to ensure that the supplementary lights do not cast inappropriate shadows across and away from any existing lights which appear in frame and additional fill is often needed to give shadow detail.

Dramatic lighting of people most frequently refers to theatrical conventions and cinematic genre. Multiple small sources, focused spotlights, casting very hard-edged shadows, can be made to emulate heightened emotions through the contrast and difference of light and shade, or cinematic *film noir* conflicts of good and evil.

At a more routine level the lighting of intricate multifaceted subjects (product shots, pack shots, clothing samples, jewellery and glass) often require the simplicity of medium-to-large light

sources so that soft shadows or shadowlessness, complement, simplify and clarify the objects for the final image. Such subjects can be shown to clear effect with overhead light from softboxes (or just to the side to once again imply a window) or a light tent which envelops the still life object in a diffuse, highlight enhancing, large source (Figure 7.8).

Figure 7.8 A light tent for still-life photography.

Lighting equipment

Most professional photographic lighting is produced with flashlights – it is very powerful, relatively lightweight and cool running. Much can be achieved with flashguns but studio lighting; portable flash kits and rechargeable flash kits are the most practical means of lighting still life, portraits, group portraits, interiors and exteriors.

Power pack (monobloc)

Power packs generate power for separate flash heads. They contain capacitors, which store power at very high voltage to be switched to a number of flash heads. They can be suspended from the studio ceiling in a *lighting grid* or can stand on the floor. Their power is rated in watt seconds (or Joules); a reasonably powerful pack, capable of powering up to three flash heads would be rated at 3000 W sec. A symmetric pack splits power equally to additional heads, an asymmetric pack allows variations of power to the flash heads.

Flash heads include the flash tube; a glass tube of Xenon gas, which emits light (flashes) when excited by the high voltage from the power pack passes through it. The flash tube encircles a *modelling light*, a bright tungsten source which can be switched on continuously so that the quality and spread of flash to come can be visualized. The flash head has a fitting to which *light moderators* can be attached – reflectors, barndoors, focusing spots, snoots, honeycombs, grids-pots, umbrellas and softboxes.

Monolight

A monolight combines the powerpack and the flash head. Their compactness does not allow them to be as powerful as a powerpack/flash head combination. They are typically rated at 250–500 W sec. Their advantage is their comparative lightness and portability. They can also be fitted with the full range of light modifiers.

Reflector – spill kill, wide angle, flood, capped flood

The reflector contains and directs the flashlight. A wide-angle reflector is chrome-lined, short and flared to direct the light most widely. A flood is broader and may come with a cap to conceal

the flash tube and modelling light – this ensures that the light is a single reflected medium source rather than a combination of small source flash tube and medium source reflector (which gives two shadow edges (Figure 7.9 (a)).

Barn doors
Hinged metal flaps that attach to reflectors to further direct light and prevent spill (Figure 7.9 (b)).

Honeycombs or lighting grids
Metal grids in the shape of honeycombs which gather the light to a narrow area; the finer and more extended the honeycomb cells the more focused will be the area of light.

Snoot
A conical attachment to narrow the pool of light (Figure 7.10).

Umbrellas
A reflecting umbrella is fitted to the flash head to bounce light to the subject. A silver-lined umbrella is the most efficient but focuses light more narrowly than a white umbrella. Some umbrellas are tinted gold to produce a warmer light. A transmission umbrella is made of white translucent material. The flash head is aimed through it to enlarge the light source in relation to the subject. As light is also reflected more light is spread around the set which acts as a secondary fill source (Figure 7.11 (a)).

Softbox
A rectangular, lightweight box with a reflective interior and a translucent front. Light from the flash head is directed into the box where it is reflected and diffused to create a medium light source (Figure 7.11 (b)).

Lightbank
A large softbox.

Flag
Any object used to prevent light from spilling into unwanted areas.

(a)

(b)
Figure 7.9 (a) A reflector attached to a flash head, and (b) A flashead with a reflector and barn doors attached.

Figure 7.10 Flash head with snoot. A lighting grid may be attached in front of the snoot.

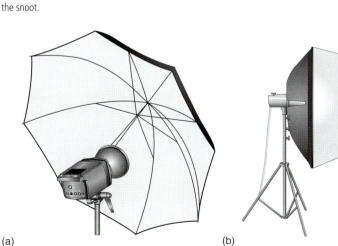
(a) (b)
Figure 7.11 An umbrella (a) and a softbox (b) attached to a flash head.

Figure 7.12 Focusing spot.

Scrim

A semi-translucent flag – used to cut down the power of light spill.

Focusing spot

An attachment including lenses to focus the flashlight into tight circles or through shapes in metal 'gobos' to provide sites or dapples of light.

Lighting principles in practice

Studio portraiture

Plan the shot in advance, have the lighting and style firmly in mind before you start and have everything in place before the subject arrives.

Figure 7.13 A medium source of light a little above and to the front and side of the subject. Fill light to the right of the camera angled into the subject using a reflector.

Fix the camera position and the subject position, ideally with plenty of space from the background so extra lights can be introduced from behind if needed. The most straightforward and conventional approach is to set up a medium source of light a little above and to the front and side of the subject (at a 10 o'clock elevation and based around 30° in an arc around from the camera (Figure 7.13)). The medium-sized light source will enhance most skin types and the gradual transition of light into shade will elegantly portray the form. Check the distribution of the light particularly across the face as seen from the camera position. If the light is very close to the subject the fall off will be dramatic – 2–3 m distance will provide reasonable evenness across a single subject. The shadow of the nose will cast a small loop shape towards the lip – this is sometimes known as 'loop lighting'.

It is also important to meter the full length of the figure or figures to be included in the image. Light can fall off significantly from head to toe – this can be particularly problematic for the exposure if the face is light skinned and the clothes dark. A solution is to aim the light at the subject's chest so that its brightest region is lighting dark clothing. Expose for the face; the slight overlighting of the clothing will reveal details in the folds of the fabric. Those with darker skin or clothing should ideally be placed to the light side of the frame so that the fall off does not plunge them into underexposure.

Move the light around to 45°. The lighting reference here is drawn from the painterly, studio and window-light convention. The angle of the light and face combine to create an inverted triangle of light around the eye furthest from the light source, the remainder of the side of the face is in shadow. This is known as Rembrandt lighting. (The positioning of the main light to the viewers' left appears to be a western convention reading from left to right and where eyes tend to scan images from left to right.)

A miniature image of the light source will appear in the iris of the eye at a 10 o'clock position. In close up it will be seen if a reflecting umbrella (one light is bounced from), a transmission umbrella (one light diffuses through) or a softbox has been used. In the first instance the round fluted shape of the umbrella will be detectable with a black keyhole shape in

the middle where the lamphead and stand obscure the reflected light. The transmission umbrella gives a clear circular shape and the softbox, a rectangular shape.

Exposure is best read with an incident light meter with a flat diffuser aimed from the subject towards the main light. Take note of the exposure. Then take a reading from the shadow side of the face. The difference in values gives the lighting ratio. One stop 2:1, two stops 4:1, three stops 8:1, four stops 16:1 and so on. A domed, 'invercone', diffuser can be used from the subject towards the camera, this averages light and shade falling on the sensor and does not enable readings of light ratios.

If the difference between light and shadow gives too much contrast, introduce a fill light. Most simply this would be a white reflector to the right of the camera angled in to the subject and bouncing light form the main light into the shadows (Figure 7.13).

Meter all parts of the subject viewed by the camera. If the light is very close to the subject the fall off will be extreme.

Finally meter the background. If the background is a mid-toned grey or other colour and is less more than three stops less lit than the side of your subject to be exposed for, then it will appear nearly black. Set the exposure to the lit side of the face and shoot. The lighting will look wonderful.

With more equipment and time, further controls and refinements can be made. If a mid-toned reproduction of a mid-toned backdrop is required in the print then it must be lit to match the foreground. For a perfectly even appearance it should be lit with *background lights* from behind the subject aimed from 45° into the centre of the background (Figure 7.14). Two or four lamps will be needed depending on the area of the background.

Figure 7.14 For a perfectly even appearance, the background should be lit with *background lights* from behind the subject aimed from 45° into the centre of the background.

Where the face is lit from the left and in shadow on the right try turning off the background light on the right. The lit side of the face will be elegantly contrasted with the shadows on the backdrop, the shadow of the face against the light from behind. This is 'Chequerboard' lighting.

To create a pure white background – set up a white backdrop, direct the lamps in the same way but increase their intensity by a stop, either by raising the power output or by bringing them close to the background. Make the exposure for the face as above. The overlit white will ensure a pure white result. Using appropriate gels can produce any colour background from this set, colour the lamps and then adjust the power – one stop less than the main light for a mid-toned colour – and successively for darker colours.

For a pure black – set up a black backdrop, turn off the backlights and ensure that no light from the umbrellas or softboxes can reach the background. Use full-length flags (black-sided polystyrene boards for example) to direct light away from the rear. Aim to have the background receive two to three stops less light than your subject.

Another convention is to introduce a 'backlight' – a small source high, from behind opposite the main light and falling on the top of the hair and on to the shoulders. This light should be a stop brighter than the exposure to be used for the face (Figure 7.14).

Setting up camera and lights

The camera lens should be fitted with a lens hood as deep as possible. If a bellows style 'pro hood' is being used, it should be extended until it can just be seen in frame then racked back just out of frame. The hood is the first guard against light spilling on the lens and causing flare (which reduces contrast as light bounces around the interior of the lens and onto the film or sensor, and can cause aperture-shaped flare spots of light). Background lights should be fitted with barn doors to mask light both from the lens and from spilling on to the subject. Any additional spill on to lens, subject or background should be flagged off, using black card, polyboard or fabric stretched on frames and clamped in place or set on separate stands.

The backlight should be fitted with barn doors, a honeycomb (or 'grid spot') or focusing spot to contain the spread of light. Prevent light spilling on to the subject and background.

If flash heads are being used with umbrellas they should be fitted with wide-angle reflectors (or 'spill kills'). These reflectors will direct all the light into the full width of the umbrellas and give one or two more stops illumination than if allowed to spill. They will also prevent unwanted light leakage onto other area of the set.

Front fill light

A very large umbrella or softbox set directly behind the camera provides a shadowless light into all areas of the scene; shadows are projected behind the subject. By careful adjustments of its power in relation to other lights on the scene it can be made the main light or a very subtle fill source (Figures 7.15 and 7.16).

Figure 7.15 Front fill light using a very large umbrella or softbox set directly behind the camera.

Figure 7.16 Front fill light with additional lighting.

The light must be large enough to wrap around the camera, tripod and photographer. The eyes of a sitter will reflect the white shape of the light and the black silhouette of the photographer (the photographer literally puts their image, in silhouette, into the image). This lighting reveals its 'unnaturalness' but makes clear reference to an idealized fashion lighting style where every blemish and wrinkle must be eliminated through flat frontal lighting. An even more flat shadowless light recurs in fashion photography with the use of the ring-flash – a doughnut-shaped light which encircles the lens. The light, designed for shadowless scientific specimen photography, can be seen in close up by the doughnut-shaped highlight around the pupil, and by the dramatic falloff across the skin towards the edges of face and limbs.

Used in conjunction with a lighting setup described above it can be set to two or three stops below the exposure from the main light on the subject for the most subtle of fill effects. Shadow areas of the background can be coloured by adding gels to this light source. The colour will be eliminated on the subject provided the main light is a couple of stops brighter.

Three (small) source lighting with a small source front fill has been widely used to emulate 1940s style film-still photography. The mainlight here is the rimlight set at approximately 110° from the camera axis. A backlight, either with a snoot or a honeycomb

Figure 7.17 Small source lighting with a small source front fill.

(gridspot) is aimed down onto the hair and shoulders of the subject. The front fill will be set two or three stops lower than the mainlight. The backlight is at least one stop brighter than the mainlight (Figure 7.17).

Balancing foreground and background lighting

On location it is often desirable to match the power of supplementary lights to the existing lights, for example when a subject is standing with their back to a window or other bright light source.

An exposure can be made for the subject by measuring the light falling on the face using an incident meter (with an invercone or flat diffuser) aimed from face back to camera. This exposure, with no additional light would result in the subject being reasonably well exposed but the background overexposed.

To balance the lighting take a meter reading out of the window, or towards the background light, using a meter in the reflected light mode or by using a spot meter or an SLR camera. An exposure for the background would result in a underexposed subject. (If the meter is pointed at a sky full of white clouds and the reading from them is used as the exposure, then the clouds will be exposed as a mid-tone grey; the land below would tend to be underexposed – darker than a midtone. A blue sky metered and exposed in the same way would correctly result in a midtone.)

Flash can be used in the foreground to *balance* the light on the subject with the light outside. (HMI light could be used, or tungsten lights with full blue filters to correct the colour balance to that of the daylight – 5400 K.)

If the background reading is *f*/11 then the flash should be set to achieve a reading of *f*/11 on the subject. The shutter speed should be that for the background exposure (provided it is not faster than the maximum synchronization speed you should use for the particular SLR or DSLR or other camera with a focal plane shutter).

The nature of the foreground light – source size, direction and colour should as always be designed to be *justified*, if it is to support existing foreground lighting, or *motivated*, if it is to imply a certain source or location, or stylized to reveal information or suggest a genre.

Darkening backgrounds with flash

This is a dramatic lighting method. It is extremely effective against cloudy skies in early evening or morning; with this method the foreground subject will be perfectly exposed and will shine out from brooding darkened backgrounds (Figure 7.19). Tests with Polaroids or digital cameras are recommended.

Balance the foreground flash with the background ambient light by matching the flash power to the ambient light exposure. The simplest way to darken the background, leaving the foreground correctly exposed, is to increase the shutter speed. With a high-speed flash, like a flashgun, the shutter speed will have no effect on the flash exposure in the foreground (where the flash duration is less than 1/1000 sec). Each increase of shutter speed will underexpose the background ambient light by one stop.

Method 1 – Increase shutter speed

Ambient light exposure f/11 @ 1/60

Flash	Exposure	Background
f/11	f/11 @ 1/60*	Balanced
f/11	f/11 @ 1/125*	1 Stop darker
f/11	f/11 @ 1/250*	2 Stops darker
f/11	f/11 @ 1/500*	3 Stops darker

Method 2 – Increase the flash power on the foreground

Ambient light exposure f/11 @ 1/60

Flash	Exposure	Background
f/11	f/11 @ 1/60	Balanced
f/16	f/16 @ 1/60	1 Stop darker
f/22	f/22 @ 1/60	2 Stops darker
f/32	f/32 @ 1/60	3 Stops darker

*Synchronization

If you are using a focal plane shutter camera make sure that the shutter speed does not exceed the synchronization speed of the camera. For example, the background reading for the scene here could also be taken as

- f/5.6 @ 1/250,
- the flash could be set to f/5.6 and
- expose at f/5.6 @ 1/250.

These settings would be fine for modern SLR cameras from the late 1980s onwards, but many early models could only synchronize up to 1/60. If you use 1/250 with such a camera more than half of the image will have the flash obscured by the shutter (Figure 7.18).

Leaf shutters will synchronize throughout their speed range as the shutter is always fully open when the flash is fired.

Slow duration flash heads

Many portable flash kits and studio flash heads have a long flash duration at full power (some can be as long as 1/90).

To darken backgrounds with such lights use 'Method 2' above, with a shutter speed no faster than 1/60. Then the foreground will not be underexposed due to the shutter 'clipping' the flash – i.e. shutting before the flash has finished its full duration.

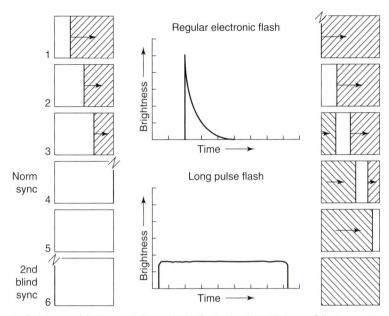

Figure 7.18 Regular flash is so brief that it can only be used with a focal plane shutter that opens fully at some point of time (near right sequence). This flash may be fired when the first blind is fully open, or just before the following blind starts closing for mixing sharpness and blur. Long-pulse flash, however, is slow enough to use with faster shutter speeds where only a slit moves across the focal plane. It fires when the first blind starts to open (far right sequence) and maintains even light until the shutter has completed its action.

It is not always desirable to have the foreground 'perfectly' exposed. If the background is the most important feature of the shot, or if the subject should be shadowy or mysterious, then underexpose the foreground by decreasing the flash power but leaving the camera set for the ambient light.

Figure 7.19 The exposure of the foreground flash has been first balanced with the sky by matching the flash power to the ambient light exposure. Then the shutter speed has been increased by three stops, so the sky is dramatically darkened by underexposure. The flash has been bounced from an umbrella and filtered with a quarter orange gel to suggest a warm, medium source, interior light. By Andy Golding.

Flash – darkening the foreground
Decrease the flash power on the foreground

Ambient light exposure f/11 @ 1/60

Flash	Exposure	Foreground
f/11	f/11 @ 1/60	Balanced
f/8	f/11 @ 1/60	1 stop darker
f/5.6	f/11 @ 1/60	2 stops darker
f/4	f/11 @ 1/60	3 stops darker

Still-life photography

Still-life photography encompasses pack shots and product shots for advertising, catalogues, brochures and web sites; food photography, car photography as well as realms of fine art photography. Lighting requirements range from the emulation of natural light to highly stylized light.

The painterly top/side medium light source formed by a softbox, lightbank or strip flash (a long thin softbox) is often favoured not only to suggest products in the artist studio (raising the status of products to that of art), but also suggesting the domestic setting with light flooding across the objects from a nearby window. Detailed fill lighting is often achieved with mirrors and foil.

At the other extreme objects are often made to appear in a pure space, as though floating in thin air, with highlights running the length of the surfaces. On a small scale this is achieved by setting the objects on a translucent light table, which is under lit. The light is balanced to a softbox the width of the set suspended above. At the greater scale cars are set on 'infinity curves' or 'coves' – a white painted surface gradually curving from the studio floor to the ceiling. The cove is evenly lit and again balances to an overhead lightbank which is sufficiently long to throw a highlight along the curves of the car's length.

Small precious objects frequently set in a light tent – a translucent fabric tent with an aperture for the lens to peek through. When lit all round the tent becomes a large light source which reduces the contrast by filling in shadows, keeping the exposure range within useful limits (Figure 7.8).

Location interior lighting

Photographing rooms and people in them, presents a number of lighting problems including low light levels, colour temperature differences and extreme contrast. If there is too little light for the required exposure then a monolight kit can be used to *substitute* as the primary light source or to *supplement* the available light.

Monolights as principal light source

A two-head monolight kit is unlikely to cover a large space of more than 20 m deep but within this the options are to create even lighting throughout by using umbrellas, softboxes or by bouncing the flash off the ceiling.

For a little more drama then use one head with an umbrella behind the camera as a front fill source and highlight your subject, or a detail of the room with the second head fitted with a reflector (or more focused through a snoot or honeycomb).

If an exposure of around f/11 can be achieved, then shooting at 1/125th is likely to ensure that the available light is overwhelmed by the flash.

A typical tungsten-lit living room might require an exposure of 1/8 second at f/11 using 100 ISO film. Exposing for the flash at 125th will render the tungsten light four stops underexposed. In these circumstances the photograph will be dominated by the flash lighting. If the flash lighting is uncoloured the light will be of neutral colour on daylight film. The resulting photograph is unlikely to reveal the atmosphere of the room's original lighting.

To create more atmosphere then either match the flash lighting to the style of the available light or let the available light become a significant component of the exposure.

Matching flash to the room lights

An umbrella light or softbox can be used to suggest the light from 'medium'-sized light sources such as window light or from table lamp shades. Use the direct flash from a reflector to suggest light from small sources such as overhead room lights or spotlights. To match them for colour use quarter or half orange lighting gels to imitate the warmth of tungsten light.

Matching the exposure to room lights

To retain the atmosphere of the room and to make best use of the effect of the existing lighting, balance the flash exposure to the available light. If the flash exposure is $f/11$ then take an available light reading at $f/11$. The reading might be in the region of 1/8th @ $f/11$. Using this exposure will give an equal balance of flash and available light. An increase of the shutter speed will reduce the effect of the available light by one stop, a decrease will increase it. The flash exposure will be unaffected.

Flashguns

The integral flash of a compact camera, the pop up flash of an SLR, the separate flash unit, can all be controlled to subtle effect. Flash will reveal detail in dark shadows, bring a sparkle to a dull day, freeze motion and can provide a sense of movement, resolve colour balance clashes in complex lighting environments and carefully filtered will warm up or cool down selected elements of the scene.

Yet for many users the flashgun is only resorted to when light is too low for acceptable exposures. Results tend to be dreadful: in the foreground over-lit faces with hard-edged shadows, the background in inky darkness and garish white light overpowering atmospheric interior lighting or exquisite sunsets.

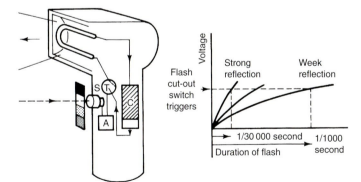

The latest generation of dedicated flashguns and cameras will resolve the exposures for you, mix flash and available light, balance the flash with backlight or allow you to increase or decrease the flash to your preference in thirds of stops (Figure 7.20). But any combination of camera and flash – old, new, cheap or top of the range can be manipulated to allow you to control the flashlight and prevent it dominating the

Figure 7.20 Near right: basic circuit of self-regulating flashgun (batteries not shown). C: light sensor behind pre-set neutral density filter. Some types use apertures of various sizes instead. A: analogue control chip. T: thyristor switching device. C: main capacitor, feeding flash tube. Far right: light reflected from subject to sensor causes a small charge to accumulate. When this reaches a set level the flash is terminated. So the closer or paler your subject, the briefer the flash (blacked-out sensor setting is manual mode).

photograph. The trick is to take control of the flash rather than allow it to dictate the play of light in the photograph.

Check your camera's handbook to discover if it has a maximum synchronization speed; new SLR film cameras with focal plane shutters may allow a speed of 1/250 (the faster the better for use with bright daylight), older models perhaps 1/125th, 1/60th or even 1/30th. Digital cameras and compact cameras vary considerably. (Flash will synchronize at most shutter speeds when used with leaf shutters since the flash is fired when the leaves are full open.) Using a speed faster than the synchronization will result in the flashlight being cut off in the frame, but it is by using slower speeds that the flash effect is lessened and the impact of the ambient light heightened.

Exposures in interiors at night, living rooms, restaurants, café, bars, using 100 ISO film, might be in the region of f/4 at 1/15th; using flash at a synch speed of 1/125th would result in the ambient light being underexposed by three stops (eight times less light). The room lights will barely be revealed, the background will appear to be in near darkness. Reduce the shutter speed to 1/30th and surrounding light will be just one stop less (half as) bright – revealing much more of the lighting quality of the environment. Lower the shutter speed to 1/15th and flash and available light will be equally balanced. Now though the shot will be overexposed, as there is light coming equally from the interior and the flash. Stop down the aperture (f/5.6 @ 1/15) and the exposure will be correct, with the room light and flash equally mixed (so-called 'mixed flash').

This effect is achieved automatically with many newer cameras by locating the 'slow-synch' setting in the flash menus. The camera's exposure system will match the flash to the surrounding lighting conditions.

Without a tripod the slower shutter speeds will result in some blur – both from moving subjects and from camera shake, but the flash will freeze elements of the scene and often give an effect of dynamism and action. Cameras with focal plane shutters normally fire the flash near the start of the exposure (when the first curtain of the shutter has crossed the sensor or film plane), so moving elements in the scene are frozen by the flash then blur from the ambient light exposure appears ahead of them. To make the 'trail' appear behind the movement check the menus of your camera to see it can allow for 'rear curtain synch' whereby the flash will be fired at the end of the exposure.

To show up background lighting or skies behind your subject simply match the flash and background exposures. If the evening background or sky exposure is 1/30th @ f/5.6, set your camera accordingly; then set the flash to f/5.6. In the resulting image the foreground subject will be lit to the same value as the background (the flash is balanced with the backlight). An increase of one stop of the shutter, here to 1/60th, will darken the background perhaps giving more drama in the sky, yet not affect the foreground (the flash fires at 1/1000th of a second or faster so is unaffected by the faster shutter speed).

This balancing act is automated by many modern amateur cameras with a 'night portrait' function, usually indicated by an icon of a silhouette head and shoulders with a star behind. Professional DSLRs will achieve this effect with matrix metering and 'slow-synch' settings.

In bright daylight the same balance can be achieved by again matching flash foreground exposure to the value of the sunlit background; this is the look of the paparazzi photography in magazines and in the more garish photography of the documentary artists movement of the

1980s (in the UK). Higher shutter speeds are needed so take care not to exceed the maximum synchronization speed. This effect will be achieved with contemporary equipment when flash is used in daylight (provided no compensation or flash underexposure has been set).

With fill-in flash the aim is to make the flash a secondary light source not the key light or main light. If shadows, which fall across your subject, are too dark and highlights too bright for the exposure range of your film or digital camera, then fill-in flash will lower the contrast and lift the shadow detail. To retain some drama in the shot add a subtle flash at two or even three stops lower than the exposure for the ambient light (Figure 7.21).

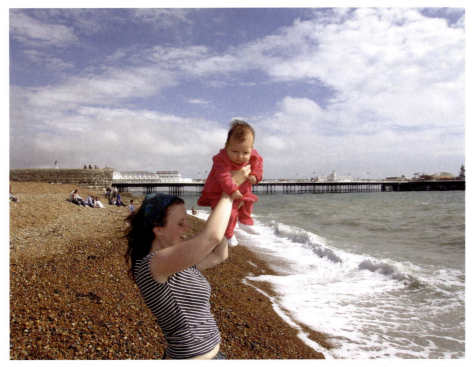

Figure 7.21 This effect has been achieved by on-camera flash set to expose two stops less than the overall exposure. The flash subtly fills the dark shadows that would otherwise have been cast across the faces by the sun. By Andy Golding.

So, for example if your exposure is 1/125 at f/11 set your flash to f/5.6 for two stops under the exposure fill-in, or f/4 for a delicate three stops under. The same method will brighten subjects on dull days, lift them from the background, add highlights to shiny elements in the scene and catch lights to eyes.

A modern camera and flashgun will have a menu to allow you to set the fill-in level in third of a stop increments; a setting of two or three stops underexposure of the flash gives most subtle results.

Finally colour the flash with filters to balance the flash with the ambient lighting and integrate the light into the scene. Use a straw-colour filter over the flash to bring the colour temperature to that of setting sun, between the colour of daylight tungsten or to other incandescent lights.

■ Small light sources produce hard-edged shadows and bright, specular highlights. As a light source increases in size, the shadow edges soften. By controlling the shape of the medium light source you can define the shape and surface of the object being photographed.

■ The direction and angle of light and the size of the light source affect the way we interpret an image. For example, sunlight implies a wealth of uplifting associations; shadow is linked to metaphors of darkness.

■ Light distribution follows the *inverse square law.* Light radiates from the source so that as distance doubles from the source, the light has spread four times as widely. Even light distribution can be achieved either by moving the light source away from the subject, or by bouncing the light; the increased area of light will reduce the distance to the overall subject.

■ You can measure contrast by taking readings of the light falling on different facets of the subject, using an incident light meter fitted with a flat diffuser. If the reading between the most important part of the scene and the shadow is one stop different then there is half as much light on the dark side, so the lighting ratio is 2:1. If the difference is two stops, a quarter of the light, the ratio is 4:1; if it is three stops the ratio is 8:1 and so on.

■ The maximum brightness range recorded by reversal films is 32:1 with full detail throughout; monochrome negatives will record around 128:1 (seven stops); colour negatives can record 128:1 in terms of detail (note that the colour begins to distort at the extremes of this range). CCD and CMOS sensors in digital cameras and backs capture a greater dynamic range than most colour films; an area array recording up to 250:1, a tri-linear array 712:1 or nine stops.

■ When addressing the lighting contrast consider the necessary detail from the brightest highlight to the deepest shadow, the reflectance range and the lighting ratio in relation to your film or digital sensor and the printer.

■ The colour temperature of the light source affects the colours of the final image. If you use film, you can measure the colour temperature and adjust the colour balance using filters. Digital cameras provide auto white balance or have presets such as 'tungsten', 'fluorescent', etc.

■ When you work on location with mixed lighting conditions, you can filter one light source to match the other. If you work on interiors, you can relight the interior with flash.

■ When a studio setup is designed to mimic a particular location the lights should be *motivated*, share the qualities of the lights they are intended to imply, and be sized, positioned and coloured accordingly. Lighting to supplement or enhance location lighting should be *justified*, designed to share the qualities of existing lighting in the home, office, shop, club, hotel, restaurant, factory and so on.

■ There are several techniques for portrait lighting. As a general rule, use a medium light source for portraits and check the distribution of light across the face. If you place the light source around 2–3 m away from the subject the lighting will be reasonably even across the subject. You may need additional lighting for fill-in, to control the background lighting, or introduce a 'backlit' appearance. Expose for the face.

■ You can use lighting techniques to balance foreground and background lighting, or relatively darken the background by using flash lighting of the foreground to give a dramatic effect.

■ For interior location lighting you can use monolights as the principal light source, with umbrellas or softboxes (or you can bounce the light). Match the exposure to room lights to retain the atmosphere of the room.

■ You can get very good lighting using flashguns, if you know how to control the flashlight and you avoid automatic control. You can balance the lighting of the subject and the background indoors or outdoors using fill-in flash, etc.

1 To control lighting you should be able to identify the lighting used in existing photographs. It is very good practice to collect images from all sources – magazines, books, exhibition catalogues and brochures, to inform and influence your own practice. Seek out three photographs representing the genres and styles you most admire and identify the lighting in each. List the lights involved and make a lighting diagram. By looking carefully at the quality of the shadow edges, the direction in which they are cast, the position and shapes of any highlights, you should be able to recognize the size, angle and relative brightness in stops (lighting ratios) of the main light as well as any fill, back and background lights.

2 Practicing the styles of the best photographers is invaluable in mastering lighting and providing the skills to create lighting techniques of your own. Replicate the lighting of one of the images you most admire. Select a photograph which you can most readily emulate; if it is a portrait, still life or landscape ensure that you have appropriate people and places available to you. Equally, select an image which has been lit in your estimation by lights which are available to you or which you can emulate with the kit at your disposal. Use a digital camera both to record the image and to record the lighting setups you create.

3 Balancing flash and available light is a key skill in the control of light. Try the following exercise to see how combinations of flash and ambient light can be determined by careful combinations of aperture and shutter speed. Use flash (either a flashgun or a flash kit) in the foreground of a room set, which includes a window. Use a digital camera on a tripod and take notes of each setting. Set and position the flash to enhance the available lighting – perhaps by bouncing from a wall, ceiling or from an umbrella or softbox. Next balance the flash to the lighting outside the window by matching its output to the aperture and shutter speed required for the view outside. Increase the shutter speed one stop at a time and note the gradual darkening of the exterior, and diminution of the interior existing lights in the images produced. Decrease the shutter speed to see the gradual lightening of the exterior scene and the increase in the influence of the room lights. Finally try filtering the flash to match the interior lights.

PROJECTS

8 Tone control

This chapter discusses all the influences on the tonal quality of your final picture. Being able to produce results with a rich range of tones is vital in black and white and equally important in colour. The difference between 'good' and 'outstanding' final print quality depends on how much care you take at a number of stages, ranging from measuring subject brightness to the way you display finished results. The tone range of your film image (negative or slide) is of special importance here and the most common single cause of poor prints. This is paralleled in digital imaging by the ability of your digital sensor and converter to capture a suitably wide dynamic range. Digital camera exposure settings or scanner settings also affect the tone quality of your images.

Starting with a review of all the tone quality factors, the first section gives an overview of the parameters that have an effect on the tonal quality of the final image. An introduction to tone control theory follows with applications to both silver halide and digital photography. Next, the zone system is explained as one method of achieving tight control over monochrome results but is also expanded to digital systems. Sometimes, sadly, important films turn out too dense, pale, contrasty or flat – but it may still be possible to make improvements, and these are described. Finally, the chapter outlines how you can create high dynamic range (HDR) images with your digital camera and image editing software.

Practical influences

Tone values, like sharpness, are one of the characteristic qualities of a photographic image. This is not to say that the full luminance range of your subject can or indeed must be reproduced accurately in your final picture. On the contrary, sometimes the shadow or highlight end of the tone scale should be allowed to distort, or all tones 'grey up', or results simplify into stark black and white if this furthers the aims of your shot. What is important is that you should have *control* over your picture's final tonal values. There should be no uncertainties and surprises which destroy images in a haphazard way.

You can influence final image tone values at some 12 stages. Most are relevant to colour as well as black and white photography.

1. *Subject–luminance range.* This is the combination of subject reflectance range and lighting ratio. By controlling one by viewpoint or arrangement and the other by additional or changed lighting you may be able to avoid excessively high or low contrast. An example is the fill-in flash technique. Extreme reflectance range combined with high lighting ratio give the longest span of image tones to deal with – possibly well beyond the range of any film or charge-coupled device (CCD) sensor.
2. *Light sources.* The size and position of the light sources and the addition of diffusers, such as softboxes, honeycombs, reflectors, etc., have an effect on the contrast of images (see Chapter 7). You should remember, however, that when the quality of light is soft, the shadow edges become less clear-cut throughout the subject.

3. *Filters*. Coloured contrast filters in black and white photography influence the tones in which colours record. Polarizing filters increase the tonal and colour richness of some surfaces with a reflective sheen. Diffusers and similar effects filters spread light from highlights into shadows, making both colour and monochrome images less contrasty (see *Langford's Basic Photography*).

4. *Lens and imaging conditions*. Lens performance, flare and atmospheric conditions all influence the tone range of the image reaching your film. Combined ill-effects tend to be like mild diffusion, a tendency for shadows to become diluted and compressed (see Figure 8.1).

5. *Light-sensitive medium*. The inherent contrast of the film emulsion, and its graininess. If small-format images show coarse grain structure, when blown up this will tend to break up areas of tone and destroy gradation. Film condition (age and storage) must be the best you can achieve, or expect degraded tone values. In digital work equivalent factors are the number of pixels sampled by the CCD or complementary metal-oxide semiconductor (CMOS) sensor, the bit depth of the A/D converter (page 238) plus any data compression – note that changing any of the above-mentioned parameters in digital photography affects the final file size of the image.

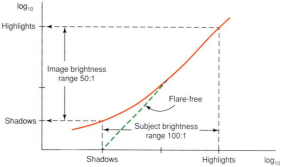

Figure 8.1 The effect of light flare on image shadows. Graph shows (baseline) subject brightness range, converted to (vertical axis) lens image brightness range. If lens was 100% flare-free the graph would show line at 45°, and both ranges would match. In practice scattered light here dilutes shadows, reduces brightness range reaching film. Flare may be due to dust, grease, condensation on optics, back or side lighting spill into lens.

6. *Exposure accuracy*. Light readings which give over- or underexposure will produce tone-crushing in highlights or shadows, respectively. Remember that film manufacturers design most monochrome negative materials to be exposed on the lower part of the characteristic curve. If you can do this consistently the negative density range will 'fit' printing paper performance like two pieces of a jigsaw and give a full tone range print. Overexposure of a CCD gives burn-out and flare around the brightest highlights; underexposure gives 'mealy' detail and incorrectly coloured pixels in deepest shadows.

7. *Film developer and development*. In black and white neg/pos work your choice of film developer and amount of development can often be geared to suit imaging conditions. Extending the development time expands the tonal separation (contrast) of the negative, useful for compensating for low-contrast images. Reducing the development time serves the opposite function for contrasty situations (see section 'The zone system', page 165). A disadvantage of 35 mm here is that with a film containing 36 exposures all having to be developed in the same way, compromise is inevitable. In this case, tonal values are controlled with exposure and, if possible, with lighting rather than at the film development stage. Colour film processing is less pliable. Pushing or holding back slide film is acceptable for some compensation of under- or overexposure (altering ISO speed) but not good practice purely for contrast control, because of side effects on image colour balance. Also make sure that your processing solutions are in good condition, at the correct temperature and are properly agitated. Any safelights you are using must really be safe, and there must be no light leaks in your darkroom to give the slightest tone-degrading fog.

8. *Image manipulations after processing*. This includes chemical reduction or intensification of your film to improve a poor tone range. Less drastically, you can 'mask' an image by sandwiching it with a weak negative or positive version which respectively reduces or increases the tone range before printing or (slide) duplicating. In digital work a range of post-camera options are possible using computer software programs such as Adobe Photoshop™. When you have excessively contrasty negatives you can reduce the effective tone range of prints by using the method of 'flashing' the paper to light (see page 176).

9. *Enlarger and enlarging technique.* The film illumination system in your enlarger influences final print tone range – from a harsh point source through condenser systems to a fully diffused lamphead for least contrasty results. Using a condenser head, you can enlarge an 0.8 density range negative onto the same grade of paper as would be needed for a 1.05 range negative enlarged with diffuser head equipment. Lens flare is an influence again here. When enlarging negatives it smudges shadows and spreads them into highlights.

10. *Input and output devices of digital images.* The reproduction of tones may differ from one input device (for example a scanner) to another. Remember that you can also select the tonal range for your images via the scanning software (brightness/contrast setting, curves, etc.) before you digitize your film or print. Display devices such as cathode-ray tube (CRT) or liquid crystal displays (LCDs) also give you the option to change their brightness and contrast. By altering these two parameters you change the tonal values of your displayed images. Printers can also print images with different contrast settings. Calibration of your computer display and the use of colour management are necessary for controllable results (see Chapter 11).

11. *Print material and processes.* Surface finish mostly determines your print material's maximum black – greyest with matt, richest with glossy. Glossy papers can produce a maximum black about 60 times as dark as the whitest highlight (Figure 8.2). Working with black and white silver halide materials, you have a choice of grade and also base tint (affects brightest attainable highlight). Variable contrast bromide paper allows you to 'split-grade' your print, dividing the overall print exposure between two different grade filtration settings to expand or contract tone ranges in chosen areas. This is a solution for printing over- or underexposed negatives. Remember the importance of being consistent with print exposure and the developer timing and temperature. Using poor-quality or badly stored materials and chemicals gives prints with degraded tone values too. Also, unsafe lighting has an effect in the contrast and is first noticed by diminished print contrast without visible fog. The reason is that it affects the characteristic curve and either D_{min} or D_{max}.

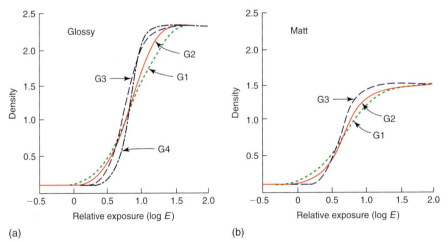

(a) (b)

Figure 8.2 The effect of printing paper on final tone range. The glossy-graded bromide paper curves, left, show that all grades give richer blacks and therefore a wider overall density range than matt surface types. If papers had tinted bases the bottom of these curves would flatten out at about 0.4 or greater, limiting range still further. Notice how contrast (slope of curve) varies. Grade 1 glossy is equivalent to between grades 2 and 3 matt surfaces.

12. *Final viewing conditions.* Prints behind glass softly lit from the front will have blacks which look only grey and all dark tones degraded. For maximum richness of tones display a print free of glass on a wall lit obliquely by a spotlight, masked down tightly to illuminate the picture area only. Project slides in a 100% blacked out room. If you are viewing digital images on a computer display, ambient lighting and lighting geometry (which may

introduce flare) will affect the tonal values of the image (see Chapter 10). The background of the displayed image will also have an effect, similar to the effect of a black, grey, white or colour frame on a printed image. Objects which are included in your visual field may affect your judgement of tone (and colour).

If your pictures lack tonal quality it will almost certainly be due to lack of care at one or more of these stages. A combination of slight neglect at several points will insidiously undermine the excellence of all your results. Sometimes it is only when you compare your work against actual prints by masters in exhibitions that these deficiencies show up. Not every picture works best with a full, rich tone range, of course, but many do, and you must be able to achieve this when required.

Tone control theory

Silver halide systems

As described in Chapter 5, the characteristic curve describes the response of a film or paper to the subject luminance (see Figure 5.14). The slope of this curve is called *gamma* (γ) and is used to describe the contrast of the exposed material (see Appendix B). Other measures of contrast have also been derived such as the *contrast index* (CI) and the *average gradient*, described in Appendix B.

Some of the links in the chain just discussed, as they apply to silver halide film and paper, are shown diagrammatically in Figure 8.3. A similar diagram which refers to digital imaging is illustrated in Figure 8.4.

The diagram for silver halide photography illustrates the contraction and expansion of tone values you can expect when a subject is imaged in the

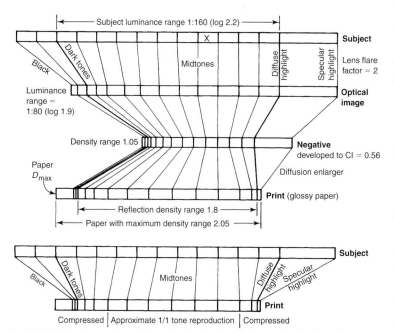

Figure 8.3 Bar chart tracing typical black and white silver halide reproduction, from subject to final print. Brightness (luminance range) is reduced by the lens, and compressed again by the negative reproduction. Enlargement and printing paper characteristics then modify and expand tone range. Given correct exposure throughout, midtone values (see X, denoting the tone of an 18% reflectance grey card) are least altered. Greatest compression is at highlight and shadow extremes, especially shadows. Bottom part of diagram allows direct comparison of the subject and print range shown above.

camera, turned into a black and white negative and then enlarged onto black and white bromide paper. Subject brightness range chosen here is 1:160 or just over seven stops – marginally in

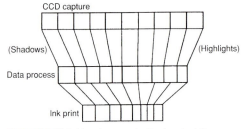

Figure 8.4 Digital imaging reproduction bar chart. Top row shows maximum image range captured by a CCD sensor. This is reduced to meet computer needs, centre. Selective use of tone curve software then flexibly adjusts the input further to create new output tones, suiting the particular picture. Here it expands shadow tones relative to highlights, before finally passing on the image file to an inkjet printer.

excess of the maximum recommended range for black and white when it is important to preserve all shadow-to-highlight detail. Dense blacks and tiny specular highlights are even further apart in value.

The light from the subject is put through a lens with a flare factor of 2 (the flare factor is calculated by dividing the subject luminance range by the illuminance range of its image). This might be for a long focal length lens used outdoors, especially if fitted with a filter. A modern multilayer-coated normal lens in low-flare studio conditions will have a factor of less than 1.5. Notice how flare compresses darker tones by spilling light (you can see this on a focusing screen – blacks turn to grey when you put something brightly lit near the front edge of a lens). The highlights are affected less. The tone range of the image actually reaching the film therefore comes down to 1:80 (or 1.9 log units).

Correct exposure places these light values on the toe and lower straight-line section of a normal contrast film's characteristic curve. The result, after standard processing to a contrast index of 0.56, shows all tones slightly compressed, darker subject tones being more compressed than others but still separable. The densities representing original important shadow and highlight detail now have a density range of only 1.05.

The bottom line of Figure 8.3 represents what happens when you print the negative through an enlarger fitted with a diffuser light source and takes the (low) enlarger lens flare factor into account. The result on grade 2 normal glossy paper is a print with a density range back to about 1.8. Notice how the darker ends of subject midtones are relatively more expanded by the paper than other tones at the printing stage, compensating for their compression in the negative. Diffuse highlights (reflection from a textured or matte surface) reproduce just marginally darker than the paper base, allowing specular highlights (reflection from a mirror-like surface) to appear pure white. Tinted papers cannot give an equivalent maximum white, and so lose these delicate highlight tones. Darkest shadow detail tones have about 90% of the maximum density the paper can give, leaving this D_{max} for subject pure blacks. Matt surface paper, with its greyer maximum black than glossy paper, loses your darker tones.

Some of the film/paper relationship is shown by linking their characteristic curves in a 'quadrant diagram' (Figure 8.5). Multistage diagrams like these show that manufacturers aim their materials to receive the image of a subject with a wide brightness range (for example, a sunlit scene), and take this through to just fill the density range offered by normal grade paper. On the way, the negative is given the least possible exposure which will still record important shadow detail. So the film performs with maximum speed rating and resolution, and least grain and light spread within the emulsion.

Notice how the system is so designed that image midtones are least compressed and distorted – manufacturers assume that these are the most critically judged parts of the picture. If you want still more midtone separation you could process the negative to a higher contrast index (say, 0.65 or 0.7), which would then really need grade 1 paper. However, by printing on

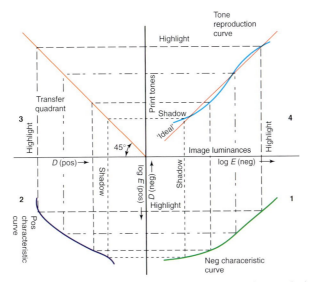

Figure 8.5 Quadrant diagram relates characteristic curves of negative and positive silver halide materials, shows the necessary 'correct' exposure and development to give acceptable tone reproduction. Quadrant 1: camera image luminance range is exposed onto film. Resulting relative density values for subject highlights and shadows are plotted off on left. (Rotate book anti-clockwise.) Quadrant 2: these negative density values exposed onto paper characteristic curve give print densities, left. Transfer quadrant 3 turns plots through 90°. Quadrant 4: here the original camera image values can be traced back and compared against final print tone reproduction. An ideal, distortion-free result would be a straight line at 45°.

grades 2 or 3 and burning in highlight detail and shading shadow detail you still squeeze all the information onto the print while achieving the extra midtone contrast.

Digital imaging systems

The characteristic curve was initially developed for silver halide photography. Its principles, however, are also applied to digital imaging, to describe the relationship between input and output intensities of an imaging device, such as digital camera, scanner, printer or computer display. This relationship is described by the *transfer function* which is equivalent to the characteristic curve of the photographic materials. The term *gamma* is then used to describe the tone reproduction properties of the device (see Chapter 10). There are, however, other methods that are also used to evaluate the tone reproduction of a digital imaging system.

You can control tone at several stages of the digital imaging chain. By controlling the exposure with your digital camera you determine the tonal values of your subject and you can follow a method such as the first stage (exposure) of the zone system (see page 165) for more accurate control. A reflectance (flatbed) or transmittance (slide) scanner also may give options for controlling the tonal scale of the output image before the digitization process via its driver software. Note that the dynamic range of tones produced by the camera or scanner is limited by the sensor.

The bit depth with which the subject is encoded affects the number of the output grey levels. In a greyscale image for example, 8-bit depth produces 256 discrete levels and 10-bit depth produces 1024 levels. The minimum number of levels that produces visually continuous tones (and is therefore suitable for photographic images) is 256. In colour images, you have three channels (red, green and blue) so the bit depth is three times the bit depth for the greyscale

image (pages 238–239). Show extra care when you control exposure using the zone system; an overexposed area may result in *clipped* values, an absence of tonal detail in highlights; underexposed images will suffer from noise. The CCD sensor has also linear response to subject luminance so its transfer function is a straight line. If the camera or the scanner however is set to give output in a specific colour space, such as sRGB (see page 338), the captured image's tonal scale is altered to meet the sRGB standard's requirements.

When the image is downloaded on a computer you can manipulate its tonal range using imaging software. A great advantage is that you can carry out the manipulation on a copy of the image without risking the original. You may also want to store your original images in RAW (unprocessed) format. The distribution of pixel values for each level can be observed from the image histogram (see page 237). There are several ways that you can manipulate the tonal range of your images using software. You can perform 'brightness' and 'contrast' adjustments on the whole image or locally. Altering the curves is another method, which is described in more detail in Chapter 11. With tone manipulation you can adjust the tones in shadows and highlights before printing the file. In addition you can also create masks to correct digital images with high or low contrast.

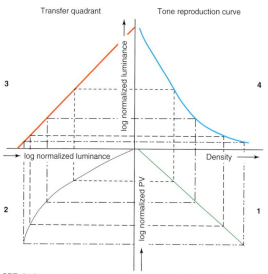

Figure 8.6 There are several different ways of plotting quadrant diagrams. This is a quadrant diagram of a digital imaging system that comprises of a flatbed scanner and a CRT display system. Quadrant 1: A greyscale with measured densities is scanned, resulting a digital image. The logarithms of the normalized pixel values of the scanned greyscale were plotted against the corresponding measured density values. Quadrant 2: The digital greyscale was displayed on a CRT monitor. In the diagram, the logarithms of the normalized luminance values of the CRT display system were plotted against the logarithms of the normalized pixel values of the scanned greyscale. Quadrant 3: A transfer quadrant turning plots through 90° and inverting the scale. Quadrant 4: The luminance values of the displayed greyscale were compared to the density values of the scanned greyscale by plotting the logarithms of the normalized luminance values against density. You can observe the effect of the CRT function on the final viewed image (see Chapter 10).

Remember, however, that manipulation of digital images is carried out by viewing them on a computer display. The display has its own effect on the tonal range of the displayed image. If your monitor is not set up correctly (e.g. it has high contrast), this will affect your ability to apply correctly tonal changes to the image. It is therefore essential to calibrate the display (and check calibration regularly) to ensure that your images are viewed correctly. This does not apply only for the tone but also for the colour reproduction of the displayed images (see page 221).

Tone reproduction is also affected at the printing stage. Parameters that have an effect include the type of printer and the method of printing (inkjet, dye sublimation, etc.), printer driver settings and the printing paper (surface, colour, quality, etc.). The dynamic range may be reduced at the printing stage.

If you know the characteristics of the imaging devices you use, you can control

the tone reproduction of your images through the imaging chain. The gamma for each device can also be calculated using its transfer function. This is useful for assessing its response but also to determine the gamma for the whole imaging chain (this is calculated by multiplying the gamma values of all devices and processes in the chain). You can then compare this value to your system target gamma value and, if they deviate, you can decide at which stage of the system you want to correct the tonal response.

You can also draw a quadrant diagram for your imaging system using the transfer functions for each component (Figure 8.6). You can then evaluate and compare all the stages of your digital imaging system. The method is based on the method used for silver halide systems.

Precision measurement of exposure

Accurate subject exposure reading is vital for tone control. As shown in *Langford's Basic Photography*, one centre-weighted measurement through the camera or a general reading made with a hand meter is adequate for average situations. However, readings of carefully chosen parts of the subject give you far greater information, although they take more time and knowledge to do. The main point to remember is that the light meter is calibrated to a 18% reflectance mid-grey (it assumes that the area measured has average luminance). The camera settings it gives aim to give suitable exposure so that this mid-grey will be reproduced correctly in the print.

A general (average) reading mixes the light from dark, medium and bright items in the picture, taking greater account of large areas than small ones. The whole lot is scrambled on the theory that this integrates all subject values to grey. A centre-weighted system does the same thing but takes less account of corners and edges of the picture because important elements are assumed not to be composed there (Figure 8.8). A similar single-reading approach is to measure a mid-grey card held where it received the same light intensity as the subject. Kodak make 18% reflectance cards for this purpose. Again, you can fit an incident-light diffuser attachment over a hand meter and make a reading from the subject towards the camera. Results should work out the same as for the grey card technique, and both avoid over influence from large but unimportant areas of the scene which are darker or lighter than your key subject.

Flash exposure can be measured with the same brightness range technique provided your equipment allows you to spot-read a trial flash. Flash is still often measured and controlled by an in-flashgun sensor which takes a general reading or, when you use a dedicated flashgun, by a centre-weighted TTL reading from inside the camera. Separate flash meters tend to give only incident light measurement, but you can use them to check lighting ratios (Figure 8.7). Take a reading from the subject pointing towards the main light, then towards any light illuminating shadows.

Stops difference	Ratio	Difference on \log_{10} scale
1	1:2	0.3
2	1:4	0.6
3	1:8	0.9
	1:10	1.0
4	1:16	1.2
5	1:32	1.5
6	1:64	1.8
	1:100	2.0
7	1:128	2.1
8	1:256	2.4
9	1:512	2.7

Figure 8.7 Three alternative ways of expressing ranges (lighting, subject brightness, image density, etc.). The log scale is most often used when exposure and density ranges are plotted as a characteristic curve performance graph.

When measuring with an incident-light hand meter remember that it will give you correct exposure for the whole scene only if the illumination level is equal in every part of the scene. It will then give the same as a reflected-light meter when measuring an 18% grey card under the same lighting conditions. Also note that you should take into account any light loss due to filters in front of the lens (use exposure compensation factors), extension tubes, bellows, etc. The same applies when you use a hand held flash meter. One practical way to check the correction needed is:

1. Place a white or grey card over your (focused-up) subject.
2. Take an exposure reading through the camera of the card, under modelling light illumination.
3. Take a hand meter reflected-light reading off the card, with the same illumination.

The difference between (2) and (3) in *f*-stops is the exposure increase needed when using and measuring flash with a separate meter.

For selective area readings, bring your general-reading camera or reflected-light hand meter close to chosen parts of the subject. If this is impossible measure nearer substitutes your eye judges an exact match. Best of all, use a spot hand meter or a camera offering spot reading mode – both allow you to measure quite small parts of the subject, even from a shooting position some way back (Figure 8.8). To avoid false readings remember to check whether there are any shadows falling on the meter's sensor, or direct light (e.g. from lighting equipment, the sun, etc.) which will cause light scatter. Also, when you are conducting measurements with a reflected-light hand meter it should be along the lens axis. Some large-format cameras have add-on meters which also make spot readings from any small selected part of the subject imaged on the focusing screen (see Figure 8.9).

Selective area reading means that you can pick the part of a scene which you want mid-grey in the final picture and base exposure purely on this. Alternatively, you can discover your subject's brightness range by measuring a diffuse highlight area such as clouds in a landscape, then measure the darkest part where you

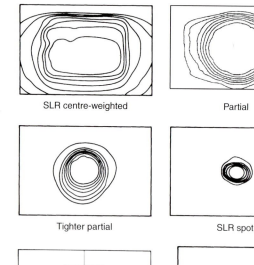

SLR centre-weighted	Partial
Tighter partial	SLR spot
SLR matrix	Large-format spot

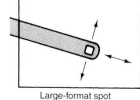

Figure 8.8 Sensitivity patterns of different through-the-lens metering modes. Centre-weighted concentrates about 60% of light reading sensitivity over a large area, centre screen. Pattern is also designed to play down sky in landscapes. Partial and spot: these give a smaller reading area that you must align with key element, then use exposure lock if this element is recomposed offcentre. Bottom: spot reading a large-format image means using a probe that you can move to measure any part of the picture. Some 35 mm SLR systems 'matrix' multi-segments which read four or five parts of the screen at once, allowing contrast measurement with one reading.

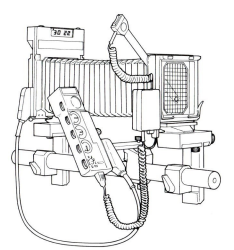

Figure 8.9 Add-on spot reading exposure reading system for a monorail view camera. You set ISO film rating and required aperture using dials on the control box. Then align the probe with the chosen part of image (sensor facing lens) and insert a darkslide behind it to prevent light entering through the back of the focusing screen. Pressing a button on the external end of the probe takes reading and sets shutter speed on bladed shutter at front end of camera. Exposure here is 1/30 sec at *f*/22.

want detail to just record. Read off the difference in stops (for the same shutter speed). If this warns you the scene is beyond the range of your film (page 136) you can either:

1. Add some fill-in illumination to reduce the range, if practical;
2. Increase exposure and curtail development to avoid a negative with excessive contrast; or
3. Decide to sacrifice one end of the tone range (top or bottom) for the sake of recording all the rest. In this case, it is usually best to expose reversal materials to preserve highlights, even though you lose shadow detail. With neg/pos materials expose to just preserve shadow detail.

Having identified the top and bottom of the subject range you want to record, average their two readings and set exposure accordingly. Some of the small-format cameras that provide spot metering automatically average readings for you. As soon as the second measurement is taken, camera settings for midway between the two appear in the viewfinder display.

The zone system

The famous American landscape photographer Ansel Adams devised what he called the 'zone system' to put tone theory into everyday practice. The system is helpful in two ways:

1. It shows you how to work out a personal routine to get the best quality out of silver halide film, paper and chemicals, under your own working conditions.
2. It allows you to accurately fine-tune your result up or down the available tone scale and to expand or contract how much scale it occupies (alter contrast) according to the needs of subject and interpretation.

In fact as an experienced zone-system user you should be able to look at any subject and 'previsualize' how it might be recorded in tone values on the final print, then steer the whole technical process to achieve these chosen qualities. Previsualizing how a colour subject will appear in black and white is a very important part of the zone system. You may want to create a black and white image that is the closest representation of the subject's tonal range. On the other hand, you may want to alter the final tonal range on the print to give a specific mood to the image.

Adams intended the zone system for black and white photography using a large-format sheet-film camera. It is based on controlling the tonal range of the image with exposure and film development rather than altering the contrast of the paper. Ability to individually process negatives and the kind of performance you get from monochrome films and printing papers are in-built features. However, the zone system can also be used for roll or 35 mm film (page 173). For the moment, to learn how it works imagine that you are using individually exposed sheets of film and measuring exposure with a hand meter.

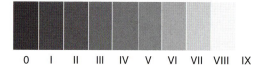

0 I II III IV V VI VII VIII IX

Figure 8.10 The zone system. A full tone range black and white photograph can be rearranged as a scale of eight tones between maximum black and clearest white (approximated here in printer's ink). Each one-stop change of exposure shifts representation of all your subject tones up or down the scale by one tone zone. Top: exposure gauged by one reflected light reading off the top of the waterline rock. This was overexposed by one stop so that instead of zone V (which all meters normally give) the rock reproduces zone VI. Bottom: the same reading but underexposed by one stop makes the rock zone IV, shifts all tones to darker values.

The zones

The essence of the system is that you look at each subject as being a series of brightnesses, from its deepest shadow to brightest highlight, and relate these to a set scale of tones. The zones start from 0 which is total black (maximum black reproduced from the paper) through to zone X which is total white (white of the paper). Zones 0 and X are the extreme zones of the scale and no detail is recorded. Zone V is mid-grey – the tone you would normally pick for subject brightness about midway between darkest and lightest extremes and equivalent to 18% reflectance card. Other parts of the scene only half as bright would fall into zone IV or, if twice as bright, zone VI, and so on. Changing exposure by one stop reallocates all the subject brightnesses one zone up or down the scale. Note that zone V corresponds to a mid-grey on the print and does not mean that the subject was mid-grey.

By previsualizing your final print you can decide which areas of the subject you want to be exposed as zone IV, zone V, zone VI, etc. For example, you may decide that a specific area of the subject should correspond to zone VI. You can measure the area with your light meter (which will give you a correct exposure for mid-grey zone V) and overexpose by one stop (see Figure 8.10).

You should also take into account the luminance range of your scene and the stop difference between the shadows and the highlights. Remember that no detail is recorded in zones 0 and I and detail appears from zone II. Similarly there is no detail recorded in zones IX and X. Your subject tonal range should therefore lie between zones II and VIII if you want to record detail in both highlights and shadows. Also note that for black and white negatives you expose for the shadows and develop for the highlights. For colour negatives you expose for the shadows but you cannot alter the processing time. With colour slides and digital sensors you expose for the highlights. Note however that, with digital sensors, underexposure may introduce noise.

The span of 10 different zones (excluding zone X) covers a subject brightness range of over 1:500, only rarely encountered in scenes backlit by some harsh light source. Eight zone-system zones (1:128), which is just seven stops difference, are considered to be more typical. This is just below the maximum subject range that normally processed film and paper will reproduce on a full tone range print, using a diffuser enlarger. See Figure 8.3.

Your technique must be sufficiently under control for you to be sure that a chosen brightness really value does reproduce as a chosen zone value on the final print. Then other brightness values will also fall into predictable places along the tone scale. As a result you can decide at the shooting stage which parts of a scene you want to make a particular zone and then previsualize how the whole print will finally look. Another stage of the zone system is the control of the film development time, where you can expand or contract the tonal range of the negative record.

In digital imaging, there might be limitations when using the zone system (which was originally developed for film) due to the fact that the sensor may have a lower dynamic range than a film. The control of the tonal range depends on the exposure and any alterations you make later when processing the image on the computer. Note that if you expose a scene by setting the mid-grey to zone V and its highlights exceed zone VIII, *clipping* may occur and loss of detail will result in the highlights. To avoid this you can measure the highlights first using an exposure meter, and expose the scene so that the highlights fall into zone VII or VIII. You can then use software to adjust the shadows by manipulating the tone-scale curves. You can also check whether highlights are clipped by observing the histogram of the image (see page 237). Some digital cameras offer an image histogram feature and this can be used to help you adjust the exposure accordingly.

A high dynamic range (HDR) image is an image that has a dynamic range that apparently exceeds the dynamic range of a normally exposed image. With Adobe Photoshop (version CS2, and later) you can create HDR images using multiple bracketed exposures of the same scene with a digital camera. An HDR image can be created by bracketing the exposure and digitally merging the exposures into a single image. It is preferable to use a tripod when capturing the images and ideally, the scene should not have any moving objects, such as leaves blowing in the wind or water flowing, as this will result in unwanted blurring in the final image. Make a correct exposure and record the *f*-number and the shutter speed. Then, manually overexpose and underexpose the scene with a series of bracketed exposures, changing the aperture by one stop. You can use two or more images to create your final HDR image.

You can create the HDR image in Adobe Photoshop CS2 as follows: Select *File → Automate → Merge to HDR* and a dialog box will open from which you can select the exposures you want to merge (Figure 8.11(a)). Select the images, click 'Open' and when you return to the 'Merge to HDR' box you click OK. You will then see a new window with a preview of the final HDR image and thumbnails of all the exposures you used (Figure 8.11(b)). Note that the image you view is a 32-bit image and you will need to convert it to a lower bit depth (16-bit or 8-bit). When you convert to a lower bit depth you can choose 'compress highlights' from the 'Merge to HDR' dialog box so that only the extreme highlight tones will be compressed without compressing the whole tonal range. Another option is to use 'local adaptation' which calculates the necessary correction for local brightness regions in your image. Other options are manual adjustment exposure and gamma of the image and histogram equalization.

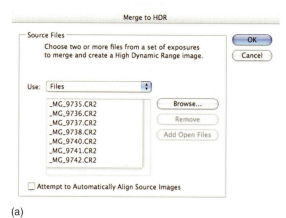

(a)

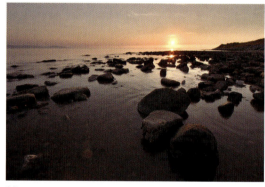

(b)

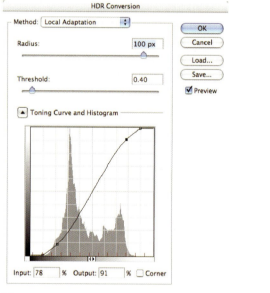

(c)

(d)

Figure 8.11 Creating an HDR image (a) From the Merge to HDR dialog box you select the exposures you want to merge, (b) Preview of the final HDR image and thumbnails of all the exposures you used, (c) Local adaptation settings for conversion to a lower bit depth, (d) the final image and the set of seven images that were used. By Andrew Schonfelder.

Personalized film speed

The manufacturer's recommended ISO speed ratings and development time assume 'average' subject and lighting, typical exposure measurement and the kind of negative which prints well in popular enlargers. Their assumptions may not apply to you exactly. The first step, therefore, is to assess the effective speed of each of the films you use. Do this by finding the exposure needed to record deep shadow detail as zone II (just perceptibly darker than the film's palest tone) on the negative in the following way:

1. Find or set up in the studio a contrasty scene with a span of eight zones. Check with your camera or hand meter – brightest parts should need seven stops less exposure than darkest shadow.
2. With the camera or meter set for the ISO speed printed on the film box, measure exposure for the darkest shadow where you still want detail to just record. Meters making a single-subject measurement read out the exposure needed to reproduce this part of the subject as zone V. However, you want darkest shadow detail to be about zone II on the final print, so reduce the exposure by three stops (three zones) before exposing the picture.
3. Shoot four other exposures, rating the film twice, one-and-a-half and one quarter its box speed. Then give all your exposed film normal processing in whatever developer you have chosen.
4. When results are dry, judge carefully on a lightbox which negative carries just perceptible detail in the shadow area you measured. The speed setting used for this exposure is the effective speed setting for your film used under your working conditions.

Personalized development time

Next, review your film development time. Exposure does most to determine shadow tone, but highlight tones are the most influenced by development. While you still aim to reproduce shadows just above the negative's palest tone you can decide to record highlight parts of your test subject as just below the film's darkest tone. The reasoning here is that you make maximum use of film tone range.

In the zone system, normal development N represents the standard development of the negative. $N + 1$ is the development that expands the zone range of subject luminances by one stop and development $N + 2$ expands the zone range by two stops. Similarly development $N - 1$ contracts the zone range by one zone and $N - 2$ contracts it by two zones (see Figure 8.12).

You can find the standard development time and the times for overdevelopment and underdevelopment with the following method:

1. Make a series of seven identical exposures of your test subject, as measured with the film rated at your effective speed. You may need sheet-film for this.
2. Give each exposure a different development time – one can have normal time, others 10%, 15% and 25% less and 15%, 25% and 40% longer. Be very accurate with temperature and agitation technique.

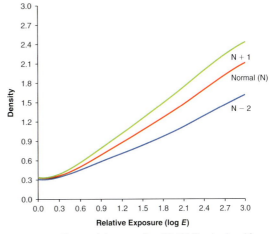

Figure 8.12 Characteristic curves of an ISO 400 film developed for N, $N + 1$ and $N - 2$. The exposure range is for zones 0 to X.

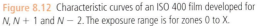

3. Carefully judge which test negative records brightest important subject details just short of being too dense to print with acceptable detail and contrast with your enlarger. Make trial prints as necessary to check quality. The development time which gave the best negative is correct under your conditions for an eight-zone subject. (If this differs much from the development used when you established film speed you may have to modify your speed rating. Retest for speed if necessary.)

From your tests you can determine the development time that you need to use to expand or contract the zone range by one or two zones.

Now you can start to shoot pictures with a more controlled technique, adjusting development when necessary to expand or contract tone range. Always begin by separately reading the exposure for lightest and darkest important detail in any subject. Then compare them (in number of stops) to discover what zone range your picture spans. If the range is high (over eight zones) there are three alternatives:

1. Sacrifice either shadows or highlights to improve tonal reproduction at the opposite end of the scale. For example, underexposing by one stop shifts all tones down one zone. This sacrifices shadow details which move off-scale to zone 0 or beyond on your print but lets in highlight detail to now record as zone VIII. Overexposing one stop shifts all tones one zone in the opposite direction, moving highlights off-scale but improving shadow tones which now print as zone II. To take this decision, you must look at the scene, previsualizing it on the final print either with its palest detail indistinguishable from white paper or its darker shadow detail featureless black.

2. If you do not want to lose detail at *either* end of the tone scale then earmark the film for reduced ('held back') development. You already know from your tests the development time needed for an eight-zone range. Go back to your tests to discover how much reduction in this time will contract the zone range by one zone. Do not overdo development control, though. Avoid changes from the manufacturer's regular development time greater than 40–50% otherwise you get negatives too flat to print on any grade of paper. Also, since this amount of development reduction affects both shadow and highlight tones you have to start readjusting your effective film speed (downrating to allow for holding back).

3. Adjust subject lighting range by adding more fill-in or wait for a change in existing light conditions. Even adjust viewpoint so that your picture contains a lesser range of tones. As before, check out the effect by comparing separate light readings of darkest and lightest subject detail to discover the new zone range.

Your problem may be the other way around – an excessively flattened subject spanning perhaps fewer than six zones. Control this by either (2) or (3) but reversing the suggested technique. It will also help if you can change to a slightly more contrasty film such as one with a lower speed rating.

Including your printing conditions

It is true to say that, having got a really good negative with the right tone range and all the detail, your picture should almost 'print itself'. In any case, within the darkroom it is easy to work trial-and-error methods not possible when shooting. However, you can choose to adopt a similar zone system approach here as well, to establish personalized exposure and development times geared to your printing paper and enlarging equipment.

First, test for exposure with just a clear piece of film in the enlarger negative carrier. Set your most usual lens aperture (typically, two to three stops down). Expose a half sheet of normal graded or grade 2 filtered variable contrast paper with strips of six to eight test exposures, bracketed closely around the time you estimate will just produce a full black. Process the paper in your normal developer for its recommended time, then check your print to find the strip

beyond which extra exposure does not give a deeper black. This is the paper's maximum black produced from clear (subject zone X) parts of the negative. (All other tones should then follow on, up to something almost indistinguishable from the paper base from subject zone 0 areas of your negatives.)

Next, test for best print development time. Working with the clear film and giving the exposure time you have just established, expose a full sheet. However, before processing your paper cut it into nine equal pieces, each numbered on the back. You then develop each piece for a different period bracketed around the recommended time. For example, if the regular time for fibre-based paper is 2 min, range from 1 to 3 min at 15-sec intervals. From the processed strips decide which time has just produced the paper's fullest black, and then make this your standard print development time for the zone system.

Putting the zone system to work

Y ou have now standardized your technique, from film speed to print development. It forms a chain giving fullest tone reproduction from your silver halide materials (regard paper contrast grades and local printing-in or shading as extra adjustments for corrective or expressive use). Successful use of the zone system relies on your keeping this core technique very carefully under control. You should then be able to look at and measure a subject, decide and forecast the final print, and be reasonably certain of achieving it (Figure 8.13).

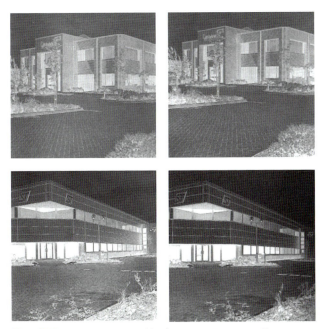

For example, you might be shooting a portrait in soft, diffused light. Delicate flesh tone detail is of utmost importance. For a Caucasian you might decide to make this zone VI (see the scale on page 166), in which case take a single meter reading of the face and increase exposure one stop. A dark-skin face would be better reproduced as zone V, achieved by giving the meter indicated exposure straight.

Perhaps the subject is a harshly lit building, mostly in shadow. You judge the shadowed parts as most important, but reckon it would look wrong to have them any lighter than zone IV. So read the shadow only and decrease exposure by one stop. Another treatment, if the building has an interesting shape, is to make it a

Figure 8.13 Rejigging exposure and development to compensate subject contrast. Top right and bottom left: normally developed contrasty and flatly lit subjects, respectively. Top left: negative given more exposure and less development has less contrast. Bottom right: negative with less exposure and more development increases in contrast. Reproductions here can only approximate photographic film results.

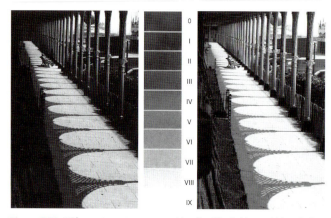

Figure 8.14 With an extreme tone range subject like this, decide at which end of the scale you can best afford to sacrifice detail. For the left-hand picture, sunlit paving was exposed to record zone VIII although shadowed earth is lost into zones III and II. In the right-hand picture, giving more exposure holds this shadow detail at zone IV but the paving now reproduces beyond zone IX.

silhouette. This means reallocating the shadowed walls as perhaps zone I by underexposing their reading four stops.

Suppose you now move around the building to a viewpoint from which there is a harsh mixture of important sunlit and shadowed areas (Figure 8.14). You want detail in both but start off reading the lit part. Consider making it zone VIII. Now measure the shadowed walls – perhaps this reads six stops more, a difference of six zones. Can you accept detail here as dark as zone II? (A print from the negative may be wanted for reproduction on the printed page, where good separation of tones in darker areas of the picture is always important.)

It might therefore be a better compromise to raise the whole picture by one zone, making sunlit walls zone IX and shadows zone II. Do this by reading sunlit parts and decreasing exposure three stops, or reading shadowed parts and increasing exposure two stops. Another option would be to avoid a contrasty negative by decreasing development by an amount which reduces picture zone range from six to five zones. (If you decide to do this, consider halving the ISO setting on your meter before taking final readings, or bracket at both settings.)

Finally, check out the blue sky behind the building. Will any building tone match the sky too closely so that in monochrome they run together, losing subject outline? Decide this by eye, or compare readings from blue sky and sunlit parts of the building. If you forecast that tones are too similar (for example, the sky is less than one stop darker, one zone lower), you could separate them by using a filter. Try a polarizer or a yellow or green coloured filter on the camera. Do not forget the filter factor if you are not metering through the lens.

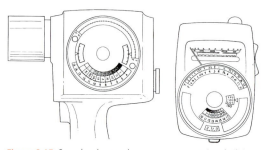

Figure 8.15 Some hand meters have zone system settings built in. Other dial types (right) can be adapted by sticking on tiny pieces of a bromide paper greyscale to represent zones I–IX. Zone V should be pasted over the normal-setting arrow. Each paler tone corresponds to higher light readings, darker tones to lower readings. Now, by measuring any chosen part of the subject, you can align its light reading with the tone you want it to be in your final print (assumes normal development).

Metering for zoning

If you use the zone system you fully appreciate the value of accurately reading light from chosen parts of any subject. Generalized readings are not very helpful. A spot reading system is ideal, but short of this, be prepared to come close with the camera or hand meter or read off a handy visually matching substitute.

If you have a hand meter with a suitable large calculator dial you can make a simple 'zone scale' to attach to it. These small segments of tone, perhaps cut from your bromide paper tests, give direct visual readout of how different subject brightnesses will reproduce (see Figure 8.15).

Limitations to the zone system

The zone system offers a sound technical grasp of tone control, but you must also recognize its limitations. The system best suits black and white landscape and still-life large-format photography where time permits careful measurement of different elements in the picture.

Many other picture-shooting situations are too fleeting to allow several local readings. Again, it is less easy to individualize degree of development when using a rollfilm camera or a 35 mm film containing up to 36 different shots. One solution is to pick development which suits the most important pictures on the film, then rely on adjusting the tone scale of prints from your other negatives through paper grades. Alternatively, fill a whole rollfilm with bracketed exposure versions of each picture. If your camera has interchangeable magazines, or you have several bodies, organize your shooting so that all pictures requiring the same amount of development accumulate on the same film.

The 35 mm format films are also more vulnerable to the side effects of over- or underdevelopment as part of system control. For example, overdevelopment increases graininess, and although this may barely show in enlargements from 4×5 in. negatives, the same size prints from 35 mm quickly become unacceptable. You must remember that your tests for the zone system refer only to the specific film, developer, enlarger, paper and paper developer you used. Any change of these parameters means having to make new tests. Also note the effect of colour filters on the tonal range of the scene (Figure 8.16).

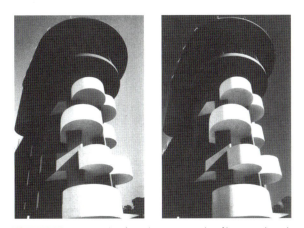

Figure 8.16 Zones can leapfrog when you use colour filters on coloured subjects. Left-hand picture here was unfiltered, the other exposed through a deep-red filter. Notice how the bottoms of balconies are darker than the blue sky in left version, but a tone lighter than the sky on the right. Always previsualize zones looking through the filter.

Colour films cannot be given adjusted processing to expand or contract tones as freely as black and white because of unacceptable distortion of colours. Zone system methods for colour negatives especially are limited to light measurement and exposure. (Here it can be argued that a trial shot taken on instant-picture material gives you an equally valid and faster tone value guide.)

However, even if you do not work the zone system in detail, understanding it will definitely help you previsualize the final monochrome print at the time of shooting. Remember the concept whenever you light-measure different parts of a scene. It makes you stop and think what will be

the most suitable tones for each part you read, and, where necessary, to put aside exposed material for modified development. Also bear in mind that a full detail, full rich tone image does not always mean a great photograph. You must know when to make an exception – break away from this 'look' if it is likely to work against the style and mood of a particular picture. The zone system is a technical control but not something that should ever control and limit you.

Tone changes after film processing

You can alter tone values in a processed film by chemical or physical means to get better final image quality. Most chemical treatments are for emergencies when mistakes have been made or subject conditions were beyond the range of the film. Physical methods such as duping or masking (sandwiching the film with a weak positive or negative contact printed from it) are less drastic. They do not alter your original film image itself, which remains safe. You can also scan your films and carry out corrections by using imaging software.

Chemicals to reduce or intensify image tones often create permanent changes, so you should choose and use them with due care. There is always some risk of ruining the image through stains or some other chemical or handling mishap, so it is a sensible precaution to make the best possible print first, as a standby. Always start out with a film which is properly fixed and washed before treatment, and for safety test out one image alone first. If possible, preharden in liquid hardener. During reduction or intensification keep the film agitated gently all the time it is in the solution, and afterwards thoroughly wash it before drying. It is important to observe health and safety recommendations when mixing, using and disposing of chemical solutions. Read over the points on page 376.

Correcting dense black and white silver negatives

Negatives which are too dense might have been overexposed, overdeveloped or slightly fogged overall. Perhaps the subject spanned too great a tone range and was exposed mostly for midtones and shadows. Dense flat negatives can be duplicated (easiest by rephotographing at 1:1) onto colour slide film. The resulting negative will be more contrasty, and by careful choice of exposure important subject brightnesses may reproduce as properly separated tones.

Figure 8.17 When chemically reducing a film, check results visually by working near a lightbox or window (but avoid direct sunlight). Have a water supply nearby to rinse and halt the action when tone changes have progressed far enough.

Alternatively, chemically change the flat original negative in a subtractive type reducer such as the Farmer's one-solution ferricyanide reducer R-4a (see formula, page 373). This removes nearly equal quantities of silver from dark, medium and pale tones, and so has greatest effect on pale tones, making the negative more contrasty as well as less dense (Figure 8.17).

Dense but contrasty negatives, perhaps due to overdevelopment, are best reduced in a *proportional* reducer

such as Kodak's R-8. If subject highlights are very dense (an overdeveloped contrasty scene, for example) use a *superproportional* reducer instead. Superproportional R-15 persulphate reducer removes more silver from dense areas than pale areas of your negative. Used carefully, it reduces the density and printed tone separation of subject highlights without much affecting shadow tones. (Formulae and method are in Appendix C.) If you are working on a negative 4 × 5 in. or larger it may be practical to reduce just chosen areas of the image by applying one of these reducers locally, by swab or brush. Another approach is to reduce contrast by masking.

Correcting dense colour slides and transparencies

Colour films (and black and white negatives carrying a final dye image) do not contain silver. Therefore you cannot treat them in the chemical solutions used to reduce regular black and white negatives.

However, surprising improvements are sometimes possible by copying your dense transparency onto reversal dupe film (see page 298), giving an exposure which will produce lighter results. (As a guide, give one stop overexposure for every half stop the original was underexposed.) Once again, you reach the limit of this technique when shadow tones appear an unnatural, featureless grey. You must also accept a generation loss – the kind of optical and tonal deterioration which happens when any image designed for final viewing is copied.

Correcting pale black and white negatives

The usual causes here are underexposure and/or underdevelopment or a very contrasty subject exposed mostly for midtones and highlights. Negatives which are severely underexposed with loss of shadow tones and detail are very difficult to salvage. You cannot put back information which has not recorded at all in the first place.

Figure 8.18 A flat, underdeveloped negative intensified (left two-thirds) in chromium intensifier. Darkest tones strengthen most, increasing contrast.

Various chemical intensifiers are designed to build up existing tone values in silver image negatives. They all increase graininess too. Flat, underexposed or underdeveloped negatives are best treated in a solution such as Chromium Intensifier IN-4 (Figure 8.18). The intensifier bleaches the film, which you then wash and redarken in any fast-acting developer such as print developer (see page 374). Tones are strengthened in proportion to the amount of silver originally present, and you can repeat the treatment to increase the effect. Rapid Selenium Toner is also used as a substitute to the Chromium Intensifier IN-4.

Negatives which are contrasty and thin will need the most density build-up in their palest tones. You therefore need a subproportional formula such as Kodak Intensifier IN-6 (see formulae).

Pale colour negatives

An underexposed or underdeveloped colour negative is unlikely to give a satisfactory colour print. Missing shadow tones reproduce darker parts of the subject as devoid of detail, and usually

with a strong colour cast. Low-contrast images 'mis-match' the quite critical relationships of negative and print material. For example, you will not be able to print with the same tone contrast or colour balance at shadow and highlight ends of the subject's tone scale. Try printing with a condenser enlarger (rather than the usual diffuser lamphead type used for colour). You may achieve best results by abandoning colour altogether and printing onto hard-grade black and white bromide paper.

Pale slides and transparencies

There is almost no way to improve overexposed, overdeveloped or fogged reversal films because the subject's lightest detail is 'burnt out'. If results are also flat you can sometimes make improvements with a contrast-increasing mask. Even though you are only adding a weak black and white positive to the transparency to add weight to tones already there, results look much more acceptable. Otherwise, if the shot is important and unrepeatable you will need to have the best possible reversal print made – and then pay for this to be retouched.

Controls during enlarging

Sometimes quite simple changes in your darkroom equipment or techniques can give a significant improvement in the printing quality of an excessively contrasty or flat negative. For example, if you are trying to print a contrasty image in a condenser enlarger and do not have a diffuser head (such as a colour head) available, place tracing paper over the top of the condensers. This gives a dim but one-gradesofter light source. If this is not a sufficient improvement, try 'flashing' – evenly fogging the printing material to a small quantity of light.

A correctly flashed print changes only in subject highlights. Your normal exposure to the contrasty negative is too weak to give a developable image here. However, the extra photons of light the paper receives from flashing are sufficient boost for traces of subject detail previously 'sub-latent' to develop up. Overdone, flashing gives a print with flat grey highlight detail and a fogged appearance, so there are limits to the amount of contrast reduction possible. You can also use flashing when printing onto reversal materials (i.e. colour prints from slides) or when duplicating contrasty transparencies. This time, flashing helps to bring up better *shadow* detail but overdone shadows start to look flat grey.

The amount of light needed to flash the emulsion after image exposure has to be found by testing. With colour printing try removing the film from the enlarger carrier, placing a 2.0 neutral density filter (factor × 100) under the lens and giving your paper the same exposure time over again. For black and white you can simply leave the negative in place and hold thick tracing paper about 3 cm below the lens. This scrambles the light sufficiently for the paper in the enlarging easel to receive even illumination. Try giving about 10–20% of the previous exposure.

Figure 8.19 Reducing the effective size of the lamp in a condenser enlarger lamphouse – gives harder illumination and a more contrasty print.

To increase the printing contrast of a flat-tone range negative, make any change which will harden the enlarger light source. Change from

a diffuser to a condenser head. Better still, change to a condenser enlarger with a point-source lamp. Alternatively, you can harden up a regular opalized lamp with a hole in opaque foil (Figure 8.19), but make sure your negative is still evenly illuminated – you may have to raise or lower the lamp. The much dimmer image will have to be compensated for by a wider lens aperture or longer exposure time.

■ To control tone values, look after all the links in the chain – subject and lighting contrast; filtration; lens and imaging conditions; film contrast and grain; exposure accuracy; development; reduction, intensification or masking; enlarging conditions; print material and techniques like 'split-grade' exposing; and also final viewing conditions. Working digitally, recognize the ill-effects of over/underexposure and excessive contrast range.

■ Typically, subject brightness range is compressed as recorded on the negative, especially shadow tones. It expands again to some extent (especially in darker tones) when printed. Quadrant diagrams prove the importance of correct exposure – partly on the toe of the film curve – to make proper use of the full tone range of the paper. They are also used in digital imaging for tone control through the imaging chain.

■ Try to get your subject brightness range within reasonable limits in the first place by care over lighting. Compensate extreme contrast by reduced film development (but overdone, your negatives will be too flat to print well). Gear exposure and development to your own printing conditions. Over- or underexposed negatives will not 'fit' any paper. You can manipulate the tonal range of your images digitally.

■ Tone can be controlled at the different stages of the digital imaging chain. The transfer function of a digital imaging device is equivalent to the characteristic curve of photographic materials and it describes the response of the device to the subject luminance.

■ Any single light measurement reads out camera settings which reproduce this part of the subject as mid-grey. You get greatest exposure information from several local area readings. Separately reading highlights and shadows shows whether subject contrast is within the range of the film. It warns you to compensate by lighting fill-in or adjusted development, or to accept loss of top or bottom of the tone range.

■ The zone system helps you to devise your own practical routine for tone control. Subject brightnesses are previsualized against a range of zones (I–VIII), with mid-grey zone V, black (0) and white (X). Changing exposure one stop shifts all subject brightness one zone up or down.

■ To work the zone system you must have your exposure/development/printing technique firmly under control. Then adjust one or more of these stages to get the best possible tone range reproduction for your particular shot. First, establish the effective speed of your film. Find development times for high, medium and low subject brightness ranges to get negatives with the right tone range to print well through your equipment. Similarly, you can establish best paper development time.

■ Use the zone system by picking a key subject brightness, deciding the tone it should reproduce and then exposing so you know you will achieve this precisely. You can also measure darkest and lightest important detail, and by picking the right exposure and development arrange that this just fills the full tone range offered by your printing paper.

SUMMARY

■ The zone system best suits sheet-film black and white pictures of inanimate subjects. It can be adapted to rollfilm and 35mm sizes provided you can locate all pictures needing the same development together on the same roll. For colour slides and negatives and for digital photography you can control only exposure using the zone system. Even if you do not work every aspect of the system, remember the concept and train yourself to tonally previsualize your results.

■ You can modify tone qualities at later stages to improve or salvage results. Use appropriate chemical reducers to lighten dense black silver negatives. Reducers also alter contrast – subtractive types increase it, proportional or superproportional reducers maintain or reduce contrast.

■ Dense, flat colour transparencies may improve if duped. Treat pale black and white silver halide negatives in chromium intensifier or (contrasty negatives) use a subproportional intensifier. Remember health and safety advice.

■ Reduce tonal contrast at the enlarging stage by diffusing the light source or 'flashing' the paper to light. To increase contrast, change to a condenser head and more point-source lamp.

1 In this project you will make a set of exposures that cover the 10 zones of the zone system. You will need an evenly lighted textured surface, a camera on a tripod, black and white film and paper. Load the film in the camera and set the film sensitivity. Look through the viewfinder, and focus on the surface. Determine the correct exposure using your camera (or a handheld) light meter. Using the table below, write the combination of aperture/shutter speed for correct exposure, e.g. f/5.6, shutter speed 1/30 in the box for zone V. Fill in the table with the corresponding aperture/shutter speed settings for all zones (zone 0 to zone X). *The table is filled as an example.*

Expose your film for all the zones using the settings in your table. Develop the film for normal time and print a contact sheet using medium grade. Make exposure tests to determine the exposure time for which the frame that corresponds to zone V is printed as medium grey and print the contact sheet for this time.

Observe the zones from 0 to X and check from which zone you start discriminating detail. Remember that your results depend on the specific development time you use, the enlarger type, etc.

2 Use a digital camera and find a subject with a wide range of tones such that with the midtone in zone V the highlights will be recorded in zone VIII. Expose using the settings for zone V and then make another exposure, overexposing by two stops. Observe the changes in the tone scale of the image and especially the highlights.

PROJECTS

Zone	0	I	II	III	IV	V	VI	VII	VIII	IX	X
Stop difference	−5	−4	−3	−2	−1	0	+1	+2	+3	+4	+5
Aperture	f: 5.6	f: 5.6	f: 5.6	f: 5.6	f: 5.6	f: 5.6	f: 5.6	f: 5.6	f: 5.6	f: 5.6	f: 5.6
Shutter speed	1/500	1/250	1/125	1/60	1/30	1/15	1/8	1/4	1/2	1	2

3 Use a spotlight meter and find subjects with low and high contrast. Measure the shadows, the midtones (a mid-grey area and the highlights). Using a zone system table (as in Project 1) write the combination of aperture and shutter speed in the box under zone V and fill the rest of the boxes. Check in which of the zones do your measurements for the shadows and highlights correspond. What is the stop difference between them? Would you need to expand or condense the tones?

4 Find a subject with a wide range of tone values. Measure the shadows and determine the correct exposure which will place them at zone II. Measure the midtones in your scene and calculate the stop difference from the shadows. Taking into account the stop difference at which zone will they be placed? If they are not placed in zone V, consider whether your negative needs overdevelopment of underdevelopment to achieve this.

This chapter is subject orientated. It takes a cross-section of 11 kinds of subject matter from sports to simple astronomy, outlining some typical professional markets and the general organization and technical approach to the work, plus hazards to avoid. Of course, whole books could be written about each subject, but running them together here points out the different pressures and priorities they impose on you as a photographer. Perhaps you will never have to tackle all of them, but then you are unlikely to specialize in only one type of subject either, especially if you are just setting up as a professional.

It is dangerous to be too categorical about the technique used by different individual photographers. People have an idiosyncratic approach to equipment and working method. After all, it is *possible* to use a large-format camera for candid documentary photography and 35 mm for still lifes and architectural interiors. Similarly, some photographers heavily impress their own particular style on whatever they shoot, almost to the point of excluding the purposes for which the picture will be used. These, however, are the exceptions.

Generally, market forces, your own specialist subject experience and even equipment design determine why and how pictures are taken. Convenience and common-sense dictate your best technical approach. Most photographers tackle jobs in the way outlined here – just remember that no approach is set and immutable. New markets and new kinds of equipment (digital, for example) mean that subject problems and their solutions change over a period of time. In any case, newcomers to photography should always question the way things were done previously, for breaking away and finding new visual solutions is one way of beating your own path to success.

Most commissioned photographic jobs have to fulfil some form of commercial need or requirement of communication. They also challenge you with extra constraints. The final image may have to fill a long low format, it may have to be quite small (calling for a simple, bold approach) or it has to work when converted later into stark black and white only. Even when you have not been *assigned* to photograph a subject as a job it is important to set yourself tasks or projects. This gives you a structure to work within, while still allowing experiment. In portraiture, for instance, you might discipline yourself to produce six pictures of *pairs* of people, and then consider all the ways subjects could relate – mother and son, husband and wife, old and young, etc. Equally, your series might all be people living in the same building, or all in uniform or travelling. Then when you have actually taken pictures along self-set lines and processed and contact-printed results you start to discover take-off points for further extending your project or progressing into new ones. For example, two of the people you photographed might appear in an interesting location which leads on to a series on environmental interiors, or accidentally blurred detail in one frame suggests a series on movement and abstraction.

In this chapter each subject area is discussed under three headings. *Purposes* means typical functions and markets, reasons why pictures are taken. *Approach and organization* discusses planning and your relationship with the subject, while *equipment and technique* suggests how to put it on light-sensitive material, using appropriate gear.

Sport and action

Purposes

Strong, topical action pictures are always of interest to newspapers and the sporting press. Over a period of time a sports photographer accumulates a vast range of shots filed, for example, under the specific occasion, the personalities shown and more generalized pictures of different activities. The best of these photographs will sell over years to publishers of magazines, books, posters and other advertising. They may be used for anything from editorial illustration to product packaging or textile designs. Freelance sports photographers therefore tend to contribute to or run their own comprehensive picture libraries. Others are on the staff of news agencies or specialist publications, or may work directly or indirectly for sport sponsors and sports goods manufacturers.

Approach and organization

First, you should fully understand the sports or activity you are covering. You also need patience, the ability to anticipate a high point in the action and to immediately respond to some vital moment, which can often be unexpected. The main aim is to capture participants' skill, anguish and tension, plus the dramatic excitement and atmosphere, preferably all summed up in one shot. Experience and preplanning are of great importance. Familiarize yourself with the rules of the game, if you are covering sports, and anticipate the right moment to take a photograph. Aim to pick out the best possible viewpoint in terms of perspective, background (atmospheric but not confusing) and where the action will be most intense. If you do your homework properly you should be in the correct position for a left- or right-hand golfer and know which end a particular vaulter gets his legs over the bar. Make sure that the place you stand is safe when you cover sports such as motorsports, and always follow the regulations of the organizers. Some sports like athletics or cricket consist of mostly repetitive actions, and the problem is to find a picture which is interestingly different. Other events take place all over the field, so you must keep all your options open, working with a kit of lenses from one or more key positions.

Go for the expressions and body language which visually communicate how it feels to be taking part (see Figure 9.1). Look at the tension competitors go through just before an event and the reaction of spectators, as well as the vital peak of action itself. At the same time, your photography must never interfere with the sport or activity – you must know and respect its requirements and rules. Wherever possible, get the

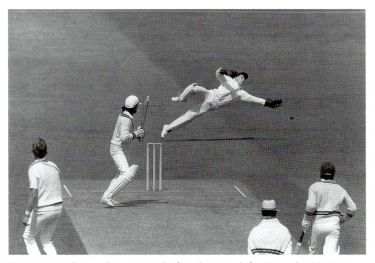

Figure 9.1 A split second at a test match, after a long period of waiting and anticipation. Patrick Eagar shot this using an extreme telephoto lens, for *The Sunday Times*.

cooperation and interest of people organizing the event. This will lead to viewpoint opportunities not otherwise open to you.

Equipment and techniques

When capturing action it is essential to have a good range of lenses. If you use a digital single lens reflex (DSLR) camera, make sure that you have with you memory cards that will provide you with enough storage. You may use many times the 'Burst Mode' to capture a sequence of images and this means that you will need to store a large number of images in the memory cards. Fast data-transfer rate is also important. If you use film, a motordrive is an important aid in sport and action photography. You may need two camera bodies, fitted with different lenses, depending on the subject.

Wide-angle lenses are useful for crowd shots, general scenes and dramatic, steep perspective close-ups. However, for many sports your enforced distance means that you will rely on long focal lengths – 600 mm or more in the case of cricket or baseball. All these lenses need to be as wide aperture as you can possibly afford. You are likely to work at shutter speeds of 1/500 and upwards, and the shallow depth of field given at wide apertures is helpful in subduing distracting backgrounds. In the case where the ambient lighting is low and you cannot use longer exposures or open the aperture, you will need to change the ISO speed of your digital camera to higher sensitivity. Note however that this will add some noise in your images. With film cameras you can use a film of higher ISO rating (you can have two camera bodies loaded with films of different sensitivities). In that case the image will appear with more grain. This is subject to the sensitivity and also the type of film. Fill-in flash can solve the problem but remember that in many sports events the use of flash may be prohibited. Ask the organizers on any regulations regarding flash photography before using it. Telephoto lenses with long focal length are heavy and a tripod or monopod is necessary to keep your images sharp and retain your composition especially when you capture sequences of images.

Sports	
2 digital or 35 mm film bodies with motor drive	
Wide-aperture lenses:	50 mm
	24 or 28 mm
	70–200 mm
	300 or 400 mm
	600 mm
Tripod	
Monopod	Remote release

On the other hand, it is a good idea to freeze only those elements in a picture which need to be seen in detail (facial expressions, for example). Rapidly moving extremities – arms, legs, wheels symbolize action much more effectively blurred, especially when shot in colour. This takes judgement and risk in choosing the shutter speed for any one occasion. There is always the possibility of excessive abstraction. Panning your camera to follow the action of track or field events is another way of making blur dramatize speed and isolating subjects from often distracting surroundings.

Despite autofocus cameras, experienced sports photographers often prefer to prefocus on some key spot on the ground and shoot when the action reaches this point. Others pull focus by hand to keep the main element sharp – preferring the freedom this gives to the always centre-frame focusing of automation.

Never assume that by shooting a rapid series of frames you are *bound* to capture the vital moment of an event. This depends on the frames per second that a camera can capture and

currently digital cameras offer speeds of around 3–10 frames per second, depending on the manufacturer and the model. For example, at three frames per second, pauses between pictures are still around 300 times longer than the moments being recorded. With the earlier digital cameras the *shutter lag*, the delay between the moment that you press the shutter release button and the moment that the image is captured, was causing problems in action photography. Nowadays DSLRs have fast shutter lag, allowing you to capture the action with accuracy. Another issue with digital cameras was the time needed for the camera to store the image after exposure, before taking the next picture. Again, this is not a problem with current DSLRs. Although digital and film SLRs give the option of exposing sequences of images in high speeds (several frames per second), there is really no substitute for foreseeing what will be the peak of action and learning to press the shutter just a millisecond or so ahead. Pictures covering an important event are often urgently needed back at a newspaper's sports desk, to catch an edition. This may well justify the cost of a digital SLR camera able to download shots via modem and mobile phone direct to the editor's computer screen.

Photo-journalism/documentary

Purposes

In-depth journalistic picture series are like essays or published articles, as opposed to press pictures which singly cover deadline news. The whole concept of 'photo-journalism' was pioneered in the late 1930s by magazines such as *Life* and *Picture Post*. A good *visual* story, strong photography with a point of view, plus intelligent layout on the printed page together form a powerful kind of communication. In recent years markets for photo-journalistic essays in magazines and newspaper supplements have greatly declined. However, strong documentary pictures are still in demand for travelling exhibitions, books of photographs and new forms of publication such as CD-ROMs and the Internet.

Most subject themes revolve around human events – after all, most people are interested in people. The relationship of people to their environment, society, work, violence or some catastrophe are constantly recurring story lines. Some of the best journalists – like the best documentary writers – have been obsessed by their subject matter to the extent that it becomes a crusade rather than a job. (See the work of Farm Security Administration photographers revealing the 1930s plight of destitute US farmers, and Eugene Smith's book *Minamata*, on industrial pollution.)

Approach and organization

You must decide the theme of your story and give plenty of time and thought to the best approach. As far as possible plan a mental list of vital pictures, so that your project is structured and shows various aspects of the subject and theme. At the same time keep open-minded and aim to take a lot of pictures which can be edited down later. Good selection then allows you (or, more often, the art editor) to lay out pictures which determine the order of viewing, make comparisons through being run side by side and so on.

Documentary		
2 digital or 35 mm film bodies with motor drive		
Flashgun (GN 30–60)		
Wide-aperture lenses:	24 mm	
	35 mm	
	50 mm (2)	
	70–200 mm	
Tripod or clamp		

Perhaps you will want to show differences between young and old, rich and poor or contrast people's public and private lives. People at work could be photographed to show both social life and working activity. At public events turn your camera on spectators and events behind the scenes as much as the scenes everyone else sees and photographs.

Equipment and techniques

Mostly you will want to be inconspicuous, and merge in with the people around you. This means dressing appropriately and simplifying your camera kit which you carry in a bag not too obviously photographic. 35 mm is the ideal format because of its compactness. Autofocus is also helpful on occasions, especially if you must grab pictures without looking through the viewfinder (for example, over people's heads). Have two camera bodies fitted with different lenses and, if they are film cameras with different motordrives. Be prepared to wind on film manually in situations where motor noise will attract attention.

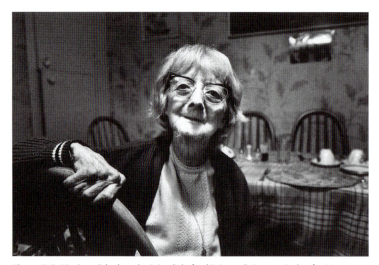

Figure 9.2 Monique Cabral used existing light for this journalistic portrait shot for *New Society* magazine. 35 mm camera equipment offers lenses with wide aperture and adequate depth of field to record environment, even under poor light.

attention. Use existing light as much as possible (Figure 9.2) but pack a flashgun for times when conditions and depth of field requirements are beyond even the fastest film, or when you must fill in ambient light to reduce contrast (page 153).

Most work will probably be done with a wide-aperture standard lens, but have a wide angle for interiors and whenever foreground detail should look large and dominate the general environment. Pictures taken close with a wide-angle lens add to a sense of 'being there' when you are among a crowd, and during a threatening situation even increase the apparent aggression. Shooting from afar using a moderately long focal length 'puts together' elements in mid-distance and background. You can also use it for unobtrusive head shots some distance away (sometimes an easy option – you will get a less 'detached' perspective by shooting closer with a normal lens).

Portraiture

Purposes

Apart from mere physical identification, most deliberate portraits are shot either to flatter the sitter or to express individual character. Of course, these purposes are not mutually exclusive,

but flattery portraiture is mostly commissioned by or taken for your actual sitter or his or her family or business organization. Sitters expect to be shown favourably, perhaps portrayed as they see themselves or hope others see them. However, with portraits commissioned by third parties such as magazine editors you can forget flattery and sum up a person as a character, even if this is cruelly revealing. It is helpful to know how a picture is to be used – perhaps framed in a commanding position on a boardroom wall, reproduced single column or full page in a magazine or even sent out in response to fanmail. Pose, lighting and size of detail within the frame can then be geared to this end form.

Approach and organization

It definitely helps to be extrovert and good with people. You may prefer to photograph in the studio, isolating your sitters from their normal surroundings. The studio is easier for you but often more intimidating for your sitter. Going instead to their own environment (home or work) means that you can make local features form a part of the portrait, adding information and allowing you scope for interesting composition (Figure 9.3). Unlike candid portraiture, the sitter must be *directed*. Uncertainty or overmanagement on your part is likely to result in either self-conscious or 'stagey'-looking portraits. Make up your mind what facial features you should emphasize or suppress. Observe the way your sitter uses hands, sits or stands. You need to establish a relationship, talking and putting the sitter at ease while you decide setting, pose, lighting and viewpoint.

Figure 9.3 A formal approach to portraiture in this nearsymmetrical baby shot by Sue Packer. It was photographed on location with bounced studio flash, using a 6 × 6 cm camera. The simplicity of the lighting makes the throne-like chair shape all the stronger. From series 'Baby Sittings'.

If hands are important you might have the sitter at a desk or table, perhaps at work. He or she will take up a much more relaxed, expansive pose in an armchair than perched on the corner of a stool. Photographed from a low angle someone will look dominant, whereas shown from a high viewpoint they can appear dominated. A broad face or broad shoulders look narrower from a three quarter viewpoint instead of square-on. Organize everything for a natural and productive relationship between you and your subjects. Minimize the machinery. Do not have people trapped into straight-jacketed poses and critical lighting arrangements which are bound to make them look artificial and ill at ease.

Equipment and techniques

This type of subject lends itself well to medium-format cameras. High-resolution digital cameras or camera backs are also suitable for portrait photography. The extra picture qualities outweigh equipment size and weight. It is a good idea to use a tripod anyway. You can more easily fine-tune

Portraiture
High-resolution digital camera or camera back, or 6 × 6 cm film camera 150 mm, 250 mm, 80 mm lenses 2 studio flashes Flash meter Tripod, cable release Reflectors, diffusers

lighting, etc. without moving the camera and disturbing composition. If you stand to the left or right of the lens you naturally get the sitter to look to the right or left in your picture, without direct instructions. For half-length or head shots, pick a slightly longer than normal focal length lens (i.e. 150 mm for 6 × 6 cm or 85 mm for 35 mm). You can then work from a more distant viewpoint, giving a less steep, more flattering perspective and intimidating the sitter less with your camera equipment.

Of the three light sources – daylight, tungsten lamps or studio flash – daylight indoors often gives excellent natural qualities but it can be difficult to control. Flash scores over tungsten lighting in terms of heat and glare. Its power allows you to shoot on slower, finer-grain film. Be sure to have plenty of light reflectors and diffusers. Try to go for a simple lighting arrangement within which the sitter can freely change poses without instantly calling for light-source adjustments or altered exposure. One soft main light from a 'natural' angle plus reflectors to return light into the shadows and help to create catchlights in both eyes is a typical starting arrangement (see Chapter 7). As soon as possible, stop tinkering with the equipment and concentrate on your relationship with the sitter.

Weddings

Purposes

Photographing weddings is often regarded as a chore, but the fact is that within a family a wedding is a very special occasion. Consequently, covering such an event is a serious responsibility. Indifferent or missed pictures will deprive participants of important memories. Your work must be good enough to be framed and put in albums, and looked at over the years by different generations. Wedding photographs are a kind of time-warp within which families measure themselves, so results are of increasing value and interest.

Approach and organization

Meet the bride, groom and parents before the event to talk over the scenario. Clear permission with the religious or official authorities so that you know where photographs can and cannot be taken during the ceremony. Find out if there are to be any unusual events – for example, the bride arriving in a horse-drawn trap or the appearance of some invited celebrity. If the proceedings are to follow an unfamiliar ethnic procedure it is vital to learn the order and significance of each stage. Before the event, make sure that you have made precise notes regarding the requests of the families and prepare a list of all the images that have to be taken before, during the wedding and after the wedding, at the reception.

On the day itself remember that you are a part of the proceedings. Dress neatly, in deference to other participants, and arrive early. This allows you to assess potential backgrounds, lighting and best camera positions. Avoid backgrounds which are cluttered, ugly or inappropriate (church gravestones, for example). You can also start photographing the arrival of guests, preferably posed in groups. Follow this through with the arrival of key figures such as groom and best man, bride and father. Where there are noticeable differences in height it is best to step back and take full-length shots rather than half-lengths and close-ups.

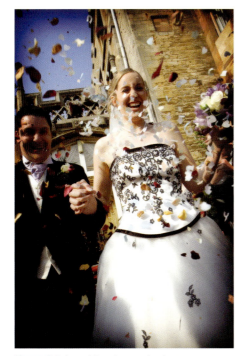

Figure 9.4 In wedding photography also try to capture special moments and try different angles of view.

After the ceremony there will be formal groups. Start with husband and wife alone, then work outwards, adding the immediate family and increasing numbers of close relatives until the final group includes most guests, if there is sufficient space. With the smaller groups, especially, pay great attention to detail. Make sure that men have jackets buttoned and no flapping ties, long dresses are arranged neatly, hair and headdresses tidy. Later, complement these somewhat cliché but popular pictures by taking informal shots at the wedding reception (see Figure 9.4). Similarly, look out for, and record, any unexpected event which people will enjoy recalling – the groom arriving by motorbike because of a car breakdown, the best man hunting for the ring, even just a pile of hats in a church porch, or puddles and umbrellas if it rains.

Equipment and techniques

A medium-format (preferably magazine-loaded) camera allows you to work fast yet give excellent detail. This is especially important for groups. Digital cameras are also used extensively in wedding photography due to the high resolution provided by the current sensors, and advantages such as no risk of damaged films during processing, no need to change film during the event, flexibility to adjust colour balance and to make corrections to the image using software. Image manipulation is also useful if you want to omit any background detail, provide to your clients both colour and black and white images, make a montage from several images, etc.

Use mostly standard and moderately long focal length lenses, the latter mainly for head shots and half-lengths. Have a wide-angle lens for interior general views, but do not use it for shots of people or groups unless space limitations are desperate. A lens hood is useful to avoid any flare from the sun if the subjects are backlit. A tripod is important. It sets the camera position so you can go forward and adjust some detail or tactfully ask people to change places or move closer. You must also have a powerful variable-output flashgun to deal with daylight fill-in

Weddings
Medium-format SLR camera (digital or film camera)
6 × 6 cm or 6 × 7 cm with 80 mm, 150 mm, 65 mm lenses
35 mm camera with 35–100 mm lens
Alternatively small-format DSLR with a ranges of lenses from 35 to 100 mm
Flashgun, light meter
Effects filters
Tripod

problems – for example, people arriving at a doorway photographed from within the building or filling the shadows under the eyes of the subjects. Flashguns are also useful in rainy days when most of the images will be taken indoors. A few effects filters such as 'misty' diffusers are useful, along with pins and clips to help arrange dresses. If you use a medium format digital or film camera, a 35 mm SLR or DSLR outfit with zoom or wide-aperture normal lens is the best

equipment for candid shots at the wedding feast. If you have an assistant he or she can use this equipment to cover incidentals at the ceremony.

Landscapes

Purposes

Landscapes are photographed for a wide variety of purposes. Detailed, representative shots are needed as picture library material for travel, ecology and educational publications of all kinds. Many of these photographs have timeless qualities which make them sell over a long period. However, landscape also lends itself to personal expression and interpretation. It can be majestic and dramatic, undulating and gentle, an abstract mixture of patterns or stark slabs of tone. From early times creative photographers have recognized landscapes' visual possibilities. Pictures on exhibition walls, published as book portfolios or framed prints, prove how landscape photography can symbolize concepts like ageing, rejuvenation, a joyful sense of life, etc. or mystery and gloom.

Yet again, the main point of a landscape photograph may be much more social documentary, with the significance in *what* it contains. Threatened coastlines, pollution from industrial plant, the carving up of countryside by new roads and other developments need to be brought to the attention of the public and those who make planning decisions.

Approach and organization

Landscape photography looks deceptively easy. After all, the subjects themselves are largely unchanging and always there. Yet your total experience of a landscape includes space, distance, air movement, sounds and smells – you look around you and notice the changing juxtapositions of elements near and far as you walk. These things are difficult to sum up within one still photograph, unless in some way you can isolate just a part which will encapsulate the character of the whole scene. Perhaps this means a low viewpoint, wide-angle shot which exaggerates jagged foreground rocks and, through differences of scale, emphasizes the depth and distance between them and distant, brooding mountains.

Sunlight and shadow changes transform landscapes too. Differences of weather, time of day and season of year all make startling differences to appearance. You need the care and organization to pick conditions which strongly convey the mood of the place. Direction and quality of light can emphasize textures, patterns, colour and linear and tonal perspective (Figure 9.5). So you have to be

Figure 9.5 The mood of the landscape changes with the time of the day. Try to shoot landscapes at different times and seasons.

dedicated enough to get yourself and equipment to a particular chosen viewpoint at a calculated time.

Look at the way one form overlaps another. Think about the best proportion of land to sky, that all-important placing of the horizon which occurs with practically every shot. The picture may depend greatly on some feature such as a line of cast shadow, reflections in water, or some small, strongly placed shape.

Equipment and technique

Landscapes lend themselves to medium- or large-format photography provided that you are prepared to transport the equipment. Larger cameras offer finer tonal qualities and detail, plus possibilities of camera movements (swings to extend depth of field from foreground to horizon; shifts to adjust converging lines). Often there is plenty of time to set up a check of composition and exposure while you wait for the right lighting conditions. However, difficult locations may have to be handled with a high-resolution digital SLR camera or with a 35 mm film camera using slow, high-resolution film. The 'Burst mode' in digital or a motordrive in film cameras is also handy for shooting negatives for mosaic panoramas. Consider too the possibilities of using a panoramic camera (see page 315).

Landscape
High-resolution digital camera (medium- or large-format camera)
Normal, wide-angle and moderately wide-angle lenses
Filters, including polarizer
Tripod
Meter
Instant-picture back if using film camera

A tripod will prove vital for serious work, as you may be shooting at dawn or dusk (Figure 9.6). With a digital camera you can convert the image to black and white, alter the contrast, and alter the colour balance. A polarizing filter may also be useful. When you use film, filters are very important.

Figure 9.6 Choose the right lighting conditions and use a tripod, if necessary, which will enable you to use small aperture, for maximum depth of field, with slow shutter speed.

When shooting in black and white, have orange or red contrast filters to darken the tone of blue skies and a green filter to lighten vegetation. For colour, have a polarizing filter and an ultraviolet absorbing or 'warm-up' (haze) filter to reduce blue casts when you are working at high altitudes or near the sea. Include colour-correcting and colour-balancing filter types. A graduated grey filter is handy to prevent sky and cloud 'burning out' when you are exposing for darker ground detail.

Architecture

Purposes

Photographs of the exteriors and interiors of buildings are required by architects, real estate agents, conservationists, historians, local authority and community groups, etc. Architecture, like landscape, still-life and other 'non-people' subjects, is also chosen by some photographers concerned with expressing their own ideas in pictures which are ends in themselves. All these people use photography for different purposes. The architect of a new structure will want striking dramatic pictures for magazine articles and exhibitions. You need to show the spirit of the place, as well as its character and broad features (form and texture). For more technical publications important details must be stressed, and the architecture generally shown with less visual licence. Specialist readers need information on its structure and proportions.

Environmentalists may want photographs to show the relationship of a new building to its local community, perhaps stressing detrimental influences. Real estate agents want a highly complimentary portrayal, showing space and light, and all the best features, but with no signs of the cement works and fertilizer factory next door. If the purpose of the pictures is freer and mainly to express yourself it can be argued that you are very much in the hands of the original architect. Like photographing sculpture, it is not easy to take someone else's creative work to form original images of your own. The challenge is often to express the impressions the architecture makes on you as an observer.

Approach and organization

Good preparation is important before you start your photographic work. If you are commissioned to produce images of a specific building or area you must discuss in detail with your client, the requirements of your project. You need to know how many images and views are required, obtain information on the lighting (orientation of the building and interior/exterior artificial light sources), what permissions are needed to get for photographing the building or the interior, and in what media do the clients want the images. It is also important to know what will the output media be for the images. Will they be published in a book or brochure, enlarged at poster size, or used for presentations? You will have to choose your camera format, lenses, film or resolution if you use a digital camera, to meet these requirements and produce images of the highest quality. You also have to discuss and negotiate with your client your fees, copyright, etc. (see Chapter 15).

Your two most important controls are lighting and camera viewpoint. Make up your mind about the important features to show and plan the best time and lighting conditions to bring these out in your pictures. Unlike landscape photography, your choice of camera position may be quite restricted – and this then determines the time of day you must shoot. A compass and watch are useful tools in planning where the sun will have to be to pick out different facets of the building. Better still, keep returning to observe throughout the day how lighting changes the appearance of volume, surface, colour and shadow pattern (Figure 9.8). The time of the year has an effect not only on the angle of the sun but also on the environment. The colours in nature change through the seasons. You will have warm yellow and red colours in the autumn, bright colours in the spring, etc. You must take this into account when you plan your work. Also think about any seasonal decorations that may be present when you start your work. Unless your

Architectural
Large-format monorail camera
Shift camera, or medium-format camera with shift lens
Normal and wide-angle lenses having good covering power
Filters, flashgun, compass, meter, lamp kit with clamps, spirit level, instant-picture back

client wants the decoration to be present in the images, you must avoid viewing angles that include it.

List the shots to do at any one time. This might include close-ups of embellishments at one part of the building and, at the same time of day, general views of a totally different part, because light will then just be brushing across large wall surfaces. Do not overlook the possibilities of exteriors at dusk. Arrange to have all the lights on early enough for you to shoot a series while natural light fades and the dominant illumination changes from outside to inside the building.

The main problem with exteriors is the weather, as well as irrelevant surroundings such as parked cars and building plant. Listen to the weather forecasts. For many situations soft but directional hazy sunlight is best. Totally overcast conditions give a lifeless, tone-flattening effect (although this might better suit a social documentary shot of poor housing).

Avoiding unwanted elements is mostly a matter of devising the right camera location. Sometimes this is quite hazardous, but you may need to be above parked cars, traffic and people, or block them out by some foreground feature. All this is best worked out in advance, helped if you know how much you can include with each of your different focal length lenses. Architecture which is essentially low in structure with surrounding grounds usually looks more impressive from a high viewpoint outside the area. If necessary, turn to low-level aerial photography (see page 198).

Figure 9.7 Good composition and attention to the lighting is essential when you photograph interiors. In this image the indoor and outdoor lighting are well balanced and we are able to see detail from the window. You may need to apply special techniques for this such as multiple exposure or image manipulation to optimise your results.

The main difficulty with architectural interiors is the unevenness and mixed colour balance of the light and the need to include as much as possible (Figure 9.7). Check whether all light bulbs or tubes in a room are working and that they have the same colour temperature. If they have different colour temperatures this will be recorded in your images producing colour casts in different areas and it may be very difficult to correct. If it is not possible for the bulbs or tubes to be changed, try to choose an angle that will minimize the effect. Your eye tends to scan an interior, and it is not easy to match this with any wide-angle lens which does not also distort shapes. Like landscape, you may have to seek out some part which epitomizes important features of the whole. Be prepared to shoot

rooms from outside windows or from corridors looking through doorways. The normal content of rooms often looks cluttered in photographs, so expect to spend time removing or rearranging items to avoid confusion and give a sense of space when seen from the camera's static viewpoint. As in still-life work, take out anything which will not be missed from your picture. Before moving any personal items, however, you must have the permission to do so. You can ask your client to arrange this. The same applies when you include people in the interior or exterior images. In that case you will need model releases (see page 363).

Equipment and techniques

A camera with movements is essential for serious architectural photography, although detail work can be carried out with any regular camera. Vertical lines shown strongly converging are acceptable for dramatic, linear compositions but they look wrong (or careless) when just off-true. In any case, you will need shift and probably swing movements to work from high or low viewpoints, extend depth of field over a chosen plane, etc. Your lenses – especially wide angles – must therefore offer really generous covering power. Remember that lenses give best results when used at an aperture around the middle of the aperture range. Use an incident light meter to determine the correct exposure. If you use only your camera's built-in light meter make sure that you measure a mid tone area for correct exposure. Your method depends on your camera's available light-metering system (centre weighted, matrix, spot, etc.). With digital cameras ensure that you do not overexpose the highlights because you will lose all detail in these areas. If available, check the histogram of your image on the camera display before exposure (see page 237).

Have a kit of lamps or portable studio flash to help fill in and reduce contrast and unevenness with interiors. For colour shots, have blue acetate so that, where necessary, you can match up lamps with daylight seen through windows. However, never overdo your extra lighting – often it

Figure 9.8 The lighting of exteriors at dusk adds colour and reveals different aspects of the architectural design.

is vital to preserve the existing lighting scheme as part of the character of the building itself. For this reason, soft, bounced illumination is often best. Take some blue-tinted domestic lamps to swap for lamp bulbs in any desk lamp, wall lights, etc. included in the picture if an orange cast here is objectionable on daylight film stock. You also need a powerful variable-output flashgun for situations where there is no suitable electricity supply. If you work with a large- or medium-format camera using film an instant-picture back helps you to preview whether fill-in is sufficient yet natural-looking. Remember that either tungsten light or flash can be used from several different positions during a time exposure (covering the lens in between) to fill-in dark areas. Another way of working

is to shoot at dusk and use tungsten light film or set the white point of your camera to tungsten – at one point your interior will be lit at the same intensity as the outside orangey daylight view.

Have filters which include a polarizer to help control unwanted reflective glare as well as darken sky tones. A strong neutral-density filter allows you to extend exposure (say, ×100, a filter density of 2.0) so that in daylight shots moving people or traffic are so blurred that they do not record. If you use film, have light-balancing filters for daylight and for different forms of tungsten and fluorescent lighting, plus any colour-correcting filters needed for reciprocity failure compensation, and the usual contrast filters for black and white shots. A spirit level will let you check that the camera is truly upright, and a small hand torch helps to make camera settings in dim interiors or when shooting at night.

Built studio sets

Purpose

A set built in the studio to represent a room, patio, etc. has the advantage that it can be designed in every detail to suit a drawn layout. Sets range in complexity from a couple of simple wallpapered 'flats' to three sides of an elaborate room. Building time and cost involved is often much higher than working in a real location. However, this is justified for jobs such as product advertising in bulk (for example, for mail order catalogues), where you want to shoot a series of kitchen suites or fitted bedroom units one after another, just changing the curtains and decorations. A built set may also be the only practical way you can put together a historical scene, such as a Victorian kitchen for an editorial feature on nineteenth-century recipes. The accessories can come from television/film prop hire, or loaned or bought from dealers. The main advantage of a well-planned set is that you have the greatest possible freedom of camera viewpoint and lighting. The absence of a 'ceiling' and fourth 'wall' gives plenty of space for equipment outside the picture area, and complete control over every element shown.

In macro form there are similar advantages when you photograph scale models for architects, town planners, exhibition designers, etc. The usual purpose here is to give a realistic preview of something which has not yet been constructed. You must therefore match the technical accuracy of the model with properly worked-out lighting and a scaled-down 'human eye' viewpoint for the camera.

Approach and organization

Set building may take several days – far longer than the photography. Sets are best constructed from clamped-together 'flats', like theatre and television scenery (see Figure 9.9). Working from the angles of view of your lenses for normal or steepened perspective viewpoints, plan out the total size of the set on paper first. Remember to leave sufficient gap between the flats and studio walls and ceiling to get in lights, reflectors, etc. The main danger is that a constructed, propped set becomes too perfectionist, and lacks the idiosyncrasies and untidiness of an actual room. Results then look self-conscious and sterile, like a museum exhibit. Naturalness is also important in the lighting. Illumination should appear to come through windows (or imaginary windows in a wall unseen), not from a ceiling grid of top lights as in a television soap.

With scale models, take particular care over the height and direction of the 'day' light. This needs to comply realistically with any compass bearing marked on the model, not shine from one or more impossible quarters. If a model building has to be shown internally illuminated, as at night, use scaled-down sources which light limited areas just as they might be in reality.

Equipment and techniques

Apart from having a studio of sufficient size and with good access, you need basic carpentry and general do-it-yourself skills to construct flats. Whenever possible, incorporate standard builder's doors and window frames. Clamps and clips can take the place of nails and screws, provided they are unseen. If the budget is sufficient you may be able to have a stylist to decide and track down necessary props. There is little point in not using a large-format camera, together with an instant-picture back or a hired computer-linked digital back. You are certain to want camera movements to give the freedom to shoot from a higher or lower viewpoint without always showing vertical lines converging. Have plenty of studio lighting units – tungsten or flash to light various areas of the set. They can also give general soft light, bounced off the studio ceiling and perhaps walls behind window frames. Have a sufficiently high level of illumination so you can stop down for sufficient depth of field without reciprocity failure. Remember that with flash you can fire and recharge again several times during one exposure.

Figure 9.9 Simple corners of 'rooms' can be quickly constructed from wooden flats, G-clamped together and propped up from behind.

For scale models, it may be physically easier to work with a medium or small-format camera, unless you need comprehensive movements. For realism, scale down your viewpoint to match the model. For a 'standing spectator' viewpoint (say, 1.6 m above the ground in a 1:50 model) have the centre of the lens 3.2 cm (1.6 m divided by 50) above the base. A wide angle is the most useful lens. Stop down fully, because shallow depth of field is the biggest give-away that the subject is not full size.

Studio still-lifes

Purpose

Still-lifes (inanimate objects) cover everything from factual records of technical subjects through catalogue illustration to abstract images intended purely for mood and atmosphere. Your subject may be some form of merchandise for advertising, or perhaps the need is for a 'scene-setting' editorial illustration or cover shot to suit the theme of a magazine article or section of a book. It may be a collection of shapes and forms you put together for a picture which is complete in itself, as a piece of fine art or a social or political statement. Sometimes a plain background is necessary, for clarity of outline. However, more often you have to devise a background or setting which positively contributes to picture content, helping to put your subject in context without dominating it or confusing important features.

Approach and organization

By photographing a still-life subject in the studio you have a totally controlled situation. It is so open-ended that you can miss pictures by the sheer range of opportunities, skipping from one possibility to another. A disciplined approach is therefore essential. For example, decide the most important subject qualities (perhaps some aspect of form, shape, texture, colour) you need to show. Perhaps the subject itself will fill and bleed off the frame so there is no need for a setting, as in Figure 9.10, or the space around may be filled up with props or an area of appropriate background. Look at the subject from different points of view and choose the most interesting angle. Many photographers create a sketch with the composition of the image before setting up the subjects in the studio. Think thoroughly about the shapes and colours in your composition and whether you want symmetry in your image. Consider setting the subject of interest off-centre. This can make your composition more interesting. Ensure, however, that you compose your image well; otherwise it may seem that the subject is off-centre by mistake. Simplicity is often best – the more you can take *out* of your picture and still make it work, the better. Any items you include in the image must support the composition. Remember that many items in the image may guide the

Figure 9.10 A still-life shot by Philip Fraser-Betts (for British Petroleum) making graphic use of simple shapes and colours. It is the sort of picture which can be used time and time again for brochure covers, exhibition displays and advertisements. Immaculate subject matter and tight control of lighting are vital. The tone range includes good shadow and highlight detail without flatness – which reproduces well on the printed page.

viewer's attention away from your main subject. Where you have to include many items on a background it is often best to work them into a group which has a satisfying overall outline and shape. Observe all items that form your composition carefully and make the necessary adjustments. For example, if you use fabric as background or as an item, it should not have any creases. If there are any folds, these should be done carefully so that they follow the symmetry of the composition. Build up the lighting gradually, starting by deciding the position and quality of your main source. We are used to viewing objects in our environment lit by one light source, the sun. For realistic results, therefore, you should aim for one main lighting source and some complementary lighting to fill shadows, illuminate the background, etc. (see Chapter 7). Keep

returning to the camera (on a stand) every time you adjust lights or the position of objects, to check how these changes actually look within the frame.

When shooting promotional pictures of products, food, flowers, etc. it is essential that the particular specimen in front of your camera is in immaculate condition. Special preparation for photography is advisable, although you must not break laws protecting the consumer from false appearances. Food shots usually mean calling in expert help from a home economist who can prepare your dishes in the studio. Whenever possible, have two examples of each item made – one to set up, compose and light, the other to be substituted fresh just before shooting.

Equipment and techniques

The gradual build-up of a still-life picture suits the considered approach of a large- or medium-format camera. They also offer shift, swing and tilting movements. Use a normal lens or a slightly longer focal length for objective work where steep perspective and distortion are undesirable, and keep close viewpoints with a wide-angle lens for rare dramatic effects. Seriously consider use of a digital back for bulk shooting sessions – to illustrate mail order catalogues, for example. It can pipe the images as you shoot them direct to a page-layout computer present in the studio – allowing you and a graphic designer to put together complete, finished spreads *on the spot*.

Studio still-life
Large- or medium-format camera
Normal and wide-angle lenses
Studio flash or tungsten lights
Meter, CC filters
Camera stand
Instant-picture back
Fibre optics lighting

Studio flash is the best lighting equipment for any delicate subject matter which is easily heat damaged. Have a good range of light heads, especially softbox or large umbrella types. For subjects with highly reflective surfaces you will probably have to build a light-diffusing tent (Figure 7.8). In the cases where you cannot avoid reflection of the surrounding environment (walls, softbox, camera, etc.) on the subject, try to change slightly your camera position (and thus the viewing angle) and aim to integrate any reflections in the composition. You may need to change the surrounding so that its reflection on the subject will not give objectionable results in the image. For exploded views items will have to be supported from behind or suspended from a gantry. Consider the use of a still-life table if your composition requires back diffused lighting or lighting from below. Even quite small subjects often demand more studio space than you might expect. Remember, too, that still-life photography – with its progressive refining of ideas and approach – can often take longer than most other subjects.

Natural history

Purposes

Natural history pictures span a vast range of subjects, from plants to birds, tiny insects to herds of wild animals. Mostly they are needed for detailed factual information in educational publications (books, specialist magazines, exhibitions) as well as for general illustration. This is therefore another area where you can build up a specialist subject picture library. The secret of successful natural history photography is to show your subject and its environment accurately, but at the same time turn it into a creative picture which non-specialist viewers will also enjoy.

Approach and organization

This is an area where it is helpful to have special knowledge (as a biologist, ornithologist or zoologist) outside photography itself. You need to understand where and when to locate your chosen subject, best location and time of year, and (animals and birds, etc.) regular drinking or eating habits. Practise within an enclosed location such as a butterfly farm, plant sanctuary or safari park, where there will be a range of good specimens in a reasonably natural setting. Zoos are the easiest places for animal portraits, but these habitats are often ugly, and the inmates' behaviour usually quite different from that in the wild.

Figure 9.11 In nature photography you usually need to use high shutter speed and long focal length lenses. This photograph was taken with a 560 mm telephoto lens, a shutter speed of 1/500 sec and f/4.

Natural history
35 mm film or digital camera
Macro, normal, 80–200 mm zoom,
500 mm mirror lenses
Spot meter, motordrive
Tripod and clamp
Flashgun, remote control
Notebook

For animals and birds you need the ability to track down locations, perhaps with expert help. Then by stealth, anticipation and a great deal of patience you must photograph your subject from an effective angle and showing an identifiable activity. Sometimes it is more appropriate to work from a hide and watch and wait for your subject (Figure 9.13). Unless your hide is a permanent feature it may have to be assembled gradually over a period of time so that the animals and birds accept changes taking place. Then whenever you go to the hide take someone with you who soon leaves, making your subject think the hide remains empty.

With flowers and plants choose perfect specimens in their natural setting and photograph to emphasize their form, structure and colour. It is often helpful to include a scale for sizing – show this along one edge of the picture where it can be trimmed off later if necessary. With all natural history work there are two golden rules. Always log details of what, where and when you photographed; and do not damage or seriously disturb the plants or creatures which form your subjects.

Equipment and techniques

Most subjects are best photographed using a 35 mm film or digital camera, giving you the benefit of its range of lenses. With a digital camera you have to consider the number of frames per second in Burst mode. This is important in nature photography if your subjects are animals, birds, insects, etc. which may move fast. Long focal length lenses are particularly important for wild life, giving a good-size image from a distance and picking out subject from background by shallow depth of field (Figure 9.11). Mirror-type designs are the lightest to carry and hold. Even so, a lightweight but firm tripod is essential. If your camera or hand meter takes spot readings this is especially helpful when birds and animals are moving against changing backgrounds (Figure 9.12). Autofocus also helps in these circumstances.

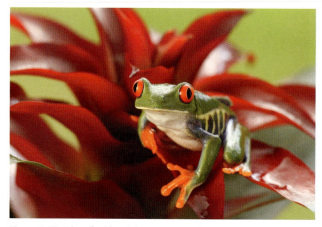

Figure 9.12 A long focal length lens is important for wild life because it allows you to photograph the subject from a longer distance and get an image with shallow depth of field. Spot readings are helpful especially when the subject moves against changing backgrounds.

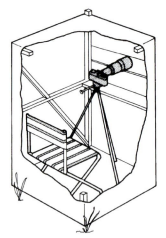

Figure 9.13 Portable photographer's hide must offer ample space for you and equipment over long periods. A long focal length zoom lens is helpful here.

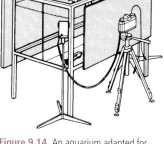

Figure 9.14 An aquarium adapted for photography. Pick a suitable muted colour non-reflective backdrop. Black card around the camera prevents reflection of you and your equipment. Use main and fill-in flash from well to the sides for controlled illumination.

You need a macro lens for insects, flowers, etc. A flashgun (on an extension lead) is also important for close work, allowing you to shoot at a small aperture to improve the shallow depth of field and freeze movement. Make sure that lighting direction will enhance form. Flowers often need card outside the picture area to act as a windbreak when you are shooting outdoors. However, try to avoid card backgrounds – the trick is to include some information on habitat in your background but without confusing detail. If you want to take photographs of the inside of an aquarium, you need special arrangement for your camera and lighting (Figure 9.14).

With subjects such as birds frequently returning to a nesting or feeding place you can gradually build up a motor-driven camera system clamped in some nearby position, or use the Burst mode in your digital camera. Include flash if necessary. Then trigger the camera by radio or infrared pulse (page 24) from a remote hide where you observe the action through binoculars.

Sometimes you can use an infrared trigger beam across the path of the subject itself so that it keeps taking its own photograph. At night you can photograph light-shy creatures with the flash filtered down to emit infrared radiation only and expose on infrared film.

Aerial subjects

Purposes

Air-to-ground photography at low altitude is used for pictorial shots of architecture and estates, records for traffic surveys, city planning and proposed new developments. It also forms a platform for press photography when covering large open-air events. In archaeology, aerial pictures (taken at dawn and dusk, when sunlight rakes the ground contours) often show up

evidence of early structures invisible at ground level. Similarly, colour-filtered black and white shots or infrared colour pictures in flatter light (during the middle of the day) reveal patterns in crops denoting earthworks and geological changes beneath the soil, as well as crop diseases. All these pictures are valuable for research, information and education. At higher altitudes, specialist aerial survey photography forms a vital reference for preparing accurate maps for resource planning and military purposes. (This merges into remote electronic imaging from satellites.) Air-to-air pictures of aircraft, ballooning, etc. are used for technical record, sales and general press pictures.

Approach and organization

The camera can be flown at low levels, up to 90 m (300 ft) or so, in a model aircraft, balloon or kite and operated remotely from the ground. However, for more accurate, sustained work you need to be up there aiming the camera from a helicopter, fixed-wing aircraft or balloon (Figure 9.16). Helicopters are ideal for controlling your position in space but are expensive to hire and suffer from vibration. Air balloons make expensive, much less manoeuvrable but smoother camera platforms. You are most likely to do general low-level aerial photography from a light aircraft – preferably a high-wing type because this allows you maximum visibility. Have a window removed for oblique shots, and use an aperture in the cabin floor for vertical pictures.

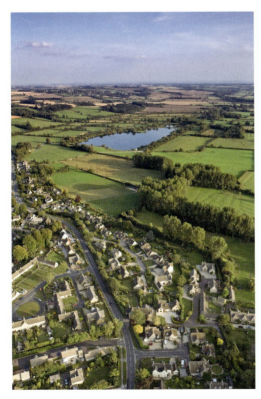

Figure 9.15 In aerial photography clear visibility is vital. This photograph was taken from a hot air balloon with a shutter speed of 1/125 sec and f/4.8.

To make best use of your rental costs, pick weather conditions which give the lighting you need (Figures 9.15 and 9.17). For example, air is clearest after a cold front has passed. Work out the time of day for the best direction and height of sunlight for your subject. Plan with the pilot the best flying height (links with focal length), provided that this complies with regulations. The lower the height, the less light-scattering haze between you and your subject, so you get greater tonal contrast and purer colours. Fix up a clear means of communication between you and the pilot. His cooperation and understanding of your needs are vital.

Equipment and techniques

Model aircraft, balloons and kites are able to lift a 35 mm camera (with motordrive, if it is a film camera), triggered by radio or controlled through the tethering wire. You operate the camera when it is seen to be pointing in the correct general direction. However, if your balloon or kite is powerful enough it will be practical to fit a miniature closed-circuit television camera to the still camera eyepiece and so check what you are shooting from a monitor at ground level.

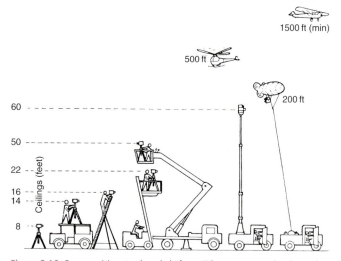

Figure 9.16 Camera-raising stands and platforms. Where you cannot be alongside the camera yourself, use video to monitor viewpoint (on mast and balloon here).

Figure 9.17 In aerial photography it is essential to take photographs at the time of the day when you have the best direction and height of sunlight for your subject.

The best equipment for working from a full-size aircraft for general oblique photography is either a hand-held aerial camera or a 35 mm SLR with normal and moderately wide-angle and long focal length lenses. Small-format cameras have the advantage of wider maximum apertures. Depth of field is not a problem, and this means that the best automatic exposure programme to use is shutter priority. Keep to 1/1000 or 1/500 sec minimum, and let the camera's light reading control *f*-number.

Cushion the camera with your body or support it in a special hanging cradle – do not rest it on any part of the vibrating aircraft body. If you use a digital camera you can adjust colour balance and contrast later on the computing using imaging software. With film cameras, filters are important to emphasize tone contrasts in black and white photography, and correct colour balance for colour work. An ultraviolet-absorbing filter is best fitted as standard along with an efficient lens hood.

Vertical survey cameras are most often clamped on shock-absorbing supports looking downwards from within the aircraft fuselage. Digital aerial survey cameras have a charge-coupled device (CCD) or a complementary metal-oxide semiconductor (CMOS) sensor (see Chapter 6). There is a specified nominal ground sampled distance (GSD) that is represented by each pixel of the image. The film cameras typically shoot pictures 23 cm² on wide rollfilm, through a glass plate pressed hard over the emulsion and engraved with crosses at 1 cm intervals. By recording lens focal length, aircraft height, and ground speed as data alongside each frame you can make accurate measurements of ground distances from the processed film. You can use film which is scanned later using a photogrammetric scanner. You work then with

the digital image. This is called 'derived digital imagery'. As in digital aerial imagery, each pixel of your image represents the nominal GSD. It is vital that the aircraft flies at a steady height and speed over carefully planned flight lines so that by triggering cameras at timed intervals you get each shot overlapping in subject content by 60%. You can view prints or transparencies from such a series through a stereo viewer (page 319) or lay them out in an overlapping mosaic, from which maps are prepared.

Night skies

Purposes

Serious astronomical photography is mostly for experts, scientists with access to specialist equipment. However, as a non-expert you may want to photograph night skies as dramatic backgrounds for advertising products, fashion, etc. or as part of landscape or architectural pictures. (Remember though that when star pictures are reproduced in print any specks of light smaller than the dots of the halftone screen will disappear.)

Approach and organization

For best detail pick a clear atmosphere and shoot in a rural area well away from towns or highways, which will spill light upwards (Figure 9.18). With digital cameras you can use special filters that minimize the effect of light pollution, called *light pollution reduction* (LPR) or *light pollution suppression* (LPS) filters. These filters minimize the transmission of the wavelengths of artificial lighting. You can also process your images afterwards. Use RAW file format to preserve all the information of the image. You can convert your images to other formats such as Joint Photographic Experts Group (JPEG) after image processing. If there is a product to be shown against the sky this can be lit independently by flash. Where you want some suggestion of detail in the landscape, take a series of pictures in clearest atmosphere at twilight (dawn or dusk). Stars appear at a constant intensity as the sky lightens or darkens, so the scene goes through a whole range of different lighting balances. The moon, like the sun, appears less bright when near the horizon. With careful planning you can record the moon with its surface detail at dawn or dusk, and still show most of the landscape detail (most realistically shot with the land one-and-a-half to two stops underexposed.)

Equipment and techniques

Long focal length lenses enlarge moon detail but, curiously, have little effect on the image *size* of individual stars because of their vast distance away. Shooting with a telephoto simply limits your field of view. For starry skies it is often best to use a medium- or small-format camera with a wide-aperture, normal or wide-angle focal length high-resolution lens. Then you can enlarge from this picture later. Remember that the colour of starlight, and also the moon when high in the sky, is effectively the same as sunlight. Set the white balance of your digital camera to daylight or use daylight colour film if you use a film camera. With digital cameras, you do not need exposures as long as with film. Note that when you use high ISO speed setting, the noise in the images increases.

Length of exposure may have to be found by trial and error, although most through-the-lens (TTL) meter systems will measure exposures of several minutes. Test exposure with the camera

programmed for aperture priority. If you use a digital camera you can see the image immediately and adjust the exposure time until you have the results you want. With a film camera, time the exposure the metering system gives and bracket around this with further shots. The longer the exposure, the more faint stars will record and bright stars flare. However, in practice, choice of exposure is also influenced by four factors:

1. Blur caused by rotation of the Earth
2. The light-gathering power of the lens (not *f*-number in this instance)
3. The reciprocity failure of your film (see Figure 5.22) or the noise in digital images due to long exposures and
4. Light pollution when you use film – the general background brightness of the sky, particularly near cities. This gradually accumulates as light on the film, swamping detail.

The amount that the images of stars move during any given exposure depends on the part of the sky and your lens focal length. The pole star appears to remain stationary while all other stars rotate about it, 360° in 23 hours 56 min. As a guide, stars are likely to record as streaks instead of dots in a 1 sec or longer exposure with a firmly clamped 500 mm lens. To keep all star images still, borrow an equatorial telescope mount which has motors and gears to gradually pan the camera against the Earth's rotation.

Another special feature of astronomical work is that a lens's starlight-gathering power depends on the *area* of its effective aperture, not its relative aperture (*f*-number). The wider the 'hole', the more photons of starlight the film will accumulate in a given time, irrespective of focal length. So a 500 mm lens at *f*/11 (effective aperture diameter 45 mm) becomes faster than an 80 mm *f*/2 (effective aperture diameter only 40 mm). This applies for point sources such as stars; for extended sources such as comets or nebulae the relative aperture is important.

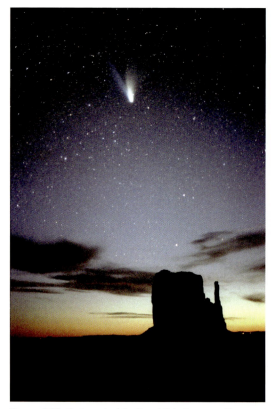

Figure 9.18 Photograph of the Comet Hale-Bopp over Monument Valley, Arizona, taken in March 1997. Shot on ISO 800 film and scanned using a Nikon Coolscan 4000ED.

■ In sports photography you need subject know-how and anticipation, patience and fast reaction. Pick moments of human tension and reactions. Learn the rules of the game and anticipate the right moment to take the photograph. A good viewpoint is vital, plus a good range of lenses – mostly telephotos. With a digital camera you can send your images very fast and meet publication deadlines. Go for movement and dynamic action, often through controlled blur, dramatic angles, correct choice of moment. Do not rely on autofocus and burst mode (or motordrive) to create good pictures.

■ A good documentary picture story needs research, ample shooting time to express a point of view and sympathetic final layout. Often the best work is people based. Adopt a positive, determined approach yet remain sensitive to significant events. A small-format inconspicuous camera kit and use of existing light will least influence your subject matter. Close viewpoint and wide-angle lens give a sense of dramatic involvement and overcome lack of distance in tight situations. Standing back with a telephoto more closely relates near and far components.

■ Portraits (for flattery or character) might be shot in the studio or in the sitter's own environment to add to content. Decide what features and postures to emphasize. Camera viewpoint, your personal direction of the sitter, lighting and surroundings are all important but never so fixed that they prevent freedom to relax and relate as person to person. Work with a longer than normal focal length lens; using studio flash or existing light.

■ Weddings are undervalued but responsible occasions for a photographer. Contact the people concerned, go over the details, plan your key shots. Dress appropriately. Pick the best possible backgrounds. Work calmly but authoritatively, covering formal and informal elements. In the recent years many photographers use digital cameras for wedding photography. If you use film cameras have a medium-format camera and tripod for groups, hand-held 35 mm for incidentals. Consider use of digital means for any necessary postcamera image adjustments.

■ Landscape photography ranges from a personal art form through pictorial travel illustration to objective geographic records. Pictures can symbolize abstract feelings, concepts or document social ecology. Plan the work, picking weather and time of day (lighting), distance and viewpoint. Consider creating panoramas either by taking several images and stitching them together or by using a dedicated panoramic camera. Medium- or even large-format cameras offer best tone qualities and detail compared to 35 mm. Do not overlook filters.

■ Architectural photography ranges from the needs of real estate, architects or environmentalists, to being a subject of form and texture for self-expression. Time the best lighting for chosen viewpoints – avoid flat, overcast conditions. Check the external appearance of lighted buildings at dusk. Expect to simplify internal furnishings, and counter lighting which is excessively uneven or of mixed colour temperature. Have a camera with movements, and include a high-quality wide-angle lens, flashgun or lamps and filters.

■ Studio sets, built from flats, allow unobstructed use of lighting and camera viewpoint. Chosen props mean that you control every detail but avoid a false 'museum' look; do not overlight. For realism with scale models, accurately scale down your viewpoint and maximize depth of field. Use a camera with movements.

■ Still-lifes (advertising merchandize, technical records and editorial or poster illustration) need a disciplined approach to a totally controlled situation. Make a sketch of the final image and decide important subject qualities, pick appropriate non-confusing props and background, build up your lighting. Simplicity

throughout is often best. For most work, subject matter must be immaculate. Have prepared foods made up professionally, undercooked for optimum appearance. Pay attention to highly reflective objects such as mirrors, jewellery, etc. Expect to use studio flash and a camera offering movements. Bulk catalogue assignments are ideal for using a digital camera linked to a computer with page-layout programme.

■ Natural history illustration needs to combine scientific accuracy with strong visual qualities and is helped by specialist subject know-how. Research best natural location and timing to suit subject habits. Pick an informative activity and background. Long focal length lenses are often vital. For some animals or birds, shoot from a hide or use a remote controlled or subject-triggered camera. Tackle flower/insect close-ups with a macro lens and an off-camera flash. Log subject information.

■ Aerial photography includes obliques of architecture, highways, archaeology, etc.; vertical surveys for map making; air-to-air shots of other aircraft. Appropriate choice of lighting, filtration and special (infrared) film helps reveal features not normally visible from the ground. Work from a helicopter or high-wing light aircraft, timing your flight according to light and weather. Use a rollfilm aerocamera or 35 mm SLR, working shutter priority mode (1/500 sec or faster). Survey cameras, set vertically within the aircraft and fired remotely, record speed and height data alongside the image.

■ Night-sky pictures for general purposes are best shot in clear air, far from town lights. With digital cameras you can use light pollution reduction filters. Dawn and twilight offer greatest choice of landscape/starlight/moon balance. For starry skies, use a DSLR (or medium- or small-format film camera and daylight colour film) with a good wide-aperture normal lens. Exposures beyond a few seconds blur from Earth rotation (unless you have an equatorial mount). Other limitations are film reciprocity failure, the area of your effective lens aperture, and ambient light polluting the sky.

1 In architectural photography you usually need to record the building without the presence of people or cars in motion. You can achieve this by using a low ISO setting or slow film and long exposure times. You may also need a neutral density filter in front of your camera lens so that you can use very slow shutter speeds for the ambient light, and a tripod.

Select a scene that includes moving subjects such as people, cars, trains, etc. and work preferably at dusk when the ambient lighting is low. Set the ISO 100 setting on your camera and determine the correct aperture for a shutter speed of 1/4 sec, using your camera's TTL metering system or a handheld light meter. Shoot with this shutter speed and observe how the motion of the subjects has been recorded. Shoot with slower shutter speeds, always adjusting the aperture for correct exposure. The moving subjects will disappear when the shutter speed is around 4 sec, 8 sec or longer, depending on their speed.

2 The choice of black and white or colour in landscape photography can change the whole mood of the scene. With a digital camera take a picture of an interesting landscape scene.

Convert the image to black and white and compare it to the colour version (alternatively, shoot the same scene in both black and white and colour negative film). Observe how different the landscape appears in these images. Process the image further, by altering the colour balance and the contrast and see how the landscape changes. If you use film, change the contrast of the black and white image in the printing stage and, if you print the colour image yourself, change its colour balance. Compare all images, colour and black and white and see the differences in style and mood.

3 Experiment in portrait photography with different lenses and angles of view. Use a digital or film camera and select a series of lenses (or a zoom lens) with a range of focal lengths, from wide-angle to telephoto. Use the lighting techniques described in Chapter 7 and take pictures with the different lenses (for example, wide-angle, normal and telephoto lens). Take several pictures with each lens changing the viewing angle. Experiment with the distance between the camera and the subject. Compare your results and see which images are more flattering, show a specific character, etc.

PROJECTS

10 Digital imaging systems

The imaging systems today comprise of several components from image capture to image outputting, merging in many cases silver halide photography systems with digital imaging systems. Some imaging systems are still following only the silver halide route (film camera, film processing and printing in a darkroom) while other systems follow only the digital imaging route (digital camera, image processing, display, digital printing). This chapter focuses on computer-based digital imaging. It starts with a basic overview on the computer workstation and continues with the scanner as an input device. Digital cameras have been described in detail in Chapter 2. It continues with the display as an output device, focusing on the *cathode-ray tube* (CRT) and *liquid crystal display* (LCD) technologies and finally on the digital printers.

The computer workstation

Digital imaging is essentially computer based. The computer is at the centre of any digital photography system (Figure 10.1). (Some point-and-shoot digital cameras will simply connect directly to a printer to output pictures you have taken, but this then cuts out a huge range of controls over results known as *image processing*.) One of the great strengths of working with an image in digital form is the way its data can be adjusted at the computer stage. Your final result can be previewed on its desktop (the monitor screen) and, provided you *save* (record in memory) your original input image, you can step back to where you started any time you make a mistake or change your mind.

A computer setup for digital imaging work consists of several units of hardware, typically:

1. *The computer central processing unit* (CPU) *itself*. This box-like central processing unit contains the motherboard and processor chip. It must also have a CD-ROM or DVD-ROM fast drive and ample *random access memory* (RAM). The compact disk drive allows input of any photographic images you have had converted to CD-ROM or DVD-ROM and, most importantly, software operating programs such as Adobe Photoshop which come in this form. Digital imaging demands more RAM than is needed for simple word processing. Memory chips rise in multiples of 256, 512 MB, or 1 GB; a total of at least 1 GB RAM is desirable. Without this there will be frustratingly long delays in bringing large images on screen and in effecting every change. Bear in mind that RAM is temporary storage, so when the computer is switched off everything stored in RAM is lost. Therefore each time you start up all the image data and the software program you are using must be input into RAM. Any work or program you finally wish to keep has to be 'saved' before switching off – either to the computer's internal hard disk (preferably storing at least 100 GB) or to a removable USB2 or FireWire hard drive or onto DAT or DLT tape.
2. *The computer monitor* may be a *cathode-ray tube* (CRT) display or a *liquid crystal display* (LCD) and it should have at least a 17 in. screen. Otherwise you have to keep moving various elements being shown around the screen, and find that things get covered up. Contrast, brightness and colour settings need to be set so that the

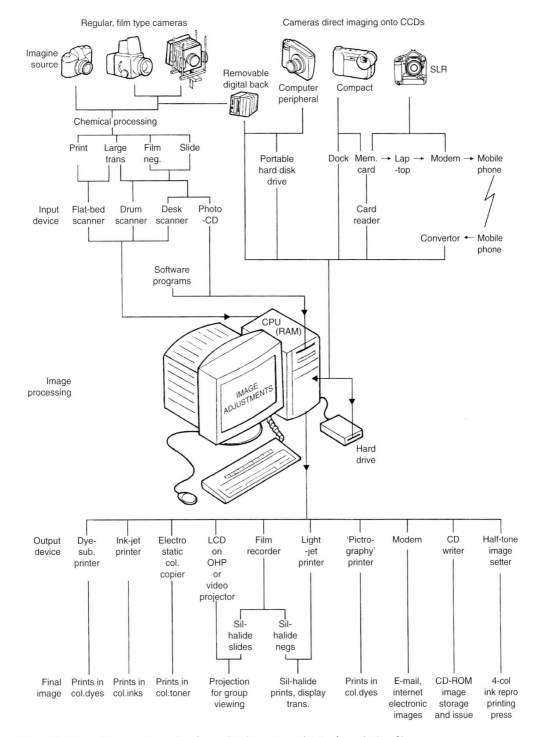

Figure 10.1 Some of the routes into, and out from, a digital computer workstation for production of images.

monitor matches characteristics of your output system as far as is possible. This will mean that by looking at the screen image you can visually predict final printed results. Software programs known as *colour management systems* help to eliminate discrepancies, by standardizing the way each colour appears on the screen and when printed on paper (for example, by inkjet) providing viewing conditions remain constant (see page 258).

3. *The mouse* enables you to move a cursor or visual elements around the screen, 'click' onto a tool box icon, choose from the screen's menu bar or select a command option. The computer keyboard, although less used, allows you some special commands and the ability to shortcut certain actions, as well as write in words to title image files, etc.

4. *Peripheral devices* include a drive for removable hard disks, and memory card reader. You might also have a graphics tablet and stylus as a higher precision substitute for the mouse. Some units – scanner, direct digital camera, printer – need connection to the computer through a USB2, FireWire or SCSI (pronounced 'scuzzy') interface. This is a small cabled device which allows high-speed communication of data between computer and peripheral.

Image processing

The computer is your image-processing workstation, but it only works given the electronic 'tools' provided by whatever software program you install (typically fed in from a CD-ROM or downloaded directly from the Internet). Once combined with the image(s) you have also input, software such as Adobe Photoshop sets out the picture on the monitor with a tool bar down one side and a range of options you can 'pull down' from a menu bar at the top.

Hundreds of changes – from subtle invisible mending to bizarre surrealist constructions are now possible. For example, you can remove colour casts, correct converging verticals, limit the depth of field or increase it by combination of multiple exposures, erase spots and blemishes, create high dynamic range images, introduce movement blur into chosen parts, etc.

Inputs

There are two ways of inputing images into a computer system: The first way is the direct camera imaging of your subject onto a charge-coupled device (CCD) or complementary metal-oxide semiconductor (CMOS) sensor – in other words use of a digital camera or digital back. A digital camera may be cabled direct to the computer, or record into the camera's internal memory system or onto a memory card. The internal or card systems will later need to read image data into the computer via a camera cable, camera 'docking' unit or card reader. Digital data feedout from a camera back is wired direct into the computer memory system, or when working on location it can be captured using a battery-powered portable hard disk system. Bear in mind that high-resolution image capture systems create huge image files.

The second way is by digitizing printed photographic images or images on processed silver halide film. You can digitize images by one or more means. A film scanner will accept and digitize 35 mm or larger format positive or negative films. A flat-bed scanner digitizes prints, even rigid mounted prints, and many types handle transparencies too. Higher-end, although also much more expensive, a drum scanner will handle negatives or transparencies of practically all sizes and also (unmounted) prints (Figure 10.2). With all scan-in systems remember that you have to make the correct settings (pixels per inch) to suit the resolution of your intended print outputting device and planned image size (see page 212).

Figure 10.2 Scanners to convert silver halide images to digital data. A: scanner for individual 35 mm slides or negatives. B: flat-bed scanner, accepts reflective media such as prints up to A4. Most offer transmission illumination adaptors to accept film transparencies too. C: drum scanner. Film or (unmounted) prints are taped to revolving cylinder, lit by transmission or reflection.

(a) (b) (c)

Types of scanners

P reparing highest quality four-colour and other separations is still a specialist task. Some firms, such as service bureaux, specialize in 'reproduction' or 'origination' and then pass on their product as electronic files or film ready for other (printing) firms to use. Large printing houses have their own origination departments. At one time all this meant was that you, as a photographer, could regard your tasks as done and leave everything else to the experts. But developments in digital methods have progressed 'down the line' to the point where it is important for photographers to understand something of how scanners convert pictures to digital files. After all, scanners have become companions to desktop computer workstations. Recently the all-in-one devices which combine scanner, photocopier and printer are becoming more and more popular.

Drum scanners

The conversion of photographic originals into halftone separations was once done by copying through a large process camera. However, electronics first made possible the use of much more efficient drum scanner recorders (Figure 10.3). In drum scanners an original colour transparency or negative is taped to a clear perspex drum and rear-illuminated by a tiny point of light. An extension of the cylinder in a lightproof housing may carry the photographic process film ready to receive the four separation images.

Figure 10.3 Drum scanner, internal optics. Light from source (L), ducted along fibre optic tube, focuses on to tiny area of original transparency (T) taped around transparent drum. Drum rotates and optical section tracks through it to scan every part of the image. Transmitted light passes out to sensor unit also tracking alongside drum. Here three 45° semi-reflective mirrors split and direct light through R, G or B filters (F) on to photo-multiplier tubes. PMTs output analogue tricolour signals which then pass through an A/D converter.

As the cylinder rotates, the analysing light spot gradually moves along the cylinder, progressively scanning every part of the transparency. A colour-sensor unit with *photomultiplier tubes* (PMTs) to read red, green and blue (RGB) values tracks along in parallel outside the cylinder, turning the changing light values it receives into a long stream of electronic signals. This data is passed through an *analog-to-digital* (A/D) converter to turn it into a digital form and translated into screened colour separation signals by computer software programs. Meanwhile, at the exposing end of the cylinder a small beam of light focused on the separation film dims and brightens according to signals received. The exposing optics track along the rotating cylinder, gradually exposing each of the black and white film separations which will finally give cyan, magenta, yellow and black printing images.

The analysing unit (which, incidentally, also accepts prints, bouncing a light spot off the surface) feeds to the exposing unit through circuitry which allows the operator to carry out almost limitless contrast masking and dye-deficiency masking. The system will also electronically generate the required high-resolution dot shape to suit known printing/ink/paper conditions. Most modern scanner/recorders now have separate input and film exposing output halves (Figure 10.4). The scanner part can then produce digital files on computer hard disks or CD-ROMs which can be used for image distribution and use with a wide range of display and printout devices.

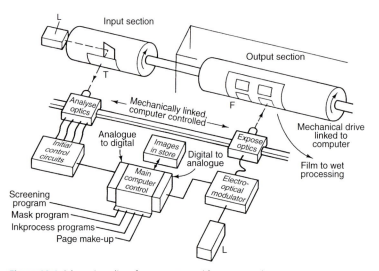

Figure 10.4 Schematic outline of components used for pre-press electronic scanning. Original colour transparency (T) is scanned by light source (L) in the input section. The four-colour signals produced can be stored and manipulated, then exposed in halftone dot form on to graphic arts film (F) in the light-tight output section. Normally a batch of originals are all scanned in at one time, light source and sensing system moving along the transparent cylinder (see Figure 10.3). Software programs adjust data between analysing and exposing stages, creating appropriate halftone screens, colour and contrast masking, etc. to achieve optimum separation images for the printing press.

Flat-bed (reflectance) scanners.

As a lower cost approach today's compact flat-bed scanners and film scanners use CCDs instead of photomultiplier tubes. As Figure 10.5 shows, a typical flat-bed is about the size of a photographic lightbox with an A4 platen. It contains a linear array comprising a row of several thousand CCD elements which is used to scan any print or document placed face down on a top glass plate (Figure 10.6). During scanning a light source, a fluorescent lamp, and mirror unit gradually move down the length of the picture, reflecting lines of image data onto the CCD array in the base of the box. Some newer models incorporate a xenon gas cold cathode fluorescent lamp. Single pass colour scanners use arrays of filtered red, green and blue; others make three

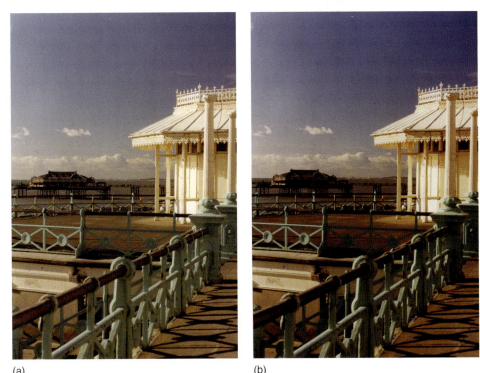

(a) (b)

Figure 10.8 The scanner driver gives several options to adjust the tone scale of the image. You can for example adjust the curves or choose among settings that alter brightness or contrast. In this example, the first image (a) was scanned using the automatic mode while image and (b) was scanned using a 'high contrast' setting.

film brand. The reason is that the colour characteristics of each film's emulsion can differ and the scanner uses specific profiles for each film to compensate for this. Also do not forget that the colour negative film has an orange colour mask which the scanner has to take into account in order to produce correct colours. The scanning application may also give you the option to use custom profiles you may have created to scan your films thus enabling you to have full control of the output.

Other settings are the resolution, bit depth (colour/greyscale/black and white), brightness/contrast curves and colour balance (Figure 10.8). Some scanners allow you to set either the gamma of the scanner (measured in a similar way as the film gamma) or the gamma of the display (see page 219). Also you are usually given the option to use colour management and profiles and to select the output colour space (for example, sRGB, Adobe RGB, etc.).

When the film or print is scanned, you can save the digital RGB image as a TIFF, Bitmap, JPEG or PNG file (see page 240).

Driver features for automatic corrections

Manufacturers may provide additional features with the scanner driver for automatic corrections. One of these features is for the automatic removal of artefacts in the digital image arising from dust and scratches on the film. The method of detection is based on illuminating the film with infrared radiation. The location and size of the artefacts is then determined and the artefacts are removed using processing which combines this information with information from

the surroundings obtained by scanning with white light. Other features include the restoration of colour saturation in discoloured or faded images, or shadow correction which may be required when images from a book are scanned.

Scanning films and prints

Before scanning your films or prints you must prepare their surfaces. If you are using a flat-bed scanner, you must also clean its glass plate. Dust or marks on the film or print surface will be recorded by the scanner and may appear in the digitized image. The same applies if there are dust or marks on the glass plate of the scanner. The effects are similar to dust and marks on the film surface or the glass film carrier when you are printing in a darkroom. Use a blow brush or compressed air to remove all dust from the surfaces of the print (or film). You can also clean the scanner glass plate with a special cleaner. If there are scratches on the film or print, however, you can remove them digitally using image editing software. Some scanners have a scratch-reduction feature that you can use to correct the problem, as previously mentioned.

If you are scanning films using a film or flat-bed scanner familiarize yourself with the film carrier and the way you load the film. Remember that when the film is scanned the emulsion should face the sensor (in a similar way that the emulsion of the film faces the light-sensitive surface (emulsion) of the paper when printing in the darkroom). One reason that film is loaded with the emulsion side facing the sensor is that the scanner optics are focused on the emulsion. Another reason is to avoid slight diffusion of the image. This occurs due to the fact that light would pass first through the emulsion and then the film base (which is thicker than the emulsion) before reaching the sensor.

When placing prints on the glass plate of a flat-bed scanner make sure that they are centred evenly over the surface. Remember that if the images you are scanning are on a thin paper which is printed on both sides, the text or other images which are printed on the rear face of the paper may be visible in the digital image. In this case it will be difficult to do corrections with an image editing software. Try using a black card to cover the paper. The image in the preview will appear darker but you can adjust brightness and contrast manually before scanning. If you scan printed halftone images you may get *moiré* patterns.

If you have both a film and a print of the same image it may be better to scan the film rather than the print, provided that you have access to a film scanner or a flat-bed scanner that produces high-quality film scans. The film is a first-generation image compared to the print which is a second-generation image. Inevitably some information is lost when the film is printed on paper due to differences in the colour balance (the colour of the print may not be an exact match to the colour in the film), dynamic range (the dynamic range of the paper is smaller than that of the film) or sharpness.

Scanning and copyright

When you scan any material, you must remember that its copyright is protected by law. So, unless you scan your own photographs or material for which you own the copyright, you have to ask the copyright owner for permission before you proceed to scanning and reproduction of the material. The laws on copyright give detailed information on your rights to reproduce or use material that is protected by copyright.

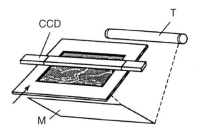

Figure 10.5 A flat-bed scanner has a glass-top surface where the hardcopy is placed for scanning.

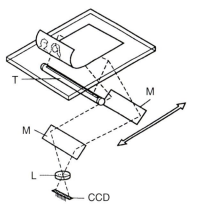

Figure 10.6 Interior of flat-bed scanner. Original print, face down on glass top, is scanned by light from tubular source (T) which moves together with a mirror under the glass. From here light is reflected to a second, stationary, mirror and lens unit (L) down on to a linear CCD array.

scans, each time changing the colour of the light. The analogue signals are then passed to an A/D converter for conversion to digital data. Some flat-beds include a light-transmitting optical system on their cover so you can scan-in film originals. All can give good results from large-format transparencies up to 8 × 10 in., but for 35 mm formats only the highest optical resolution (over 2000 pixels per inch) flat-bed scanner will do.

Another technology used today for flat-bed scanners is the *contact image sensor* (CIS). It is based on red, green and blue *light-emitting diodes* (LEDs) and a row of sensors which has a width equal to the width of the scanning area, i.e. the glass plate. A scanner with CIS technology does not need an optical system, lamp and filters. The image is illuminated at a 45° angle by the red, green and blue LEDs and captured by the sensors. The CIS enables the scanner to be slimmer and lighter than a scanner with CCD sensors, costs less to manufacture because it does not incorporate an optical system and has lower power consumption. The technology is continuously improving and is approaching the accuracy and quality of CCD scanners.

Film/Transparency (transmission) scanners

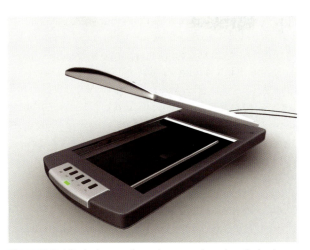

Figure 10.7 35 mm desktop scanner. Light from source (T) is reflected through the mounted film image, which slowly tracks under linear array CCD sensor.

Most desktop film scanners (Figure 10.7) are designed for 35 mm or for rollfilm size originals. There are also scanners which can scan films or transparencies of larger format. Some use a linear sensor – a row of filtered CCDs moving in steps across the rear-lit film (taking between 30 sec and 5 min per 35 mm frame) or one row of unfiltered CCDs making three passes with the light changed between RGB. In other types of film scanners, the CCD array is stationary and the film moves across the array. Alternatively the scanner has a matrix block CCD sensor, which is able to capture the full film image each time in a series of RGB exposures.

Using a flat-bed or film scanner demands fewer skills than a drum unit, but you must still carefully use your computer to set the resolution of the scan (in pixels per inch) to suit the precise size and resolution of your intended print. Any later unforeseen change in this final aim will mean going back and rescanning your original.

Scanner characteristics

Resolution

The resolution of a scanner is measured in *pixels per inch* (ppi) or *samples per inch* (spi). You may also see resolution quoted in *dots per inch* (dpi) although this term refers mainly to printers or displays. In the technical specifications of scanners manufacturers quote the *optical resolution* of the scanner and in many cases the *interpolated resolution*. There is an important difference between them. The *optical* resolution of a scanner depends on the number of pixels in the CCD sensor. The amount of detail that can be recorded by the scanner is therefore limited by the optical resolution. The scanner driver however may give you the option for a higher scanning resolution than the optical. This is achieved by *interpolation* (see page 250). Interpolation increases the number of pixels in an image and therefore the file size but it does not add any more detail to the image. There are several types of interpolation (e.g. nearest neighbour, bilinear, bicubic) that give slightly different results. You may need however an output digital image with different pixel dimensions than those after scanning with optical resolution. If you want to have full control of the interpolation method, you can scan the film or print at the optical resolution and rescale it using image editing software, such as Adobe Photoshop, which gives you the option of selecting one of several different interpolation methods.

The output resolution varies depending on the type of scanner. Flat-bed scanners may provide an output optical resolution of 2400 ppi or higher, while the typical resolution of film scanners can range from 1000 ppi to 8000 ppi, depending on the maximum film format they can scan. The output resolution of a drum scanner is in the range 8000–12 000 ppi.

You will notice that manufacturers usually quote the optical resolution of scanners with two numbers. For example, 1200 × 1200 ppi. The first number refers to the number of the elements in the sensor array. The second number refers to the distance the sensor is moved to make the next reading. If the two numbers are different, for example 1200 × 2000 ppi, you should take the smallest number as the optical resolution.

Choosing the optimal scanning resolution

The optimal scanning resolution is based on the resolution of the output media (display or printer, for example) and is not always the highest that your scanner can give you. You should avoid high scanning resolution when it is not necessary because it can result in a large image file size. Note that the high resolution images will take up a lot of space in your computer's hard disk. Storage can be an important factor to consider if you scan large volumes of images at a daily basis. Also remember that the manipulation of an image with a large file size will take longer. Depending on your work, this may have an effect on the productivity if you process a large number of images. Also, you will not necessarily gain higher image quality if the intended output media are of lower resolution. The additional information in the image may not be used in this case.

For example, if your image is going to be viewed on an Internet page, and displayed with the same dimensions as the original, a scanning resolution of 72 or 100 ppi is sufficient because it will be a close match to the display resolution (see page 220). As a general rule, calculate the pixel dimensions of your output image, taking into account its final dimensions and display or printing resolution. Then find the scanning resolution that will give you the same image pixel dimensions when you scan your original image (again taking into account the original's physical dimensions).

Dynamic range

The dynamic range of a scanner represents the range of tones it can capture in an image. It is measured in a logarithmic scale and it is the difference between the *optical density* (OD) of the darkest shadows (D_{max}) and the OD of the brightest highlights (D_{min}). By knowing the dynamic range of your scanner you have information on the range of density values that it can distinguish. The minimum density value (D_{min}) can be as low as 0 while the maximum value that D_{max} can take is around 4.0. Owing to losses in the analogue to digital conversion the dynamic range may be lower than the estimated. Some manufacturers may quote the D_{max} for the scanner instead of the dynamic range.

The dynamic range is also related to the bit depth of the scanner. A 48-bit scanner will have a higher dynamic range than a 24-bit scanner. Note that the dynamic range of the output digital image also depends on the dynamic range of the scanned film or print which may be lower or higher than the dynamic range of the scanner. In the latter case some tones in the film or print will not be accurately represented in the digital image. More effective use of the scanner dynamic range is made since the tonal range that the scanner can record will be adjusted accordingly.

Bit depth (or colour depth)

The bit depth defines the number of definable output colours (see page 238). A scanner driver may offer several options for the bit depth setting of the digitized film or print. For example, 1-bit (Black and White), 8-bit (Greyscale with 256 shades of grey) and 24-bit (True Colour – 16.7 million colours). Most models today offer an input bit depth of 48 bits but the output is generally reduced to 24 bits. The additional information is used by the scanner to avoid information loss during image adjustments (e.g. curve adjustments). Some scanners, however, provide the option of 48-bit output colour. Note that the scanner bit depth may be quoted as number of bits per channel (e.g. 8-bit/channel) or the total number of bits for all three channels (e.g. 24-bit).

The scanning mode you use affects the file size because it is related to the bit depth of the image. For example, a greyscale image is an 8-bit image (256 shades of grey) while a colour image may have 24-bit colour information or more.

Scanning speed

Scanning speed varies between models and it is an important parameter to consider if you scan large volumes of images because it affects the overall productivity. Technology has progressed since the earlier scanning devices. Scanning speed depends on the dimensions of the film or print and also on the scanning resolution. Typical time needed for a flat-bed scanner to scan, say, an A4 colour print at 300 ppi is 14 sec and at 600 ppi is 25 sec. For a 35 mm film, positive or negative, the flat-bed scanner may need 35–50 sec. A film scanner may need around 20–50 sec to scan a 35 mm film.

Setting up the scanner

The first step in setting up your scanner is to select a suitable location taking into account environmental conditions, such as humidity and extreme temperatures that may have an effect on the hardware. Power surges may damage the scanner electronic components so attach an *uninterruptible power supply* (UPS) device to maintain continuous electric power supply to the scanner. The same is recommended for the computer workstation as power surges may cause damage to the display.

The manufacturer should give detailed instructions on setting up the scanner such as connection to the computer and installing the appropriate software.

Image transfer

A scanner can be typically connected to a computer using four different methods: *Parallel port, small computer system interface* (SCSI), *universal serial bus* (USB) and FireWire (also known as IEEE-1394).

A connection to the parallel port of the computer is the slowest method of transferring images and is not used much today. The SCSI connection is significantly faster but it requires either a SCSI controller or a SCSI card in your computer. It has the advantage that you can connect multiple devices to a single SCSI port. For example, in SCSI 2, you can connect up to eight devices. Data rates with SCSI are very high. The latest Ultra SCSI standard provides data rates as high as 160 MB per second. SCSI can be complicated to configure, however. The parallel connection for scanners has now been largely replaced by the USB connection which is faster. The latest version is USB 2.0, and this standard is capable of transfer speeds of up to 60 MB per second, which is much higher than the 1.5 MB per second of the older USB 1.1 standard and 70 KB per second of the parallel connection. FireWire is faster than USB 1.0 and is comparable to earlier SCSI and to USB 2.0. It is used by scanners that have very high output resolutions which need faster transfer rate due to the high volume of data. USB is the most commonly used connection standard today and is used to connect a wide range of computer peripherals, including keyboards, mice, modems, scanners and cameras.

Scanner drivers

Scanners are supplied by the manufacturer with their own drivers that give you control over the scanning process. Drivers are programs that give you control over the scanner settings. You may also have the option to run your scanner through an imaging software package using the TWAIN driver provided by the manufacturer. The TWAIN standard (the word TWAIN is not an acronym) is the interface between the scanner hardware and the imaging software. It allows therefore communication between the scanner and different imaging software applications.

In many cases the functionality provided by the scanner application is independent of whether it is accessed as a standalone application or through an imaging software application using the TWAIN driver. In some cases the scanning application may give more flexibility and options than the TWAIN one. You can also use third-party scanning software.

The scanner driver often provides you with several options for setting the scanning parameters. If you are using a film scanner you have to set the appropriate film format and type (black and white, colour negative or colour positive). Some scanners also allow you to specify the

Image outputting – Displays

There are several means of outputting your images, such as displaying, printing (including film recording), storing in hard drives or CD-ROMs, DVD-ROMs, etc. When your digital images are displayed on a computer monitor, the image data output from your computer is in the form of a stream of *binary digits* (bits), which is converted by a display processor into a form suitable for the display device. The red, green and blue information for each pixel is stored in a frame buffer (memory) with size equal to the number of pixels in the image multiplied by the number of bits that are associated with each pixel. The output signal values from the memory to the display are processed via colour *look-up tables* (LUTs) and pass through the *digital-to-analog converter* (DAC). Three video signals, R, G and B, are formed and are input to the display. Computer displays are quoted with their diagonal size (e.g. 15 in., 17 in., etc.).

Cathode-ray tube displays (CRT)

The first large-scale applications of CRT display technology were for monochrome and, later, colour television and it was more recently adopted for computer colour display. The CRT display has a vacuum tube with an anode, a cathode and three electron guns. A layer of phosphors is on the inside front face of the tube, grouped in triads for the emission of red, green and blue signals, respectively. Each triad forms a pixel. The phosphors emit light when excited by an energy source. The input video signals cause emission of electrons from the cathode and an electron beam is produced from each electron gun. The beam is focused on the screen via a focusing system and deflected on the phosphor surface through a steel mask, called a *shadowmask* which has one hole for each RGB phosphor triad. This activates the phosphors which each emit red, green or blue light. The number of adjacent pixels on the area distinguished by a viewer defines the resolution of the display (Figure 10.9).

The smaller the distance (*pitch*) between two identically coloured dots the sharper the image is. The measurement of the pitch depends on the triad technology. In the literature the distance is often called *dot pitch* and refers to the *dot triad technology*. Note that the phosphors of a CRT age with time. This affects their colour and reduces the screen luminance.

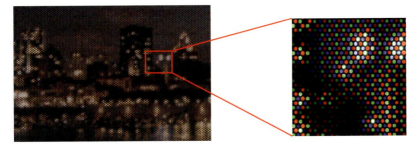

Figure 10.9 Macro photograph of an image displayed on a CRT monitor. Note the RGB dots in the magnified part of the image.

There are several characteristics of the display system, such as the tone reproduction and gamma, the colour gamut, the white point and the colour bit depth setting of the graphics adapter which affect the quality of your displayed images.

Standards such as the *Standard RGB* (sRGB) colour space or models such as the gamma model have been originally developed based on the characteristics of the CRT displays and are currently being adapted for LCDs.

Liquid crystal displays (LCDs)

The liquid crystal displays are increasingly popular and are gradually replacing CRT displays for computer monitors. They are flat, thinner and lighter than the CRTs and have less power consumption. These properties have also made them suitable for portable computers. The most common LCD technology today is the twisted nematic *active matrix LCDs* (AMLCDs). An AMLCD consists of several components as illustrated in Figure 10.10. The light source is usually fluorescent, and depending on the manufacturer and the model, it can be located at the back, top or side of the display. The light passes through a diffuser which causes scattering. It produces a uniform illumination which passes through a rear polarizing filter. The transmitted light has one polarization only. It then passes through an element with *thin film transistors* (TFTs), which control each colour pixel of the screen, to the layer of liquid crystal elements. These elements have a twisted shape which rotates light at 90°. At this stage the light can pass through the front polarizer which is orthogonal to the rear polarizer. If voltage is applied to the liquid crystals their orientation changes and the amount of light that can pass through is reduced. The light is controlled by the applied voltage and the rotation of the liquid crystals can be reduced to 0° (the shape is not twisted any more). At this stage no light can pass through the polarizers.

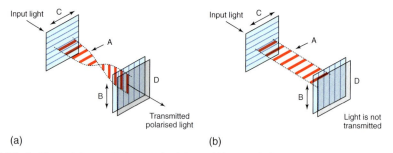

(a) (b)

Figure 10.10 (a) The liquid crystal elements (A) have a twisted shape which rotates light at 90°. At this stage the light can pass through the front polarizer (B) which is orthogonal to the rear polarizer (C) and the colour filter (D). (b) The light is controlled by the applied voltage. When the rotation of the liquid crystals is reduced to 0° (the shape is not twisted any more) no light can pass through the polarizers.

There are other technologies that do not use the twisted nematic system. One of them is the *in-plane switching* (IPS). It offers improvement regarding viewing angle, brightness and contrast.

In LCDs each pixel is covered by a group of three adjacent red, green and blue filters. There no distortions in the screen but the effect of viewing angle on image quality is significant.

Other display technologies

Other display technologies include plasma screens and organic light-emitting diode (OLED) displays. Plasma screens can be manufactured in large sizes. They have wide colour gamut (page 258), high dynamic range and there is no effect of viewing angle. OLEDs have a very wide viewing angle and can be manufactured as very thin or flexible displays.

Characteristics of display systems

Colour temperature (white point)

Display devices provide you with a range of options for setting the colour temperature, also referred to as the *white point*. You can select a preset white point, for example 5000 K, 5500 K, 6500 K, etc., and you may also be given the option of a custom setting where you can set the white point yourself with the aid of a calibration device. Your choice of white point depends on the application. For example, a recommended colour temperature for the graphic arts is 5000 K (CIE standard illuminant D50) while for photography it is 6500 K (CIE illuminant D65). If you use the sRGB colour space you should select the 'sRGB' white point preset, if available, or the 6500 K setting. The colour temperature also affects the range of colours relative to white within the display *colour gamut boundary*.

Tone reproduction

For CRT display systems, tone reproduction is described by a non-linear transfer function, which is approximately a power function. A simple equation that describes the CRT display system power function where the output display luminance (L) is plotted against the input pixel values (V) is the following: $L = V^\gamma$. The exponent is called gamma (γ), the same term that is used for conventional photography. The gamma of a CRT display may range usually between 1.8 and 2.4, with a typical value of 2.2 (Figure 10.11).

Because of the non-linear function, which is due to the physics of the CRT monitor, digital images which have been created with linear devices must be 'corrected' before being displayed. This is known as *gamma correction*. If they are not gamma corrected,

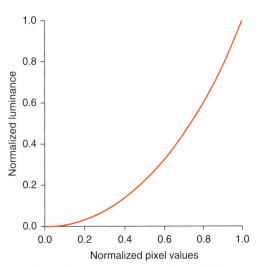

Figure 10.11 The transfer function of a calibrated CRT display set to gamma equal to 2.2. LCDs mimic the transfer function of CRTs.

they will appear dark on the screen. Gamma correction is carried out either in the image capture process or later with imaging software. When you scan an image, for example, the driver may give you the option to set the display gamma. The scanner has a linear transfer function, because the CCD sensors have a linear response. By giving information on your display gamma the driver corrects the image so that it will be displayed with the correct tonal scale on the screen. sRGB images are already 'gamma corrected' for a typical CRT display gamma of 2.2.

LCDs have a different, s-shaped, transfer function compared to the CRTs. With internal processing however their output mimics the function of the CRT display and is very close to a power function. This way images which are gamma corrected for viewing on a CRT display (for example sRGB images) are displayed correctly on LCDs with the same gamma setting.

The gamma setting of different displays may vary and this depends on their luminance (brightness) and contrast settings. The result would affect the quality of displayed images. An

image that was gamma corrected for a specific display gamma setting would appear darker if it was viewed on a display set to higher gamma and lighter if it was viewed on a display with lower gamma. You can calibrate your display to a specific gamma and colour temperature and create a *profile* (see page 260) using a calibration device. A simpler method is to use an application which will enable you to create a profile without the need for additional hardware. The profile may not be as accurate as a profile from calibration devices but it will be close enough.

Screen resolution

Resolution refers to the number of *dots per inch* (dpi) that the device can display and it depends on the dot size. Typical CRT display resolution is between 72 and 96 dpi. The term *addressability*, sometimes confused with resolution, refers to how many points can be addressed by the graphics card adapter. There are several settings for CRT displays (for example 1024 × 768 pixels and 1280 × 1024 pixels). Visually you may not see differences in image quality when changing the resolution on a CRT display, but you will notice that the image appears smaller when the display is set at a higher resolution and vice versa. The effect of resolution on image quality is scene dependent. For example, if an image has fine detail, some detail may be lost if it is displayed in lower resolution. LCDs have a specific number of pixels on the screen. The pixel dimensions of the LCD screen are referred to as its *native resolution.* You get optimal image quality only when the display resolution of the LCD is set to its native resolution. If you change the display resolution images, text may take on a slightly blurred appearance.

Colour gamut

The range of colours that can be reproduced by a computer display is described by its *colour gamut.* If the colour gamut of your image is outside the colour gamut of the display, the out of gamut colours will be clipped or mapped to the display gamut using a gamut-mapping technique (page 258). Your displayed image therefore may not faithfully reproduce the colours of your digital image. Colour management systems use profiles to ensure accurate colour reproduction throughout the imaging chain. Another solution is to use sRGB images (page 338). The sRGB standard was developed for accurate colour reproduction of images which are viewed on CRTs and it has the same gamut as a typical CRT display (see Figure 10.12).

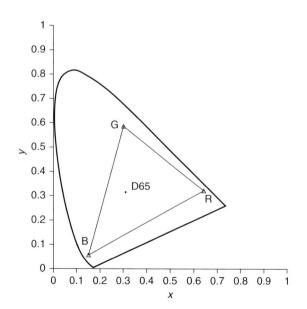

Figure 10.12 The colour gamut of the sRGB colour space in the CIE 1931 xy chromaticity diagram.

Effect of viewing conditions

As described in Chapter 8, the ambient lighting and viewing conditions affect the way you perceive the colour and tonal quality of an image. This applies to displayed images as well as to printed or projected images. The ambient light may cause a reduction of contrast on the CRT or LCD screen due to flare. Some displays are equipped with a hood which isolates the viewing screen from the effect of ambient lighting. The perceived contrast of displayed images is also affected by the intensity of the ambient lighting and the viewing angle when they are displayed on an LCD.

Other parameters that may affect the perceived colour of the displayed images are colours of the image background and monitor surround due to colour adaptation of the observer's visual system (see page 81). The same applies to the colour temperature of the ambient lighting. The intensity of the ambient lighting affects the perceived contrast of viewed images. For controlled results you should work with standardized daylight ambient illumination and a calibrated display system.

Display calibration

Calibration of your display is essential if you want accurate colour and tone reproduction of your displayed images. You should calibrate your display regularly if you want to have constant results. Remember to allow the display to warm up for about an hour before you start any calibration procedure.

Depending on the level of accuracy you need and your budget you can either invest in special calibration devices, such as the Macbeth Eye One or the ColorVision Spyder2 accompanied with the appropriate software (Figure 10.13) or conduct visual calibration using software with special test targets.

Figure 10.13 The Colorvision Spyder2PRO for monitor calibration with the Spyder PrintFIX PRO calibration device for printers.

You can use monitor calibration devices to set the target gamma and white point of your display. The devices have sensors which can measure the luminance and colour of your display, and this information is compared to the target values. You are then requested to carry out a set of adjustments on the luminance, contrast and colour of your device so that they match the

target values. After the process is completed a profile is created for your display which you can use with colour management systems.

If you choose to use software for visual calibration, the result may not be as accurate as using a monitor calibration device but it may be sufficient for your applications. The calibration software provides you with a set of test targets which you use to correctly set the luminance and contrast of your monitor, thereby ensuring that you have the best results regarding the contrast of your displayed images. Some visual calibration software applications can create a profile for your display.

Visual adjustment of brightness and contrast is affected by the intensity of the ambient lighting and their settings give optimal results only under the ambient lighting conditions under which you performed the calibration. If the ambient lighting changes you have to perform the calibration again.

Image outputting – Digital printers

You can print out your final digital image from the computer in a wide range of ways. Digital colour printers – often desktop size – print onto paper using processes such as dye-sublimation or inkjet. You can also write to film, so forming a silver halide negative or transparency from which conventional colour prints are enlarged; or print direct onto a wide roll of silver halide paper or display film using a digitally modulated tri-colour laser system.

Printing by dye-sublimation

A good dye-sublimation printer produces continuous tone images and can output near-photographic quality colour images up to about A4 size (or Letter Size, in the US). As shown in Figure 10.14, these desktop machines use a full paper width donor ribbon carrying a series of

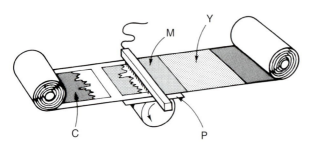

Figure 10.14 Thermal dye-sublimation printer, showing principle by which colour prints are output on paper from digital files. Receiving paper (P) fits under full-width roll of doner plastic coated with consecutive panels of cyan, magenta and yellow dyed wax. Sandwich passes under a bar of heated pins, each of which vaporizes and transfers tiny spots of colour according to scan data from image file. After each single colour is printed the wax roll shifts relative to the receiving paper, to bring its next colour into the same printing position and so build up a full colour print.

(print size) areas of transparent cyan, magenta and yellow dye. In the print head a heating element, the width of the paper, vaporizes dye onto the paper surface so that after three passes the paper builds up a full colour image. The used donor ribbon with its remaining dyes winds onto a take-up spool and is later thrown away. You must use special paper – the action of the dyes then merge pixel dots together into pattern-free areas of colour and tone. A problem with dye-sublimation printing is the relatively high cost of donor ribbon and paper, plus litter from spent ribbons. An A4 colour print takes about 11.2 min to produce.

Printing by inkjet

These printers vary greatly in image quality and price (Figure 10.15). They range from desktop for A4-size prints, to expensive types of printing machine able to turn out mural size images on a range of sheet material including quality watercolour paper and acetate.

Figure 10.15 An inkjet printer.

There are two technologies of inkjet printing: *bubble jet*, which is used by most printer manufacturers, and *micro piezo* (e.g. Epson). In bubble jet technology, each ink is forced into a tiny nozzle by heat. The heated ink forms a tiny bubble at the end of the nozzle which transfers, merging with others, to the image-receiving sheet. In the micro piezo technology, a piezo crystal becomes distorted when electric current is applied and the difference in pressure causes ink to be forced out of the nozzle. The size of the ink droplets is controlled by controlling the voltage applied on the piezo crystal, which results in different distortion. With this technology the size of droplets can vary depending on the detail of the image.

The ink droplets are measured in picolitres (1 picolitre is one trillionth of a litre) and today's printers can produce droplets as small as 1–1.5 picolitres. The smallest they are the higher the resolution of the image.

When printing, the printing head of an inkjet printer moves rapidly backwards and forwards across the width of the print like the shuttle in a weaving machine, paper advancing minutely after each pass. Inkjet printers use the *halftone method,* which is explained in more detail in page 329. High-end inkjet printers can turn out excellent photographic quality images on a wide variety of papers (made for the purpose by most silver halide paper suppliers as well as paper manufacturers). They need careful maintenance however, including regular nozzle cleaning. For colour printing they use a set of cartridges. The number of inks depends on the manufacturer and it can range from four to twelve inks (e.g. Hewlett-Packard printers).

Colour inks

Inkjet printers traditionally printed using four colour inks, cyan, magenta, yellow and black, in one colour cartridge or individual cartridges for each colour. During the last years however manufacturers introduced additional colours to enhance the quality of printed colour images by reducing the visible artifacts of halftoning. There are, for example, six-colour printers, with the additional 'light cyan' and 'light magenta' colours, seven-colour printers which also include 'light black' ink, eight-colour printers (e.g. Epson) with one more addition, the 'light light black' etc. The addition of more than one black ink aims to enhance quality when printing greyscale images, where only black inks are used. Epson eight-colour printers, for example, incorporate a 'photo black' ink, for printing on glossy paper, and a 'matte black' ink when printing on matte paper. Other printers (e.g. Canon) use red and green inks in addition to the subtractive cyan, magenta and yellow.

There are two types of inks, *dye-based* inks and *pigment-based* inks. The dye-based inks give more vivid colours than the pigment-based inks but they fade more quickly. The pigment-based inks are not as vivid. The colour gamut of the dye-based inks used to be wider than that of the pigment-based inks but today with the improvements in printing technology the gamuts are very close. Some printers may use dye-based inks for cyan, magenta and yellow and pigment-based inks for black. Canon printers, for example, use dye-based inks for cyan, magenta, yellow and black and pigment-based matte black ink.

Inkjet paper

There are several types of inkjet paper, each with a different finish (matt, semi-matt, glossy), weight, colour (white, bright white), resin coated or cotton, surface that looks like watercolour paper, etc. Because of all these differences between papers, the printer driver alters the colour saturation and the amount of ink deposited according to the paper used, to produce optimal results. It is essential therefore to select the right paper type for best printing results.

Printing quality and longevity of the prints also depend on the combination of inks and paper and are best when you use specific combinations of ink and paper. If you use inks and paper from different manufacturers, for example, you may notice differences in the print quality. You will need to do several tests with different paper types and finishes to find the ones that suit your work. Always remember to allow the ink to dry on the paper before handling, storing or framing it.

Printing by light

So called light-jet printers also use a moving printing head, but this issues a spot of light instead of inks, focused onto a roll of regular silver halide-coated photographic paper or display film in a light-tight consol unit (see Figure 10.16). The light spot is formed from the combined paths of three (RGB) laser sources, each one modulated by digital data from the computer. Light-jet printing must of course be followed by processing in machines with RA-4 chemistry or whatever is appropriate for the photographic material you used. This need, plus their high capital cost, means that light-jet printers are most often located in custom labs.

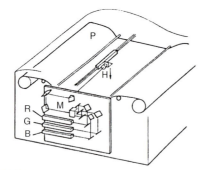

Figure 10.16 Light-jet printer: the light-tight cabinet is loaded with a 4 ft wide roll (P) of regular silver halide material – monochrome or colour paper, or display colour film. Image data from digital disk controls light intensity from R, G and B lasers which feed through mixing box (M) to a moving exposure head (H). This focuses the combined light into a tiny spot on the paper's sensitive surface. Like an inkjet system the head moves backwards and forwards as the paper slowly rolls forward. A print 50 in. long takes 10 min to expose. It is then processed as if having been made normally using an enlarger.

Other digital colour printers such as Fuji's 'Pictrography' expose the image with one pass of a row of tri-colour laser diodes onto a special light-sensitive donor paper. This is dampened with a small amount of water and heated to create a full colour dye image which is transferred under pressure and heat to a receiving paper. Some forms of laser printer machine function by using an electrostatic (Xerox type) drum. Instead of receiving its image optically, from an original placed face down on a glass plate, the digital data output from your computer controls light-emitting diodes or a laser beam which scans the image onto the electrically charged drum surface. The drum rotates, picking up coloured toner in areas unaffected by light and passing

them on to receiving paper. Four passes (CMYK) are made in this way to build up a full colour print.

Printer characteristics

Printer resolution

The printer resolution is quoted in *dots per inch* (dpi). As mentioned in the section on scanners, you should take into account the printer resolution and the final dimensions of your image before scanning your film or print. You will not gain higher quality if you have a digital image with higher resolution than the output device. The additional information will not be used by the printer.

Typical good printer resolutions are in the range 1440 dpi–2880 dpi or higher. There is however a significant difference between printer resolution and digital image resolution. The printer resolution refers to the number of dots that the printer can print per inch, and not the pixels. The printer prints more than one dot per pixel (usually around 4 dots per pixel but this varies between printers) producing visually continuous tone. The image resolution needed for a good quality print is around 300 ppi. The printing speed varies, depending on the resolution, print dimensions, printing mode and paper type.

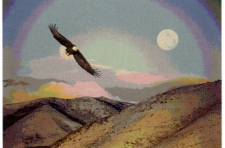
(a)

(b)

(c)

Dithering

Dithering (similar to *halftone*) is a method used by non-continuous-tone printers to create all the colours of the digital image using a limited number of inks and more than one dot per pixel, as previously mentioned. You can read more about halftone in Chapter 14. With the dithering method a colour which does not exist in a palette is visually

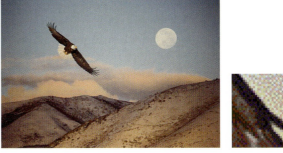

Figure 10.17 An example of dithering. The colours of a 24 bit image (a) are reduced to 256 colours. The images with reduced colours are (b) and (c). In image (b) the colours were not dithered while in image (c) you can see the effect of dithering using the method of error diffusion. The effect can be further observed in the magnified regions of the images.

simulated by mixing dots of the existing colours that closely approximate it, using information from adjacent pixels. Similarly you can observe a dithering pattern on your display when you reduce the colour depth of a digital image from 24 bit to 8 bit and select the option to dither the colours (see Figure 10.17). There are several types of dithering such as *error-diffusion*, first developed by Floyd and Steinberg. Inkjet printers designed for printing photographs produce high-quality images where the dithering pattern is not visible, using a very small palette of colours.

Colour gamut

The colour gamut of a printer has a different shape from that of the display. The two gamuts do not match (see page 258) which means that some colours that are reproduced by the printer cannot be reproduced by the display. In the same way, some colours reproduced by the display cannot be reproduced by the printer. This is an important issue when you try to print images that you have edited by viewing them on a display. Colour alterations you made to the image may not be reproduced faithfully on the print. The solution to this problem is the use of colour management systems which apply *gamut mapping*. This is a method of mapping the out of gamut colours of one device to the gamut of the other device and by choosing the rendering indent you can control the type of conversion (e.g. perceptual, relative colorimetric, absolute colorimetric, etc.).

Printer drivers

The driver gives you several options to control the printer and also to perform maintenance such as alignment of the printer heads. Alignment is an important procedure for best printing quality and sharp images and it should be performed every time you change ink cartridges. Maintenance may also include nozzle checking and cleaning. Other options include the activation of colour management and the use of profiles, choice of paper type, print quality, printing speed. You may also have the option to adjust colours manually. More advanced options may give more control over adjustments and differ between manufacturers.

Effect of viewing conditions

The viewing conditions have an effect on the perceived colour and tone of the digital prints, in the same way that they affect the perceived quality of silver halide prints. When the prints are viewed with a dark surround the tones appear lighter than when viewed in a bright surround. It is useful to remember this effect when you frame and display your images. The finish of the paper (matt, semi-matt, glossy) also has an effect on the perceived tonal range of the printed image due to flare. The colour temperature of the ambient lighting is another parameter you should take into account. You must have standardized display and viewing conditions when you manipulate images on the screen and compare them with the print. Remember, however, that the colours of the screen cannot match perfectly the colours of the print. The image from the display is formed by transmitted light and red, green and blue colours while the image on the print is formed by reflected light and cyan, magenta, yellow and black inks.

You may also observe *metamerism* (see page 82) with some inks, causing the colours of the print to appear different under different lighting conditions. This may be more obvious if there is metamerism in a greyscale photograph which may appear with colour casts instead of a neutral tonal scale.

SUMMARY

■ The computer setup consists of several components. Its central unit is the computer workstation which is connected to several peripheral devices. Computer software enables you to process images and alter their colour, correct converging verticals, remove marks, spots, blemishes and produce special effects.

■ The scanner is an input device which can digitize films or prints. There are different types of scanners: drum, flat-bed and film scanners. Drum scanners provide high resolution and overall quality. Technology of flat-bed and film scanners has improved and the digitization of images is of high quality. Some models of flat-bed scanners can also scan film.

■ Scanning resolution is an important parameter. Always check for the optical resolution that is quoted by the manufacturer. Higher resolution than the optical is obtained via interpolation.

■ When you scan your images choose the optimal resolution for your output device. Higher resolution than that will not improve the quality of your image. The output will not use the additional information.

■ The dynamic range of the scanner represents the range of tones that the scanner can capture in an image. Some manufacturers may quote the maximum OD (D_{max}). The bit depth defines the number of output colours. The scanner may scan at bit depth higher than 24 bits. The output image you will get however is usually in 24 bits.

■ There are four different types of scanner connections. The most common and fast connection is the USB2. The scanner can be accessed from your computer via its own driver or a TWAIN driver. With the TWAIN driver you access the scanner via an imaging software package. The driver allows you to set the scanning parameters.

■ The two most common displays are the CRT display and the LCD. They have different technologies and properties. The display properties may affect the colour and tone of the displayed images.

■ The transfer function of the CRT monitor is non linear. Images can be displayed correctly on a CRT display when they are *gamma corrected*. This is performed either in the acquisition device or later using imaging software. sRGB images are gamma corrected. The LCDs apply internal processing to mimic the transfer function of the CRT displays.

■ The viewing conditions affect the perceived tone and colour of displayed images. You should calibrate your display regularly for standardized results. Calibration can be conducted using calibration hardware or software.

■ There are several types of printers, such as dye-sublimation, inkjet, laser, pictography. They all use different technologies.

■ Inkjet printers use either the 'bubble jet' or the 'micro piezo' technology. They use four or more inks. Inks are dye or pigment based. Dye-based inks are more vivid than pigment based. Pigment-based inks have higher longevity.

■ There are several types of paper available. It is important to select the correct paper type in the printer driver for best results.

■ The printer resolution is quoted in dots per inch and refers to the number of dots that the printer can print per inch and not the pixels of the image. Halftone printers apply dithering.

■ The colour gamut of the display and the printer do not match. Gamut mapping is necessary to map the out of gamut colours of one device to the gamut of the other.

■ The perceived tone and colour of a print is affected by the ambient lighting conditions. You may also observe metamerism resulting from the inks, so the colours of your print may appear different when you view it under different lighting conditions.

1 In Adobe Photoshop open a 24-bit colour image and convert it to an 8-bit image (256 colours) from Menu > Image > Mode > Indexed colours > System (Mac OS or Windows), selecting the 'None' in the Dither options. Open again the 24-bit image and convert it to 8 bit but this time select 'Diffusion' from the Dither options. Observe the effect of dithering. Try the other dithering options (Pattern and Noise) and observe the different results.

2 Select a black and white image with medium contrast. Display it on your computer monitor, first with all the lights on in the room. Observe the tonal scale of the image. Turn all the lights off and view the image again. Observe the change in the perceived tones of the image.

3 Using Adobe Photoshop, open an image and rescale it at different, increasing levels using interpolation. Observe the blurring of the image when you increase too much the pixel dimensions. Interpolation just adds pixels in the image but no additional detail.

11 Digital image manipulation

This chapter deals with all aspects of digital imaging. Digital images are at their most fundamental sets of numbers rather than physical entities. One of the key differences between working with traditional silver halide photography and working digitally is the vast range of options that you have at your fingertips, before, during and after image capture. Of course the problem with this is that things can get very complicated. You need an understanding of all aspects of the digital imaging chain to ensure that you get the optimum results that you require. Digital image manipulation involves playing with numbers and what is more, this can be done in a non-destructive way. Image manipulation is not, however, confined to the use of image processing applications such as Photoshop. The image is changed at every stage in the imaging chain, leading to unexpected results and makes the control of colour a complicated process. The path through the imaging chain requires decisions to be made about image resolution, colour space and file format, for example. Each of these will have an impact on the quality of the final product. To understand these processes, this chapter covers five main areas: digital image workflow, the digital image file, file formats and compression, image processing and colour management.

What is workflow?

The term *workflow* refers to the way that you work with your images, the order in which you perform certain operations and therefore the path that the image takes through the imaging chain. Your workflow will be partially determined by the devices you use, but as important is the use of software at each stage. The choices you make will also depend upon a number of other factors, such as the type of output, necessary image quality and image storage requirements.

General considerations in determining workflow

Because of the huge range of different digital imaging applications, there is no one optimal workflow. Some workflows work better for some types of imaging and most people will establish their own preferred methods of working. The aims to bear in mind however, when developing a workflow, are that it should make the process of dealing with digital images faster and more efficient and that it should work towards optimum image quality for the required output – if it is known. Figure 11.1 illustrates a general digital imaging workflow from capture to output. At each stage, there will be many options and some stages are really workflows in themselves.

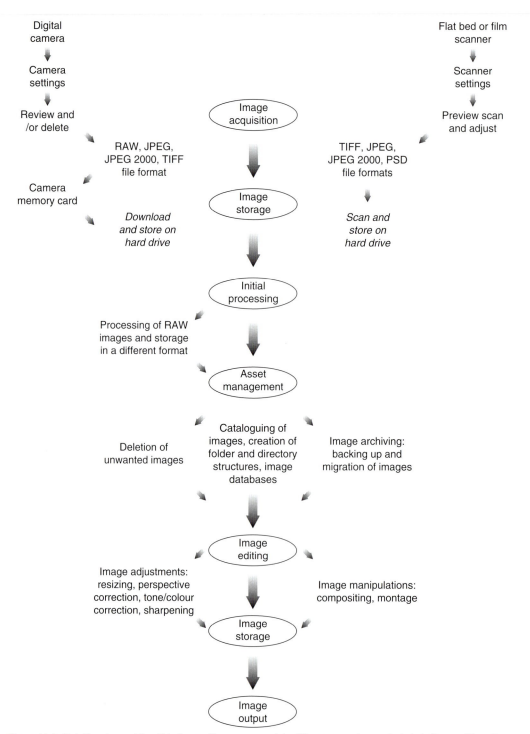

Figure 11.1 *Digital imaging workflow*. This diagram illustrates some of the different stages that may be included in a workflow. The options available will depend on software, hardware and imaging application.

Optimum capture versus capture for output

When digital imaging first began to be adopted by the photographic industry, the imaging chain itself tended to be quite restricted in terms of hardware available. At a professional level the hardware chain would consist of a few high-end devices, usually with a single input and output method. These were called *closed loop* imaging systems and made the workflow relatively simple. The phrase was originally coined to refer to methods of colour management (covered later in this chapter), but may equally be applied to the overall imaging chain, of which colour management is one aspect. Usually a closed loop system would be run by a single operator who, having gained knowledge of how the devices worked together over time, would be able to control the imaging workflow, in a similar way to the quality control processes implemented in a photographic film processing lab, to get required results and correct for any drift in colour or tone from any of the devices.

In a closed loop system, where the output image type and the output device are known, it is possible to use an 'input for output' approach to workflow, which means that all decisions made at the earlier stages in the imaging chain are optimized to the requirements of that output. If you are trying to save space and time and know for what purpose the image is being used, then it is possible to shoot for that output. This may mean, for example, when shooting for web output, capturing at quite a low resolution and saving the image as a Joint Photographic Experts Group (JPEG). However, if it is known that an image is to be printed to a required size on a particular printer, the image can be captured with exactly the number of pixels required for that output, converted into the printer colour space immediately and by doing so, the image quality should be as good as it can be for that particular system. The image will need less post-processing work if any and will be ready to be used straight away, correct for your required output. This method of working is simple, fast and efficient. Additionally, if that same method is to be used for many images, then steps in the workflow can be automated, reducing the possibility of operator error and further speeding the process up.

However, it is important to remember that this workflow is designed for one particular imaging chain. As soon as other devices start to be added to the imaging chain, or the image is required for a different type of output, for example to be used in a web page, the system starts to fail in terms of efficiency and may no longer produce such high-quality results. The situation just described is much more typical of the way in which we work in digital imaging today, particularly as the Internet is now a primary method for transmitting images. The use of multiple input and output devices is commonplace by both amateur and professional and these types of imaging chains are known as *open loop* systems. Often an image may take a number of different forms. For example, it may be that a single image will need to be the output as a low-quality version with a small file size to be sent as an attachment to an email, a high-quality version for print and a separate version to be archived in a database.

Open loop systems are characterized by the ability to adapt to change. In such systems, it is no longer possible to optimize input for output and in this case the approach has to be to optimize quality at capture and then to ensure that the choices made further down the chain do not restrict possible output or compromise image quality. Often multiple copies of an image will exist, for the different types of output, but also multiple working copies, at different stages in the editing process. This 'non-linear' approach has become an important part of the image processing stage in the imaging chain, allowing the photographer to go back easily and correct

mistakes or try out many different ideas. Many photographers therefore find it is simply easier to work at the highest possible quality available from the input device, at the capture stage and then make decisions about reducing quality or file size where appropriate later on. At least by doing this, they know that they have the high-quality version archived should they need it. This is optimum capture, but requires a decent amount of storage space and time, in both capture and subsequent processing.

Standards

Alongside the development of open loop methods of working, imaging *standards* have become more important. Bodies such as the International Organization for Standardization (ISO), the International Colour Consortium (ICC) and the JPEG work towards defining standard practice and imaging standards in terms of technique, file format, compression and colour management systems. Their work aims to simplify workflow and ensure interoperability between users and systems and it is such standards that define, for example, the file formats commonly available in the settings of a digital camera, or the standard working colour spaces most commonly used in an application such as Adobe Photoshop.

Standards are therefore an important issue in designing a workflow. They allow you to match your processes to common practice within the industry and help to ensure that your images will 'work' on other people's systems. For example, by using a standard file format, you can be certain that the person to whom you are sending your image will be able to open it and view it in most imaging applications. By attaching a profile to your image, you can help to make sure that the colour reproduction will be correct when viewed on someone else's display (assuming that they are also working on ICC standards and have profiled their system of course).

Software

There is no standardization in terms of software, but the range of software used by most photographers has gradually become more streamlined, as a result of industry working practices and therefore a few well-known software products dominate at the professional level at least. For the amateur, the choice is much wider and often devices will be sold with 'lite' versions of the professional applications. However, software is not just important at the image editing stage, but at every stage in the imaging chain. Some of the software that you might encounter through the imaging chain includes:

- Digital camera software to allow the user to change settings.
- Scanner software, which may be proprietary or an independent software such as Vuescan or Silverfast.
- Organizational software, to import, view, name and file images in a coherent manner. In applications such as Adobe Bridge, images and documents can also be managed between different software applications, such as illustration or desktop publishing packages. Adobe Photoshop Lightroom is a new breed of software, which combines the management capabilities of other packages to organize workflow with a number of image adjustments.
- RAW processing software, both proprietary and as plug-ins for image processing applications.
- Image processing software. A huge variety of both professional and lite versions exist. Within the imaging industry, the software depends upon the type and purpose of the image being produced. Adobe Photoshop may dominate in the creative industries, but forensic, medical and scientific imaging have their own types of

software, such as *NIH image* (Mac)/*Scion Image* (Windows) and *Image J*, which are public-domain applications optimized for their particular workflows.
- System software, which controls how both devices and other software applications are set up.
- Database software, to organize, name, archive and backup image files.
- Colour management software, for measuring and profiling the devices used in the system.

It is clearly not possible to document the pros and cons, or detailed operation, of all software available to the user, especially as new versions are continually being brought out, each more sophisticated than the last. The last three types of software in the list, in particular, are unlikely to be used by any but the most advanced user and require a fair degree of knowledge and time to implement successfully. It is possible, however, to define a few of the standard image processes that are common from application to application and that it is helpful to understand. In terms of image processing, these may be classed as *image adjustments* and are a generic set of operations that will usually be performed by the user to enhance and optimize the image. The main image adjustments involve resizing, rotating and cropping of the image, correction of distortion, correction of tone and colour, removal of noise and sharpening. These are discussed in detail later in the chapter. The same set of operations is often available at multiple points in the imaging chain, although they may be implemented in different forms.

In the context of workflow and image quality, it is extremely useful to understand the implications of implementing a particular adjustment at a particular point. Some adjustments may introduce artefacts into the image if applied incorrectly or at the wrong point. Fundamentally, the *order* of processing is important. They may also limit the image in terms of output, something to be avoided in an open loop system. Another consideration is that certain operations may be better performed in device software, because the processes have been optimized for a particular device, whereas others may be better left to a dedicated image processing package, because the range of options and degree of control is much greater. Ultimately, it will be down to users to decide how and when to do things, depending on their system, a bit of trial and error and ultimately their preferred methods of working.

Capture workflow

Whichever approach is used in determining workflow, there are a variety of steps that are always performed at image capture. Scanning workflow has been covered in Chapter 10, therefore the following concentrates on workflow using a digital camera. When shooting digitally, there are many more options than are available using a film-based capture system. Eventually, these settings will become second nature to you, but it is useful to know what your options are and how they will influence the final image. Remember, the capture stage is really the most important in the digital imaging chain. A number of settings are set using the menu system and selecting settings or image parameters. Other settings are used on a shot-by-shot basis at the point of capture.

Formatting the card
There are a variety of different types of memory card available, depending upon the camera system being used. These can be bought reasonably cheaply and it is useful to keep a few spare, especially if using several different cameras. It is important to ensure that any images have been downloaded

from the card before beginning a shoot, and then perform a full erase or format on the card in the camera. It is always advisable to perform the erase using the camera itself. Erasing from the computer when the camera is attached to it, may result in data such as directory structures being left on the card, taking up space and useless if the card is used in another camera.

Setting image resolution

Image resolution is determined by the number of pixels at image capture, which is obviously limited by the number of pixels on the sensor. In some cameras however it is possible to choose a variety of different resolutions at capture, which has implications for file size and image quality. Unless you are capturing for a particular output size and are short of time or storage space, it is better to capture at the native resolution of the sensor (which can be found out from the camera's technical specifications), as this will ensure optimum quality and minimize interpolation.

Setting capture colour space

The colour space setting defines the colour space into which the image will be captured and is important when working with a profiled (colour managed) workflow. Usually there are at least two possible spaces available, these are sRGB and Adobe RGB (1998). sRGB was originally developed for images to be displayed on screen, such as those used on the web and in multimedia applications. As it is optimized for only one device, the monitor, it has a relatively small colour gamut. Printer gamuts do not match monitor gamuts well and therefore images captured in sRGB, when printed, can sometimes appear dull and desaturated (see page 226). Adobe RGB (1998) is a later colour space, with a gamut increased to cover the range of colours reproduced by printers as well. Unless you know that the images you are capturing are only for displayed output, the Adobe RGB (1998) is usually the optimum choice.

When using the RAW format, setting the colour space will not have an influence on the results, as colour space is set afterwards during RAW processing.

Setting white balance

As discussed in Chapter 4, the spectral quality of white light sources varies widely. Typical light sources range from low colour temperatures at around 2000 or 3000 K, which tend to be yellowish in colour up to 6000 or 7000 K for bluish light sources, such as daylight or electronic flash. Daylight can go up to about 12 000 K indicating a heavy blue cast. Our eyes adapt to these differences, so that we always see the light sources as white unless they are viewed together. However image sensors do not adapt automatically. Colour film is balanced for a particular light source. The colour response of digital image sensors is altered for different sources using the white balance setting. This alters the relative responses between red-, green- and blue-sensitive pixels.

White Balance may be set in a number of different ways.

White balance presets

These are preset colour temperatures for a variety of typical photographic light sources and lighting conditions. Using these presets is fine if they exactly match the lighting conditions. It is important to note that colour temperature may vary for a particular light source. Daylight may have a colour temperature from approximately 3000 up to 12 000 K depending upon the time of day, year and distance from the equator. Tungsten lamps also vary especially as they age.

Auto white balance

The camera takes a measurement of the colour temperature of the scene and sets the white balance automatically. This can work very well, is reset at each shot, and so adapts as lighting conditions fluctuate.

Custom white balance

Most digital single-lens reflexes (SLRs) have a custom white balance setting. The camera is zoomed in on a white object in the scene, a reference image is taken and this is then used to set the white balance. This can be one of the most accurate methods for setting the white balance.

White balance through RAW processing

When shooting RAW, it is not necessary to set white balance as this is one of the processes performed in the RAW editor post-capture using sliders. It is still useful to have an idea of the colour temperature before capture, but the temperature will be displayed in the RAW editor.

Setting ISO speed

The ISO setting will determine the sensitivity of the sensor to light, ensuring correct exposure across a variety of different lighting levels. The sensor will have a native sensitivity; usually the lowest ISO setting and other ISO speeds are then achieved by amplifying the signal response. Unfortunately this also amplifies the noise levels within the camera. Some of the noise is present in the signal itself and is more noticeable at low light levels. Digital sensors are also susceptible to other forms of noise caused by the electronic processing within the camera. Some of this is processed out on the chip, but noise can be minimized by using low ISO settings. Above an ISO of 400, noise is often problematic. It can be reduced with noise filters during post-processing, but this causes some blurring of the image.

ISO speed settings equate approximately to film, but are not exact as sensor responses vary. For this reason, the camera exposure meter is usually better than an external light meter for establishing correct exposure.

Setting file format

The file format is the way in which the image will be 'packaged' and has implications in terms of file size and image quality. The format is set in the image parameters menu before capture and will define the number of images that can be stored on the memory card. The main formats available at image capture are commonly JPEG, TIFF (tagged image file format) (some cameras), RAW (not yet standardized, newer cameras) and RAW + JPEG (some cameras).

RAW capture

RAW files are a recent development in imaging and are slowly altering workflow. Capturing to most other image file formats involves a fair degree of image processing being applied in the camera, over which the photographer has limited control. Settings at capture such as exposure, colour space, white balance and sharpening are applied to the image before it being saved and the image is therefore to some extent 'locked' in that state. RAW files bypass some of this, producing data from the camera that is much closer to what was actually 'seen' by the image sensor and significantly less processed.

The RAW file consists of the pixel data and a header which contains information about the camera and capture conditions. Most digital sensors are based on a Bayer array (see page 114), where each pixel on the sensor is filtered to capture an intensity value representing only the amount of red, green or blue light falling at that point. When capturing to other file formats, the remaining values at each pixel are then interpolated in the camera – this process is described as *demosaicing*. However, all that is actually being captured at the sensor is a single intensity value, recording the amount of light that was falling on the pixel whether filtered or not. RAW files store only this single value in the pixel data, and the demosaicing is performed afterwards. The upshot of this is that for an RGB image, despite the fact that no compression is being applied, there will be fewer values per pixel stored at capture and therefore a RAW file will be significantly smaller than the equivalent TIFF.

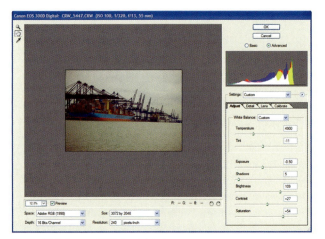

The RAW file is opened after downloading in RAW conversion software, which may be proprietary or a more generic plug-in such as the Camera RAW plug-in in Adobe Photoshop. At this point the image is demosaiced and displayed in a preview window (see Figure 11.2), where the user then applies the adjustments and processing that would have been applied automatically by the camera.

Figure 11.2 Camera RAW plug-in interface.

The great advantage of this is that it allows you to control the processing applied to the image post-capture. You have a choice over aspects such as colour space, white point, exposure and sharpening. It also allows alteration of tone, contrast and colour. The image is optimized by the user meaning that the numbers of decisions made at capture are reduced and mistakes can be corrected afterwards. You also view the image on a large screen, while processing, rather than making judgements from the viewing screen on the back of the camera.

It is clear that this offers photographers versatility and control over the image capture stage. The images, being uncompressed, may be archived in the RAW format, and can be opened and reprocessed at any time. After processing, the image is saved in another format, so the original RAW data remains unchanged, meaning that several different versions of the image with different processing may be saved, without affecting the archived data.

The downside of capturing in RAW is that it requires skill and knowledge to carry out the processing. Additionally, it is not yet standardized, each camera manufacturer having their own version of RAW optimized for their particular camera, with a different type of software to perform the image processing, which complicates things if you use more than one camera. Adobe has developed Camera RAW software, which provides a common interface for the majority of modern RAW formats (but not yet all). The problem is that it is a 'one size fits all' solution and therefore is not optimized for any of them. It makes the process simpler, but you may achieve better results using the manufacturer's dedicated software. Despite this, RAW capture is becoming part of the workflow of choice for many photographers.

Adobe digital negative

In addition to the Camera RAW plug-in, Adobe are also developing the Digital Negative (.dng) file format, which will be their own version of the RAW file format. Currently it can be used as a method of storing RAW data from cameras into a common RAW format. Eventually it is aimed that it will become a standard RAW format, but we are not at that stage yet, as most cameras do not yet output .dng files. A few of the high-end professional camera manufacturers do, however, such as Hasselblad, Leica and Ricoh.

Exposure: using the histogram

A correctly exposed image will have all the contained pixels within the limits of the histogram and will stretch across most of the extent of the histogram, as shown in Figure 11.3(a). An underexposed image will have its levels concentrated at the left-hand side of the histogram, indicating many dark pixels, and an overexposed image will be concentrated at the other end. If heavily under- or overexposed, the histogram will have a peak at the far end of it, indicating that either shadow or highlight details have been *clipped,* Figure 11.3(b) and (c). The narrowness of the spread of values across the histogram indicates a lack of contrast. If the histogram is narrow or concentrated at either end, then it indicates that the image should be re-shot to obtain a better exposure and histogram. It is particularly important not to clip highlights within a digital image.

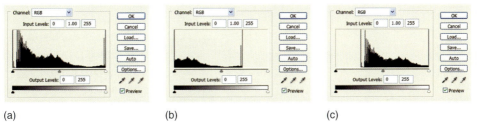

(a) (b) (c)

Figure 11.3 (a) Image histogram showing correct exposure, producing good contrast and a full tonal range. (b) Histogram indicating underexposure. (c) Histogram indicating overexposure.

Digital image files

The types of images used in digital photography are *raster images,* or *bitmaps,* where image data is stored as an array of discrete values (pixels). A digital image requires that values for position and colour of each pixel are stored, meaning that image files tend to be quite large compared to other types of data.

Any type of data within a computer, text or pixel values, is represented in *binary digits* of *information.* Binary is a numbering system, like the decimal system, where decimal numbers can take 10 discrete values from 0 to 9 and all other numbers are combinations of these; binary can only take 2 values, 0 or 1 and all other numbers are combinations of these.

An individual binary digit is known as a *bit.* 8 bits make up 1 byte, 1024 bytes equal 1 KB, 1024 KB equal 1 MB and so on. The file size of a digital image is equal to the total number of bits required to store the image. The way in which image data is stored is defined by the *file format.* The raw image data within a file format is a string of binary representing pixel values. The process of turning the pixel values into binary code is known as *encoding* and is performed when an image file is saved.

File size

The file size of the raw image data in terms of bits can be worked out using the following formula:

File size = (No. of pixels) × (No. of colour channels) × (No. of bits/colour channel)

This can then be converted into megabytes by dividing $8 \times 1024 \times 1024$.

Image file size is therefore dependent on two factors: resolution of the image (number of pixels) and *bit depth* of the image, i.e. the number of binary digits used to represent each pixel, which then defines how many levels of tone and colour can be represented. Increasing either will increase the file size.

Bit depth

The bit depth of image files varies, but currently two bit depths are commonly used to represent photographic quality, 8 bits and 16 bits. Why? Binary code must represent the range of pixel values in an image as a string of binary digits. Each pixel value must be encoded *uniquely*, i.e. the code must relate to one pixel value; no two pixel values should produce the same code, to prevent incorrect decoding when the file is opened. The number of codes and the number of tonal values possible with k binary digits are defined by 2^k. So the number of distinct colour values represented by 4 bits is $2^4 = 16$ and the number by 7 bits is $2^7 = 128$ (Figure 11.4).

Why 8 bits? It is based on the human visual system response. We are used to viewing photographic images and seeing a continuous range of tones and colours. This is because silver halide materials create changes in tone and colour by tiny silver halide particles or dye clouds, which are too small to be distinguished. The random particle layers add to the illusion, creating the

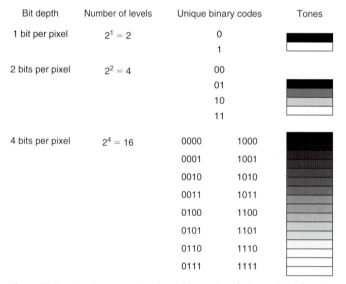

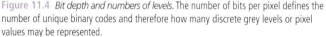

Bit depth	Number of levels	Unique binary codes		Tones
1 bit per pixel	$2^1 = 2$	0		
		1		
2 bits per pixel	$2^2 = 4$	00		
		01		
		10		
		11		
4 bits per pixel	$2^4 = 16$	0000	1000	
		0001	1001	
		0010	1010	
		0011	1011	
		0100	1100	
		0101	1101	
		0110	1110	
		0111	1111	

Figure 11.4 *Bit depth and numbers of levels.* The number of bits per pixel defines the number of unique binary codes and therefore how many discrete grey levels or pixel values may be represented.

appearance of continuous tone. In digital images the image is made up of discrete non-overlapping pixels which can only take certain values. To give the impression of continuous tone, the pixels have to be small enough not to be distinguished when viewed at a normal viewing distance with enough discrete steps in the range of values to fool the eye into seeing smooth changes in tone or colour.

Our ability to discriminate between individual tones and colours is complicated, because it is affected by factors such as ambient lighting level, but under normal daylight conditions the human visual system needs the tonal range from shadow to highlight to be divided into between 120 and 190 different levels to see continuous tone. Fewer than this and the image will appear *posterized*,

an image artefact that is a result of insufficient sampling of the tonal range, resulting in large jumps between pixel values. This is particularly problematic in areas containing smoothly changing tone where this quantization artefact appears as contour lines (see Figure 11.16). 8 bits will produce 256 discrete levels, which prevents this and leaves a few bits extra. For an RGB image, 8 bits per channel gives a total of 24 bits per pixel and produces over 16 million different colours.

8 Bit versus 16 bit workflow

Often, image-capture devices will capture more than 8 bits. It is the process of quantization by the analogue-to-digital converter that allocates the tonal range to 8 bits or 16 bits. The move towards 16 bit imaging is possible as a result of better storage and processing in computers – working with 16 bits per channel doubles the file size. 8 bits is adequate to represent smoothly changing tone, but as the image is processed through the imaging chain, particularly tone and colour correction, pixel values are reallocated which may result in some pixel values missing completely, causing posterization. Starting with 16 bits produces a more finely sampled tonal range helping to avoid this problem. Figure 11.5 illustrates the difference between an 8 bit and a 16 bit image after some image processing. Their histograms show this particularly well: the 8 bit histogram clearly appears jagged, as if beginning to break down, while the 16 bit histogram remains smooth.

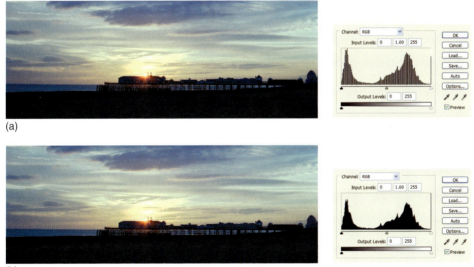

(a)

(b)

Figure 11.5 (a) Processing operations such as levels adjustments can result in the image histogram of an 8 bit image having a jagged appearance and missing tonal levels (posterization). (b) 16 bit images have more tones available, therefore the resulting histogram is smoother and more complete, indicating fewer image artefacts.

Using a 16 bit workflow can present an opportunity to improve and maintain image quality, but may not be available throughout the imaging chain. Certain operations, particularly filtering, are not available for anything but 8 bit images. Additionally, 16 bit images are not supported by all file formats.

Image modes

Digital image data consists of sets of numbers representing pixel values. The image mode provides a global description of what the pixel values represent and the range of values that they

can take. The mode is based on a colour model, which defines colours numerically. Some of the modes are only available in image processing software, whereas others, such as RGB, can be used throughout the imaging chain. The common image modes are as follows:

- *RGB* – Three colour channels representing red, green and blue values. Each channel contains 8 or 16 bits per pixel.
- *CMYK* – Four channel mode. Values represent cyan, magenta, yellow or black, again 8 or 16 bits per pixel per channel.
- *LAB* – Three channels, L representing tonal (luminance) information and A and B colour (chrominance) information. LAB is actually the CIELAB standard colour space (see page 79, Chapter 4).
- *HSL* (*and variations*) – These three-channel models produce colours by separating hue from saturation and lightness. These are the types of attributes we often use to describe colours verbally and so can be more intuitive to understand and visualize colours represented in red, green and blue. However they are very non-standardized and do not relate to the way any digital devices produce colour, so tend not to be widely used in photography.
- *Greyscale* – This is a single-channel mode, where pixel values represent neutral tones, again with a bit depth of 8 or 16 bits per pixel.
- *Indexed* – These are also called *paletted* images, and contain a much reduced range of colours to save on storage space and are therefore only used for images on the web, or saturated graphics containing few colours. The palette is simply a look-up table (LUT) with a limited number of entries (usually 256); at each position in the table three values are saved representing RGB values. At each pixel, rather than saving three values, a single value is stored, which provides an *index* into the table, and outputs the three RGB values at that index position to produce the particular colour. Converting from RGB to indexed mode can be performed in image processing software, or by saving in the graphics interchange format (GIF) file format.

Layers and alpha channels

Layers are used in image processing applications to make image adjustments easier to fine tune and to allow the compositing of elements from different images in digital montage. Layers can be thought of as 'acetates' overlying each other, on top of the image, each representing different operations or parts of the image. Layers can be an important part of the editing process, but vastly increase file size, and therefore are not usually saved after the image has been edited to its final state for output – the layers are merged down. If the image is in an unfinished state, then file format must be carefully selected to ensure that layers will be preserved.

Alpha channels are an extra greyscale channel within the image. They are designed for *compositing* and can perform a similar function to layers, but are stored separately and can be saved and even imported into other applications, so are much more permanent and versatile. They can be used in various different ways, for example to store a selection which can then be edited later. They can also be used as masks when combining images, the value at each pixel position defining how much of the pixel in the masked image is blended or retained. They are sometimes viewed as transparencies, with the value representing how transparent or opaque a particular pixel is. Like layers, alpha channels increase file size, but are generally a more permanent part of the image. Again support depends on the file format selected, although more formats support alpha channels than layers.

Choosing file format

There are many different formats available for the storage of images. As previously discussed, the development of file format standards allows use across multiple platforms to allow interoperability between systems. Many standards are free for software

developers and manufacturers to use, or may be used under licence. Importantly, the code on which they are based is standardized, meaning that a JPEG file from one camera is similar or identical in structure to a JPEG file from another and will be decoded in the same way.

There are other considerations when selecting file format. The format may determine, for example, maximum bit depth of the image, whether *lossless* or *lossy* compression has been applied, whether layers are retained separately or flattened, whether alpha channels are supported and a multitude of other information that may be important for the next stage. These factors will affect the final image quality; whether the image is identical to the original or additional image artefacts have been introduced, whether it is in an intermediate editing state or in its final form and of course, the image file size. Whichever format is selected, will contain more than just the image data and therefore file sizes vary significantly from the file size calculated from the raw data, depending on the way that the data is 'packaged', whether the file is compressed or not and also the content of the original scene (Figure 11.6).

Image details		
2120 × 3336 pixels RGB, 8 bits per channel	Raw data, uncompressed	20.2 MB
File format	*Compression/details*	*File size*
EPS (encapsulated postscript)	Uncompressed	34.2 MB
TIFF (tagged image file format)		20.2 MB
TIFF	LZW compression	14.7 MB
PSD (photoshop)	Layers merged	20.2 MB
BMP (bitmap)		20.2 MB
PDF (portable document format)	Uncompressed	12.8 MB
PNG (portable network graphics)	LZW compression	11.0 MB
GIF (graphics interchange format)	Indexed, 256 colours	3.71 MB
JPEG (joint photographic experts group)	Quality setting 12 (high)	7.5 MB
JPEG	Quality setting 6 (medium)	413 KB
JPEG	Quality setting 3 (low)	216 KB

Figure 11.6 File sizes using different formats. The table shows file sizes for the same image saved as different file formats.

Image compression

The large size of image files has led to the development of a range of methods for compressing images, and this has important implications in terms of workflow. There are two main classes of compression; the first is *lossless compression*, an example being the LZW compression option incorporated in TIFF, which organizes image data more efficiently without removing any information, therefore allowing perfect reconstruction of the image. *Lossy compression*, such as that used in the JPEG compression algorithm, discards information which is less important visually, achieving much greater compression rates with some compromise to the quality of the reconstructed image. There is a trade-off between resulting file size and image quality in selecting a compression method. The method used is usually determined by the image file format. Selecting a compression method and file format therefore depends upon the purpose of the image at that stage in the imaging chain.

Lossless compression

Lossless compression is used wherever it is important that the image quality is maintained at a maximum. The degree of compression will be limited, as lossless methods tend not to achieve compression ratios of much above 2:1 (that is, the compressed file size is half that of the original) and the amount of compression will also depend upon image content. Generally, the more fine detail that there is in an image, the lower the amount of lossless compression that will be possible (Figure 11.7). Images containing different scene content will compress to different file sizes.

If it is known that the image is to be output to print, then it is usually best saved as a lossless file. The only exception to this is some images for newspapers, where image quality is sacrificed

INITIAL FILE SIZE (UNCOMPRESSED) 17.2 MB
ALL FILES WERE COMPRESSED LOSSLESSLY USING TIFF WITH LZW COMPRESSION

(a) Compressed file = 8.7 MB

(b) Compressed file = 12.3 MB

(c) Compressed file = 6.9 MB

(d) Compressed file = 7.7 MB

(e) Compressed file = 8.1 MB

(f) Compressed file = 10.1 MB

Figure 11.7 Compressed file size and image content. The contents of the image will affect the amount of compression that can be achieved with both lossless and lossy compression methods.

for speed and convenience of output. As a rule, if an image is being edited, then it should be saved in a lossless format (as it is in an intermediate stage). Some lossless compression methods can actually expand file size, depending upon the image; therefore if image integrity is paramount and other factors such as the necessity to include active layers with the file are to be considered, it is often easier to use a lossless file format with no compression applied. Because of this, the formats commonly used at the editing stage will either incorporate a lossless option or no compression at all. File formats which do include lossless compression as an option include: TIFF, PNG (portable network graphics) and a lossless version of JPEG 2000.

If an image is to be archived, then it is vital that image quality is maintained and TIFF or RAW files will usually be used. In this case, compression is not usually a key consideration. Image archiving is dealt with in Chapter 14.

Lossy compression

There are certain situations, however, where it is possible to get away with some loss of quality to achieve greater compression, which is why the JPEG format is almost always available as an option in digital cameras. Lossy compression methods work on the principle that some of the information in an image is less visually important, or even beyond the limits of the human visual system and use clever techniques to remove this information, still allowing reasonable reconstruction of the images. These methods are sometimes known as *perceptually lossless*, which means that up to a certain point, the reconstructed image will be virtually indistinguishable from the original, because the differences are so subtle (Figure 11.8).

(a) (b)

Figure 11.8 Perceptually lossless compression: (a) original uncompressed image and (b) image compressed to a compression ratio of 10:1.

(a)

(b)

(c)

(d)

Figure 11.9 Loss in image quality compared to file size. When compressed using a lossy method such as JPEG, the image begins to show distortions which are visible when the image is examined close-up. The loss in quality increases as file size decreases. (a) Original image, 3.9 MB, (b) JPEG Q6, 187 KB, (c) JPEG Q3, 119 KB and (d) JPEG Q0, 63.3 KB.

The most commonly used lossy image compression method, JPEG, allows the user to select a quality setting based on the visual quality of the image. Compression ratios of up to 100:1 are possible, with a loss in image quality which increases with decreasing file size (Figure 11.9).

More recently, JPEG 2000 has been developed, the lossy version of which allows higher compression ratios than those achieved by JPEG, again with the introduction of errors into the image and a loss in image quality. JPEG 2000 seems to present a slight improvement in image quality, but more importantly is more flexible and versatile than JPEG. JPEG 2000 has yet to be widely adopted, but is likely to become more popular over the next few years as the demands of modern digital imaging evolve.

Compression artefacts and workflow considerations

Lossy compression introduces error into the image. Each lossy method has its own characteristic artefacts. How bothersome these artefacts are is very dependent on the scene itself, as certain types of scene content will mask or accentuate particular artefacts. The only way to avoid compression artefacts is not to compress so heavily.

JPEG divides the image up into 64 × 64 pixel blocks before compressing each one separately. On decompression, in heavily compressed images, this can lead to a *blocking* artefact, which is the result of the edges of the blocks not matching exactly as a result of information being discarded from each block. This artefact is particularly visible in areas of smoothly changing tone. The other artefact common in JPEG images is a *ringing* artefact, which tends to show up

around high-contrast edges as a slight 'ripple'. This is similar in appearance to the *halo* artefact that appears as a result of oversharpening and therefore does not always detract from the quality of the image in the same way as the blocking artefact.

One of the methods by which both JPEG and JPEG 2000 achieve compression is by separating colour from tonal information. Because the human visual system is more tolerant to distortion in colours than tone, the colour channels are then compressed more heavily than the luminance channel. This means however that both formats can suffer from colour artefacts, which are often visible in neutral areas in the image.

Because JPEG 2000 does not divide the image into blocks before compression, it does not produce the blocking artefact of JPEG, although it still suffers to some extent from ringing, but the lossy version produces its own 'smudging' artefacts (Figure 11.10).

(a)

(b)

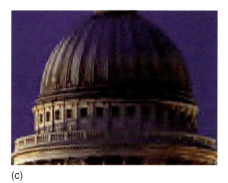
(c)

Figure 11.10 (a) Uncompressed image. Lossy compression artefacts produced by (b) JPEG and (c) JPEG 2000.

Because of these artefacts, lossy compression methods should be used with caution. In particular, it is important to remember that every time an image is opened, edited and resaved using a lossy format, further errors are incurred. Lossy methods are useful for images where file size is more important than quality, such as for images to be displayed on web pages or sent by email. The lower resolution of displayed images compared to printed images means that there is more tolerance for error.

Properties of common image file formats

TIFF (tagged image file format)

TIFF is the most commonly used lossless standard for imaging and one of the earliest image file formats to be developed and standardized. Until a few years ago, TIFF was the format of choice for images used for high-quality and professional output and of course for image archiving, either by photographers or by picture libraries. TIFF is also used in applications in medical imaging and forensics, where image integrity must be maintained. TIFF files are usually larger than the raw data itself unless some form of compression has been applied. A point to note is that in the later versions of Photoshop, TIFF files allow an option to compress using JPEG. If this option is selected the file will no longer be lossless. TIFF files support 16 bit colour images and in Photoshop also allow layers to be saved without being flattened down, making it a reasonable option as an editing format (although other formats are more suitable). The common colour modes are all supported, some of which can include alpha channels. The downside is the large file size and TIFF is not offered as an option in many digital cameras as a result of this, especially since capture using RAW files has now begun to dominate.

PSD (photoshop document)

PSD is Photoshop's proprietary format and is the default option when editing images in Photoshop. It is lossless, and allows saving of multiple layers. Each layer contains the same amount of data as the original image; therefore saving a layer doubles the file size from the original. For this reason, file sizes can become very large and this makes it an unsuitable format for permanent storage. It is therefore better used as an intermediate format, with one of the other formats being used once the image is finished and ready for output.

EPS (encapsulated postscript)

This is a standard format which can contain text, vector graphics and bitmap (raster) images. Vector graphics are used in illustration and desktop publishing packages. EPS is used to transfer images and illustrations in postscript language between applications, for example images embedded in page layouts which can be opened in Photoshop. EPS is lossless and provides support for multiple colour spaces, but not alpha channels. The inclusion of all the extra information required to support both types of graphics means that file sizes can be very large.

PDF (portable document format)

PDF files, like EPS, provide support for vector and bitmap graphics and allow page layouts to be transferred between applications and across platforms. PDF also preserves fonts and supports 16 bit images. Again, the extra information results in large file sizes.

GIF (graphics interchange format)

GIF images are indexed, resulting in a huge reduction in file size from a standard 24 bit RGB image. GIF was developed and patented as a format for images to be displayed on the Internet, where there is tolerance for the reduction in colours and associated loss in quality to improve file size and transmission. GIF is therefore only really suitable for this purpose.

PNG (portable network graphics)

PNG was developed as a patent-free alternative to GIF for the lossless compression of images on the Web. It supports full 8 and 16 bit RGB images and greyscale as well as indexed images. As a lossless format, compression rates are limited and PNG images are not recognized by all imaging applications.

JPEG (joint photographic experts group)

JPEG is the most commonly used lossy standard. It supports 8 bit RGB, CMYK and greyscale images. When saving from a program such as Photoshop, the user sets the quality setting on a scale of 1–10 or 12 to control file size. In digital cameras there is less control, so the user will normally only be able to select low-, medium-, or high-quality settings. JPEG files can be anything from 1/10 to 1/100 of the size of the uncompressed file, meaning that a much larger number of images can be stored on a camera memory card. However the large loss in quality makes it an unsuitable format for high-quality output.

JPEG 2000

JPEG 2000 is a more recent standard, also developed by the JPEG committee, with the aim of being more flexible. It allows for 8 bit and 16 bit colour and greyscale images, supports RGB, CMYK, greyscale and LAB colour spaces and also preserves alpha channels. It allows both lossless and lossy compression, the lossless mode meaning that it will be suitable as an archiving format. The lossy version uses different compression methods from JPEG and aims to provide a slight improvement in quality for the same amount of compression. JPEG 2000 images have begun to be supported by some digital SLRs and there are plug-ins for most of the relevant image processing applications, however JPEG 2000 images can only be viewed on the Web if the browser has the relevant plug-in.

Image processing

There are a huge range of processes that may be applied to a digital image to optimize, enhance or manipulate the results. Equally, there are many types of software to achieve this, from relatively simple easy-to-use applications bundled with devices for the consumer, to high-end professional applications such as Adobe Photoshop. It is beyond the scope of this book to cover the full range of image processing, or to delve into the complexities of the applications. The Adobe Photoshop workspace and various tools are dealt with in more detail in *Langford's Basic Photography*. There are however a number of processes that are common to most image processing software packages and will be used time and again in adjusting images; it is useful to understand these, in particular the more professional tools. The following sections concentrate on these key processes and how they fit into an image processing workflow.

Image processing techniques are fundamentally numerical manipulations of the image data and many operations are relatively simple. There are often multiple methods to achieve the same effect. Image processing is applied in some form at all stages in the imaging chain (Figure 11.11).

The operations may be applied automatically at a device level, for example by the firmware in a digital camera, with no control by the user; they may also be applied as a result of scanner, camera or printer software responding to user settings; and some functions are applied 'behind

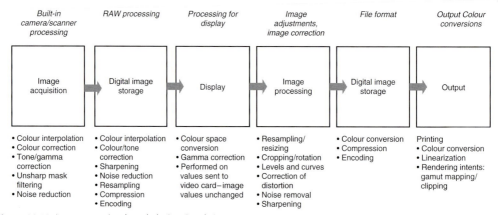

Built-in camera/scanner processing	RAW processing	Processing for display	Image adjustments, image correction	File format	Output Colour conversions
Image acquisition	Digital image storage	Display	Image processing	Digital image storage	Output
• Colour interpolation • Colour correction • Tone/gamma correction • Unsharp mask filtering • Noise reduction	• Colour interpolation • Colour/tone correction • Sharpening • Noise reduction • Resampling • Compression • Encoding	• Colour space conversion • Gamma correction • Performed on values sent to video card – image values unchanged	• Resampling/ resizing • Cropping/rotation • Levels and curves • Correction of distortion • Noise removal • Sharpening	• Colour conversion • Compression • Encoding	Printing • Colour conversion • Linearization • Rendering intents: gamut mapping/ clipping

Figure 11.11 Image processing through the imaging chain.

the scenes', such as the gamma correction function applied to image values by the video graphics card in a computer monitor to ensure that image tones are displayed correctly. The highest level of user control is achieved in a dedicated application such as Adobe Photoshop or Image J.

Because the image is being processed throughout the image chain, image values may be repeatedly changed, redistributed, rounded up or down and it is easy for image artefacts to appear as a result of this. Indeed, some image processing operations are applied automatically to correct for the artefacts introduced by other operations, for example image sharpening in the camera, which is applied to counteract the softening of the image caused by noise removal algorithms and interpolation. When the aim is to produce professional quality photographic images, the approach to image editing has to be 'less is more', avoiding overapplication of any method, applying by trial and error, using layers and history to allow correction of mistakes, with care taken in the order of application and an understanding of why a particular process is being carried out.

Using layers

Making image adjustments using layers is an option in the more recent versions of applications such as Photoshop and allows image processing operations to be applied and the results seen, without being finalized. A background layer contains the unchanged image information, and instead of changing this original information, for example, a tonal adjustment can be applied to all or part of the image in an *adjustment layer*. While the layer is on top of the background and switched 'on' the adjustment can be seen on the image. If an adjustment is no longer required, the layer can be discarded. Selections can also be made from the image and copied into layers, meaning that adjustments may be performed to just that part of the image, or that copied part can be imported into another image. Layers can be grouped, their order can be changed to produce different effects, their opacity changed to alter the degree by which they affect the image and they can be blended into each other using a huge range of blending modes. Layers can also be made partially transparent, using gradients, meaning that in some areas the lower layers or the original image state will show through. Working with layers allows image editing to become an extremely fluid process, with the opportunity to go back easily and correct, change

or cancel operations already performed. When the editing process is finished, the layers are flattened down and the effects are then permanent.

Image adjustment and restoration techniques

Image adjustments are a basic set of operations applied to images post-capture to optimize quality and image characteristics, possibly for a specific output. These operations can also be applied in the capture device (if scanning) after previewing the image, or in RAW processing and Lightroom software. Image adjustments include cropping, rotation, resizing, tone and colour adjustments. Note that image resizing may be applied without resampling to display image dimensions at a particular output resolution – this does not change the number of pixels in the image and does not count as an image adjustment.

Image correction or restoration techniques correct for problems at capture. These can be globally applied or may be more local adjustments, i.e. applied only to certain selected pixels, or applied to different pixels by different amounts. Image corrections include correction of geometric distortion, sharpening, noise removal, localized colour and tonal correction and restoration of damaged image areas. It is not possible to cover all the detailed methods available in all the different software applications to implement these operations; however some general principles are covered in the next few sections, along with the effects of overapplication.

Image processing workflow

The details of how adjustments are achieved vary between applications, but they have the same purpose, therefore a basic workflow can be defined. You may find alternative workflows work better for you, depending upon the tools that you use; what is important is that you think about why you are performing a particular operation at a particular stage and what the implications are of doing things in that order. It will probably require a good degree of trial and error. A typical workflow might be as follows:

1. *Image opened, colour profile identified/assigned*: In a colour profiled workflow, the profile associated with the image will be applied when the image is opened (see later section on ICC colour management). This ensures that the image colours are accurately displayed on screen.
2. *Image resized*: This is the first of a number of *resampling* operations. If the image is to be resized down, then it makes sense to perform it early in the workflow, to reduce the amount of time that other processes may take.
3. *Cropping, rotation, correction of distortion*: These are all spatial operations also involving resampling and interpolation and should be performed early in the workflow allowing you to frame the image and decide which parts of the image content are important or less relevant.
4. *Setting colour temperature*: This applies to Camera RAW and Lightroom, as both are applications dealing with captured images, and involves an adjustment of the white point of the image, to achieve correct neutrals. This should be performed before other tone or colour correction, as it will alter the overall colour balance of the image.
5. *Global tone correction*: This should be applied as early as possible, as it will balance the overall brightness and contrast of the image and may alter the colour balance of the image. There are a range of exposure, contrast and brightness tools available in applications such as Photoshop, Lightroom and Camera RAW. The professional tools, allowing the highest level of user control, especially over *clipping* of highlights or shadows, are based upon *levels* or *curves* adjustments, which are covered later in this chapter.

6. *Global colour correction*: After tone correction, colours may be corrected in a number of ways. Global corrections are usually applied to remove colour casts from the image. If across the whole range from shadows to highlights, then this is easier, changing a single or several colour channels; and the simpler tools, such as 'photo filter' in Photoshop, will be successful. More commonly there will be just part of the brightness range, such as the highlights that will need correcting, in which case altering the curves across the three channels affords more control. There are other simple tools such as colour balance in Photoshop, and the saturation tool. Care should be taken with these, as they can produce rather crude results and may result in an increase in colours that are out-of-gamut (i.e. they are outside the colour gamuts of some or all of the output devices and therefore cannot be reproduced accurately).

7. *Noise removal*: There are a range of filters created specifically for removal of various types of noise. Applying them globally may remove unwanted dust and scratches, but care should be taken as they often result in softening of edges. Because of this, it is often better to apply them in Photoshop if possible, as you have a greater range of filters at your disposal and you can use layers to fine-tune the result.

8. *Localized image restoration*: These are the corrections to areas that the noise removal filters did not work on. They usually involve careful use of some of the specially designed restoration tools in Photoshop, such as the healing brush or the patch tool. In other packages this may involve using some form of paint tool.

9. *Local tone and colour corrections*: These are better carried out after correction for dust and scratches. They involve the selection of specific areas of the image, followed by correction as before.

10. *Sharpening*: This is also a filtering process. Again, there are a larger range of sharpening tools available in Photoshop and a greater degree of control afforded using layers.

Image resizing, cropping, rotation and correction of distortion

These are *resampling* operations that involve the movement or deletion of pixels or the introduction of new pixels. They also involve interpolation, which is the calculation of new pixel values based on the values of their neighbours. Cropping alone involves dropping pixels without interpolation, but is often combined with resizing or rotation. Depending upon where in the imaging chain these operations are performed, the interpolation method may be predefined and optimized for a particular device, or may be something that the user selects. The main methods are as follows:

- *Nearest neighbour* interpolation is the simplest method, in which the new pixel value is allocated based on the value of the pixel closest to it.
- *Bilinear interpolation* involves the calculation of the new pixel value by taking an average of its four closest neighbours and therefore produces significantly better results than nearest neighbour sampling.
- *Bicubic interpolation* involves a complicated calculation involving 16 of the pixel's neighbouring values. The slowest method also produces the best results with fewer visible artefacts and therefore is the best technique for maintaining image quality.

Interpolation artefacts and workflow considerations

In terms of workflow, these operations are usually the first to be applied to the image, as it makes sense to decide on image size and content before applying colour or tonal corrections to pixels that might not exist after resampling has been applied. Because interpolation involves the calculation of missing pixel values it inevitably introduces a loss in quality.

Nearest neighbour interpolation is a rather crude method of allocating pixel values and produces an effective magnification of pixels as well as a jagged effect on diagonals (see Figure 11.12(b)) – this is actually an *aliasing* artefact – see Chapter 6 – as a result of the edge being

undersampled. Both are so severe visually that it is hard to see when the method would be selected as an option, especially when the other methods produce much more pleasing results.

Bilinear and bicubic interpolation methods, however, involve a process of averaging surrounding values. Averaging processes produce another type of artefact, the blurring of edges and fine detail (see Figure 11.12(c) and (d)). This again is more severe the more that the interpolation is applied. Because bicubic interpolation uses more values in the calculation of the average, the smoothing effect is not as pronounced as it is with bilinear.

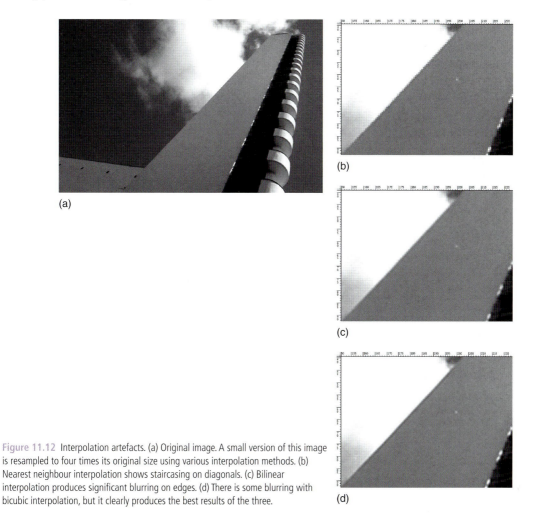

(a)

(b)

(c)

Figure 11.12 Interpolation artefacts. (a) Original image. A small version of this image is resampled to four times its original size using various interpolation methods. (b) Nearest neighbour interpolation shows staircasing on diagonals. (c) Bilinear interpolation produces significant blurring on edges. (d) There is some blurring with bicubic interpolation, but it clearly produces the best results of the three.

(d)

Repeated application of any of these operations simply compounds the loss in image quality, as interpolated values are calculated from interpolated values, becoming less and less accurate. For this reason, these operations are best applied in one go wherever possible. Therefore, if an image requires rotation by an arbitrary amount, find the exact amount by trial and error and then apply it in one application rather than repeating small amounts of rotation incrementally. Equally, if an image requires both cropping and perspective correction, perform both in a combined single operation to maintain maximum image quality.

Tone and colour corrections

These are methods for redistributing values across the tonal range in one or more channels to improve the apparent brightness or contrast of the image, to bring out detail in the shadows or the highlights or to correct a colour cast. These corrections are applied extensively throughout the imaging chain, to correct for the effects of the tone or gamut limitations of devices, or for creative effect, to change the mood or lighting in the image.

Figure 11.13 Auto brightness control applied to the image.

Brightness and contrast controls

The simplest methods of tonal correction are the basic brightness and contrast settings found in most image processing interfaces, which involve the movement of a slider or a number input by the user (Figure 11.13). These are not really professional tools, and are often simple additions or subtractions of the same amount to all pixel values, or multiplication or division by the same amount and

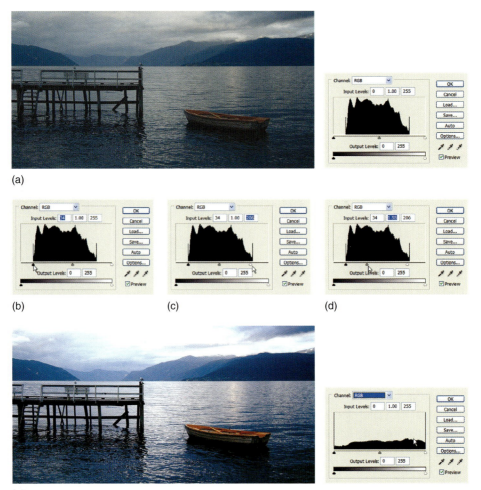

(a)

(b) (c) (d)

(e)

Figure 11.14 Levels adjustment to improve tone and contrast: (a) original image and its histogram, (b) shadow control levels adjustment, (c) highlight control levels adjustment, (d) mid-tone adjustment and (e) final image and histogram.

mean that there is relatively limited control over the process. With even less control are the 'auto' brightness and contrast tools which are simply applied to the image and allow the user no control whatsoever, often resulting in posterization as a result of lost pixel values.

Adjustments using levels

Levels adjustments use the image histogram and allow the user interactive control over the distribution of tones in shadows, midtones and highlights. A simple technique for improving the tonal range is illustrated in Figure 11.14, where the histogram of a low-contrast image is improved by (1) sliding the shadow control to the edge of the left-hand side of the range of tonal values, (2) sliding the highlight slider to the right-hand side of the range and (3) sliding the mid-tone slider to adjust overall image brightness.

The same process can be applied separately to the channels in a colour image. Altering the shadow and highlight controls of all three channels will improve the overall image contrast. Altering the mid-tone sliders by different amounts will alter the overall colour balance of the image.

Curves

These are manipulations of the tonal range using the *transfer curve* of the image, which is a simple mapping function allowing very precise control over specific parts of the tonal range. The curve shows output (vertical axis) plotted against input (horizontal axis). Shadows are usually at the bottom left and highlights at the top right. Before any editing it is displayed as a straight line at 45° (Figure 11.15(a)). As with levels it is possible to display the combined curve, in this case RGB, or the curves of individual colour channels.

The curve can be manipulated by selecting an area and moving it. If the curve is at an angle steeper than 45°, and if this is applied globally to the full range of the curve as shown in Figure 11.15(b), then the contrast of the output image will be higher than that of the input. If the curve is not as steep as 45° then contrast will be lowered.

Multiple points can be selected to 'peg down' areas of the curve allowing

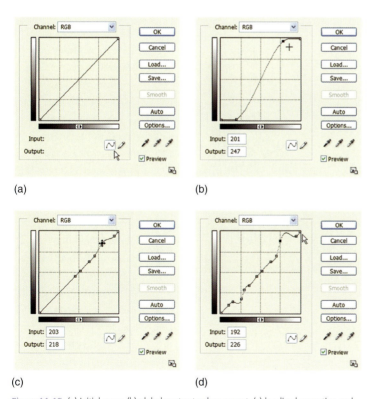

(a)　　(b)　　(c)　　(d)

Figure 11.15 (a) Initial curve, (b) global contrast enhancement, (c) localized correction and (d) overcorrection as a result of too many selection points.

the effect to be localized to a specific range of values. The more points that are added around a point in question, the more localized the control will be. Again, a steeper curve will indicate an

increase in contrast and shallower a decrease (Figure 11.15(c) and (d). Using a larger number of selected points allows a high degree of local control, however it is important to keep on checking the effect on the image, as too many 'wiggles' are not necessarily a good thing: in the top part of the curve in Figure 11.15(d), the distinctive bump actually indicates a reversal of tones.

Using curves to correct a colour cast

This is where having an understanding of basic colour theory is useful. Because the image is made up of only three (or four) colour channels, then most colour casts can be corrected by using one of these. Look at the image and identify what the main hue of the colour cast is. From this, you can work out which colour channel to correct. Both the primary and its complementary colour will be corrected by the same colour channel:

Colour cast	Correction channel
Red or Cyan	Red
Green or Magenta	Green
Blue or Yellow	Blue

(a)

(b)

(c)

Figure 11.16 (a) Original image. Posterized image (b) and its histogram (c).

Artefacts as a result of tone or colour corrections

As with all image processes, overzealous application of any of these methods can result in certain unwanted effects in the image. Obvious casts may be introduced as a result of overcorrecting one colour channel compared to the others. Overexpansion of the tonal range in any part can result in missing values and a posterized image (see Figure 11.16). Lost levels cannot be retrieved without undoing the operation, therefore should be avoided by applying corrections in a more moderate way and by using 16 bit images wherever possible.

Another possible effect is the clipping of values at either end of the range, which will result in loss of shadow detail and burning out of highlights and will show as a peak at either end of the histogram.

Filtering operations

Both noise removal and image sharpening are generally applied using filtering. Spatial filtering techniques are *neighbourhood* operations, where the output pixel value is defined as some combination or selection from the neighbourhood of values around the input value. The methods discussed here are limited to the filters used for correcting images, not the large range of special effects creative filters in the filter menu of image editing software such as Adobe Photoshop.

The filter (or mask) is simply a range of values which are placed over the neighbourhood around the input pixel. In *linear* filtering the values in the mask are multiplied by the values in the image at neighbourhood at the same point and the result is added together and sometimes averaged. Blurring and sharpening filters are generally of this type. *Non-linear* filters simply use the mask to select the neighbourhood. Instead of multiplying the neighbourhood with mask values, the selected pixels are sorted and a value from the neighbourhood output, depending on the operation being applied. The *median filter* is an example, where the median value is output, eliminating very high or low values in the neighbourhood, making it very successful for noise removal.

Noise removal

There are a range of both linear and non-linear filters available for removing different types of noise and specially adapted versions of these may also be built-in to the software of capture devices. Functions such as digital ICE™ for suppression of dust and scratches in some scanner software are based on adaptive filtering methods. The linear versions of noise removal filters tend to be blurring filters, and result in edges being softened; therefore care must be taken when applying them (Figure 11.17). Non-linear filters such as the median filter, or the 'dust and

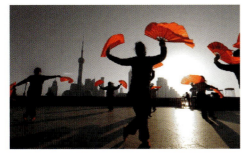

(a)

(b)

(c)

Figure 11.17 Filtering artefacts: (a) Original image (b) Noise removal filters can cause blurring and posterization, and oversharpening can cause a halo effect at the edges. This is clearly shown in (c) which illustrates a magnified section of the sharpened image.

speckles' filter in Photoshop are better at preserving edges, but can result in posterization if applied too heavily.

Sharpening

Sharpening tends to be applied using linear filters. Sharpening filters emphasize edges, but may also emphasize noise, which is why sharpening is better performed after noise removal. The *unsharp mask* is a filter based upon a method used in the darkroom in traditional photographic imaging, where a blurred version of the image is subtracted from a boosted version of the original, producing enhanced edges. This can be successful, but again care must be taken not to oversharpen. As well as boosting noise, oversharpening produces a characteristic 'overshoot' at edges, similar to *adjacency* effects, known as a *halo* artefact (Figure 11.17 (c)). For this reason sharpening is better performed using layers, where the effect can be carefully controlled.

Digital colour

Although some early colour systems used *additive* mixes of red, green and blue, colour in film-based photography is predominantly produced using *subtractive* mixes of cyan, magenta and yellow (Chapter 4). Both systems are based on *trichromatic matching*, i.e. colours are created by a combination of different amounts of three pure colour *primaries*.

Digital input devices and computer displays operate using additive RGB colour. At the print stage, cyan, magenta and yellow dyes are used, usually with black (the *key*) added to account for deficiencies in the dyes and improve the tonal range. In modern printers, more than three colours may be used (six or even eight ink printers are now available and the very latest models by Canon and Hewlett Packard use 10 or 12 inks to increase the colour gamut), although they are still based on a CMY(K) system (see Chapter 10).

An individual pixel will therefore usually be defined by three (or four, in the case of CMYK) numbers defining the amount of each primary. These numbers are coordinates in a *colour space*. A colour space provides a three-dimensional (usually) model into which all possible colours may be mapped (see Figure 11.18). Colour spaces allow us to visualize colours and their relationship to each other spatially (see Chapter 4). RGB and CMYK are two broad classes of colour space, but there are a range of others, as already encountered, some of which are much more specific and defined than others (see next section). The colour space defines the axes of the coordinate system, and within this, colour gamuts of devices and materials may then be mapped; these are the limits to the range of colours capable of being reproduced.

The reproduction of colour in digital imaging is therefore more complex than that in traditional silver halide imaging, because both additive and subtractive systems are used at different stages in the imaging chain. Each device or material in the imaging chain will have a different set of primaries. This is one of the major sources of variability in colour reproduction. Additionally, colour appearance is influenced by how devices are set up and by the viewing conditions. All these factors must be taken into account to ensure satisfactory colour. As an image moves through the digital imaging chain, it is transformed between colour spaces and between devices with gamuts of different sizes and shapes: this is the main problem with colour in digital imaging. The process of ensuring that colours are matched to achieve adequately accurate colour and tone reproduction requires *colour management*.

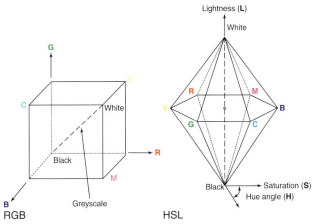

RGB HSL

Figure 11.18 RGB and HSL: colour spaces are multi-dimensional coordinate systems in which colours may be mapped R (red), G (green), B (blue), M (magenta), C (cyan) and Y (yellow).

Colour spaces

Colour spaces may be divided broadly into two categories: *device-dependent* and *device-independent* spaces. Device-dependent spaces are native to input or output devices. Colours specified in a device-dependent space are specific to that device, they are not absolute. Device-independent colour spaces specify colour in absolute terms. A pixel specified in a device-independent colour space should appear the same, regardless of the device on which it is reproduced.

Device-dependent spaces are defined predominantly by the primaries of a particular device, but also by the characteristics of the device, based upon how it has been *calibrated*. This means, for example, that a pixel with RGB values of 100, 25 and 255, when displayed on two monitors from different manufacturers, will probably be displayed as two different colours, because in general the RGB primaries of the two devices will be different. Additionally, as seen in Chapter 4, the colours in output images are also affected by the viewing conditions. Even two devices of the same model from the same manufacturer will produce two different colours if set up differently (see Figure 11.19). RGB and CMYK are generally device dependent, although they can be standardized to become device independent under certain conditions (sRGB is an example).

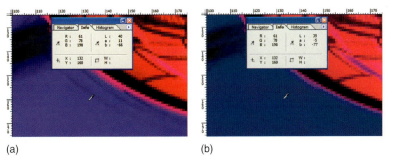

(a) (b)

Figure 11.19 Pixel values, when specified in device-dependent colour spaces will appear as different colours on different devices.

Device-independent colour spaces are derived from CIEXYZ colourimetry, i.e. they are based on the response of the human visual system. CIELAB and CIELUV are examples. sRGB is actually a *device calibrated* colour space, specified for images displayed on a cathode-ray tube (CRT) monitor, if the monitor and viewing environment are correctly set up, then the colours will be absolute and it acts as a device-independent colour space.

A number of common colour spaces separate colour information from tonal information, having a single coordinate representing tone, which can be useful for various reasons. Examples include hue, saturation and lightness (HSL) (see Figure 11.18) and CIELAB (see page 78); in both cases the Lightness channel (L) represents tone. In such cases, often only a slice of the colour space

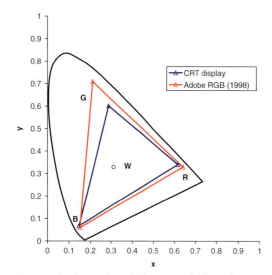

Figure 11.20 Gamut mismatch: The gamuts of different devices are often different shapes and sizes, leading to colours that are out-of-gamut for one device or the other. In this example, the gamut of an image captured in the Adobe RGB (1998) colour space is wider than the gamut of a CRT display.

may be displayed for clarity; the colour coordinates will be mapped in two dimensions at a single lightness value, as if looking down the lightness axis, or at a maximum chroma regardless of lightness. Two-dimensional CIELAB and CIE xy diagrams are examples commonly used in colour management.

Colour gamuts

The colour gamut of a particular device defines the possible range of colours that the device can produce under particular conditions. Colour gamuts are usually displayed for comparison in a device-independent colour space such as CIELAB or CIE Yxy. Because of the different technologies used in producing colour, it is highly unlikely that the gamuts of two devices will exactly coincide. This is known as *gamut mismatch* (see Figure 11.20). In this case, some colours are within the gamut of one device but lie outside that of the other; these colours tend to be the more saturated ones. A decision needs to be made about how to deal with these *out-of-gamut* colours. This is achieved using rendering intents in an ICC colour management system. They may be *clipped* to the boundary of the smaller gamut, for example, leaving all other colours unchanged, however this means that the relationships between colours will be altered and that many pixel values may become the same colour, which can result in posterization. Alternatively, *gamut compression* may be implemented, where all colours are shifted inwards, becoming less saturated, but maintaining the relative differences between the colours and so achieving a more natural result.

Colour management systems

A colour management system is a software module which works with imaging applications and the computer operating system to communicate and match colours through the imaging chain. Colour management reconciles differences between the colour spaces of each device and allows us to produce consistent colours. The aim of the colour management system is to convert colour values successfully between the different colour spaces so that colours appear the same or acceptably similar, at each stage in the imaging chain. To do this the colours have to be specified first.

The conversion from the colour space of one device to the colour space of another is complicated. As already discussed, input and output devices have their own colour spaces; therefore colours are not specified in absolute terms. An analogy is that the two devices speak different languages: a word in one language will not have the same meaning in another language unless it is translated; additionally, words in one language may not have a direct translation in the other language. The colour management system acts as the translator.

ICC colour management

In recent years, colour management has been somewhat simplified with the development of standard colour management systems by the International Color Consortium (ICC). ICC colour management systems have four main components:

1. *Profile connection space (PCS)*

 The PCS is a device-independent colour space, generally CIEXYZ, or CIELAB which is used as a software 'hub', into which all colours are transformed into and out of. Continuing with the language analogy, the PCS is a central language and all device languages are translated into the PCS and back again: there is no direct translation from one device to another.

2. *ICC Profiles*

 A profile is a data file containing information about the colour reproduction capabilities of a device, such as a scanner, a digital camera, a monitor or a printer. There are also a number of intermediate profiles, which are not specific to a device, but to a colour space, usually a *working colour space*. The profiling of a device is achieved by *calibration* and *characterization*. These processes produce the information necessary for mapping colours between the device colour space and the PCS. The ICC provides a standard format for these profile files, which allows them to be used by different devices and across different platforms and applications. This means that an image can be *embedded* with the profile from its capture device and when imported into *any* computer running an ICC colour managed system, the colours should be correctly reproduced. Images can also be *assigned* profiles, or *converted* between profiles (see later section on using profiles).

3. *Colour management module (CMM)*

 The colour management module is the software 'engine' which performs all the calculations for colour conversions. The CMM is separate from the imaging application. There are a number of standard ones for both Mac and PC, which can be selected through the system colour management settings.

4. *Rendering intents*

 Rendering intents define what happens to colours when they are out-of-gamut. The rendering intent is selected by the user at a point when an image is to be converted between two colour spaces, for example when converting between profiles, or when sending an RGB image to print. There are four ICC specified rendering intents, optimized for different imaging situations. These are: *perceptual*, *saturation*, *relative colourimetric* and *absolute colourimetric*. Generally, for most purposes, you will only use perceptual and relative colourimetric; the other two are optimized for saturated graphics and for proofing in a printing press environment respectively and are less likely to give a satisfactory result for everyday imaging. Previewing when converting or printing will allow you to select the best one for your image.

Fundamental concepts

ICC colour management requires a bit of work in setting up and understanding how it works, but provides an elegant solution to a complicated problem. In summary:

- *Profiles* provide information about colour spaces. The information in the file allows correct conversion of colour values between the particular colour space and the PCS.
- The image is assumed to have a profile associated with it at all stages in the imaging chain. The profile may be that of an input or output device, or a *working space profile*.
- If an image enters the workspace without a profile, then a profile may be *assigned* to it. This does not alter the underlying pixel values.
- Images may be *converted* between profiles at any point in the imaging chain. Conversion will change the image values, but should not alter the image appearance.
- Each conversion between profiles requires a *source* and a *destination* profile.

- When converting the image, the user selects a rendering intent, which specifies how out-of-gamut colours will be dealt with.
- Only *convert* between colour spaces when actually necessary, to minimize colour artefacts.

Profiling: calibration and characterization of devices

Fundamental to all colour management is knowledge about the devices and materials being used. Without this information, it is impossible to perform the conversions between colour spaces and ensure correct colour reproduction. This requires two processes.

Calibration

Calibration is twofold: there is the initial setup of the devices in an imaging chain to a required state, followed by ongoing calibration to return them to this state. Initial calibration will normally involve setting a number of characteristics which will control device contrast, tone reproduction and colour gamut. The methods used will vary from device to device. As shown in Chapter 10, calibration of a monitor usually involves setting of brightness and contrast controls, colour temperature and sometimes individual balancing of the RGB controls. Calibration of a printer involves selection of inks and paper, and setting of a gamma value, which ensures that all tones from shadows to highlights are correctly spaced.

It is important to remember that a profile is created for a device when it is in a particular calibrated state. If the device changes from that state, the profile will no longer be accurate. For this reason, ongoing calibration is an important aspect of colour management. This also means that, each time a change is made at the print stage, for example, a different ink set or a different type of paper is used, the system must be recalibrated and a profile created for that particular condition; in the end you will need profiles for each paper surface that you use.

Characterization

Following the initial calibration, characterization involves the reproduction of a set of standard colours by the device being profiled. For a camera or scanner, a standard test chart is captured; for a printer the test chart is printed. For a monitor a standard set of colour patches is displayed on screen, usually produced automatically by the software of the profiling device. The colours produced by the device are then measured *colourimetrically* and their values compared with the original values. From this information the profiling device software then creates the profile.

There are a number of profiling devices available. These vary in complexity and price. Generally the devices will perform both calibration and characterization. Calibration devices for monitors (see page 221) tend to be reasonably affordable therefore, at the very least, try and invest in one. The display is the most important device in terms of colour management, as most of your 'work' on the images will be performed on screen and displays need to be calibrated regularly. Printer calibration tools tend to be more at the professional end of the market, and therefore more expensive. Often profiling devices will be multi-functional and come with bundled software, which allows you to profile all the devices in your imaging chain. If you are serious about colour management, you need to consider this, but do your research first and ensure that you get proper training as part of the package.

Although theoretically, all the devices in the imaging chain should be profiled, it is possible to get away without profiling input devices. Scanners tend to be very stable in their colour reproduction. If a scanner is to be profiled, it must be profiled for each type of material being scanned, e.g. each film type. Often manufacturer profiles will be provided with the scanner

software for a range of different materials. Because scanning is a relatively slow process, where the image is often viewed and adjusted on a large preview screen, these may well suffice.

Cameras are a different issue. Profiling a digital camera involves photographing a test chart under even illumination. The profile created will only be really accurate under the same illumination. The range of different shooting conditions which you will usually encounter means that a camera profile created in this way is not going to be particularly useful or meaningful (note however that under scientific conditions, where images are all being shot in a very controlled manner a profile is essential).

Generally therefore, you will simply set the capture colour space using one of the options available in the camera software. This will capture your camera into one of the standard workspaces, sRGB or Adobe RGB (1998) (see the section on Capture workflow, earlier in this chapter).

Setting colour preferences in Photoshop

This is the first stage in the process of colour management. It does not need to be done each time the application is opened up, but should be done before you start. The colour preferences define the overall default behaviour of Photoshop. To set the preferences go to the *edit* menu and select *colour settings*. A window will open up with a number of default settings. These define the working colour spaces and colour management policies. The default RGB colour space is generally sRGB. As stated before, sRGB is a semi-standardized colour space optimized for multimedia images. Unless all of your images are to be viewed on screen, it is suggested that you change this to Adobe RGB (1998), because its larger gamut is more likely to match the range of printers you may use.

Figure 11.21 Colour settings in Photoshop.

The CMYK colour space defines the gamut of the ink set you are most likely to encounter if your images are published in print. This should be set according to your geographical location. If in Europe, select one of the European sets, if in the United States, select one of the U.S. sets, etc. It is suggested that the remaining settings are set as in Figure 11.21. These ensure that if an image enters the workspace with a profile, then that profile will be preserved and there will be no automatic conversion. Additionally, if the image has a corrupted or missing profile, Photoshop will flag this up, allowing you to decide which profile you will assign to it.

Dealing with profiles: assigning and converting

Images will often come into the application workspace with an *embedded* profile. Camera software, for example, may automatically embed the profile in the image, its contents providing the colour management system with the information required to correctly interpret the image pixel values.

There will be times however, when images enter the workspace without a profile for some reason, or with a corrupted profile. If the colour settings in Photoshop are set as suggested above, the application should then flag this up. It is at this point that it is useful to *assign* a profile. To do this, go to image>mode>assign profile. A window will pop-up as shown in Figure 11.22.

Figure 11.22 Options when assigning a profile.

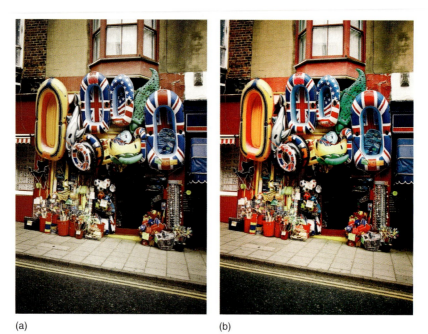

(a) (b)

Figure 11.23 Assigning different profiles. The image colours change when the image is assigned. (a) Wide Gamut RGB and (b) sRGB.

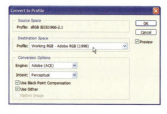

Figure 11.24 Converting between profiles. The user must specify source and destination profiles, the CMM and the rendering intent.

The profile menu lists all the profiles on the system, including workspace profiles, manufacturers' profiles and device profiles. Assigning a profile allows the user to test out different profiles, to identify the one that best displays the image. Assigning will not convert the underlying pixel values, but may change image appearance; it is as if viewing the image through a coloured filter (see Figure 11.23).

At certain points in the imaging chain, it may also be necessary to *convert* between profiles. This is really a conversion between two colour spaces and therefore requires a source and destination profile. The source profile will be the one either embedded in or assigned to the image. The destination profile will be the one you are converting it to. To convert an image go to image>mode>convert to profile and a window will pop-up similar to the one in Figure 11.24. You must specify the output profile, the CMM (the 'Engine') and the rendering intent.

Conversion involves a non-reversible change in the image values; however the change in image appearance should be minimal. The colour values in the image are being converted into the closest possible values in the destination space. Almost inevitably, some colours will be out-of-gamut, so some values will be slightly different, i.e. some loss will occur. It is therefore important that you do not convert images more often than is necessary.

Colour management using Photoshop

The following provides some guidelines for implementation of profiled colour management in Photoshop. Some aspects may vary depending upon the version of Photoshop being used, so

also check the help files for your version. Refer to the previous sections for details on the methods at each stage. It assumes that you are working with RGB images at input.

1. Set Photoshop colour preferences (this need only to be done once).
2. Profile your devices. At the very least, profile your display. If you do not have access to a profiling device, use visual calibrator software such as Adobe Gamma (Windows) (see page 339) or Monitor Calibrator (MacOS). Ensure that the correct profile is being used by the display.
3. Importing images:
 (a) When an image is imported into Photoshop and has a correctly embedded source profile, preserve the profile (if you have set up Photoshop as shown, you will not need to alter anything).
 (b) If an image is imported without a profile, or with a corrupted profile, assign a profile to it. You may assign a number of different profiles, to find the one producing the most satisfactory colours, or choose to assign your working space RGB profile.
4. Editing images: It is common nowadays to work in an RGB colour space, only converting to CMYK at the last minute. This is because images are not always going to be printed, or it may be that they are to be published on the Web as well, so an RGB version is needed. CMYK gamuts are always smaller than RGB, therefore by using an RGB space you will have more colours available at the all-important editing stage. It can be useful to convert the image into a standardized RGB space, so you may choose before editing to convert to your working RGB colour space using the *convert-to-profile* command.
5. *Soft proof* when printing images: Soft proofing allows you to display your image colours on screen so that they appear as close as possible to the way they will look when printed, to allow for last-minute adjustments. Your display must be calibrated and profiled and the printer must be profiled for the paper and inks that you are using. To set up soft proof, go to *view>Proof Setup> Custom* and in the window that pops up, set your printer profile and required rendering intent. To view the soft proof, go to the *view* menu and select *Proof Colours.*
6. The final colour conversion when printing can be performed within Photoshop or by the printer software, so needs to be enabled in only one of them. Otherwise, the conversions will be performed twice, with unpredictable results. The suggested process is as follows:
 (a) Open up the print command window using file>Print with Preview (see Figure 11.25). Ensure that 'colour management' is selected in the top-left drop down menu, as shown. 'Document' should be selected as source space as shown, and the correct printer profile and required rendering intent should be selected in print space. Black point compensation ensures that the black point will remain black in the printed image, so unless you have very good reason, you should leave this checked.

 Figure 11.25 Print with preview window in Photoshop.

 (b) Set the page setup parameters in the right-hand side of the window. The position of the printed image will appear in the pane on the left. The page setup button allows you to alter the orientation of the paper and the paper size. Once completed, press the print button.
 (c) A second print window will open up. Ensure that colour management is turned off in this window, as this is the device software window. This will make certain that colour management is only performed by Photoshop.

■ Workflow defines the way in which you work with images through your imaging chain, and should make the process of dealing with your images quicker and more efficient.

■ The specifics of workflow will depend upon a number of factors, including devices being used, required output (if known), required image quality, image storage and speed of processing. Ultimately these will be determined by the type of imaging.

■ Closed loop imaging systems were common early in digital imaging. Consisting of a limited number of devices, a known output and a skilled operator, workflow was simple but restricted.

■ Open loop systems are now more commonplace, to accommodate the use of multiple input and output devices in the imaging chain, across different platforms and the easy and widespread transmission of images. Open loop systems are characterized by flexibility, based upon imaging standards and adapt to change easily.

■ There are two approaches to capture workflow: capture for output, which can be efficient if there is to be a single known output, or capture for optimum quality, which is more suitable in an open loop system.

■ RAW capture allows images to be acquired in a relatively unprocessed state. The majority of the image processing that would be carried out automatically in the camera for other formats is carried out in RAW processing software by the user, allowing a greater degree of control over the image post-capture.

■ Images require a minimum of 8 bits per channel to represent photographic quality. However the processing through the imaging chain can result in lost levels in the tonal range and a posterized image. 16 bits per channel helps to prevent this happening, but doubles the file size.

■ There are a range of image file formats available, but only a few that are suitable for high-quality photographic imaging. The file format determines the final image quality, bit depth support, file size, layer and alpha channel support, colour spaces and compression.

■ RAW and TIFF files are lossless and suitable for archiving images, PSD files are suitable as an intermediate lossless editing format, EPS and PDF files enable postscript and vector graphics. JPEG is optimized for lossy compression of continuous tone images, with an associated loss in quality; JPEG 2000 has both lossless and lossy versions. GIF and PNG are suitable for primary web images.

■ Lossy compression formats such as JPEG and JPEG 2000 produce a high level of compression, but introduce artefacts in the process, therefore should be used with caution.

■ Image processing occurs throughout the imaging chain, in device software as well as applications such as Photoshop. Some of the processes are user led; others are automatically applied in device firmware.

■ Many image processes are not reversible and may cause characteristic artefacts if overapplied. In device software, some image processing operations are applied automatically to correct for the artefacts introduced by other operations.

■ There are a huge range of image processing tools available and these vary from application to application. Often there will be a number of different methods to achieve the same result. There are, however, a number of image adjustments and restorations that tend to be common to many applications and may be defined as part of a generalized image processing workflow.

■ Spatial operations involve interpolation and include rotation, translation, resizing and perspective correction. Artefacts vary depending upon the interpolation method used.

■ Tone and colour corrections may be applied in a number of different ways. It is preferable to correct tone before colour, as tonal corrections may result in a change in colour balance.

SUMMARY

■ Simple tools such as brightness, contrast and saturation sliders are common in many applications, but do not afford a high level of user control and can result in posterization and clipping. Professional tools such as *levels* and *curves* are better suited for high-quality photographic output.

■ Most applications also include noise removal and sharpening tools. These are filtering operations. Applications such as Photoshop tend to offer a much larger range of filters than device applications.

■ Overapplication of noise removal filters may result in posterization or blurring of the image. Oversharpening can emphasize noise and produce halo artefacts at edges. Both may be more subtly applied using layers in an application such as Photoshop.

■ Digital colour is represented using a range of colour spaces. These are numerical models defining coordinate systems in which colours are mapped. Colour spaces may be device-dependent or device-independent.

■ Device colour gamuts are mapped within colour spaces and define the limits of the colours reproduced by the device.

■ As an image passes through the imaging chain, its colours move through different colour spaces. Colour management systems are designed to manage this process.

■ ICC colour management systems use profiles, which are descriptions of the colour properties of devices and the PCS, which is a central device-independent colour space into which image colours are converted.

■ ICC colour management systems require calibration and characterization of devices, to create accurate profiles.

■ Profiles provide information for the colour management system to convert between device colour spaces and the PCS.

■ Profiles may be embedded in images. Images may also be assigned profiles, which will change image appearance without altering the underlying pixel values. Images may also be converted into other profiles, which will alter pixel values but should not alter image appearance.

■ Often gamuts of devices do not match, leading to out-of-gamut colours. Rendering intents are used in ICC systems to deal with these colours.

1 This project is on defining an optimum workflow:

(a) Identify an imaging chain that you have access to, from digital capture (scanner or camera) to printed output.

(b) Decide on a printed output size. Produce two identical printed images: the first where you have captured for this output, the second where you capture for optimum quality and then resize for output. The colour space at capture should be the same in both cases.

(c) Evaluate the two images side-by-side. Decide which method of workflow suits you best and produces the best results in your images.

2 In this project you will work on image compression:

(a) Open up Photoshop.

(b) Select a number of *uncompressed* TIFF images, of similar dimensions (i.e. numbers of pixels: you can check this in image>image size in Photoshop) with a range of different image content, for example: (a) a close-up portrait, (b) an image with a lot of fine detail, (c) an image with a lot of smooth or flat areas and (d) an image with lots of high-contrast edges.

(c) Crop the images so that they are all the same size. Save them again as uncompressed TIFFs.

(d) Save these new images with new file names as JPEG files, using a quality setting of 4.

(e) Outside Photoshop, look at the file sizes of the compressed files. Identify which file compresses the most.

(f) Inside Photoshop, open up the JPEGs and their TIFF originals and look at them side-by-side. Identify which have suffered from the greatest distortion from the compression.

3 This project is on assigning and converting profiles:

(a) Set the colour settings in Photoshop as described earlier in the chapter.

(b) Open up an RGB image containing reasonably bright colours in Photoshop. If it has a profile, then preserve this profile, if not, assign it the working space profile. Make two copies of the image. Display them side-by-side.

(c) On one of the copies, go to image>mode>Assign Profile. Ensure that the preview box is ticked and try assigning a range of different profiles. Select one which produces a significant difference and click OK.

(d) On the other copy, go to image>mode>Convert to Profile. In the 'destination space' box, select the same profile that you used in step 3 and click OK.

(e) Examine and compare the three images side-by-side.

PROJECTS

Film processing management and colour printing

This chapter describes the current ways of film and paper processing, monochrome and colour, and methods of colour printing. It starts with the main processes and the different kinds of equipment designed to get chemicals to act on film or paper. The chapter also discusses the ways you can monitor the processes for quality control and the treatment/discharge of solutions containing silver by-products.

It continues with methods of colour printing assuming that you already have experience with black and white printing but are approaching practical colour printing on silver halide material for the first time. This section starts with an overview of equipment used for colour printing and continues with the methods of printing from negatives and slides. It also includes various 'cross-over' techniques that you can apply.

The processes themselves

When your volume of work starts growing, you have to think how to organize your processes. You may want to give your films and prints out to professional laboratories for processing or you may decide to become self-sufficient in all your processing. In this case, you must afford the necessary equipment and the expense of running it. You therefore have to see first if you have a sufficient volume of work that can justify the use of automatic machinery. You also have to conduct process control to ensure high image quality of the processed films and prints.

The processing procedure consists of a sequence of stages set out by the manufacturers. You do not need to know in detail the chemical basis of what is going on, but it is essential to keep the solutions in good condition, and organize timing, temperature and agitation required for each step of the process. This way you will ensure that the processing will have its proper effect, otherwise you can ruin expensive solutions or be left with images which are too pale or too dense, wrong in contrast, off-colour or impermanent. In some instances (steps in the wrong order, for example) there may be no final image at all. You must also keep the processing equipment well maintained to avoid any scratches, marks or stains on the emulsion of your film or paper.

Virtually all colour negative films need the same process C-41 and reversal colour films the same process E-6, except Kodachrome which needs the process K-14. Negative/positive colour paper uses the process RA-4 and positive/positive Ilfochrome paper, the process P3 which is a dye-bleach process. The typical current types of processes are summarized below.

Black and white negatives

Black and white negatives need only the simple sequence of developer, stop bath, fixer and wash. You have a wide range of developers to choose from, from soft-working speed-reducing types such as Ilford Perceptol, through general fine-grain developers such as Kodak D-76/Ilford ID-11 to high-acutance or speed-enhancing types and high pH extreme contrast solutions for specialist functions. 'High tech' grain structure black and white films – Delta grain, T-grain, etc. are accompanied by developers which are designed to maximize their qualities. With these films you can also use traditional developers such as the D-76 or ID-11, following the manufacturer's recommendation for dilution and development time (see *Langford's Basic Photography*, Chapter 11).

The film you are using, the subject conditions and the required image 'look', are the main factors that influence your choice of developer. The results are affected by the type of the solution relative to type of emulsion as well as dilution and timing. With most black and white developers you can work at any temperature between 18°C and 24°C and fully compensate by adjusting time.

Sometimes you may have to process on location, so it is essential to work on a 'one-shot' basis, discarding the solution after use. On the other hand, for studio work you might have a developer you can keep using for three months (with replenishment) in a deep tank.

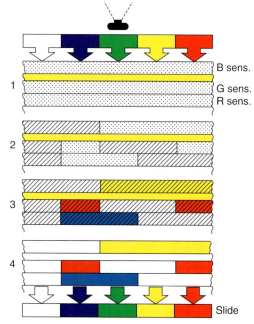

Figure 12.1 Cross-section (simplified) of reversal colour slide film incorporating couplers. Stage 1: emulsions receive image in camera. 2: after first development. Black silver created where B, G or R sensitive emulsions respond to image. 3: after remaining halides are chemically fogged and developed in colour developer, giving silver and either yellow, magenta or cyan in each layer. 4: after bleaching and fixing away all black silver. The remaining dye-only images reform subject colours.

Colour slides and transparencies

The E-6 process for colour transparencies, designed for the great majority of films having colour couplers in their emulsion, consists of several stages (Figure 12.1): The first stage of reversal processing is active black and white development. The next stage chemically fogs all remaining silver halides in the film. Then colour developer turns these remaining halides into metallic silver, forming by-products which join with different colour couplers in each layer to create cyan, magenta and yellow dye images. Colour formation in this way is known as *chromogenic development* – dye amounts are in direct relation to the amounts of silver the colour developer forms. The pre-bleach stage follows, which enhances dye stability and prepares the emulsion for bleaching, which is followed by fixing. Bleach and fix may be combined in one solution on shortened three-bath E-6 processing. The later stages of bleaching can

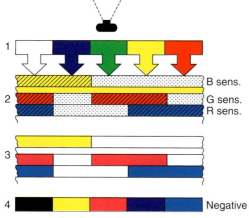

Figure 12.2 Negative/positive colour reproduction. 1: original image exposed in camera. 2: after colour development the colour negative film carries black silver plus yellow, magenta or cyan coupled dye where emulsion layers have responded to image colours. 3: after bleaching and fixing away black silver. 4: the resulting colour negative. Note that the negative mask is omitted for clarity.

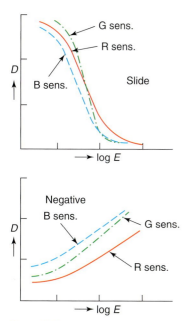

Figure 12.3 Inaccurate processing can produce 'crossed curves' in the response of (top) colour reversal, and (bottom) colour negative film. The slide here will have a magenta cast to shadows, cyan cast to highlights. Colour prints from the negative will show an increasingly greenish cast in darker tones when correctly filtered for palest parts of the picture.

take place in normal lighting because there is nothing light-sensitive left to fog. As the black fades, you start to see colours for the first time. Soluble by-products and absorbed processing chemicals are then washed out.

If all this sounds complicated, it is far less demanding than the older K-14 Kodachrome process. Kodachrome has no couplers built in, so each emulsion layer has to be separately fogged and separately cyan, magenta and yellow colours developed.

Colour negatives

The processing of colour negative films with the C-41 process starts with colour development, which is the most critical stage (Figure 12.2). Next the metallic silver is removed with bleaching and fixed. Finally the film is washed and stabilized. During development (and subsequent silver removal and stabilization) fine changes also occur to the integral colour masks. Properly carried out, this should give a colour negative matched in contrast range and different absorptions of red, green and blue light to 'fit' the characteristics of the same maker's negative/positive colour printing paper. Departures from normal such as lack of correct temperature, agitation and timing control produce problems at the printing stage. Such negatives are mismatched to the paper and they may have crossed curves (Figure 12.3). No one set of filters can correct this during enlarging. Absolute consistency of film processing is therefore important.

Chromogenic (dye image) monochrome negatives

Chromogenic monochrome negative films produce black and white images with the convenience of C-41 instead of black and white processing because they contain couplers in their several emulsion layers. Resulting images have a warm, brownish black – the combined dye layers give a rich tone scale and allow good exposure latitude. Chromogenic monochrome negative films are optimized for printing on black and white paper (e.g. Ilford XP2 Super) or colour negative paper (e.g. Kodak BW400 CN).

If this film	Is given this processing	The result will be
Regular B & W	E-6 or C-41	Clear film
Slide (E-6 type)	C-41 B & W neg	Contrasty, unmasked colour neg Pale B & W neg*
Kodachrome	E-6 B & W neg	Clear film B & W neg with backing** dye still present
Colour neg (C-41 type)	E-6 B & W neg	Low contrast, cyan cast slide Ghost-thin B & W neg* with mask colour

*May be possible to salvage as a colour neg.
**Removable in film strength rapid fixer plus 8 grams/litre citric acid.

Figure 12.4 What happens when you put film through the wrong process. 'Regular' black and white means silver image films, not dye image types designed for C-41. (Some of these may differ in detail according to brand and types of film.)

Cross-processing of films

Treating films in a processing sequence designed for another film type gives a variety of results, depending on the brand and the particular film you used (Figure 12.4). Sometimes you may use the wrong combination by error or you may do intentional cross-processing to produce unusual colour images for illustration purposes, especially in the fashion and music business. Similar results are possible by digital manipulation – without risk to any of your original shots.

If you want to create images by cross-processing of films it is always better to shoot generously, setting different ISO speed ratings and then ask the lab to give your films clip tests before deciding the best development time. Not all labs offer cross-processing, as this holds up other work. There is also a limitation on how many films can be cross-processed in a lab, for example colour negative films processed in E-6, without having an adverse effect on the E-6 process.

Black and white prints

Fewer developers are designed for printing papers than for films, and they are all more active and fast working. Choice centres on the 'colour' of the black and white image it will produce. Regular, PQ type developers (they include phenidone and hydroquinone developing agents) give neutral black images on both fibre- and resin coated- (RC) based bromide papers. RC papers develop much faster than fibre-based papers because of developing agents already incorporated into the emulsion which hasten the start of visible image formation. The non-absorbing base of RC papers also minimizes carry-over of chemicals so that further stages – especially final washing – are much shorter compared to the fibre-based papers. Other 'restrained' type developers for chlorobromide emulsion papers give results ranging from cold black to rich brown, according to formula.

Generally, you should keep print-development times constant. Too little development gives grey shadows and weak darker tone values; too much begins to yellow the paper base and highlights due to chemical fog. After development, stop bath and acid hardening fixer can be the same formula as the films, although the fixer is used at greater dilution.

Prints and display transparencies from colour negatives and slides

The two-solution RA-4 process used for negative/positive print materials is like a truncated form of colour negative film processing. All colour printing papers have an RC base. During the

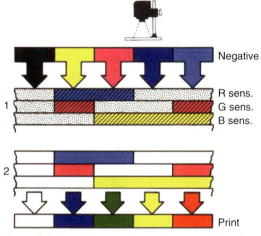

Figure 12.5 1: negative exposed onto colour paper, which is then colour developed. Black silver and a coupled dye form according to each emulsion response to exposure. 2: after bleaching and fixing. Seen against its white base, dye layers reproduce colours of the original camera image.

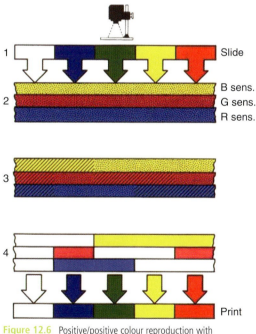

Figure 12.6 Positive/positive colour reproduction with dye-bleach paper. 1: slide, projected by enlarger. 2: simplified layers, already containing dye with silver halides, exposing to image. 3: after development, black silver negative images form in each layer according to emulsion response. 4: after silver/ dye-bleaching. Dyes remain only in areas unaffected by development. The print reproduces the colours and tones of the original slide.

critical first stage the colour developer produces black silver in exposed emulsion layers and by-products which react with different couplers in each layer to give cyan, magenta and yellow image dyes (see Figure 12.5). This is followed by a bleach-fix stage to convert the silver into soluble compounds you remove in a final wash.

As in C-41 processing, there is no flexibility in timing and temperature control is critical. It is very important that processing gives print-to-print consistency. Variations create images with colour shifts, poor tone range and stains. They can totally confuse your attempts to control results on the enlarger through filtration and exposure. Also note that colour printing materials may be suitable for printing with both analogue and digital enlargers but usually they are optimized for one of the two methods.

You can print colour display transparencies from colour negatives by using film-based material which is handled and exposed like sheets of negative/positive paper. The same colour print chemicals are used but stages need different timings. This is an effective way to make large-scale transparencies for lightbox display in exhibitions. Digital images can also be printed on specially designed display transparencies which are processed with the same RA-4 method as the colour printing paper. Display transparencies from slides can be printed with Ilfochrome materials, which are available in clear and translucent polyester films, using the same P3 processing as for Ilfochrome paper.

Printing from slides can be carried out using Ilfochrome paper which requires dye-bleach processing. Ilfochrome material has fully formed cyan, magenta and yellow dye layers already present in the red-, green- and blue-responsive emulsion layers (see page 221). The first stage of the P3 process (P 3X for roller transport processors – see page 277)

is dye-bleach. Dye-bleach processing uses first a black and white developer to form a negative black silver image in each emulsion layer according to its response to light. The second chemical step is a bleach which removes the silver *and the dye where silver is present.* At the next stage the by-products of bleaching are made soluble by fixing and finally removed by washing. The remaining unbleached dyes leave you with a positive colour image matching your slide.

Points to watch

Whatever process you intend to carry out, the key aspects to organize properly are: temperature, timing, agitation, physical handling without damage and the condition of the chemicals.

Temperature

Temperature must be tightly controlled if you expect to handle critical processes with any consistency. Large volumes of each solution hold their temperature longer than small ones. Small quantities can be brought to the correct temperature quickly but equally they soon change again if poured into a tank or through which is colder or warmer. They can also be affected faster by changes of the ambient room temperature.

The temperature of the solutions can be controlled and kept constant with water jackets. The tanks with the solutions are immersed in the water jacket and their temperature is controlled by controlling the temperature of the water.

Colour materials have less tolerances to temperature changes of the processing solutions compared to black and white materials. Any deviations in temperature during processing affects the rates of development in different emulsion layers, so you may get a faulty colour balance.

When you hand-process black-and-white film, however, and you have to use temperature other than that which has been specified, you can alter the processing time to compensate for the change in temperature. You can find the processing time that corresponds to the temperature you are using for your particular developer and film in time/temperature tables or graphs (Figure 12.7). You should not exceed the upper and lower limits of development time and temperature because the processing characteristics will change beyond these limits.

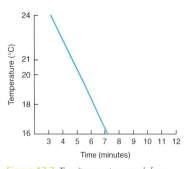

Figure 12.7 Time/temperature graph for a black and white developer which gives correct density and contrast when used for 41.2 min at 20°C. Between 16°C and 24°C temperature changes can be largely compensated for by altering time.

Timing

Accurate timing is as important as accurate temperature. Times given for each step when you hand-process include a 10-sec drain period for films (20 sec for prints) to avoid carry-over of chemical into the next solution. Timings are usually different when you process by machine, depending on how the film is agitated in your type of equipment. You must keep tight control of timing when processing colour negatives at all stages. In colour slide processing increases or

reductions in the timing of black and white development (not colour development) stage push or hold back films to compensate for under- or overexposure, similar to black and white processing. Similarly the degree of development alters the contrast of your result. Note, however, that you must not alter the times for the other processing stages. Remember that the range of adjustments open to you is much more limited compared to black and white film. Beyond a certain point the image looks 'wrong', with coarser or flatter colours, pale shadows and a tendency to take on a colour cast which differs according to brand type.

Agitation

Agitation is an important part of processing, especially at the development stage because it affects the degree of development. If the agitation is too little then the development is uneven across the film and there is insufficient density in the negative highlights. By-products diffuse from emulsions too slowly, forming streamers. Over agitation also allows more fresh developer to reach the emulsion than is intended for the process giving extra highlight density. In colour films it disturbs the way by-products are produced in emulsion layers giving excessive dye formation. It may also create uneven 'flow marks' particularly in films carrying perforations. In automatic processors agitation takes place through movement of the material (see page 276) but some automatic processing machines or deep tank lines have systems that provide controlled agitation with solution recirculation or gaseous-burst agitation (see Figure 12.9). When you carry out hand processing of films or paper you must follow precisely the agitation instructions provided by the manufacturer of your processing solution for consistent results.

Physical handling

Physical handling of the materials, if it is not carried out carefully, may cause them damage during processing and this is most critical when processing films. The gelatin of photographic materials is thin and designed to absorb liquids. Before processing you must be therefore careful to avoid any splashes on the unprocessed film or handling it with damp hands. Careful loading of the film in the reel is essential to avoid any contact of the film with the side of the tank during agitation. You must also ensure that the reel and tank are dry before loading the film.

When the material is being processed and is wet and swollen, it is especially delicate. Good maintenance of the rollers in roller transport machines is important to avoid any problems. Otherwise chemical by-products, flakes of gelatin, scale or grit build up on rollers and damage everything you put through. You must also check whether the water you use for diluting chemicals or washing the film (or paper) has any debris. The debris will remain and dry on the emulsion and any attempts to remove it will result in scratching the material. The same applies if there is dust in the air where the film or paper dries. Check if the filter of the air dryer needs changing. During that stage you must also be careful and avoid any splashes on the material when it is dry or nearly dry. Remember to drain and wash the processing and washing tanks when the processor will not be used for more than six weeks, to avoid build up of algae.

Chemical solutions

Points to watch here are accurate mixing; prevention of contamination and avoiding the use of exhausted solutions. The processing chemicals are packaged in the form of powder or liquid and are ready to be added to water. Accurate mixing is very important and demands constant

attention, especially when dissolving powders. Component powders or liquids mixed in the wrong order may never dissolve or may precipitate out unexpected sediment. Stirring, with a suitable chemically inert and non-absorbing mixing rod, is essential when mixing. The mixing water should be at the recommended temperature or some chemical contents may be destroyed (much higher temperature) or some components may not dissolve (much lower temperature). *Observe health and safety recommendations* shown on page 376. Mix in a well ventilated place, wear gloves and do not lean over the solution you are preparing. This applies especially to bleaches and stabilizers. Always remember that you must not store chemicals or chemical solutions in areas where you store food, such as the refrigerator.

Avoid all risks of cross-contamination between solutions, especially between developers or developers and bleach-fix, when mixing or processing. Thoroughly wash mixing equipment, measures, bottles and tops, and thermometer before changing from the preparation of one chemical solution to another and never let film hangers, thermometer, etc. trail one solution across a container holding another. To be on the safe side, always mix a kit of chemicals in the same order as the process, starting from the developer. For some automatic film processors and minilabs the processing solutions are available in cartridges, so you do not need to mix chemicals.

Solutions often start to deteriorate as soon as they are left uncovered in contact with air as well as when used to process emulsions. This is where 'one-shot' processing has its main advantage. However, throwing away chemicals after every process is expensive and impractical for large-volume processing and continuous-processing machines. Developer-storage tanks (or deep-processing tanks when not in use) need floating lids to minimize contact with the air. Log the total amount of material you put through one solution and try not to exceed the maximum area recommended by the manufacturers for that volume. As repeatedly used developers become weaker you may be able to compensate by increased processing time, or, better still, work a system of replenishment.

Chemicals and chemical solutions before and after mixing should be stored at temperatures between 5°C and 30°C. The period for which they can be stored is given by the manufacturer.

Replenishment

Replenishment means adding chemicals to gain a longer life from repeatedly used black and white and colour developers. Bleaches and fixers can also be replenished and 'regenerated' but stop baths and stabilizers are relatively long-lasting and cheap, so they are worth discarding completely when used up. Each replenisher solution (or powder) is formulated for a particular developer, designed to replace those of its constituents such as developing agents most used up during processing. It also has to be strong enough to help counterbalance the by-products that film and developer create between them, which accumulate in the solution and slow up development action. Replenisher is designed to be added to the main solution in carefully measured quantities. Too much or too little will seriously alter performance instead of the main aim of keeping processing consistent, so follow carefully the instructions of the manufacturer for the specific chemicals and tanks .

Fixers and bleaches can be replenished with calculated volumes of either fresh amounts of the original chemical or specially formulated replenisher solution. The very action of fixing and bleaching causes silver salts to accumulate in these solutions. Silver can actually be reclaimed and sold and the 'regenerated' solution replenished and returned for use in film processing (see page 284). Eventually, of course, every processing solution, however carefully replenished,

approaches a terminal state of exhaustion and must be thrown away. The whole point is to keep it working consistently for as long as possible, so that you get greatest value for money.

Equipment

ighly controlled machine processing is ideal for the least flexible, temperature-critical processes such as colour negatives and prints, and reversal colour films and prints. It also suits black and white RC prints. On the other hand, the variety of developer/ emulsion combinations you can pick from for black and white negative and fibre-base printing paper still makes hand-processing attractive. Hand-processing is also the easiest way to vary development times for individual sheets

For hand-processing	For machine-processing
Flexibility	Consistency
Low capital cost	Convenience
Less money committed to chemicals	Speed of throughput
Can stand idle at times	Low cost per film/print (if sufficient
Suits process manipulation	quantities)
Less risk of mechanical damage	Less labour-intensive
	Can handle long rolls of film/paper

Figure 12.8 The advantages of hand-processing and machine processing.

or rolls of film, as required for the zone system (page 165). Figure 12.8 compares the technical and economic features of manual and machine processing.

Processing in trays

Manual processing in open trays or troughs is still appropriate for small volumes of black and white non-panchromatic prints or sheet films. It is very flexible: you can easily check results under safe lighting during processing and use relatively small quantities of chemicals.

Equipment is cheap too. However, trough or tray processing is messy, unhealthy (you breathe in chemical) and not very consistent, and solutions oxidize quickly. All colour work and any processing needing total darkness is too awkward and unpleasant to be handled this way.

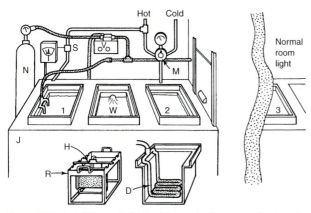

Figure 12.9 Basic 15 litre tank sink line. Water jacket (J) encloses all tanks and is fed from thermostatic mixing valve (M) which also supplies wash tank (W). Temperature monitoring unit T has probe directly below critical developer tank (1). If temperature drops, monitor causes solenoid (S) to inject additional hot water. Nitrogen gas passes through electronic valve (V) regulating the frequency and duration of each burst. It then supplies flat tube distributor (D) moved from tank to tank along with rack (R) of films on hangers (H). After first stages demanding total darkness you pass the film rack through a trap to the other half of unit, in room lighting. Here another gas/air distributor can take over.

Tanks and tank lines

Small roll or sheet film hand-tanks are the cheapest reliable method of processing one to three films at a time (see *Langford's Basic Photography*). The next step up is to have a run of deep tanks, each 15 litre tank (Figure 12.9) set into a temperature-controlled water or air jacket. Each tank contains a separate chemical solution, according to the

process you are running, plus a rinse/wash tank. You can process individual sheet film in hangers, agitating them by hand and moving them from tank to tank in darkness. Quantities of sheet film, rollfilms in reels and printing paper can be handled the same way in purpose-made racks. A single rack will accommodate up to 20 or 30 reels of 120 or 35 mm film, or 24 sheets of 4 × 5 in. film (102 × 127 mm).

Tank lines are fairly cheap to set up and run for any process, and allow sufficient throughput for smaller professional users. However, someone has to be present to manually handle every batch – reversal processing is especially hard work. You must take care over process control and replenishment if you want consistency.

Drum processors

The heart of a drum processor is a light-tight cylinder you load with paper (or film in a suitable adaptor). All processing stages then take place in normal light. The cylinder rotates on motor-driven rollers within a water jacket and you pour in a small quantity of processing solution through a light-trapped funnel (Figure 12.10). Within the turning drum the solution spreads rapidly and evenly over the surface of the emulsion. Drum movement backwards and forwards gives agitation; your thermostatic water jacket controls temperature. Notice how, unlike tank processing, where material is totally immersed in solution and given intermittent agitation, drum processors give intermittent immersion and continuous agitation. This may mean changing timings, even though solutions and temperatures remain the same.

Drum processors work on the discard principle – at the end of each step you tilt the drum, discard the used solution, then return it to the horizontal and pour in the next liquid. A few models can be programmed to work automatically, but most are labour-intensive. However, a drum processor is versatile and reliable and also the most economic way to process occasional large colour prints, although it is slow and inconvenient for large quantities of paper or film. Maximum capacity per loading ranges from 4 to 20 prints 8 × 10 in. (203 × 220 mm) or 2–10, 120 rollfilms, according to drum size.

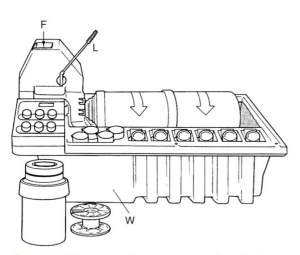

Figure 12.10 Drum processor. Drums accept print or film (roll or 35 mm on reels) loaded in the dark. Storage containers, measured volumes of solutions in containers ready for use, and drum are all half submerged in a temperature-controlled water jacket (W). Drum couples to motor unit through magnetic lid. Lever (L) is used to tilt drum at end of each stage, discarding used solution down drain. The next chemical is then poured into funnel (F) while drum continues to rotate.

Automatic processors

With fully automatic, programmed processors you are moving up into the big league – financially and in terms of throughput. The cost of equipment may be 10 times as much as a manual drum system. The main types described below are the roller transport, dip-and-dunk and continuous-strand

machines, according to the way they move the material through solutions. Most need large and therefore expensive tanks of processing chemicals which make them uneconomic to run unless you process at least a 100 films or 50 prints per week. They are ideally suited to multiple-stage, rigorously controlled colour processes – you can safely leave them like washing machines and do other jobs while they are at work.

Roller transport machines

These machines contain dozens of slow-moving rollers, turning continuously to transport *individual* films or sheets of paper, usually up and down along a sequence of deep tanks. They may be designed to be built through the darkroom wall (Figure 12.11) and into a lit area. More often film processors offer loading arrangements you can use in normal room lighting. Here a light-tight box at the feed end has armholes fitted with gloves through which you can open a film holder, or unseal a rollfilm and 'post' the exposed material direct into the machine. Either way you feed your material through dry receiving rollers in darkness and receive it back dry from the delivery end of the machine where it has finally passed through an air-jet drying unit.

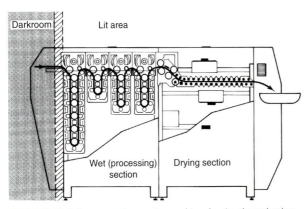

The large-volume tanks are thermostatically controlled; the rollers give continuous agitation. Roller speed is the same in all tanks – for the longest stages of processing you have tanks which are deeper or longer than tanks for short stages. You can run the whole machine slower or faster while films (or paper) to be pushed or held back are passing through the developer stage.

Figure 12.11 Roller transport processing machine, showing the path taken by sheets of material. This one is designed for colour paper – similar types made for films differ in their roller surface and dryer detail.

Roller transport machines are very convenient to use. You can feed in a mixture of sheets or lengths of film (or sheets or rolls of paper) at any time. However, each machine tends to be dedicated to a particular process. Changing to another is possible but normally means draining and changing expensive volumes of solution, which can be a major operation. Typically a 24-in. (610 mm) wide roller machine designed to process negative/positive colour prints at 200 mm per minute can turn out up to 120 prints 8 × 10 in. every hour.

In deep-tank roller transport machines the chemicals have to be very carefully replenished, usually by automatic injection.

Dip-and-dunk film processors

Also known as 'rack and carriage' or 'rack and tank' processors, these are effectively a robot form of deep-tank hand line. As Figure 12.12 shows, the machine stands in the darkroom and films are suspended from hangers on a motorized lift/carriage unit over a series of tanks. The machine lowers hangers into solution, gradually inches them along the full length of the first tank, then lifts and lowers them into the next solution. The longest stages have the longest tanks, and the

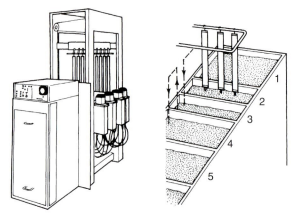

solutions are thermostatically heated and pump-circulated. Films on their hangers finally pass along a drying compartment. There is no risk of damage from poorly maintained rollers with a dip-and-dunk processor. Mechanically, the equipment is fairly simple but requires a lot of space (with good headroom) and large volumes of solutions.

Machines are also dedicated to particular processes. You can put through material of mixed sizes at any time by attaching a rack of films to the transport mechanism at the start point of the process. Output ranges from about 40 to 100 rollfilms (120) per hour, according to the size of the machine.

Continuous-strand processors

Machines of this type are designed for processing long lengths of film (aero-survey or movie films, for example) or paper (output from roll paper printers). They work like roller transport deep-tank units but only have rollers at the top and bottom of each tank (see Figure 12.13). To start up, you must thread the machine with a leader and then attach to the end of this the material you want to process. Other lengths of the same width are attached in turn to the end of previous material, forming one or more continuous strands passing through the machine at

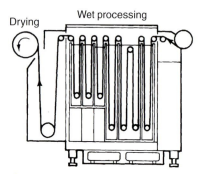

Figure 12.13 Continuous-strand processor, working from a bulk reel of exposed film.

constant speed and rolling up dry at the other end. When used for prints, really accurate instrument control of image exposure and light filtration is essential, for it is not very practical to put through test exposures.

Agitation takes place through movement of the material you are processing through the tanks, but some processors inject gas-burst agitation into key solutions as well. Each machine is dedicated to a particular process. Solutions are continually replenished and recirculated through filter and heater units by pumps. A large paper-processing machine of this kind can produce about 500 8 × 10 in. colour prints per hour.

Mini-labs and hybrid systems

So called 'mini-labs' are typically paired, free-standing, units intended for photographic retail stores – they are able to provide colour negative film processing and printing to one or more fixed sizes on a semiautomatic basis. High-end machines can be very expensive, and contain negative scanning systems which allow monitor screen previews of print results given

automatically programmed colour correction, local shading, etc. Prints are exposed onto roll paper.

Hybrid roll paper minilab systems (or digital minilabs) which can print images from films (colour negatives and slides) and digital files have become more common. When printing from films, they first scan each frame, and then pass the digital file through an image processing station where computer software automatically makes corrections to density, contrast and colour balance, displaying changes on a monitor screen. Then this image data is transferred to an output section – a printer containing a laser exposure system with red, green and blue lasers. The light sources are moderated by the digital image information as they scan as a combined focused spot of light over the surface of a roll of silver halide negative/positive colour paper. Finally the exposed paper goes through a conventional RA-4 chemistry roller processor. The prints can have dimensions up to 305×457 mm. There are also minilabs that print up to 210×914 mm, depending on the aspect ratio of the image. Other options such as ID photo printing, multiple photos, etc. are also available.

Some of these systems can also be connected directly to a digital camera (or PDAs and mobile phones via a USB port or Bluetooth) to download the digital images or they read image files from storage media such as CD-ROMs, DVDs, memory cards, etc.

Direct conversion from digital to silver halide image is now an important way of printing large-size high-resolution colour prints. Several digital printers (e.g. Oce 'Light-jet', Durst 'Lambda') are designed to function direct from any suitable digital image data. Like the mini-lab printer described above, a light-tight unit houses R, G and B lasers moderated by the disk's R, G and B digital signals. The three sources merge into a spot of light which moves backwards and forwards across the surface of a wide roll of colour paper or display film. Total exposure time depends upon the output resolution you have set, as well as size. Typically a 40×50 in. (1000×1300 mm) image takes 5 min to expose at 400 dpi – significantly faster and less messy than an inkjet printer.

The advantage of these direct digital printers, especially for murals, is that huge darkrooms and horizontal enlargers become unnecessary; and provided your digital file contains sufficient data the image resolution is excellent since the (overlapping) scan lines reveal no pattern, and total absence of enlarger optics eliminates hazards like resolution fall-off at the corners of your image. The picture can be instantly changed in size, as can the type of wide-roll silver halide print material the unit has been loaded with – colour or black and white, on paper or display film base.

Thanks to all this 'hybrid' work labs can still run RA-4, C-41 and E-6 chemical processing machines alongside their new digital electronic systems. Additional non-silver halide activities come within the lab's orbit too – computerized image manipulation, for example, plus printout by inkjet or dye sublimation (see Chapter 10). Many of these services demand very expensive high-end equipment, and are only financially viable for large custom labs and bureaux servicing professional photographers.

Making a choice

There is clearly a great difference between a simple hand-tank and a fully automatic processing machine, although they can both basically run the same process. Similarly, every update in a process which can reduce the processing time (or, better still, combine

solutions without loss of quality) means a substantial increase in output from the bigger machines. Before deciding on what equipment to buy (or whether to use a reliable custom laboratory instead) think hard about each of the following.

Pattern of workload

Is this steady and consistent, or varied and erratic? Do you want facilities that are flexible, or need to churn out steady quantities using one process only? How important is speed? Would it be best to buy something that has greater capacity than your immediate needs, with an eye on the future? (Perhaps you could also do some processing for other photographers in the first instance.) Should you consider buying a digital printer or digital minilab?

Cost

This is not just the capital cost of the equipment but the often high-priced chemicals it uses, plus servicing and spares. Cheapest outlay is on labour-intensive facilities like a hand-tank line, but this will take up a lot of your time. Paying someone else to work it could prove more expensive than an automatic machine.

Installation

Do you have enough darkroom space, suitable water supplies, sufficient ventilation – especially where dye-bleach processing will take place? (Some chemical kits include a neutralizer that you mix with discarded bleach before disposal.) Will the floor stand the weight? Large tanks of chemical or wash water are very heavy. Is the ceiling high enough? Apart from dip-and-dunk needs, large roller processors must have sufficient headroom to enable you to pull out racks vertically for cleaning. Perhaps you should consider a minilab as the most compact and self-contained kind of machine for large volumes of small prints?

Troubleshooting

Are you the type to conscientiously maintain good batch-to-batch quality on the kind of equipment you intend to have? For example, it may be best to choose some form of one-shot processing if you are likely to forget to replenish. Are you prepared to wash out racks of rollers thoroughly or trolley-in a heavy cylinder of nitrogen? Above all, if results come out with increasingly green colour casts or some other unexpected effect, will you wish you had used a laboratory or do you have enough persistence and interest to track down the cause and correct it? This is where some form of process monitoring will let you know what is going on. Monitoring can reveal subtle changes before they start to noticeably damage your results and become difficult to rectify.

Process control

The best way to monitor the total effect of your processing system solution condition, temperature, timing, agitation and general handling – is to put through some exposed film. Then by comparing your results against some of the same film processed under ideal conditions variations can be measured. To do this job properly, you need the following items:

1. An exposed test piece of film or paper to process, plus another identically exposed to the same image and known to be correctly processed;

2. A densitometer: an instrument to make accurate readings of results and

3. The monitoring manual or software package issued by the film/ processing kit manufacturer to diagnose likely causes of any differences between your results and the reference film.

None of this is cheap, but it is a form of insurance which becomes more valid the larger the scale of your processing. However, there are also some short cuts, as you will see shortly.

Process-control strips

These are strips of film or paper a few inches long exposed by the film manufacturer under strictly controlled conditions and supplied ready for processing in boxes of 10 or 20 or so. Different strips are made for each black and white and colour process in which process control is normally practised. Each strip has been exposed to a scale of light values (Figure 12.14). Colour strips also contain some coloured patches and (sometimes) a head and shoulders colour portrait image. One strip in each box has been processed by the manufacturer under ideal laboratory conditions to act as a comparative standard. Each reference strip and control strip have a code number that indicates the batch of film (or paper) that was used. The manufacturer provides correction numbers for the specific batch. Follow the manufacturer's instructions when you change to a new batch of strips.

Unprocessed control strips are best stored in a freezer at –18°C or lower so that changes in the latent image cannot occur. Allow them time, around 15 min, to return to room temperature before use (the same applies for the reference strip – if it has not reached room temperature the density readings will be wrong). The idea is that one control strip is processed at regular intervals (once a day, once a week, or even with every batch of film, according to your pattern and volume of processing) alongside the batch of film you are processing, then checked against the manufacturer's reference strip. Unprocessed control strips must be handled by the edges to avoid any damages on the emulsion or fingerprints. Store the reference strip in its envelope. You will avoid colour fading of the strip due to unnecessary exposure to light.

Reading results

After you process the test strip, you can do an initial check by viewing it side by side with the reference strip on a lightbox. This will show you any major processing errors at once (Figure 12.16). For a more thorough evaluation of the process, however, and to detect very slight drifts (especially colour) you must use an instrument known as *densitometer*.

With a densitometer you can accurately make spot readings off the tone or colour patches on your process-control strip. The densitometer has a transmission illumination head for films (passes light through the film base from below) plus a reflection head which reflects light off print surfaces at a fixed angle. Light-sensitive cells receive the light and make a Status V reading of black and white visual density. For reversal film or colour printing papers, Status A red, green and blue responses are measured and correspond broadly to the visual effects of the cyan, magenta and yellow dye images present. Equal red, green and blue Status A readings indicate a visual neutral. Red, green and blue Status M responses are measured for colour negative films and can be used to predict printing conditions necessary for consistently neutral balanced prints, as well as for quality control purposes when appropriate test strips are used. Density values appear on a readout panel.

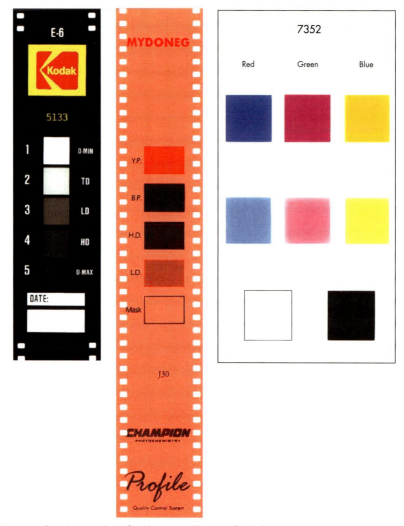

Figure 12.14 Processed monitor control strip for colour reversal (positive) film (left), colour negative film and negative/positive colour paper.

The difference between each reading and that of the equivalent part of the reference strip is logged on a special chart (Figure 12.15). The procedure is much easier if your densitometer feeds a computer plotter with a program which places each reading you make directly onto a chart displayed on its monitor screen. Plots can then be printed out as hardcopy and archived on computer disk.

Deciding what it all means

Your process-control chart is designed to make variations stand out clearly. Unless something disastrous has happened (developer contaminated with bleach/fix, for instance), plots should not

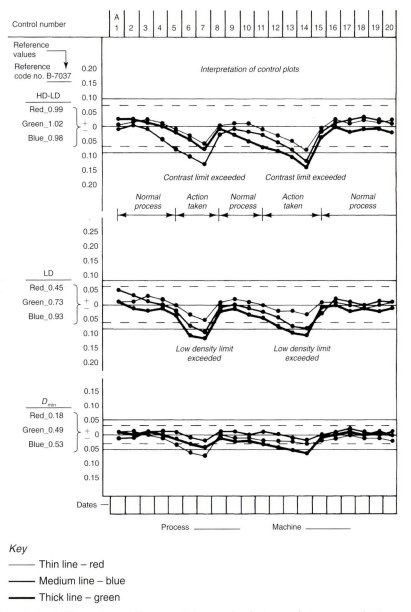

Figure 12.15 Monitoring chart for a colour negative process. Reference values for the manufacturer-processed strip appear in left-hand column. For each strip put through with film, red, green and blue readings are made from each of high density, low density and D_{min} steps. These are turned into density difference (top), low density (middle) and D_{min} (bottom) comparisons with reference values. Notice how the tolerance limits (shown by broken lines) become narrowest at D_{min}.

vary greatly. Trends are more important than individual values. Plots which show upward trends indicate overactivity, with too much dye formation in colour materials. Downward trends usually suggest the need for replenishment. Also note that sudden changes indicate different types of problems in the processing than gradual changes.

Typical film appearance	Probable cause
Colour reversal film	
Too dark, with colour cast	Insufficient first development
Completely black	First and colour developers interchanged, or first developer omitted
Yellow, with decreased density	Fogged in first developer
Yellowish cast	Colour developer fault, e.g. too alkaline
Very light, blue cast	First developer contaminated with fixer
Too light overall	Excessive first developer
Contrasty colour negative	Contamination of first developer. Given colour negative processing
Blue spots	Bleach contaminated
Fungus or algae deposits	Dirty tanks
Scum	Dirt in solutions
Control plots showing:	
all densities up or down	First developer errors creating speed changes
all low, blue plot least affected	Excessive first development
Colour negative film	
Image light, and with reduced contrast	Underdevelopment
Image dense and very contrasty	Overdevelopment
Streaked and mottled image	Insufficient agitation
Heavy fogging, partial reversal	Exposure to light during development
Reddish-brown patches	Contamination of solutions
Completely opaque, or cloudy image	Bleach or fixer stage omitted
Colour positive, with strong cast	Given reversal processing
Opalescent yellow overall	Exhausted bleacher
Fungus, blue spots	As per reversal transparencies

Figure 12.16 Colour film processing faults. (Some of these may differ in detail according to brand and types of film.)

The manufacturer's manual or computer software for the process will reproduce similar patterns and give help and advice on action to be taken. You must check whether any of the process parameters exceed tolerance limits. In that case you have to stop the processing and determine the problem. Always make any adjustment gradual and allow it time to take effect.

If you do not want to do the process control yourself and purchase further equipment, you can subscribe to the manufacturer's laboratory check service.

Silver recovery

Discarding chemicals in the drain pollutes the water and you can be prosecuted if you do not do something to reduce effluent silver polluting public waste treatment systems, as laid down by ecological controls. Check with your water supplier or local environmental authorities to ensure that you dispose photographic chemicals safely.

Film fixing and bleach/fix solutions gradually accumulate an appreciable quantity of soluble silver salts from the materials they have been processing. Used black and white fixer can contain up to 4 g of silver per litre. It is possible to reclaim some of this metal from fixer solution and sell it to a silver refiner. Silver recovery is an option that you should consider not only for ecological but also for financial reasons, depending on the quantity of photographic materials you are processing. The method of silver recovery depends on the volume of disposable chemicals, the cost of the recovery equipment and the time and effort needed to use it.

Metal exchange Electrolysis

Figure 12.17 Two methods of recovering silver from a spent fixing bath. Metal exchange technique uses iron (steel wool) which is in a container where the spent fixer solution passes from and bleds off to waste. The steel wool converts over several weeks to grey silver. In electrolysis current flows from anode (A), plating the silver onto cathode (C).

In practice studios and smaller labs often go for a bulk collection service. Big users, processing over 50 000 films a year, can seriously consider on-site *treatment* or on-site *recovery*, and here the two most common methods are *metal exchange* and *electrolysis* (Figure 12.17).

Colour printing equipment

Colour printing is more demanding than black and white because in addition to your skills of judging exposure, shading and printing in, etc. you have to develop the skill of judging colour and make colour corrections. You work in different darkroom conditions, under very dim safelights or in complete darkness. The processing of the printing material is also different, you do not work with open trays and you have to keep tight control of the processing conditions. It is also important to check whether you have normal colour vision, if you find subtle colour differences difficult to detect (see page 82).

To colour print you basically need an enlarger with a lamphouse which not only evenly illuminates the film in the carrier (as in black and white) but can also be altered in colour content. Colour adjustment is vital to give you *flexibility* – within reason, you can match the colour balance of the film image you are printing to suit the batch of colour paper, compensate for enlarger lamp characteristics, etc. Above all, it lets you fine-tune your record or interpretation of the subject. There are two main ways of controlling illumination colour:

1. Giving one exposure using yellow, magenta or cyan filters in the light path. This is the most common method and known as 'subtractive', or
2. Giving three different exposures, separately through blue, green and red filters. This is known as 'additive' printing (see Chapter 4).

Subtractive filter ('white light') enlarger heads

A typical colour head enlarger uses a tungsten halogen lamp with built-in reflector. (More light is needed than given by most black and white heads, due to losses later in the filtering and light-mixing optics.) Power to the lamp should be through a voltage-stabilizing transformer which smoothes out any dips or surges of current caused by other electrical equipment nearby that would produce changes of lamp colour temperature.

Next in line come three strong yellow, magenta and cyan filters. These slide into the light beam by amounts controlled by three finger dials on the outside casing or solenoids in circuit with some electronic system such as a colour analyzer (see page 296). Filters themselves are

dichroic types, glass thinly coated with metallic layers which reflect the unwanted parts of the spectrum and transmit the remainder, instead of filtering by dye absorption of light. This gives them a 'narrower cut', a more precise effect on wavelengths, avoiding the usual deficiencies of dyes. They are also more fade-resistant – important when you keep introducing part of a filter into a concentrated light beam.

The effect on printing light colour depends on how much of each filter enters the beam – a 130 Y filter pushed across one fifth of the light beam has a 26 Y effect. Values are shown on finger dials or diodes, typically between 0 and 130 or 200 for each hue.

The stronger the yellow filtering you use, the more blue wavelengths are subtracted (absorbed) from the white enlarger light. Similarly, magenta filtering subtracts green and cyan subtracts red. You can watch the light changing colour as you turn the dials. Altering each control *singly* from zero to maximum units tints the light increasingly yellow, magenta or cyan; increasing filtration on *two* controls together gives red, green or blue. If you advance *all three* controls the light just dims because, when equal, the three filters simply form grey neutral density (Figure 12.18). There is no appreciable colour change but the exposure time becomes

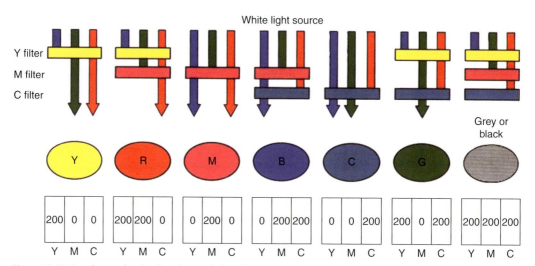

Figure 12.18 An enlarger colour head may have only three filters, but by adjusting dial-in controls you can change the light through a wide range of primary and complementary colours. Each primary colour is made by dialling in two filters at a time (shown maximum here). Never use more than two filters at once.

longer. So if during printing you make changes which bring three values into use you should 'subtract neutral density' by taking away the lowest value setting from each, making one of them zero, as shown in Figure 12.19.

There may also be a separate drawer or shelf within the lamphouse where you can fit an additional Colour Printing (CP) acetate filter when the filtration you need is beyond the range of the dichroic system. This is occasionally useful for effects or when printing from early colour negatives. Colour Compensating (CC) gelatin filters are placed under the lens using a filter holder. They can be used for shading or printing-in (see page 293) but note that because they are located between the lens and the paper they may introduce distortions or reduce its sharpness. Always handle the filters carefully to avoid marks, scratches or fingerprints.

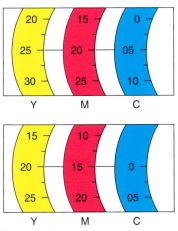

Figure 12.19 Eliminating neutral density. Top: colour head settings here are utilizing all three filters. Bottom: to avoid unnecessary neutral density the lowest setting has been subtracted from all three controls. Colour remains the same but light is brighter.

Most enlargers use interchangeable colour or black and white heads. You can even use a colour head for black and white printing. Dial out all colour filtration, or use the yellow and magenta filters to control variable contrast monochrome paper, following the manufacturer's instructions (see table in Appendix A, page 372).

The remainder of the enlarger – column, movements, timer, masking frame – are basically the same as for black and white printing (see *Langford's Basic Photography*). Some enlarger baseboards can have a roller paper easel attached in place of the regular masking frame.

The enlarger head also contains two permanent filters. One is a heat filter to subtract infrared wavelengths and avoid film overheating, the other an ultraviolet one to absorb any unwanted ultraviolet from the lamp so that it does not affect the photographic paper.

After passing through the filters, the part-tinted light beam is thoroughly scrambled by bouncing it around a white-lined box and passing through a diffuser, large enough to cover the largest size film carrier you will want to use. This way it reaches the film carrier perfectly, even in colour (Figure 12.20). Diffuser enlargers are preferred for colour printing because the resulting contrast matches the contrast of the colour negative and scratches on the film are less noticeable (light is scattered less by the film scratches when a diffuser enlarger is used compared to a condenser enlarger).

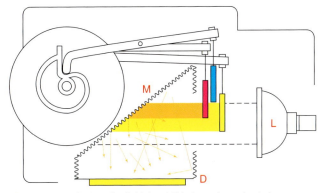

Figure 12.20 Side view of a dial-in head. This shows the mechanical arrangement for raising and lowering the filters into the light beam when finger dials (protruding from lamphead, left) are turned. Matt white lightmixing box (M) scatters and directs light down through diffuser (D) to evenly illuminate negative held in a carrier below.

Enlarger lens

The quality of the enlarger lens is very important because chromatic and/or spherical aberrations caused by low-quality lenses will affect the sharpness of the printed image and may also cause distortions (see Chapter 3). Always fit the best enlarger lens you can afford, preferably one of at least four elements. All modern enlarging lenses are corrected for colour, and there are also apochromatic lenses (APO) with corrected axial chromatic aberration for the red, green and blue wavelengths (see page 46). You choose the focal length of the lens according to the format of the film. For a 35 mm negative or slide use 50 mm lens, for medium format film use 80 mm and for large format, 4 × 5 in., use a 150 mm lens. It often helps to buy a lens with a wider maximum aperture than for black and white work. This makes the focusing of masked

negatives easier to see and more critical. However, always aim to expose with your lens stopped down to about the middle of its *f*-range for best performance.

Additive heads

A few enlargers and printers do not use a variable-strength filtering system. Instead they have deep red, green and blue filters, one fixed over each of three lamps or flash tubes or rigged on a moving carrier which positions one filter after the other across the light beam. Every print is given three exposures, and by varying the times for each colour (with flash the number and strength of flashes) you control the effective colour of the light. Additive printing can therefore be said to expose each of the red-, green- and blue-sensitive emulsion layers of the colour paper separately. It is a system which still suits some automatic or electronically controlled equipment, as all adjustments can be made by timing. Again, it is a low cost way of using a black and white enlarger. However, with a sequence of three exposures, shading and printing-in become difficult.

The subtractive method, however, is the one that is mainly used in photography for colour printing and this is described later in this chapter.

Print materials

Colour print materials are of three main types: Chromogenic negative/positive ('C' type) material such as Ektacolor or Fujicolor, designed for printing from negatives; Chromogenic positive/positive, reversal ('R' type) material; and Dye-bleach positive/positive material such as Ilfochrome.

Both the second and third types are for printing from slides or larger format transparencies, with the second method not being used much any more. Each material needs completely different processing. Most printing papers come in a selection of surface finishes – typically glossy, lustre or semi-matt. Although there is no range of contrast grades as such, some papers intended for direct commercial and advertising uses are made with slightly higher contrast than 'medium' contrast papers for portraiture and pictures for newsprint reproduction.

All colour printing materials have multi-layer emulsions sensitive to the three primary colours of the spectrum. However, unlike camera materials, most papers have emulsions in reverse order, with the red sensitive cyan-forming layer on top. A slight amount of image diffusion is inevitable in the bottom layer but is more hidden if this is yellow instead of the heavier cyan. Emulsion colour sensitivities have steep, well-separated peaks corresponding to the maximum spectral transmissions of the three dyes forming the film image. Remember, printing paper does not receive light from the same wide range of subject colours as camera film – everything is already simplified to combinations of three known dyes. In part of the spectrum (Figure 12.21) print material sensitivity can be sufficiently low to permit the use of safelights which would fog colour film.

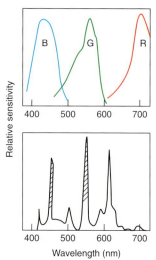

Figure 12.21 Safelighting for colour printing. Top: spectral sensitivity of the paper's three emulsions. Bottom: spectral emission from sodium type safelight. A filter within the unit absorbs the two shaded bands. Peak emission therefore matches the 'gap' between green and red paper sensitivity. However, level of brightness must remain low to avoid fogging from lower energy bands.

Characteristics of the same manufacturer's colour negative films are taken into account in the design of negative/positive print materials. The two are to a certain extent 'keyed' in terms of contrast and the effects of integral colour masking used in the film. Cross-printing maker A's negatives on maker B's paper may need different filtration, but the result, with its mixed use of dye characteristics, may well suit your style of work.

Because of slight variations in manufacture, a few brands of colour print material are labelled with filter and exposure changes relative to other batches, like sheet colour film. (see Figure 12.22). Whenever you buy a stock of paper try to ensure that it is all from the same batch. Take care over storing printing materials too. Keep your stock sealed and located in a refrigerator at 10°C or less, but prevent moisture from condensing on the cold emulsion surface by allowing it time to reach room temperature before use. Exposed paper must be processed as soon as possible to ensure stability of the latent image. If this is not possible, the exposed paper should be refrigerated. Allow it to reach room temperature before you process it.

	Previous print	New print
Paper label	50 Y 40 M 00 C Exposure factor 70	30 Y 25 M 00 C Exposure factor 90
Enlarger setting	60 — 45 — 0 Old subtracted 10 — 5 — 0 Y M C	40 — 30 — 0 Y M C
Time	0 10	$\times \dfrac{\text{New EF}}{\text{Old EF}}$ 0 13

Figure 12.22 When changing from one paper batch to another in the middle of colour printing, compare the paper labels. Differences here guide you to reset filtration and exposure time so that results remain unchanged.

Negative/positive colour printing

The advantage of making colour prints from colour negatives rather than slides is that you get better results from a wider range of subject lighting conditions. The information encoded within a properly exposed integral-masked colour negative allows you to make greater adjustments of colour and tone during printing, without unwanted side-effects such as poorer shadow or highlight quality. However, colour negatives are not easy to judge. The tinted mask and complementary image colours make colour balance impossible to assess visually except in the broadest terms, and negatives often look denser than they really are. It helps to check negatives looking through a piece of unexposed but processed colour negative film of the same brand – the start or end of a rollfilm, for example. The mask colour filters your eye and discounts the mask density present in the negative. Avoid negatives where important shadow detail is recorded as faint or non-existent. As in black and white printing, when you shade these areas the image tones they contain will print artificially flat and will also probably show a colour cast. Panchromatic film and paper should be preferably handled in total darkness. There are safelights which have filters suitable for different types of panchromatic material (see page 288) but even these are not absolutely 'safe'. Panchromatic film and paper should not be therefore exposed to safelight for extended times (try not to expose the photographic paper to safelight for

longer than one minute). Safelight filters have to be tested regularly because they fade with time and they allow a larger part of the spectrum to pass through.

Practical procedure

To contact-print your negatives, proceed as for black and white, projecting an even patch of light on the enlarger baseboard and fitting your strips of film into holding grooves under the glass of a contact printing frame. Stop down the enlarger lens aperture two to three stops. If you are printing these colour negatives for the first time, without any analysing aid or previous notes, set the yellow and magenta filters according to the paper manufacturer's recommendation. If you do not have this information try setting 40 Y 30 M. (Cyan filtration is rarely used in negative/positive printing, except for effects.) Lay a half sheet of paper under part of the set of negatives representative of the whole and give a series of doubling exposure times roughly based on what you would give for black and white paper. Note down filtration and exposure in a notebook or on the back of the sheet. When your test is processed, judge it under your viewing light. Make sure that the paper is dry when making judgements (the colours and density of a wet print change significantly when it dries). If it is out on exposure you may have to test again, but get the density as correct as possible (at least to suit the majority of negatives on the sheet) before you go on to assess colour.

Visual colour assessment is quite a challenging task at first. The rule is to reduce a colour cast, you reduce complementary colour filtration. So you must always remember the 'double-triangle' diagram (Figure 12.23), which relates primary and secondary colours. If your test looks too green, for example, reduce the magenta filtration. This turns your enlarger light greener, which makes the negative/positive colour paper give a more magenta print. So what was originally 40 Y 30 M might be changed by 10 M to 40 Y 20 M for a moderate change of colour. A 05 unit difference of filtration gives a just perceptible alteration; use 20 or more for bigger steps.

If there is not enough filtration already present for you to reduce further, then add filters matching the print cast. For example, a test filtered 00 Y 40 M 00 C may look about 10 units too blue. You cannot reduce enlarger settings by 10 Y, so change the settings to 00 Y 50 M 10 C to increase blue (cyan + magenta) instead. With each change of filtration check out from the manufacturer's data whether you also have to compensate exposure.

Once you have a good set of contact prints you can choose which shot you are going to enlarge, and set up this negative in the enlarger. Filtration is likely to remain the same as for the contact print version, but retest for colour as well as for exposure. Similarly to black and white printing, use paper of the same thickness as your photographic paper on the easel when you are focusing the image, and a focusing magnifier (or 'grain magnifier') for accuracy. Remember to open fully the lens aperture and to remove the colour filters from the light path when focusing, for a brighter image. After focusing, stop down the lens, add the colour filters and start with a series of double exposure times. As with the contact sheet printing, make tests first for correct exposure and then for colour.

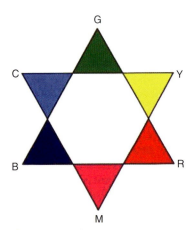

Figure 12.23 Colour relationships (of light). Complementary colours are shown opposite their primaries – cyan opposite red, for example. Any one colour can be made by adding equal amounts of the two colours either side of it.

Use a masking frame with several segments (Figure 12.24) which allows you to cover the paper and expose each time one part of it. To determine the correct exposure more accurately, expose the same part of the image by repositioning the masking frame. Exposure time should be kept within 5–30 sec, otherwise colour shifts may occur due to reciprocity failure (see page 295). If the print needs shorter or longer exposure times, alter the lens aperture.

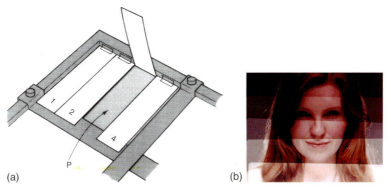

(a) (b)

Figure 12.24 (a) Four hinged flaps of opaque card (white on top) so only one quarter of the paper (P) is exposed at one time. (b) You can also test exposure by covering part of the paper. Times here, top to bottom, are 15, 12, 9, 6, 3 sec.

Process the test print and judge exposure and colour under standard viewing light. Exposure and colour corrections are carried out in the same way as for the contact print.

Colour prints from black and white negatives

By printing black and white negatives on negative/positive colour paper you can produce results which look like toned prints. The image can be one colour overall or different areas of the paper can be given different colours or made to graduate from neutral to a colour (see Figure 12.25). Sandwich your negative with a piece of unexposed, processed colour negative film. Its yellowish mask avoids the need for heavy filtration to get a neutral result, so you then have a wider range of filter options for print colouring.

First, you must establish the filtration for a neutral black and white result. Make a series of exposure tests across several pieces of paper each given large (50-unit) filter changes. Then,

Figure 12.25 Colour print from a black and white negative. The graduated coloured tones in the picture below were created by hand shading, then printing back with changes in the Y + M filtration. Effects are similar to selective toning but more muted and subtle. (By Tim Stephens, courtesy Faber and Faber.)

depending on the colour and intensity of cast in your result, work back with progressively smaller changes until you reach neutrality. Now you select the image colour of your print by appropriate filtration – for example, reducing yellow or increasing cyan to get a warm tint. For a change of tint in chosen areas, shade these parts during the main exposure, then alter filtration and print them back in again. With care you can achieve quite subtle, graduated results, such as a winter landscape greeny-grey at the bottom becoming blue-grey towards the top. It is also possible to work by hand-tinting chosen areas of black and white (large-format) negatives, which then print in complementary colour.

Positive/positive colour printing

When you print images from positive film it is easier to judge for colour balance. You must remember that by increasing the exposure the print becomes lighter instead of darker. When you shade areas they become darker.

Transparency film has no integral masking, and its contrast is greater than a negative because it is designed to look good as an end in itself rather than suit colour paper. Both these features limit your print quality.

Overexposed slides are not suitable for printing because all the detail in the highlights is lost. Choose slides which have medium or low contrast. Also you may prefer to print slides slightly underexposed because the highlights will have detail and can lighten the image in printing. Make sure your film is spotlessly clean. Any debris on the slide prints as black, which is much more difficult to spot-out than the white specks this would produce on negative/positive prints.

Practical procedure

Set up your film in the enlarger, focus the image, stop down the lens and initially set the filtration as recommended by the paper manufacturer for your brand of slide. Test first for correct exposure, then for colour as in negative/positive printing. Vary each band of exposure by about 50% around what you estimate (or measure) to be correct. Try to keep exposure time within 5–30 sec (see page 295).

Process your material and examine dry results under your standard viewing light to judge density and colour. Remember that the darkest segment has had least exposure. Isolate your best exposure result and compare colour with your transparency. If the test looks, say, too yellow, reduce your yellow filtration. If it looks too green, reduce yellow and cyan equally – but if one of these is down to 00 filtration already you can add magenta instead. Avoid having a neutral density situation through using all three filter colours (page 286). Filtration changes of 10 units have a barely discernible effect. Expect to alter 20 units at a time, or 30–40 for more effect – all bigger steps than you normally need in negative/positive colour printing. Get used to making notes of filter and exposure time settings on the back of prints or in a notebook. Having reset your filtration, check whether the changes will necessitate any adjustments to exposure. Calculate this from the manufacturer's table or read it with an analyser.

Shading and printing-in

In negative/positive printing, shade or print-in chosen areas which otherwise print too dark or light, using the same technique as for black and white printing. Sometimes, however, pale neutral areas of your picture tend to pick up too much colour when darkened by extra exposure. This is where it helps to have a selection of gelatin CC filters to use between lens and paper (do not use CP acetate – this upsets definition when used between lens and paper). If the part you are printing-in tends to pick up, say, yellow, then print-in through a hole in a card covered by a pale yellow filter such as a CC 10 Y. Alternatively, add equivalent extra yellow units to your filter head just while you give this extra exposure. Again, when shading a shadow area which has an unwanted greenish tinge, use a green CC filter, such as a 30 G (or 30 Y + 30 C), as your dodger. If this filter is too strong, use it for part of your shading and change to an opaque dodger the rest of the time. If negatives are too contrasty or too flat to print well, pick a paper of lower or higher contrast if available, or try cross-printing on another manufacturer's paper. Alternatively, add a weak black and white mask to reduce or increase contrast.

In positive/positive printing you shade pale parts to make them darker and give heavy areas more exposure to lighten them. You can make local colour corrections by shading with filters. For example, if part of an outdoor shot includes shadow excessively blue-tinted by blue sky, shade this area with a CC 10 Y filter.

If prints show excessively harsh contrast you may have to lower the contrast of your slide by masking it with a faint black and white contact printed negative. As a quicker solution (although more limited in effect) try 'flashing' the paper after exposure. Remove the film from the enlarger, cover the lens with an ND2.0 filter and repeat your exposure time. With dye-bleach materials you may reduce image contrast by developer dilution, but this is likely to make highlights, including whites, darker.

Making a ring-around

A set of differently filtered versions of the same picture made on your equipment forms a visual aid for judging filter changes. This is especially useful since you are working in 'negative colours'. Pick an evenly lit, accurately exposed negative of an easily identifiable subject. It must have been shot on the correct stock for the lighting (unless you habitually use some other combination) and should include some area of neutral tone or pale colour. Make one print with correct colour and density, then change filtration by steps of 10, 20 and 30 units in six directions in turn – blue, cyan, green, yellow, red and magenta (see Figure 12.26). A chart is also provided in Appendix G. Remember to correct exposures as necessary so that all prints match in density.

For positive/positive printing pick a slide which includes some pastel hues and grey or white. Make the best possible correctly exposed and filtered small print first, then increase filtration (or reduce complementary colour filtration) by steps of – say – 20 or 30 units and make other small prints with casts progressively in the directions magenta, blue, cyan, green, yellow and red.

Caption each print with the difference in filtration between it and the correct colour version. (The visual colour change this difference produces remains a constant guide, no matter what

 80Y+80M

 80M

80M+80C

 40Y+40M

 40M

40M+40C

20Y+20M

 20M

20M+20C

20Y

 20Y + 20C

20C

40Y

40Y + 40C

40C

80Y

80Y + 80C

80C

Figure 12.26

negative (or slide) you print.) You must obviously process all prints with great consistency, preferably as one batch. Mount up results logically in chart form and keep them in your print-viewing area.

Use your ring-around by comparing any correctly exposed but offcolour test print from another film against the chart to decide which print most closely matches it in colour cast. Then read from the caption how much to remove from the test print filtration to get a correct print. Remember to avoid neutral density (page 286) and adjust exposure as necessary for the changed filtering. Sometimes your test will fall between two of the ring-around 'spokes', in which case estimate a combination of the two captions and subtract this from your filtration instead. For example, if test filtration of 40 Y 40 M matches a chart cast captioned 10 Y, change to 30 Y 40 M; but if it looks somewhere between 10 M and 10 R (which is 10 Y + 10 M), subtract 10 Y 20 M, resulting in 30 Y 20 M.

Additional points to watch

I f you are only used to black and white there are two further aspects you must remember when subtractively printing all types of colour print material (negative/positive and positive/positive). One is concerned with batch-to-batch variations and the other with reciprocity failure.

Changing batches

Occasionally, in the middle of colour printing, you finish one box of paper and have to start another which you find is of a different batch with different 'white light' filter and/or exposure recommendations printed on the label. The rule with filtration is (1) subtract the filter values on the old package from your enlarger head settings. Then (2) add the values on the new package to the enlarger (see Figure 12.22). Where the new pack shows a different exposure factor, divide the new exposure factor by the old one and multiply your previous exposure time by the result.

Exposure time and reciprocity failure

All colour printing materials suffer from low-intensity reciprocity failure (i.e. greatly reduced image brightness cannot be fully compensated for by extending exposure time). Emulsions become effectively slower with the long exposures for stopped-down images from dense negatives or slides, or at great enlargement ratios. For example, a ×4 enlargement at $f/11$ may need 7 sec. When you raise the enlarger four times as high for a ×16 result the calculated or

Figure 12.26 (Continued) A ring-around chart for negative/positive colour printing. Filtration data shows what to subtract from present filter settings if a print showing this cast is to revert to correct colour, centre of chart. Extreme colour shifts of 80 are included here to clarify the differences between the six colours – particularly between red and magenta, and between blue and cyan. Exposure times have been adjusted where necessary to compensate for filter change effects on density. This page is a guide to the direction and intensity of colour shifts, but for greater accuracy make your own chart using actual colour prints. In the illustrated ring-around, the filtration for the image in the centre was Y = 53, M = 6, C = 0 (Exposure: $f/5.6$, 8 sec). Some examples of filtration in this ring-around: Image 40Y: Y = 93, M = 6, C = 0. Image 20M: Y = 53, M = 26, C = 0. Image 40C: Y = 53, M = 6, C = 80. (Images printed with a Durst Pictochrom Diffuser Enlarger with a Schneider 50 mm $f/2.8$ lens.) Reproductions here can only approximate print results. Images and ringaround by Andrew Schonfelder.

light-measured exposure becomes 112 sec. However, at this long exposure the print appears underexposed, and if you further increase the time, results become correct density but show changes in colour balance and contrast due to different responses in each emulsion layer.

The best way to avoid trouble is to aim to keep all exposure times within about 5–30 sec by altering the lens aperture whenever possible. Colour enlargers designed for large prints therefore need to have powerful light sources. They may have a diaphragm near the lamp so you can easily dim the illumination for smaller prints without changing colour content. You will also find some negative/positive papers with reciprocity characteristics specially designed to give best performance with long exposures, i.e. big prints.

Colour/exposure analysing aids

The less filter calculation and guesswork you have to do, the faster you get to a good colour print. There is a choice of several analysing aids, from viewing filters to expensive colour video. All the devices described below are designed for negative/positive printing, and most also work for positive/positive printing.

Viewing filters

If you view a faulty test print through a filter of appropriate colour and strength you can tell the best change to make to enlarger filtration. Look through CP acetates, as used for filter drawer enlargers, or buy sets of similar filters (Figure 12.27) in cardboard mounts. Have the print under your standard viewing light and hold the filter about midway between print and eye. Do not let it tint everything you see and do not stare at the print through it for more than a few seconds at a time – keep flicking it across and back. Viewing too long allows your eye to start adapting to the colour (see page 81).

Figure 12.27 Colour print viewing filters. You need a set of six of these triple filter cards. Each card has filters which are the same colour but differ in strength. Pick the filter which best corrects your test print cast.

If your test print is too 'warm' in colour, try looking through blue, green or cyan filters; for 'cold' prints, try yellow, magenta or red. As with colour transparencies viewing through a filter tints the appearance of highlights far more than shadows. So only judge appearance changes to your print's lighter middle tones. Having found which viewing filter makes these tones look normal, read off the required enlarger filter changes printed on its cardboard mount. (Negative/positive colour printing changes appear one side and positive/positive changes on the other.) Alternatively, if you are viewing through CP filters and printing negative/positive the rule is: *remove from the enlarger filtration the same colour but half the strength of your viewing filter*. For example, if a test print with a green cast shows corrected midtones viewed through a 20 M filter, remove 10 M from the enlarger. If this is impossible, add 10 Y + 10 C.

Electronic analysers

There are a great number of electronic analysers available. All make tricolour measurements of your negative or slide and read out the most likely filter for your enlarger and paper batch. They also measure exposure. Most analysers are for 'on-easel' use – they have the advantage of

measuring the same image light that will eventually expose the paper. Some analysers are 'off-easel'. They work separately, like a densitometer used for process monitoring, and allow you to measure your film images outside the darkroom before printing. One skilled user can therefore serve a number of enlargers.

Off-easel analysers have to be programmed for the characteristics of the particular enlarger through which your film will be printed. Then they compare readings of each negative against a memorized standard negative for which correct filtration and exposure are known. This kind of equipment best suits large laboratories employing many staff and turning out volume work.

Self-correcting systems

Several professional colour enlargers have built-in systems for self correcting colour filtration. To begin with, the lamphouse may include a 'closed loop' in which tricolour sensors in the lower part of the mixing box (Figure 12.28) measure the colour content of light reaching the negative. It detects whether any changes have occurred since the enlarger was set up – perhaps through a lamp change, changing to a larger format mixing box, or just the slow effects of ageing throughout the system. The information feeds back and causes small compensating adjustments to the zero position of the filters. So each time you start up the enlarger it runs through a brief light-checking program, ensuring that any filter values you use will have exactly the same effect on the image as last time.

Other systems go further and set filters for you by evaluating a test print. You first have to expose an enlargement test strip, choosing a suitable mid-grey area of your film image or using a grey negative supplied. After processing and drying, the paper test strip is either clipped over a window on the side of the lamphouse or, in some systems, is placed in a special holder replacing the film carrier. Here sensors compare its greyness against a built-in reference grey patch, both being illuminated by the light of the lamphouse itself. Sensor circuitry determines what filter and exposure changes are needed to correct any difference between the two for your next print. Test analysis of this kind checks all your variables – from lamp to processing chemicals – and can be repeated more than once to finely tune results before your final print.

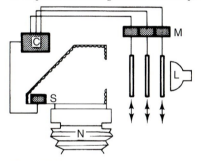

Figure 12.28 Basic layout of a 'closed loop' lamphouse system. S: sensor for illumination colour. C: control unit. M: motors to adjust the zero position of filters so that lighting colour is always consistent. (N: negative.)

Video aids

Video analysers are off-easel systems which may consist basically of an inverted enlarger colour head (forming a lightbox for your film image) viewed by a special closed-circuit colour video camera with zoom macro lens. The tricolour channels of the video system must closely match the relative colour sensitivities of the three emulsion layers in photographic colour paper. Your picture appears on a colour monitor, and, by turning a switch, colour negatives are presented as high-quality positive colour images. So it becomes easy to evaluate picture content, portrait expressions, etc. and you can zoom in to preview how different kinds of cropping might look.

These features alone make video a useful tool for selecting colour and black and white negatives for printing when contact prints are not available. For colour analysis, adjust filtration

on the lightbox until the picture on the screen looks at its best, then transfer these settings to your enlarger. Like all off-easel systems, video analysers have to take into account your enlarger characteristics and current paper batch data, programmed in and held in a memory.

Other colour lab procedures

Display colour transparencies

By using colour print emulsions coated onto sheets and rolls of film you can make enlargements for various kinds of public display. Some of these materials (such as Kodak Endura display materials) are negative/positive working and processed in RA-4 colour chemicals, although given longer times than paper. Others (such as the Ilfochrome display film) work on a positive/positive basis, allowing you to print direct from a colour transparency but requiring appropriate R-3 or dye-bleach reversal processing.

Print film materials are made with various bases, designed for different applications. With a clear base film type, for example, you can make standard 10 × 10 in. (254 × 254 mm) transparencies used as visual aids on an overhead projector for group audiences at sales presentations, teach-ins, etc. Large, clear film transparencies can also be displayed on any lightbox fitted with a diffuser, and since they can be 'stacked' this is a simple way of sandwiching together several images, or image plus text, to form composites. Print film on a translucent self-diffusing base allows your enlarged image to be displayed either on a lightbox or just in front of bare strip lights – for billboards, illuminated panels at exhibitions, gallery shows, shops, restaurants, etc. This can be a very effective way to make and show high-quality colour images.

All print film material is handled in a similar way to paper. When making tests you must view and judge your processed results against the same lighting system to be used when the work is finally displayed. Overhead projector transparencies, for example, must be much paler than transparencies destined for lightbox displays.

Dupe slides from slides and transparencies

Duplicating films are in a variety of sizes, from 35 mm to sheet film. Using low contrast 35 mm reversal duplicating colour film, you can make colour slides from other slides and transparencies.

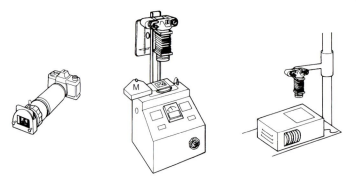

Work with a 35 mm camera and macro lens in conjunction with one of the copying devices shown in Figure 12.29. The camera's through-the-lens (TTL) light reading takes close-up imaging into account. Some copiers contain their own light sources – either flash (suits daylight film) with modelling light for focusing and exposure-metering, or a tungsten light enlarger

Figure 12.29 35 mm copying systems. Left: simple tube attachment incorporating 1:1 close-up lens. Centre: copier containing flash unit and modelling lamp. Right: inverted head from a colour enlarger forms a tungsten lightbox for copying. Controls here adjust colour balance.

lamphouse used upside-down. Simpler copying attachments have to be pointed towards a suitable source. They hold the slide at the far end of a tube containing optics for 1:1 imaging. Since camera and subject are firmly locked together you can hand-hold even quite slow shutter-speed exposures. No slide reproduced in these ways will quite match the sharpness and tone gradation of an original shot, so it is always better to run off a series of slides from the original subject if you know that several copies will be wanted. Nevertheless, you can definitely improve slides which have a colour cast by duplicating them through a complementary colour filter (see Figure 12.30) or scan them and correct the colour cast digitally. You can also improve on a slightly dense, underexposed slide by giving extra exposure while copying it. Copiers have other useful functions for special effects such as sandwiched slides, double exposures, etc. Duplicating film is processed in regular E-6 colour reversal film chemistry.

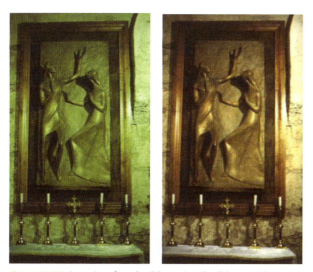

Figure 12.30 Correction of cast by slide copying. The slide, near right, was shot in fluorescent lighting and shows a characteristic green cast. In making the 1:1 copy, far right, a CC30 M filter has produced correction.

■ Today's mainstream chemical processes for silver halide *films* are black and white negative, colour reversal and colour negative types. Dominant *print* processes are black and white negative/positive, colour negative/positive, colour positive/positive. Each colour process comes as a planned kit – sometimes in amateur or professional, shortened or regular versions.

■ The widest choice of developers exists for black and white processing. Differences include contrast, film speed, grain and resolution. Some are designed for you to dilute and use one-shot, others have long-life performance for use in a deep tank.

■ Monochrome print developers are chosen mostly for the image 'colour' they give, especially with chlorobromide emulsions. Fast developing RC papers can be machine processed.

■ Timing of the first stage of reversal colour film processing (black and white development) is adjustable to push or hold back film speed.

Colour development times, during which couplers form dye images should be considered inflexible for colour films. Times can also be varied when developing monochrome chromogenic films.

■ Cross-processing colour films gives coarsened subject hues and distorted contrast. Both can be effective for off-beat images.

■ Negative/positive colour printing materials include (RC) paper and film base. Colour development is followed by bleach/fix and washing.

■ For reliable processing look after temperature, timing, agitation, the state of chemicals and the way photographic material is physically handled. In all processing, be accurate and consistent.

■ Prepare chemical solutions safely, and according to detailed instructions. Do not risk contamination through insufficient rinsing of mixing gear, containers, etc. or sloppy working.

SUMMARY

■ Process control allows you to monitor your entire system by regularly processing pre-exposed control strips, then comparing results against a manufacturer-processed strip. You can send off for regular analysis or measure results on the spot using a computer-aided densitometer and diagnostic software.

■ Ecology-based laws prohibit you from discharging silver effluent. Use a bulk collection service for spent fixer. Large labs may economically opt for on-site metal exchange treatment, and/or electrolysis silver recovery. The latter allows you to regenerate your fixing solution and put it back to use.

■ Subtractive, 'white-light' enlarger heads use different strengths of yellow, magenta and cyan filters, two (but not three) colours at a time. Additive enlargers/printers control print colour via differences in exposures through each of deep blue, green and red filters.

■ Darkroom facilities beyond black and white requirements include an analyser, appropriate safelights, increased ventilation. Have a white-light viewing area for judging colour tests.

■ The main types of colour print materials are chromogenic negative/positive and dye-bleach positive/positive. Colour sensitivities of each 'set' of emulsion layers correspond to peak transmission of the three image dyes in colour film. Similarly, print materials are keyed to the contrast and masking (if any) of the same manufacturer's film. Store in refrigerated conditions.

■ Colour negatives are difficult to assess, but working negative/positive suits wider ranging subject conditions and allows greater adjustment of colour and density. Test your print first for exposure, then for colour. Avoid negatives that are underexposed. To reduce a print cast, decrease complementary filtration; shading and printing-in follow black and white practice. When printing from slides, increasing the exposure lightens the print, and to reduce a cast, reduce filtration matching it in colour. Shading darkens and printing-in makes areas lighter. A ring-around print set forms a filtration visual aid. Always judge prints dry. Changing filtration has a stronger effect in negative/positive than the same filter shift in positive/positive printing.

■ Avoid long exposure times – reciprocity failure upsets colour and contrast, although some colour papers are made specially for long exposure (large print) conditions. Where possible, widen the aperture instead.

■ Viewing filters provide a simple test-print colour-analysing aid. Add to the enlarger half the strength of the filter making positive/positive midtones look correct (complementary colour if negative/positive). Electronic analysers work 'on-easel' or 'off-easel' serving several enlargers, make integrated or spot readings of colour and exposure. They compare characteristics of film images to be printed against a standard image for which settings are known.

■ Basic additive colour printing demands simplest gear, although it is also difficult to shade or print-in. Colour is controlled by the proportion of three separate exposures through deep blue, green and red tri-colour filters.

■ Prints made from black and white negatives onto colour paper can be given a toned image appearance. Establish filtration for neutral black and white. Then vary colour and intensity across chosen areas by shading, changing filtration and printing-in.

■ The modern colour lab handles a mixture of silver halide and digital systems.

1 Make a ring – around of colour prints from black and white negatives, using the filters of a colour enlarger.

(a) Sandwich your black and white negative with a piece of unexposed processed colour negative.

(b) Make tests for correct exposure and establish the filtering that gives you a neutral result.

(c) Make one print with correct colour and density, and then change filtration by steps of 10, 20 and 30 units in six directions – blue, cyan, green, yellow, red and magenta (see chart in Appendix G). You must correct exposure when you change filtering so that all printed images have the same density.

(d) Keep a record of exposure and filtering for each print, for future reference.

2 Test both exposure and colour filtering with one sheet of colour paper. Use a device (you can also make it yourself) that has segments which allow you to expose one part of the paper each time (see Figure 12.24). The flaps should be white on top so that you can see the projected image when they are closed. Set filtration for the film type as recommended by the paper manufacturer.

(a) Lift the first flap and expose four bands for different exposure times, shading with card. Return the flap to its original position.

(b) With all flaps protecting the paper, switch on the enlarger again so that you can view the projected image on the closed flaps. You want to test exposure and filtering at the same area of the image so you have to shift the masking frame so that the strip of image exposed when you opened the first flap now falls on the second flap. Increase or reduce filtration by appropriate units in one direction.

(c) Switch off enlarger, lift the second flap, and expose four exposure bands again. Continue for the rest of the flaps. When you process the sheet you will have a series of different filtrations at four exposure levels.

PROJECTS

This chapter discusses six main topics. They are all imaging techniques that deviate from the 'usual' techniques discussed up to this point. They may require particular skills, material and apparatus such as special filters, films or sensors, dedicated lenses, viewing devices, etc. Infrared (IR) photography, ultraviolet (UV) reflectance and UV fluorescence photography are used often to determine properties in captured scenes that are not distinct enough or even invisible under visible light. Underwater photography needs specialized waterproof equipment. Panoramic photographs can be created using an array of techniques and equipment, from conventional to very specialized. Stereo imaging requires pairs of cameras with matched lenses, linked shutters and diaphragms. The results, which appear three-dimensional, are often viewed with specialized accessories. Finally, working with liquid emulsions as well as transferring pictures from Polaroid material comes under the heading of home-made printmaking.

Photographing the invisible

The human eye is limited to perceive only a very small part of the electromagnetic spectrum which extends from the blue-violets to deep reds at wavelengths from 380 to 700 nm. The sensitivities of photographic material and sensors extend beyond the visible and can record properties in the world around us that the eye does not see. The interaction, by way of reflected or absorbed energy from particular subjects of UV or IR rays yields information that can be used for scientific purposes, but equally may enrich the creative photographic experience. The properties and proper use of photographic sources, media and methods for recording beyond the deep reds and the blue-violets are discussed later.

Infrared photography

Infrared photography uses a small part of the invisible infrared spectrum – wavelengths ranging from about 700 to 1200 nm – which extends beyond the deep reds. This part of the infrared spectrum is referred to as near infrared to distinguish it from far infrared which is the spectral region used in thermal imaging. Traditionally, infrared images were captured using a black and white film, or a 'false-colour' infrared reversal film. With the use of digital cameras today infrared photography is easier than ever.

Infrared properties

To make most of your photographic sources and the scenes that you capture it is important to know some basic properties of infrared radiation. To start with, infrared is strongly reflected by chlorophyll. This is why in final prints of infrared photographs any living green flora (plants, leaves on trees, etc.) appears whitish and, if under strong sunlight which provides plenty of

infrared, snow-like or luminescent. There is a small contribution from chlorophyll fluorescence but this is not the main reason why foliage appears bright in infrared photographs. Chlorophyll reflectance makes infrared photography important to agriculture and forestry applications.

There is a strong absorption of infrared by water and moisture in the atmosphere. Thus, often lakes, but also clear skies, appear very dark in prints with small white clouds standing out starkly (see Figure 13.1). All these characteristics give a strange dream-like atmosphere to scenes and can be very attractive. Because of the penetrative properties of infrared, there is a slight diffusion of detail when images are recorded, specifically on of Kodak high-speed infrared film. This is a property of this film only but adds to the ethereal mood.

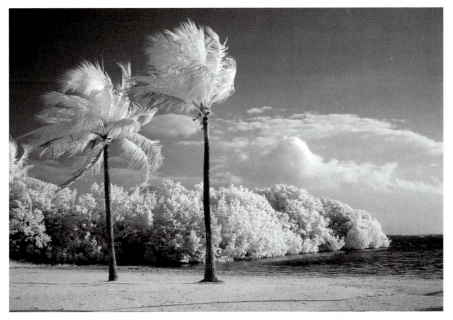

Figure 13.1 Living green flora appears whitish while the sky and the water appear dark in this infrared image.

Infrared has the ability to penetrate where visible light cannot. It penetrates the top layers of the epidermis and is reflected back from deeper in the skin. Portraits are turned into weird-looking macabre faces with translucent facial tones and bleached lips. Also, the visibility of the veins is accentuated. Haze penetration (that is in dry atmosphere, but not vapour, fog or smoke) by infrared is caused by reduced scattering in the atmosphere compared to visible light. That makes often distant landscapes look exceptionally clear with plenty of detail and is the reason infrared is commonly used in long-distance and aerial photography. All glasses transmit infrared, but also plastic, and some types of inks and paints transmit infrared. The infrared penetrative properties turn this type of photography into a useful tool in police investigations, such as forgery detection, where invisible details underneath document surfaces can be picked up in photographic prints. In museum application it is used for restoration or historical purposes to discover any underlying layers in paintings and other artefacts, or to differentiate inks and pigments. In medicine it is used to image clotted veins and poor blood circulation.

Infrared sources and filters

Apart from the sun which provides ample infrared, artificial light sources are also very common in subject lighting. Since heat emission is accompanied by infrared radiation, the tungsten filaments in incandescent lamps and in photoflood and flash lamps are especially suitable as they heat metal filaments to incandescence (see Chapter 4). They have the peak of their emission in the part of the infrared where the films and sensors have their maximum sensitivity. Electronic flash tubes are also excellent near infrared sources whereas fluorescent tubes used for indoor lighting have poor infrared emission. Bear in mind that it is possible to record radiated heat from objects from above approximately 300°C to incandescent temperature. Most infrared photography is accomplished by infrared shone on subjects and reflected back to the camera, as little infrared is emitted by non-incandescent bodies.

Unless you use a filter to block visible light your infrared films and digital camera sensors (with infrared blocking filter removed) will record both infrared and light reflected from the scene. Blocking partially or totally the visible light is achieved by deep red filters which stop blue and green wavelengths or visually opaque filters, called *barrier filters*, with various cut-off points. It is possible to record infrared only in the darkness by filtering the light source, so that only infrared reaches and is reflected from the subject (Figure 13.2). In most cases barrier filters are fitted over the lens, for example the Kodak Wratten, series #87, #88A, #89A, Hoya #72 and others (Figure 13.3).

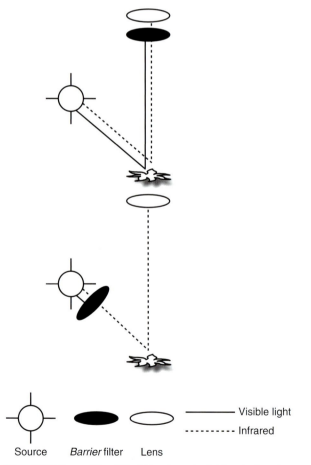

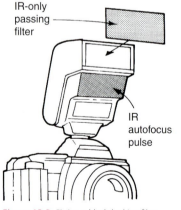

Figure 13.2 Fitting a black-looking filter over the flash window allows you to take pictures without the flash seeming to fire. The flash unit may also have an infrared prepulse unit for autofocusing.

Figure 13.3 You can filter visible light and record only infrared reflected from your subject by placing a barrier filter either in front of the lens (top) or in front of the light source (bottom).

Traditional photographic techniques

Two or three brands of infrared-sensitive film and one brand of infrared colour reversal film are produced today. Most cameras can be used for infrared photography with the exception of plastic-body cameras (infrared penetrates plastic, see page 303) as well as cameras that have infrared sprocket-hole sensors that will fog infrared film. Also, not all dark slides and bellows in large format cameras are opaque to infrared radiation and should be tested before use in infrared photography. Most camera lenses are not designed to focus infrared exactly at the same point of focus as visible light, as they usually refract infrared radiation a little differently from the visible. You need to compensate for this focal shift or shoot at a high enough f-stop to cover focus errors. When the lens of a single-lens reflex (SLR) camera is covered with a barrier filter that is opaque and stops visible, focusing through the lens becomes impossible. If lenses have a red point on the side of the lens-setting mark, you should focus visually (manually or using autofocus), note the subject distance reading at the regular lens mark, then reset manually the distance against the red dot instead and finally place the filter in front of the lens (Figure 13.4). A tripod is necessary while you compose the picture.

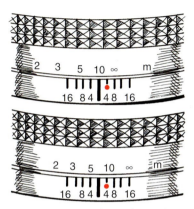

Figure 13.4 Red spot denotes focus setting for infrared. If visible light from your subject is sharply focused when the lens is set for 10 m (top), then re-set 10 m against the spot (bottom).

The accuracy of your exposure metering system is not predictable. It will depend on the individual sensors' infrared response, the absorption, reflection and transmission of infrared in the scene and the film you are using. One technique is to use a hand-held meter set to International Organization for Standardization (ISO) 50 for Kodak infrared film and take the reading without the filter. This will read out approximately correct exposure settings for the camera with a deep-red filter over the lens. It is always safest to shoot a bracketed series of exposures.

Infrared-sensitive films need cold storage as they are prone to fogging from thermal events. Also, the sensitizing dyes employed tend to be less stable than in other films and exposed film should be promptly developed. Films should be loaded and processed in total darkness and using metallic tanks to avoid fogging (remember infrared penetrates plastic). Standard developing solutions are used for infrared material, although prolonged development is recommended. Note finally that the large grains in infrared films make image noise a part of the infrared look.

Infrared photography using a digital camera

The charge-coupled device (CCD) and complementary metal-oxide semiconductor (CMOS) arrays in digital cameras have an inherent sensitivity to infrared. The only difficulty in using them for infrared photography is that cameras are equipped with infrared blocking filters in front of the light-sensitive array that stop infrared radiation which enters the lens and degrade visible light image quality in 'normal' photography. Removing the infrared filter is a possibility in some camera models. Otherwise, with the infrared blocking filter in place you can still use a barrier filter, give more exposure and capture only deep red and infrared. Exposure

Figure 13.5 An infrared image captured with a Canon EOS 5D digital camera.

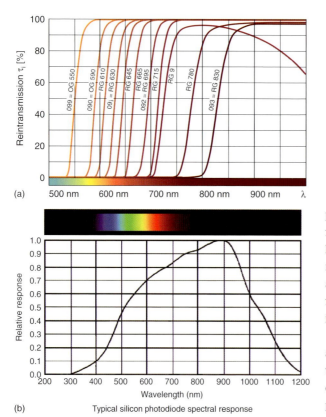

Figure 13.6 (a) Transmittance of various B&W filters used for infrared photography. Reprinted with permission from Schneider Kreuznach. (b) Silicon photodiodes are sensitive to infrared. Image from 'Sam's Laser FAQ', © Samuel M. Goldwasser, www.repairfaq.org.

compensation depends on how your camera sensor reacts to the infrared, how much infrared the camera filter is blocking and on the barrier filters you are using (Figure 13.6). It will also vary with infrared source and scene properties (Figure 13.5).

In non-SLR digital cameras, real time viewing of the picture on the liquid crystal display (LCD) helps exposure, composition and focusing. You can use auto-exposure and autofocus that in most cases work well. In digital SLRs exposure is measured by a different sensor than the imaging sensor, which probably has a different response to infrared. Thus, you cannot rely on auto-exposure. Additionally, when using any SLR in which viewing is accomplished through the lens you will need to compose and focus the picture without the infrared (barrier) filter, then put it on and shoot. White balance is best carried out in custom mode, with the infrared filter fitted and while pointing the camera at foliage, which reflects most of the infrared, at least in outdoor scenes.

Your final RGB digital images will appear having a reddish or purple tint that will vary according to the camera and the filters you use. Post-processing usually includes image de-saturation or conversion to greyscale and tone adjustments such as tonal stretching. In case you want to retain some colour information,

you can always manipulate the RGB channels individually (see Chapter 11). Digital infrared photographs may be noisier than your 'normal' photographs. Noise can be removed quite successfully with various noise reduction filters. Slight sharpening is commonly used to bring up other important detail.

UV photography

UV photography can be split into two types: UV reflectance and UV fluorescence. In UV reflectance the photographic record is made of UV radiation reflected from the subjects. In contrast, UV fluorescence employs UV radiation to illuminate (and excite) certain materials which then 'glow' with white or coloured visible light that is captured. Other types of radiation can be used to produce fluorescence, but UV is the most common.

UV properties and applications

Similarly to infrared, only a part of the UV spectrum is used in UV imaging. Long UV wavelengths from 340 to 400 nm can be transmitted by photographic glass lenses but shorter ones in the middle and far UV region require quartz or fluorite lenses. Below 200 nm is the vacuum UV, named as such because air does not transmit it and thus it cannot be used for photography. Various optical media transmit UV in a different fashion. UV below 350 nm is poorly transmitted by regular optical and window glass and various plastics. Modern photographic lenses have restricted transmission to 400 nm, especially when are coated with anti-reflection material.

Much of the UV radiation is harmful. Fortunately, ozone in the upper atmosphere absorbs most of the harmful UV coming from the sun. Considerable amounts are however found at sea level due to scattering. It can cause reddening of the skin, is dangerous for the eyes and can cause snow blindness. Long-term exposures to UV causes premature yellowing of the eye and cataract, premature aging of the skin and skin cancer. It is imperative that you use precautions around UV sources. Avoid staring directly at any UV lamps unless your eyes are protected with UV-absorbing goggles.

Owing to shorter wavelengths UV is scattered more than visible or infrared wavelengths. It does not have as strong penetrative properties as infrared, although long-wave UV radiation penetrates deeper into the skin than visible light does. UV reflectance photography is widely used to record, just a few millimetres under the surface of the skin, areas of strong pigmentation. There is virtually no penetration of UV into the tissues, therefore there is no scattering. This results to sharper pictures of the top layers of the skin surface. UV reflectance is a useful method for visualization of skin aging, the damage produced by the sun, tattoos, birthmarks, fingerprints, freckles and ageing spots.

In archaeology and museum applications photographs taken in UV illumination can reveal the structure of a painting's surface layers. UV causes varnishes to fluoresce, and the specific manner and colour of the fluorescence aids in identification of retouching and overpainting or differences in painting pigments.

Reflective UV photography reveals old bruising and bites that are no longer visible. It also works well for cuts, scratches and scars, and organic fluid compounds. This makes it a valuable tool in crime scene investigations. Other types of physical evidence that may fluoresce under UV are fingerprints, gunpowder, footwear impressions and clothing fibres. Further forensic

Figure 13.7 Image illustrating UV fluorescence of pollen. © Bjørn Rørslett/
NN/Samfoto.

applications include examination of old faded documents under UV to obtain better sharpness. Also, different inks show a difference in visible fluorescence when illuminated with UV sources.

UV aerial photography of snowy regions helps in the identification and counting of animals with white coat that reflects all visible wavelengths. While the snow also reflects strongly UV (which explains why it is so easy to get a sunburn while skiing), an animal's coat absorbs it. Other applications where UV imaging is important include astronomy and remote sensing.

UV photography may be used less often than infrared for creative purposes but you can certainly produce very pleasing imagery by employing UV techniques. In exterior scenes foliage appears darkish due to low UV reflectance (unlike infrared), while water is very bright because the surface reflects plenty of UV (this is why we also get sunburned when swimming). Flowers emerge differently than in visible records because there are different amounts of UV reflected from flower petals, often much less in the central area of the flower. Also, the nectar glands and pollen may fluoresce under UV illumination (Figure 13.7). UV visible marks on the petals attract bees – which have a UV-enhanced vision – towards the nectar and pollen of the flowers. This makes UV imaging useful to natural scientists.

UV sources and filters

There are various UV sources with different compositions and methods of use. As with all types of photography sunlight is the most available and cheapest source but the intensity of UV is very variable. It contains long, short and some middle wavelengths of UV. Although much of its short and middle UV content is lost on its way to the earth's surface, much of the long passes through the atmosphere, especially in bright sunny days. In contrast, common tungsten and tungsten–halogen lamps which are rich in infrared are poor UV sources; the latter when operated in high temperatures and contained within a quartz envelope emit some UV.

UV fluorescent tubes coated with a special phosphor (Wood's Coating) absorb most visible and transmit most UV with long wavelengths used in photography. The tubes appear as a very deep violet-blue and they are referred to as 'black lights'. They are the most available UV sources. Another suitable artificial source is the electronic flash which can be used efficiently in combination with aluminium reflectors. Be aware, as often flash units have UV-absorbing glass over the flash tube for the purpose to reduce UV output. This must be removed before the exposure. Otherwise high- and low-pressure discharge lamps emit some strong UV

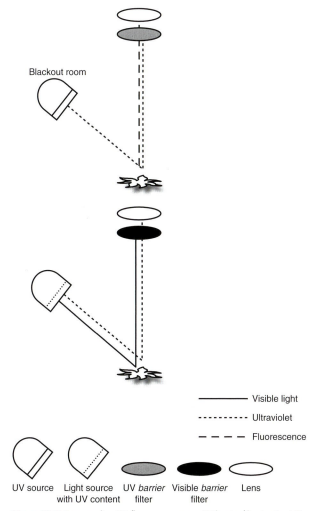

Blackout room

—————— Visible light
- - - - - - - Ultraviolet
— — — Fluorescence

UV source | Light source with UV content | UV *barrier* filter | Visible *barrier* filter | Lens

Figure 13.8 For recording UV fluorescence use a UV barrier filter to stop UV entering the lens so that you can only record the fluorescence from the subject (top). In UV reflectance use a visible barrier filter so that you can record only the UV reflected from the subject (bottom).

lines. Arcs provide substantial emission of UV and are still used as primary sources in photography. The xenon arc lamp is a pretty good continuous source of UV.

As with infrared, you need to use blocking filters to record only the UV reflected from your subjects. These UV-transmitting filters, such as the Hoya U-360 or the Kodak Wratten 18A, are commonly known as 'black light filters'; they may have some violet and infrared transmittance too. In contrast, photographic UV-absorbing filters with spectral transmissions named as 'UV', 'haze', 'skylight' are related to Kodak Wratten series such as 1A and 2B–2E. These absorb UV radiation and reduce the effects of haze without affecting the rendering of visible colours. Absorbing UV filters protect from harmful UV and can be found in sunglasses, goggles and protection sun lotions. In photography glass filters are placed over the lens to avoid much UV to fall on films and camera sensors, to which they are naturally sensitive. Use 'barrier' UV filters that almost totally block UV when you want to record only the fluorescence from subjects that occurs in the visible (Figure 13.8). For UV fluorescence an exciter filter can be placed over the source to allow only those wavelengths through which will cause fluorescence.

UV reflectance techniques

In UV reflectance photography the reflected UV from the subject is captured while visible is blocked with UV exciters in front of the camera lens. All silver halide films, including colour negative and slide films, are sensitive to near UV although pure UV images are recorded only in the blue-sensitive layer. For striking, unusual imaging you can use false-colour infrared slide with appropriate filtration to block the visible and capture simultaneously UV and infrared reflected from the subject, with the UV recorded on the blue and the infrared on the

red-sensitive layers. Images formed with UV tend to be low in contrast and therefore high-contrast films or development should be preferred. Exposure times vary from 4 to 15 stops over what is needed for capturing the visible. Photographing UV reflectance requires a lens that passes sufficient amounts of radiation, thus less compensation is required when using quartz lenses. In any case it is necessary to use a tripod and bracket exposures. Owing to long exposures reciprocity law failure effects may be present.

Remember that UV focuses in a different point to visible, but the focus point displacement is opposite to that of infrared. Unlike infrared photography, correction is not achieved by altering the lens's focal point as there are no UV markers on any SLR lenses. To achieve sharper results focus on the subject in visible light and then close down the aperture to obtain more depth of field. The shorter the focal length the less stopping down you need. Test exposures are the best means for determining the optimum aperture.

Digital camera sensors without UV blocking filters respond to UV too, but are not used as much as they are for infrared recording. Exposure compensation depends largely on your sensor's response and the lens's UV transmittance. It also depends on the available levels of UV radiation and the filter's transmittance. When using non-SLR cameras real time viewing of the picture on the LCD helps exposure – which can be handled usually quite well by the camera – focusing and composition. One way to ensure correct exposure is to check the LCD histogram. As in the case of infrared, RGB digital images are weirdly coloured, with some cameras yielding bluish and some pink or magenta results. Contrast is also low. Since you might end up with relatively long exposures digital noise is likely to degrade your pictures. Similarly to infrared, post-manipulation is required to turn images to black and white or to 'false-colour' records. See infrared photography above for colour manipulation techniques, noise removal and contrast optimization.

UV fluorescence techniques

In UV fluorescence a visible record is obtained from subjects that glow when they are illuminated with UV, whilst UV barrier filters block the UV from entering the lens. Fluorescent part of the subject will glow brightly and you will record exactly what you see (without the barriers the subject is recorded as if bathed with blue light, blotting out most colours). To photograph the fluorescence excited by UV usual colour films and digital sensors can be used. To capture only the glowing visible wavelengths you need to work on a blacked-out studio with your subject illuminated by one or more UV lamps, which usually emit a dim blue light. For controlled fluorescence, use exciter filters over the source. Indoors you might choose to add a little visible daylight from back, the side or the rear. Otherwise the fluorescent parts of the subjects will bath in a black sea. Outdoors natural light does this job, but you might want to filter out some reflected wavelengths, using appropriate colour filtration, to allow mostly the coloured fluorescence to pass.

Apart from flowers, minerals are good subjects for creative photography as well as especially designed plastic jewellery, day glow inks on posters and graphiti sprays (Figure 13.9). Even washing liquid, face powder and teeth will glow to a greater or lesser extent. Some parts of banknotes and labels for consumer products will also fluoresce when illuminated with UV. Measure exposure from the fluorescing parts using regular techniques with your camera or light meter. Spot measuring is often best. Be always aware of the danger of the UV lamps, so use UV-absorbing goggles.

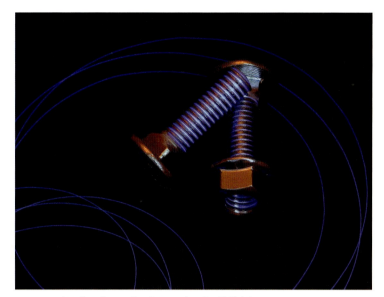

Figure 13.9 You can use several products for creative photography using UV lighting.

Underwater photography

Most underwater photography is intended to show fish and plant life. However, you may also want to take underwater pictures of products, ranging from industrial equipment to fashion items (Figure 13.10). Yet another facet is record photography of wrecks, archaeological objects or marine engineering subjects.

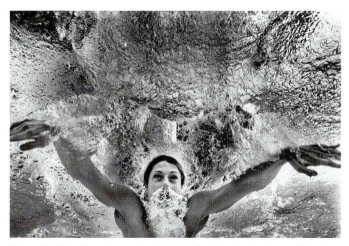

Figure 13.10 An impressive angle on the butterfly stroke, showing how an Olympic swimmer expels air underwater. Chris Smith took this sport shot sitting at the bottom of the pool using a 35 mm lens on a conventional SLR camera.

You can photograph small objects, fish and plants in a glass-sided aquarium. True underwater photography, however, means shooting with your equipment submerged. Apart from having waterproof equipment you have to also be aware of the changes created while imaging in the water and not in the air, as refraction of the light rays in water is greater than refraction in the air (see *Langford's Basic Photography*). As a result,

underwater subjects appear closer and larger than they actually are. This upsets distance guessing and focusing, but otherwise the camera is affected the same ways as your eyes. Never underestimate the potential dangers of diving underwater and try to always have one other person with you.

Photographic equipment and techniques

Water causes serious spectral absorptions. As a result, daylight reduces in *intensity* and changes *colour content* (loosing red) with increased depths. Beyond approximately 10 m depth there is no colour differentiation and natural daylight is blue-green. For greater penetration it is best to work at around noon, when sunlight is closest to a right angle to the water and there is less reflection off the surface. Below 10 m, the blue-green cast can be photographically corrected by filtering, using 30 or 40R filters for example. Ultimately, the corrective filtration will depend on depth and water turbidity. Automatic white point correction can be problematic when using most digital cameras. Often white balanced underwater images have a pink or purple cast and look unnatural. Shooting at RAW image format can help digital post-shooting white point correction. If you want to shoot general views, for which only natural daylight is appropriate, better shoot in shallow waters (Figure 13.11). For close work and at depths where only blue twilight remains flash, strobes and battery lamps are the only satisfactory ways to show bright, faithful subject colours. Be also aware that water turbidity and the concentration of suspended matter, such as plankton, will introduce backscatter of any incident light. Loss of visibility underwater is largely due to backscatter, so is loss in contrast. To avoid backscatter, you have to move the light source away from your camera. A waterproof flashgun on a long-jointed arm, which positions the light well to one side of the lens axis and closer to the subject, is the best option. Light from the flash or strobe should ideally supplement the existing light unless you shoot in caves or shipwrecks where daylight is non-existent. However, synchro-sunlight is virtually impossible underwater unless the water surface is included in the shot.

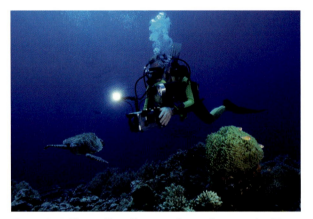

Figure 13.11 Diver working with a camera in an underwater casing. Water filters out longer wavelengths from daylight, giving a typical blue/cyan cast. Fit a compensating reddish filter or shoot with flash to render the colours faithfully.

There are two approaches to underwater camera equipment. Most often, an underwater housing for conventional cameras, such as a 35 mm, digital SLRs or compact cameras, is used. Here rods attached to the main camera controls pass through the casing to oversize knobs on the outside and access the controls inside (Figure 13.12). Such housings can be expensive but safe down to depths of around 40 m, ample for practically all professional sub-aqua assignments. They also have connectors to attach external flash units. Housings allow the lens to look through a *domed* port, or a *flat* port. Dome ports are used for wide-angle lenses, the curvature of the dome is ideally matched to the lens's focal length. The dome creates a virtual image that lens focuses on. Often a dioptric supplementary lens is required on the camera to facilitate this. Dome

ports do not introduce problems associated with refraction, radial distortion and axial chromatic aberrations (see page 44). Flat ports are used with long lenses for close-ups or shots that start or end above the water; they do not require a dioptre. Flat ports are unable to correct for the distortion produced by the differences between the indexes of light refraction in air and water. They introduce refraction, distortion and chromatic aberration problems when used underwater (see Figure 13.13).

In some cases the housings are made with other additional optics to make the apparent

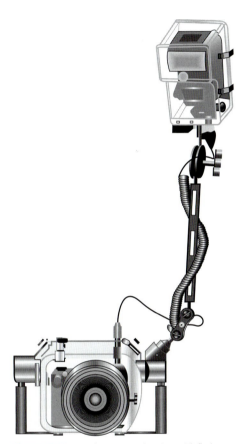

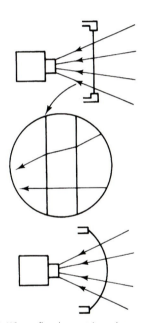

Figure 13.12 Digital SLR camera housing, with flash on a long adjustable extension arm. Flash should not be directed from the camera, but from well to one side.

Figure 13.13 When a flat glass port is used on an underwater housing (top and centre) oblique image light is distorted. Domed port (bottom) presents the glass at right angles to all rays.

angle of view wider. This is particularly useful to some digital cameras with small sensors that do not achieve wide angles of view with the conventional lenses. Both wide angle and close-up supplementary lenses are available, often as 'wet lenses' that can be added or removed underwater.

Alternatively, you can use a 35 mm film camera system specially designed with a waterproof metal body and lens, such as the Nikonos produced by Nikon. These cameras became obsolete in 2001 but are still the preferred choice of some keen underwater photographers. Amphibious cameras are nowadays made by Sea & Sea, Reef and other manufacturers. Otherwise, digital underwater cameras are often 'normal' cameras provided together with waterproof housing and settings such as focus, exposure programs and flash modes, for both land and underwater photography.

All lenses narrow their angle of view by 30% when used in water instead of air. For example, an extreme focal length type, such as a 21 mm on a 35 mm camera reduces its angle of view to that of a 30 mm lens in air. All other lenses tend to be of shorter rather than longer focal length, because you need to minimize your distance from the subject due to lack of clarity underwater (Figure 13.14). Wide-angle lenses are by far the most useful choice underwater. They allow you to get everything in from a shorter lens-to-subject distance, so you suffer less light loss and contrast flattening from particle backscattering. Macro lenses are also useful, as the subject is often only inches away from the camera (Figure 13.15). With macro lenses, distortions caused by refraction are not an issue. Note that when using macro lenses, you are more likely to use strobe light for the exposure. The subject will often be too close to the lens and the available sunlight will probably not suffice. A strobe is required for correct colour balance at all depths below about 3 m if accurate colour rendition is required. Otherwise, most underwater camera lenses do not give satisfactory quality on land (the scale of focusing distances also alters). However, if the camera accepts a range of interchangeable lenses, one of these is likely to be designed for use in non-underwater situations such as surfing and other marine sports.

Finally, wear the smallest volume face mask so that you can get your eye as close as possible to the eyepiece. If possible, change the regular SLR pentaprism for a sports action optical viewfinder – this lets you see the whole focusing screen from several inches away. Good housings will provide viewfinder correction optics to aid underwater use. Compact cameras often have a sports finder.

Figure 13.14 Ken MacLennan Brown shot this life size picture of juvenile squid on Fuji Velvia film, with a 35 mm Nikon F90x, equipped with a 105 mm lens in Subal housing.

Figure 13.15 Image shot with a Nikon D80 camera in a Sea&Sea housing. The lens was a Nikkor macro 60 mm and the subject was lit with a flash. ISO 100, 1/125 second, f/11. Photograph by Muna Muammar.

Panoramic photography

anoramic photography covers, more or less, all types of imaging with fields of view wider than the eye, while maintaining sharpness in the entire picture. Wide-angle photography can also be referred to as panoramic, however, true panoramic images give an impression similar to that when looking at a scene slowly while rotating your head from side to side (horizontally), or from up to down (vertically) and have, in general, large aspect ratios. Complete panoramas cover 360° views. Panoramic photographs give new life to large groups, open landscapes, cityscapes and large interiors. The picture proportions are interesting and dramatic and results helpfully exaggerate depth and distance.

When shooting panoramas it is a good idea to avoid subjects in the immediate foreground which will reveal distortion, unless you aim for a special effect. Miscellaneous foliage, grass or sky is acceptable but, in most cases, not cars or buildings (Figure 13.16). Nevertheless, when close-ups in panoramic images are appropriately handled the results can be very effective. A rule of thumb in achieving impressive vistas with great depths is to concentrate on the middle third of your panorama the faraway point in the scene, while you arrange the rest of the scene elements that are closer to you to surround this middle point.

Figure 13.16 Place in the middle of your panorama the faraway point in the scene and avoid subjects in the immediate foreground.

Photographic equipment and techniques

There are many ways to create photographic panoramas, either by using dedicated cameras, special lenses or simply by printing or stitching multiple images together. Digital photography offers an enormous advantage, as you can easily stitch multiple shots in Adobe Photoshop (or other imaging software packages), or better assemble a mosaic of pictures in especially designed software, or even create interactive panorama movies. Formally, panoramic photography is divided into *single* and *multiple frames*.

Single-frame panoramas

One way to obtain single-frame panoramas is by using film cameras with *rotating* (or *swing*) *lenses*. The lens rotates around its rear nodal point – from which the back focal length is measured – while a vertical slit exposes a strip of film which is aligned with the optical axis of the lens. Lens and slit scan horizontally across the panoramic scene. Typically, the shots encompass

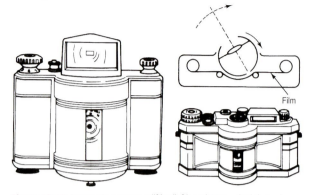

Figure 13.17 Panoramic cameras rollfilm (left), and 35 mm (right). As shown in plan view the lens and slit of the 35 mm camera form a drum which rotates about a 110°–140° horizontal field of view.

110°–140° field of view horizontally and 60° vertically, thus the horizontal image size will commonly take up 1.5–2.5 the length of a common 35 mm frame (Figure 13.17). Unfortunately, most swing lenses come with a fixed focal length and can focus appropriately at 10 m or more. To shoot subjects which are closer than that use a small aperture to provide big depth of field. However, as the number of shutter speeds in these cameras is limited you might have problems at low light levels.

Rotating panoramic cameras function in a similar way, but in this case it is the camera body that rotates around the front nodal point of the static lens. They are also referred to as *slit* or *scanning cameras*. The horizontal panoramic coverage can be up to 360° and in some cases more. A mechanism rotates the camera continuously while the film (which sits on a curved plane) rolls in the opposite direction in such a way that the speed of the film matches the speed with which the image is moving across the image plane. The film is exposed through a thin slit and thus a sharp image is produced throughout.

Digital rotating panoramic cameras (or line cameras) compose 360° full panoramas by scanning line-by-line with a line sensor (Figure 13.18). The principle of image capture is similar to those of a scanner, where a filtered RGB sensor scans the documents linearly. In rotating panoramic cameras the sensor, which typically comprises of 3 × linear CCD arrays of approximately 10 000 pixels, moves around a fixed rotation axis. The image size of a 360° panorama depends on the lens used and can reach values between 300 and 1200 mega pixels at high bit-depths. Digital panoramic cameras are often used for producing indoor and outdoor panoramas of large buildings and historical sites.

The results you get when using swing lens and panoramic cameras are without the extreme distortions of lines, which are often seen in extreme wide-angle lenses, but image perspective is unique. You have to level the camera correctly, that is parallel to the subject plane, otherwise you will introduce distortions. By tilting it up or down horizontal lines near the top and bottom of the frame will curve down or up, respectively. When your subject is at close distance horizontal lines will converge at the middle ends of the picture. Consequently, in a scene containing a building at a near distance, even if the camera is flat on, the horizontal building lines will be

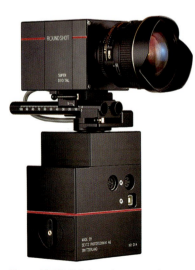

Figure 13.18 Digital rotating panoramic camera which covers 360°. Image reprinted with permission from Roundshot/Seitz Phototechnik.

reproduced curved up together at each end of the frame. On the other hand, a curved subject – such as a long group of people sitting around a concave row of chairs – reproduces as a straight line. Tilting the camera up or down causes vertical lines to converge at the top and bottom of the frame, respectively (Figure 13.19). Saying that, sometimes extreme perspective can be used to give an extremely dramatic viewpoint.

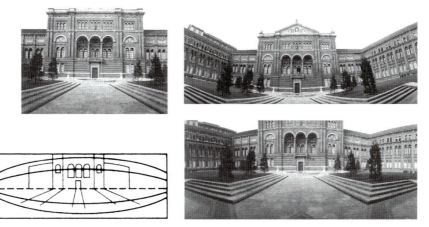

Figure 13.19 Subject shot (left) with a regular 35 mm camera and 28 mm lens, and (right) with a 35 mm panoramic camera and 28 mm lens. If you tilt a panoramic camera up or down, shapes are wildly distorted. Even when you keep it horizontal (bottom right), parallel horizontal lines in the subject reproduce curving together at each end of the picture. To see accurately, curve the page and view close.

A different type of panoramic cameras, with stationary fixed lenses and a flat – as opposed to curved – film plane, is the *wide-angle* or *wide-field* camera systems. These are the most common panoramic cameras (Figure 13.20). They come at various image formats, from 2:1 to 4:1 aspect ratios, and may vary significantly in quality and price. Note that the APS format cameras offer single-frame panoramic shots by cropping the frame into a panoramic aspect ratio. Image of true

Figure 13.20 With correct choice of viewing angle you can control distortions in the image. Photograph taken with a Widelux wide-angle camera.

wide-view cameras is relatively distortion free but the panoramic coverage is restricted when compared to swing lens or to rotating cameras. Nevertheless, they are popular for shooting architectural panoramas as they do not cause lines to curve or produce perspective distortions. Another great advantage of this type is the instantaneous exposure of the frame as opposed to the longer, sweeping exposures of other types of panoramic cameras. The use of flash is also not restricted, as it often happens with cameras that only expose one part of the image at a specific moment. Typically, the maximum angle of view with a flat film/sensor camera is about 90°, although lenses with up to 150° can be used. In this latter case you might need to use a neutral density 'centre' or 'spot filter' in front of your camera's wide-angle lens to eliminate optical vignetting, which reduces exposure of the film at the edges of your frame, but at the expense of approximately 2 EV. A good tripod will greatly help stability and a spirit level will assist you align the camera plane parallel to the subject plane, thus minimize line convergence.

For digital work, you can use one-shot 360° digital panoramic cameras which use parabolic mirrors and relay lenses to capture the entire view in one frame. With the camera's software you can then 'flatten' the distorted image and create a panorama. Alternatively, especially designed digital camera lens attachments with an optical reflector can be fitted directly or with an adapter to many digital cameras for one-shot 360° panoramic photography. Image quality depends on the quality of the reflectors and can be very impressive.

Multiple-frame panoramas

Most keen photographers carrying conventional cameras have tried to create panoramic imagery by rotating themselves around a fixed point, capture separate fields of the panorama and then stitch the images together. Quality multiple-frame panoramas are created using all kinds of cameras but they require extra apparatus and skill. To create good panoramic images you must accommodate for exposure variations between individual shots, lens and camera tilt related distortions.

A tripod with a panoramic rotating head will help you control camera shake, position and rotation around the nodal point. Levelling errors will produce a curved annular montage, so use a spirit level. Allow a minimum of 10% overlapping between the frames to accommodate for lens geometric distortions seen at the extreme parts of the frame. More overlapping is required if you use a wide-angle lens which distorts larger parts of the frame. Although wide-angle lenses require fewer shots to cover the same view they make things appear smaller and more distant. Try to avoid extremes in lighting between the frames and expose manually, setting up an average exposure taken from the entire panorama. Exposure problems are greater on clear sunny days, as there are plenty of bright highlights and dark shadows. In such days shoot midday to keep the light between frames even, also try to 'hide' the view of sun behind large objects, such as buildings, trees, etc. When shooting indoors better avoid shooting windows (Figure 13.21).

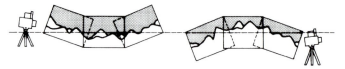

Figure. 13.21 Panoramas. When shooting a series of pictures for a join-up panorama, avoid pointing the camera either downwards or upwards, however slightly. Results will have a dished or humped horizon. Instead use a spirit level to help set the camera exactly horizontal. A rising or drop front (e.g. shift lens) then allows you to reposition the horizon higher or lower in the frame if needed.

Before digital photography this good practice was an indispensable element of good-looking panoramic images. Modern digital cameras are often equipped with dedicated software which can stitch images together, correct for uneven lighting and all kinds of distortions and even extrapolate information to match image perspective. The quality of result depends largely on the capabilities of the software, although starting with fewer exposure, distortion and levelling problems is an advantage (Figure 13.22). It is also better to avoid automatic white balance. Various panorama-making software applications are also available that are not attached to specific cameras. Further, the Apple's Quick Time VR – as well as other analogous software – let you make 360° *cylindric panoramas* and display them as immersive virtual reality pictures in

Figure 13.22 An example of a stitched panoramic photograph. The multiple shots were taken with a Canon 5D camera and a 17 mm lens, attached on a panoramic head.

which the viewer can interactively pan around, look in different directions and zoom in or out by changing the zoom angle. QTVR files can be played back on any computer platform and using any movie player, provided that Quick Time and Quick Time VQ extensions (or plug-ins for viewing from web pages) are installed. Such interactive panoramas can also be constructed using one-shot panoramic techniques.

Stereo photography

Stereo (or 3-D) photography exploits the fact that when a three-dimensional scene is viewed through a pair of eyes – binocular vision – the parallax difference between the two viewpoints makes foreground objects appear in front of different parts of the background. To some extent you 'see around' nearby objects. For example, hold your thumb up about 30 cm away. Then, without moving your head, notice where the thumb coincides with some distant wall detail, just using the left, then the right eye. This parallax difference is only one of the main functions the eye employs to sense three-dimensional depth and distance; this is why stereo photography comes with its problems – it does not represent a 'perfect' 3-D world. Other functions tend to be differences in scale, tone, focus and in the greater image shift of near objects relative to distant ones when you move your head.

Photographic and viewing equipment and techniques

Stereo cameras are *pairs* of cameras with matched lenses, linked shutters and diaphragms. The two halves of a stereo camera have their lens centres about 65 mm apart (stereo separation),

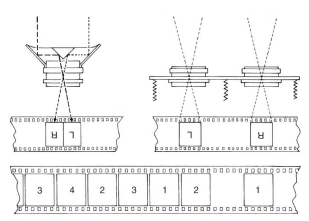

Figure 13.23 How stereo pairs record on 35 mm film. A beam splitter attachment exposes half-frame pictures within the regular format (left). Left- and right-hand versions are correctly located when you turn pictures the correct way up. When you use a stereo camera half-frame images record with two spaces between them. This is filled in with parts of other pairs to save film. Your film winds on two half frames each time, interlinking pairs as shown below.

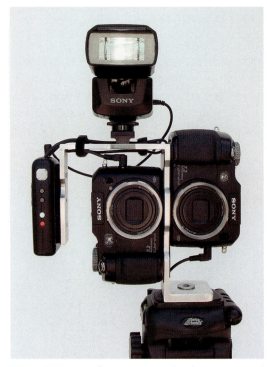

Figure 13.24 A pair of two Sony DSC-V3 digital cameras mounted together on a CNC milled aluminium mount for stereo photography. The system includes a Sony HVL-F32X flash for stereo photography and is controlled by a LANC Shepherd Pro stereo electronic controller. Image courtesy of Ledametrix.com.

matching the average separation or *interocular distance* between a pair of human eyes. This also leaves room for a direct viewfinder between the two. Pictures are exposed in pairs onto 35 mm film, each one being half-frame or 24 mm square format. Frames are often interleaved and so must be sorted and paired up after processing (see Figure 13.23).

Alternatively you can just pair up two regular cameras – 35 mm SLRs or digital cameras, for example (Figure 13.24). Paired cameras are best used with electric releases, wired in parallel to synchronize shutters and so work with flash or shoot moving subjects. Motorwind is also a helpful feature. Generally speaking, the separation between the two cameras should change proportionally with the distance of the subject from the cameras. When you are shooting stereo photographs, point the cameras at your subject and place a feature in the background in the same position in both left and right shots. Avoid aiming the two cameras directly at the subject, keep them parallel instead. The appropriate stereo separation should produce approximately 7 mm difference in the subject between the two images. For very close subjects use a smaller than 65 mm separation (*hypostereoscopy*), as normal 65 mm separation gives such extreme parallax difference that your eyes cannot fuse results into one three-dimensional image. For larger than life size images you work using a separation of 65 mm divided by magnification. In opposition, for faraway subjects a larger separation is required (*hyperstereoscopy*). When shooting landscapes the stereo separation is typically measured in fractions of a metre whereas

close-up subjects require a separation in millimetre. Experiment to find the appropriate camera separation that best suits the subject and the equipment you use.

Another approach to stereo photography is to use a *stereo attachment*, a beam-splitter device which fits over a regular camera's standard lens, like a lens hood (Figure 13.23). It splits the usual horizontal format picture into a stereo pair of upright half-format pictures. Inside, four front-silvered mirrors redirect the light so that your pictures are taken with viewpoints 65 mm apart. The attachment is best used on an SLR camera, where you can see the effect on the focusing screen. Results can be seen in three dimensions, using a hand viewer of similar design or by projection methods discussed later. A quite different stereo attachment takes the form of a sliding bracket fitted between a tripod and a regular camera. It is designed for making stereo pairs of relatively static subjects – you take one full-frame picture then slide the whole camera quickly 65 mm to one side before taking another.

There are different ways to view each pair of photographs and make them appear as a single three-dimensional picture (*stereogram*) (Figure 13.25). In all cases it is essential that left- and right-hand side versions are seen by the left and right eyes, respectively. You can use hand viewers for slides or for prints. Alternatively, you can project slides using two projectors to give offset images in the same screen. In this case you need to give your audience spectacles which permit each eye to see one image only. You can achieve this by fitting left or right projectors with colour filters, picking any two rather opposite hues, well separated in the spectrum such as deep green and red or magenta and cyan. Spectacles matching these hues allow the correct image to be seen by each eye, although the 3-D resulting image (*anaglyph*), even from colour slides, is seen as monochrome. Alternatively you may use pairs of linear polarizing filters for the projectors, orientated orthogonally to each other, and have matching glasses. This arrangement allows showing stereo colour slides in full colours, but your screen must have a metallized (silver) surface so that polarization is unaltered when image light is reflected and reaches the audience. Another way of showing three-dimensional results is by a special parallax stereogram print. This works without needing spectacles but is more suited to mass production. The results are less notable than by other viewing methods.

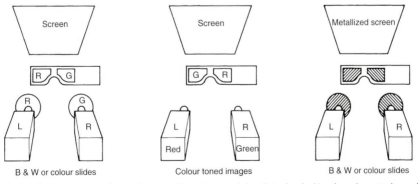

Figure 13.25 Ways of projecting pairs of stereo images, with results encoded so that when looking through spectacles each eye only sees its correct left- or right-hand side picture. Left: deep colour filters over projectors; results look monochrome, even if slides are colour. Centre: black and white images colour toned; results are monochrome. Right: the best arrangement using correctly orientated polarizing filters and metallized screen; images can appear in full colour.

Digital monochrome anaglyphs can be made easily from digital stereo pairs. It suffices to convert an RGB image pair first to greyscale, copy and paste the right image into a new RGB image file of the same size and finally copy and paste the red channel only of the left image into that new image file. The new image's colour channels will be as follows: the red channel will have the left stereo image and the green and blue channels will have the right stereo image. A similar technique can be used to create colour digital anaglyphs. This time the entire right RGB image is copied into a new RGB image file and the red channel of the left image replaces the red channel of the new image file. The colour quality of the anaglyph will depend on the colours of the scene but will never be totally faithful to the original. Some colour de-saturation will be needed in the green and more in the blue channels to compensate for the eye sensitivities. Without the 3-D glasses the new image will appear rather dim but will improve substantially when the glasses are put on.

A different viewing technique that also does not require stereo viewing equipment is the *free-vision fusion*, in which the left-eye and right-eye images are visually merged into a single stereogram. In the *crossed-eye free-vision fusion* the left eye looks at the right-hand image while the right eye looks at the left-hand image. In the *parallel-eye free-vision fusion* the centres of the photos must be approximately the same distance as the interocular distance. *Motion 3-D* or *wiggle stereoscopy*, on the other hand, relies mainly on the fact that as we move our heads rapidly the changing relationship of objects around us are processed in such a way from our brain to give a 3-D impression. In this stereo viewing method the left and right images of a stereo pair are displayed (by an appropriate animated file or application) alternately so that the 'wiggling' result gives a stereo feeling to the viewer.

Special software and freeware to handle stereo pairs is available today to stereo imaging fans. It provides various possibilities for editing and viewing stereo pairs, for example positioning the two images in selected distances for free-vision fusion or creating different hue anaglyphs that match the hues of your viewing glasses.

Applications

Stereo photography is useful wherever three-dimensional information is needed, for measurement, training and education or simply for pictorial effect. It is an important aspect of aerial survey photography, where it allows observing the relative heights of buildings and the general terrain. Modern high-end 3-D imaging is employed today by the computer game and film industries. 3-D is becoming also important to other fields such as molecular modelling, photogrammetry, flight simulation, visualization of multi-dimensional data, architecture and medical imaging such as remote surgery. 3-D scanners are used to record 3-D information (geometric samples on the surface of the subject). The depth information is then reconstructed to create meaningful pictures from two images by corresponding the pixels in the left and right images.

Over the last decade a number of manufacturers offer various 3-D displays technologies for visual stereo presentations. For example, stereo pair-based displays distribute left and right views of a scene to the left and right eyes of the viewer independently and can be viewed either with or without viewing devices. Further, head-mounted displays for 3-D viewing are helmets or glasses that incorporate two small liquid crystal displays or organic liquid crystal displays and magnifying lenses. An offset image is displayed to each eye. This technology is to show stereo

films, images or video games. It is also employed in *virtual* or *augmented reality* displays (Figure 13.26).

'Hand-made' image processes

To get something physically different from your 'normal' printed or displayed photographic images your can look at the possibilities of light-sensitizing your own choice of artist's papers, or any other suitable material, or in transferring colour images onto them from instant pictures.

Liquid emulsion

It is possible to mix up your own emulsion from chemicals such as silver nitrate, potassium bromide and gelatine. Preparation is time consuming and often tricky so instead, you can buy containers of ready-to-use gelatine emulsion with which you coat (in the darkness) your chosen base material and allow it to dry before exposing it, using an enlarger and processing it in the normal way. The type of surfaces you can coat include drawing paper, wallpaper, canvas, wood, plaster, most plastics and glass. Try coating three-dimensional objects like egg- or

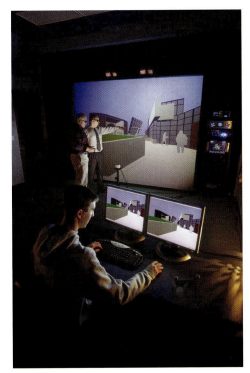

Figure 13.26 This figure illustrates the use of a VisBox-X2 Immersive 3D Display at Valparaiso University, USA. Architecture is one of the areas where the immersive display is used. In this image architectural details are shown to be discussed between Dr. Jeffery Will of the University's Engineering Department and Jeff Jacobs of Design Organization. The VisBox controls are monitored by the student Mike Steffen.: © 2005 Aran D. Kessler.

seashells, fragments of stone, ceramic tiles or plates. Since the coating is thin and transparent it takes on all the texture and colour of whatever base material you use. Choose a picture which suits the nature of the unusual base, both in subject matter and visual design. Highly textured materials need simple images (Figure 13.27).

Emulsion lift

Emulsion lift simply means 'floating off' the emulsion layer from a processed Polacolor instant print and repositioning it on a fresh base.

Figure 13.27 Example of coating and exposing with ready-made emulsion, here a ceramic tile. (1) The emulsion comes in solid jelly form which you will have to turn it into liquid by warming up the top part of the container in water. (2) For coating use a flat brush and criss-cross your strokes on the material. Then leave it for several hours in darkness until fully dry. (3) Use some test material first under the enlarger to make an exposure series before the final exposure. Once your final result is produced, materials such as ceramic or metal can be sealed over with matt clear varnish to help protect the image.

During this procedure you can stretch, crease and tear the membrane, or just settle it straight onto a textured or transparent surface. The creases and tears become quite dominant, so you need to consider this feature when planning your shot (Figures 13.28 and 13.30).

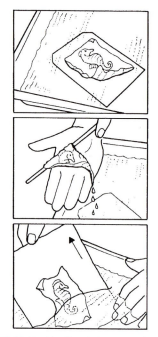

Figure 13.28 Emulsion lift technique. Top: Polaroid print soaked for 5 min in hot water begins to frill. Centre: Freed from its backing paper the emulsion membrane can be rolled on to a pencil. Gently agitate it in clean warm water to remove unwanted bits. Bottom: Float emulsion on water surface, withdraw receiving paper from underneath it and draw out with image in contact. Adjust shape with watercolour brush, then tape paper to flat surface to dry out flat.

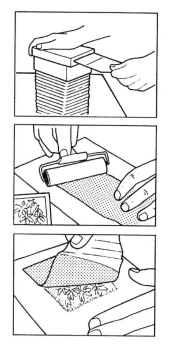

Figure 13.29 Image transfer technique. Top: Slide or transparency on light box is copied on peel-apart Polacolor material. After pulling through the rollers material is only allowed 10 sec before peeling print and negative apart. Centre: Print part discarded, the paper negative is pressed face down on predampened watercolour paper and rolled evenly with ink roller for approximately 1 min. Bottom: Leave 30 sec then gently peel off. Leave to dry. Spot-in any blemishes using watercolours.

Image transfer

This again uses peel-apart instant picture material, but with its processing time curtailed so that the image has only developed on the negative sheet but not yet formed a positive on the receiving sheet. Then you peel the two sheets apart. The original receiving paper is discarded and the negative sheet rolled into tight contact with dampened watercolour paper. After about 1 min you gently peel away the negative, leaving a positive image on the new base, which is left to dry.

Damp paper transferring diffuses your image slightly, but this can be used for effect. 'Dry' transfer is more uncertain and difficult than it sounds – it is easy to leave part of the image behind and form pinholes and other minor blemishes (see Figures 13.29 and 13.31). Images with many dark shadows are most likely to leave bits stuck to the negative. Colour balance is also changed because some of the yellow and magenta image dyes in the negative sensitive material

Figure 13.30 Image produced by 'emulsion lifting' Polaroid material. Since creases, folds, and frayed edges are inherent in this process plan and use them as an integral part of your picture. This can also be a start point for the creation of composite pictures, provided you let the emulsion dry thoroughly before adding further lifts. By Alastair Laidlaw.

Figure 13.31 An image transfer, using the (processed) negative half of peel-apart instant picture material rolled immediately into contact with water-colour paper. Characteristically, colours become more muted. Your receiving material is best first soaked in distilled water, then blotted off. By Alastair Laidlaw.

will have migrated to the Polaroid receiving paper and been lost. You may therefore have to compensate by shooting with a reddish filter over the lens. For hit-or-miss reasons like these it makes sense to work by copying an existing transparency. You can then repeat yourself easily, making adjustments to timing and physical technique.

■ Infrared photography is carried out using infrared monochrome film, which is sensitive up to 900 nm, infrared colour reversal film that gives a mixture of false colours, or with the use of digital cameras, which are naturally sensitive to infrared. Digital cameras often incorporate an infrared blocking filter which partially stops infrared falling on the camera sensor. If the filter is not removable, longer exposure times allow infrared to be recorded. In infrared photography, deep red or infrared, only passing filters are used. Re-set your focusing scale or stop down to provide a large depth of field.

■ Sunlit living foliage reflects plenty of infrared and thus appears whitish on positive monochrome images, whereas blue skies and water appear black as they mostly absorb infrared. Landscapes and portraits take a strange, dream-like look. Infrared photography is used widely in forensic and medical applications and aerial surveys.

■ UV photography can be split into UV reflectance and UV fluorescence. In both cases UV sources are used to illuminate the subject. In UV reflectance visible barrier filters are placed in front of the lens to allow only the reflected UV from the subject to be recorded. In UV fluorescence UV barrier filters are used to allow recording of the subject's fluorescence (occurring mostly in the visible).

■ Much of the UV radiation from the sun is harmful, but most of it is absorbed by the atmosphere. It has the property to penetrate surface layers. This makes UV reflectance recording useful for imaging strong skin pigmentation, cuts and scratches that are no longer visible and the structures of the painting's surface layers. UV fluorescence recording is useful in crime scene investigations.

■ Panoramic photography includes all types of imaging with fields of view wider than the eye, although true panoramas have larger than 2:1 aspect ratios. Complete panoramas cover 360° views. It is suitable for shooting large groups, open landscapes, cityscapes and large interiors.

■ *Single-frame* panoramas are often captured with panoramic cameras that use rotating lenses or rotating bodies. Resulting dramatic perspective is unique – straight lines in the subject may appear straight. Otherwise, the most common single-frame panoramas are shot with *wide-field* camera systems which are relatively distortion-free but the panoramic coverage is restricted. For digital panoramic work, especially designed digital cameras are used or camera lens attachments with an optical reflector that can be fitted directly, or with the use of an adapter, to many digital cameras for one-shot 360° panoramic photography. They come with software which then 'flattens' the distorted image and create a panorama.

■ *Multiple-frame* panoramas are created with conventional film or digital cameras, with the aid of a panoramic head, to control camera shake and positioning, and a spirit level for camera levelling, i.e. helps avoiding errors that produce a curved annular montage. Modern digital cameras are often equipped with dedicated software which can stitch images together, correct for uneven lighting and all kinds of distortions and even extrapolate information to match image perspective. Apple's QTVR lets you make 360° *cylindric panoramas* and display them as immersive virtual reality pictures.

■ Underwater photography requires waterproof equipment and knowledge of the changes created while imaging inside the water and not in the air. Underwater subjects appear closer and larger than they actually are, due to the greater refraction of the light rays. Water also reduces the *intensity* and changes the *colour content* of daylight, thus ultimately a strobe is required for correct colour balance at all depths below 3 m.

■ For underwater photography fit an underwater housing to a regular analogue or

digital camera. Such housings have connectors to attach external flash units and allow the lens to look through a *domed* port (which is advantageous as it reduces distortions and aberrations), or a *flat* port. Port shape is a function of lens's focal length.

■ Stereo photography needs capturing pictures in pairs, with viewpoints normally 65 mm apart. Stereo cameras come with matched lenses, linked shutters and diaphragms. However, you can use a regular camera and shift the camera or subject between exposures or use two cameras wired in parallel. You can give *hyperseparation* (i.e. greater than 65 mm) for very faraway subjects or *hyposeparation* (i.e. smaller than 65 mm) for very close subjects.

■ Pairs of pictures are combined to produce a three-dimensional image, which can be viewed using hand viewers, twin projectors and appropriate viewing glasses. *Free-vision fusion* and *wiggle stereoscopy* are methods to see 3-D images from stereo pairs without stereo viewing aids. Stereo imaging is used for measurement or pictorial effect. It is employed nowadays by the computer game and film industries and is becoming particularly important in modelling, simulation and medical imaging.

■ 'Hand-made' printing allows you to break away from the regular appearance of photographic prints. Examples include coating liquid silver halide emulsion on selected surfaces, coating your choice of paper with a gum/pigment mixture sensitized with potassium dichromate or use Polaroid material that allow to 'emulsion lift' the colour image from the print and membrane it to a different support.

PROJECTS

1 Go out on a bright sunny day with your digital camera, a tripod, a filter such as the number 87 or/and 87A Kodak Wratten filters and a filter holder that fits your lens. Try to find a location where there is plenty of foliage and a pond or a lake. Expose your subjects with and without the filters, in the latter case having set your camera to obtain a black and white record. Notice the differences in exposure and the resulting tones in your images.

2 Next time you find yourself in a club, bar or any indoor location lit by deep blue or 'back lights' notice the teeth and skin of the people around you. What do you observe?

3 With digital photography it is easy to make spectacular panoramas. Use your digital camera, a tripod and a spirit level. Find a place in the city where there are many roads meeting (e.g. a small roundabout). Place yourself and the camera in the centre of the roundabout. Take multiple shots ensuring plenty of overlapping. Expose manually, after having measured an average exposure from all frames. Using your camera's software stitch the images together. Examine the result; what would you have done better if you were to repeat the shooting?

4 Next time you go swimming take a small single-use underwater camera. While on the beach try to take a picture of a nearby to your lens object with half the camera's lens immersed in the shallow water and the other half in the air. What do you notice in the resulting image? Once you are underwater, take some pictures of the same objects (rocks, algae, fish) with and some without flash. Examine the differences.

5 Go on the Internet and type the words 'stereo photography without glasses'. You will find plenty of links to Internet sites showing stereo pairs that can be viewed with parallel or cross-eyed free-vision fusion. Try to discover the underlying 3-D image by following the given instructions.

6 Next time you want to make a present consider purchasing a small container with liquid emulsion. Coat a mug, a tile or a piece of wood and expose on it your favourite black and white negative. Try to match the texture of the chosen material with the image texture in detail.

Reproduction and archiving

This chapter starts with relating photography with the printing presses for outputting large quantities of pictures in magazines, books, etc. Printing and photography has had a long-standing association. Today many of the pre-press stages are handled by digital means, controlled by computers. Modern digital photography allows for making images widely available, also by means other than the printed media – this is the discussion of several further sections. Once in the form of digital data, images can easily be manipulated and transmitted for distribution to clients and agents, or for publication on the World Wide Web. In mixing techniques, still further, there is 'multimedia', under which umbrella photography is combined with audio–visual projections, sound and lighting effects to create new forms of image presentation. Preservation, storage and archiving conclude the chapter. Ensuring image longevity presents various challenges. Some are common and some are different in silver-based and in digital media. Storing photographic films, prints and digital media under controlled environmental conditions, handling them with care and migrating digital image files from old to newer media are all techniques which help to prolong the lifespan of photographs.

Reproduction of the printed page

Three systems

Traditionally the three main methods of reproduction in the printing trade are letterpress, photogravure and lithography. *Letterpress* uses a raised printing surface (Figure 14.1), like the keys on a typewriter. The surface is inked and then pressed onto the receptive surface, such as paper, to obtain an image in reverse. It is the oldest form of printing, originated for letter forms and later for pictures hand engraved on wooden or metal blocks – areas to print pale being etched or gouged out. Letterpress is still used for a few hand-made limited edition art books, design posters and cards.

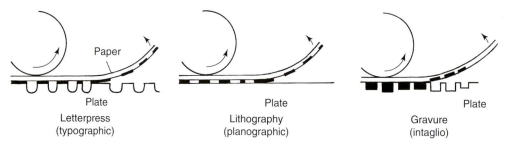

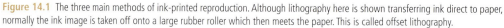

Figure 14.1 The three main methods of ink-printed reproduction. Although lithography here is shown transferring ink direct to paper, normally the ink image is taken off onto a large rubber roller which then meets the paper. This is called offset lithography.

Photogravure works in the reverse way. Areas to print dark are etched as hollows into metal, then filled with a thin ink and the whole top surface wiped clean. It was originally developed to provide a way of producing permanent (lasting) photographs. Because of the rich tonal range it produced, a result of a variable depth of the etched plate, photogravure was used by many art photographers of the nineteenth and early twentieth century, such as Alfred Stieglitz and Alvin Langdon Coburn, whose work was often seen in the art magazine Camera Work. Rotogravure or simply *gravure* also uses etched plates, but they are industrially produced. It is an intaglio printing process which uses a rotary printing cylinder which is rather slightly etched compared to photogravure's etching. When the gravure surface comes into contact with absorbent paper, the ink filling each hollowed-out cell is transferred into the paper fibers (Figure 14.1). Gravure cylinders are expensive and relatively slow to prepare, but they can give good-quality results on only average paper and because they stand up to very large printing runs, they are used for some weekly magazines, newspaper supplements, etc. Gravure is also chosen for some art books. But cost of plate preparation, and what is often a short print run on high-quality paper, again makes the resulting publication expensive.

Lithography originated about 200 years ago when artists drew on the flat surface of limestone – a porous rock. It is based on the fact that greasy ink and water repel one another. Today called photolithography, it uses a thin porous metal sheet treated so that the areas to print dark will not retain moisture. The surface is then wetted, rolled over with greasy ink (which only holds in the non-porous areas) and printed onto paper. As Figure 14.2 shows, on the press the thin litho sheet is wrapped around the outside of a cylinder. It comes into contact with a water damping roller, then greasy ink rollers and finally a larger rubber roller which transfers the ink from plate to paper. This 'offsetting' means that, the litho plate never comes into direct contact with the paper, card, tin, etc. It can print at speed with minimum wear. The vast majority of modern newspapers, brochures, posters, packaging and books (including this one) are printed by offset photolithography.

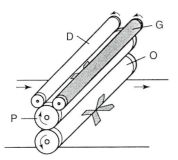

Figure 14.2 Principle of offset photolithography press: D, dampening roller; G, roller carrying greasy ink; P, printing plate with image; O, large rubber offsetting roller transfers image ink to moving paper.

Note that none of the systems described above lends itself to equipment cheap enough and small enough to allow desktop unit printing. For this you must turn to devices such as dye-sublimation, laser or inkjet printers, see page 222.

Halftone printing

As you can see from Figure 14.1, letterpress and lithography printing are all-or-nothing processes. The paper either receives a full loading of ink or remains white. To reproduce the range of greys in a photograph, *tones* are turned into a fine pattern of *dots* of different sizes. Take a look at any black and white photograph in this book through a magnifier and you will find that a mid-grey area is really a mosaic of black dots and clear spaces, about 50:50 in ratio. Darker tones contain more black than white, while pale greys are the reverse. A fraction of each image pixel is covered with ink so that the 'averaged' reflectance of the pixel corresponds to the image's grey level. This clever use of pure black and white gives a wide range of '*halftones*'. The process is based on the eye's inability to resolve very fine detail. Dot patterns of about 133 per

inch (5–6 per millimetre) or finer merge into what appears to be an even tone at normal reading distance (see Figure 5.13). The same eyesight limitation is exploited when spotting prints and in additive screen colour films.

To turn the continuous tones of a monochrome photograph into a halftone image for printing, the picture used to be (camera) copied onto high-contrast film, through a glass screen carrying a fine soft-edged ruled grid and positioned in front of the emulsion. Shadow parts of the original picture were recorded as a pattern of *small* dots, while highlight areas spread into a pattern of *large* ones (more light to pass through the screen in these parts (Figure 14.4)). This halftone negative was then contact printed onto the appropriate printing surface, made temporarily light-sensitive (Figure 14.3). Later this was treated to form a raised (letterpress) or hardened (lithography) surface, ready for the press to reproduce the original image with ink dots.

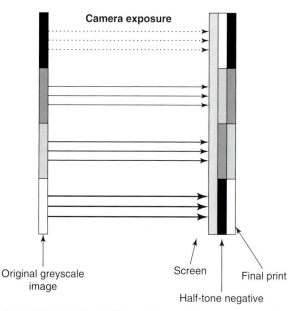

Figure 14.3 In traditional halftone printing methods, a screen was put in perfect contact with an unexposed high-contrast negative film. A given camera exposure was creating varying dot sizes on the high-contrast negative in response to the amount of light that was transmitted from areas of the original. The halftone negative was then printed on a light-sensitive printing surface.

Today a halftone dot image is still said to be 'screened', but this is now generated electronically by computer software. Your photograph, scanned-in or otherwise supplied as a digital file, and with its data moderated by the software program, controls a fine laser beam in an 'image-setter' machine. Here the screened image is scan-exposed onto high-contrast film or light-sensitized printing plate material.

The halftone image pixel is subdivided into an array of $n \times n$ subpixels; it is the subpixels that are later individually inked. Most modern graphic arts scanners divide each pixel into a 12×12 array of subpixels. Ink can be then deposited from 0 to 144 of them, giving 145 different grey levels. The problem, however, is that the ink spot must be very small and hence the writer's resolution very high. A 150 lines per inch screen image requires a printer resolution of 150×12 or 1800 dots

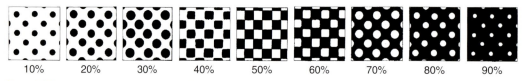

Figure 14.4 Halftone printed images appear to have a range of greys but in fact these are made up of pure black and pure white dots, in different proportions. The pattern below is about 16 times coarser than would be used normally. View the page from about 6 m away to see these patches as a grey scale.

Figure 14.5 Part of the picture on page 7 reproduced here screened at 40 instead of 150 lines per inch. Coarse screening clearly shows up the structure of reproduction and destroys tonal accuracy and fine detail.

per inch. Digital methods offer a vast range of dots per inch settings. The more dots in the screened image the finer the tonal accuracy and detail shown. However, a major limiting factor here is the paper your halftone reproduction will be printed on. The pages of this book are printed on a paper which will take 150 lines to the inch. If it were printed on cheaper stock (or on newsprint, which is still more absorbent) such fine ink dots would smudge and clog together, destroying tone separation. Coarser screens of about 80 lines may be the best that newsprint will accept, and consequently fine detail will suffer. Screens for huge poster images can be scaled up to something as coarse as 10 lines, because results will be viewed from great distances (see Figure 14.5).

Gravure uses a screening system for halftones, but this does not affect tone reproduction in the same way. Unlike the other processes, more ink is deposited from deep cells of identical area in the etched metal and less from shallow ones, so the build-up of densities is truly graduated from dark to light, not an optical illusion.

Four-colour reproduction

To print a colour photograph by any of these mechanical printing processes the monochrome procedure has to take place at least four times. The image is 'colour separated' into red, green and blue records by photographing (for example, digitally) or by scanning an existing colour print or transparency through filters of these colours (see Chapter 10). Each RGB screened separation is then inverted (i.e. the negative of the red record is a cyan image, etc.) and printed in cyan, magenta or yellow inks, respectively, superimposed together with a fourth, pale, image in black ink. The black printer gives added tone and body to shadows and better contrast, as shown in Figure 14.7. It is exposed, without filter, at the same time as the other separations, or generated by combining digital data from the other three. Printing colours are designated CMYK. The 'K' stands for black but using its last letter instead of the first to avoid confusion with blue. Printing inks are semi-transparent so that they can be printed on the top of each other and produce various hues. For example, red is produced by magenta and yellow dots on the top of each other. When you view all these coloured and black dots on the printed page your eye's limited resolution fuses them into a dominant hue in each area, just like viewing screened additive colour film or images on displays.

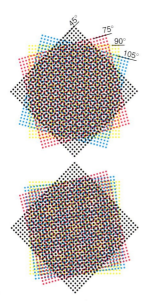

Figure 14.6 Four-colour printing, greatly magnified. Top: when each screen is set to the best angle most dots of colour fall adjacent, not on top of each other. Patterns formed are also least assertive (central area here represents even, dark grey). Bottom: if one or more separations are made with screen rulings at incorrect angles a patchy moire pattern results. View this page from distance.

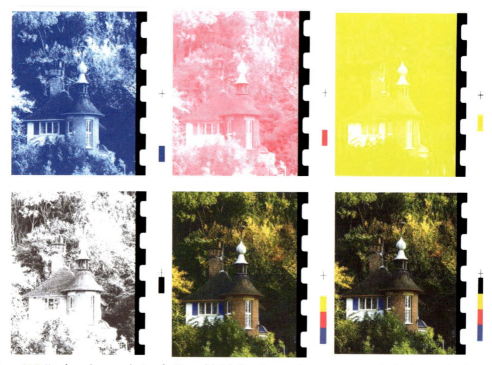

Figure 14.7 How four-colour reproduction of a 35 mm slide is built up. Top row: the cyan, magenta and yellow images printed separately. (Notice the printer's colour control patches, right, later trimmed off.) Bottom left, the black printing image. Bottom centre: cyan, magenta and yellow images printed together but without the black. Bottom right: the three colours plus black. Notice the extra body this gives to shadows, impossible from three-coloured inks alone.

To minimize the formation of assertive moire patterns as well as to prevent the dots centres from completely coinciding, the screens are rotated at different angles between the making of each separation (Figure 14.6). This produces the complex mixture of so-called four-colour dots you can see through a magnifying glass from reproduced colour photographs. Otherwise, the newer emerging *six-colour reproduction printing* adds also orange and green inks; this addition results in wider colour gamuts and therefore more vivid colour reproductions.

Bear in mind that computer monitors and TVs create colours by mixtures of RGB phosphors (in cathode ray tube (CRT) display technology) or RGB filters (in liquid crystal display (LCD) and plasma display technologies) (see page 217). At the printed reproduction stage CMYK inks cannot exactly match every possible colour displayed by RGB, such as the most saturated primary hues. This difference is a problem when you are manipulating colour images and judging results on a computer workstation monitor. You need to use colour management system (CMS, page 258), by which you smooth out mismatches when RGB data will later be converted to CMYK separations; similarly between various components of your equipment chain – digital back, monitor, scanner, film-writer, etc.

Duotone reproduction

Monochrome remains the 'poor relation' of photomechanical reproduction: most modern improvements have benefited colour. However, it is possible to greatly improve the reproduction

of a black and white photograph by running the paper through the press twice and printing (in register) from two versions of the same halftone image. One version may carry delicate highlight detail down to darker midtones; the other is paler but with more contrast, carrying well-separated tones from midtones into rich black shadows. Collectively, this duotone printing gives good tone separation over a much wider range of values than is possible from one impression alone. (It is similar to the effect of the black printer in colour reproduction and multiple build-up of dye in gum-bichromate printing.)

Anything from two to four or more impressions can be used, with corresponding increase in cost and ever smaller improvements in image reproduction. The separations can differ in density, contrast and the 'colour' of the ink in which they are printed. Inks can be different shades of neutral grey, black, brownish black, etc. When superimposed, these will reproduce most of the subtleties of even a rich chlorobromide photographic paper.

Figure 14.8 This black and white photograph is reproduced here using four-colour printing. Results show improved tone range – compare with single-colour reproduction on page 166. This is not as good as duotone, however and 'drifts' in printing can make unwanted tints appear.

Monochrome can also be reproduced using four-colour printing techniques. This makes sense when high-quality black and white and colour pictures must be printed on the same sheet. For monochrome the yellow, magenta and cyan impressions all carry the same image, and, together with the black printer, build up a good tone range in visually neutral density. However, unlike duotone, any misregistration or 'drift' during a printing run can introduce startling bits of colour or casts into a colourless illustration.

Supplying photographs for reproduction

D espite the aids and controls possible when your pictures are reproduced on the printed page, you still get the best quality by having a technically good original in the first place. You may supply images in analogue or in digital form. Over the past few years, digital photography has caused a revolution in how images are submitted for publication, having shifted from providing film-based images to providing mostly images shot with digital cameras. If your images are still captured on film it is best to provide the originals for maintaining quality. For images produced using conventional photography, try to meet all the following requirements:

1. *Size*. Avoid large differences in size between original and final reproduction. To take an extreme example, a 35 mm transparency for a 12-sheet poster or a 12 × 15 in. (305 × 381 mm) print for a 2 × 2.5 in. (51 × 64 mm) book illustration is difficult to handle. Adjustments may even mean having to go through an intermediate copying stage, with consequent loss of quality. Remember, too, in shooting, that when the final reproduction will be small you should keep your picture content broad and simple.

2. *Form*. Colour originals are still preferred in the form of transparencies, partly for their greater saturation and colour fidelity and partly just because of long-standing print technology bias. Original transparencies always tend to reproduce better than duplicates. If you have prints, do not supply them mounted – they may have to be wrapped around a scanner drum.

3. *Grain and surface.* Image graininess depends mostly on the original's emulsion speed and the reproduction ratio. It may be worth enlarging your picture or reducing it to final size to see what contribution grain will make to detail or mood. Do not submit prints with a surface finish texture such as lustre or stipple. The pattern may interfere with the screening process. Glossy (especially when glazed) gives greatest tonal range, especially in the shadows.

4. *Contrast.* Film has a longer tone range than the contrast that can be reproduced by photomechanical printing, especially on cheap paper and/or using a coarse screen. So try to limit contrast, preferably by shadow-filling when lighting. If you have to send in a high-contrast image, indicate whether you want the printer to bias best reproduction towards highlight or shadow areas, since you cannot have both. However, do not send in flat grey prints for reproduction either. It is important to keep well-separated tones, especially in shadow and highlight detail. Printing on excessively low-contrast bromide paper tends to merge tones within either or both these extremes. It is often better to print on slightly harder paper but dodge and burn-in. In general, a rich tone range print which looks good in photographic terms will reproduce best.

5. *Exposure and colour balance.* Pitch the exposure of slides and transparencies to give sufficient detail and saturation in highlight areas, even if this means dense shadows. With negative/positive materials avoid the kind of detailless grey or distorted colour shadows in prints resulting from underexposed negatives. Colour shots with a colour cast may just be possible to improve in colour reproduction but at the cost of general tone and colour accuracy. Always take care in selecting your best originals to send for reproduction. Make sure that your lightbox, or top viewing light for prints, gives a known correct colour temperature and is sufficiently bright. When you judge a transparency on a lightbox always mask off glare from around the edges of the picture using wide opaque card. This makes a great difference to the overall contrast and the detail you can see in the film's darkest areas.

6. *Labelling.* Photographs need to be clearly labelled for submission and accompanied with copyright notice and, when appropriate, with model and property release forms (see chapter 15). Publishers often require an image description/caption for all images which may include location information, details of any unique photographic techniques, details on the photographed subjects, etc.

The form of images captured digitally should adhere to requirements specified by the publishers. Depending on the medium your images will be reproduced (e.g. book, newspaper) the requirements will differ. There are no universal specifications for digital image submission and thus there is a lot of confusion on the matter. The Digital Image Submission Criteria (DISC™) is an industry group, made up of many of the top publishers and printers in the US, which tries to help standardizing digital image submission throughout the printing industries. Generally, specifications include:

1. *Size, resolution and bit depth.* The image size, in megabytes (MB) will depend on the printed image size, the required resolution and bit depth. Often image size is also specified in camera mega pixels (MP). A fairly high-quality standard will be 50 MB, or approximately 16 MP, at 300 dots per inch (i.e. 150 line screen for halftone screening) and 24 bits per pixel (i.e. 8 bits per colour channel). Line art (bitonal or 1 bit per pixel) is required at much higher than colour image resolutions, typically at 1200 or 2400 dots per inch.

2. *File format/compression.* RAW or/and TIFF uncompressed files are most often demanded, although in some cases compressed at high quality – level 8 – JPEG files may be preferred. The RAW files may be required in Adobe Digital Negative format. Whenever possible shoot in RAW and keep your 'master' RAW files safe, as you might be asked copies of them in case the publishers need to perform in-house enhancements.

3. *Colour space and colour profiles.* Most publishers ask you to choose Adobe RGB (1998) colour space, which is the preferred colour space in the industry, otherwise, standard RGB (sRGB). Be aware that, after submission your RGB files will be converted to CMYK for reproduction. Gamut mismatches between RGB and CMYK colour spaces might give rise to different reproductions of your images than those you might expect (see Chapter 11). For this reason, along with the RGB files, you can choose to supply separated CMYK files. This, however, will

need some communication between you and the printers of the publishers. An embedded profile often needs to be available.

4. *Processing*. View your images at 100% to 'clean' them from any pixel-to-pixel defects. Do this manually using cloning or stamp tools. Image sharpening should be kept to a minimum, or even better, avoid it altogether. Do not resize or interpolate, this is usually done by the publishers. Finally, flatten the images before submission (no layers) and remove any extra channels, selections or masks.

5. *Metadata and media*. Make sure that you accompany your images with appropriate metadata to mark your identity. Often standard fields in the metadata are required by publishers, such as photographer's name, address,

Figure 14.9 In Image Info data panels you can complete relevant information to your photographs and save them as XMP (Extensible Metadata Platform) files, a labeling technolgoy that allows you to embed information about an image file, known as metadata, into the file itself. The Adobe XMP standard is compatible with EXIF (Exchangeable Image File Format) data, generated by most digital cameras.

copyright notice, keywords, etc. In Photoshop you can complete relevant information in the metadata fields in the 'File Info' dialogue box (Figure 14.9). Files are most often submitted on CD-ROM – preferred in the ISO 9660 format (see page 344) – in a single session, or on DVD. If you need to transmit files instead of delivering them you will probably have to ZIP them or use JPEG compression.

Picture libraries

Picture libraries are agencies that negotiate a fee for a photograph on the photographer's behalf in exchange for a percentage of this fee and sometimes the copyright of the images. You might want to place your images on one or more picture libraries, which often specialize in particular genres or themes. The agency is set to market the images. It is responsible for finding customers (or clients), who pay either to use the images for multiple

times (royalty free) or pay each time the image is used. You have to apply to join an agency and, once approved, you will provide your images. You might fund your own photographic project or develop projects in collaboration with the agency to meet the agency's needs.

Picture libraries may accept images in analogue (transparencies or prints) or digital form, however more and more agencies require submissions in digital form and accept only images scanned from film or shot digitally. Submission requirements (i.e. image sizes and resolution, file formats, etc.) follow the digital image submission requirements of the printing industries, listed in the previous section. There are agencies that operate only on the Internet, in which case approved photographers upload their images through the agency's website.

Images on the World Wide Web

The World Wide Web has become one of the most popular media for photographers to display their work and make it accessible to larger audiences. The web is a common space where you can share your images efficiently and inexpensively with other people. You can place pictures online by simply signing up to a photo-sharing service, such as Kodak Gallery, Snapfish and Flicker (Figure 14.10). Most of them offer free photo posting and additional

Figure 14.10 Photo sharing services (such as the Kodak Gallery) allow you to easily select images from your hard disk, upload them with the click of a button on the service's server and create photo albums that you can share shared online.

services. Using a photo service requires no knowledge on website development. You can easily post images on the web server by following the photo service software instructions and add information and tags to facilitate other users to locate them. If you choose, you may make your photo collection viewable only to those who have permission.

Although photo services offer ease in publishing your photographs online they do not allow much flexibility on how these are displayed. If you are serious about making your work available on the web, it is best to create a website with your portfolio (Figure 14.11). Photographers prefer to make choices on how their images are displayed as their online presentation can be thought as an integral part of their artistic or professional style. There are various online portfolio website providers for photographers that offer you, for a monthly fee, ways to create, update and maintain your online portfolio without the need for web coding. You can design your website using available templates that incorporate features specifically designed for photographers' work. Alternatively, if you prefer to personalize fully the way of showing your

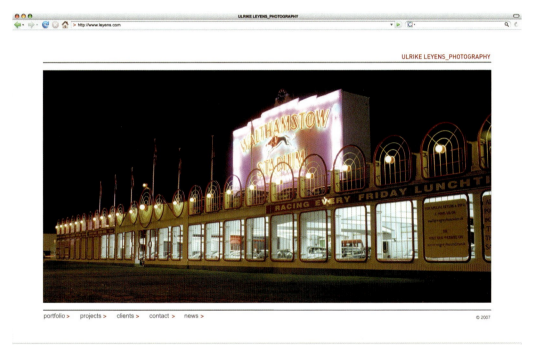

Figure 14.11 A photographer's web page. © Ulrike Leyens.

photographic work you may create your own website from scratch, or pay a professional web designer to do it for you. If you do not have extensive web design experience, creating your own website can be challenging and time consuming. Today's websites can be pretty sophisticated and require knowledge on a set of software applications and advanced techniques.

Whether you create your own portfolio website or pay someone else to do it for you, think of the layout and presentation. It is a good idea to visit various photographers' websites for inspiration. Photographs are usually grouped by theme, for example reportage, landscapes, portraits, etc., or by project tile. Pictures in a group are displayed as series of thumbnails which,

when clicked upon, are presented one by one in larger size. The viewer may either navigate though images in a group using forward and previous arrows, or buttons, or be presented with slide shows. Some photographers prefer to accompany their photos with titles or captions that provide relevant information whereas some others let the images speak for themselves. In the latter case additional web pages with image information should be made available to enable people using search engines to find your work. Make sure that you also publish your contact details so that you can be contacted by those who might be interested in your work. The choice of background colour and borders is also personal. Keep in mind that coloured backgrounds will affect, not only the overall 'mood' the website conveys, but also the perceived colours in the images. Neutral backgrounds are the best choice if you like the viewer to concentrate in the photographic content. Remember that, the lighter the background the darker and more contrasty the image is perceived by the viewer.

Image size is always a compromise on the web and, although small image sizes mean fast downloading of the website content, tiny thumbnails disadvantage, especially images with detail, and therefore may discourage viewers from looking at the bigger picture. The choice of image dimensions is made according to average network speeds and monitor dimensions, but care has to be also given to image aesthetics. Common monitor resolutions range between 72 and 96 dpi (see Chapter 10), so resize and save your images accordingly. There are only a small number of image file formats which are supported by all web browsers, the most common formats being PNG, GIF and JPEG (see Chapter 11). The majority of photographs in online portfolios are JPEG files, compressed at a perceptually lossless-quality level. A compromise between image quality (and therefore file size) and downloading speed has to be made, also when choosing compression level.

Consistent colour reproduction of images published on the web requires a colour space that is compatible with the display tone (i.e. luminance and contrast) and colour characteristics (i.e. white point and RGB primaries). It also depends on the viewing environment. The sRGB colour space was developed in the 1990s to facilitate consistent colour reproduction of images on the Internet. Its RGB primaries are based on the most common CRT display phosphor primaries and the encoding of the gamma function, which largely governs the displayed image contrast, is based on the default CRT display gamma (see Chapter 10). Although LCD is now the predominant display technology, sRGB is still the suggested colour space for images on the Internet. Currently, LCDs are manufactured (or can be set up) so that they mimic the CRT colour and tone reproduction characteristics. It is therefore recommended that you save your web images in sRGB and encourage the visitors of your website to set their displays and display viewing conditions according to the sRGB standard (see Figure 14.12) for correct image viewing. Although it is often difficult (if not impossible) to achieve the exact required viewing conditions, displays should be, at least, placed away from windows and be prevented from direct light

Display luminance level	80 cd/m^2
Display white point	D65 (6500 Kelvins)
Display model offset (R, G and B)	0.0
Display gamma (R, G and B)	2.2
Ambient illuminance level	64 lux
Ambient white point	D50 (5000 Kelvin)
Veiling glare	1%

Figure 14.12 Specifications for sRGB reference display and recommended viewing (ambient) conditions. The reference red, green and blue displayed phosphors are based on the ITU-R BT.709-2 reference primaries. Specifications for the reference viewing environments are based on ISO 3664. The reference observer is the CIE 1931 two-degree standard observer from ISO/CIE 10527.

to avoid reflections. Bear in mind that the LCDs are less prone to reflections than the CRT displays due to their matt faceplates. Otherwise most modern displays can – theoretically – be set up to the sRGB standard, just by making the appropriate selection in the display set up menu. This however does not guarantee consistent displayed tones and colours. There are various reasons why a

display cannot be correctly set up just with the press of a button, amongst which the incorrect setting of the luminance and contrast settings and the age of the display. There is a number of software utilities that allow for visual calibration of the display gamma (which should be set to 2.2), which you might want to make available to the visitors of your website to ensure that images are viewed at least with the appropriate contrast (Figure 14.13).

Use an FTP (File Transfer Protocol) programme or a file management utility to place your images in line. Once your portfolio website is live e-mail your friends and clients the web address. You can also submit the link to various websites that are set to promote photography in your region or country. Such organizations often organize online photographic exhibitions (virtual exhibitions), which are also a good way to promote your photographic work. Online exhibitions may be set around a specific theme or you might be just given the chance to show what you like. You are usually asked to send electronically a specified number of images, of a given image size, resolution and file format and often a short explanation about the images.

Figure 14.13 A number of software utilities can be used to visually set up monitors to specific parameters, such as optimal brightness and contrast, target colour temperature and target gamma. With Adobe Gamma for example, you can use either the control panel – shown here – or a step-by-step wizard to make all the adjustments necessary for calibrating your monitor.

Multimedia

Computers and appropriate software applications allow the presentation of still photography to be integrated with video, sound, lighting, LCD projection and various interactive devices. Audio–visual (AV), meaning the use of banks of 35 mm slide projectors, was well established as a powerful way of creating spectacular, high-quality forms of image presentation for conferences, exhibitions, prestige tour introductions for visitors to museums, etc. This form of imagery presentation has been nowadays replaced largely by controlled LCD or video projectors. With the use of editing software, which can, for example, dissect a scanned-in image and allocate its parts digitally to several projectors, digital projection has changed the production of multimedia shows. High-quality still images, moving images, sound and effects commands can all be played out directly from your computer's hard disk.

At the same time, interactive forms of presentation are possible, both in an audience situation and the kind of one-to-one programme (often on CD or DVD), by which individuals view material on computer screen and relate with it through displayed touch-sensitive response

panels. Interactive elements may include voice command, touch screen and mouse manoeuvring, text entry and video capture of the user. If you are an ambitious photographer working in either a commercial or fine art field, it is important to keep in touch with future multimedia developments. Knowledge here will help you build new markets for your photography. It also enables you to present your work in the most effective form of installation at gallery shows or hand out examples of your work on CDs or DVDs.

Permanence, storage and archiving

Image permanence is a major concern not only shared by photographers, photographic agents and clients but also by curators of photographic collections and archives, who are often responsible for heritages of great historical value. The fact is that no image lasts for ever, but as a professional photographer you have to make sure that your work will last for a guaranteed number of years or, at least, sufficient time for its intended purpose. Storage and preservation of photographs is a very different matter in photographic and in digital media. The world 'archival' was used to describe photographic material with a long lifespan, typically a 100 years. This is the minimum period that conventional photographic media with archival properties are expected to last, provided that they are kept in appropriate conditions. The subject of image permanence has become, however, very complex with the introduction of digital photography. Much less is known about the stability of digital prints as well as the media used to store digital image files. Digital media have expected lifetimes which are much less than 100 years. Apart from the physical and chemical degradation digital media suffer also from the problem of obsolescence. Therefore the term 'life expectancy' is more commonly used today instead of the term 'archival', especially when we refer to the longevity of digital prints and digital image storage media.

Silver halide-based media

The longevity of silver halide-based media depends on the photographic medium itself, the chemical processing and the subsequent storage conditions. Fibre-based printing papers, especially silver-enriched premium weight types, provide better image stability than resin-coated material. Printed photographs are generally more susceptible to degradation than negatives, while fine-grain film is more susceptible than large-grain. Colour photographic media are more at risk than black and white. Photographic materials have to be properly developed, fixed and washed to avoid later yellowing and fading on storage (see *Langford's Basic Photography*). There are types of developers, stop bath solutions and fixers which advantage film or print longevity. So, if you are keen to produce images on photographic media with archival properties, you should probably consult manufacturers' specifications and choose processing solutions accordingly. You can improve the archival properties of black and white materials by using certain toning treatments, for example brown or sepia toning (see *Langford's Basic Photography*). These are more commonly applied after processing to prints to change the tone of a black and white image, but can also be applied on films and photographic plates to enhance

the stability of the silver image. Be aware that toning solutions may contain toxic chemicals that are commonly found in photographic darkrooms, so take the appropriate precautions when you use them. Also, immersing thoroughly washed print material in gold protective toning treatments, provides print protection while changing the image tones only slightly.

According to work published by the Image Permanence Institute (IPI) of the Rochester Institute of Technology (RIT) in USA there are three categories of environmental-induced types of deterioration in photographic media: *Biological decay* involves living organisms, such as mould and bacteria that damage films and prints. Mould, once present and if left untreated, eventually destroys all pictorial information. *Mechanical decay* is related to changes in the structure of the photographic image, such as its size and shape. Over absorption of moisture from photographic media found in humid environments causes swelling, equally lack of humidity and dryness in the atmosphere cause shrinking and cracks. Finally, *chemical decay* changes the chemistry of the photographic image. Incorrect processing – for example leaving residual chemicals or final prints with an unfavourable pH value – causes fading of the image dyes in colour materials. This is known as *dark fading*, a fading process which involves chemical reactions that depend on the structure of the dyes. The dark fading of image dyes is also influenced by various environmental factors, such as the temperature, the relative humidity and common atmospheric gases. Other general effects of polluting gases include yellowing and fading of the image at the edges, orange or red spots. *Light fading* of the photographic dyes is the fading that results from exposure to light and UV radiation. The fading of dyes depends of the intensity, duration and type of radiation. Light fading takes place when you are viewing and displaying your images, for example when displaying prints on the wall, especially close to windows, or when projecting slides. Dye fading of photographic prints usually results in a magenta or pink cast, because the yellow and cyan dyes fade faster than the magenta dye.

Storage and environmental conditions play a crucial role to the longevity of your photographs and influence all types of decay listed above. High temperatures and humid environments aggravate harmful effects (encourage mould growth, structural and chemical changes) whereas lower temperatures and humidity levels as well as dark storage greatly improve media stability. There are several international standards (ISO) that propose recommendations for storing photographic media. In general, when storing photographs make sure that the temperature does not exceed 21°C and the relative humidity (RH) is in the range of 30–50%. For archival storage, lower temperatures and humidity levels are recommended (typically from 7 to 0°C at 30% relative humidity), as well as the use of sealable polypropylene bags – equipped with a humidity indicator – to protect the material from harmful atmospheric gases.

Digital prints

The problem with digital images is that, unless they are rendered, they do not actually exist except as a bunch of numbers, stored under contemporary file formats in contemporary digital storage media. When you consider the preservation, storage and life expectancy of digital images it is a good idea to differentiate between rendered or printed images, and digital image files and media.

Preservation of digital prints is important, especially knowing that the longevity of digital image files suffers from rapid changes of technologies and media obsolescence. Photographs produced by digital colour printers are printed in materials that differ in composition from conventional photographic materials and in their response to environmental factors that damage them. Keep in mind that high temperatures and humidity, long exposure to light, atmospheric pollutants and mould are common factors affecting image permanence in both conventional and digital prints, although not to the same degree. The permanence of digital prints varies widely with the technology or recording, printing material and characteristics of the colourants used to produce them (see Chapter 10). For photo quality printing choose inkjet prints, as they generally provide better image stability than thermal transfer prints of which the permanence has not been well documented. Electrophotographic prints are reasonably stable, as the pigment particles in the toner are fused into the paper base, which is usually uncoated (not photo quality).

The structure of your inkjet print will partially govern its future integrity. Inks may be made from dyes (similar to those used in traditional photographic prints) or pigments (which are also used in toners). Pigments tend to be more stable, as they are less sensitive to water, humidity and high temperatures than dyes (see page 223). The choice of paper is also important. Although uncoated (plain) paper offers greater ink stability, you cannot use it for photo quality prints. Acid-free, buffered and lignin-free paper bases are recommended for better print longevity. Inkjet paper, coated with swellable polymer coating suffers less from degradation caused by atmospheric pollutants than porous paper (with no protective polymer) which in turn is more resistant to moisture and humidity.

Generally more and more inkjet paper manufactures claim 'archival' properties of their papers (typically up to 200 years). Yet, there are no standard measures for inkjet print longevity and no standard recommendations for their storage. Longevity claims vary with manufacturer and product. It is often argued that in accelerating fading procedures (tests that involve exposure of images to intense light to predict fading rates) not all manufacturers follow the same methodologies and therefore the predicted fading rates are not comparable. Until universal guidelines are published follow the recommendations specified for conventional colour prints. Keep inkjet prints in dark conditions to protect them from light fading, away from air pollutants, in low temperatures and humidity levels.

Digital storage and image migration

The longevity of your digital images depends to some extent on the storage medium, the conditions under which the medium is kept, the file formats you use to store your image data and the image encoding (or colour space). Unfortunately, even if you ensure best media and storing conditions, the success in securing the longevity of your photographs is only partial, as it is impossible to rely upon the hardware and software used to store the digital images being available in the future. Modern storage media have two life expectancies: one refers to the physical and chemical lifetime and the other to the expected time of obsolescence. It is important you have an understanding of the media for image storage conditions and the preservation requirements for each of them. Storage media have varying suitability according to the storage capacity required and preservation or access needed.

Magnetic storage media use magnetically coated surfaces to store information. They are re-writable media and information is accessed (read and written) by magnetic heads. The most common magnetic image storage devices are hard disks (fixed or portable) and magnetic tapes (commonly in cartridges and cassettes). On hard disk, digital information is accessed randomly and thus very rapidly, in magnetic tapes sequentially. Although the reliability of magnetic media has improved substantially in the recent years make sure you still purchase your hard disks from reputable suppliers. The very rapid increase in disk space and data access speeds for hard disks makes them very suitable as 'working' storage media. Magnetic tapes, in contrast, are cheap, have large data capacity (typically 20–40 GB) but short lifespan. This is why they are recommended for keeping additional copies (back-ups) in image archiving – where rapid and frequent access is not required – provided that tapes are replaced annually. The longevity of magnetic media is not one of their advantages, their very weakness being the way they read and write information. You should ensure storage of magnetic media away from high-intensity magnetic fields. Hard disks require a certain range of air pressure to operate properly and very high levels of humidity can cause damage of the heads and corrosion. Normal use can eventually lead to failure of these rather fragile devices, so make sure that you back-up your images frequently. Magnetic tapes should be best kept in cool conditions, good-quality air and at maximum 50% relative humidity for best preservation. Binder degradation can cause uneven tape transport and layer separation. You should handle tapes with care, as they are thin and fragile.

The most popular storage for digital images is *optical disk storage,* including types such as CD, CD-R, CD-RW, DVD, DVD-R and DVD-RW. Optical disk drives use laser diodes to illuminate the information engraved as pits on the disk's reflective layer(s) (the land). The laser beam is reflected back from the reflective metallic surface (aluminium or gold) to a sensor which 'reads' the information. Fast random access is the result of the continuous sequence of sectors on the spiral lay-out of the disks. The basic structures of CD, CD-R and DVD-R are shown in Figure 14.14. CD and DVD are read-only storage media, CD-R, DVD-R and DVD+R are recordable once, and CD-RW, DVD-RW, DVD+RW can be used for re-recording digital information. They are removable media, which can be duplicated and handled quite easily. CDs are preferred for image archiving

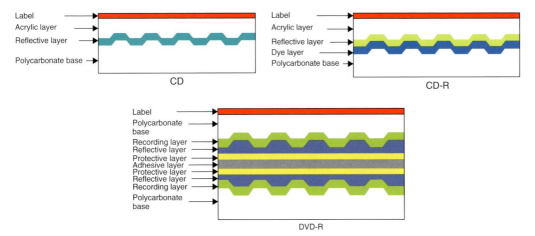

Figure 14.14 Cross-sections of CD (top-left), CD-R (top-right) and DVD-R (bottom).

because of their write-once capability which provides high security from data erasure or modification. Use the ISO 9660 for recording on CD media, as it ensures access of the stored data from all current computer platforms and operating systems. The ISO 9660 is a standard published by the International Organization for Standardization (ISO) in 1988, which defines a method of organizing computer files for CD-ROM media. An extension to ISO 9660, the Joliet system format, allows longer file names and non-ASCII character sets. DVDs may also use the ISO 9660 file system, although the Universal Disk Format (UDF), based on the ISO 13346 standard, is more appropriate on DVDs. It has better support for the larger storage media and is more suitable to the needs of modern operating systems. CD and DVD writers are common and inexpensive nowadays. CD type of disks can store over 600 MB, a capacity which is rather limited for contemporary image sizes but they cost very little. DVDs are more recent optical storage media with capacity to store 4.7–18 GB.

Although optical media have long physical and chemical lifetimes (often stated as 75–100 years) and generally are more robust than magnetic media they are still subject to deterioration, which may result from poor storing conditions and handling. Large and rapid temperature fluctuations can cause layer separation, lack of planarity, cracking and pinholes. Pollutants and high-humidity levels can cause corrosion and mould. Writable disks are susceptible to light exposure that degrades the dye layers. Keep your CDs and DVDs in cool environments (ISO recommendation 21°C) and maximum 50% relative humidity.

Other image storage media include Flash cards and Solid State Disks (SSD) that have very fast data access and are used as mostly as temporary storage devices. The life expectancy of such media is difficult to obtain so do not use them for archiving your photographs. Otherwise, an alternative to in-house storage of your digital images, or indeed for extra safety, consider to 'trusting' your image files to long-term digital storage providers. These are institutions or companies which, for a monthly or yearly fee, will take care of the storage and maintenance of your images. Remote storage is becoming more and more popular, especially from institutions that hold large amounts of digital information.

If you are interested in the longevity of your image data you better store one copy of each image in a form as close as possible to the original capture (see Chapter 11). This enables you to always refer back to your 'master' copy. You need to understand however that your image might not be optimized for a specific output (display or print). Nevertheless, this is the best your capturing device can give you. If you choose to archive only an optimized copy be aware that you will probably have a loss in quality (for example, the colour gamut of the image might be compressed by saving it to the sRGB colour space) but you have the advantage of a ready-to-use image. Save your master copy in the native RGB space of your device. If you decide to save only an optimized version of the image file, it is recommended that you choose Adobe RGB (1998) for print and sRGB for display media.

The requirements of a file format for archiving are that an open standard, non-proprietary file format, and preferably no compression is used – although lossless compression may be acceptable. Uncompressed TIFF (Tagged Image File Format) is one of the most popular choices for archiving images (see Chapter 11). The TIFF is thoroughly documented and it is easily converted between various operating systems and platforms. The first version of TIFF specifications was published in 1986. Since the structure of the TIFF has been expanded around a basic frame which makes older versions backwards compatible (thus it has been tested

sufficiently and has had a relatively long lifespan). The current TIFF 6 version was released in 1992. The latest update to the TIFF format was in 2002 and gives the choice of ZIP and JPEG compression to TIFF, both of which are better avoided if you are concerned with longevity. In 2004, Adobe proposed the DNG (Digital Negative) format as a non-proprietary file format for storing camera RAW files (see Chapter 11) that can be used by a wide range of hardware and software vendors. Like most RAW file formats, the DNG file holds the RAW data in a TIFF-based format. DNG is an extension of the TIFF standard which includes metadata – information that describes how this raw data is to be interpreted. DNG is quickly becoming a choice for image archiving purposes. Otherwise, the PNG (Portable Network Graphics) file format is an open source image format working towards official standardization, and is considered as a possible replacement for TIFF.

As mentioned earlier, preservation and long-term access to your digital image data depends, not only upon the physical lifespan of the storing media and conditions but also the lifespan of the file formats, the hardware and the software used to read the information. One recommendation is that digital data should be periodically transferred from old storage to new media. This process is known as *data migration*. It is suggested that permanence of digital storage should be considered as a measure of the renewal period. There is no degradation in the migration process, since digital information, unlike any other form of information, has the advantage of duplication without a loss. Depending on the amount of data you hold, this might not be the simplest solution. However, be aware that most existing media and file formats are unlikely to be around in 20 or so years, so consider your migration strategies if you are keen to save your photographs. The migration of digital information is the only solution in archiving situations for the preservation of visual heritage.

SUMMARY

- The three traditional systems of reproducing photographs on the printed page are letterpress (raised surface), lithography (water repelling greasy ink) and gravure (ink-retaining hollows). Pre-press preparation is predominantly by digital methods today.

- For letterpress or litho reproduction continuous-tone photographs are converted into a fine pattern of halftone dots. Your eye's limited resolution reads purely black and white dots as a fulltone range, according to ratio and distribution.

- Duotone reproduction of black and white pictures enriches tone range and density but needs at least two halftone separations and two runs through the press. The finer the halftone screen ruling, the greater the detail, provided that it suits the paper being used.

- To reproduce full colour requires at least four separations, printing in yellow, magenta, cyan and black inks. (Screens rotated to different angles.) Scanners convert picture information into a stream of signals representing the four separations. While in digital form images can be masked for contrast and colour, retouched and screened, then re-exposed back onto process film as halftone dot separations.

- Photographic originals supplied for reproduction should not have major differences from the final size; be in appropriate form for being drum scanned; avoid surface texture; have a tone range appropriate to the style of image; avoid underexposed shadow detail or burnt out highlights.

- Digital images supplied for reproduction must originate from high-quality digital cameras or scanners; they must be stored at 300 dpi, 8 bits per pixel; TIFF, RAW or high-quality JPEG compressed files are preferred; choose Adobe RGB, 'clean' them at 100% viewing resolution and avoid sharpening; accompany the images with metadata.

- Picture libraries are agencies that negotiate a fee on the photographer's behalf in exchange for a percentage. Once you have joined an agency you can provide your own photographs or work in collaboration with the agency to produce projects that meet the agencies' demands.

- The World Wide Web is a useful space for sharing images by uploading them on photo-sharing photo services or, better, by displaying them in your own website. Choose the design and colours in your website so that they reflect your personal style. Be aware of the effect the background colours have to the photographic content. Disseminate your URL to friends, clients and organizations that are set to promote photography.

- Multimedia integrates photography, video, audio, etc. in computer-controlled presentations. Multimedia installations include interactive presentations – a smart way to present your photographic work.

- For best preservation, traditional photographic media need to be properly processed, thoroughly washed and stored in dark environments, away from polluting gases, in low temperatures – preferably freezing – and low relative humidity levels. Bad storage conditions result in biological, structural and chemical decay of prints and films. Colour images suffer greater deterioration than black and white due to the fragility of their dyes.

- Digital print stability varies with printing technology and printing media. Inkjet prints produce the most lasting photo quality prints, but they have not yet prove to be stable media despite opposite claims from manufacturers. Print using pigments instead of dyes if you care about image stability. Follow the storage conditions recommended for conventional prints to extend the lifespan of your prints.

- Digital image longevity depends on the storage medium, the conditions under which the medium is kept, file formats and image encoding. Digital storage media have a physical lifetime and a time of obsolescence. If kept in good storage conditions and handled

with care the time of obsolescence is often shorter than their physical lifetime.

■ Magnetic storage media use magnetized surfaces to store digital data which are written and read with magnetic heads. They store large amounts of data. Hard disks have fast access but are fragile; they are good as working storages. Magnetic tapes are cheap, but have slow access; use them for back-ups but remember to renew them frequently. Keep magnetic media away from strong magnetic fields, in cool conditions, good-quality air and at a maximum of 50% relative humidity for best preservation.

■ Optical storage media, such as CD and DVD types are the most robust type. Data is engraved on reflective surfaces and is read using a laser that illuminates the reflective medium and a light sensor that reads the reflected light. CDs, recorded using the ISO 9660 method, are the preferred media for archiving, but do not hold the large amounts of data that the DVDs do. Keep optical media away from pollutants, store them in cool (and if writable dark) environments and low relative humidity.

■ TIFF is the preferred file format for archiving digital images, it has been tested by time, and is compatible with all software and hardware. DNG, which is more and more employed for RAW image file storage and PNG formats are becoming more and more popular.

■ The preservation of digital image information requires periodical transfer from old storage and file formats to new media. Data migration can be laborious and complicated but it is necessary if you care about keeping your digital photographs for more than few years.

PROJECTS

1 Take a good look at an image printed on a newspaper using a magnifying loop. Notice the patterns that result from screening and halftoning. Observe how different colours are reproduced and decide whether black and white text and pictures are produced in the same fashion as colour pictures. Then change printed medium. Check with your magnifier images printed on a poster and later some printed in a good photographic book. Make a note of the differences in screen patterns, if any.

2 Visit the websites of various photographers. Try to navigate through the images and decide which designs and layouts are more suited to your photographic work and to your taste.

Notice the differences that background lightnesses, colours and image sizes make to the photographic content and check whether you prefer images presented on their own or with relating text. Once you have seen many sites, make quick sketches of the website you would like to build to display your photographs.

3 The next time you come across old photographic prints observe any structural changes, changes in the emulsion and the colours. Look for different types of decay, such as colour casts, colour spots and yellowing and try to relate them to different causes of deterioration.

Business practice

This chapter aims to introduce you to some of the activities that you need to know about in starting up and managing a photographic business. An attraction for many people in choosing to work in photography is the freedom and flexibility offered through self-employment; however, it requires a certain degree of skill and knowledge to make a successful living from working in this way, as you do not have the protection in terms of employment laws or a guaranteed regular income, paid annual leave and other employment benefits offered by working for an organization. It may be that at certain times in your career, you may be employed by an organization as a staff photographer; or you may do both, combining part-time work for an organization with your own business. Additionally, depending upon the type and size of business, you may employ others to work for you. Business practice varies with the nature of the work, and the location, but there are certain aspects common to all types of photographic practice that it is important to be aware of, to protect yourself and the people working for you, to protect your work and your equipment and of course to ensure that your business runs smoothly and is viable. This chapter aims to identify these areas and give a general overview. It is important that you find out the specifics for your own practice from relevant sources relating to your area. There are many useful publications covering business practice in photography in more detail. Often photographic associations will produce their own publications covering practical and legal considerations for a particular type of photography; therefore these can be a good starting point.

Starting out

Most photographers do not rely solely on freelance work until they have established themselves to some extent. Initial photography jobs may not be paid, but used to build up a portfolio. This requires that you have an alternative source of income to fall back on as you begin to work in photography. These may be activities unrelated to photography, but it makes more sense to begin working in an image-related area if possible, simply because it can provide valuable insight into the industry.

Starting gradually also allows you to build up some capital, vital at the beginning, as, depending upon the area that you are working in, the nature of commissioning means that for some jobs you may not be paid for several months, and you will need to be able to cover your overheads and living expenses in the meantime. The alternative to having your own capital is a bank loan and for this you will need a well-defined business plan. Either way, you need to have identified various aspects before you begin, such as the type of work you will be doing, format and equipment required, how you will sell the work, your market and any additional start-up costs, such as rental of equipment or premises.

Working in the industry, for example as a photographer's assistant, also allows you to begin to establish a network of useful contacts. It is important to remember that, vital as self-promotion and marketing is in running a successful business; the people that you get to know are also a key resource. The majority of photographic industries, whatever the type of imaging, are built on communication through networks and via word-of-mouth, from those commissioning, buying and using the images, to the photographers themselves, the people working with the photographers (assistants, models, retouchers) and all the companies supplying the industry with services, materials and equipment. Establishing relationships with the organizations and people that will be relevant to your practice will save you huge amounts of time and money in the long run.

As well as networking, working in the industry before going completely freelance allows you to test and develop your skills. For this reason, many photographers start out by assisting other photographers, learning from the way they work and using the opportunity to practice and improve in their use of equipment, as well as learning about the way the business operates.

Working as an assistant

The tasks involved as a photographer's assistant will vary depending upon who you are working for and the type of work they do, particularly whether it is on location or mainly studio based. It may involve anything from checking equipment, loading film, downloading images or setting up lights, to maintaining studios, meeting and greeting clients, and sending out invoices.

You will need basic photographic skills and an understanding of the different formats. Having knowledge of digital technology and some basic retouching skills in Adobe Photoshop are also useful, particularly if the photographer has made the complete transition from film to digital. Being motivated, reliable and able to learn quickly are often more important qualities than having advanced knowledge of, for example, lighting techniques, which can be picked up as you go along. Many assistants begin when they are still at college. Volunteering to work for an initial few days for free, or arranging a week's work experience can be a way of getting your foot in the door. If the photographer likes you, they may offer you more days or even something more permanent. Photographers may be happy to take on relative beginners, as long as they show that they have the right attitude, are willing to learn and get on with them – after all that is how many of them will have started out.

Often photographic associations have systems to put photographers in touch with prospective assistants, or they may advertise assisting jobs, which may be one-off or more long-term. Generally the work will be paid according to a day rate and based on your level of experience. The rate of pay also depends on the type of work. Advertising photography, being the most lucrative area, pays much better than most other areas. It is worth finding out what the going rate is from other assistants or relevant associations and agreeing this beforehand.

As an assistant, you will usually be working on a freelance basis and will work as and when the photographer needs you. This requires that you are flexible and prepared for quiet periods and a relatively low income. However, this allows you the freedom to use your spare time to work towards your ultimate goal of working as a photographer rather than an assistant. Putting together a portfolio is not a one-off job; you should be constantly reviewing and updating it.

Fashions in photography change, as does the way in which the work is presented. Looking at other people's work, fellow assistants, photographers and exhibitions will provide inspiration. You may decide that you need more than one portfolio, depending upon who it is aimed for, or you may have a pool of images (which you can constantly add to) that you can chop and change to tailor the portfolio to the person you are showing it to.

As an assistant you may have opportunities to use or create images which you will then put in your portfolio. It is vital if you are using someone else's equipment that you have the agreement beforehand and are clear about the terms of use. The same rules in terms of legal requirements and insurance apply as if you are working as a photographer, particularly governing working with other people. You will need to make sure that you are adequately covered in terms of Employers' Liability insurance in particular. See later in this chapter for more details. If you are assisting a photographer in an organization and are using their equipment and facilities, you must also be very clear about copyright ownership. Occasionally you will come across an organization that specifies in their contracts that they own the copyright of any images taken using their resources; it is obviously best to avoid this, as you need to maintain your own copyright wherever possible.

Because assisting work varies so much, it is difficult to generalize about the business aspects, but this is the time to get into some good habits, as these will be just as useful when you are working as a photographer. Basic book-keeping, where you track jobs, invoices and expenses is a fundamental skill. Keeping records of jobs, writing things down and obtaining confirmation are also important and will make your life much easier, as you will see, particularly if anything unexpected happens. At the very least, you should become accustomed to ensuring that you clarify the terms of a job before you start; the dates, length of time and payment of fees and expenses. This means that both you and the photographer will be clear about what you expect from each other, misunderstandings are less likely to happen and you are more likely to be booked again.

Becoming a photographer

Working as a freelance photographer

Whether you start out as an assistant or work in another area as you are establishing yourself, the process of becoming self-employed and supporting yourself through your photographic work may well take several years. Building up a client base may require that you begin by taking on some jobs for free. This should not be viewed as a waste of time however; you never know when you are likely to come across someone who really likes your work and not only re-books you but recommends you to someone else. You will also be producing work for your portfolio as an ongoing concern.

During this time you will need to work out what area of photography you want to work in. From this you can perform a skills audit, identifying what you need to know and where you need to improve. This will also identify how you go about obtaining work and finding clients.

For example, the skills required to become an architectural photographer are highly technical, such as the use of larger format equipment, the ability to light interiors and create mood. The photography may be either advertising or editorial and you will need to network with people already involved in these areas, contact organizations and agencies requiring these sorts

of high-quality images and probably to assist photographers also working in architectural photography. You will need to be taking your portfolio to art directors and picture editors for relevant publications. How you go about this will depend upon the way the industry works in your geographic location.

The skills required by a photojournalist are somewhat different however. This type of photography is less structured and more immediate. It tends to be predominantly 35 mm format or equivalent and there is a much greater emphasis on candid images, seizing the moment and being in the right place at the right time. Where editorial and advertising photography will often involve an entourage of people in any one shoot, the photojournalist works mainly on their own. There is not the time available as there is in more formal photography, for images to be retouched, possibly by someone else. The photojournalist these days works mainly using digital equipment from capture to output, with a laptop to retouch the images and transmit them wirelessly as important a part of their everyday kit as their camera. The skills required are more geared towards this way of working. This type of work requires them to think on their feet and to be able to constantly adapt as a situation changes or a news story breaks.

You will find that the conventions for getting your work seen differ depending upon where you are and what type of work you are doing, either as a result of particular legislation applying to the industry but also to do with the level of competition for that type of work. For example, the highly competitive environment in a city such as London or New York means that you may not have face-to-face access to picture editors and will have to leave your portfolio for them to have a look at, in the hope that something in it will catch their eye and they will call you back. In a smaller city elsewhere in the world, things may work differently, with a much more personal approach and the ability to sit down and talk through your portfolio with the relevant people. Any type of photography that is ultimately going to be published in magazines or newspapers is likely to require that you seek out and get your portfolio seen by the right people. However, the area you decide to specialize in will define the people that you need to get to know and the way in which your work should be presented. Presentation is extremely important if the final output is in advertising or something similar.

For photojournalism, however, the content and meaning behind the images, and the speed at which you get them seen is more important. News photography in particular relies more and more on the publication being the first to obtain the rights to the image. Many photojournalists will go out on speculative shoots, following a particular news story, trying to get a decent image and then being the first to get it to a news desk (Figure 15.1).

Figure 15.1 Photographers await Sir Elton John and David Furnish to leave Windsor Guildhall after their civil ceremony, Wednesday, 21 December 2005. Image © James Boardman Press Photography (www.boardmanpix. com). Freelance press photographers often go out on speculative shoots, covering local events or current news items. They will then email the image to all newspapers for a prospective sale. There is a lot of competition when working in this way – it will often depend upon who gets their image of an event to a picture desk first.

You may therefore first get noticed by a picture editor through a specific image that has been emailed rather than through a portfolio. A lot of money can be made if the image is covering an important news item, but obviously these types of images have a short shelf life. If someone else gets the image to the picture desk first, even if it is of lower quality or not as good a shot, and that image is published, particularly on the web, then it may render your image redundant, however good it is.

Working as a staff photographer

An alternative to starting out on a self-employed basis is to become a staff photographer for an organization. There are a number of areas where this is more common, for example, local newspapers will often employ photographers on a more permanent basis. Other fields include forensic photography, for example, or medical photography. There are advantages to starting out in this way, as the organization will offer the same rights to a staff photographer as to any other employee. Although you sacrifice the freedom and flexibility of freelancing, you are afforded protection in a number of ways, and have paid holiday, annual leave and a steady income. Additionally, the organization will often buy your equipment for you, which can be a godsend if you require expensive digital kit. Your overheads will also be covered, for example, materials, and communications costs; in some cases a company car may even be provided.

This all sounds rather comfortable, but employed photographers do not tend to have the same earning capacity as freelancers. Another key issue is that of copyright. You will be tied in by a contract and this may well state that the organization not only owns the copyright on any images that you take for them, but also on any images that you take for yourself using their equipment and facilities. In the more scientific fields however, you may not have any alternative as there may not be the option of working as a freelancer; the organizations simply do not work like this.

The issue of whether you want to be employed or freelance is therefore another consideration when deciding on the area that you are going to work in. Certain specialisms in photography rely solely on employed photographers and this may be something that you are happy to do, either because you appreciate the security, or because you are very clear that this is the type of photography you wish to do. Alternatively, you can choose to work as a staff photographer as an intermediate stage to become freelance.

To summarize, there are a number of aspects common to the process of becoming a working photographer, once you have decided what type of photography you are going to work in. These include purchasing equipment (unless working as a staff photographer), gaining experience in your chosen field, identifying and obtaining required skills, creating and updating your portfolio and getting your work seen by the relevant people, either future employers or future clients. Although the details may vary, the qualities required are similar: to work in photography, whatever the field, you need to be highly motivated, organized and creative both in your work and in your approach to business. You also need patience and persistence. Although technical skills and creativity are of primary importance, personality plays an essential role in achieving success as a practising photographer. Sheer grit and determination may be necessary at times to ensure that your work gets seen. You must believe in yourself and be prepared to market yourself and your skills. You must also be prepared for knock-backs; it may take some time before you start to sell your work.

Running a business

To run a photographic business successfully you have to master certain management skills, even though you may work on your own. Some of these activities are specifically photographic but most apply to the smooth running of businesses of all kinds. If you are inexperienced try to attend a short course on managing a small business. Often seminars on this theme are run by professional photographers and associations. There are also many user-friendly books and videos covering the principles of setting up and running your own business enterprise.

Many photographers choose to operate their businesses as sole traders. This is the simplest method and offers the greatest freedom. The photographer interacts with others as an individual, has sole responsibility in making decisions, but also personal liability for debts if the business fails. It is vital if working in this way that you separate business from personal financial transactions, having a separate business account. It is also important to ensure that business costs are met before personal profit may be taken. When working as a sole trader, discipline is necessary in keeping track of income and expenditure. Book-keeping need not be complicated, particularly if you hire an accountant to do your end-of-year returns, as long as you set up some sort of system and use it consistently.

An alternative method of business set-up is some sort of partnership. This can be a useful way to share the resources and start-up costs. The way in which the industry has changed since the use of the Internet and digital technology have become more widespread, means that it can be useful to offer a range of services alongside photography, such as the design of graphics or web-pages, and the scanning, retouching and compositing of images. Some photographers have expanded their skills, meaning that they can offer some of these additional services themselves, but a partnership can be a useful way for several freelancers with different skills to work together. In partnerships, the partners are jointly liable for debts. This can be an advantage, as the pressure is taken off the individual; however it is important that all partners are very clear from the outset on the terms of the partnership and responsibilities involved in the business. The business relationship should be defined legally and ideally partners should try to discuss possible issues that might arise and how they will be dealt with, before the business is set up.

The most formal method of running a business is to set it up as a company. This is less common; it tends to happen more with businesses with a higher turnover. Advantages include removal of individual liability should anything go wrong, and the fact that the business will remain, should an individual choose to leave (which can be a problem in less formal partnerships). However running a company is significantly more complex; more administration and organizational procedures are involved and it may be more laborious and time consuming to make long-term decisions.

Book-keeping

Book-keeping fundamentally involves keeping a record of any financial transactions to do with the business, incoming or outgoing. However the photographer chooses to operate their business, book-keeping will be a fundamental part of the day-to-day management. Many photographers, particularly those working as sole traders, will manage the process of

book-keeping themselves, but pay an accountant to deal with their books at the end of the year to calculate their tax returns. This may sound the dullest aspect of professional photography. But without well-kept books (or computer data) you soon become disorganized, inefficient and can easily fall foul of the law. Good records show you the financial state of your business at any time. They also reduce the work the accountant needs to do to prepare tax and similar annual returns, which saves you money.

Having set up a separate business bank account, it is necessary to keep a record of income and expenditure, have a method for tracking and archiving invoices and somewhere to keep receipts. The process of recording can be performed in some sort of accounting software, but can be as simple as a spreadsheet on which income and expenditure are entered on separate sheets on a regular basis. A filing system can then be set up corresponding to this, to store the hard copies of receipts and invoices, to be passed to the accountant at the end of the financial year.

A large aspect of your book-keeping will be to record individual jobs. You will need some sort of booking system which may be separate to your accounts, but for financial purposes, you need to record all the jobs in terms of their invoices. The expenses associated with each job should in some way be linked to the invoice, both in software and in hard copies. The client will usually be charged for the majority of expenses (such as materials, processing, contact sheets, prints and taxis) associated with a job. Expenses will appear as money coming into the account but they are not counted as income as you will have spent money up front for them and are simply claiming it back from the client, so it is important that they are identified and not taxed.

When you raise an invoice, you should record the invoice number, client name, description of the job, date, amount and expenses. When the invoice is paid, you should then identify it as paid in your invoice record and include the date, amount and method of payment. Alongside this, you need a receipt book, in which to record payments received from customers. After giving the customer a receipt, record the receipt number in the invoice record. You may prefer to create your own receipts electronically, but must make sure that you back them up. Receipt books are usually simpler as they contain carbon copies and keep all the receipts you write out in one place.

Alongside your computer records of invoices, you should also keep hard copies of invoices in a filing system. A simple method can be to file all information from the job together, which makes it easy to access and means that you do not have many different filing systems. You could for example, include the original brief (if there was one) and any notes you made at the time, confirmation from the client (printed out if by email), delivery note, model release forms, contract, copies or record of receipts (originals should be kept elsewhere, as they will need to be submitted to the accountant) invoice and captions. Jobs can then be filed in date order and possibly by client if they regularly commission work from you. If you then have any queries you can go back and see all the details in one place.

You should also keep a separate record of outgoings in terms of purchases of goods and services. You can simply list all suppliers' invoices, with a note of what they are for, the date and when and how they are paid. You can link this to your depreciation record (see below).

For small purchases that you may buy from time to time, for example stationery, which are not to be associated with a particular job, it is useful to operate a petty cash tin, in which you keep a cash float. Each time you pay for something from the tin, you place the receipt in the tin. When the float is low, you can add up all the receipts on a petty cash sheet and keep them all together, then topping up the float to its original amount. A petty cash system saves cluttering up

your main records with small entries. It also points up the vital need always to retain every relevant receipt – big or small.

You also need to keep records of all your main items of equipment. This forms an inventory (against fire or theft), but more importantly you can agree a 'depreciation' rate for each piece with your accountant. For example, a camera may be given a reliable working life of five years, which means that its value depreciates by a set amount each year (effectively this is the annual cost to your business of using the camera, and part of your overheads when calculating trading profits for tax purposes).

Insurance

Because photography involves such expensive equipment, you will undoubtedly have given some thought to equipment insurance. It is important to check your policy very carefully, to ensure that it covers, for example, equipment transported in a car, and overseas. You should also make sure that you are clear about whether it involves new for old replacement of equipment. The insurance should be enough to cover the value of your equipment, and you should make sure that the maximum for a single item of equipment is adequate and that the single item excess is not impractical for making a claim. It is probably best to seek out a company specializing in insurance for photographers, as they will tend to have policies tailored to the high value of individual pieces of equipment. Standard contents insurance is usually inadequate for these purposes.

There are legal requirements for a working photographer (or assistant) to have a basic level of certain other types of insurance, to protect the business against claims for damage to property or people, or negligence such as mistakes in or loss of images leading to additional expenses for clients. These will vary depending upon where in the world you are working, you can assume that similar rules will apply, but must check the legal requirements for the country in which your business is registered. The following is an example of some of the relevant insurance policies available in the UK. It is not exhaustive; check Photographers' Associations in your field for more details.

Employer's Liability insurance

This is a compulsory insurance in the UK, if a photographer has anyone working for them, even if they are not being paid. If an employee has suffered an injury for example, while working for a photographer, and the courts decide that the photographer was negligent and therefore liable, then the Employer's Liability insurance protects the photographer and will meet the costs of the employee's claim. This insurance covers death, injury and disease.

Public Liability insurance

Similar to the Employer's Liability insurance, this covers property rather than people and protects the photographer from liability for loss or damage of property, and injury, disease or death of a third party (who is not working for them).

Professional Indemnity insurance

Although optional, this is one of the more essential ones when working professionally, as it protects against claims of professional negligence. These may be about very minor things, but can cost a business a lot of money. Examples include infringement of copyright, mistakes leading a reshoot being required, loss or damage of images, etc.

Charging for jobs

Knowing what to charge often seems more difficult than the technicalities of shooting the pictures. Charging too much loses clients; charging too little can mean periods of hard work for nil profit. It is not seen as good practice to drastically undercut your contemporaries; it can undermine future jobs and would not make you friends. The amount to charge will depend fundamentally on the type of work you do and who it is for.

If the work is commissioned, then you will be agreeing a price up front. Advertising is by far the best paid, but the amount will depend very much on how big the job is, the type of media and the circulation (as well as your reputation of course). Press photography varies widely – the sky is the limit if you are covering a big story and have obtained an exclusive image which you are able to tout to the highest bidder. Editorial work tends to be more poorly paid, sometimes a fifth or a tenth that of standard commercial rates. For all of the above areas, it will depend fundamentally upon who is buying your image and what the convention is in the region that you work. Newspapers and magazines often have a set day rate, which may be negotiable, but this will be the key-determining factor. If you tend to do more commissioned photography for individuals, for example photographing social events, then it is more common for you to set your day rate as a starting point and the client to then negotiate with you from that.

Working out your day rate

It can be helpful to find out what your competitors are charging before you start and it is useful to be flexible; you may have different day rates for different types of jobs, depending upon their complexity, and also for different types of clients. You may not always work for your day rate (particularly when working for publications that specify their own day rates and are relatively intransient in this), however it is important to have a rate in mind during negotiations which makes sense for you and your business. It is also an important benchmark for you to help in deciding when to turn down work. It may seem strange to think in these terms, but there will be some jobs where the money on offer will not be enough to cover your overheads or make it worthwhile for you. There may be some situations where you choose to take on this work, but having a day rate which has been worked out systematically allows you to identify these jobs and make informed choices about whether you take them or not. Hopefully in more cases the money offered will be higher than your day rate rather than lower.

Working out a reasonable day rate is based on costing. Costing means identifying and pricing everything you have paid out in doing each job, so that by adding a percentage for profit you arrive at a fair fee. This should prevent you from ever doing work at a loss, and provided you keep costs to a minimum the fee should be fully competitive. Identifying your costs means you must include indirect outgoings ('overheads') as well as direct costs such as materials and equipment hire. Typical overheads include rent, electricity, mobile phone, broadband Internet connection, water, cleaning, heating, building maintenance, stationery, petty cash, equipment depreciation and repairs, insurances, bank charges, interest on loans and accountancy fees.

You then need to work out what you want to pay yourself as a salary and any other staffing costs. You must take into account the number of days you are aiming to work over a year, including holidays and the fact that it is unlikely that you will be shooting five days a week, as you will need several days a week for the associated activities in terms of managing your images

and managing your business. From this you will be able to work out how much you need to charge a day.

When it comes to costing, you base your fee on a number of elements added together

1. What the business cost you to run during the time period you were working on the job. This is worked out from your overheads and salary requirements as above.
2. The percentage profit you decide the business should provide. Profit margin might be anywhere between 15 and 100%, and might sometimes vary according to the importance of the client to you, or to compensate for unpleasant, boring jobs you would otherwise turn away.

This gives you your basic day rate. You then need to add expenses:

3. Direct outgoings which you incurred in shooting (such as the materials and storage media, travel, accommodation and meals, models, hire of props, lab services, image retouching and any agent's fee).

Because you have paid out for the expenses already, these are not part of any profit you make and should not be taxed.

Most photographers will charge for a full day, however long the job lasts, fundamentally because some of the day will be taken up with travelling to and from the job and you will also need to allow for the time spent in related activities, such as going to pick up prints. You may choose to offer a half-day rate for jobs that are not going to take much time, but you must bear in mind that taking these jobs will usually mean that you are unavailable for other work on that day.

You will also need to consider the use of the image. It is most common for the photographer to retain the copyright and for the usage to be agreed beforehand. Usage specifies how many times an image may be reproduced, what region of the world and on what type of media. It may also determine whether the buyer has exclusive rights to the image and if so for how long. This is particularly important in news images, as their exclusive rights prevent you from reselling the image and therefore represent a loss of potential profit for you. The more that the buyer of the image wants to use it, the more you should be able to charge for it. This is an important part of the original negotiations and should be confirmed in writing (even if by email) before the image is used. For commissioned work it will usually be written into a contract. This is covered in more detail later in the chapter.

Invoicing and chasing payment

You should have a consistent system for sending out and chasing outstanding invoices as part of your book-keeping system and should check all outstanding accounts on a regular basis to ensure that you keep on top of things.

To make sure that you get paid you must first ensure that the client receives the images *and* a copy of your terms and conditions – this is important. When sending out images, either soft or hard copies, you should always include a delivery note. The delivery note will include your terms and conditions for the client's use of the image. By accepting the image and the delivery note the client is accepting your terms and conditions; they will be in breach of copyright if they use the image without paying you and will be liable for legal action. If sending out hard copies, unless delivering them yourself, then use a courier to make certain that the images will be covered by insurance for their safe delivery. If using an alternative method of delivery then you should make sure that you insure the images yourself.

You can follow the images up with a phone call or email to make sure that the client has received them, and send the invoice a few days later. As well as the information about the job, you should clearly state on the invoice what your terms are for payment, i.e. how long before you expect them to pay, for example 30 days. When you get paid depends of course on who you are working for and where. Some clients may take several months to pay; this can be particularly true of newspapers in the UK, whereas others will pay promptly after two weeks.

If you check all your payments on a regular basis, it will be simple to send out monthly statements to clients with outstanding invoices. This can be backed up with regular phone calls. As long as you have clearly stated terms and conditions written on a contract and a delivery note, then you should have no problem getting payment eventually, although you should be prepared for the fact that it may involve a frustrating amount of time spent in chasing them. It is important that you do follow-up when payments have not arrived; invoices are too easily lost and some companies seem almost to have a policy of non-payment until you do chase them. It is also important to remember that the person who commissioned work from you may be far removed from the finance department and may have no idea that you have not been paid; in other words, the onus is very much on you to ensure that you get paid, not on them.

Uneven cash flow is the most common problem with small businesses. Clients (especially advertising agencies) are notorious for their delay in paying photographers. Often they wait until they are paid by *their* clients. It is therefore advantageous to have one or two regular commissions which might be mundane, but are paid for promptly and even justify a special discount. The length of time it can take for payment to come through is something to bear in mind when setting up your business. It may be several months before you see any money coming in and you will need to have some sort of financial safety net available to cover this period; enough to cover your living costs and overheads for two to three months at least.

Commissioned work

The majority of photographic work is commissioned, i.e. you are booked to produce particular images, rather than speculative (these are images that you shoot without being booked to do so, and then try and sell; they tend to be more common in photojournalism). Commissioned work will involve several interactions between you and the client before the job is completed and you are paid. The formality of this process will depend upon the field that you are working in and your individual way of working, but you should have a system for recording and tracking the progress of a particular commission. Some of this may involve standard forms, either yours or the client's, whereas other aspects might be communicated by email. It is important that you keep written records and are able to easily access information relating to a particular piece of work.

Job sheets

One good way of keeping track of a job in progress (especially when several people are working on it at different times) is to use a job sheet system. A job sheet is a form the client never sees but which is started as soon as any request for photography comes in. It follows the job around from shooting through printing to retouching and finishing, and finally reaches the invoicing person's file when the completed work goes out. The job sheet also carries the job instructions, client's name and telephone number. Each member of the team logs the time spent, expenses, materials,

etc. in making their contribution. Even if you do all tasks single-handed, running a job sheet system will prevent jobs being accepted and forgotten, or completed and never charged for.

Contracts

The agreement between you and a client should be defined by a contract, which is a legally binding document. The process of deciding on fees, terms and conditions, and usage and copyright of images is actually the negotiation of the contract. It is important that both photographer and client are clear about the terms of the contract; if either side fails to fulfil their half of the deal then the other party may pursue them for compensation through the courts. The aim therefore is to protect the interests of both parties. For this reason verbal agreements about a photographic assignment should always be followed up with something written down, even if by email; having something traceable prevents later misunderstandings. Photographers should obtain written confirmation of conversations and include terms and conditions covering details of copyright, usage, third parties, cancellation, etc. (see below). Once all the terms have been agreed and written down by one party, they should be sent to the other party, to be signed and sent back. Both sides should keep a copy of the contract.

Often publications such as newspapers or magazines will have their own standard contracts which they will expect you to work to. These may include how much they are prepared to pay you and will undoubtedly include their terms and conditions. It is important that you check exactly what is being offered before accepting a job from them, as by doing so you will be entering into a contract with them. Such contracts may or may not be negotiable; if you do negotiate, again you must ensure that you obtain the negotiated terms in writing.

Initial booking

In the beginning a booking will often be by phone or email contact, and it is at this point that you will obtain details of the images required. The client may give you a clear written briefing, or you may need to define exactly what they require in conversation with them. As well as the information about the images required, you will need to know about the date, location, format and media, and some idea of how the images are to be used, i.e. if they are to be published and if so how many times and where. You should make notes of these initial conversations and it is helpful to keep them with the other documentation for the particular job, to be easily referred to if necessary. It is also at this point that you will be negotiating your fee. It may be that the client comes with a specific budget in mind, which you may or may not accept, or that you will use the information gathered to specify the fee based on your day rate. You should also clarify issues around copyright ownership and licensing, which will have an impact on the fee charged.

Confirmation

Once the details of the job and fee have been agreed, the next stage is to confirm them in writing. It is possible that you will do this by email or more formally using a commissioning form, or commission estimate. The form should be designed so that it has spaces for subject and location, likely duration of shoot, agreed fee and agreed expenses. It also specifies what the picture(s) will be used for and any variations to normal copyright ownership. If using a commissioning form, you should also include your terms and conditions. Signed by the client this will serve as a simple written contract. The form therefore avoids difficulties, misunderstandings and arguments at a later date – which is in everyone's interests.

Terms and conditions

Your terms and conditions should be included on the majority of the paperwork that you send out; it is common practice to print them on the back of all standard forms. These define the legal basis on which the work is being carried out; however, if the client includes a different set of terms and conditions on any paperwork they send to you, they may override yours, so this is something to keep in mind. Clients may choose to negotiate your terms and conditions; particularly in terms of copyright and usage of images: if they do not then you can assume that they are accepted and they become a part of the contract between you and the client.

Terms and conditions allow you to be specific about how you will work: they spell out details such as cancellation fees, the extent of a 'working day' and so on. Importantly, they should include details of copyright, usage, client confidentiality, indemnity and attribution rights. Photographic associations will often have standard sets of terms and conditions for you to use: an example set for photographers in England and Wales produced by the Association of Photographers (UK) is reproduced in Figure 15.2.

Terms and conditions

1. Definitions

For the purpose of this agreement 'the Agency' and 'the Advertiser' shall where the context so admits include their respective assignees, sub-licensees and successors in title. In cases where the Photographer's client is a direct client (i.e. with no agency or intermediary), all references in this agreement to both 'the Agency' and 'the Advertiser' shall be interpreted as references to the Photographer's client. 'Photographs' means all photographic material furnished by the Photographer, whether transparencies, negatives, prints or any other type of physical or electronic material.

2. Copyright

The entire copyright in the Photographs is retained by the Photographer at all times throughout the world.

3. Ownership of materials

Title to all Photographs remains the property of the Photographer. When the Licence to Use the material has expired the Photographs must be returned to the Photographer in good condition within 30 days.

4. Use

The Licence to Use comes into effect from the date of payment of the relevant invoice(s). No use may be made of the Photographs before payment in full of the relevant invoice(s) without the Photographer's express permission. Any permission which may be given for prior use will automatically be revoked if full payment is not made by the due date or if the Agency is put into receivership or liquidation. The Licence only applies to the advertiser and product as stated on the front of the form and its benefit shall not be assigned to any third party without the Photographer's permission. Accordingly, even where any form of 'all media' Licence is granted, the photographer's permission must be obtained before any use of the Photographs for other purposes e.g. use in relation to another product or sublicensing through a photolibrary. Permission to use the Photographs for purposes outside the terms of the Licence will normally be granted upon payment of a further fee, which must be mutually agreed (and paid in full) before such further use. Unless otherwise agreed in writing, all further Licences in respect of the Photographs will be subject to these terms and conditions.

5. Exclusivity

The Agency and Advertiser will be authorised to publish the Photographs to the exclusion of all other persons including the Photographer. However, the Photographer retains the right in all cases to use the Photographs in any manner at any time and in any part of the world for the purposes of advertising or otherwise promoting his/her work. After the exclusivity period indicated in the Licence to Use the Photographer shall be entitled to use the Photographs for any purposes.

6. Client confidentiality

The photographer will keep confidential and will not disclose to any third parties or make use of material or information communicated to him/her in confidence for the purposes of the photography, save as may be reasonably necessary to enable the Photographer to carry out his/her obligations in relation to the commission.

7. Indemnity

The Photographer agrees to indemnify the Agency and the Advertiser against all expenses, damages, claims and legal costs arising out of any failure by the Photographer to obtain any clearances for which he/she was responsible in respect of third party copyright works, trade marks, designs or other intellectual property. The Photographer shall only be responsible for obtaining such clearances if this has been expressly agreed before the shoot. In all other cases the Agency shall be responsible for obtaining such clearances and will indemnify the Photographer against all expenses, damages, claims and legal costs arising out of any failure to obtain such clearances.

8. Payment

Payment by the Agency will be expected for the commissioned work within 30 days of the issue of the relevant invoice. If the invoice is not paid, in full, within 30 days The Photographer reserves the right to charge interest at the rate prescribed by the Late Payment of Commercial Debt (Interest) Act 1998 from the date payment was due until the date payment is made.

9. Expenses

Where extra expenses or time are incurred by the Photographer as a result of alterations to the original brief by the Agency or the Advertiser, or otherwise at their request, the Agency shall give approval to and be liable to pay such extra expenses or fees at the Photographer's normal rate to the Photographer in addition to the expenses shown overleaf as having been agreed or estimated.

10. Rejection

Unless a rejection fee has been agreed in advance, there is no right to reject on the basis of style or composition.

11. Cancellation & postponement

A booking is considered firm as from the date of confirmation and accordingly the Photographer will, at his/her discretion, charge a fee for cancellation or postponement.

12. Right to a credit

If the box on the estimate and the licence marked 'Right to a Credit' has been ticked the Photographer's name will be printed on or in reasonable proximity to all published reproductions of the Photograph(s). By ticking the box overleaf the Photographer also asserts his/her statutory right to be identified in the circumstances set out in Sections 77–79 of the Copyright, Designs and Patents Act 1988 or any amendment or re-enactment thereof.

13. Electronic storage

Save for the purposes of reproduction for the licensed use(s), the Photographs may not be stored in any form of electronic medium without the written permission of the Photographer. Manipulation of the image or use of only a portion of the image may only take place with the permission of the Photographer.

14. Applicable law

This agreement shall be governed by the laws of England & Wales.

15. Variation

These Terms and Conditions shall not be varied except by agreement in writing.

Note: For more information on the commissioning of photography refer to Beyond the Lens produced by the AOP.

Figure 15.2 Standard set of terms and conditions for photographers in England and Wales. (© Association of Photographers. This form is reproduced courtesy of the AOP (UK), from *Beyond the Lens*, 3rd edition, www.the-aop.org).

Standard Release Form

Photographer: _____	Agency/Client: _____
Model/s: _____	Art Order No.: _____
Product: _____	Brand Name: _____
Date/s: _____	Hours Worked: _____

For valuable consideration received *I/we hereby grant the *photographer/agency/client, and any licensees or assignees, the absolute right to use the photograph(s) and any other reproductions or adaptions, from the above mentioned photographic shoot, but only for the product or brand name specified above, solely and exclusively for:

Media

☐ Advertising - national press
☐ Advertising - trade press
☐ Editorial - consumer press
☐ Editorial - trade press
☐ Editorial - national press
☐ Catalogue
☐ Test/personal/portfolio (not for commercial use)
☐ Other _____ *(specify)*

☐ Brochure
☐ Point of Sale
☐ Inserts
☐ Poster _____ *(specify)*
☐ Packaging
☐ Television/Cinema/Video
☐ Full library use

Territory

☐ UK
☐ Single EC country _____ *(specify)*
☐ Continental Europe
☐ USA

☐ English language areas (book publishing)
☐ Worldwide
☐ Other _____ *(specify)*

Period of Use

☐ One year
☐ Two years
☐ Other _____ *(specify)*

For specific restrictions/conditions/agreements see attached.
Electronic rights must be negotiated separately.

*I/We understand that the image shall be deemed to represent an imaginary person unless agreed otherwise, in writing, by my agent or myself.

*I/We understand that I/we have no interest in the copyright, nor any moral rights, in the photograph.

**I am over 18 years of age.

Name of *model/model agency: *(print)* _____

Signature of *model/model agency: _____ Date: _____

**Parent/guardian or model agency must sign for models under 18 years of age.*

In accepting the above release it is the responsibility of the *photographer/agency/client not to use or authorise the use of the material except for the above media, territories and time periods. Further usage must be negotiated and agreed beforehand, in writing, with the *model/model agency.

Delete as appropriate

ISSUED IN 1995 BY THE ASSOCIATION OF PHOTOGRAPHERS LTD,
THE ASSOCIATION OF MODEL AGENTS AND THE INSTITUTE OF PRACTITIONERS IN ADVERTISING

Figure 15.3 Example of a Standard Model Release Form. (© Association of Photographers. This form is reproduced courtesy of the AOP (UK), from *Beyond the Lens*, 3rd edition, www.the-aop.org).

Model release

Anyone who models for you for a commercial picture should be asked to sign a 'model release' form (see Figure 15.3). The form in fact absolves you from later claims to influence uses of the picture. Clients usually insist that all recognizable people in advertising and promotional pictures have given signed releases – whether against a fee or just for a tip. The exceptions are press and documentary type shots where the people shown form a natural, integral part of the scene and are not being used commercially.

After the shoot: sending work to the client

Once the shoot has been completed, what happens to the images will depend upon what you have agreed with the client. It will also be based on what type of media you work in, either film or digital. If you are using film, you may well need to send the originals to the client, unless they only want prints. The risks in terms of loss of originals are obviously greater with film, as digital images allow you to keep archived originals as well as sending them out. It is therefore important that you make sure that images are insured while in transit. Often clients will want printed contact sheets even if you are working digitally and this can be an opportunity to make a selection of the better images and present them in an attractive manner. If producing film originals, the client may want digitized versions as well. Offering image scanning as an additional service can be an extra source of income, whether you have time to do this yourself, or choose to get them scanned by a lab. For news images, it is possible that you will be sending the finished images over the Internet. It is important in this case that you ensure that the images are saved to the correct image dimensions, resolution and file format for the client. The way in which you present your work, whether transparencies, film, contact sheets or digital images is important: although they may not be the finished product, it helps to make you appear more professional, which can be important in marketing yourself and obtaining more work. An example of a selection sent out to a client is shown in Figure 15.4.

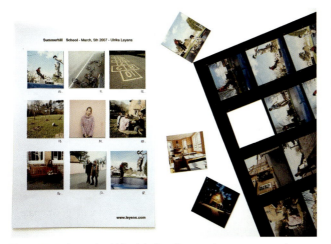

However you send your images, whether electronically or as hard copies, it is vital that you protect yourself against loss or damage to the images and also against clients using them without your permission. To do this you need to include a delivery note whenever you send images to another party, which can be either digital or hard copy. It should include details of the client's name, address, contact name and phone number/email, method of delivery, date of return and details of fees for lost or damaged images. The number, type and specifics of the images should be described. Terms

Figure 15.4 The way in which originals and contact sheets are presented to a client is important. Attractive presentation may help in both selling the images and obtaining further work from the client and may be used as part of your self-promotion. Image © Ulrike Leyens (www.leyens.com).

and conditions should be printed on the reverse and this clearly stated on the front of the note. It should have a unique number to allow you to track and file it. You should also have a specific statement regarding your policy about the storage or reproduction of the images without your permission. By accepting the images with the delivery note, the client is agreeing to these terms.

Copyright

Be on your guard against agreements and contracts for particular jobs which take away from you the copyright of the resulting pictures. This is important when it comes to reprints, further use fees and general control over whom else may use a picture. If an agreement permanently deprives you of potential extra sources of revenue – by surrender of transparency or negative, for example – this should be reflected by an increased fee. Generally, in most countries around the world, copyright automatically belongs to the author of a piece of work, unless some written agreement states otherwise, therefore you will retain ownership unless you choose to relinquish it. By including your terms and conditions with all documentation and having a written contract, you are protecting your copyright. As owner of the copyright of the image, you may choose what you do with it and you can prevent others from reproducing it without your permission.

You can *assign* your copyright to someone else, in other words you choose to give it up or sell it. What this means is that you will no longer have any rights to the image, any control over how it is used and most importantly, you will no longer be able to make any money from it. Bearing in mind that your back catalogue of images can potentially be an ongoing source of income it is not wise to ever give up your copyright unless you have very good reason to.

It is much more common, however, to retain copyright and agree usage of the image. This is in the form of a *licence*, which defines the reproduction rights of the client based on what they have paid you. The licence will specify among other things: type of media e.g. printed page, web page, all of Internet; length of time that the client may use the image; quantity of reproductions (this may be approximate, but is generally an indicator of circulation); number of reproduced editions; territory (this specifies the geographical area that it may be published in, for example, Europe only or worldwide use). The licence may be exclusive, meaning that for its duration, you may not sell the image on to anyone else and no other party may use it. It protects the interests of the client and allows them to take legal action if anyone else infringes the copyright during this period. This is quite common in press photography in particular. Once the duration of the licence has ended, the client may no longer use it. If the licence was exclusive, then at the end of its duration you will be free to sell the image on. You may choose to syndicate your image, in other words sell it on to multiple magazines or newspapers, which can be very lucrative. The client may, however, negotiate an extension or a further licence and will again pay a fee for this. Before this you may continue to use it for self-promotion, in your portfolio or on your website, but will be restricted from using it elsewhere.

There are some cases where you will have no choice but to give up your copyright, for example if you are working as a staff photographer, where it is specified in your contract of employment. Some of the large news agencies, such as Reuters or the Associated Press have also introduced contracts where they own the copyright of images and you are just paid a day rate. If they choose to use your images more than once, it may be possible to negotiate a deal for further fees.

Digital rights

Digital imaging has made enforcement of copyright more difficult, as images are much more widely distributed and it is simple to make copies of digital images, download them and store them on a computer. It is also easy to alter digital images with image processing software. Both are infringements of the image copyright. You should ensure that your images on the web carry copyright information, and that it easily visible. You may also choose to use some form of watermarking or image security software. This may involve simply embedding copyright information in the image, which will be visible if the image is downloaded, however many watermarks can be removed; it may be something more sophisticated, which prevents the user from copying or altering the image and identifies if an image has been tampered with. The issue around image altering is an important one too. It is surprising how many people working in the imaging industries are unaware that this is copyright infringement. It is quite common to find that an image submitted to a news desk by the photographer is subsequently published with significant alterations without his permission. This cannot be prevented, but you can protect yourself legally by including a clear copyright statement about reproduction, making copies and altering of the image whenever you send the image to anyone.

Marketing your business

Like any other service industry, professional photography needs energetic marketing if it is to survive and flourish. The kind of sales promotion you need to use for a photographic business which has no direct dealings with the public naturally differs from one which must compete in the open market place. However, there are important common features to bear in mind too.

Your premises need to give the right impression to a potential client. The studio may be an old warehouse or a high-street shop, but its appearance should suggest liveliness and imagination, not indifference, decay or inefficiency. Decor and furnishings are important, and should reflect the style of your business. Keep the place clean. Use equipment which looks professional and reliable.

Remember that you yourself need to project energy, enthusiasm and interest and skill and reliability. Take similar care with anyone you hire as your assistant. On location arrive on time, in professional looking transport containing efficiently packed equipment. If you want to be an eccentric this will ensure you are remembered short term, but your work has to be that much better to survive such an indulgence. Most clients are archconservatives at heart. It is a sounder policy to be remembered for the quality of your pictures rather than for theatrical thrills thrown in while performing.

During shooting give the impression that you know what you are about. Vital accessories left behind, excessive fiddling with metres, equipment failures and a feeling of tension (quickly communicated to others) give any assignment a kiss of death. Good preparation plus experience and confidence in your equipment should permit a relaxed but competent approach. In the same way, by adopting a firm and fair attitude when quoting your charges you will imply that these have been established with care and that incidentally you are not a person who is open to pressure. If fees are logically based on the cost of doing the job, discounts are clearly only possible if short cuts can be made to your method of working.

The methods that you use to market your work and the way in which it is presented will depend upon your field. But whatever area you work in, you will undoubtedly need a portfolio.

In some cases this may be the only opportunity to make an impression on a potential client, as you may be asked in some cases to leave your book with them and never get the chance to meet them face-to-face. The images in your portfolio of course need to be relevant to the field you are working in, both stylistically and in substance. It is also possible that you will need to change them to suit the interests of different clients.

The content therefore needs to be carefully thought out and put together. The images must be selected with care; they should be your best pieces of work and effectively represent the range of your skills and abilities. You should not include everything: avoid duplication and streamline where possible: a smaller more concise portfolio appears more professional than one that contains every piece of work that you have done. It is also important that you include some recent work. You should review your portfolio(s) every few months and update them where necessary.

You should aim for some sort of consistency in your images, for example, grouping them according to type or content. They will look better if all presented in the same way wherever possible, on the same type of paper, similar dimensions and the same method of mounting. Paramount of course is the quality of the prints. It can be extremely useful to look at other people's portfolios to get an idea of different styles of presentation. Figure 15.5 shows some examples.

It is also useful to include examples of work that has been published, for example, page layouts from magazines that include your images. If you have the opportunity to meet with clients then you should make sure that you talk them through your images; this is a good chance to put your ideas and your enthusiasm across.

If you are going to leave your portfolio with a client, include a delivery note: the same rules apply as for sending images, in terms of protecting yourself against loss or damage to your images. You may want to include other material as well, particularly if you are not able to actually meet with the client. Giving them something they can take away with them will help to remind them of you and your work; even if they do not choose to use you at this point, they may do so in the future. This may be a short CV or covering letter along with a business card.

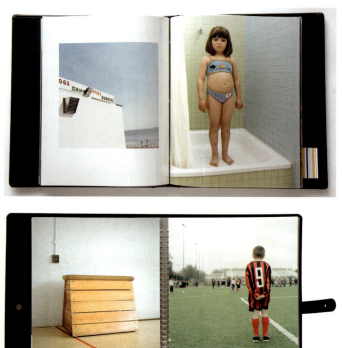

Figure 15.5 Presentation in portfolios. Images © Ulrike Leyens (www.leyens.com) and Andre Pinkowski (www.onimage.co.uk).

Figure 15.6 Postcards and business cards can be useful marketing tools. Image © Ulrike Leyens (www.leyens.com).

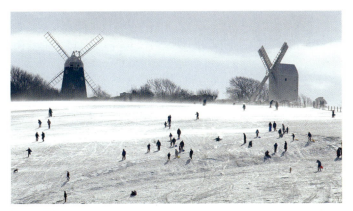

Figure 15.7 Families brave the cold temperatures and snowy conditions on top of the South Downs at Clayton in Sussex. Jack and Jill windmills are seen in the background. Image included in the Press Photographers Year Awards 2006 © James Boardman Press Photography (www.boardmanpix.com).

The business name, logo, notepaper and packaging design, along with all your printed matter, should have a coherent house style. Better still get a booklet or some postcards with your images and logo printed, and include these (see Figure 15.6). These can also be useful to send out to ongoing clients as a way of keeping in touch and touting for more work.

Entering photographic competitions are another way to get your work seen and capture the attention of picture editors in particular. Professional competitions such as Press Association Awards (see Figure 15.7), for example, will be attended by the people buying the images. Often entries will be placed in an exhibition and in an associated book, even if they do not win an award, giving you free publicity and the opportunity to get your images seen by the people that count. The private views for these types of competitions are high profile events and a good chance to network.

As well as the other benefits that membership of professional societies and associations offers, they may be able to help to publicize your work. Most have related publications in which they showcase member's work. They also often have sections for members' portfolios on their websites.

Of course, the widespread use of computers and the Internet mean that a website is a vital marketing tool. It can be easy to direct someone to your work and include your URL on every email, meaning that you reach a much wider audience without the labour involved in booking appointments and carting round a portfolio. Additionally, you may present your work on CD or DVD, however this should not be considered a replacement for a portfolio; many people prefer to sit down and browse through high-quality and nicely presented prints rather than look at them on a computer screen.

You may choose to pay someone to design your website for you, however there are a number of software applications that make it relatively easy for you to create one yourself if you are prepared to learn how to. Similar rules apply in terms of selection and presentation of images as for your portfolio, although you may choose to include more images on a website (see page 337). Because websites are interactive and inherently non-linear, it can be useful to group your images in different galleries and therefore you have an opportunity to present much more work, although again you must make sure that they represent the best of your work. You will also have an opportunity to include a short CV and information about yourself. You may even use the site to sell images. Bear in mind the issues around copyright: include copyright statements clearly throughout and give some consideration to image security and watermarking.

SUMMARY

- Unless you choose to work as a photographer employed by an organization, being successful in a career in photography involves an understanding of a number of aspects of business practice, including book-keeping, insurance, contracts, the nature of commissioning, general administrative systems and self-promotion.

- Although you may use an accountant for end of year tax returns, you will need a number of systems to keep track of the financial aspects of your business, including invoices, expenses, purchasing, petty cash and the depreciation of equipment.

- You will need to make sure that you have insurance to cater for the needs and size of your business. At the least you should have equipment insurance and if you have anyone working for you, paid or unpaid, you will need Employer's Liability insurance, or the equivalent. Other useful insurance includes Public Liability insurance and Professional Indemnity insurance.

- When deciding what to charge for a job, it will usually be based upon your day rate. In some cases the client may specify a day rate; otherwise your day rate should be calculated to take into account business overheads and your salary. Also included in the fee will be expenses directly associated with a particular shoot.

- You will need to track the progress of individual jobs and expenses and ensure that you have a consistent process for invoicing and chasing payment. To do this you will need a good system of paperwork, which should include the terms and conditions for an individual contract. This ensures that you cover yourself and can take legal action for non-payment.

- Your terms and conditions define the legal basis for work to be undertaken. They will be negotiable before a contract being agreed. You must ensure that both parties are clear about the terms and conditions for a particular job, as clients' terms and conditions can override the photographer's. All changes should be confirmed in writing.

- A model release form should be used when photographing people, other than in certain documentary or press shots where the people are a natural part of the scene. This is particularly important when photographing minors.

- Copyright is important in protecting your interests and ensuring that your images are not used without your permission.

- Copyright, in most cases, automatically belongs to the photographer (unless working as a staff photographer or for some news agencies). You should avoid giving up or assigning your copyright wherever possible, as this means that you will no longer have any control over the image and cannot make money from it.

- You may instead licence your images, which allows a client to use the images under specific conditions and for a particular duration. Clients may ask for an exclusive licence for that period. They may also negotiate further licences once one has expired.

- Copyright is more complicated when referring to digital images. The storage of copies of digital images and the altering of digital images constitutes copyright infringement.

- Self-promotion is vital to the success of your business. Care must be given to the way in which you present yourself, your premises and your work. A portfolio is an important opportunity to present your work and should be carefully compiled. A website is also a necessary marketing tool.

Appendices

A: Optical calculations

Formulae below relate to lenses, and make use of the following international symbols:

f = focal length

u = distance of object from lens (measured from front nodal point*)

v = distance of image from lens (measured from rear nodal point*)

d = total distance between object and image, ignoring nodal separation

O = object height

I = image height

m = magnification

(*Warning: these distances are difficult to measure accurately with telephoto and inverted telephoto lenses, because the nodal points may be well in front or behind the centre of the lens. See page 56).

You can calculate focal length, or image and object distances, or magnification, when other measurements are known.

The key equation is:

$$\frac{1}{u} + \frac{1}{v} = \frac{1}{f}$$

From which are derived:

$$m = \frac{v}{u}$$

$$u = \left[\frac{1}{m} + 1\right]f = \frac{d}{m+1} = \frac{vf}{v-f}$$

$$v = (m+1)f = \frac{dm}{m+1} = \frac{uf}{u-f}$$

$$d = u + v = (m+1)u = \left[\frac{1}{m} + 1\right] = \frac{f(m+1)^2}{m}$$

$$m = \frac{v}{u} = \frac{I}{O} = \frac{d-u}{u} = \frac{v}{d-v} = \frac{f}{u-f}$$

Bear in mind that when you are using an enlarger or projector the 'object' refers to the negative or transparency; the 'image' is that projected on the baseboard or screen.

Depth of field

When the object distance is greater relative to focal length, the simplest way to calculate depth of field is to work from hyperfocal distance (see Glossary). This gives sufficient accuracy for most practical purposes.

$N = f$-number

c = diameter of acceptable circle of confusion

h = hyperfocal distance

$$h = \frac{f^2}{Nc}$$

Distance from lens to nearest part of object in focus $= \dfrac{hu}{(h + u)}$

Distance from lens to farthest part of object in focus $= \dfrac{hu}{(h - u)}$

Exposure increase in close-up work

Owing to the effect of the inverse square law when the lens is located much beyond the focal length from the image plane, exposure time indicated by an external meter should be multiplied by a factor calculated as

$$\frac{v^2}{f^2} = (m + 1)^2 = \left[\frac{u}{u - f} \right]^2$$

Of these the middle formula is the easiest to apply; remember that m is the height of an object divided by its image height on the focusing screen.

Supplementary lenses and focal length

Assuming that the supplementary lens is placed very close to the main lens:

s = focal length of supplementary lens*

When using a converging supplementary:

Combined focal length $= \dfrac{sf}{(s + f)}$

When using a diverging supplementary:

Combined focal length $= \dfrac{sf}{(s - f)}$

Cosine law

Illumination across the field of a lens reduces as the fourth power of the cosine of the angle made between the portion of field and the axis. This means that less light is received at the corners of the frame in the camera than at the centre – noticeably so with wide-angle lenses of non-retrofocus construction. With negative/positive

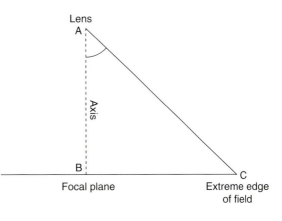

Lens
A

Axis

B

Focal plane

C

Extreme edge
of field

* In same units as f. If in dioptres, divide dioptre value by one metre to get s.

photography the effect of the camera lens is often compensated for by the cosine law effect on the enlarger lens. But with positive/positive printing corner darkening is cumulative.

Light filtration for Ilford multigrade IV black and white paper, using a colour head enlarger

Paper grade effect	Durst (max 170M) head	Durst (max 130M) head	Besseler; Chromega; Vivitar; De Vere	Meopta
00	150Y	120Y	199Y	150Y
0	90Y	70Y	90Y	90Y
$\frac{1}{2}$	70Y	50Y	70Y	70Y
1	55Y	40Y	50Y	55Y
$1\frac{1}{2}$	30Y	25Y	30Y	30Y
2	0	0	0	0
$2\frac{1}{2}$	20M	10M	05M	20M
3	45M	30M	25M	40M
$3\frac{1}{2}$	65M	50M	50M	65M
4	100M	75M	80M	85M
$4\frac{1}{2}$	140M	120M	140M	200M
5	170M	130M	199M	–

B: Gamma and average gradient

The gamma of a film is the slope of the straight-line portion of the characteristic curve of the film, as shown in the graph.

$$\gamma = \tan c = \frac{D_2 - D_1}{\log E_2 - \log E_1} = \frac{\Delta D}{\Delta E}$$

The average gradient \bar{G} is a measure of contrast using the characteristic curve of a film. First you have to find two points on the characteristic curve, as shown in the graph. The first point is at 0.1 above Dmin. The second point is at 1.5 units log relative exposure from the first point. The average gradient is the slope of the line joining the two points.

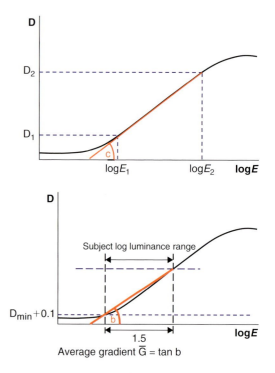

Average gradient $\bar{G} = \tan b$

C: Chemical formulae: Health and safety

Chemicals picked out with asterisk (*) need careful handling (see Safety advice page 376).

Monobath

Single-solution combined developer and fixer for black and white films. Gives a set degree of contrast. Works on the basis of active developer components developing fully during long inertia period before fixer begins to affect film. May cause dichroic fog with some film types. Process to completion – about 6 minutes at 20°C.

Water (hot)	750 ml
Sodium sulphite (anhydrous)	60 g
Hydroquinone	30 g
Sodium hydroxide*	25 g
Phenidone	3 g
Sodium thiosulphate (crystals)	150 g
Cooled water, to make	1 l
Before use, add 40% formaldehyde*	10 ml

Reducers for black and white silver image materials

Reducer R-4a is a subtractive reducer for correcting the effects of overexposure. Maintains image contrast, also removes veil due to fog.

Stock solution A	
Water	250 ml
Potassium ferricyanide	38 g
Water, to make	500 ml
Stock solution B	
Water	1 l
Sodium thiosulphate (crystals)	480 g
Water, to make	2 l

Mix one part solution A, four parts solution B and 27 parts water just before use. When reduction is sufficient, halt action by transferring film/paper to tray of running water. Finally wash fully and dry.

Reducer R-8 is a proportional reducer. Reduces density and also slightly reduces contrast.

Water (about 32°C)	600 ml
Ferric ammonium sulphate	45 g
Potassium citrate	75 g
Sodium sulphite (anhydrous)	30 g
Citric acid	20 g
Sodium thiosulphate (crystals)	200 g
Water, to make	1 l

Use at full strength. Treat negative for 1–10 min (18–21°C), then wash fully. For slower action dilute 1 + 1.

Reducer R-15 has a super-proportional effect, reducing mostly high-density areas and therefore lowering contrast.

Stock solution A	
Water	1 l
Potassium persulphate*	30 g
Stock solution B	
Water	250 ml
Sulphuric acid (10% sol)*	15 ml
Water, to make	500 ml

Use two parts A and one part B. Pre-treat negatives in liquid hardener, then wash. Reduce by inspection, then fix and wash fully.

Iodine bleacher

For total erasure of image, to 'shape-out' subjects on prints; can also be applied on tip of brush to convert black specks to white (these can then be spotted in normally).

Warm water	750 ml
Potassium iodide	16 g
Iodine*	4 g
Water, to make	1 l

Keeps well. Apply undiluted with brush or cottonwool. To remove the intense brown stain, rinse and treat in a small quantity of print fixing bath (10 min). Discard fixer. Wash fully.

Intensifiers for black and white silver materials

Intensifier IN-4 is a proportional type (chromium intensifier). Strengthens image without much change in contrast.

Stock solution	
Water	500 ml
Potassium dichromate*	90 g
Hydrochloric acid (concentrated)*	64 ml
Water, to make	1 l

Use one part stock and ten parts water. Preharden negative. Then bleach the black image in reducer, wash for 5 min and redevelop in regular bromide paper developer. Work in white light (but not direct sunlight). Finally rinse, fix and wash. Can be repeated to increase the effect.

Intensifier IN-6 is a sub-proportional intensifier. Strengthens paler densities more than high-density areas, so it reduces contrast. Works best with fast negative materials.

Stock solution A	
Distilled water (about 21°C)	750 ml
Sulphuric acid (concentrated)*	30 ml
Potassium dichromate*	23 g
Distilled water, to make	1 l
Stock solution B	
Distilled water (about 21°C)	750 ml
Sodium metabisulphite	3.8 g
Hydroquinone	15 g
Wetting agent (Kodak Photo-Flo)	3.8 g
Water, to make	1 l
Stock solution C	
Distilled water (about 21°C)	750 ml
Sodium thiosulphate (crystals)	22.5 g
Water, to make	1 l

For use add two parts B to one part A, stirring continually. (Note: add sulphuric acid to water very slowly, with constant stirring. It is dangerous to add water to sulphuric acid). Then, still stirring, add two parts C and one part A. Wash negative for 5–10 min, treat in hardener for 5 min and then wash again for 5 min before intensifying. Treat negative for up to 10 min (20°C) with frequent agitation. When using a tray, treat only one piece of film at a time and discard solution afterwards. Finally wash negative for 15 min.

Black and white silver halide emulsion

Chlorobromide enlarging type. Normal contrast, warm black tones.

Solution A	
Water	750 ml
Gelatine	25 g
Potassium bromide	53 g
Sodium chloride	15 g
Cadmium chloride*	2 g
Hydrochloric acid (30% sol)*	2.5 ml
Solution B	
Water	1400 ml
Silver nitrate*	100 g
Solution C	
Water	250 ml
Gelatine	150 g

Bring all the above solutions to 60°C. Then, under amber safelighting, add solution B to solution A in three separate and equal parts at intervals of 5 min. Some 5 min after the last addition, add solution C.

Ripening. Hold the emulsion at 60°C for 30–45 min, covered from all light.

Coating additions. Cool the emulsion (but keep it liquid enough to coat paper – about 40°C). Then make the following additions (quantities here per litre of emulsion).

Potassium bromide (10% sol)	2 ml
Chrome alum (10% sol)	15 ml
Formalin (40%), 1 part plus 3 parts water*	40 ml
Alcohol (rectified spirit)	10 ml
Glycerine	10 ml
Sulphuric acid, 1 part in 10 parts water*	3 ml

Once prepared, the emulsion can be stored in an opaque container in a refrigerator. For coating, follow information as for commercial emulsion.

Handling and using chemicals safely

Most common chemicals used in photography are no more dangerous to handle than chemicals – oven cleaners, insect repellents, adhesives – used as a matter of course around the home. However, several of the more special-purpose photographic solutions such as bleachers, toners and intensifiers do contain acids, irritant or toxic chemicals which must be handled with care. These are picked out with an asterisk (*) in the formulae given here and earlier. Your response to direct contact with chemicals may vary from finger staining to direct irritation such as inflammation and itching of hands or eyes, or a skin burning or general allergic reaction which may not appear until several days later. People who suffer from any form of skin disease, or from allergic conditions such as hay fever or asthma, should be particularly careful as their skin tends to be more sensitive.

The following guidelines apply to all photographic chemical processes:

- Avoid direct skin contact with all chemicals, especially liquid concentrates or dry powders. Do this by wearing thin plastic (disposable) gloves, and using print tongs when lifting or manipulating prints during processes in trays.
- Avoid breathing in chemical dust or fumes. When weighing or dissolving dry powders work in a well-ventilated (but not draughty) area. Do not lean over what you are doing, and if possible wear a respiratory mask (the fabric type as used by bikers is inexpensive).
- Be careful about your eyes. When mixing up chemicals wear eyeshields, preferably the kind you can wear over existing spectacles. (Remember not to rub an eye with a chemically contaminated gloved hand during processing.) If you do splash or rub an irritant into your eye rinse it with plenty of warm water immediately. Repeat this at least for 10 min – it is important that the eye surface be washed and not just the eyelids. Install a bottle of eye-wash somewhere close to where you are working.
- Keep things clean. Liquid chemical splashes left to dry-out turn to powder which you can breathe in or get on your hands or clothes, as well as damaging films and equipment. Similarly do not leave rejected test prints, saturated in chemical, to dry out in an open waste bin close to where you are working. To prevent chemicals getting on your clothes wear a PVC or disposable polythene-type apron.

- Labels are important. Carefully read warnings and procedures, the chemical manufacturer has printed on the label or packaging, especially if you have not previously used the product. When a product is, or contains, a chemical which may be dangerous the manufacturer must by law publish a warning. The warning notice may incorporate a symbol plus a risk statement and safety statement advising you of any simple first-aid actions to follow if necessary.
- Clearly label the storage containers for chemicals and stock solutions you have made up yourself. Never, ever, leave photographic chemicals in a bottle or container still carrying a food or drink label. Conversely do not put food in empty chemical containers.
- Keep chemicals and food and drink well separated. Even when properly labelled keep all your chemicals well out of reach of children – never store them in or near the larder. Avoid eating in the darkroom, or processing in the kitchen where food is prepared.
- Chemical procedure. Where a formula contains an acid which you must dilute from a concentrated stock solution, always add the acid slowly to the water (adding water to acid may cause splattering). Do not tip one tray of chemical solution into another of a different kind, as when clearing up – cross-reaction can produce toxic fumes.
- In rooms where chemicals are handled and processing machines run every day you may need to install an extra local ventilation system. Make sure this draws fumes away from you, not towards you.

D: Lighting and safety

Mishaps with lighting are a common cause of accidents in photography. Here are some safety guidelines:

1. Lighting heads are potentially most unstable when their floor stands are extended to full height. Make sure the whole unit will not topple over if a cable is tugged – clip the cable to the stand at floor level. Weigh down the base if a sudden gust of air might bowl over a unit (a monobloc head with umbrella or softbox fitted and raised to the top of its stand is especially vulnerable).
2. Try to run cables where they will not be walked over or stood on. Do not overload cable with too many lights through the use of distributor boxes or adaptors. Avoid powering a lighting unit through cable tightly coiled on a drum. Electricity can heat a coiled-up cable until it smoulders.
3. Do not drape materials over incandescent lamp sources to diffuse or filter light. Use the proper fittings which space accessories away from hot surfaces. Fires can also start from litter (for example, background paper) trapped between electrical plugs and sockets.
4. Lights or powerpacks suspended from ceiling track must be fitted with safety chains. Always raise these overhead units after use; similarly lower floor standing units.
5. Electricity and water (including condensation) do not mix. Avoid storing or using lighting where it may come into contact with moisture unless specially protected first.
6. Never open up an electronic flash to attempt to repair it. Units are not intended for user servicing, and even a small flashgun may give you a shock. Do not disconnect, or reconnect, a flash head to a fully charged powerpack because this may cause contacts to 'arc-over'.
7. Make sure all your lighting equipment is efficiently grounded ('earthed').

E: Batteries

Batteries are vital power sources for most kinds of cameras, power-winders, hand flash units and exposure or colour temperature meters. So battery failures mean breakdowns that can ruin

a shooting situation, especially when on location, unless you can anticipate problems. Each of the main types of battery has different practical characteristics.

Alkaline: Good staying power, as needed for micromotors and camera circuitry, as well as flash units and meters. Virtually leak-proof. Good shelf life, and still work quite well at low temperatures.

Nickel cadmium (Ni-Cad): These batteries are rechargeable. Batteries and charging gear are expensive, but with two batteries and a charger you should always have fresh battery supplies. However, Ni–Cads need charging more often than you would have to replace alkaline types, so you may be caught out by your batteries 'dying' on a shoot. Ni–Cad batteries do not have infinite life, and need recharging more frequently as they age. Since these batteries deliver high amperage they can damage components in some electronic circuits, and so should only be used if specifically recommended by the equipment manufacturer.

Silver oxide: Very suitable for LED displays in camera viewfinders, etc. Gives constant voltage throughout a long life.

Lithium: Covers a number of individual types, all of growing importance. Has a long storage life. However, unless your equipment is specifically designed for lithium batteries, their useful life may be short. They must be effectively leak-proofed – never leave an exhausted lithium battery in any equipment.

Storing batteries

Remember, batteries work by chemical reaction, which is speeded up by high temperature and slowed down in the cold. Warm storage reduces life – the spare batteries in your pocket are probably losing power almost as fast as those in your camera. At low temperatures many batteries become sluggish. Outside on a cold day you may have to raise battery temperature with body heat to gain sufficient power to run your equipment. By the same token batteries sealed into a polythene bag and stored in a refrigerator or freezer have greatly extended shelf life.

Battery care

- Always check the polarity of batteries before fitting. Make sure they face the appropriately marked terminals.
- As far as possible, when you load a battery run a (cleaned) pencil eraser over both contacts. Complete the process by rubbing the contacts on clean paper. This can improve performance by 50%.
- Never attempt to recharge batteries other than Ni–Cad types.
- Do not attempt to open battery cases. Do not throw any battery into the fire. Keep batteries away from young children.
- It is always best to remove batteries before storing equipment for more than a week or so. Avoid leaving any exhausted battery in any equipment, and change your batteries at least once a year.

F: Colour conversion filter chart

Locate the colour temperature of your subject light source in the left-hand column. In the right-hand column find the colour temperature to which your film is balanced. Use a straight edge to connect these two figures (see example) and read off the number of the correction filter you need from the middle column. In the example shown a subject in 5500 K daylight exposed onto type B tungsten film requires use of an 85B filter.

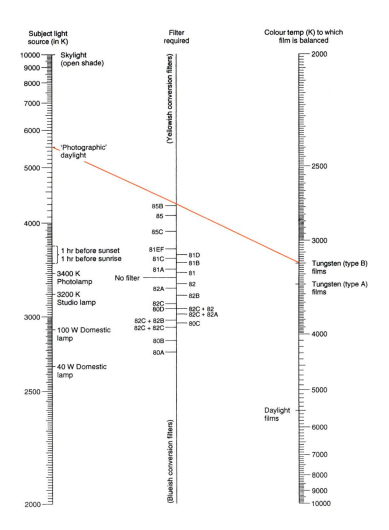

G: Ring around chart

Chart mapping the relationship of filter colour and strength. Strongest filtration is furthest from the centre. Using combinations of filters you can change the colour of light in directions between the main 'spokes' – for example, choosing yellowish orange (10R + 20Y) or reddish orange (20R + 10Y). Filter values hold good for CC filters used in shooting or printing; also for the relative strengths of filters in a colour head enlarger. To make up red, green and blue use combinations of yellow, magenta and cyan filters.

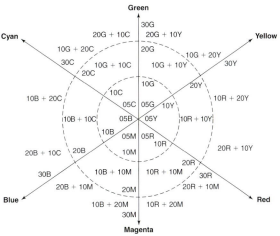

Glossary

Abbe number The reciprocal of *dispersion*.

aberrations Optical errors in a lens which limit its capabilities – causing the images it forms to differ from subject appearance, usually in small details.

accelerator Chemical ingredient of developer to speed up the otherwise low activity of developing agents. Normally an *alkali* such as sodium carbonate, borax or (high-contrast developers) sodium hydroxide. Also known as 'activator' or 'alkali component'.

achromatic lens Corrected for chromatic aberration exactly in two separate wavelengths, usually red and blue, which are brought into the same focus plane.

acid Chemical giving solutions in water with pH below 7. Because acid neutralizes an alkali, acidic solutions are often used to halt development – as in *stop bath* or *fixer*.

active pixel sensor See *CMOS*.

acutance Physical measure of how the transition from high density to low density reproduces in a developed film which has been exposed to a high contrast (test chart) subject.

A/D converter A device used to convert analogue (continuously variable) signals to digital (discrete steps) data.

adaptation Ability of the eye to change its sensitivity to light (generally, or in different colour receptors). Adaptation occurs naturally when there is a change in the colour or intensity of the subject light.

adaptor ring Narrow threaded ring which fits the front rim of a lens to allow use of accessories of a different ('step-up' or 'step-down') diameter.

additive colour processes Processes which represent subject colours by adding together different quantities of primary coloured light – red, green and blue, characterized by the use of narrow cutting red, green and blue filters or the equivalent phosphors.

additive printing Printing onto colour paper by giving separate red, green and blue light exposures.

addressability Refers to how many points on the display screen can be addressed by the graphics card adapter.

AE Automatic exposure metering.

AE lock (AE-L) Control for holding a particular automatic exposure reading in the camera's memory.

aerial perspective Sense of depth conveyed by changes of tone with distance. Typically seen in a rolling landscape when atmospheric haze is present lowering the contrast of distant areas.

AF Autofocus.

AF illuminator Infrared source, in camera flashgun or built into body, used to illuminate subject and assist the image-measuring autofocus lens mechanism.

AF lock (AF-L) Locks an autofocus lens in its present focus setting.

alkali Chemicals giving solutions in water with pH above 7. Solution feels slippery to the touch, can neutralize acid. See also *accelerator*.

aliasing Also known as 'jaggies'. A rough-edge effect seen most clearly on diagonal lines in an electronic image. Created by undersampling. Forms a noticeable 'staircase' appearance due to the large square pixels present. Becomes invisible in high-resolution (small pixel) images.

ambient light General term covering existing subject lighting, i.e. not specially provided by the photographer.

anaglyph Method of viewing stereo pairs by which left- and right-hand positive stereo images are presented overlapped and in contrasting colours (typically deep red and deep green). You view these results through spectacles with green and red eyepieces, so that each eye sees only its respective image and you experience one 3D picture.

anastigmat lens Lens corrected to be largely free of astigmatism (totally so at one subject distance), and having minimal curved field.

angle of view Angle, formed at the lens, between lines from the extreme limits of a (distant) scene just imaged within the diagonal of the picture format. Varies with focal length and format size.

anhydrous (anhyd) Dehydrated form of a chemical. More concentrated than the same substance in crystalline form.

ANSI speed number American National Standards Institute number designating the light sensitivity of a printing paper.

anti-aliasing filter A filter in front of the digital sensor and behind the camera lens, minimizing aliasing and moire patterns.

anti-halation Light absorber present in film to prevent reflection or spread of light giving 'haloes' around bright highlights. Disappears during processing.

aperture preview SLR camera control to close the lens diaphragm to the actual setting used when exposing. For previewing depth of field.

aperture priority mode You set the lens aperture you require and the camera sets the appropriate shutter speed, to give correct exposure according to the camera's built-in metering system.

apochromatic (apo) lens Lens highly corrected for chromatic aberration at three wavelengths (usually blue, green and red) instead of the customary two. Also dispenses with the need to correct your focus setting when taking infrared pictures.

APS Advanced photographic system. System of amateur easy-load cameras and film 24 mm wide, introduced in 1996.

area array A CCD sensor in the form of a flat grid of photosites. Therefore allows the full image in the camera to be captured instantaneously, i.e. moving subject matter, or use of flash.

archival processing Procedures during processing aiming for the most stable image possible.

artificial light General term for any man-made light source. Artificial-light film, however, normally refers to tungsten illumination of 3200 K.

ASA American Standards Association, responsible for ASA system of speed rating. Doubling the ASA number denotes twice the light sensitivity. Now replaced by *ISO*.

aspheric contour A shape not forming part of a sphere. In lens manufacture this is physically difficult because most grinding/polishing equipment functions with spherical action.

auto-bracketing A rapid series of pictures taken by the camera automatically, each giving a slightly different exposure.

autochrome Early colour transparency (plate) system, using a mosaic of additive colour filters.

autofocus System by which the lens automatically focuses the image (for a chosen area of subject).

Av Aperture value. Auto-exposure camera metering mode. You choose the aperture, the meter sets the shutter speed. (Also known as *aperture priority* mode.)

average gradient A measure of contrast using the characteristic curve of a film. It is obtained by finding two points on the characteristic curve, the first at 0.1 above Dmin and the second at 1.5 units log relative exposure from the first point and taking the slope of the line joining the two points.

B setting See *bulb*.

bag bellows Short, baggy form of bellows used on view cameras for a wide-angle lens. Allows camera movements otherwise restricted by standard lens bellows.

barn doors Set of folding metal flaps fitted around front of spotlight. Controls light spill or limits beam.

barrel distortion Aberration by which the image of a square is more magnified at the centre than at its edges – forming a shape like the cross-section of a barrel.

barrier filters Deep red filters which stop blue and green wavelengths or visually opaque filters. Used for infrared photography.

baryta paper See *fibre-based paper*.

baseboard camera Camera with fold-open baseboard, which supports lens and bellows.

between-lens shutter Bladed (or 'leaf') shutter positioned between elements of a lens, close to aperture.

bicubic interpolation Interpolation method where the new pixel is calculated involving 16 of the pixel's neighbouring values.

bilinear interpolation Interpolation method where the new pixel is calculated by taking an average of its four closest neighbours.

biological decay Type of deterioration in photographic media. It occurs due to living organisms, such as mould and bacteria that damage films and prints.

bit Short for binary digit. The smallest unit of digital information in a computer, a 1 or a 0.

bit depth The number of bits used to represent each pixel in a digital image. (Determines its colour or tone range.)

bitmapped An image formed by a grid of pixels. The computer assigns a value to each pixel – ranging from 1 'bit' of information (simply black or white) to as much as 24 bits per pixel (assigning *x, y* coordinates and value) for full colour images.

black body (Planckian radiator) A solid metal dark body that does not reflect incident light. When heated it becomes incandescent and radiates continuously throughout the spectrum. It first emits red light and as the temperature increases, its colour changes towards blue or 'white hot'.

bleacher Chemical able to erase or reduce image density.

blocking Artefact due to compression (JPEG). The edges of the pixel blocks created by the compression algorithm may not match exactly as a result of information being discarded from the block.

blooming The electronic equivalent of flare. Leakage of charge between CCD elements caused by gross overexposure forms streaks or haloes around bright image highlights.

blooming, of lenses See *lens coating*.

blue-sensitive Emulsion sensitive to the blue region only of the visible spectrum. Also known as 'ordinary'.

bounced light Light which is reflected off an intermediate surface before reaching the subject. If the surface is relatively large and matt surfaced the resulting illumination will be soft in quality.

bracket In exposure, to take several versions of a shot giving different exposure levels. See also *autobracketing*.

brightness range The difference in luminance between darkest and lightest areas of the subject or image. Combined effect of lighting ratio and subject reflectance range.

bromide paper Printing paper with predominantly silver bromide emulsion.

bubble-jet Inkjet printer technology where each ink is forced into a tiny nozzle by heat.

bulb Also 'brief'. The B setting on a shutter – keeps the shutter open for as long as the release remains pressed.

bulk film Film sold in long lengths, usually in cans.

burning-in See *printing-in*.

burst mode Mode in digital cameras to capture a rapid sequence of images (similar to the motor drive in film cameras).

byte Standard measurement of digital file size. One byte represents 8 binary digits, allowing 255 possible numerical combinations (different sequences of 1s and 0s). One kilobyte is 1024 bytes and so on. See also *grey level*.

C-41 Processing chemicals and procedure used for the vast majority of colour (and monochrome chromogenic) negative films.

cable release Flexible cable which screws into the camera shutter release. Allows shutter to be fired (or held open on 'B') with minimal shake.

capacitor Unit for storing and subsequently releasing a pulse of electricity.

cast Overall bias towards one colour.

CC value (colour compensating value) It is the nominal value of the required CC filter.

CCD element A single light-sensitive area within a CCD (charge-coupled device) able to record a unique image detail. Known also as a photosite. The distance between the centres of two adjacent CCD elements is known as their element pitch.

CD-ROM Compact disc, read-only memory. Similar in appearance to 5.25 in audio CD, able to carry large quantities of computer compatible digital data, including images and application software programs.

CdS Cadmium disulphide. Battery-powered light sensor cell, widely used in exposure hand meters.

characteristic curve Graph relating image density to \log_{10} exposure, under given development conditions. Also known as H and D curve.

chemical decay Type of deterioration in photographic media. It is related to changes of the chemistry of the photographic image.

chlorobromide paper Warm-tone printing paper. Emulsion contains silver chloride and silver bromide.

chromogenic process Colour process which uses dyes chemically formed during processing to create the hues of your final image. Results contain no silver.

CI See *contrast index*.

cibachrome Outdated product name for dye-bleach colour print material now known as Ilfochrome.

CIE Commission Internationale de l' Éclairage. Originator of a standard system for precise description of colours.

circle of acceptable definition Defines the physical extent of an image through the lens that will be sharp and conform to some measure of acceptable objective image quality.

circles of confusion Discs of light making up the image formed by a lens, from each point of light in the subject. The smaller these discs the sharper the image.

CIS (contact image sensor) Scanner technology based on red, green and blue LEDs and a row of sensors which has width equal to the width of the scanning area, i.e. the glass plate.

click stops Aperture settings which you can set by physical 'feel' as well as by observing a printed scale.

clipping Occurs when one or more of the red, green or blue values of the output image reaches the maximum or minimum value of which the system is capable.

close-up lens Additional element added to the main lens, to focus close objects.

closed loop imaging system Hardware chain which consists of a few high-end devices, usually with a single input and output method.

CMM (colour management module) Software 'engine' which performs all the calculations for colour conversions.

cold-light enlarger Enlarger using a fluorescent tube grid. Gives extremely diffused illumination. Also known as a cold-cathode enlarger.

CMOS (complementary metal-oxide semiconductor) More recent, and potential successor to CCD as an electronic imaging light-sensor. Advantages include higher pixel count, less battery power consumption and lower cost.

CMYK Cyan, magenta, yellow (and black). The first three are the basic subtractive colour dyes formed in most colour emulsions, and for printers' inks. (As pure black is unobtainable by combining CMY inks, it is added as a '4th colour' in printing, to improve image body and contrast, and to economize in the use of the much more expensive colour inks, if all three would be present in any area.)

colloidal silver A suspension of finely divided silver particles – e.g. coating the bottom of trays and deep tanks containing used developer, or covering the emulsion itself as 'dichroic fog'.

colour development A step in processing (or toning) in which coupler compounds form dyes where development is taking place.

colour filter array An arrangement where each pixel of the sensor is covered by a red, green or blue filter.

colour gamut The range of colours that can be output by an imaging system under particular conditions.

colour head An enlarger lamphead with a CMY colour printing filtering system built in.

colour interpolation See *demosaicing*.

colour separation exposures A series of three separate exposures, taken through deep red, green and blue filters onto panchromatic black and white film. By recombining these images in appropriate final dyes, inks or pigments, all the hues of the original scene can be recreated.

colour management system (CMS) Electronic calibration program to ensure uniformity of colour appearance of digital images across input/monitor/output devices. Should ensure that what you see on the monitor matches what you finally receive printed out.

colour space Three-dimensional system where each colour is described by three coordinates.

colour temperature Way of defining the colour of a (continuous spectrum) light source, in Kelvin. Equals the temperature, absolute scale, at which a blackbody radiator would match the source in colour.

complementary colours Resulting colour (cyan, magenta or yellow) when one of the three primary colours (red, green or blue) is subtracted from white light. Also called 'subtractive primaries', 'secondary colours'.

compression Compression of digital image data, to reduce storage requirements or transmission speed across networks. Can be 'lossless' or 'lossy' (allowing greater compression at the expense of resolution). See also *JPEG*.

condenser Simple lens system to concentrate and direct light from a source, e.g. in a spotlight or enlarger.

contact print Print exposed in direct contact with negative, therefore matching it in size.

contrast index (CI) A measure of contrast used by Kodak. Determined, in simple terms, by drawing an arc 2.0 (baseline) units long cutting the material's characteristic curve and centred on a point which is 0.1 units above minimum density. The slope of the straight line joining these two points is the contrast index. You give it a numerical form by continuing the straight line until it cuts the baseline, then quote the tangent of the angle made. Typically a film developed to a CI of 0.56 should print well on grade 2 paper, using a diffuser enlarger.

control strips Pre-exposed strips of film or paper used to test the accuracy and consistency of processing.

coupled dyes Compounds which have reacted to the (by)products of colour development to form visible colours.

covering power The area of image considered of useful quality that a lens will produce. Must exceed your camera picture format, generously so if movements are to be used.

CPU Central processing unit. The main box-like part of a computer, containing its processor chip and motherboard.

crop factor The ratio of the sensor format relative to a 35 mm frame.

cropping To trim one or more edges of an image, usually to improve composition.

cross front Camera movement. Sideways shift of lens, parallel to film plane.

CWA Centre-weighted average. Exposure measured by averaging out picture contents, paying more attention to central areas than corners.

CRT Cathode ray tube. Display technology based on a vacuum tube with an anode, a cathode and three electron guns. A layer of phosphors is inside the front face of the tube, grouped in triads for red, green and blue colours.

D log E curve See *characteristic curve*.

D_{max} Maximum density.

D_{min} Minimum density.

dark current Spurious electrical charge which progressively builds up in CCD elements without exposure to light. Creates 'noise'.

darkslide Removable plastic or metal sheet fronting a sheet-film holder or film magazine.

data migration Periodical transfer of digital data from old storage to new media.

daylight film Colour film balanced for subject lighting of 5500 K.

DCS Digital camera system. The designation used by Kodak/Nikon for their range of SLR digital cameras.

dedicated flash Flash unit which fully integrates with camera electronics. Sets shutter speed; detects film speed, aperture, light reading, subject distance, etc.

demosaicing The process of calculating missing colour values from adjacent colour filtered pixels.

dense Dark or 'thick', e.g. a negative or slide which transmits little light. Opposite to 'thin'.

densitometer Electro-optical instrument for reading the densities of a film or paper image.

density Numerical value for the darkness of a tone. The log (to base 10) of *opacity* (qv).

depth mode Automatic-exposure camera program which aims to preserve as much depth of field as possible in selecting aperture and shutter speed settings.

depth of field Distance between nearest and furthest parts of a subject which can be imaged in acceptably sharp focus at one setting of the lens.

depth of focus Distance of the film (or printing paper) can be positioned either side of true focus while maintaining an acceptably sharp image, without refocusing the lens.

developing agent Chemical ingredient(s) of a developer with the primary function of reducing lightstruck silver halides to black metallic silver.

device-dependent colour space Colour space native to input and output devices.

device-independent colour space Colour space that specifies colour in absolute terms.

diaphragm Aperture formed by an overlapping series of blades. Allows continuous adjustment of diameter.

diffraction Change in the path of light rays when they pass close to an opaque edge.

diffusion transfer process Any process by which a positive photographic print is made by physically transferring silver, or dyes, from the exposed material onto a receiving surface.

digital Something represented by, or using, numbers. A string of pulses of either 0 or 1 values only. Images in digital form are relatively easy to manipulate electronically, edit and re-record

without quality losses. Also used in photography as a general term to differentiate forms of image sensing, processing, etc. which function by electronic rather than chemical means.

digital lenses Lenses, normally for medium- or large-format cameras, designed to give appropriately high optical image resolution and flat field to match the performance of high-end matrix or linear array digital (CCD) sensors.

DIN Deutsche Industrie Normen. German-based system of film speed rating, much used in Europe. An increase of 3 DIN denotes twice the light sensitivity. Now replaced by *ISO*.

dioptre Reciprocal of a metre. The dioptric power of a lens is its focal length divided into 1 m.

dispersive power Related to the change in the refractive index of the optical material with respect to the wavelength of the light. The greater the difference between the refractive indexes for red and blue light, the greater the dispersion in the glass.

dithering Method used by non-continuous tone printers to create all the colours of the digital image using a limited number of inks and more than one dots per pixel.

dodging See *shading.*

dome ports Used in the housings for underwater photography. Dome ports are used for wide-angle lenses. The curvature of the dome is ideally matched with the focal length of the lens.

DPI Dots per inch. A measure of the image resolution of an electronic printer.

drum scanner Highest quality scanner for transparencies, negatives and prints. Originals are mounted on the curved surface of a rotating transparent drum, read by a fine beam of transmitted or reflected light line by line and gradually advancing in very fine increments.

drying mark Uneven patch(es) of density on film emulsion, due to uneven drying. Cannot be rubbed off.

DSLR Digital single lens reflex camera.

dummy pixels See *optically black pixels.*

DX coding Direct electronic detection of film characteristics (speed, number of exposures, etc.) via sensors in the camera's film-loading compartment.

dye-bleach processes Colour processes by which three even layers of ready-formed dyes are destroyed (bleached) in certain areas. The dyes remaining form the final coloured image.

dye-image film Film in which the final processed image comprises dyes, not black silver.

dye-sublimation A desktop digital printing process which uses tiny heating elements to evaporate CMY pigments from a plastic carrier band, depositing these smoothly onto a receiving surface such as paper.

dynamic range Electronic terminology for the maximum tone range that a recording medium can capture.

E-6 Processing chemicals and procedure used for the vast majority of colour slide/transparency films.

easel See *masking frame.*

edge numbers Frame number, film-type information, etc. printed by light along film edges.

effective diameter (of lens aperture) Diameter of light beam entering lens which fills the diaphragm opening.

electronic flash General term for common flash units which create light by electronic discharge through a gas-filled tube. Tubes give many flashes, unlike expendable flashbulb systems.

emulsion Mix of light-sensitive silver halides, plus additives and gelatin.

emulsion lift Term referring to the process by which the image-carrying top surface of a Polaroid print is removed from its paper base, physically manipulated and resited on a new (paper or film) support.

encoding The process of turning the pixel values into binary code.

EV Exposure value.

exposure-compensation dial Camera controls effectively overriding film-speed setting (by + or – exposure units). Used when reading difficult subjects, or if film is to be 'pushed' or 'held back' to modify contrast.

exposure latitude Variation in exposure level (over or under) which still produces acceptable results.

exposure zone One of the 0-X one-stop intervals in which the exposure range of a negative is divided in the zone system.

extension tube Tube, fitted between lens and camera body, to extend lens-to-film distance and so allow focusing on very close subjects.

f-numbers International sequence of numbers, expressing relative aperture, i.e. lens focal length divided by effective aperture diameter. Each change of *f*-setting halves or doubles image brightness.

false colour film Film designed to form image dyes which give a positive picture in colours substantially different to those in the subject.

fast Relative term – comparatively very light-sensitive.

ferrotype sheet Polished metal plate used for glazing glossy fibre-based prints.

fibre-based paper Printing paper with an all-paper base.

field angle of view See *angle of view.*

field camera Traditional-type view camera, often made of wood. Folds for carrying on location.

file format Defines the way in which image data is stored.

file size Volume of digital data. Determined by (a) chosen image resolution and (b) the dimensions of your final image.

fill factor The ratio of the photosensitive area inside a pixel to the pixel area.

fill-in Illumination that lightens shadows, so reducing contrast.

film holder Double-sided holder for two sheet films, used with view cameras.

film pack Stack of sheet films in a special holder. A tab or lever moves each in turn into the focal plane.

film plane The plane, in the back of the camera, in which the film lies during exposure.

film speed Figure expressing relative light sensitivity. See *speed point*.

filter (optical) Device to remove (absorb) selected wavelengths or a proportion of all wavelengths.

filter (electronic) A device built into a software program, or added as a 'plug in', to alter a digital image in some specific way. Examples – blur, sharpen, dispeckle and distort shape.

filter factor Factor by which exposure should be increased when an optical filter is used. (Does not apply if exposure was read through lens plus filter.)

fisheye Extreme wide-angle lens, uncorrected for curvilinear (barrel) distortion.

fixer Chemical solution which converts silver halides into soluble salts. Used after development and before washing, it removes remaining light-sensitive halides, so 'fixing' the developed black silver image.

flare Unwanted light, scattered or reflected within lens or camera/enlarger body. Causes flare patches, degrades shadow detail.

flare factor Subject luminance range divided by the illuminance range of its image.

flashbulb Older type of flash source. Usable only once and ignited by simple battery/capacitor system.

flashing Giving a small extra exposure (to an even source of illumination) before or after image exposure. Lowers the contrast of the photographic material.

flash memory Secure Digital or Compact Flash. Card system able to remember image data, even when power is turned off. Used to store images in many compact digital cameras, and removable plug-in card reader, laptop computer, etc.

flat A subject or image lacking contrast, having minimal tonal range. Also the name for a temporary structure used in the studio to simulate a wall.

flat-bed scanner Lightbox-type device able to convert photographic prints, artwork or transparencies up to about 8×10 (including mounted originals) into digitized data for inputting to computer.

flat ports Used in the housing for underwater photography. Flat ports are used with long focal length lenses for close-ups or shots that start or end above the water; they do not require a dioptric correction lens.

fluorescence The visible light radiated by some substances when stimulated by (invisible) ultraviolet radiation.

focal length Distance between a sharp image and the lens, when the lens is focused for an infinity subject. More precisely, between this image and the lens's rear nodal point.

focal plane Plane on which a sharp-focus image is formed. Usually at right angles to lens axis.

focus hold See *AF lock*.

focus priority See *trap focus*.

fog Unwanted veil of density (or bleached appearance, in reversal materials). Caused by accidental exposure to light or chemical reaction.

format or 'frame' General term for the picture area given by a camera.

FP sync Camera shutter flash synchronization circuit designed to suit FP ('focal plane') flashbulbs, now discontinued.

frame transfer array A CCD architecture. It comprises an imaging area, a charge storage area and a serial readout register array.

FTP File transfer protocol.

gamma Tangent of the angle made between the base- and straight-line portion of a film's characteristic curve. In digital imaging devices it is calculated using their transfer function.

gamut See *colour gamut*.

gamut mismatch Occurs when the gamuts of two imaging devices do not coincide.

gelatin Natural protein used to suspend silver halides evenly in an emulsion form. Permits entry and removal of chemical solutions.

glossy Smooth, shiny print-surface finish.

gradation Variation in tone.

grain Clumps of developed silver halide crystals forming the silver image. Coarse grain destroys detail, gives a mealy appearance to even areas of tone.

graininess A subjective measure of film grain, taking into account the overall visual impression of the enlarged result under practical viewing conditions. It has to be based on 'average' observers reporting on just acceptable levels of grain pattern.

granularity An objective measure of film grain. It is measured under laboratory conditions using a microdensitometer which tracks across the processed image of an even mid-grey tone.

grey level Each discrete tonal step in an electronic image, encoded in its digital data. Most electronic images contain 256 grey levels (=8 bits) per colour.

grey scale Set of tones, usually in steps from minimum to maximum density. Grey scales are available on paper or film base. They can be used to lay alongside subjects to act as a guide in final printing. Grey scales exposed onto photographic material act as process control strips.

GN guide number Number for simple flash exposure calculations, being flashgun distance from subject times *f*-number required (ISO 100/21° film). Normally relates to distances in metres.

hard Contrasty – harsh tone values.

hard disk Digital memory device, often permanently housed inside the computer but also in removable form.

hardener Chemical which toughens the emulsion gelatin.

hardware Equipment. In digital photography the computer, film scanner, digital back, etc. rather than the software programs are needed to run them. Similarly in silver halide photography items such as the camera, enlarger, processor, rather than film or paper.

high key Scene or picture consisting predominantly of pale, delicate tones and colours.

highlights The brightest, lightest parts of the subject.

histogram The tonal range of an image shown graphically as a chart containing a series of vertical bars, the relative frequency of occurrence plotted against image density or pixel value.

HMI Hydrargyrum (mercury) medium arc iodide. Specialist continuous-type light source, flicker-free and with a daylight matching colour temperature.

holding back Reducing development (often to lower contrast). Usually proceeded by increased exposure. Also called 'pulling'. Term is sometimes used to mean *shading* when printing.

hot shoe Flashgun accessory shoe on camera; it incorporates electrical contacts.

hue The colour – blue, green, yellow, etc. – of a material or substance.

hyperfocal distance Distance of the nearest part of the subject rendered sharp with the lens focused for infinity.

hypo Abbreviation for sodium hyposulphite, the fixing agent since renamed sodium thiosulphate. Also common term for all fixing baths.

ICC Profile See *profile*.

image adjustments A generic set of operations that are usually performed by the user to enhance and optimize the image. They involve resizing, rotating and cropping of the image, correction of distortion, tone or colour, sharpening and removal of noise.

image noise (in digital images) A random variation in pixel values throughout the image. Often described as the equivalent to grain in silver halide film.

image setter Digital output device. A high-resolution laser exposes image data, typically in screened form, onto photographic film which is then used to make ink printing plates.

incandescent light Illumination produced from electrically heated source, e.g. the tungsten wire filament of a lamp.

incident light Light reaching a subject, surface, etc.

incident-light reading Using an exposure meter at the subject position, pointed towards the camera, with a diffuser over the light sensor.

indexed image Image that contains a reduced range of colours to save on storage space. The palette is a look-up table (LUT) with a limited number of entries (usually 256).

infinity A subject so distant that light from it effectively reaches the lens as parallel rays (in practical terms the horizon).

inkjet printer Digital printer forming images by using a very fine jet of one or more inks.

instant-picture material Photographic material with integral processing, e.g. Polaroid.

integral tripack Three-layered emulsion. Term still often applied to modern colour emulsions which may utilize many more layers but are still essentially responsive to red, green and blue.

interline transfer array A CCD architecture. Each pixel has both a photodiode and an associated charge storage area.

internegative Intermediate negative – usually a colour negative printed from a colour transparency to make a negative/positive colour print.

Internet Global connection system between computer networks, for two-way flow of information.

interocular distance The distance between a pair of human eyes.

interpolated resolution See *interpolation*.

interpolation Increasing the number of pixels in an electronic image file by 'filling in' the missing colour information from the averaged values of surrounding pixels. Image definition is reduced. May be necessary if an image was scanned in at insufficient resolution for your final print size.

inverse square law With a point source of light, intensity at a surface is inversely proportional to the square of its distance from the source, i.e. half the distance, four times the intensity.

inverted telephoto lens A lens with rear nodal point well behind its rear element. It therefore has a short focal length but relatively long lens-to-image distance, allowing space for an SLR mirror system.

IR Infrared. Wavelengths longer than about 760 nm.

IR focus setting Red line to one side of the lens focus-setting mark, used when taking pictures on IR film.

ISO International Organization for Standardization. Responsible for ISO film speed system. Combines previous ASA and DIN figures, e.g. ISO 400/27.

joule See *watt-second*.

JPEG Joint Photographic Experts Group. Standard image data 'lossy' compression scheme used to reduce the file size of digital images.

Kelvin (K) Measurement unit of colour temperature. After scientist Lord Kelvin.

key light Main light source, usually casting the predominant shadows.

kilowatt One thousand watts.

kilobyte 1024 bytes of data.

large format General term for cameras taking pictures larger than about 6 × 9 cm.

laser printer Normally refers to digital printers using the xerographic (dry toner) process, although several other devices such as light-jet employ laser technique.

latent image Exposed but still invisible image.

latitude Permissible variation. Can apply to focusing, exposure, development, temperature, etc.

LB value (light-balancing value) Refers to the red or blue LB filter. It is the difference between the selected film's colour temperature and that of the measured light source.

LCD screen Liquid crystal display screen. Commonly used for laptop computer monitors and desktop computer displays; small playback or viewfinder screens attached to compact digital cameras or used as a transparent frame on an overhead projector to form a 'data projector' for presenting large images direct from computer memory. Also the source of electronically energized black lettering, symbols, etc. used in a camera's viewfinder or top-plate readout.

leafshutter See *between-lens shutter.*

LED Light-emitting diode. Gives illuminated signal (or alphanumeric information) alongside camera viewfinder image, and in other equipment displays.

lens coating Transparent material deposited on lens glass to suppress surface reflections, reduce flare and improve image contrast.

lens hood, or shade Shield surrounding lens (just outside image field of view) to intercept sidelight, prevent flare.

light meter Device for measuring light and converting this into exposure settings.

light trap Usually some form of baffle to stop entry of light yet allow the passage of air, solution, objects, according to application.

lighting ratio The ratio of the level of illumination in the most strongly lit part of the subject to that in the most shadowed area (given the same subject reflectance throughout).

line image High-contrast image, as required for copies of line diagrams or drawings.

linear array CCD sensor comprising a narrow row of RGB bar-filtered photosites. This scans across the image (within a camera or flat-bed scanner, for instance) driven by a stepper motor.

linear perspective Impression of depth given by apparent convergence of parallel lines, and changes of scale, between foreground and background elements.

line pair (lp) One black line plus the adjoining white space on an optical test chart pattern.

lith film Highest contrast film. Similar to line but able to yield negatives with far more intense blacks.

log E scale Range of exposures expressed on a logarithmic scale (base 10). Here each doubling of exposure is expressed by an increase of 0.3.

long-peaking flash Electronic flash utilizing a fast stroboscopic principle to give an effectively long and *even* peak of light. This 'long burn' allows an FP shutter slit to cross and evenly expose the full picture format, at fastest speeds.

lossless compression Compression algorithm that retains all the information, allowing perfect reconstruction of the image.

lossy compression Compression algorithm that discards information which is, visually, less important.

low key Scene or picture consisting predominantly of dark tones, sombre colours.

luminance The amount of light energy emitted or reflected.

LUT Look-up table.

M Medium-delay flashbulb. Flash sync connections marked M close the circuit before the shutter is fully open. Sometimes found on vintage cameras. Do not use for electronic flash.

macro lens Lens specially corrected to give optimum definition at close subject distances.

macrophotography Term often used incorrectly, see *photomacrography*.

magnification In photography, linear magnification (height of object divided into height of its image).

manual override The capability to operate an automatic camera in a manual, i.e. non-automatic mode.

masking General term for a wide range of methods of selectively modifying tone, contrast and colour rendering of existing negatives or transparencies before printing or reproduction. Achieved through sandwiching a parent image with film bearing positive or negative versions made from it and having controlled tonal characteristics. Also achieved electronically, e.g. during scanning for photomechanical reproduction.

masking frame Adjustable frame which holds printing paper during exposure under enlarger. Also covers edges to form white borders.

mat, or overmat Cardboard rectangle with cut-out opening, placed over print to isolate finished picture.

matt Non-shiny, untextured surface finish.

maximum aperture The widest opening (lowest *f*-number) a lens offers.

ME Multiple exposure control. Allows superimposition of pictures in the camera.

mechanical decay Type of deterioration in photographic media. It is related to changes in the structure of the photographic image, such as its size and shape.

megabyte (MB) 1024 kilobytes of data.

megapixel One million pixels.

microlenses Small lenses fitted to the surface of each pixel of a sensor.

microphotography Production of extremely small photographic images, e.g. in microfilming of documents.

micropiezo Inkjet printer technology where a piezo crystal becomes distorted when electric current is applied and the difference in pressure causes ink to be forced out of the nozzle.

midtone A tone midway between highlight and shadow values in a scene.

mired Micro-reciprocal degree. Unit of measurement of *colour temperature*; equal to one million divided by colour temperature in Kelvin.

mirror lens Also 'catadioptric' lens. Lens using mirrors as well as glass elements. The design makes long focal length lenses more compact, less weighty, but more squat.

mirror lock (ML) Enables the viewing mirror of an SLR camera to be locked in the 'up' position while the shutter, etc. is used normally. Used to avoid vibration, or to operate motor drives at fastest framing rates, or to accommodate an extremely short focal length lens.

mode The way in which a procedure (such as measuring or setting exposure) is to be carried out.

modelling light Continuous light source, positioned close to electronic flash tube, used to preview lighting effect before shooting with the flash itself.

modem MOdulator/DEModulator. Converts digital data to analogue signals and as such is the unit which connects your computer to a non-digital telephone system for transmission of information by audio means.

moiré pattern Coarse pattern formed when two or more patterns of regular lines or textures are superimposed nearly but not exactly in register. Term derived from pattern effects when layers of moiré silk are overlapped.

monoblock Generates power for separate flash heads. It contains capacitors which store power at very high voltage to be switched to a number of flash heads.

monochrome Single colour. Also general term for all forms of black and white photography.

monolight Combines the powerpack and the flash head. Typically rated at 250–500 W sec.

monorail camera Metal-framed camera, built on rail.

motor drive Motor which winds on film after each exposure.

MTF Modulation transfer function. A measure of the ability of an imaging system (lens, or recording medium, or both) to resolve fine detail.

Multimedia Presentation method (often interactive) integrating still images, video, text and audio components. Ranges from theatrical scale shows to CD-ROMs produced for use by individuals on personal computers.

ND Neutral density. Colourless grey tone.

natural vignetting See *vignetting*.

nearest neighbour interpolation Interpolation method where the new pixel value is allocated based on the value of the pixel closest to it.

neutral density filter Colourless grey filter which dims the image by a known amount.

nodal points Two imaginary points on the lens axis where it is crossed by the principal planes of the lens (given that the same medium, e.g. air, is on both sides of the lens). Rotating a lens about a vertical axis passing through its rear nodal point leaves the image of a distant subject stationary – a principle exploited in panoramic cameras.

noise See *image noise*.

normal lens Lens most regularly supplied for a particular camera; typically has a focal length equal to the diagonal of the picture format.

notching code Notches in sheet film, shape-coded to show film type.

offset lithography High volume, ink-based mechanical printing process, by which ink adhering to image areas of a lithographic plate is transferred (offset) to a 'blanket' cylinder before being applied to paper or other suitable receiving surface.

OHP Overhead projector. Lightbox with lens and 45° mirror unit supported above it. Projects large transparencies etc. onto a screen for group viewing.

one-shot processing Processing in fresh solution, which is then discarded rather than used again.

opacity Incident light divided by light transmitted (or reflected, if tone is on a non-transparent base).

open flash Firing flash manually while the camera shutter is held open.

optical resolution Defined by the number of individual elements and their spacing.

optically black pixels Groups of photosites that are covered by a metallic light shield that prevents light from reaching the photosites during exposure.

OLED displays Organic light-emitting diode displays.

ortho Orthochromatic sensitivity to colours. Monochrome response to blue and green, insensitive to red.

out-of-gamut colours The colours, visible to the human observer, which lie outside the gamut of an imaging system.

outputting Creating an actual print or transparency of some kind from a digital image. (Image quality and size mainly determined by file size.)

paletted image See *indexed image*.

pan and tilt head Tripod head allowing smooth horizontal and vertical pivoting of the camera.

pan film Panchromatic sensitivity. Monochrome response to all colours of the visual spectrum.

panning Pivoting the camera about a vertical axis, e.g. following horizontal movement of the subject.

parallax Difference in viewpoint which occurs when a camera's viewfinding system is separate from the taking lens, as in compact and TLR cameras.

PC lens Perspective control lens. A lens of wide covering power on a shift (and sometimes also pivoting) mount. See *shift lens*.

PCS (profile connection space) A device-independent colour space into which all colours are transformed into and subsequently out of it.

PE Continental code for resin-coated paper. See *RC paper*.

PEC Photoelectric cell. Responds to light by generating minute current flow. Used in older, non-battery hand meters, and some cameras.

pentaprism Multi-sided silvered prism. Reflects and converts laterally reversed image on the focusing screen of an SLR camera to a right-reading form.

PF Power focus control. Manual focusing performed electronically by pressing buttons or a lever on the camera body. (Like controlling electrically driven windows in a car.)

pH Acid/alkalinity scale 0–14, based on hydrogen ion concentration in a solution. 7 is neutral, e.g. distilled water. Chemical solutions with higher pH ratings are increasingly alkaline, lower ones acid.

photoCD A Kodak designed CD format for storing photographs as digital files. Typically one disc may contain up to 100 images, each one stored in five levels of resolution.

photoflood Bright tungsten studio-lamp bulb. Often either 3400 or 3200 K.

photogram Image recorded by placing an object directly between sensitive film (or paper) and a light source.

photomacrography Preferred term for extreme close-up photography giving magnification of ×1 or larger, without use of a microscope.

photomicrography Photography through a microscope.

photosite The area on a sensor that contains a photodiode.

pincushion distortion Aberrations by which the image of a square is less magnified at the centre than at its edges – forming a shape like a nineteenth century pincushion.

pixel Abbreviation of 'picture element'. The smallest element capable of resolving detail in a light-sensitive (i.e. CCD) device, or displaying detail on a monitor screen. Digital images are composed of thousands or millions of pixels – the eye merges these differently coloured spots into areas of continuous tones and additively formed colours.

pixel pitch The centre-to-centre distance between pixels. It relates to the overall pixel size. Important in determining the maximum level of detail that the system is able to reproduce.

Planckian radiator See *black body*.

PMT Photomultiplier tube. Light-sensing devices long established in use in drum scanners.

polarized light Light waves restricted to vibrate in one plane at right angles to their path of direction.

polarizing filter Grey-looking filter, able to block polarized light when rotated to cross the plane of polarization, used to block surface reflections, and for haze penetration in landscapes.

Polaroid back Camera magazine or film holder accepting instant-picture material.

positive Image with tone values similar to those of the original subject.

posterized image (digital) An image artefact resulting in large jumps between pixel values. Result of insufficient sampling.

powerpack See *monoblock*.

PPI Pixels per inch. A measure of the image resolution of an electronic scanner or display.

PQ Developer using phenidone and hydroquinone as developing agents.

preservative Chemical ingredient of processing solution. Preserves its activity by reducing oxidation effects.

press focus Lever on most large-format camera shutters. Locks open the shutter blades (to allow image focusing) irrespective of any speed set.

primary colours Of light: red, green and blue.

printing-in Giving additional exposure time to some chosen area, during printing.

profile A data file containing information about the colour reproduction capabilities of a device.

program, programme or P Setting mode for fully automatic exposure control. The camera's choice of aperture and shutter settings under any one set of conditions will then depend on its built-in program(s).

program back Data imprinting camera back with additional camera control features such as autobracketing, time-lapse and exposure program display.

program shift 'Program' mode allows the camera to select both shutter and aperture settings, but the shift control allows user to bias it towards faster shutter speeds, or smaller apertures ('speed' or 'depth'). May also be biased automatically, when you fit either a wide-angle or a telephoto lens.

pulling See *holding back*.

push-processing Increasing development, usually to improve speed or increase contrast.

quantization The process of allocating a continuous input range of tone and colour to a discrete output range which changes in steps.

RAM Random access memory. Integrated circuits providing a temporary data store in a computer, etc., to allow rapid data access and processing. Data held on RAM is lost when the computer is switched off. See also *ROM*.

rangefinder Optical device for assessing subject distance, by comparison from two separate viewpoints.

rapid fixer Fast-acting fixing bath using ammonium thiosulphate or thiocyanate as fixing agent.

RC paper Resin (plastic)-coated base printing paper.

rebate Unexposed parts outside a film's picture areas.

reciprocity failure Breakdown of the usual reciprocal exposure relationship between time and intensity (twice the exposure time compensates for an image half as bright, and vice versa).

reciprocity law Exposure = intensity × time.

reducer Chemical able to reduce the density of a processed image. (Paradoxically the chemical term 'reducing agent' is also applied to developing agents.)

reflected-light reading Measuring exposure (usually from the camera position) with the light sensor pointing towards the subject.

refraction Change in the direction of light as it passes obliquely from one transparent medium into another of different refractive index.

refractive index Relates to the light-bending power of a glass. The refractive index of an optical material varies with frequency and hence wavelength.

relative aperture See *f-number*.

replenisher Solution of chemicals (mostly developing agents) designed to be added in controlled amounts to a particular developer, to maintain its activity and compensate for repeated use.

resampling See *Interpolation*.

resolution The capability of an imaging system to distinguish between two adjacent points in an image and is a measure of the detail recording ability of a system.

restrainer Chemical component of developer which restrains it from acting on unexposed halides.

retrofocus lens See *inverted telephoto lens*.

reversal system Combination of emulsion and processing which produces a direct image of similar tonal values to the picture exposed onto the material.

RGB Red, green, blue. The primary colours of light. The tri-colour (additive) filter colours used in digital cameras, scanners, etc. to record the full spectrum of image colours. Images are also reformed on computer monitors, TV screens and additive photographic colour materials by means of primary coloured phosphors or filter mosaics.

RH Relative humidity.

ring flash Circular electronic flash tube, fitted around the camera lens.

ringing Compression artefact (JPEG), visible around high-contrast edges as a slight 'ripple'.

rising front Camera front which allows the lens panel to be raised, parallel to the film plane.

rollfilm back Adaptor back for rollfilm.

ROM Read only memory. Form of digital memory which can only be read from – cannot be overwritten. The basic instructions that make a computer work, permanently installed at the factory, are stored in ROM. See also *RAM*.

safelight Working light of the correct colour and intensity not to affect the light-sensitive material in use.

saturated colour A strong, pure hue – undiluted by white, grey or other colours.

scanners A variety of computer input devices, able to convert an existing image into a stream of digital data. See *Flat-bed, Drum*, etc.

screen ruling (also screen frequency) The number of rows of dots in a halftone image within a given distance – normally quoted in lines per inch (lpi).

SCSI Small computer systems interface. Cabled hardware used between a computer and peripheral devices. Allows data to be transferred at high speed. (Cable length is, however, restricted.)

second curtain sync Camera synchronization for electronic flash whereby contacts are closed just before the second blind of the FP shutter starts to close. With long-duration exposures this means that flash records sharp detail at the *end* of exposure, and blur trails due to any movement record during the earlier part – e.g. moving objects in pictures 'head up' their blur, and do not record as if moving backwards.

secondary colours See *complementary colours*.

selective focusing Precise focus setting and shallow depth of field, used to isolate a chosen part of a scene.

self-timer Delayed-action shutter release.

shading Blocking off light from part of the picture during some or all of the exposure.

shadows In exposure or sensitometric terms, the darkest important tone in the subject.

sheet film Light-sensitive film in the form of single sheets.

shift camera General term for a bellowless, wide-angle architectural camera with movements limited to up/down/sideways shift of the lens panel. No pivots or swings.

shift lens Wide-covering power lens in a mount permitting it to be shifted off-centre relative to film format.

shutter lag The delay between the moment that you press the shutter release button and the moment that the image is captured.

shutter priority mode You set the shutter speed and the camera sets the appropriate aperture to give correct exposure according to the built-in metering system. Also known as *Tv mode*.

signal-to-noise ratio In digital data the ratio of valid information to unwanted electrical interference. The S/N ratio should always be as high as possible.

silver halides Light-sensitive compounds of silver plus alkali salts of a halogen chemical – e.g. bromine, chlorine, iodine. Now also used as a general term for photography using chemical-coated film and paper, to differentiate it from newer electronic methods of photography, i.e. utilizing CCD light sensors.

slave unit Flash unit which reacts to light from another flash and fires simultaneously.

SLR Single-lens reflex.

snoot Conical black tube fitted over spotlight or small flood. Restricts lighting to a small circular patch.

soft (1) Low contrast. (2) Slightly unsharp or blurred.

spectrum Radiant energy arranged by wavelength. The visible spectrum, experienced as light, spans approximately 400–700 nm.

speed mode Automatic exposure camera program aiming to preserve as much freezing of action as possible in selecting shutter speed and aperture.

speed point Point on a photographic characteristic curve used to determine the speed rating of a film (or paper). For example, in current ISO and DIN systems two points (M and N) are shown on the material's characteristic curve. M lies where processed density is 0.1 above fog. N lies 1.3 log exposure units from point M in the direction of increasing exposure, and development time is picked which makes N correspond to a processed density of 0.8 greater than M. When these conditions are satisfied the exposure at M is the numeral value from which the speed rating is calculated.

spot meter Hand meter, with aiming viewfinder, to make spot exposure readings.

spot mode Narrow-angle exposure reading of the subject with a TTL meter. The small area measured is outlined on camera's focusing screen.

spotting Retouching in small white specks or hairs, generally on prints – using water colour, dye or pencil.

standard lens See *normal lens*.

still life General term for an inanimate object, set up and arranged in or out of the studio.

still video A now largely outdated electronic camera system producing an analogue signal recorded onto an internal floppy disk. Overtaken by modern digital camera devices.

stock shots Photographs taken for long-term picture library use (and often sold time and again over the years). Stock shots are catalogued under thousands of cross-referred subject types. They are increasingly marketed as CD-ROMs containing 100 or so images per disk.

stock solution Chemical stored in concentrated liquid form, diluted for use.

stop bath Acidic solution which halts development, reduces fixer contamination by alkaline developer.

strobe Inaccurate general term for electronic flash. Strictly means fast-repeating stroboscopic lamp or flash.

subject The thing being photographed. Term used interchangeably, and inaccurately, with object, although more relevant to a person, scene or situation.

subtractive colour processes Processes which represent subject colours by superimposed cyan, magenta and yellow images. Each of these layers subtract unwanted quantities of red, green or blue respectively from white light.

super-sampling Chopping an analogue signal range into more digital steps than are required in the final data. (In digital cameras this helps to improve image shadow detail.) Results in an enlarged file.

supplementary lens. See *close-up lens*.

sync lead Cable connecting flashgun to shutter, for synchronized flash firing.

synchro-sun Flash from the camera used to 'fill-in' shadows cast by sunlight.

T setting 'Time' setting available on some large format camera shutters. Release is pressed once to lock shutter open, then pressed again to close it.

tele-extender Supplementary lens system fitted between camera lens and body, to increase focal length. Also reduces the relative aperture of the lens.

telephoto Long focal length lens with shorter back focus, allowing it to be relatively compact.

tempering bath Large tank or deep tray, containing temperature-controlled air or water. Accepts drums, tanks, bottles or trays to maintain their solution temperature during processing.

TFT (thin-film transistor) TFTs control each colour pixel of the LCD screen.

tinting Applying colour (oils, dye, water colours) to a print by hand.

TLR Twin-lens reflex.

tone curve In digital photography a graph, displayable on the computer monitor, representing the ratio of input to output image tone ranges. (A 'no change' situation is represented by a straight line at 45°.) Acts as a control guide when modifying contrast, or density, or the individual tone ranges of each colour channel, e.g. to alter colour balance.

toning Converting a black silver image into a coloured compound or dye. The base remains unaffected.

transfer curve A mapping function of input and output tone values of an imaging device, allowing precise control over specific parts of the tonal range.

transparency Positive image on film. Term includes both 35 mm and 120 slides and larger formats.

trap focus Autofocusing mode by which the camera shutter remains locked until an object moves into the lens's zone of sharp focus.

TTL Through-the-lens camera reading, e.g. of exposure.

tungsten-light film Colour film balanced to suit tungsten light sources of 3200 K.

Tv mode Time value exposure mode. Used on some cameras to designate *shutter priority mode.*

uprating Increasing your film's speed setting (or selecting a minus setting on the exposure compensation dial) to suit difficult shooting conditions. Usually followed up with extended development.

UV Ultraviolet. Wide band of wavelengths less than about 390 nm.

UV filter Filter absorbing UV only. Appears colourless.

value Term used in the Munsell colour system. It refers to a colour's luminance factor or brightness.

variable-contrast paper Monochrome printing paper which changes contrast grade with the colour of the exposing light. Controlled by filters.

View camera Camera (usually large format) in which the image is viewed and focused on a screen in the film plane, later replaced by a film holder. View cameras are primarily used on a stand. See also *field camera.*

viewpoint The position from which the camera views the subject.

vignetting Fading off the sides of a picture into plain black or white, instead of having abrupt edges.

warm tone A brownish black and white silver image. Often adds to tonal richness.

watt-second Light output given by one watt burning for one second. Used to quantify and compare the power output of electronic flash (but ignores influence of flash-head reflector or diffuser on exposure).

wetting agent Detergent-type additive, used in minute quantity to lower the surface tension of water. Assists even action of most non-acid solutions, and of drying.

white light Illumination containing a mixture of all wavelengths of the visible spectrum.

wide-angle lens Short focal length lens of extreme covering power, used mostly on cameras to give a wide angle of view.

working solution Solution at the strength actually needed for use.

X Electronic flash. Any flash sync socket and/or shutter setting marked X is for electronic flash. (Also suits flashbulbs at exposures of 1.8 sec or slower.)

zone system System embracing subject brightness range, negative exposure, development and printing, to give you control over final print tone values. Ideally allows you to previsualize and decide the tonal range of your result at the time of shooting.

zoom lens Lens continuously variable between two given focal lengths, while maintaining the same focus setting.

zooming Altering the focal length of a zoom lens.

Index